ALSO BY JACKIE WULLSCHLAGER

Hans Christian Andersen: The Life of a Storyteller

Inventing Wonderland

Chagall

Chagall

A BIOGRAPHY

Jackie Wullschlager

Alfred A. Knopf New York 2008

THIS IS A BORZOI BOOK
PUBLISHED BY ALFRED A. KNOPF

Copyright © 2008 by Jackie Wullschlager

Library of Congress Cataloging-in-Publication Data
Wullschlager, Jackie.
Chagall : a biography / by Jackie Wullschlager.
p. cm.
ISBN 978-0-375-41455-8
1. Chagall, Marc, 1887-1985. 2. Artists–Russia (Federation)–Biography. I.
Title.
N6999.C46W85 2008
709.2–dc22
[B] 2008006162

Manufactured in the United States of America
First Edition

For William

CONTENTS

ILLUSTRATIONS

IN TEXT

COLOUR PLATES

Chagall, *Nude over Vitebsk,* 1933, oil on canvas

Chagall, *White Crucifixion,* 1938, oil on canvas

Chagall, *Tribe of Simeon,* 1961, stained-glass window for Hadassah Hospital, Ain-Kerem, Jerusalem (Reproduced by courtesy of Hadassah, The Women's Zionist Organization of America, Inc.)

Chagall, stained-glass windows for All Saints, Tudeley, installed 1967–85, East Window of All Saints Church, Tudeley, Kent, England (Reproduced by permission of Tudeley PCC. Detail of angel from window with inscription "VAVA," All Saints Church, Tudeley, Kent. Reproduced by permission of Tudeley PCC.)

Chagall, *Clowns at Night,* 1957, oil on canvas

Chagall, *The Prophet Jeremiah,* 1968, oil on canvas

ACKNOWLEDGEMENTS

My greatest debt is to Meret Meyer Graber, Chagall's granddaughter, without whom this book could not have been written. I would like to thank her first for the exceptional generosity and confidence with which she allowed me access to the Archives Marc et Ida Chagall, including the extensive collection of Chagall's letters and papers hitherto unseen by scholars, and for giving me freedom to quote from them while claiming no influence on my narrative or interpretation. She also put at my disposal the vast resource of drawings, paintings, studies, and photographs, many little known and unpublished, in the family archive, guided me through it to select illustrations, and, in a gesture of extraordinary magnanimity, substantially reduced reproduction fees, which would otherwise have been prohibitive. I owe more than I can say to Meret: I have benefited, too, from her memories of her grandfather, her acute understanding of family identity, her perception as an art historian, and from her warm, extended hospitality, which brought Chagall's Parisian environment to life.

One revelation of the family archive was the correspondence between Chagall and his first wife, Bella, whose contribution to his art, especially in keeping Russia alive for him in exile, had a defining impact. In tracing Bella's role, I supplemented information from her letters by conversations with her niece Bella Zelter, whom I would like to thank for her great kindness in sharing her memories, giving me access to her papers and photographs, and providing valuable background on the Rosenfeld family in Vitebsk.

For details of the second part of Chagall's life, I am most grateful for

many chances to talk to the late Virginia Haggard-Leirens. Virginia generously showed me her letters, photographs, and sketches, and discussed with me her years as Chagall's companion. Her daughter Jean McNeil was also extremely helpful and illuminating about this period.

Anyone writing on Chagall is incalculably indebted to two seminal works which continue to shape understanding of his work: the first book on the artist, by his friends Abraham Efros and Yakov Tugendhold, published in Moscow in 1918, and the unrivalled art-historical study by his son-in-law Franz Meyer, first published in German in 1962, and written in close collaboration with the artist. I have also drawn on Chagall's own memoir *My Life,* published in French in 1931. Benjamin Harshav's *Marc Chagall and His Times: A Documentary Narrative* (2004), a pioneering collection of mostly Yiddish correspondence, has been a vital resource, as has work on Chagall's early years by Yakov Bruk, archivist at the Tretyakov Gallery, Moscow, published in the catalogue to the Tretyakov's landmark Chagall exhibition of 2005.

I owe special debts to the immensely knowledgeable and very kind Myrtille Giraud at the Comité Marc Chagall in Paris, who located and supplied images for almost all the illustrations, and to Jean-Louis Prat, president of the Comité and former director of the Fondation Maeght, for allowing me to tap his long reminiscences of Chagall and for hospitality in St. Paul de Vence. I am also particularly indebted to the warmth and generosity of Hilary Spurling, most inspiring of biographers, and Jan Dalley, arts editor of the *Financial Times,* who have been staunch enthusiasts, perceptive readers of my manuscript in whole or in parts, and have given me invaluable advice from first to last.

Dmitri Smirnov, Elena Firsova, and Philip Firsov proved indispensable as translators and for their inexhaustible knowledge of Russian culture. Early enthusiasm from Gerard and Alison McBurney, beacons for all aspiring scholars of things Russian, was stimulating and reassuring. Elizabeth McKellar gave courage and faith in the project at moments of doubt. Alastair Macaulay's continuing support and pertinent responses from both sides of the Atlantic benefited every aspect of the book, and Lorna Dolan's gesture of confidence made an enormous difference.

At all stages, scholars, curators, gallerists, and librarians across the world have been generous with help, information, or sharing their memories of Chagall: Ruth Beesch at the Jewish Museum, New York; the late Heinz Berggruen, founder of the Museum Berggruen, Berlin; Valentine

Dolla, formerly of the Foundation Maeght, St. Paul de Vence; Jean-Michel Foray, former director of the Musée National Message Biblique Marc Chagall, Nice; Jennifer Francis at the Royal Academy, London; Miriam Haefele, who kindly copied unpublished letters written by Chagall and his daughter at the Deutsches Literaturarchiv in Marbach; Tamara Karandacheva, director of the Museum of Fine Arts, Minsk; Ludmila Khmelnitskaya, director of the Marc Chagall Museum, Vitebsk; Maria Liberman at the International Center for Russian and East European Jewish Studies, Moscow; Florence le Moing at the Réunion des Musées Nationaux, Paris; Vera Moriakhina at the European University, St. Petersburg; Norman Rosenthal, former exhibitions secretary at the Royal Academy, London; Eugenia Petrova at the State Russian Museum, St. Petersburg; Guy Picarda at the Francis Skaryna Belarusian Library, London; Ekaterina Seleznyova at the State Tretyakov Gallery, Moscow; Leily Soleimani at the Guggenheim Museum, New York; Annette Weber, professor of Jewish Art History at the Hochschule für Jüdische Studien, Heidelberg; Seth Wolitz, professor of Judaic Studies at the University of Austin in Texas. Staff at the British Library also made heroic efforts on my behalf in tracking down and ordering material published in Russian.

My publishers Stuart Proffitt at Penguin and Charles Elliott at Knopf and my agent and friend Carol Heaton offered unwavering support, understanding, and meticulous attention, as well as good company, during a project that they gracefully accepted as taking far longer than anticipated. I am also very grateful to Penelope Vogler, Cecilia Mackay, and Philip Birch at Penguin and Leslie Levine, Wesley Gott, and Andrew Dorko at Knopf.

It is a pleasure to acknowledge, too, the advice, assistance, or insights of many other friends and colleagues: Monica Acosta; Aline de Bievre; Christopher Cannell; Dinah Cannell; Theresa Chiccano; Joanna and Sue Freeman; Louise Gale; Robert Greskovic; Mark and Sarah Holford, for exuberant hospitality in Cap Ferrat; Howard Hodgkin; Robert Hughes; Ian Jack; Rahul Jacob; Nicolette Jones; Nella Lodola; the late Hyam Maccoby and Cynthia Maccoby; Veronica Marris; Monsignore Klaus Mayer of St. Stephan's Cathedral, Mainz; Werner Merzbacher; Richard Nathanson; Sam and Tess Neaman; Martin and Catherine Rodger, for an introduction to All Saints, Tudeley; Rebecca Rose; Natasha Semenova; Miranda Seymour; Lindy Sharpe; Natasha Staller; Deborah Steiner; Andy Stern; Daniel and Zehava Taub; and David Vaughan.

My interest in Chagall has endured over decades, and many ideas were

discussed with my father, Gunter Wullschläger, before he died, and with my mother, Maria Wullschläger, whose wonderful commitment to the project and indefatigable domestic help were essential. My best thanks go to her and to my children: Naomi Cannell for joyful company on many Chagall journeys, where her calm and diplomacy smoothed rough paths; Zoë Cannell for long chats about art and people, which enriched my perceptions of both; Raphael Cannell for illuminating the mother-son relationship that Chagall reckoned the bedrock of his art.

But this book could not have been begun, sustained, or finished without my husband, William Cannell. He shared every thought, hope, and dilemma as I wrote, countered my uncertainties, and was always there for me: *l'amor che move il sole e l'altre stelle.*

Chagall

Prologue

On a sultry June day in 1943 in a small Manhattan apartment on East 74th Street, four Russian Jews are gathered: a painter, his writer wife, an actor, a poet. Two have just arrived in New York from Moscow on an unprecedented diplomatic visit; two are recent exiles from occupied France. Born at the end of the nineteenth century in outposts of the tsarist empire, they are close, old friends, now sharing intense memories of artistic collaboration in 1920s Russia. Over tea sweetened with jam, they talk urgently: about the Nazi advance across eastern Europe and their hopes of the Red Army in halting it; of families, lost or in hiding, who may or may not still be alive; of painting, theatre, literature. Sometimes the conversation takes flight into a dance or a joke, yet it is never entirely free, for all four know that at least one among them is a spy. But no one is sure who it is, and even the spy himself fears that he too may be spied on. As they try to untangle the truth, all precariously balance survival and the demands of their art with loyalty to one another, to their Jewish roots, to Russia. Each, too, is under FBI surveillance.

Marooned in wartime New York and refusing to learn English, Marc Chagall is at this point in the middle of a long life. His straitened circumstances in America give little suggestion either of his frenzied past as a pioneer of modern art in Montparnasse and an avant-garde leader in revolutionary Russia, or of his future as the famous, affluent, longest-surviving member of the École de Paris. In 1943, though Chagall has a dealer in New York, he is not selling many paintings. The one he is working on is a double portrait in a snowy moonlit landscape, slightly surreal, full of menace, called *Entre Chien et Loup,* where a streetlamp with legs crosses a murky road but sheds

no light. Chagall's face in the painting is a blue mask; his wife, ghostly white, is wrapped in a red shawl: the colours evoke the tricolor and their longing for France.

The others in the claustrophobic living room are on edge, fearing for their lives: none will outlast the decade. Charming, good-looking poet Itzik Feffer, with a wide smile and large glasses, is a military reporter, a lieutenant colonel in the Red Army and a public hero in the Soviet Union, but he has just joined the NKVD–Stalin's secret police–and he is watching his friend Solomon Mikhoels at every move. Charismatic Mikhoels, an actor with a lilting voice and acrobatic body, is Chagall's closest friend from Moscow. Ostensibly in New York to drum up funds for the Soviet war effort, he has a secret agenda to investigate a report by a Russian physicist on atomic structure theory. Yet he himself is under suspicion from Stalin, and knows that war alone, and his use as propagandist and spy, is prolonging his life. To Chagall, however, Mikhoels and Feffer symbolise the path not taken: Jews who stayed in Russia and are not now enduring exile.

The hostess in the apartment, Bella Chagall, soaks up news from home like a parched sponge. She is trying to finish *Burning Lights,* a Yiddish memoir of her Russian childhood, and looks to the Moscow visitors for word of her and Chagall's native town, Vitebsk, which has fallen to the Nazis. They would have to wait another year for news of its liberation, in June 1944, in fighting so bitter that the city was razed to the ground. Fifteen buildings remained, and of a population of 170,000, only 118 survivors emerged from the cellars.

Marc Chagall, pioneer of modern art and one of its greatest figurative painters, invented a visual language that recorded the thrill and terror of the twentieth century. On his canvases we read the triumph of modernism, the breakthrough in art to an expression of inner life that, paralleling the literature of interiority–Proust, Kafka, Joyce–and Freud's psychoanalysis, is one of the last century's signal legacies. At the same time Chagall was personally swept up in the horrors of European history between 1914 and 1945: world wars, revolution, ethnic persecution, the murder and exile of millions. In an age when many major artists fled reality for abstraction, he distilled his experiences of suffering and tragedy into images at once immediate, simple, and symbolic to which everyone could respond.

Chagall broke away from the poor, drab surroundings of his childhood, only to re-create them in the scenes with which he is forever associated–the wooden huts and synagogues, violinists and rabbis, of late nineteenth-

century Russian-Jewish small-town life. Effortlessly assimilating every aesthetic innovation of his times, he developed a radical, original style–his shtetl settings fuse everyday reality with an imaginative world, conveying both loss and the miracle of survival. He himself negotiated exile by a series of adaptations as he journeyed from east to west, from oppression in tsarist then Soviet Russia to Berlin and Paris, from Nazi Europe to America. Each hard-won change gave his art renewal and resonance; Russia, however, remained the wellspring. "In my imagination Russia appeared like a paper balloon suspended from a parachute. The flattened pear of the balloon hung, cooled off, and slowly collapsed over the course of the years." Eventually in his paintings of Vitebsk he transformed fear and nostalgia for a milieu vanquished by midcentury terror into an emblem of memory itself.

For few painters have art and life been so inextricably entwined. Chagall's work and everyday existence alike turned on his triple fixations: with Judaism, Russia, and love–or put universally, on mankind's timeless concerns of religion, sense of social and emotional belonging, and sex. Yet repeatedly the relationships that fuelled his art threatened personal devastation. His mother, his girlfriend Thea, his daughter Ida, his first wife, Bella, and his companion Virginia, were sacrificed in different ways. Only with his second wife, Vava, as wily and tough as he was, did he meet his match–when the exchange was reversed, and his art lost out to the comfort of his life.

His wife Bella had a special role. Their correspondence reveals a difficult, bittersweet relationship, which is belied by her image as his muse. For Bella, the need to adapt was interwoven with another twentieth-century revolution, the struggle of women for an independent creative and professional existence. Chagall's portraits eloquently narrate the battle of an imaginative, intellectual, assertive woman to live her own life: audacity and hope in *My Fiancée in Black Gloves* in 1909; fulfillment in *Bella with White Collar,* painted on the brink of the Russian Revolution; the fight for identity in *Bella with a Carnation* in 1925; desperation in *Bella in Green* (1934). Yet to Chagall she always embodied Jewish Russia: "To whom compare her? She was like no other. She was the Bashenka-Bellochka of Vitebsk on the hill, mirrored in the Dvina with its clouds and trees and houses." In August 1923, in a letter written during a stormy period, when he lived in Paris and she in Berlin, he feared he was asking too much–he wanted her, he said, using a Russian phrase, "to wake up in my own hangover." She was the living connection to Russia that allowed him to evolve as an artist in exile, in contrast to most Russian artistic émigrés, whose work withered once they left their

homeland. But then that link suddenly snapped, and Chagall, great artist and driven egoist, flailed around wildly to recall "stretches of my own Vitebsk and the time when I walked its streets, over rooftops and chimneys, thinking that I was the only one in the town and that all the girls were waiting for me, and that the graves in the old cemetery were listening to my voice, and the moon and the clouds were following in my path and, together with me, were turning the corner to enter yet another street . . ."

PART ONE

Russia

"My Sad and Joyful Town"

Vitebsk, 1887–1900

Every painter is born somewhere," Chagall mused as an exile in the
United States in the 1940s. "And even though he may later respond
to the influences of other atmospheres, a certain essence—a certain
'aroma' of his birthplace clings to his work . . . The vital mark these early
influences leave is, as it were, on the handwriting of the artist. This is clear
to us in the character of the trees and card players of a Cézanne, born in
France,—in the curled sinuosities of the horizons and figures of a Van Gogh,
born in Holland,—in the almost Arab ornamentation of a Picasso, born in
Spain—or in the quattrocento linear feeling of a Modigliani, born in Italy.
That is the manner in which I hope I have preserved the influences of my
childhood."

Vitebsk, "my sad and joyful town," was approaching the zenith of its
development as a solid, provincial military outpost of the vast Russian
empire when Chagall was born there on 7 July 1887. The baroque green and
white Uspensky Cathedral, on the hill crowning the city skyline of thirty
bright onion-domed churches and sixty synagogues, and the jumble of
wooden houses and wandering Jews depicted in paintings such as *Over
Vitebsk* announce a long, mixed cultural heritage. The artist Ilya Repin
called Vitebsk "the Russian Toledo" because, like El Greco's city, its tum-
bling silhouette was characterized by a mix of Christian and Jewish spires,
towers, and domes, dating back to the twelfth-century Church of the Annun-
ciation. Set in a region of blue lakes, pine forests, broad plains, and gentle
hills, the picturesque old White Russian city rises high on the banks of the
wide Dvina River where two tributaries, the Vitba and the Luchesa, join it.

Life here, during snow-filled six-month winters and short sultry summers, when bathing huts appeared briefly on the riverbanks, had always been tough: Vitebsk was a contested town throughout its history. A fortification on the profitable trading routes between Kiev, Novgorod, Byzantium, and the Baltic Sea since the tenth century, it belonged to Lithuania in the Middle Ages, then to Poland, though it was frequently torched by invading Russians. It was annexed by Russia in the eighteenth century and became the northeastern fringe of the Pale of Settlement, the area–comprising present-day Belarus, Lithuania, parts of Poland, Latvia, and Ukraine–to which Catherine the Great confined all the Jews of her empire.

By 1890 there were five million of them there, concentrated in middle-sized towns like Vitebsk and neighbouring Dvinsk (now Daugavpils) and constituting 40 percent of world Jewry. From the 1860s the new Moscow-Riga and Kiev-St. Petersburg railways, crossing in Vitebsk, brought people streaming into the city from the countryside, and thus for the first time an urban proletariat appeared here. Between 1860 and 1890 Vitebsk's population doubled to 66,000 people: more than half of them were Jews, engaged mostly in the small trading enterprises–dealing in paper, oil, iron, fur, flour, sugar, herring–by which the town thrived. The rest were Russians, White Russians, and Poles, but so vital were the Jews in trade and business that one inhabitant recalled,

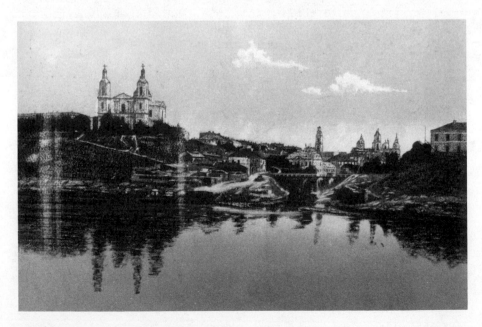

Vitebsk with the Dvina River, circa 1900

If I were a stranger and not a Vitebskite, and after having read the signs on stores and the names of tenants and offices, recorded on the lists of tenants in every yard along all the streets, I would have said that Vitebsk was a purely Jewish city, built by Jews, with their initiative, energy, and money. The sense that Vitebsk is a Jewish city is felt especially on Sabbath and Jewish holidays, when all the stores, offices, factories are closed and silent. Even in government offices, such as the Government Bank, the Notary, the Courthouse, Post and Telegraph Offices, and so on.

Yiddish, here as throughout the Pale, was mother tongue to almost all the Jewish population, half of whom could speak nothing else. It set the Jewish culture of cities like Vitebsk apart from the sea of backward, brutalised Slavic villages that encircled them, their peasants still serfs only a generation before Chagall's birth. Yiddish was Chagall's principal language until adolescence, the language of the family home, and its use enshrined a feeling of security and belonging, of participating in an autonomous system of values, religious traditions, and laws, that a Jew in the nineteenth century could find nowhere else.

The Jews who arrived in Vitebsk from smaller settlements in the Pale, therefore, felt quickly at home. Among them in 1886 was a slim, slight girl of twenty, Feiga-Ita Tchernina, eldest daughter of the kosher butcher and slaughterer in the small country town of Lyozno, forty miles to the east. Her mother, Chana, had recently died, and Feiga-Ita was leaving behind a slumbering existence where her father "lay half his life on top of the stove, a quarter in the synagogue, and the rest in the butcher shop," surrounded by the indolent among his offspring, the ones who had not made it to the city. His famous grandson later portrayed them, affectionately, as a caricature of Russian provincial inertia: Uncle Leiba sitting all day on a bench outside his house while "his daughters browse like red cows"; pale Aunt Mariassaja "lies on the sofa . . . her body elongated, exhausted, her breasts sag"; Uncle Judah "is still on the stove, he seldom goes out"; Uncle Israel "is still sitting in his same place . . . warming himself, eyes closed, in front of the stove"; only Uncle Neuch, with his cart and mare, immortalised in the painting *The Cattle Dealer,* did any work. This was the rural Russia of which the St. Petersburg bureaucrats and intellectuals despaired–"nowhere else in Europe can one find such incapacity for steady, moderate, measured work," wrote the nineteenth-century historian Vasilii Kliuchevskii–but it was nonetheless full of sensuous colour and life.

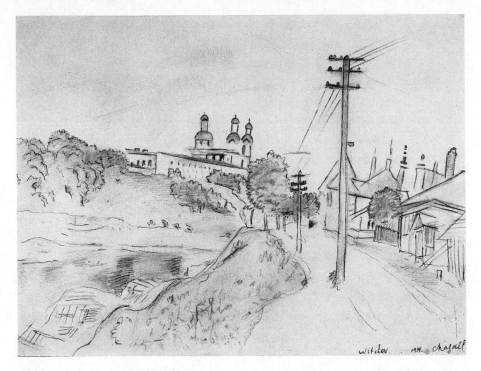

Chagall, "Vitebsk," 1914, drawing

Feiga-Ita came to Vitebsk to marry twenty-three-year-old Khatskel (the Yiddish form of Ezekiel, translated into Russian as Zakhar, and abbreviated within the family to Hasha, Chaty, or Chazia) Shagal, a distant cousin whom she had never met; as was customary for Orthodox Jews of the time, it was an arranged marriage. Khatskel had left Lyozno not long before with his parents, David and Basheva, for the burgeoning city; he worked as a labourer at Jachnine's herring warehouse on the banks of the Dvina and lived near the town prison in the newcomers' northern suburb of Peskovatik under the shadow of its seventeenth-century Holy Trinity Church, commonly known as "the Black Trinity." His father, already in his sixties, scraped a living as a small-time teacher of religion to poor local boys. A fragile younger brother, Zussy, stayed behind in Lyozno, apprenticed to a hairdresser; unenterprising and childishly vain, he was the only one of the extended family later to take an interest in his nephew's paintings, though he declined to keep a portrait of himself, judging it insufficiently flattering.

Peskovatik means "in the sands," and the home where Feiga-Ita joined Khatskel was not so different from the country town she had just left. The

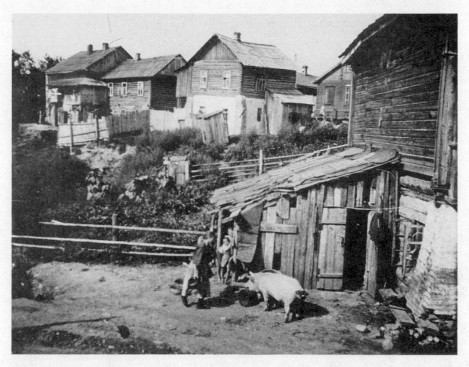

Peskovatik, the suburb of Vitebsk where Chagall was born, photographed in the 1900s

roads were unpaved, frozen in the winter and full of muddy puddles in the summer; haphazardly built along them were wooden shacks with small backyards where chickens and goats scratched; cattle wandered on dirt tracks and into houses and shops, giving the area a rural appearance. Feiga-Ita milked goats in their yard, but even the wealthy Rosenfelds, Bella's parents, kept a cow in the courtyard beneath their apartment, along with horses and chickens, and insisted that their servants feed the children fresh milk. When they went to a dacha for the summer, their cow trailed behind the wagons of provisions and bedding at the end of a rope. Even in the affluent part of Vitebsk, the countryside never seemed far away.

Feiga-Ita and Khatskel, however, had no intention of staying in Pesko-vatik. Their wedding photograph shows a pair who typify the upwardly mobile, provincial-to-urban Jewish class of the time. Feiga-Ita stands neat and steady in tight-fitting black silk with high neck, long cuffs, ruches, and ribbons; she fixes the camera with a determined, lively gaze and clasps a book, though she was virtually illiterate. She looks sensible and practical; by the time of her wedding, she was already playing mother to her tribe of

younger sisters. After her own marriage she would check out their fiancés, travelling to neighbouring towns to inquire into their suitability, entering shops to pick up local gossip, peering through windows to keep informed, a step ahead of the game.

Sitting at her side, broad-shouldered Khatskel in a kaftan-like greatcoat and peaked cap has the strength, beefiness, and taciturn expression of the focused young labourer; the gentle melancholy that was part of his character shines through too. Soon he became bent and permanently exhausted, defeated by his hard job and large family; at his wedding, however, his son claimed, "my father had not been a poor young man. The photograph of him in his youth and my own observations of our wardrobe proved to me that when he married my mother he had a certain physical and financial authority, for he presented his fiancée . . . with a magnificent shawl. Once married, he gave up turning his wages to his father and supported his own household."

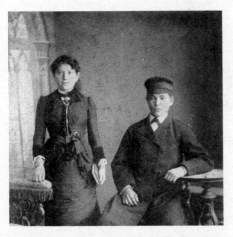

Feiga-Ita and Khatskel Shagal, the artist's parents, on their wedding day, 1886

The splendid lace shawl appears in later photographs, but spirited, hopeful Feiga-Ita soon found that, despite shared aspirations and an unquestioning acceptance of a traditional religious way of life, Khatskel was not someone she could talk to. Feiga-Ita had more ambitious hopes and dreams than he could understand, and an energy that constantly sought new outlets. As a young mother, her intensity, and her loneliness within the marriage, as well as her naturally warm and kind-hearted nature, all unleashed in her a passion for her first child, Moyshe—always known to his parents as Moshka, though listed by them on a family birth certificate as Movsha Khatskelev: Movsha (the Russian form of Moses), son of Khatskel. Born a year after his parents' marriage, Chagall was lavished with unwavering adoration by Feiga-Ita until her death in 1915, and he saw Vitebsk as literally his mother town, his art rooted in his closeness to Feiga-Ita. "If I have made pictures, it is because I remember my mother, her breasts so warmly nourishing and exalting me, and I feel I could swing from the moon," he recalled when he was seventy-nine. To his son-in-law Franz Meyer, he explained his art thus: "It needs a withinness. An artist is tied to his mother's apron strings, humanly and formally obsessed by her closeness. Form derives not from aca-

demic teaching, but from this withinness." The dreaminess that fuelled his art, he knew, came from Feiga-Ita. "Dreams, I am a dreamer–I inherited my dreaminess from my mother–this is true, and you, my dears, you don't even know what a *baba* I am," he told his sisters in a letter in 1912, when he was twenty-four. "There is no one else in our family who so wants to know everything as me–I am not praising myself here . . . I am interested in trivial things, don't judge me for that because I am a man." The love and identification between him and Feiga-Ita gave him a robustness and basic optimism and made him a survivor in life; it also lent him a vulnerability in his extreme dependence on women. A strikingly beautiful boy with curly hair and wide blue eyes, he remained Feiga-Ita's favourite of her nine children, and his unrivalled position was one he expected, unconsciously but uncompromisingly, to be replicated in every future relationship. A sister, named Chana after Feiga-Ita's mother, was born a year after him in 1888, but her arrival did not detract from the closeness of mother and son. In a family with just enough to go around, Feiga-Ita used to slip her firstborn extra snippets of food, strengthening him physically as well as emotionally; he lived longer than any of his eight siblings, only two of whom reached old age.

Like most men who rise from obscurity to fame, Chagall mythologised his childhood. *My Life,* his memoir of his experiences in Russia, written when he was thirty-five and about to leave it forever, dwells at length on his early years in Vitebsk, and though some parts are romanticised and unreliable, many details are corroborated by factual sources, letters, and photographs, and the general tenor chimes with other memoirs of shtetl childhoods of the period. He opens with a drama: "My mother told me I came into the world during a great fire and that the bed in which we were lying was moved from place to place to save us. Perhaps that is why I was always so agitated." The fire, one of many that swept through the wooden-built sections of Russian towns like Vitebsk, is documented for the day of his birth; the inhabitants usually fled to safety in the river. Chagall attributed his restlessness to these events of his birthday; as a child, he found the smoke and smouldering roofs and the flurry down to the Dvina exciting. The burning wooden houses in his paintings were a vivid recollection–he saw, for example, the conflagration in 1904 of the ancient wooden Ilyinskaya Church close to his home; later they became, as well, a symbol of the destruction of Jewry.

In 1887, however, his birthplace was saved. "That little house near the Peskovatik road had not been touched," he wrote in 1922. "The place reminds me of the bump on the head of the rabbi in green I painted, or of a

potato tossed into a barrel of herring and soaked in pickling brine. Looking at this cottage from the height of my recent 'grandeur,' I winced and I asked myself: 'How could I possibly have been born here? How does one breathe?' "

He was, he says, born dead—"I did not want to live"—and was thrown into a trough of water to be revived; a trough lies at the foot of the bed in several paintings called *Birth*. The story hints at depression, passivity, resignation to fate, all characteristics he shared with his father and that were as fundamental as the instinct for survival and energy-bearing hope that he inherited from Feiga-Ita. A self-absorbed, soft-spoken, small child with a slim frame and delicate features, he grew up enveloped in the closed, exclusive atmosphere of Jewish Vitebsk. For his first thirteen years his was the tradition-bound upbringing of Orthodox eastern European Jewry, marked by strong family and community bonds, a modest, entirely religious education, poverty, and suspicion—he used to hide under the bed whenever a policeman passed the window—if the Christian world drew near. Even within the Pale of Settlement Jews did not have full civic rights; official policies were shaped by imperial advisers such as Konstantin Pobedonostsev, procurator of the Holy Synod under Alexander III, who suggested solving "the Jewish problem" by converting a third of the Jews, expelling a third, and killing a third. Jewish access to Russian schools and universities was restricted by quotas; Jews were banned from the civil service and the judiciary and were subject to the looting and violence of periodic pogroms; Raissa Maritain, Chagall's Parisian Jewish friend who grew up at the same time as he in the southern Pale, then converted with her family to Catholicism, recalled "the mob which passed by, the cross at its head," explaining that her mother's "memory of the cross carried aloft during the pogroms delayed her conversion for a long time." In response eastern European Jewry shaped itself into a vivid, independent community with its own identity and ritual, little touched by secular influence, little tempted by assimilation. The centres of imperial power, St. Petersburg and Moscow, were remote, forbidden, barely relevant; Vitebsk's Jews looked to Vilna (now Vilnius) as their capital. This "Jerusalem of the East" was the old seat of Jewish learning in the former Lithuanian empire, known in Yiddish as *Litah* (German *Litauen*) and the country to which they felt they belonged.

Vitebsk's rich Jews, such as Bella's parents, lived in the oldest part of town, in the shadow of those buildings representing the Christian establishment—the neoclassical governor's palace where Napoleon had briefly resided on his way to Moscow in 1812, the pink and cream tiers of the city hall. The best addresses in Vitebsk were on two long avenues of mid-

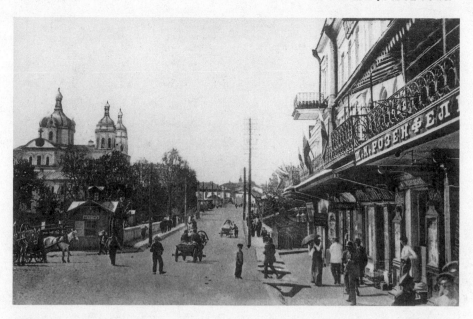

Vitebsk, 1900s. On the right is the Café Jeanne-Albert and the jewellery store marked
Sh N Rosenfeld, belonging to Chagall's father-in-law.

nineteenth-century terraces with painted facades, Smolenskaya and Pod-
vinskaya (now Lenin and Tolstoy streets), which met at the banks of the
small Vitba River. The mansion of Swiss confectioner Christian Brozi–
which housed the popular patisserie Konditorei Jeanne-Albert and, beneath
its ornamental terrace, the jeweller marked "Sh N Rosenfeld"–stood on this
corner. This area was always busy with shoppers, travellers, carriages, and
after 1898 the first trams; through the winter horse-drawn sleighs waited in
a taxi rank opposite the Rosenfelds' house. On one side of a bridge spanning
the Vitba loomed the Alexander Cathedral; on the other, the imposing dis-
trict court. Here cultural and intellectual life blossomed. By the end of
the nineteenth century Vitebsk boasted its own symphony orchestra, which
toured to Vilna and Riga, several theatres, and the only art school in the
Pale.

The metropolitan hub of interlocking streets and squares, located in the
area where the Vitba joins the majestic Dvina River, was known as the "big
side" of town. A large wooden bridge with elaborate balustrades crossed the
Dvina, which was dense with ferries and barges bringing logs for the prof-
itable paper factories and shipyards. It led to the more impoverished "small
side," where Chagall grew up and where most of the poorer Jews were clus-
tered in frame cabins or log houses known as *izbas*. Some of the huts lined

the riverbank, the water coming up to the doors. Vitebsk was described by the *Encylopaedia Britannica* in 1911 as

> an old town, with decaying mansions of the nobility and dirty Jewish quarters, half of its inhabitants being Jews. There are two cathedrals, founded in 1664 and 1777 [no one thought to mention the sixty synagogues] . . . The manufactures are insignificant, and the poorer classes support themselves by gardening, boat-building and the flax trade, while the merchants carry on an active business with Riga in corn, flax, hemp, tobacco, sugar and timber.

The Western Dvina, which flows 250 miles northwest to the Baltic port of Riga, was the city's lifeblood. In springtime rafts coursed downstream and sometimes broke up when they hit the stone piles of the bridge, leaving boatmen perched on a single trunk, furiously plying their poles to stop the logs from escaping. In summer people swam and children played in the river–Chagall remembered squirming into the water in embarrassment as the other boys shouted, "See what a little one he has!" In winter the Dvina froze, and an ice rink was set up by the bridge that even fastidiously brought-up girls like Bella were allowed to visit. "For us the bridge was heaven," she wrote.

> We escaped to it from cramped homes with low ceilings. On the bridge we could see the sky. In the narrow streets it was hidden by houses and steep-roofed churches. But by the bridge the river stretched out flat, and the air was empty between water and sky. A breeze brought the scent of flowers down from the public gardens. The bridge joined the two halves of the town and was full of people during the day. In the streets they walked with deliberate tread. But on the bridge they felt uplifted by wind and water. Coolness rose up between the wooden planks. Everyone wanted to stay there, not to have to come back to earth and the hard pavements.

On the "small side" the commercial heartland of warehouses and stores spanned out from the railway station, about a mile from the old town. Here, Chagall wrote, "houses stand crooked / And a road leads to the graveyard";

nearby was the Ilyinskaya Church and the nineteenth-century Spaso-Preobrazhensky (Transfiguration) Church, whose green domes are one of the most frequently recurring images throughout Chagall's paintings. This church and the small houses constituted the view from the attic of 29, Second Pokrovskaya (later renamed Bolshaya–Big–Pokrovskaya), the small wooden house (one storey with additional rooms under the roof) where the Shagals moved with three-year-old Moyshe and little Chana in 1890. That year Khatskel's father died, and his mother Basheva, then forty-eight, returned to Lyozno to marry Chagall's other grandfather the butcher; merging two households yielded a small amount of extra money by which the next, urbanised generation of Shagals could afford the new home.

Here on Second Pokrovskaya the growing family flourished. David, named after the recently dead grandfather, was born in May 1891, and in a musty attic room decorated with blue wallpaper, the two brothers shared a bed, sleeping head to toe. A few days before David's birth Moyshe was bitten by a mad dog, and an uncle took him to the Pasteur Institute in St. Petersburg for treatment against possible rabies. He loved being the centre of attention and dreamed of meeting the tsar on the street. When he came home, the house was full of women decked out in their best clothes; his mother, half naked and flushed, was in bed, and there came from her room the piercing scream of a newborn baby. Again and again he repainted that scene, which must have become commonplace to him: after Chana and David, six more girls were born to the Shagals between 1894 and 1905: Zina (known as Zislya to her parents), Lisa (Leah or Leya in Yiddish), Mania, Roza, Marusia (called Mariaska, or the diminutive Mariasenka, at home), and Rachel, who died as a toddler, according to family legend poisoned because she ate charcoal.

The house on Second Pokrovskaya, which was the Shagal family home from 1890 to 1921, photographed in the 1970s

In Pokrovskaya energetic Feiga-Ita set up a grocery shop, the one Chagall so often depicted, with the spelling mistake on the sign; she supplied it "with a whole wagon load of merchandise, without money, on credit" and thus supplemented the family income by selling herrings, sugar, flour. *Shop in Vitebsk* (1914) portrays the mundane interior as a child's treasure box, fish glistening on the scales, boxes shining like jewels: a haven of calm and plenty. In the store next to the house, and at home, Chagall remembered, his mother managed the household, ordering his father about, standing at the door as they left in the morning, then sending each child into the shop to grab a herring by its tail in the evening. It was always herring, usually accompanied by bread, cheese, and the black peasant grain kasha, for supper; Khatskel alone, watched jealously by his children, was served roast meat on the Sabbath. Almost defensively, Chagall reiterates in his memoirs that the family was never hungry, that everywhere he went he had a piece of bread and butter in his hand, but many who knew him later in life questioned whether he ever fully recovered from the desperate relationship with food of

Chagall, "Mother and Son," etching from *My Life*

the poor child. "Often when he went into the bistros, he would almost automatically break a hard-boiled egg on the counter. I had the impression that his childhood, which had been spent in poverty, had not yet stilled his hunger," recalled the Lithuanian photographer Izis, who met him in the 1940s; one of the first impressions of Virginia Haggard, his companion in those years, was that "Marc always dispatched his food hastily and without undue refinement."

Chagall was dismissive of Freud, but the memory of a home where he was always nourished and sheltered was crucial to his self-image. For so imaginatively fearful a child, given to stuttering and fainting fits—he later brought them on deliberately to avoid any sort of confrontation—the overwhelming first influence within this milieu was the protective sensuality of his mother: "I am a little boy and Mama is a queen." As a teenager, he remembered, "I was still so timid that I held tight to my mother's skirt whenever we left our part of town, as if I were a child and afraid of losing her in the crowd," while at home,

when I was too frightened, my mother would call me to her. That was the best shelter. No hand towel will be changed into a ram and an old man, and no sepulchral figure will glide across the frozen windowpanes . . . Neither the hanging lamp nor the sofa will frighten me as long as I am in Mama's bed . . . She is stout, with breasts as plump as pillows. The softness of her body, from age and from bearing children, the sufferings of her maternal life, the sweetness of her workaday dreams, her legs fat and rubbery.

In *Mother by the Stove* the housewife putting bread into the oven is transformed into the ruling goddess of the house, her bearing proud and upright, her face caught in a halo of crimson reflections from the flame. In the left-hand corner a tiny bearded man, Chagall's father, leans on a stick; his diminutive presence reinforces her significance. As in Russian icon paintings, the figures' relative size is symbolic. This was how Chagall perceived his parents: his mother monumental, alive, and as warmth-giving as the big old stove by which she stands, his father frail and dependent.

"Was my mother really so very short?" Chagall wondered later.

In our eyes, our mother had a style that was rare, as rare as possible in her workaday surroundings . . . She loved to talk. She fashioned words and presented them so well that her listener would smile in embarrassment. Like a queen, erect, motionless, her pointed coiffure in place, she asked questions through closed lips that scarcely moved . . . With what words, by what means can I show her smiling, seated for hours at a time in front of the door or at the table, waiting for some neighbour or other to whom, in her distress, she may unburden herself . . . Ah, that smile, mine! . . . I wanted to say that my talent lay hidden somewhere in her, that through her everything had been passed on to me, everything except her spirit.

The dominant hues in *Mother by the Stove* are black and white: the solid, classical colours of portraiture. *Portrait of My Father,* painted at the same time, is by contrast a rippling mass of sulphur yellow and shades of deep blue and brown whose undulating surfaces and blurred lines reflect Chagall's ambivalent response to his father. The uneasy, tense figure of Khatskel Sha-

gal looks out warily, a hunted expression in eyes full of alarm. Framed against a window, he is edged into the centre of the picture by a cat and by the tiny figure of his headscarfed mother Basheva: "all there was to that little old woman was a scarf around her head, a little skirt and a wrinkled face . . . in her heart, a love devoted to her few favourite children and to her book of her prayers." Everything looks forlorn, faded, old, yet Chagall portrays his father as a thoughtful, weary, ancient Jew, pondering life and its griefs. Where Feiga-Ita was practical and alert, Khatskel was pious and reflective. He rarely addressed his children, except to quote some religious text, on which he also enlightened his wife: once a year at Yom Kippur she struggled through the synagogue service with the women's prayer book, which Khatskel marked for her "Begin here," "Weep," "Listen to the cantor." Although she would lose the thread of the prayers anyway, "Mama went to temple assured that she would not shed tears uselessly, but only at the proper places." On the other hand Khatskel rose daily at six, summer and winter, to go to the prayer house, returned to prepare the samovar, drank his tea, went to work, came home exhausted, rolled a mountain of cigarettes for the next day, and fell asleep over supper.

"Have you sometimes seen, in Florentine paintings, one of those men whose beard is never trimmed, with eyes at once brown and ash-gray, with the complexion the colour of burnt-ochre and all lines and wrinkles?" Chagall asks in *My Life*. "That is my father." The portrait he painted of him

> was to have had the effect of a candle that bursts into flame and goes out at the same moment. Its aroma—that of sleep . . . Must I talk about my father? What is a man worth if he is worth nothing? If he is priceless? My father was not a clerk but, for thirty-two years, simply a labourer. He lifted heavy barrels and my heart used to twist like a Turkish bagel as I watched him lift those weights and stir the herring with his frozen hands. His huge boss would stand to one side like a stuffed animal. My father's clothes sometimes shone with herring brine . . . Everything about my father seemed to me enigma and sadness . . . In his greasy, work-soiled clothes . . . he would come home, tall and thin. The evening came in with him.

Chagall wrote this in Moscow in 1922, when proletarian roots were an asset; in fact Khatskel was a member of the Union of Store Managers in

Vitebsk from 1905 until 1918 when, following the revolution, he worked in a cooperative. Nevertheless his father was, said Chagall's son-in-law, "an object lesson in drudgery that Chagall never forgot," comic butt of a domestic farce that he could not control: the workman who had his weekly Sabbath wash, Feiga-Ita pouring a pitcher of water over his blackened hands and body while he groaned "that nothing was ever in order, that there was no washing soda left"; the parent reduced to scooping up his children's excrement because, Chagall recalled, "in particular we liked to do . . . at night in the yard. Excuse my vulgarity? Am I coarse? It's only natural that, in the moonlight, when you're afraid to go too far—we children couldn't even budge, our legs simply wouldn't move. The next morning Father would

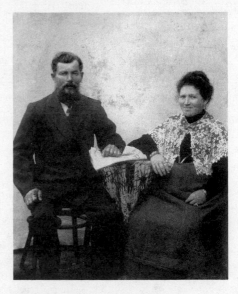

Khatskel and Feiga-Ita Shagal in the 1900s

scold his children for their shameful conduct." Several of Chagall's romantic paintings of his hometown, such as *Over Vitebsk,* include the figure of a defecating child.

Chagall's memories of his parents were coloured and intensified by a nostalgia for a home to which, after he left Russia in 1922, he had no physical access; honouring his parents turned naturally to sentimentalising them. To the world beyond Russian Jewry, he closed rank: "I never quarrelled with my parents. For me parents are sacred. Nothing in the world could have turned me against mine," he told Virginia Haggard; as an old man revisiting Russia in 1973 he ingratiated himself with pronouncements such as "In spirit I was always here . . . Say of me what you will, that I am a great painter or not, but I remained faithful to my parents from Vitebsk." At the other extreme was the reaction of his own daughter Ida, brought up and educated in Paris, who returned to meet her relatives in 1959 and was shocked by the uneducated Shagals. This was not a result of Soviet coarseness; Ida was enchanted by her mother's relations ("serene, intelligent, adorable . . . unexpected wonderful contact"), who were by then no better off than the Shagals. "I spent a lot of time with the families," Ida wrote tersely. "It is difficult to speak about Father's one, except that he is without a doubt a great artist, but that it took also to be a genius to get out from that family."

Nonetheless, according to the memories of the sister and nieces who in

the 1990s at last talked of Chagall, after seventy years of state-encouraged silence, "the whole family was very cheerful and musical . . . they joked about each other, sang and played instruments." Mariaska, the last surviving sister, remembered Moyshe especially for his "fibs and fantasies" and his musical gifts. He played the violin, taking evening lessons from an ironmonger who lived on their courtyard. ("I scraped out something. And no matter what, or how, I played, he would always exclaim, beating time with his foot: 'Admirable!' ") He had a fine childish soprano voice and assisted the cantor in the synagogue, though he hated being woken early to go there on holy days. ("Why does one run like that in the gloomy night? I'd have been much better off in my bed.") Throughout his life he loved music; records, especially Mozart, often played in the studio as he worked.

The family remembered Chana, the eldest sister, as "big, confident and with a steady character," reliable as a rock, pragmatic, and sensible; *Portrait of Anyuta* (her Russian name) shows a solid, firm young woman. Zina, the second sister, was by contrast the most aesthetically sensitive and liked to draw; a family photograph shows a handsome, forceful girl who seems to chafe at her restrained role. She had the most troubled personality of the sisters: "She hides something inside . . . She's doing something which is not very beautiful. She has something in common with you, but she is wretched," Bella wrote to Chagall of Zina in her late teens; even at a distance, Zina was the one sister whom Chagall would discuss so frequently with his Paris friends that she appears in a poem written by one of them.

The sisters called David "a talented person . . . the support and hope of the family . . . He wrote poems that were printed in the Vitebsk local newspaper, played the mandolin marvellously, and sang excellently," teaching them opera arias. Chagall's relationship with his only brother–and thus his potential rival in the family–was more ambivalent. His depictions of him are full of empathy, and he would name his only son after him, but he was also critical; in 1912, when David was twenty, he told his sisters that he would dream of helping him "with one condition, that he would live like a human being (his behaviour makes it impossible to show himself to people), it's impossible to take him out."

From his sisters, on the other hand, he had no competition. Almost ceaselessly their role was to help their mother in her inexhaustible activities; Chagall's stepdaughter Jean McNeil notes that this was the only occupation he ever expected from young girls. Although he was fond of his sisters, he also found them a nuisance. "My sisters laugh and cry. / They stand together

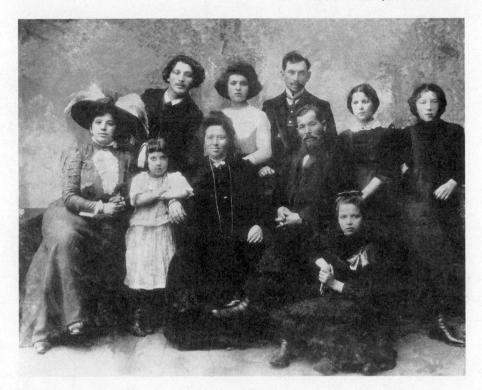

The Shagal family, late 1900s: from left to right, back row: Chagall, Zina, Uncle Neuch, Lisa, Mania; front row: Chana, Marusia, Feiga-Ita, Khatskel, Roza

in the door / Look for something in the window / And seek happiness forever," he wrote in his autobiographical poem "My Old Home." His favourite was Lisa, born in 1896. "A brilliant, light person, she always glowed," her family said of her. "She was very pretty until the end of her life, cheerful, kind and laughed a lot." Her lightness of being is captured in Chagall's depictions of her, thoughtful and engrossed in *Lisa with a Mandolin* and *Lisa by the Window.*

Beyond the family home the neighbourhood near the railway station, almost entirely Jewish, was a busy, secure place for a small boy. "Around me come and go, turn and turn, or just trot along, all sorts of Jews, old and young, Javitches and Bejlines. A beggar runs towards his house, a rich man goes home. The *cheder* boy runs home. Papa goes home. In those days there was no cinema. People went home or to the shop." Like most children from poor families, Moyshe spent much of his time on the streets; he remembered being fascinated by sheds and roofs, beams, courtyards, and the hidden worlds behind them. The inhabitants of Bolshaya and Malaya (Little)

Pokrovskaya lived publicly and noisily: a carter swayed drunkenly along the road with his horse and his wife sold vodka illegally; Tanjka, a laundress and a thief, made trouble; a chimney sweep quarrelled loudly with his wife; a man and a dwarf trafficked in horses and stolen pigeons. The boys were always visiting the baker and his wife, the most respectable family on the street, whose lights burned from five o'clock in the morning, and eyeing another attraction at the back of the block: the large barracks of the 41st infantry division and 41st artillery brigade of the Russian army, which had been billeted in Vitebsk since the end of the nineteenth century. Chagall remembered these details: the soldiers in his pictures—*The Soldier Drinks, Soldier and Peasant Girl, Soldiers*—often have the number 41 inscribed on their shoulder straps.

During the long winters, boys from the age of three or four to thirteen attended *cheder*. When Chagall was three years old an elderly *cheder* teacher appeared at the house: "We hadn't even sent for him. He came of his own accord, the way the marriage-broker comes or the old man who carries away corpses. 'One season, two . . .' he said to my mother." *Cheder* literally means "room"; for the younger children, the teachers were glorified child-minders who for a small fee took charge of around eight local boys in the main room of their own house, teaching them to read prayers and passages from the Hebrew Bible. It was so boring that teacher and children often fell asleep—Moyshe was bitten by his teacher's dog because the teacher had retired to bed with his wife at midday. As each child progressed, he moved to a more advanced teacher. Chagall had two barely educated ones before graduating to the capable, modern Rabbi Djatkine, who prepared him for his bar mitzvah and infused him with a love of the Bible. Still, days begun and ended in the dark during the snowy winters seemed endless, and Chagall could hardly wait to be released back to daydreaming: "my sweet stars; they accompany me to school and wait for me on the street till I return . . . Every night, a lantern in my hand, I went back home."

In the summer Feiga-Ita sent her children back to Lyozno to the home of their double grandparents, Khatskel's mother and her own father the butcher, and the ramshackle house that she had recently left seemed to them a paradise. Cowhides and lambskins were hung up to dry like linen. In stables full of doomed beasts, dogs and chickens rustled and clucked behind the slaughterer, waiting for a bit of meat. Mingled with the blood and guts was the undertow of religious exaltation in the prayers said by her flamboyant, lazy father, as he chattered to the animals moments before plunging the

Chagall, "The Butcher," 1910, gouache on brown paper:
a portrait of Chagall's Lyozno grandfather

knife into them. ("Eh, listen here! Give me your legs. I'll have to tie you up.
We need goods, meat, you understand?") Then the freshly roasted stomach,
neck, ribs appeared at the table: every smell and taste intoxicated the chil-
dren. It was one of Chagall's childhood treats to go out in the cart with cattle
dealer Uncle Neuch, Feiga-Ita's brother, to the marketplace, where her sis-
ters, Aunts Moussia, Gouttja, and Chaja, flew across the stalls with baskets
of berries, pears, and currants.

Chagall, "Lyozno," 1911, drawing

These summers in the Pale, short, sweet, hot, abundant, left an indelible impression on Russians later in exile. "Like the cold of our continental winter, the heat of summer was extreme," recalled Raissa Maritain after decades of living in Paris. "The months of May and June were overflowing with roses and cherries . . . their perfume made one giddy. The summer abounded also in melons and watermelons, in plums and in apricots as sweet as honey . . . it seems to me I have never eaten such good things as we had in Russia." For Chagall, the mix of opportunity offered by a hard urban setting, combined with the easygoing ways of the country, its earthy yet tender acceptance of the interdependence of man and beast, was one of Feiga-Ita's lasting gifts. His work is filled with images of animals: his mother's world, made visionary in the homesick canvases—*I and the Village, To Russia, Asses and Others*—which he painted after he first left Russia in 1911.

Colouring all of them, and every aspect of Chagall's childhood, in town or country, summer or winter, was the drama and ritual of the Jewish religious calendar, its feasts and fast days, its stories and prayers, its faith in miracles and the supernatural, and the conviction of divine election that went with it. A palpable second reality at the heart of daily life, it gave at once consolation for hardship and an encouragement to submit to fate, the characteristic Jewish resilience and the capacity for suffering. When Chagall wrote in 1944,

addressing Vitebsk, that "I didn't have one single picture that didn't breathe with your spirit and reflection," it was this metaphorical, spiritual country of childhood that he meant.

"For my parents, religion was the axle around which their whole existence revolved," Chagall said. "Every holy day brought its own atmosphere," Bella Chagall wrote in her memoir of Vitebsk; each had its own customs, legends, food. The ten Penitential Days of Awe were full of agitation and nightly prayers; the Day of Atonement, heavy and oppressive, was heralded by the arrival of the dark-clad slaughterer scooping up the roosters and hens to be killed. The New Year, Rosh Hashanah, was "clear and pure, like the air after rain," following the "sombre nights during which we prayed for forgiveness." Hanukkah was the children's winter festival of lights; during Purim, promising the arrival of the pale spring sun, baskets of presents flew from home to home and theatre troupes, the Purim Spieler, danced and acted across the town. At Passover especially Chagall recalled being transported imaginatively through the purple wine in his father's glass to the exiled Jews' tents in the burning Arabian desert, then rushing to open the door on the cold Vitebsk street, white stars against a velvet sky, and wondering, "Where is Elijah and his white chariot? Is he still lingering in the courtyard to enter the house in the guise of a sickly old man, a stooped beggar, with a sack on his back and a cane in his hand?"

Chagall, "Purim Players," from *First Encounter*

Raissa Maritain similarly remembered waiting for Elijah on a Passover night "heavy with adoration and fear." "Next year in Jerusalem" is the Passover chorus: in this milieu, the miraculous might wait on any street corner; just a breath would be needed to bring instantly to life the Old Testament characters and the story of the Jewish nation, which blended seamlessly with the children's daily lives. Thus the exalted, otherworldly names—*wunder-rebbe* (miracle-man), *luft-mensh* (man who lives on air)—given to the semibeggars who made up a substantial minority of the Jewish Pale population; such a character, sack over his back, depicted flying over the roofs in Chagall's paintings, was an everyday personage as well as an image of the timeless Wandering Jew.

Between the feast days, Bella recorded, "there stretched out a line of ordinary days—silent, sunless, flat and gray. The rain fell ceaselessly, as if it had forgotten how to stop. The windows seemed to be weeping. Inside the house it was dark even during the day, which ended almost as soon as it began." The festivals and the weekly Sabbath ceremonies pierced this bleak reality, giving to every taste and tale a Proustian intensity of memory, layering the glowing, imaginary city of Jerusalem onto the prosaic dull one of Vitebsk, which in turn was already crystallising in childhood to become Chagall's own city of the mind. Most significantly for his future, these rituals were rich in fantasy, poetry, and music—but almost wholly lacking in visual representation: a culture awaiting its artist.

The emotionally heady nature of the particular Jewish sect, the Hasidim, to which Chagall's and Bella's families belonged, was generations away, culturally, from the enlightenment that had by then been secularising Jewish circles in western Europe for a century. The Hasidic movement, popular with a mass of uneducated eastern European Jews from the eighteenth century onward, advocated song and dance as an expression of devotion, laying an almost mystical emphasis on the oneness of all life, the importance of love for people and animals as a way of joyful, intuitive communion with God. Hasidic ideals of harmony between man and nature underline Chagall's work during every decade. He identified especially with cows and once considered using the image of one on his calling card; fish have symbolic links to his father, the labourer in a herring warehouse; roosters suggest life-giving energy and are also, along with goats, associated with the Day of Atonement. The references are especially potent in works that are important autobiographical statements. The happiest of all his self-portraits, *The Poet Reclining* (1915), in London's Tate Modern, shows the artist on his hon-

eymoon lying in a field with horse and goat. A farmyard menagerie accompanies the actors and musicians in *Introduction to the Jewish Theatre* (1920), the opening to the series that Chagall considered his definitive depiction of Russian Jewry. *The Flayed Ox* was a version of a self-portrait painted at an anxious time in 1929 and again at a tragic one in 1947.

Hasidism's spiritual current lifted the poor community beyond concerns of mere survival, to a worldview sustaining the defiant vitality and celebratory humanism with which Chagall transformed the cramped, dull backstreets of his childhood to a vision of beauty and harmony on canvas. Russians, who knew these places in all their everyday ugliness, were the most astonished. "That this 'Jewish hole,' dirty and smelly, with its winding streets, its blind houses and its ugly people, bowed down by poverty, can be thus attired in charm, poetry and beauty in the eyes of the painter—this is what enchants and surprises us at the same time," wrote the artist and critic Alexandre Benois. Only those inside could feel the strong, steadying influence of this sealed, conservative background. If, before 1900, it tended to produce a people, like Chagall's father, disinclined to question or change, it was also a culture whose rich vein of myth gave nourishment to those rare artistic talents who did break away. Each one—Yiddish storyteller Sholem Aleichem, born in Ukraine in 1859, dramatist S. Ansky, author of *The Dybbuk*, born in Vitebsk in 1863, Isaac Bashevis Singer, born in Poland in 1904, painter Chaim Soutine, born in Lithuania in 1893—took with them both its hallucinatory enchantment and its age-old melancholy, that lament with which Bella concludes the first part of her memoir *Burning Lights*: "How doth the city sit solitary! Shall joy never return to us?"

The grinding, unchanging poverty that pushed the Russian Jewish population to the extremes of fanatical Hasidism on the one hand and the absolutism of Marxism or Zionism on the other, also drove nearly a million Jews to emigrate from the Pale between 1891 and 1910. Resourceful Feiga-Ita, however, propelled the Shagals upwards to become one of Pokrovskaya's respected middle-income families in this period. Her shop was successful; with the profits, she constructed in 1897 a second wooden house in their courtyard, followed in 1902 by a one-storey square brick house, eight metres by eight (thirty feet square), four metres (thirteen feet) tall, with three windows facing the street: a sign of increased status. By 1905 the Shagals had a plot 28 by 21 metres (90 by 70 feet) on which stood the brick house and the four wooden houses, which were let to tenants. Flanked by trees and a small front garden, a wooden gate and wicket door was the entrance to all four.

They shared the same street number, as was customary for buildings belonging to the same owner, and one of them, three steps up to the door, was occupied by Feiga-Ita's shop. The family lived in the brick house; here was the kitchen and stove, heart of daily life and open to friends, customers, and relatives from Lyozno and to a passing cast of beggars and itinerant preachers.

From interiors like *Our Dining Room, The Samovar, Around the Lamp,* and *Sabbath,* we know this room, with its timber-planked floor, heavy wooden furniture, hanging lamp casting its light as a cone on to the table, and the family treasure, a giant wall clock in its case, with heavy pendulum and the exotic inscription "Le Roi à Paris." Apart from the clock, the walls are usually bare. "Among the petty traders and craftsmen that my family knew, we had no idea what it meant to be an artist. In our home town, we never had a single picture, print or reproduction, at most a couple of photographs of members of my family . . . I never had occasion to see, in Vitebsk, such a thing as a drawing," Chagall remembered. Rather, pictures such as *Sabbath,* bathed in a soft yellow haze, convey the ambience of pre-revolutionary small-town Jewish Russia: the lethargic characters, static, resigned, bound together in a cosy laziness and in their shared history, as the clock ticks the passing of time and tradition. One of Chagall's earliest supporters, Russian-Jewish critic Yakov Tugendhold, identified acutely with the milieu conjured by *The Clock.* "This black night, the night of oaths

Chagall, "My Parents, Mother's Shop," circa 1910, drawing

Chagall, "Samovar at the Table," 1910, drawing

and miracles, peers through the windows," he wrote. "The heavy pendulum counts the centuries–minutes of monotonous life, and tiny cumbersome figures seek something in the uncanny nocturnal void."

The child Chagall emerged only very tentatively from that claustrophobic yet comforting interior, but before his gentler brother and less driven sisters. "An old house with no window / Inside it is dark at night. / I came out first / And stretched out my hand" was his memory in "My Old Home." Asked in the 1960s about the essential influences on his painting, he named the mystique of Hasidim, the will to construct, and the mystique of icons. The first two of these, core ingredients of his parents' world, were immutably in place by the time he finished *cheder* and celebrated his bar mitzvah. His father, wrapped in the tallith, growled "over my boyish thirteen-year-old body, the prayer of the transfer of moral responsibility," and assumed his son would now find work as an apprentice and be off his back. But dreamy Chagall didn't want to grow up:

> I was afraid of my majority, afraid of having, in my turn, all the signs of the adult man, even the beard. In those sad, solitary days, those thoughts made me weep . . . Sometimes I would stand and gaze at myself thoughtfully. What is the meaning of my youth? I'm growing up in vain . . . At home, nobody ever asked me what

trade or profession I might want to study . . . Besides, I could
scarcely imagine, at that time, that I would ever be able to do any-
thing useful in life.

Then his pious, ambitious, loving mother took matters into her own
hands. Without a backward glance, she dragged Chagall across the bridge to
the "big side" of town, bribed the high school teacher fifty rubles to flout the
quota on Jewish pupils, and launched her first child on the path out of Jew-
ish Vitebsk.

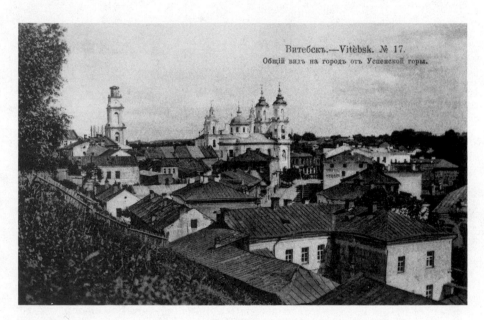

Vitebsk, 1900s

CHAPTER TWO

At Pen's

Vitebsk, 1900–1907

Leaving Pokrovskaya in his black school uniform and smart cap at the dawn of the new century, thirteen-year-old Moyshe Shagal walked into alien territory. "The cockade is alluring. They'll put it on my cap, and if an officer passes, won't I have to salute him? Officials, soldiers, policemen, schoolboys–aren't we all alike? . . . With the school cap on my head, I began to eye the open windows of the girls' school more boldly." It was the first hint of the chameleon adaptations that would characterise his life story.

The school, an old-fashioned military-style Russian *uchilische* similar in organisation and tone to a German *Gymnasium* of the times, was housed in a featureless white building with rows of evenly sized, neatly paned windows. Its aim was to instill a sound classical and Russian education into the future bureaucrats, lawyers, military officials, and businessmen of the tsarist empire, above all to infuse them with loyalty to the imperial regime–Chagall started at the school five years before the attempted revolution in St. Petersburg. When Tsar Nicholas visited Vitebsk to review the regiments that were about to go to the front in the Russo-Japanese War of 1904-5, the excited, sleepy boys were led to meet him, starting out before dawn and walking, ankle deep in snow, across fields to line up on a high road where they waited for hours for the imperial convoy and were impressed by the princes, ministers, and generals in glittering uniforms and medals, the cheering soldiers, the military bands playing continually as the frozen air absorbed the national anthem, transforming it into a plaintive melody.

This was a world away from the Jewish rituals of Pokrovskaya. To Chagall,

the school felt like a prison. "Looking at it from the outside I had thought 'I'll certainly be sick to my stomach here and the professor won't let me go outside.' " He entered the third form, the class taught by the bribed teacher Nicolas Efimowitch, and struggled from the start. Lessons were in an unfamiliar language, Russian; the Cyrillic alphabet was new to him (Yiddish is written in Hebrew characters); and he resisted this forced introduction to tsarist civilization. The shock of the school was so great that he developed a stutter and was so nervous that, although he knew his lessons, he was unable to recite anything. "Ta-ta-ta-," he stammered when asked about the Tartar occupation.

> To hell with zeros! . . . I began to tremble distressingly and when I went up to the blackboard, I turned as black as soot and as red as a boiled lobster . . . What was the good of those lessons? One hundred, two hundred, three hundred pages of my books I would have torn out ruthlessly, scattered to the four winds. Let them whisper to each other all the words of the Russian language . . . Let me alone!

The social aspect was as overwhelming: the sea of heads on rows of benches belonged to a mixed group of Russian, White Russian, Polish, and only a few Jewish boys. Here Chagall came face-to-face with class and ethnic prejudice within the tsar's empire. Among the other boys were Ossip Zadkine, the future sculptor, who was three years younger and son of a well-off Jewish classics teacher and a mother of Scottish descent; the son of Jachnine, the herring merchant for whom his father worked; and Avigdor Mekler, whose father, Shmaryahu Mekler, was Vitebsk's richest paper manufacturer–Jachnine and Mekler were among the town's elite dozen Jews listed in 1900 as belonging to the First Guild of Merchants. Both Zadkine and Mekler had artistic interests, but Chagall was intimidated by their privileged backgrounds; in contrast to such polished youths, he was a timid stutterer and a weakling, and he began training with forty-pound weights to try to beef up his muscles like his father's.

It went against his dreamy temperament to be a diligent student: he was lazy, absent-minded, unwilling to concentrate, and always claimed to understand only by instinct. In the mornings his father threatened him with the strap because he was so sluggish about getting up; at night his mother wailed at him for burning the kerosene lamp and keeping her awake, pre-

tending to study while everyone else was asleep. Only two subjects ever interested him. At geometry "I was unbeatable. Lines, angles, triangles and squares carried me far away to enchanting horizons," while in the drawing class his supremacy was such that "I lacked only a throne." Meanwhile every day he felt as if he were gripped by fever when he looked out at the Gymnasium girls; he spent much of his day fidgeting, trying to climb up near the window to get a better look at them, blowing kisses to distant figures, until he was caught and ridiculed. So little did Chagall work that at the end of the fourth form he failed the exams and had to repeat the year; he finished school eventually, in 1905, without achieving a leaving diploma.

Yet the impact of Russian culture made itself felt: he began to write poetry in Russian and hazily to consider an artistic path as a route of escape from the constrained lives of his parents. Since he was musical, he thought of training as a singer or a violinist at the Conservatory; he charmed relatives as he danced with his sisters; he wrote poems that the family applauded; he dreamed of becoming a dancer or a poet. At thirteen he abandoned religion, enjoying the transgression of munching a stolen apple on Yom Kippur, ordained as a fast day. The choice was easy: "Pray morning and evening and everywhere I go, whatever I put in my mouth and whatever I hear, immediately say a prayer? Or flee from the synagogue and, throwing away the books, the holy vestments, roam the streets towards the river?" The break promoted no spiritual crisis: Chagall never questioned his identity as a Jew. The rituals of Judaism were upheld at home, but his parents did not insist on religious observance from their children.

All over the Pale a similar generation gap opened at the turn of the twentieth century, as the pressures towards change from the secular world that led eventually to revolution were felt here. Among themselves Chagall's siblings chose to use Russian versions of the Yiddish names by which their parents still addressed them. The eldest daughter Chana became Anna, Anyuta, or Nyuta; Zislya became Zina or Zinotchka, and Leya was Lisa; similarly, Avigdor Mekler soon became Viktor. Chagall himself was Moshka to his parents but the Russified Moysey outside. Chagall's and Bella's parents did not fight the change, but the generation above them did. In Bella's house her devout grandfather wandered from room to room searching for Russian books to throw into the fire, complaining that his grandchildren should be taught Yiddish, not Russian. Young men "could not acquire the new, the alien, without renouncing the old and repudiating their unique individuality, and their most precious possessions," mourned Pauline Wengeroff, an

old lady from Bobruisk, a nearby White Russian city south of Vitebsk, at this time. "How chaotically these modern ideas whirled through the minds of young Russian Jews!"

On the streets the new mores were immediately visible among adolescents. Olga at the skating rink, Anyuta by the Dvina embankment, Nina in the country lanes of Lyozno: the girls liked curly-haired, gentle Moysey, who dabbed on makeup, darkening his eyes, reddening his lips, to make himself seductive. In Lyozno he stayed out through a hot summer night until early dawn with Nina, but "I know nothing about the realities of making love"; he ran away before her family could snap him up as a respectable fiancé. In Vitebsk "I was successful, but I was never able to profit from that success." At the end of four years' sighing after Anyuta, "all I dared do–and then only on her initiative–was to give her a startled kiss . . . I was stunned, I couldn't speak. My head whirled. But I controlled myself and deliberately did not change expression to show . . . how sophisticated I was." Days later Anyuta fell ill, and her face broke out in pimples; Chagall visited her, sat anxiously at the end of her bed, and asked "whether it was because I had kissed [her] the other night."

Chagall, "In Front of the Gate," etching from *My Life*

This generation was still anxious, prudish, instinctively associating promiscuity with disease, a link Chagall made all his life. The puritanical strain went deep in Vitebsk; when, a year after the revolution, Chagall painted a mural showing Bella flying above his head, religious women avoided the street because they found the sight of her legs and hitched-up dress embarrassing. Chagall loved flirting, but these were chaste, fearful romances among a circle of Jewish teenagers only half emerging from the straitjacket of arranged marriages that had been the norm in their parents' generation. The oldest Chagall sister Anyuta was pushed young into a marriage organised by her parents: "I heard my mother say to Father at supper, 'Hasha, why don't you do something about Hanka?'–that's what we call Nyuta–'Everything falls on me. How long has she got to wait? God willing, she'll soon be seventeen. Go and talk to the matchmaker–you pass right by his house.' "

Ambition, self-preservation, an enthusiastic embrace of the future, a sense of inferiority at school: all pushed the young Chagall to abandon Yiddish for Russian. The opportunity afforded him by the secondary school was fundamental: it put him among privileged Russians, for according to figures from 1897, the year of the first modern census in Russia, less than one percent of the tsar's subjects had attended or were attending secondary school–and nearly half of these were of aristocratic birth; even as late as 1904 only 27 percent of children of school age were even in primary education.

Joining secondary school was thus an exceptional chance for a child from Chagall's background: it gave him an entrée into a living language of culture that connected him to mainstream European thought, literature, history, and to the society of Vitebsk's Russian-speaking Jewish intelligentsia. In Yiddish he could never have managed that introduction. In 1900 Yiddish, used for commerce and everyday matters, was a language to leave behind as soon as you acquired a more civilised one; Hebrew was the dead language of scholarship, and there was nothing in between–a symbol of the impasse of pre–First World War eastern European Jewry. Russian, Chagall's first language of culture, was his escape from that impasse. And it was through these Russian connections that he first came to an awareness of visual art.

He told the story many times, changing the details and altering the date of an incident that took place around 1902-3. He was fourteen or fifteen, languishing in the fifth form at school, when in a drawing lesson a classroom rival, one who most often bullied him, suddenly showed him a sketch on tissue paper, copied from the magazine *Niva:* "The Smoker."

> I don't remember exactly, but that drawing which was not done by me, but by that fathead, threw me into a towering rage. It roused a hyena in me . . .
>
> This particular boy happened to be my worst enemy, the best student in the class and also the one who taunted me the most mercilessly for being such a *shlemiel,* because I never seemed able to learn anything in school. As I watched him draw, I was completely dumbfounded. To me, this experience was like a vision, a true revelation in black and white. I asked him how he managed such a miracle. "Don't be such a fool," he replied. "All you need to do is to take a book out of the public library and then to try your luck at copying one of the illustrations out of it, as I am doing right now."

And that is how I became an artist. I went to the public library, selected at random a bound volume of the illustrated Russian periodical *Niva,* and brought it home. The first illustration that I chose in it and tried to copy was a portrait of the composer Anton Rubinstein. I was fascinated by the number of wrinkles and lines in his face that seemed to quiver and live before my eyes.

The story has shades of a more famous legend, the one Matisse told of his awakening to drawing, in the provincial backwater of French Flanders twenty-five years earlier. Like Chagall, the young Matisse seemed an untalented waster; his conflict with his pragmatic family drove him to nervous collapse, and recovering in a hospital bed, he watched his neighbour copying a Swiss landscape. "Seeing that I was becoming a burden to myself during my convalescence, my friend advised me to try the same distraction. The idea didn't please my father, but my mother took it upon herself to buy me a paintbox with two little chromos in the lid, one showing a water mill, the other the entrance to a hamlet." Matisse's neighbour explained that the pastime was not only relaxing but expedient: "And then, you see, you end up with something to hang on the wall." And so Matisse began with the water mill: "Before that, I had no interest in anything. I felt a great indifference to everything they tried to make me do. From the moment I held the box of colours in my hand I knew this was my life. Like an animal that plunges headlong towards what it loves, I dived in."

Both anecdotes reveal the gulf between daily life and visual art in provincial Europe at the turn of the twentieth century, a gulf almost incomprehensible in a twenty-first-century culture saturated with images, reproductions, advertisements. The very word *artist* sounded alien to a small-town boy like Matisse or Chagall. "I knew all the [Russian] curses on the street–and some respectable and modest words as well," Chagall recalled.

But such a fantastic, bookish word, such an unreal word: *khudozhnik* [artist]–I never heard. That is, I did hear it, but in our city it was never used. How would we rise to that . . . If not for my schoolmate who, after several visits in our room, seeing my paintings hung on the wall, blurted out: "Hey, listen, you are a real *khudozhnik*!"

"What does it mean, *khudozhnik?* Who *khudozhnik?* Could I really be sss . . . uch?"

He left and didn't answer. And I remembered that somewhere in the city of Vitebsk I had really seen a big sign, as on store fronts, that said: "School of Painting and Drawing of the *Khudozhnik* Pen." And I thought: My destiny is set.

It was the blue and white colours of the painted sign blazing out on Gogol Street as the tram climbed the hill of Cathedral Square that comforted Feiga-Ita Shagal some months later as her son trawled her across town to the substantial white-balconied apartment belonging to the art teacher. " 'Gurevich's Bakery and Pastry Shop,' 'Tobacco, Variety of Tobaccos,' 'Fruit and Vegetables,' 'Warsaw Tailor,' 'School of Painting and Drawing of the Artist Pen'–all this looks from the outside like a *shtikl gesheft* [a viable business]," Chagall remembered her saying. She had had no idea what being an artist meant when he announced to her that he had found his vocation; she had agreed, however, to consult Great-Uncle Pissarevsky, "a man who read newspapers and thus enjoyed, in our family circle, the reputation of being a cultured man of the world." By then, although his religious parents did not mind his sketches on the wall ("it never occurred to any of us that these little pieces of paper might be what was thus so solemnly forbidden"), superstitious Uncle Israel in Lyozno was too frightened to shake the hand that drew the human figure.

Great-Uncle Pissarevsky mentioned approvingly the names of some famous Russian artists, "but he also added that men like Repin and Vereshchagin had talent, something that had never yet occurred to any of us. My mother decided, however, on the spot that she would allow me to study art if Professor Pen, who certainly knew his own business, expressed the view that I had talent." Khatskel hurled out five rubles, the cost of a month's tuition from Pen, and Chagall and Feiga-Ita were off.

The smell of paint, the feel of plaster, the impact of the portraits of Vitebsk's gentry, chests bright with medals, bosoms opulent and bejewelled, all beckoned young Chagall as he mounted the stairs to Pen's studio, clutching his bundle of drawings. Feiga-Ita, eyes wandering into all the corners, climbing the canvases in amazement, ranging across Greek plaster heads, ornaments, heaps of papers on the floor, suddenly turned to her son and said, "almost imploringly, but in a firm, clear voice . . . 'Well, my son . . . you see: you'll never be able to do things like that. Let's go home.' " Chagall ("for my part I've already decided I'll never paint like that. Is it necessary?") stood mute but inwardly resolute ("prepare yourself, with Mama

or without her!"). Pen was out, and a pupil astride a chair, making a sketch, airily answered Feiga-Ita's query about the possibilities afforded by his craft: "Art isn't a trade that implies keeping a shop or selling any wares."

Then Pen arrived. Bowing negligently but offering a friendly Yiddish "a gut morgn," he would have recognised the scenario of the shy young man and uncertain mother at once: twenty-five years earlier he himself, a poor young Jew still wearing the traditional shtetl clothes, devoutly observant and speaking no Russian, had stood outside St. Petersburg's Academy of Arts. Feiga-Ita addressed him in Yiddish, just bringing herself to utter the strange Russian word:

> "Here he is. I don't know myself. He's taken it into his head to become a *khudozhnik* . . . Surely a madness. Take a look, that's what he's done. If it's worth anything, let him study; if not . . . Let's go home!"
>
> Pen didn't even blink . . . Mechanically, as out of habit, he takes my copies from the *Niva* and mumbles something like "yes–there is talent". . . For me it was enough.

Chagall, still at secondary school, was enrolled on the spot as Pen's pupil; after he left school, he combined study at Pen's with an apprenticeship as a photographer's retoucher, the compromise suggested by his mother between learning a trade and his own dream of becoming an artist. He hated the apprenticeship and was never good at the work or at ease with the smug, puffed-up photographer in his shop, with its sign "Khudozhestvennaya Fotografiya" (Artistic Photography), in the grand part of town, close to the Rosenfeld jewellery shop. Art, the photographer used to say, "is a fine thing, but it won't run away from you! And besides, what good is it? Just see what a fine setup I have! Nice apartment, fine furniture, customers, wife, children, the respect of all–you'll have all that, too. You'd better stay with me." To Chagall, between this "dyed-in-the-wool bourgeois" on the one hand and his uneducated family on the other, Pen stood like a beacon.

The *khudozhnik* Yuri Moyseevich Pen (as was the custom, he had Russi-fied his name from the Hebrew Yehuda, son of Movsha) was then about fifty years old, a small, precise, absorbed man with a long jacket, a glittering watch chain, and a blond pointed goatee. Born into a large impoverished family in Novo-Alexandrovsk (now Zarasai, Lithuania)–his father died when

he was four—he was apprenticed to a Hasidic house painter in Dvinsk, his mother having noticed his early passion for drawing. The house painter thrashed Pen for making drawings and told him to stop fancying himself a *kinstler,* for "artists were drunkards and beggars who died of consumption or went mad." But while visiting a cultured neighbour, Pen met an art student from St. Petersburg, who encouraged him to take the test for the Academy. He failed, then spent a year living illegally in the Russian capital, paying the yard keeper not to inform on him and visiting the Hermitage to prepare for a second attempt at the exam, which he passed in 1880. He was a pioneer: a year later the newspaper *The Russian Jew* opened

Yuri Pen, *Self-portrait, 1905*

for the first time a discussion on whether the old canard that "the entire history of the Jewish people attests to their inaptitude in the plastic arts" remained valid.

Pen acquired an impeccable mastery of traditional techniques but showed neither originality nor any desire to be modern. He derived his style from a painstaking allegiance to Rembrandt, whose works, first encountered at the Hermitage's outstanding collection, he copied endlessly, and from the careful realism of the Russian Peredvizhniki (Wanderers) group. In the 1860s and 1870s this group of artists, including Ilya Repin and Alexei Savrasov, promoted paintings of Russian landscapes and down-to-earth provincial scenes in reaction against the backward neoclassicism of the academies. The Wanderers—their name came from their exhibitions, which innovatively travelled to the regions beyond Moscow and St. Petersburg—established a narrative realism focused on national identity and issues of social injustice (as in Repin's *Barge Haulers on the Volga*) as the dominant mode of late nineteenth-century Russian art. They were supported by the wealthy merchant collector Pavel Tretyakov, whose collection now forms the core of Moscow's Tretyakov Gallery. "I don't need either rich nature, or magnificent composition and lighting effects and miracles of any kind. Let it be a dirty puddle, if only it has the truth," Tretyakov said; his favourite work was Savrasov's *The Rooks Have Returned,* depicting the beginning of spring as snow melts, earth reappears, and buds appear on bare trees in a scruffy rural scene. By the 1880s and 1890s the influence of impressionism on this style was beginning to be felt in the works of Valentin Serov and Isaac Levitan, but still the emphasis was on the sublime of the everyday. Levitan's *The Village* was the favourite work of Chekhov, who rated it above the Monets and Cézannes he had seen in the West. It shows, Chekhov said, "a village that

was dull and miserable, Godforsaken and lifeless, but the picture imparts such an inexpressible charm that you can't take your eyes off it. No one has managed to achieve the simplicity and purity which Levitan achieved . . . and I do not know if anyone else will ever achieve anything like it."

"We all considered Levitan a great man, in those days," Chagall remembered of the 1900s. Levitan had died in 1900, Repin, born in 1844 and already a teenager when Russia's serfs were liberated in 1861, lived on, going in and out of fashion, until 1930, by which time he was mythologised as the forerunner of socialist realism. Pen particularly admired him and had paid visits of homage to his summer estate at Zdrawnewo, near Vitebsk, through the 1890s and 1900s. Oblivious to new trends in both Russia and the West, Pen transformed the Wanderers' romance of everyday Russia into a recording of the minutiae of Jewish life in the Pale: *izbas,* rabbis and Talmudic scholars, Sabbath meals and matchmakers, above all Jewish clockmakers and watchmakers, were his obsessive subjects. He painted them in their workshops, constructing the instruments to mark the time that in Pen's still paintings never changes: figures as anachronistic as his own art, as attentive as he was to the tiniest detail, living within an ancient tradition that he never expected to change, and portrayed with scrupulous exactitude but deadening stiffness; even in his society portraits, from which he made a fine living through commissions from Vitebsk's bourgeoisie, the naïve folklore mentality of Pen's background still slipped through the veneer of high culture acquired in St. Petersburg.

Pen was single-minded, hardworking, devoted to his craft. He never married, and he opened his school in Vitebsk to offer boys—and, radically, girls—of his background the training he had had to fight so hard to acquire, aware that attitudes towards art among Jews in the Pale remained backward. "The entire goal of my articles on art is to awaken love for the fine arts among our fellow believers and to popularise facts of art. We are still looking for material benefit in everything and above all national benefit, forgetting that any Jew is a human being and should love art and knowledge, even if they are unrelated to Jewish nationality," begged Mordecai Zvi Maine, a journalist writing in Hebrew in 1897, the year Pen opened his school in Vitebsk. For some years his was the only art school in the Pale; lining his walls with his own and his pupils' works, he also provided Vitebsk's only museum. Though mostly Jewish, his students came from all ethnic groups and were diverse in age, ranging from ten-year-old children to bourgeois matrons. Each lesson cost a ruble, payable on the spot, but talented children from poor families were taken on free.

Although towards the end of the nineteenth century some Russian Jews became famous artists—Levitan was a Jew born in Lithuania, and Jewish sculptor Marc Antokolsky (1843-1902) became a St. Petersburg celebrity— they did so by assimilating into the heart of the Russian mainstream and taking Russia as their primary subject. Antokolsky formed an artistic circle with Repin and Mussorgsky, while Levitan was a close friend of Chekhov's, who sought in his Russian landscapes the inspiration for typical provincial scenes, describing them to create the atmosphere of *The Cherry Orchard* and *The Three Sisters.* The lives and art of such Jews were remote from provincial Vitebsk. Pen, on the other hand, stayed within his native milieu; he was an observant Jew who kept the dietary laws, shut his school on the Sabbath, and spoke Yiddish with his pupils. He became a much-loved and inspirational Vitebsk character, showing that it was possible, within a culture with little history of visual art and a religion that forbade the creation of graven images, to be both Jew and artist. His genre scenes, moreover, dignified Jewish life for the first time as a subject worthy of art. Neither lesson was lost on Chagall.

At Pen's Chagall received the solid classical art education, organised along academic lines—lessons in drawing plaster casts, copying drawings, working with a model, depicting a still life from nature—that was the bedrock from which all the revolutionary Russian modernists, from Kazimir Malevich to Wassily Kandinsky, went their own ways. Exact reproduction of nature, mastery of drawing, rhythm and proportion: Chagall learned the basics of his craft easily and quickly from the patient, enthusiastic, nurturing Pen, who empathized passionately with his pupils. In a photograph of 1910 with half a dozen female students, he is a beaming, avuncular figure in his prime. Inwardly serene, adaptable within his small milieu, he is an equally benign and respected figure sitting at the centre of a group of postrevolutionary artists in a photograph from the 1920s, when the next generation continued to revere the elderly man though his art belonged in a forgotten era. With all his students Pen delighted in sharing his own creative experiences and in getting to know them as individuals; he often painted their portraits.

Pen would eventually pay with his life for his connection with his thrusting, restless, most famous pupil. But when Chagall joined the school around 1903-4, all was quiet and calm. He made friends with two other young painters, Mikhail Libakov and Ilya Masel, who remembered that "with our albums, we often walked down the streets of the town and drew the poor Jewish houses; when Chagall joined the class, all three of us made sketches of

Vitebsk's alleys." Masel, three years younger than Chagall, had been study-
ing with Pen since he was nine; also studying there were Viktor Mekler, the
classmate who had noticed Chagall at high school, Ossip Zadkine, and Lazar
Lissitzky (later El Lissitzky), also three years
younger. Lissitzky came from the nearby village
of Pochinok, went to school in Smolensk, where
his grandfather was a craftsman, and studied with
Pen in Vitebsk in his summer vacations. His story
emphasizes Pen's importance as the only route to
an art education for children in the Pale.

Chagall as a schoolboy, circa 1905

Pen did much of his teaching *en plein air*,
accompanying his students around the streets
and out into the countryside, communicating his
own love of Vitebsk. "You see, I love the portrait-
like nature of towns," he used to say. "Every
town should have its own portrait, and our
Vitebsk here has its own images that distinguish
it from all other towns. Let's take, for instance,
Markovshchina. It is a wonderful place, where
one can have one's fill of fresh air and cleanse
one's blood enough to make a jolly landscape the
next day. That air, I tell you, will itself settle down
on your canvas." Thirty years later Chagall reminisced to his teacher, "How
are my little huts where I spent my childhood, and which we both once
painted together. How happy I would be . . . to sit with you on a porch at
least an hour, and paint a study."

Pen's *plein air* motifs were Jewish versions of the themes favoured by the
Russian realists: incidents of country life in *Bathing a Horse, Water Tower
near the Prison, Barn on the Vitba;* tumbledown huts like *House Where I
Was Born;* water carriers, old women carrying baskets across empty fields.
Thus his students received, as their first taste of a painterly style, an intro-
duction, diluted through Pen's imitations, to the narrative approach of
Russian art that had enjoyed its heyday in the 1870s, when the Wanderers
had toured the countryside raising public consciousness of art. "When the
exhibitions came," remembered Ilya Minchenkov, "the sleepy country
towns were diverted for a short while from their games of cards, their gossip
and their boredom, and they breathed in the fresh current of free art. Debates
and argument arose on subjects about which the townfolk had never thought

before." So it was with Pen's influence in remote Vitebsk—forty years later, by which time the style was quite out of date. Quietly and doggedly, Pen continued reproducing it through the early years of modernism, abstraction, suprematism, and constructivism, until by the 1930s his simple figuration had something in common again with socialist realism.

Chagall rejected every technical element of Pen's slavish, sombre naturalism, while absorbing from him the connection with narrative art and its focus on the Jewish world. The paintings that he hung above his mother's bed during his first months at Pen's depicted "water carriers, little houses, lanterns, processions on the hills." Pen used the journal *East und West,* published by a Zionist organisation in Berlin, to steep his pupils in the concerns of Jewish art. As a genre painter, he shared the aspirations of Jewish writers such as Ben Ami, who wrote in 1898 that "I sought to recreate . . . as best as I could, the life of the mass of our people, or to be more precise, those aspects of the life I was most familiar with, the way I know them, recreating them as a participant who has experienced and suffered it all, together with the rest of the people, rather than as an alien and indifferent onlooker."

Chagall would transform this world, turning it literally upside down with a modernist vision that Pen could not begin to comprehend, though he, too, remained rooted in Jewish Vitebsk. From the start he fought against his teacher, beginning with the rebellion of painting in violet; he later made the fanciful claim that this act of daring so impressed Pen that he waived his fee. In *Woman with a Basket* (1906-7), painted from life in Pen's studio, violet and lilac hues combine with shades of grey. Chagall had departed already from Pen's stereotypical realistic model to give vitality by emphasising the unusual and the individual—the woman's contorted crippled hands, wrinkled face, the ornamental decorations on her shawl—through sharply hatched shadows and the wash of colour enveloping the model. A similar restless, mysterious atmosphere is captured in *Old Man,* also painted from life at Pen's, and in the white-grey watercolour of a wintry Vitebsk scene "The Musicians" (1907), where shambling *izbas* seem to pulsate to the music. Here dark, roughly sketched bodies are deliberately clumsy and distorted against the bright snow, and the central musician stands stubbornly with in-turned feet. Half a century later Chagall told his son-in-law that "they were meant first of all as a provocation, as an emphatic refusal of realism" as advocated by Pen. The caricaturelike satirical quality of some early pencil drawings—a grotesque lumpen couple with almost animal snouts in *Love,* another misshapen, comically indifferent pair in "Couple On the

Bench," and a set of gauche frenzied dancers in *The Ball*—suggests Toulouse-Lautrec, though Chagall would not have known his work then; they, too, strike out against provincial complacency and limitation.

Chagall's primitive energy barely troubled Pen, but it attracted the enthralled admiration of Viktor Mekler. "Black hair, a pale face, he was as foreign to me as his family was to mine. When he met me on our bridge, he never failed to stop and question me, blushing, about the colour of the sky or the clouds . . . 'Don't you think,' he said to me, 'that that cloud down there near the river, is intensely blue? Where it is mirrored in the water it turns to violet. Like me, you adore violet. Don't you?' "

"Ignoring the wealth and ease that surrounded him," Viktor, a year older than Chagall, sensed Chagall's superior talent and asked him to give him

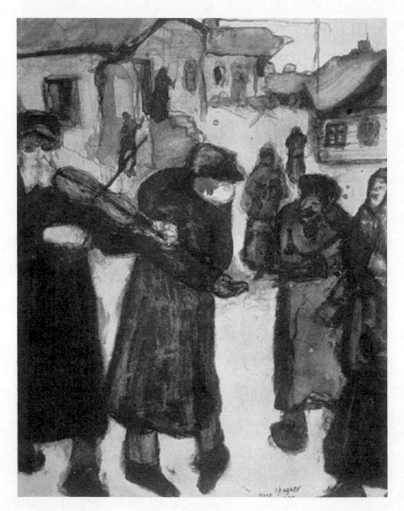

Chagall, "The Musicians," 1907, watercolour on paper

Chagall, "Couple on the Bench," 1906–7, drawing

lessons. Chagall refused to be paid, and the two became close friends, committed to each other and to art, which eclipsed everything else. Chagall was too shy and preoccupied to become seriously involved with girls: it was useless, he remembered, for his first girlfriend, Anyuta, to "go with me when I painted outside of town on the Jules hill. Neither the peace of the nearby forest, nor the deserted valleys, nor the vast fields, gave me the strength I would have needed to overcome my timidity." Instead his emotional energy poured towards Mekler. Nor was he insensitive to male beauty–including his own, which he continued to touch up with makeup: "the face of my precocious adolescence was a mixture of Passover wine, ivory-coloured flour and faded rose petals . . . How I admired myself." He appreciated Viktor's fragile looks and effeminate charm, too, so different from the rough, worn characters of Pokrovskaya.

But Mekler's chief attraction was that he opened the door to a cultured milieu centred on his own generation, who, unlike Pen, looked beyond Jewish Vitebsk to satisfy their ambitions. "We meet the Russian people through their culture," commented the Zionist Vladimir Jabotinsky in 1903. "Many, too many of us, children of the Jewish intelligentsia, are madly, shamefully in love with Russian culture, and through it with the whole Russian world." Mekler's father, Shmaryahu, paper manufacturer and owner of stationery shops, was a Merchant of the First Guild and was therefore allowed to travel freely with his son to and from St. Petersburg, where Viktor observed new trends long before they reached Vitebsk. Though Shmaryahu was a Jewish

community leader, the family was progressive and spoke Russian at their home on the "big side" of town, where they were neighbours of the Rosenfelds. They welcomed Chagall and became his entrée into the world of the rich Jewish-Russian intelligentsia, his circle for the next half decade. Thus it was that he spent more and more time away from home at Viktor's dacha, "where we roam the fields and lose ourselves. Why do I write about this? Because only the big-city attitude of my friends gave them the courage to think that I was worth more than just Moska from Pokrovskaya Street." A sense of social inferiority, coupled with a conviction that he was the more serious artist, complicated his friendship with Mekler. While Mekler was materially indulged, Chagall still struggled to afford tubes of paint, and he claimed that his sisters rounded up his works, conveniently heavy and thick, to be used as carpets. Increasingly, his family's cultural ignorance and lack of aspirations forced him to look beyond Vitebsk. Pen and Viktor were the chief conduits by which he did so: they were the first in a series of figures, each slightly more connected with secular values than the last, through whom young Chagall nervously approached the wider world.

Pen, the father figure, provoked in him violent ambivalence: Chagall was at once the rebellious son and sentimentally attached to this important representative of his youth. In a letter from Paris in 1912, he fumed that his former teacher was a bad influence on innocent minds: "He is pathetic and provincial, his business is to kill bedbugs and he doesn't want to learn as the great painters did . . . Poor teacher who didn't receive anything from God . . . I am miserable that I received a very bad education at Pen's school. What I learnt from him I now have with great difficulty to use poison to throw out, to eject from my body." But by 1921, when he was more confident, he wrote to Pen, "Even if the path which I have chosen is different from yours, I retain the memory of you as a great worker, my first master. I love you for that." And in 1927, in permanent exile in Paris, he wrote nostalgically, "If I am jealous of anything–it is that Pen still lives in Vitebsk . . . All my life, no matter how different our art is from one another, I remember his trembling figure. He lives in my memory as a father. And often, when I think of the deserted streets of the city, he appears now here, now there. And I cannot refrain from entreating you: remember his name." Chagall's art was fuelled by the twin drives to escape and to remember; his confused response to Pen embodied that conflict.

If Pen was an alternative father, Viktor was the prototype for another character that Chagall liked to draw to himself: the accomplice in the battle

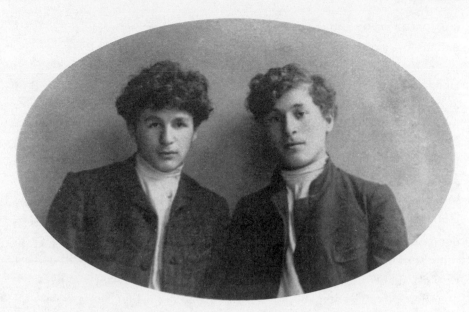

Viktor Mekler and Chagall, 1906

for his vision of art. Before his marriage such relationships–Viktor would have successors in both St. Petersburg and Paris–were so heady, involved, and dependent that they were not ultimately sustainable. Chagall, as social climbers do, wrung them dry, then proudly turned away. But in 1906 Viktor was emotionally and practically essential to him. By the early winter months of that year, Pen's school had become, to both of them, "nothing special," Vitebsk was stifling, and Viktor urged his friend to undertake a radical adventure–to study art together in St. Petersburg. Chagall was timid and frightened of travelling; only the assumption of the worldly, well-travelled Mekler that this was the natural next course slowly overcame his fears.

With certain exceptions, Jews needed special certificates to enter St. Petersburg and were officially banned from living there, though their numbers had been steadily rising since the mid-nineteenth century, from around 6,000 in 1869 to over 20,000 in 1900, when they constituted 1.6 percent of the population. Jewish Merchants of the First Guild, however, were exempt from the restrictions, and St. Petersburg was therefore open to Shmaryahu Mekler and his son; he provided a merchant's certificate, stating that Chagall was doing business on his account, to allow him into the capital. His own father offered twenty-seven rubles–the equivalent of a month's rental of a cheap room–and warned there could be no more; Pen was encouraging

and sent a recommendation to a St. Petersburg photographer, Jaffe, for Chagall to work at retouching photographs, as he had done in Vitebsk.

Before they left their hometown in the last weeks of 1906, Mekler and Chagall had their photograph taken together: friends and rivals, full of anticipation on the brink of adult life in a new city. Mekler, scion of a pampered family, has the more refined, delicate features but is burdened by an uneasy, self-absorbed look, his narrow eyes shifting unsurely. Bella, who knew him before she met Chagall, remembered that "he had a strikingly good-looking, rather girlish face. But it was like bitter chocolate, and like his own painting: slightly repellent." Chagall, more anxious practically about the path they were taking, shows on the other hand an inner confidence and resolution that make Mekler appear weak; his strong chin, determined forehead, bright, steady eyes, and independent expression all suggest resolution and drive. "I have chosen to paint; for me it has been as indispensable as food," Chagall said toward the end of his life. The 1906 photograph of the two adventurers, the one suggestive of the fading energy of old privilege, the other of the unstoppable force of new ideas and a new class of Russians, is a premonition of Russia's revolutionary fate. The invention of modern art was part of that future. At nineteen, Chagall was ready to seize his role in shaping it.

Forbidden City

St. Petersburg, 1907–1908

The two pioneers from Pen's reached St. Petersburg after a ten-hour journey in a cramped third-class compartment and joined the crush of travellers spilling out onto the platforms of Vitebski Station in southeastern St. Petersburg. Vitebski, Russia's oldest railway terminus, was built for the imperial family to travel to their country palace at Tsarskoe Selo, but it had recently been renovated, in 1904, and was now a cathedral to style moderne–Russia's equivalent of art nouveau. With its white marble staircase, elaborate ironwork, stained-glass murals, and resplendent restaurant, it announced itself as gateway to a proud, up-to-date European capital. The impression was daunting and alienating to a pair of provincial Jews. "Terror gripped me," Chagall remembered. "How could I manage to feed myself, since I'm good for nothing but perhaps to draw?"

At the foot of the station steps lay the broad Zagorodny Prospekt and to one side the formal garden square Pionerskaya, but to reach central St. Petersburg, Chagall and Mekler had to cross a rougher part of the capital. Walking north, they soon reached Sennaya Ploschad (Haymarket), the original cattle market, a place of squalor whose "airlessness, the bustle and plaster, scaffolding, bricks and dust . . . that special St. Petersburg stench . . . and the numerous drunken men" Dostoyevsky had described in *Crime and Punishment.* By the 1900s Sennaya Ploschad was teeming with confused, hopeful newcomers like Chagall: in that decade nearly three-quarters of St. Petersburg's two million inhabitants described themselves as having recently arrived in the city from the country–"snatched from the plough and hurled straight into the factory furnace," in Trotsky's phrase. Here Cha-

St. Petersburg, 1900s

gall the artistic adventurer became just one anonymous immigrant among many looking for work and lodgings.

"Rooms, alcoves to rent, as many as you wish. Advertisements were as plentiful as the dampness," he noted. An average sixteen people, with six per room, lived in a typical St. Petersburg apartment, according to a survey in 1904, with cellars, hallways, and kitchens all divided and subdivided by racketeering landlords out to profit from the surge of new arrivals. Chagall presented himself at the home of Pen's friend Jaffe, who took him on in his atelier, paying his board as recompense for the dull work of correcting wrinkles and crow's feet, and providing him with lodgings shared with a young sculptor.

St. Petersburg has little daylight in December and January, and in his first weeks Chagall found himself shut in like a character in nineteenth-century fiction, leaving for and returning from Jaffe's under a black sky and cooped up all day in a dark studio. Beyond, the scope, extravagance, and sense of history that screamed from every building in the capital was overwhelming. Chagall had, he said, no "enthusiasm" for it at first: "It was hard for me to define exactly what I wanted. Too provincial, if I must admit it frankly."

When he did venture out, a city thrillingly different from Vitebsk confronted him. A few steps away from Sennaya Ploschad along a bend on the Griboedova Canal lay the heartland of Russian culture: the Mariinsky Theatre, its neo-Renaissance facade recently remodeled, and the Conservatory, another fin-de-siècle neoclassical building, with the shiny new statue of Glinka, erected in 1906, outside. The young Prokofiev and Stravinsky were currently studying there under Rimsky-Korsakov, who was writing his final work, the satire on autocracy *The Golden Cockerel,* which the tsar would ban later in the year. Across the square the blue and white baroque St. Nicholas Cathedral, with its five gilded cupolas and the spire of its bell tower, gleamed against the winter sky, and the yellow colonnaded Yusupov Palace towered over the Moyka Canal. The Yusupovs were then one of the richest families in Europe, wealthier even than the Romanovs whom they served; when he was not touring his estates in a private railway carriage, the son of the house and future heir, Prince Felix Yusupov (born the same year as Chagall), lived here with a menagerie of macaws and bulldogs and hundreds of servants collected from across the Russian empire, whom he dressed up as slaves and pretended to kill with daggers in the mosaic-patterned Moorish Room. Opposite, on the Moyka's northern bank, another pampered youth, seven-year-old Vladimir Nabokov, was growing up at 47 Bolshaya Morskaya in a mansion decorated with sculpted rosettes and a filigree of pink flowers in the latest art nouveau fashion. His father, a liberal, at least sent his son to school, and though the democratically inclined teacher begged Vladimir to take the tram there, the child insisted on being driven by one of his father's two chauffeurs, in the family's new grey Benz. "A large majority of the Russian nation," Nabokov wrote of this period, "was left out in the cold veil of slow snow beyond the amber-bright windows, and this was a tragic result of the fact that a most refined European culture had arrived too fast in a country famous for its misfortunes, famous for the misery of its numberless humble lives." When he was set free from Jaffe's, it was outside such bright windows that the impoverished nineteen-year-old Chagall stood and gazed in his first evenings wandering the streets of the unfamiliar capital.

St. Petersburg, in those days, was still the chiaroscuro city of Gogol and Dostoyevsky, a nineteenth-century sprawl of ostentatious wealth versus cockroach poverty, byzantine bureaucracy, and gradations of social rank visible on every street. Karl Bulla's photographic panoramas from the 1900s show crowds dwarfed by the solemn splendour of Rastrelli's baroque Winter Palace—then painted a dull red—and people mere specks against the back-

Studio of K. Bulla, "View of the Winter Palace from the Neva River," St. Petersburg, 1900s

drop of the icy Neva. Yusupov's memoirs record banquets for two thousand at the family's palace on the Moyka, the salons decked out with Fabergé silver swans and the drawing rooms hung with Rembrandts and Watteaus. Behind such set pieces threaded a grimy, dank web of slum streets and factories that flooded the canals with stinking industrial waste. Sanitary conditions were infamous—fewer than one in three apartments had a lavatory or running water, and excrement piled up in backyards and was collected nightly in wooden trucks. Guidebooks warned travellers to take along flea powder, expect bedbugs, and never drink unboiled water (this last is still true), and mortality rates were the highest of any capital in Europe.

Such extremes, according to the writers who mythologised St. Petersburg, made madness an inseparable part of it. Some of the hopeful artists and intellectuals converging there from the provinces in the 1900s did in fact go mad. The symbolist painter Mikalojus Ciurlionis, for example, who arrived from Vilna in 1908, two years after Chagall, felt desperately homesick and swamped in "this porridge of two million." In St. Petersburg, he wrote, "some strange heavy spirit settled on me, such a big one, with black wings. It was very bad." He lived in squalid lodgings, painted without an easel, pinning paper to his walls instead, offered his paintings to occasional visitors for one kopek, and died insane in 1911. Embodied in Dostoyevsky's

Raskolnikov, the idea that something in St. Petersburg prompts psychological instability was almost as old as the capital itself. Dostoyevsky had called it "a city of the half insane," whose "low ceilings and tight rooms cramp the mind and soul." Gogol's tales such as "Nevsky Prospekt" and "Stories of a Madman" portray an unreal place where nothing is what it seems; his story of a disappointed clerk whose corpse wanders the streets ripping coats from the backs of passersby in "The Overcoat" is a bitter satire on an autocratic, cold capital of tsars and officials offering the individual neither sympathy nor protection. Beyond it is the obsessive hero of Pushkin's "The Queen of Spades," who loses his mind in the city over a gambling secret. These ghostly characters haunted the texture of the shabby streets and alleys where Chagall first found lodgings in 1907, when Dostoyevsky had been dead only a quarter of a century and there were still people living in the city who remembered Pushkin's funeral in 1836.

That St. Petersburg had been so intensely constructed into a landscape of the mind by its writers is what made it–for Chagall, Mekler, and hordes of other young provincials pouring in from the Pale of Settlement in the decade before the revolution–the focus of the culture that was their route out of the shtetl. "I love you, work of Peter's warrant, / I love your stern and comely face, / The broad Neva's majestic current, / Her bankment's granite carapace, / The patterns laced by iron railing, / And in your meditative night / The lucent dusk, the moonless paling," Pushkin had written of the grid of windswept squares, arrow-straight boulevards, and long sweeping canals that form the centre of the watery capital. Built out of nothing by slave labour on the frenzied orders of Peter the Great, on swampy islands where the broad river Neva breaks up and enters the Baltic, St. Petersburg's existence announces the triumph of imperial power over nature and the common man, for its foundations are literally cemented over the bones of the workers sacrificed for its austere, steely loveliness. Dostoyevsky called the result "the most abstract and intentional city in the whole round world." Since its creation in 1703 as Peter the Great's rejection of backward Moscow and Russia's window on Europe, foreigners have marvelled at this glassy stage set, its facades looking almost unreal as they are reflected in rivers and canals against the changing northern light.

To anyone born within the empire and steeped in Pushkin, Gogol, and Dostoyevsky, all the extremes of beauty and decadence, suffering and madness of Russian art were condensed here by the 1900s. In literature and painting, Russia had embraced symbolism and art nouveau in the flowering of culture now defined as the Silver Age, which had begun in the 1890s and

by 1907 was on the wane, though not yet replaced by the avant-garde. In lush melodic verse, symbolist poet Alexander Blok anatomised St. Petersburg between 1904 and 1908 as an illusory metropolis in his eerie poem of a dark, withering world, "The City." Around Blok and the archaic poet Vyacheslav Ivanov, Russia's Silver Age poets and artists congregated; summing up their mood of desolation crossed with flickering hope at this time, Blok wrote to his mother in 1909:

> More than ever I see that never until my dying day shall I accept or submit to anything in contemporary life. Its shameful form inspires only disgust in me. Nothing can be changed now–no revolution will change it . . . I love only art, children, and death. Russia is for me as before–a lyrical force. In fact it does not exist, never has and never will. I have been reading *War and Peace* for a long time and have reread almost all of Pushkin's prose. That does exist.

Among painters, the equivalent of the Silver Age poets was the Mir Iskusstva (World of Art) group, founded by Sergei Diaghilev and the decorative, art nouveau artists Alexandre Benois and Léon Bakst in St. Petersburg in 1898. Like their fin-de-siècle equivalents farther west–Gustav Klimt in Vienna, Alphonse Mucha in Prague, Aubrey Beardsley in London–the Mir Iskusstva artists made a cult of languorous beauty as a protest against the bourgeois utilitarianism and mechanisation that had resulted from the industrial revolution, and in Russia especially they looked back to rococo and classical styles, as well as to fairy tale, puppetry, and carnival, to escape the ugliness around them. Benois, their leading spokesman, knew that their work represented the "effeminate, spiritually tormented, hysterical time" of the fin-de-siècle; this was a light art, favouring the airy effects of watercolour and gouache, and the decorativeness of scenography for theatre productions, over full-scale oil painting. At heart the World of Art figures knew they were a mere holding operation–when Diaghilev organised a large exhibition of contemporary Russian art at the Tauride Palace in 1905, he introduced it at a banquet before the tsar with a speech anticipating "a new and unknown culture which will be created by us and which will also sweep us away." Chagall and Mekler were just beginning to discover the heritage and contemporary artistic currents of the city, but no aspiring young intellectuals like them could arrive in St. Petersburg without a dizzying sense that

they were jumping into a whirlwind where past and future met, hurtling, like Gogol's unstoppable troika of Russian history, to an unknown destiny.

Jews, although the city was forbidden to them, especially dreamed of belonging to its romantic tradition. The strict residence regulations confining them, within the Russian empire, to the Pale of Settlement were supposed to keep them out of both St. Petersburg and Moscow, but these rules were flouted so systematically as to be a joke. More than half of St. Petersburg's dentists were Jews, along with a good percentage of its doctors and lawyers, and in music, art, and theatre the Jewish presence was strong. Bakst, a Jew from the Pale, was a major figure, as were Levitan's impressionist landscapes. Quotas limited Jewish numbers at the universities and academies, but the tsar's finance minister V. N. Kokovtsev mourned in 1906 that Jews were so clever that no law could be counted on to restrict them; Pobedonostsev had written similarly to Dostoyevsky a generation earlier, in 1879, that "they have undermined everything, but the spirit of the century supports them." He meant that the Jewish presence in Russian public life had escalated with the growth of capitalism in the later nineteenth century, with Jews taking the lead in banking, shipping, and mining and being responsible for the construction of most of the rail network. In St. Petersburg there lived a handful of prominent, wealthy Jews, and beneath them a second layer of well-off provincial merchants, such as Shmaryahu Mekler and his son, who entered the city freely and did business there, while a groundswell of aspiring illegal immigrants from the shtetl existed in poverty and fear. Pen had been typical of this group. He had entered the capital as an Orthodox Jew in traditional clothing in 1879 and paid constant bribes to the gatekeepers of his apartment building not to inform on him to the police. Although he was eventually admitted to the Academy of Art and finished his studies there, he managed to get a resident's passport only seventeen years later, in 1896.

Such were the barriers that poor, unconnected, timid, law-abiding Chagall faced in making a life in St. Petersburg in 1907. Arriving shortly after the failed 1905 revolution, unleashed by the Bloody Sunday massacre, and the year of unrest and general strikes that followed, he was alert to every nuance of repression, censorship, and prejudice. Compared with the slow, unchanging backwater of Vitebsk–its rhythms dictated by the Jewish ritual calendar, its many synagogues, its shop and business signs in Yiddish, the thousands of Jews in traditional dress filling its streets–St. Petersburg for Chagall felt hard, foreign, pulsating with possibilities, threats, and contra-

dictions. Not only was the European formality of its architecture alienating, it was also a flamboyantly Christian Orthodox city. The Church of the Saviour on Spilled Blood, designed in riotous Russian revival style, its five domes covered in jeweller's enamel, and its exterior decorated with thousands of square yards of mosaic panels, was finished the year Chagall arrived in the city; built to commemorate the assassination of Tsar Alexander II in 1881, it boasted 144 coats of arms on the bell tower to represent every province in the empire, intended to reflect the grief shared by all Russians for their dead leader and to symbolise the unity of the nation in its allegiance to church and emperor. How did Chagall fit into that? Aware that St. Petersburg was indispensable for his development as an artist, he nevertheless could not warm to the city. "In my stay in Petersburg, I had neither permission to live there, not the tiniest nook in which to live: no bed, no money," he wrote.

> More than once, I looked enviously at the kerosene lamp burning on the table. See how comfortably it burns, I thought. It drinks its fill of oil and I . . . ? I can scarcely sit on the chair, on the edge of the chair. And the chair doesn't belong to me . . . On the other hand, on the streets police are on guard at the police station, porters in front of their doors, the "passportists" at the commissariat.

In this nervy climate, Chagall grew tenser than ever, and his sculptor roommate "roared like a wild animal and hurled himself furiously on his clay to keep it from drying out":

> Is that any of my business?
> All the same I'm a man. I can't wake up every time he sniffs.
> One day I threw the lamp at his head.
> "Get out," I told him . . . "I want to be alone."

He gave up on Jaffe and traipsed the streets, thin and shy. Then his savings ran out, and "there were days when I nearly fainted from exhaustion and hunger. I couldn't even afford to buy a ten-kopek plate of *zrazys* [meatballs]." Changing to more cramped quarters, he shared in a communal flat, not just a room but a single bed, with a labourer, "an angel, he even flattened himself against the wall to give me more room." Soon he moved again, to a

block on Panteleimonskaya, an avenue running between two churches off the Fontanka River, near the Summer Gardens, where the room was divided by a curtain and his cotenant was a snoring typographer who played the accordion at night in the gardens, then returned home drunk and,

> after having stuffed himself with raw cabbage, insisted on making love to his wife. She pushed him away, took refuge in my half of the room and then fled into the passage, clad only in her nightgown. He pursued her, knife in hand . . . I realised then that, in Russia, Jews are not the only ones who have no right to live, but also many Russians, crowded together like lice in one's hair.

At the same time he struggled to get a foot on the art school ladder. He lacked the high school diploma that was a condition to apply to the conservative Academy of Arts, so he attempted instead the exam for Baron Stieglitz's less exclusive school for the applied arts, entry to which also guaranteed a visa to live in the city. "But the studies, copying those long plaster decorative designs that looked to me like things in a department store, all alarmed me. I thought: those designs have been chosen on purpose to frighten, to embarrass the Jewish pupils and keep them from getting the authorization they need. Alas! My presentiment was correct. I failed the examination."

He enrolled instead at the less prestigious Drawing School for the Encouragement of the Fine Arts, housed in an elegant building on the Moyka Canal, where he felt thoroughly out of place among the mostly St. Petersburg Russians, who, he thought, viewed him as a Jewish curiosity. The classrooms were cold, and "to the smell of dampness was added that of clay, paints, pickled cabbage and stagnant water in the Moyka Canal, so many odours, real or imaginary." The director, Nikolai Roerich, was an erudite, kindly painter, an archaeologist from an elite St. Petersburg family who insisted on reciting his turgid volumes aloud to his pupils. Though his own painting was primarily influenced by art nouveau, and he was closely connected to Diaghilev and Benois, his dream was to translate the primitive idiom of Gauguin's Tahiti paintings, which he had just discovered in Paris, into an art that reflected the remote Russian past, and thus he anticipated, theoretically at least, the neoprimitivism of the Russian avant-garde. It may have been through his influence that Chagall first heard of Gauguin during his initial year in St. Petersburg and was attracted to the primitivism that

was to be a vital current in his own art. Otherwise Roerich had little effect on him; he used to say mildly that art was for everyone, then leave instruction to others. The school followed an old-fashioned regime–still-life drawing, figure drawing from plaster casts, then from a live model–led by mostly second-rate teachers.

Chagall was soon bored and disaffected. The school was not completely undistinguished; the graphic artist Dobuzhinsky had studied there, and it attracted pupils from all sorts of backgrounds–Chagall's friend from Pen's, Ilya Masel, also joined the school in 1907. But Chagall was the most talented student and felt the school was inferior–he was at once upset by and contemptuous of the Russian pupils. He spent much time alone or with Mekler. After the easy flirtations with Vitebsk's Jewish girls, he was sexually frustrated, too–not confident enough to strike up friendships with the more liberated women at the school, yet too prudish, fearful, and romantic to take advantage of St. Petersburg's large population of prostitutes. The school and everything associated with it felt like a dead weight.

> What did I do there? I wouldn't know what to say. Numerous plaster heads of Roman and Greek citizens projected from every corner, and I, poor country lad, was obliged to acquaint myself thoroughly with the wretched nostrils of Alexander the Great or some other plaster imbecile. Sometimes I walked up to one of those noses and punched them. And, from the back of the room, I gazed a long time at Venus's dusty breasts.

What did he paint? Nothing remains from this time; intimidated at school, physically cramped at home, struggling to survive, overawed by his imposing surroundings, he did little actual work in his first half-year in the capital. "In those communal recesses, with labourers and pushcart vendors for neighbours, there was nothing for me to do but stretch out on the edge of my bed and think about myself. What else? And dreams overwhelmed me: a bedroom, square and empty. In one corner, a single bed and me on it."

But the impressions forming his imagination were another matter. "Is it possible that no one, anywhere, will give me a cup of tea?" he wrote of this time. "Is it possible I'll never find a piece of bread on a bench or on a post? It often happens that people leave behind a piece of bread, wrapped in paper. The essential thing is art, painting, a painting different from the painting everyone does. But what sort?" That was the question that St. Petersburg

would help answer, the question whose urgency kept him there despite the hardships, for he knew he could find no answer to it at home in the Pale. St. Petersburg in 1906–7 was not Paris, where Picasso was then working on *Les Demoiselles d'Avignon,* but Chagall was nevertheless for the first time in a major European capital, a conduit both to modernity and to a Russian artistic heritage.

Like every new St. Petersburg art student, he rushed to the Hermitage to see the works he had pored over at Pen's in reproduction, and to the Alexander III Museum of Russian Art in the Mikhailovsky Palace, less than a decade old, to which he returned repeatedly to see Andrei Rublev's icons– the only Russian art that captivated Matisse on his visit to Russia in 1911. "My heart was quiet with the icons," Chagall wrote; the other major revelation was the Hermitage's Rembrandts, an unrivalled collection including many biblical subjects and, crucially, *Portrait of an Old Jew* and *Portrait of an Old Man in Red,* on which Chagall was to muse for nearly a decade before painting his own Old Jews. The velvet and gilt-walled galleries of the Hermitage were not then the buzzing tourist honeypot of today but places of calm contemplation, quiet and heavy with the pleasures of scholarship and antiquity. Chagall loved the abundant and casual display of treasures, the three tiers of paintings, mostly European pre-nineteenth-century works, placed close together and climbing all the way to the mouldings, and people sitting for hours in chairs, sometimes with binoculars, studying them.

But just as formative was the art of the future, and Chagall's first blast of it came not from a gallery but from the theatre. By chance, the first production he saw in St. Petersburg was the one that made history as the start of Russian theatrical symbolism, Meyerhold's version of Alexander Blok's *The Fairground Booth* at Vera Komissarevskaya's theatre. It premiered on 30 December 1906 as a double bill with a Maeterlinck play, announcing Meyerhold's farewell to nineteenth-century romanticism and ushering in his experimental mode. Meyerhold himself starred as a stylised Pierrot, lying onstage in a white costume with red buttons; around him mystic characters were hidden behind cardboard cutouts. The grotesque, expressionistic effects were radical, and this and another Meyerhold production that winter, of Andreyev's *The Life of Man,* had an enormous impact on the nineteen-year-old Chagall–he quotes Meyerhold's puppetlike creatures directly in his painting *Fair at the Village* in 1908, which resembles a stage set, and his lifelong interest in harlequins and clowns dated from the Blok production.

Meyerhold opened up to him a primitivist aesthetic, unlike anything Pen

had offered; this coalesced in his mind with the discovery of Gauguin, though he saw his work only in reproduction, in black and white. The Silver Age poets shared with Gauguin an awareness that the transformations of the twentieth century demanded a new way of seeing. Chagall especially loved Blok; he now scribbled his own poems relating his downtrodden life and dreamed of sending them to the famous poet. This was a marker: at every stage in his career Chagall identified with contemporary writers rather than with artists, tapping into literary experimentation to help find his way through modernism, and using theatre as an essential backcloth. St. Petersburg taught him to think big, even to see the city as a stage.

. In early 1907, however, what whirled around in his head were half-formed, half-trusted ideas and images. He had, he wrote, a "vacillating" nature, unable to attach himself to anything definite in art. "I suppose you might have called me, in those days, a realist-impressionist," he recalled in the 1960s. Repin, Levitan, and the impressionist portraitist Serov continued to enjoy godlike status in Russia in 1907. Serov and Repin were still alive; the Wanderers also continued to exhibit. At that point Russia was decades behind western Europe–the first French impressionist paintings had not entered the country until the 1890s, and the first Gauguin arrived in 1906, when the great merchant collector Sergei Shchukin acquired *Wife of a King* and hid it behind a curtain at his Trubetskoy Palace as too shocking for most visitors. "I'm going to show you something," he told the painter Leonid Pasternak as he pulled back the curtain, adding with his customary stammer, "See what a fool has painted and another fool has bought!" Kazimir Malevich and Mikhail Larionov, soon to become the leading lights of the Moscow avant-garde, were in 1906-7 still painting in a derivative manner that merged impressionism, art nouveau, and symbolism.

Chagall, like the other Russian modernists, was seeking the new through a dissatisfied experimentation with the old. With Pen's training behind him, he rejected intuitively, as irrelevant to his purposes, the effete aesthetic of the World of Art group, seeing at once that "Bakst and his friends remained, on the whole, true to a very aristocratic and refined, even somewhat decadent, conception of art, whereas Levitan and even Repin advocated a kind of populist art that had some socialist implications, suggesting a return to the earth and to the life of the Russian people. I felt attracted to this Populist Impressionism." He was also drawn to the melancholy, frenzied, mosaic style of Russia's great symbolist, Mikhail Vrubel. Vrubel's best-known work, *The Demon Downcast,* which he had sensationally repainted–twisting the devil's lips into an ecstasy of pain, exaggerating his sinister eyes–was first

exhibited in 1902; he returned to it repeatedly until he had a nervous break-
down. The painting exercised a mesmerizing hold on Chagall's generation
through the 1900s; its sinister atmosphere and shattered fragments of paint
seemed to herald the cataclysm of modernism and the breakdown of the
imperial order.

Trying to absorb all these influences, during his first year in the city, Cha-
gall flailed about, uncertain what direction his work should take. By April
1907, however, he had done well enough at the school to be commended to
the board and was awarded an allowance of six rubles a month, a sum aug-
mented by an annual scholarship of ten rubles a month from September. To
a penniless illegal migrant, this was riches, and he could now afford to eat,
which he did almost every day at a little restaurant on Zoukowskaya. Jaunty,
eager, but still nervous in his expression, he had
himself photographed in September 1907 in the
school's distinctive uniform of a cape and cap; he
wears it as if he were dressing up and not quite
sure how to play the role. But the lessons were as
tedious as ever–students spent years in the same
class doing very little–and to his hostile drawing
teacher, Grigory Bobrovsky, a pupil of Repin, his
sketches looked like meaningless daubs. And the
scholarship did nothing to help his residence sta-
tus, which hung over him like a cloud: returning
to St. Petersburg after a visit home to Vitebsk in
the summer of 1907, after his temporary mer-
chant pass had expired, he was thrown into jail
for a fortnight for entering the city as a Jew with-
out proper papers because he was too naïve to
understand the system of bribes to minor police
officials.

Chagall in the uniform of the Drawing
School for the Encouragement of the Fine
Arts, St. Petersburg, photographed after
he had been awarded an annual
scholarship, 12 September 1907

Prison, he claimed in a romanticized account,
was a holiday after the noisy chaos of St. Peters-
burg's communal flats, for "here at least I have
the right to live." By his own account he spent
most of his time there on the toilet reading the graffiti, or sitting at the long
kitchen table slumped over a bowl of water. The electricity was switched off
at nine p.m., and after the disturbances of the communal lifestyle, he caught
up on sleep and remembered his dreams.

A dream he recorded is a fantasy of joining the mainstream: he is by the

sea with several brothers, including the painter Vrubel, who are locked in a cage and then let out. Vrubel swims away first, his golden legs spreading like scissors through the waves, but he recedes from view, an arm thrust out of the water, and he disappears. The other children wail, and in a thick bass voice the father, an orangutan with a whip, tells Chagall: "He's drowned, our son, Vrubel. All we have left is a painter son, you, my son."

In 1907 brilliant, unstable Vrubel was incarcerated in Dr. Usoltev's mental hospital in Moscow, where he was to die in 1910. If the dream Chagall recorded was true, it suggests his fixation as a young man on the idea of tormented genius, an empathy with the suffering of the caged fifty-year-old symbolist master, and the audacity that lay beneath his apparent timidity: already as an obscure twenty-year-old art student, he was presuming to inherit the role of this famous precursor of modern Russian painting. He may of course have made the dream up when, writing his memoirs in 1922, he was disillusioned and about to flee Communist Moscow. The ape thus becomes a parody of Russia as barbaric fatherland, and Chagall's alignment with Vrubel, by then dead and established as the bridge between the nineteenth century and the avant-garde, was a clever attempt to position himself in the Russian tradition. Either way, the desire to be linked to Vrubel shows a loyalty to Russian symbolism and its brooding quality, which through the 1900s reflected his own anxieties and insecurities.

When he came out of jail, he hit on the idea of apprenticing himself as a sign painter, since manual labourers obtained residence rights easily. But he failed the professional examination, believing that here, too, being Jewish had let him down, because he was not adept at the lettering–the Russian rather than the Yiddish alphabet. Thus he remained the provincial Jew at the gate of Russian culture, still yearning for permission to live in the capital.

At this low point he steeled himself to approach his one contact, a sculptor called Ilya Ginzburg, a Jew from Vilna who had studied with Antokolsky and was a friend of Pen's but also knew Tolstoy, Repin, and Gorky. Pen probably mentioned him during the summer in Vitebsk, and so in the winter of 1907 Chagall went gingerly to the Academy of Arts, where Ginzburg's studio was packed with souvenirs of Antokolsky and his own busts of contemporary celebrities: it seemed to Chagall the centre of an artistic elite and as far as possible from his own position as an illegal, penniless immigrant.

Ginzburg's habit was to present Jewish boys of merit with a letter of recommendation to the enormously wealthy banker and philanthropist Baron

David Günzburg, one of the few Jews in the empire who could claim an audience with the tsar. Born in Ukraine of German parentage (his noble title was German but was recognized in Russia), Günzburg was head of St. Petersburg's Jewish community and a patron of Jewish art. His passion was ancient oriental books, of which he was a prolific scholar and collector. He belonged to St. Petersburg's Archaeological Society and Paris's Société Asiatique and attended meetings of both, travelling between the two with a suitcase that always contained the same texts—a Hebrew Bible, a French-Arabic dictionary, and an edition of Tolstoy. He had published studies of Jewish ornamentation in African, Syrian, and Yemeni books; his own collection of 52,000 volumes, including ancient Hebrew manuscripts, was kept in his St. Petersburg palace in special oak bookcases with glass doors made in Paris and comprised one of the largest private libraries in Europe. It was here that Chagall met him in 1908.

Fifty-one-year-old Günzburg dreamed of finding a future Antokolsky in every boy who came begging to him, but he showed particular sympathy for Chagall. He offered him the customary modest subsidy of ten rubles a month—just enough for subsistence; Ciurlionis, trying to budget in St. Petersburg in 1908–9, reckoned that five rubles would feed him for ten days. But he also gave him an entrée among his rich, assimilated Russian-speaking Jewish friends. In 1908 Günzburg and Maxim Vinaver, leader of the liberal KaDet (Constitutional Democratic) party and a Duma member, founded the St. Petersburg Jewish Historical and Ethnographic Society, and Chagall, the gifted unknown from the shtetl, embodied their hopes for the future of Jews within the Russian empire. Their circle also included Vinaver's brother-in-law Leopold Sev, an attorney called Grigory Goldberg, the critic Nachman Syrkin, and the writer Alexander Pozner; all presciently recognized his promise and singled him out for encouragement.

As a lawyer, Goldberg had the right to keep Jewish servants, and he solved Chagall's residence problem by inviting him to live in his house, where he was ostensibly employed as a footman. For several months he lived in a cubbyhole under the stairs but took his meals with the family and in the spring of 1908 accompanied them as their guest to Narva, on the Gulf of Finland, where Goldberg's father-in-law, sawmill owner Naum Germonte, had a leafy estate on the seashore. It was Chagall's first taste of the dying days of the Russian *belle époque;* two early studies in colour contrasts, *Goldberg's Study* and *Goldberg's Parlour,* record with the precision and sense of emotional distance of the novice overawed by the grand setting, the milieu at the St.

Petersburg house on Nadezhinskaya–the mock Directoire furniture, the patterned rugs, the pictures and sea-green art nouveau sculpture on its stand.

On his return from Narva, Chagall was invited by Vinaver to move out of Goldberg's cubbyhole and live at the editorial offices of the Jewish magazine *Voshod* (Dawn), which Vinaver had edited. *Voshod* had ceased publication in 1906 but would be relaunched in 1910 and its editors still met there. The apartment functioned as both editorial office and Chagall's studio and sleeping quarters–he slept on a couch and worked surrounded by piles of unsold copies of the magazine, hiding behind them when Vinaver's friends and colleagues passed through the room. The first picture he painted there was a copy of a Levitan hanging on the wall, which he liked because of its moonlight effects, suggesting candles shining behind the canvas. He climbed onto a chair to copy it, because he did not dare take it down from its high position on the wall. But slowly the large apartment at 25 Zacharevskaya began to feel less intimidating and more like a home. Soon the editorial room was full of his canvases and sketches and began to look like a studio, with the editorial discussions taking place there a background to his work. Vinaver lived nearby and was steady and generous in his encouragement.

Chagall later remembered that in the drawing rooms of these men who would transform his fortune, he was so nervous that he felt as if he had just got out of the bath, his face blushing and overheated. A photograph of 1908 shows him still the gauche provincial Jew: an uncertain youth in an ill-fitting, double-breasted coat, he holds himself uneasily, arms tight behind his back, hair dully flattened, with none of the bohemian charm he would soon cultivate. When Roza Georgyevna Vinaver invited him for Passover dinner, she "looked as though she had stepped out of a fresco by Veronese . . . The reflection of the blazing candles, their odour mingling with the dark ochre of Vinaver's complexion, glowed in the room . . . I dare not show him my pictures for fear he would not like them." Oddly, he was at first most at ease with the baron himself. Chagall's earliest surviving letters are those to Günzburg written in 1908. He was, he told the baron, a "small–terribly wretched little person" with a "constantly doubting" nature and a "painful heart," tormented by the "private shortcomings" and "sad reflections" of a young man with a stutter who had difficulty "saying anything properly," and he was often in despair about his future. The plaint "Oh tell me, dear Baron, surely this can't be the end?" echoes through this correspondence, which reveals a vulnerable, self-doubting temperament.

"The main thing," he pleaded with Günzburg, "is that, with plenty of

small drawings and sketches, I would now like to do something bigger but have no pastels, watercolours, oil paints, or canvas." Materials were expensive, but his sense of being psychologically stifled, an inability to feel free enough in St. Petersburg to work, was mounting, too. This tough city took its toll on the struggling provincials who tried to make their way there. Many gifted young men were defeated, such as Ciurlionis; most of the others who fell by the wayside were too obscure to have left records. Those from better-off families, Mekler, for example, floated regularly between the capital and home, dilettantish about their work, never really forced to battle in the city. The more dedicated, like Pen, spent decades trying to gain acceptance, and Chagall too, despite the support of Günzburg, Goldberg, and Vinaver, lurched from crisis to crisis in 1908, all caused by his ambivalent status in the city.

Chagall in St. Petersburg, 1908

Little record of his works from this period survives because, soon after moving into the *Voshod* office, he "managed to overcome [his] natural timidity" and took fifty paintings and sketches to Annenkov's, a frame maker whose shop on Zacharevskaya he passed daily, "to ask him if he might be able to sell any of it." He had already sold Annenkov the moonlit impressionist scene he had copied at Vinaver's, for ten rubles, and was surprised to see it for sale in the window a few days later, signed "Levitan." With Chagall's own work, Annenkov was bolder.

> He told me to leave him my work and to come back in a few days, allowing him time to think it over. When I returned a week later, it was like a scene from a Kafka novel. [Annenkov] behaved as if he had never seen me before and claimed that I had never left him any pictures. As for me, I had of course neglected to ask him for a receipt. I even remember him asking me: "Who are you?". . . I couldn't sue him in court since I was living illegally in the Russian capital.

His status meant that not even his well-connected friends could help him take action against the frame maker, who probably gained little from the

theft–not one of Chagall's paintings from St. Petersburg before mid-1908 has ever come to light. Or did he make the story up to explain away a year in which his art had made no advance?

Shortly after the move to Vinaver's, a new crisis reared: in June Chagall's call-up papers from his native province of Orsha arrived, for he would be twenty-one on 7 July 1908 and eligible for military service–three years in the tsar's army, serving an empire in which he was a second-class citizen. Only good connections could save him. Baron Günzburg and the lawyers Vinaver and Goldberg all petitioned to the throne for his deferment, and Chagall also wrote a florid, emotional letter to Roerich, director of the Drawing School for the Encouragement of the Fine Arts, asking for his support:

> Perhaps you know me? I am your scholarship pupil, worn down (by this draft) by this insoluble situation which forces me to stay in this suffocating, granite Peter [St. Petersburg], when the sun entices me and calls me–calls me towards pure nature to draw! . . . I love art too much, I have lost too much time, and in accepting the idea of wasting three years on my military service, I would lose still more. The deferment of my military service is absolutely essential, for as long as I have not found a solid grounding and have not received a serious preparation at school.

The letter, though largely formal, was written at the moment when his discontent had reached a breaking point. Roerich vouched, in a letter to the Ministry of the Interior, that his scholarship student needed at least until 1910 to complete his artistic education and had distinguished himself brilliantly. But his progress did not look like that to Chagall. He told Roerich that he was "heartwrung . . . broken by the course of my destiny"; he felt discontented, bitter, uncertain where he was going.

"Suffocating, granite Peter" became unendurable. Thirty thousand people died of cholera that summer of 1908 in St. Petersburg, and in the aristocratic and artistic communities death was also in the air. In July the court scandal was the death in a duel of Prince Nicholas Yusupov–the twenty-five-year-old prince had deliberately courted danger in pursuing an inflammatory liaison with a married woman, seeking a confrontation with her husband, making his death effectively suicide. The same year news came from Paris that the youngest brother of the wealthy Moscow art collector and merchant family of Sergei Shchukin had shot himself; Shchukin's son

had also killed himself three years earlier. And in 1909 Arseny, younger brother of the Morozov collecting family, casually picked up a revolver while he was waiting for Maurice Denis to supervise the hanging of his paintings, asked "What if I were to kill myself," and blew out his brains. "I well remember how we waited for the end of the world in 1910: the tail of Halley's comet was expected to come into contact with the earth and fill the whole atmosphere with deadly gases in an instant," recalled the Communist writer Alexei Tolstoy of these years. "The whole of Russian art, from top to bottom, lived in dull foreboding of destruction and was one single cry of deathly boredom." Chagall lamented to Günzburg that he was a man with a "joyless heart" and immersed himself in the publishing *succès de scandale* of 1907–8, Fyodor Sologub's nihilist-symbolist novel *The Petty Demon;* he became obsessed both with the hero, a provincial schoolteacher driven by everyday frustrations to paranoia that a little demon personifying Nothing is persecuting him, and with Sologub, "the bard of death" himself, whose mother was an illiterate St. Petersburg washerwoman and who had, it was reported, never been seen laughing in his entire life.

Then, just before the holidays, his drawing teacher Bobrovsky chose to make a particularly virulent attack on his work in front of the class, culminating in the remark, "What kind of behind do you have? And a scholarship boy at that!" It was the last straw. Chagall walked out of the damp classroom on the Moyka Canal, did not bother to collect his month's scholarship money, and fled home to Vitebsk. From there he wrote to Günzburg that he was trying "to take off the mantle of my St. Petersburg failures and immerse myself in the poetry of the quiet countryside," wandering alone "along the river bank, the fields and the villages," painting especially in the evening, when "the blurred outlines of everything" and "the metallic light of the moon" aroused "a vague understanding of the sacred Height." Here Bobrovsky's criticism still stung in his ears, and indignation and pride spurred him on–but a whole level of tension lifted as soon as he was in his secure, familiar native town. Surrounded by his mother and sisters, he began the painting that he considered to be the beginning of his mature work. It was called *The Dead Man,* and it marked the point at which Chagall ceased to be a provincial student and became a major painter whose art was so individual and distinctive that it could never be mistaken for that of anyone else.

Thea

Vitebsk and St. Petersburg, 1908–1909

It was not quite dawn on a dark Vitebsk morning when Chagall, sleeping in the family home on Pokrovskaya, heard screams from the street below.

> By faint light, from the night lamp, I managed to make out a woman, alone, running through the deserted streets. She is waving her arms, sobbing, imploring the inhabitants, still asleep, to come and save her husband . . . She runs on. She's afraid to stay alone with her husband. People, alarmed, come running from every side . . . They spray him with camphor, alcohol, vinegar. Everyone groans, weeps. But the steadiest, inured to sorrows, push the women aside, calmly light the candles and, in the silence, begin to pray aloud over the dead man's head.

Hours later "the dead man, solemnly sad, is already laid out on the floor, his face illuminated by six candles"; then a black horse, "the only one to do his duty without any fuss," hauls the coffin off to the cemetery.

That is the scene that inspired *The Dead Man.* Chagall remembered it from childhood when he returned to Vitebsk in the summer of 1908 and was invited to give painting lessons at home. Teaching a young man called Galoschine, he glanced out of the window and was struck by the desolation of the empty street. "How," he asked himself, "could I paint a street, with psychic forms but without literature? How could I compose a street as black as a corpse but without symbolism?"

His answer was to paint *The Dead Man* like a stage set. In the middle of a small-town street, between wooden huts with crooked window frames, a corpse lies on the ground, surrounded by six candles. A woman–suffering humanity–screams and throws up her arms in grief. At the centre of the composition a road sweeper with his broom whisks past regardless: a prosaic grim reaper, absorbed, noncommittal–a hero of an absurdist drama. On the roof of a house a rhapsodic, otherworldly violinist draws a melody–"in harmony," wrote Chagall's early critic Abraham Efros, "with the wind howling under the glowering sky, tearing up the clouds, and shaking the leaves with a shoe and sock hanging over the huts instead of signs." Everything suggests instability, transience, the inevitability of death, yet the framed tableau, the magical lighting effect, and the dramatic action also recall a frozen scene from Andreyev's play *The Life of Man* that Chagall had seen in St. Petersburg. "Everything is dreamlike" was how Andreyev described his work; the characters must have "wooden voices, wooden gestures, wooden stupidity and arrogance. They should be so plastically absurd, so monstrously comic, that each of them, as a figure, remains in the memory for a long time."

Chagall always dated the start of his career to *The Dead Man* in 1908. The painting is the high point of his early years and predicts many strands that would characterise his mature work: the Jewish-Russian small-town setting; the harmony of contrasts; the sense of life as a theatre of the absurd; the visual image, distorted and disorientating, as a metaphor of a spiritual reality. During the next decade Chagall would learn to add the two ingredients– the expressive possibilities of flamboyant, nonnaturalistic colour, and a manipulation of the formal devices of modernism–that would allow him to join these elements together in a way that uniquely recorded twentieth-century experience. But already at the start of the century, this early masterpiece was prescient both in its unravelling of man's unconscious life and in its obsession with death. Chagall never read Freud, whose seminal works are of the same epoch as *The Dead Man–The Interpretation of Dreams* appeared in 1900, *Three Essays on the Theory of Sexuality* in 1905–but Franz Meyer reported that "referring to 'The Dead Man,' Chagall said psychoanalysis was the scientific parallel to his early works . . . both bear witness to a comparative history of spiritual life; both . . . constitute a breakthrough into hitherto unknown spiritual regions."

But if it looks forward, *The Dead Man* is also in its visceral, immediate quality a typical young man's work: a portrait of Chagall's imaginative life in his early twenties. A mental shudder courses through it, as if Chagall were

peering into the coffin. The effect may be connected with the death of his youngest sister, Rachel, in 1908:

> My eyes were scarcely wet when I saw the candles lighted at the head of her bed . . . And to think that, in a few hours, that little body will be lowered into the earth and men's feet will trample on it! . . . I couldn't understand how a living being can die all of a sudden. I had often seen people buried, but I wanted to see the one that was in the coffin. I was afraid of it, too.

Symbolism also fuelled Chagall's adolescent fixation on death. He was, according to a contemporary report, "captivated by the Russian symbolists. The ghostly lamentations of Sologub, his *Petty Demon,* and all his pessimism and rejection of the world are directly connected with Chagall's painting, where everyday life is interwoven with the fantastic, sweet endearments, with the crude denunciation of physical being." "What is death to me, poison or the gallows?" Chagall wrote melodramatically to Günzburg at this time. Death is the subject of many of the works he completed in Vitebsk that summer: the muted browns and greys of *Graves,* the sketches "Jewish Cemetery" and "Funeral with a Cart."

In *Fair at the Village* parents carry a child's small white coffin in a twilit funeral procession–perhaps a memory of Rachel's funeral. The painting's dark stagy setting, with its sickly yellow sky, was inspired by Meyerhold's production of *The Fairground Booth,* the Blok play that had such an impact on Chagall when he arrived in St. Petersburg. The work is full of characters and sets referring to the production: an acrobat, a buffoon with an open umbrella, a small theatre, and a harlequin, described by Blok and painted by Chagall as lying on an empty stage, in a white costume with red buttons. Chagall has also added his own grotesque touch–a woman leaning over her balcony to empty a chamberpot on a funeral mourner. The harlequin, holding an oil lamp, illumines the procession, and the blending of the rays from the sunset with the artificial lamplight gives the painting its hallucinatory tones. This is the fair of human existence, comic and tragic, the indivisibility of life and death, illustrated by the Russian proverb "Half the world weeps, while the other half leaps." The harlequin, destabilizing the action with his odd posture and his lamp, positioned like a stage footlight to enhance what Chagall described as "the unreality of reality," heralds the circus theme, a favourite modernist subject and one to which Chagall returned

until old age. "Of course I do not disdain the clowns and harlequins Picasso painted–quite the contrary. Nor do I deny the strangeness with which he endows them. And with what draftsmanship he presents them to us! But how much stranger and more diabolical is the character of the clown-actor painted here by Chagall! How much more rousing and sombre at once!" wrote Chagall's first French collector, Gustave Coquiot, of *Fair at the Village*. "The skintight costume he wears like a flag–white with blue and red hoops–that drink-sodden carnival mask, that stupid face, silly with surprise, those long legs, one straight, one bent–all that is a miracle."

The Dead Man and *Fair at the Village* taught Chagall that he could find the miraculous in Vitebsk, perceived anew with the eyes of a St. Petersburg sophisticate who had discovered Gauguin and Meyerhold's primitivist stagings. The leap from the sketchy "The Musicians," which he had done at the end of his studies with Pen, to these hallucinatory, solemnly assured works shows how much he had learned in eighteen months in St. Petersburg in terms of technical mastery and exposure to modern styles. But he could not have painted these works in St. Petersburg. Returning to Vitebsk, he found that alienation in the tsarist city had reinforced the familiarity of his native town, which now forced itself on him as his inescapable subject. It became his own artistic world, its visual images transformed into spiritual reality. The less radical works he painted that summer–chiefly portraits of his family, such as *Girl on a Sofa, Marysenka,* a delightfully grave, theatrical likeness of his cross-legged, appealingly gauche sister, aged six and now the smallest in the family, wearing his own too-large black beret–show his absorption of Rembrandt but above all the warm familial atmosphere that engulfed him at home.

"If I were not a Jew (with the content I put into that word), I wouldn't have been an artist, or I would be a different artist altogether," Chagall said. It was startlingly original in 1908 for a modernist artist aspiring to an international outlook to make art out of the shtetl–an environment from which anyone with cultural ambition was trying to escape and that had no pictorial traditions at all. No one else thought such a world worth recording: progressive Jews such as the Yiddish writer Moyshe Litvakov despaired of the old "shtetl alleys, hunchbacked, herringy residents, green jews, uncles, aunts, with their questions: 'Thank God, you grew up, got big!' " while metropolitan Russians treated it with condescension.

Chagall could paint Jewish Vitebsk as he did only because St. Petersburg had given him the distancing perspective to see cultural obsolescence in the

milieu that still nourished him. To preserve that world on canvas, he was, exhilaratingly, to play on every radical trend, every jarring dislocation, in early twentieth-century art. Yet the creative impetus that transformed him into an avant-garde artist heralded, too, the collapse of the shtetl life of ritual and belonging in the modern drive towards individual autonomy. It was only in the brief window of history, the single decade of the upheaval of cultural values between the first Russian revolution in 1905 and the arrival of Lenin in 1917, that Orthodox Jewry could have found its chronicler—in a Jew on his way to exile, with one foot in the shtetl and the other in St. Petersburg.

The thickly outlined, exaggerated figures and deliberately awkward forms in *The Dead Man, Fair at the Village,* and a successor to these works, "The Procession," suggest currents of Russian primitivism, expressionism, and symbolism, as well as the influence of Gauguin. But nineteenth-century Russian art is in them, too: the narrative drive, the populist impetus, the processional theme, a charged image in Russian masterpieces such as Repin's *Easter Procession in Kursk,* a panorama of all Russia, from peasant to gentry, Old Believer to soldier; Vasily Perov's funeral procession in *Last Journey;* and Levitan's *The Vladimirka Road,* depicting the route to Siberia. Pilgrimages, journeys, roads taken or abandoned, haunt the paintings and literature—Gogol's *Dead Souls,* Tolstoy's *War and Peace*—of a country whose art has long been rooted in dilemmas of national identity. In taking on such resonant, loaded subjects, Chagall became a Russian artist; in diverting the theme from the future of tsarist Russia to the crisis of the shtetl, he declared himself a Jewish one.

The breakthrough of *The Dead Man* and *Fair in the Village* was that, dispensing with the realist tradition, he brought the dramas of this world alive from the inside. "The realistic life in his pictures is permeated with the order of a different, miraculous existence," wrote Abraham Efros in the first book on Chagall, published in 1918. Shtetl Jewry remained in Pen's hands a set of archaic genre scenes; Chagall gave it the vividness of expressionist theatre. He "could realize onstage what the contemporary theatre needs more than anything—*psychological decoration,* in which mundane life style would seem real and inspired from within," wrote the Russian-Jewish critic Yakov Tugendhold. "His little churches, mills and market fair showbooths, many-coloured huts are like children's toys; his clumsy little humans at weddings and funerals are like marionettes."

This primitivism was the greatest strength for a young artist in the 1900s. Everywhere in avant-garde art circles—in Paris, Munich, Moscow—salon art

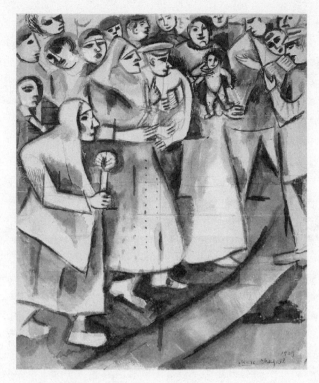

Chagall, "The Procession," 1909, pencil, ink,
watercolour, and gouache on paper

was being rejected as exhausted, overly refined, and academic, and the call
was for the freshness of the primitive, the non-European, the rawness of folk
art. Gauguin had looked to Tahiti; Picasso, Matisse, and André Derain
looked to African statuary. Picasso's *Les Demoiselles d'Avignon* acquired its
definitive form after his visit to the Ethnographic Museum in 1907; at this
time young avant-garde Russian artists such as Mikhail Larionov and
Natalia Goncharova began visiting Paris and brought new ideas back to
Moscow. As soon as it hit Russian soil, Parisian modernism became
instantly Slavified in the bright savage style of Russian neoprimitivism,
which took inspiration from the *lubok,* the cheap popular print, and the
archaic sculpture of the Scythians, such as the stone steles found on the
steppe between the Black Sea and southern Siberia. "I shake the dust from
my feet and leave the west, considering its vulgarizing significance trivial
and insignificant," said Goncharova. "My path is toward the source of all
art, the east." Russia's peasant culture and Asiatic heritage, offering home-
grown primitivist sources on Moscow's doorstep, now became of interest in

high art circles; but still there was something artificial, at one remove, about the zeal with which these high-born artists—Goncharova was an architect's daughter descended from Pushkin's wife, Larionov the son of a doctor—embraced peasant subjects such as woodcutters and reapers. Chagall's position as a shtetl artist with modernist aspirations was different. Within his own family and Jewish homeland he had on tap, ready-made for the new aesthetic, a natural, unforced link to the primitive, and his instinct for making modern art out of timeless Jewish Vitebsk showed an infallible sense of the European zeitgeist long before he encountered modern European art.

When he returned to St. Petersburg in the autumn of 1908, the currents of the Russian avant-garde were beginning to make themselves felt. Venok [Wreath]-Stephanos in Moscow in December 1907 had been the first exhibition to introduce Larionov, Goncharova, and their friends to a wide public; their work took longer to reach St. Petersburg, but in magazines such as *The Golden Fleece* the new Russian art was now featured, absorbed and discussed by Chagall and students in his circle. *The Golden Fleece* organized avant-garde exhibitions showing the Russians alongside Derain and Georges Braque in 1909, and Russian modernism received another boost that year when Shchukin opened his Moscow mansion to the public on Sundays, showing eight Cézannes, sixteen Gauguins, and rooms devoted to Matisse and Picasso. David Burliuk, Kazimir Malevich, Robert Falk, Aristarkh Lentulov, Ilya Mashkov, Pyotr Konchalovsky, and other modernizing young artists were inflamed by what they saw. Moscow, bolstered by Shchukin's collection and that of another merchant-collector, Ivan Morozov, became second only to Paris as a centre for modern art. "The gods change from day to day," complained a contemporary critic. "Cézanne, Gauguin, Van Gogh, Matisse, Picasso, are being plundered without sympathy, restraint or discrimination. It is pandemonium where everything is turned topsy turvy. Everyone tries to shout the loudest in order to appear the most modern." One Moscow professor proposed that his students be banned from visiting Shchukin's house, for "the contagion of modernism is now penetrating every class, even Serov's studio." Serov, grand old man of Russian impressionism, was still alive and had taught many young members of the Moscow avant-garde—Pavel Kuznetsov, Ilya Mashkov, Serge Sudeikin. Now he astonished everyone by learning from them in turn; in 1910 he painted a bold, bright, blocklike portrait of Ivan Morozov before a Matisse still life that looked like a manifesto for the avant-garde against which not even Serov, bastion of nineteenth-century Russian tradition, could hold out. With just a

year left to live, "he worked to be in the lead of his current life in spite of his age," Chagall noted approvingly in a letter to his sisters.

The contagion of modernism reached St. Petersburg more slowly, but Chagall followed the Moscow developments as closely as he could. From the start, though, he felt distant from the Russian primitivists and the middle-class prerevolutionary liberal sensibility.

Making art out of his own native milieu, he had a different emotional absorption in his subjects, lending his paintings an immediacy of experience that set him apart. The Russian painters to whom he was drawn at this time were two other outsiders: the Lithuanian symbolist Ciurlionis and the "Munich Russian" Alexei Jawlensky, whose primary interest was the mystical power of colour. Both were included in an exhibition of Russian art at the Menshikov Palace in January 1909; shortly afterwards Ciurlionis suffered the nervous breakdown from which he would never recover. But Jawlensky, a generation older than Chagall, became one of his earliest artistic supporters. In 1909 he had just founded with Kandinsky the Neue Künstlervereinigung München, which soon evolved into the Blaue Reiter; he came from a Russian military family and had studied at the Imperial Academy and under Repin, but he had travelled in Europe since 1896 and was influenced by Gauguin and Matisse. A deeply spiritual man, he believed that "the artist must use form and colour to say what is divine in him . . . the work of art is a visible god, and art is the longing for God." He was almost the only one among his Russian painter contemporaries for whom Chagall ever had a good word—many years later his enthusiasm, amid a slew of negative reminiscences of the art scene of his youth, was notable when Jawlensky was mentioned. "Jawlensky! What a wonderful painter!" he exclaimed. "He was one of those who encouraged me most when I was having such a hard time in St. Petersburg." Jawlensky wrote to him several times from Munich and lightened to a small degree his isolation and anxiety as he pursued a solitary path, facing his third winter in the capital as a Jew still forbidden to live in St. Petersburg or Moscow and ambivalent about his relationship with Russia.

Chagall left Roerich's establishment at the end of 1908 and spent the first part of 1909 at the private art school of Savel Saidenberg, another follower of Repin's, which turned out to be even more conservative. The only known work from his time there is a three-quarter-face *Self-portrait,* its expression dark and hesitant, which shows the continuing influence of Gauguin—the pose of the head, and the hair covering the ears and hanging at the nape of the neck, are the same as in Gauguin's *Self-portrait with Idol.*

Chagall had much to be dark about: the gloomy short St. Petersburg days, the dissatisfaction with his school and uncertainty about his own artistic development, and then, in December, his rejection by his first patron, Baron Günzburg. According to Chagall's memoir–not reliable on this point, since it was written after the revolution, when it was in his interest to denigrate his former wealthy contacts–Günzburg terminated his allowance without warning:

> One day when I went to collect the ten roubles, his imposing manservant told me, as he held out the money: "Here they are and it's the last time."
>
> Had the Baron and his family given a thought to what was to become of me when I left his magnificent staircase? Could I earn a living with my sketches? Or did he simply think: Look out for yourself, sell newspapers.
>
> Then why had he done me the favour of talking with me as though he had faith in my artistic ability?
>
> I couldn't understand. And there was nothing to understand.
>
> I was the one who suffered, no one else . . . Good-bye, Baron!

Günzburg died the following year, so Chagall could safely parody him as an example of the insensitive upper class. But his embittered account suggests that he still smarted from the relationship. Günzburg had been a confidant as well as a patron, the recipient of many of Chagall's lonely and self-doubting letters; his withdrawal of funds may have been caused by a withdrawal of his patience, taxed by Chagall's narcissistic outpourings.

That winter Chagall painted *Russian Wedding*, inspired by his sister Anyuta's wedding and the first major picture completed in St. Petersburg: a melancholy depiction of Vitebsk's treeless roads and rickety houses, the grey-brown tones illumined by a faint streetlamp. Full of pathos, the desolate provincial procession is typically Russian though also evocative of Brueghel–Chagall called him "*mujik* Brueghel," peasant Brueghel–whose work he admired at the Hermitage. The bride and groom, however, are Jewish, and so, among Russian peasants and dancers, are several other characters–the water carrier wears a tallith, the clown a skullcap, while the traditional Jewish violinist is dressed as a uniformed Russian soldier. The painting suggests Chagall's drama of identity as a Jewish painter struggling in tsarist St. Petersburg, wondering about his place in the Russian tradition.

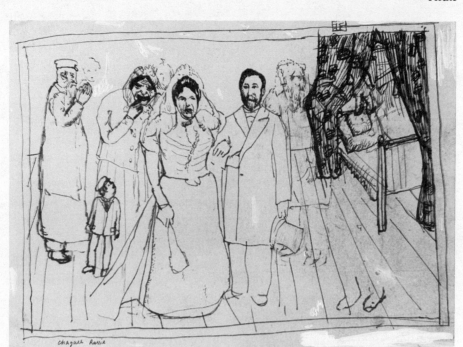

Chagall, "The Wedding," 1909, drawing

This was the first picture Chagall sold—to his patron Vinaver, an assimilated, Russified Jew, a member of the Duma whose goal was to create a democratic Russia where Jews would have a role. "A famous lawyer, a representative in parliament, and still he loves poor Jews, descending a hill with the bride, the bridegroom and the musicians in my painting," Chagall wrote. But the Jewish critic Tugendhold saw in the painting "an unhealthy childishness and a tense worry of the contemporary Jewish Pale. As if some bloody pogrom-inspired fears poisoned his childhood, and his fantastics often seemed like a feverish delirium of a sick child." In his autobiography Chagall admitted that whenever he left Vitebsk, "the farther I went, the more frightened I became. In my fear of crossing 'the frontier' and finding myself close to army camps, my colours became dingy, my painting turned sour." His son-in-law Meyer, talking of this period with the artist, concluded that at this time "Chagall's fantasies still need the protective mantle of this nocturnal atmosphere—the 'psychic light of the north' as he now calls it.' "

So his canvases of 1908–9 are dominated by browns, blacks, and muddy greens; he did not yet feel free enough to express himself with the bold pigments of the Russian primitivists or of the exiles Jawlensky and Kandinsky,

nor even in the crystalline hues of the World of Art group. Rembrandt remained a powerful influence, but even allowing for this, the darkness of *The Dead Man* and *Russian Wedding* reflect his cramped, frustrated life in St. Petersburg. "I detest the Russian or central European colour," Chagall told Pierre Schneider in 1967. "Their colour is like their shoes. Soutine, myself–all left because of the colour. I was very dark when I arrived in Paris. I was the colour of a potato."

In Chagall's mythologizing of his life, it was Paris that injected light and brightness into his work. This story omits, however, a crucial episode in St. Petersburg in 1909 when he painted two crimson and rose nudes, the most menacing, feverish he ever made, which suggest that although the forbidden city felt in many ways like a prison, it was for a shy shtetl boy also a sexual liberation.

In *Red Nude* and *Red Nude Sitting Up* Chagall models the body in a single colour, a blazing crimson with paler highlights and black underpainting, creating a vivid play of light and shadow. In *Red Nude Sitting Up* the figure is strikingly silhouetted; we see the woman from the front, her body upright, her arms stretched out, her head cropped just above the eyes in a solid composition whose verticality is accentuated by the central axis of a plant in its pot: "a sombre dark dream in which the objects had a strange character discerned by a mocking eye," according to a contemporary who saw the work.

The richer *Red Nude* is a horizontal version of the first picture, with a side view of the body, legs stretched out, breasts, trunk and head turning defiantly away from the viewer in a violent movement that commands the painting. A vase of flowers half-falling over a tablecloth enhances the loss of equilibrium, and both the still life elements and the pink body are contrasted with a dark green background. Chagall was clearly happy with the colour contrasts because he used them again the following year in *Allah* (*Portrait of a Woman*), a depiction of a Russian peasant swathed in a red scarf set against a green plant.

The savage energy of the red nudes, painted closely from the figure and shot through with the young, inexperienced painter's thrill at the female body, is striking. Gauguin–especially *Tahitian Women,* which Chagall saw in a 1909 issue of *The Golden Fleece*–remained the major influence. But the intensity and sensuality came from Chagall's relationship with the model, twenty-year-old Thea Brachmann. She was the first woman he saw naked, and he found her both alluring and threatening, her open sexuality a challenge to his fragile sense of himself. "Poor Thea! Chagall has not understood the beauty of her young body; he has only picked it out in a red light,

he must thus be expressing the fire which burns inside of him," a friend suggested later. But her effect was to overturn his subdued palette and launch him as a theatrical colourist long before he reached Paris.

An erotic charge has always animated the painted female nude, but in the twenty-first century it is hard to imagine the effect that beginning to draw from a nude model had on reserved, sexually innocent young men in the 1890s and 1900s. In 1891 twenty-one-year-old Matisse was so overcome by emotion at his first sight of a naked girl that he completely botched his initial life drawings at the Académie Julian; his teacher told him that "it's so bad, so bad I hardly dare tell you how bad it is." Russia, more prudish than France and with an art-historical tradition dating back, apart from icons, only to the eighteenth century, had virtually no tradition of the nude; the year after Chagall painted Thea nude, Sergei Shchukin wrote to Matisse revoking a commission for two large panels of nudes for the Trubetskoy Palace, explaining that the subject was indecent; then he reversed the decision, telling Matisse, "I find your panel *Dance* to be of such nobility that I have resolved to brave our bourgeoisie's opinion and hang on my staircase a subject with nudes." This is the context in which Thea, a Jewish doctor's daughter studying literature at St. Petersburg University, took off her clothes in the editorial office at Zacharevskaya and posed nude for twenty-one-year-old Marc Chagall. Both he and she felt that they were embarking on a dangerous adventure.

Chagall called his meeting with Thea a "turning point in my life." This was his "third romance," and after his timidity with Anyuta and Olga in Vitebsk, he was determined it was going to be different: "I grew bolder. I kissed right and left. I didn't hold back anymore." Thea was a bold girl, too. She saw herself as an intellectual modern woman, committed to the idea of the avant-garde; she wrote poetry, loved art, and was an accomplished pianist, liberal in her sympathies. She found in the handsome, curly-haired Chagall a figure of the talented, impoverished, misunderstood artist, a bohemian fantasy come true. Thea also came from Vitebsk, from a cultured family who had sent her to the girls' Gymnasium; clever and ambitious, she had done well enough there to be among the handful of Jewish pupils admitted to universities in St. Petersburg and Moscow. Wealthier and with no problems of residence, she was more at ease in St. Petersburg than Chagall and was enjoying the new vistas it opened. She said she posed nude in the interests of art, to help poor avant-garde painters, but she was probably in love with Chagall as well as with the ideal of the new art.

Chagall met her through Viktor Mekler, whose family moved in the same

circles as hers. As a doctor's office, Thea's home in Vitebsk was well known to the middle classes and to peasants from the countryside who pressed their way in to consult her father, bringing gifts of chickens or eggs in the hope of being seen sooner. But neighbours also paused outside the house to hear Mozart and Beethoven sonatas played by Thea's three brothers on the piano and the violin; inside the rooms were always full of flowers, plants, and twittering birds. Dr. Brachmann, genial and well liked, interrupted his rounds by stopping at the homes of his friends for a glass of brandy and a game of cards. Thea's mother was lively, friendly, and relaxed. Thea herself, a tomboy as the only girl in a family of brothers, went everywhere accompanied by her big dog Marquis; at home she was unsqueamish and sympathetic, a familiar figure at her father's surgery.

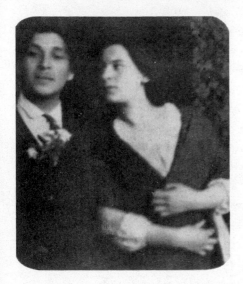

Chagall and Thea Brachmann, 1909

She was broad-shouldered and big-boned, with large hands and feet and moist, mobile lips: an extrovert's body. She always wore flowers in her hair or on her dress. A photograph of 1909, and some sketches Chagall made of her the same year, show strong, determined features: a high forehead and cheekbones, a prominent jaw, an assertive expression. "She held people spellbound with her singing, and was so witty and vivacious they doubled up with laughter. So she was very popular," wrote her best friend from school, but there was a heavier, uneasy side to her, too.

> Thea sometimes invented dramas for herself. She got bored when things were too quiet and peaceful . . . She liked being with boys, and would kiss them, quite unabashed, right on the lips. She liked fighting them too. With girls . . . she was gentle, and might spend hours gazing at a long neck or a pair of beautiful hands. Generally lively and serene, she was liable to become suddenly depressed, wrapped in a black shawl of gloom and singing sad songs in her husky voice . . . When she fell into one of her fits of melancholy, people regarded her with awe.

In the nudes and in several other pictures for which Thea modelled, Chagall caught her volatile temperament as she explored the new freedom of her

body and her independent life in the capital, yet felt weighed down by the past, unable to shake off the demands of family and social obligation. In *The Couple at Table,* also known as *The Ring,* she sits, head bowed, subdued, across a table from a downcast young man, separated from him by the central expressive motif of a bunch of pink flowers; the young people are each isolated in their own thoughts, while in the background an elderly Jewish couple sit together intimately. The painting suggests the passing of time but also the difficulties of the young girl (the man is a more marginal figure) in reconciling her intellectual hopes and emotional needs. Chagall remembered endless discussions with Thea and her group of friends; her interest in literary symbolism explains the literary allegory–the ring to indicate fidelity, the apple as woman's temptation of man–in this delicate work.

The Couple at Table introduces motifs that reappear frequently through Chagall's work: the couple, the flowers, woman as dominant and powerful. In a companion picture, *The Couple,* the man is even more sidelined. A mother–Thea–is a solid, heavy presence whose force spreads across the pic-

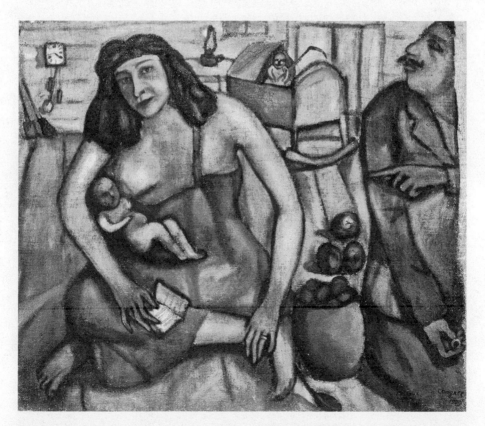

Chagall, *The Couple,* 1909, oil on canvas: the woman is modelled on Thea Brachmann

ture. She holds a baby and looks at the child as if she foresees his tragic destiny; behind her a clock marks the march of time. *The Couple* is a fervent, youthful work, driven by satirical energy, especially in the sharp, angular depiction of the father, sliced off at the edge of the picture–Joseph questioning his offstage role, worrying about having being cuckolded: a comic prop to his earthy, certain wife. This was Chagall's first venture into Christian iconography, a reworking of the Holy Family as an uneasy modern young Russian couple. The strength of the woman reflects assertive, confident Thea, the reticent position of the man his own timidity. A third portrayal of a couple made in 1909, *The Family,* sometimes known as *Circumcision,* also suggests the Madonna, child, and Joseph, and again the woman, cloaked in a patterned robe with the child on her knee, is the leading figure. Through Thea and these paintings, Chagall explored his own uncertain feelings about love and family, as well as finding his way into Christian art.

Thea was a prototype of the sort of woman Chagall would always choose in life and ruthlessly use in art: strong-minded, emotionally powerful, socially poised (Chagall's instinct as social climber never deserted him in love), intellectual, and with a tendency to depression. One of the things that animate and make Chagall's portrayals of the female form and female experience so modern is that he liked difficult women. From Thea onwards he reconstructed his passionate dependence on his lively, hopeful-sad mother in relationships with forceful women who challenged yet nurtured and supported him.

It was Thea rather than the competitive Viktor who really opened doors for Chagall into upper-middle-class intellectual circles. Vinaver, Sev, and Goldberg were sophisticated, enlightened Jews, but they were the generation before Chagall, and as a young man he was never entirely easy in their presence; he was competitive, too, with men but not with women. Thea, on the other hand, was linked to Vitebsk, reassuringly familiar yet nonetheless a fascinating new type–a modern, urban woman. Not only the nudes but also the other works in which she appears have an urban mood, characterised by the colour: cool metallic grey set against pink flowers in *The Couple at Table;* ochre dominating *The Couple.* Like Pen and Viktor, Thea was a pivotal Vitebsk figure whom Chagall used to step one farther pace from his provincial childhood. While he was painting her naked, his grandfather, "coming upon a sketch of a nude woman . . . turned his back on it, as if it were none of his business, or as if it were a strange star in the market place of no concern to the inhabitants. And I understood then that my grandfather, as well as my wrinkled little grandmother and all my family, completely

ignored my art (what an art, that doesn't even pretend to a resemblance!) and valued meat very highly."

Chagall's "Thea period" was brief but important. In the summer of 1909 she and Chagall both returned home to Vitebsk, and Thea continued to be his model. Ossip Zadkine, a schoolmate from Pen's who also returned to his native city for the summer, remembered that "the walls of his room were hung with paintings. Canvases were piled up all over the place. The pictures resembled signs for a dressmaker's or a barber's shop or a tobacconist's, but there was something primitive and natural about them that was both surprising and touching and made you smile." Feiga-Ita took a room for him that summer in the house of one of her tenants, Javitch, in their backyard, and this became his Vitebsk studio until 1911. "To reach it, you had to pass through the kitchen, the owner's dining room, where that huge bearded old man, a leather merchant, sat at the table drinking his tea . . . My room was lighted by the deep blue that fell through the solitary window. The light came from a distance: from the hill on which the church stood." In *The Window* he painted the landscape beyond the fence of the Chagall backyard, an empty field rising towards a hill layered with small timber houses, over which towers a white-domed church against a darkening sky; the motif, emblem of childhood security, recurs throughout his work. He also spent time sketching outdoors with Pen, and painting his family. Two gentle portraits of his teenage sisters, *Mania,* with its floating background patterns reminiscent of Matisse, and *Lisa,* painted in dark colours on rough-textured canvas with blooming roses in the foreground, suggest the pleasure crossed with restlessness of this second summer at home from the capital; both sisters are reading, and with casual intimacy Chagall captures their calm interiority.

In his pictures of Thea, by contrast, there is an unresolved tension and sadness. That summer she and Chagall carried on their relationship in her parents' house, lying on a worn sofa covered with black horsehair cloth, "with holes in several places. The same sofa, undoubtedly, on which the doctor examined pregnant women and sick people." Thea's house was busy and noisy; a grand piano stood in the parlour, birds swooped down on you in the front room, Marquis barked at everyone, and Thea's smiling mother flitted among her daughter's friends. Chagall spent many hours doing nothing in the airy rooms and remembered a languorous summer.

I lay down on that sofa, arms above my head and, dreaming, looked at the ceiling, the door, the place where Thea usually sat.

I'm waiting for her. She's busy. She's preparing dinner–fish, bread and butter–and her dog, big and heavy, keeps turning round her legs. I lay down there on purpose so that Thea would come over to me, so she would kiss me. I held out my arms, the arms of salvation. The bell rings. Who is that? If it's her father, I'll have to get up from the sofa and go away.

But it was not Dr. Brachmann. One late afternoon in September 1909 it was Berta Rosenfeld, Thea's friend from her school days, returned from a summer in Marienbad and wearing a new green cape that she had bought there. Opening the door, Thea looked on the verge of tears; there was a long silence, and then she introduced her friend to her lover. " 'This is the artist,' she said, coming to life at last. 'I told you about him.' "

The visitor left hastily, but Chagall, Thea, and Marquis followed and caught up with her on the bridge, where "suddenly Thea's shoulders seemed to droop as if she felt sad, and her moist lips curved in a faint smile. [She] seemed to be finding it hard to breathe. There was a red spark wavering in her eyes. What's the matter, Theanka? . . . Have I taken something away from you?"

Shortly before this encounter, the two girls had had their photograph taken together. Both look serious and thoughtful: powerful, heavy-boned Thea stares out defiantly; her friend, half-sheltering behind her, is more striking, delicate and gentle, with an oval face, thick black hair, and large dark eyes expressing both warmth and the melancholy that led to her nickname "Queen of Silence." She barely spoke on the bridge, but in romantic recollection at least, Chagall and Thea knew the game was up:

Thea Brachmann and Bella Rosenfeld, around 1909

Suddenly I feel that I shouldn't be with Thea, I should be with her.

Her silence is mine. Her eyes mine. I feel she has known me always, my childhood, my present life, my future; as if she were watching over me, divining my innermost being, though this is the first time I have seen her.

I knew this is she, my wife.

Her pale colouring, her eyes. How big and round and black they are! They are my eyes, my soul.

I knew that Thea was nothing to me, a stranger.

Writing their memoirs decades later, Berta–by then renamed Bella–and Chagall concertinaed into a moment realisations that actually took weeks or months to dawn; their romance was not smooth and a photograph from 1909 shows Chagall sandwiched between the two women. But Thea had out-lived her usefulness. Chagall never painted her again, and his next portrait, in autumn 1909, was a monumental portrait of Bella called *My Fiancée in Black Gloves.*

Chagall between Bella and Thea, 1909

CHAPTER FIVE

Bella

Vitebsk, 1909

In 1939, hiding in the South of France as Hitler marched across Europe, Bella Chagall sat down to write her memoirs in the faltering Yiddish mother tongue that she had not used for twenty-five years. Her parents' home was destroyed, her father was dead, her mother–"God only knows if she's still alive–in a profane city among strangers," Stalin's Moscow. She and her brothers were scattered far from Vitebsk, but "each carries with him, as a part of our lost heritage, like a piece of our father's shroud, the breath of home.

> I unfold my portion of the legacy, and there at once are the smells of the old house. My ears start to ring with the din of the shop, and with the lilting chant of the rabbi on holy days . . . And I want to save from the darkness one day, one hour, one moment of the old home. But . . . how can one bring such moments back, how conjure a scrap of life out of withered remains? Then I remember that you, dear friend, often used to ask me to tell you about my life before you knew me.

The shop, the holy days, the darkness, the shroud–the vividly practical, the spiritual, the desolate: what Bella took from Vitebsk formed the memories that Chagall made his own. Five years before Bella and Chagall met, twenty-two-year-old James Joyce, another modernist whose art was determined by exile, left Ireland with Nora Barnacle, confident that in her Irishness lay everything he needed from his homeland: "Wherever thou art

Bella Chagall

shall be Erin to me." In the same way Bella became Vitebsk, Jewish Russia, transported abroad and held suspended in time for Chagall.

She was born on 2 December 1889, during the children's festival of Hanukkah, the last child of Shmuel Noah Rosenfeld and his wife Alta, née Levant. At home she was always called by the diminutives Basha or Bashenka; at school and among her friends she was Berta; Bella was the name with which she reinvented herself as a French artist's wife in the 1920s. Before her had come seven brothers—Isaac, Yakov, Israel, Mendel, Aaron, Benjamin, and Abraham, known as Abraske—and a sister, Chana, who left home almost as soon as Bella could remember. As she grew up in a large, gloomy apartment above her parents' jewellery store, her childhood was shaped, like Chagall's, by the broad concerns of religion and shop, but within these constraints, it was very different.

The Rosenfelds were among the richest Jews in Vitebsk; noted philanthropists, they were ostentatious in their piety and models of social

respectability. Their wealth came from the Levants, Alta's parents Baruch Aaron and Aiga, and it had netted her in the late 1870s the trophy husband of Shmuel Noah, a formidable Talmudic scholar, educated in a yeshiva, and a deeply religious man—scholarship being as desirable, in men, as wealth in middle-class Jewish circles. Shmuel Noah, "my pious, silent father," was a tall, thick-set figure with dreamy blue eyes, a wary look, and the typically long beard of the Hasidic sect, who was usually lost in thought, "pondering the passage from the Torah that he'd been studying that morning . . . or brooding over the new woes he imagined lurking on all sides." In photographs he appears earnest, self-contained, and quiet, while Alta is statuesque, an authoritative, energetic matriarch, too fixed in her formal pose to venture a smile, imprisoned in a double-breasted coat. She ordered her clothes from the best dressmaker in town, a Polish general's widow, and for celebrations she dressed Bella in a pink silk frock and patent leather shoes to dance the mazurka with her brother Abraske while friends chorused approval: "Hands stretched out and drew us toward them. 'How old are you, little girl? Oh, it's Alta's youngest! . . . Such nice children. May they be safe from the evil eye.' " But only once a week, on Thursday evenings when she went with her daughter to the ritual Jewish bathhouse on the dark bank of the little Vitba River, did Alta really relax enough to throw off the cares of the shop and household; being held by her mother in the rushed sleigh ride there is almost the only moment of intimacy Bella records between them. The rest of the time, "busy all day in the shop, she didn't have time to remember that in the house her children were growing up, turning into adults. It didn't occur to her that they might have separate lives of their own. Her whole life was in the shop, and she assumed it must be the same for her sons and daughters." It was useless for Bella to try to talk to her, for she "never had time to listen to long rigmaroles. 'Be quick, I'm in a hurry. Just tell me the end.' "

Among eastern European Jewry, even among the upper bourgeois class, women were pivotal figures in commerce—the Western nineteenth-century ideal of the leisured mistress of the house never took root. Alta, although wealthier and better supported, was still a storekeeper like Feiga-Ita—and not much better educated; like Chagall, Bella includes in her memoirs a vignette of the men of her household marking passages in the Bible for the rare occasions when her mother went to the synagogue, so that she could weep in the right places. Alta ran the main jewellery store with her husband in a canny division of roles; she served the everyday customers, while

Shmuel Noah, who prayed or studied the Talmud until eleven every morn-
ing with the family's live-in rabbi, "couldn't be bothered with ordinary cus-
tomers. If it wasn't someone really important, who would deal with him and
with him only, he didn't even stand up when they came in. But when some
merchant arrived from far away to buy jewellery, then he'd stretch a point
and converse about worldly matters." He was a timeless Hasidic type, serene
and pious, reassuringly observant, yet crafty and cautious in business: to
customers, a comforting mix of the spiritual and the secular. He disdained
the hustle and bustle of the shop and its showiness: " 'Why do you put so
much in the window?' he'd say to my brothers. 'It only excites people's imag-
ination. Every good-for-nothing can gawk in, and they think the shop's
stuffed with gold and diamonds.' " As, of course, it was–but "only father
ever touched the really valuable pieces; only he knew what was inside every
parcel. He could tell just by touching it, as if his fingers could see. And he
touched each packet differently, his eyes changing colour according to the
colour of the stones."

Beneath him, a gaggle of cashiers and assistants were endlessly to be kept
in order, as were the ferociously observant family cook Chaya, the gentile
maidservant Sasha, and the porter Ivan, while everyone was frightened of
the boys' dozy but violent religious teacher, the rebbe. On the Sabbath the
house filled with visitors, often strangers, passing through Vitebsk, invited
back for the ritual meal after the synagogue service; each Friday afternoon
before the Sabbath began, the beggars of Vitebsk gathered at the shop door

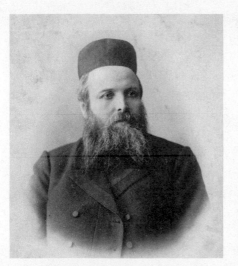
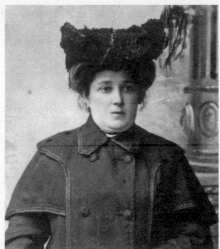

Shmuel Noah and Alta Rosenfeld, Bella's parents, 1900s

for alms; every festival had its own cast list of characters in the Rosenfeld employ–from Purim players to the workmen who annually repainted the entire dining room for Passover. Bella was aware from an early age that to be known across town as "Alta's youngest" was a mark of respect, yet keeping up appearances, socially and in matters of religion, was also a joyless stricture. "There was no piano or violin in our house. At dusk, if I felt sad, I'd hurry over to Thea's. Her house was always full of people, fun, and laughter.

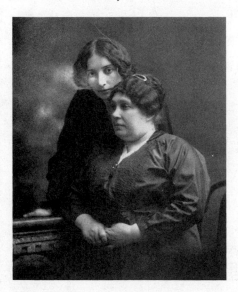

Bella with her mother, late 1900s

I dreamed of living in a house like that." The dusky Rosenfeld home, by contrast, was full of Alta's tears. "The murmur of her voice filled the darkening room. A fine mist hung in the air, blurring her glasses. She wept, swaying her head from side to side . . . It was as if the shades of our grandmothers and grandfathers rose out of the hollow chanting. They wavered, grew long like threads. I was afraid to turn around. Perhaps someone was standing behind me waiting to grab me." If Chagall took from religious Vitebsk mostly a happy security and the instinct for survival of an ancient tribe, Bella took its sadder undercurrent: the tears of the sad holy days when her parents wept out their hearts in the synagogue, and the ancient iniquities against Jews in biblical times merged in the imagination with fears of pogroms and prejudice in the tsarist empire.

"When you think, Alta! What does it all mean? What can we do? You struggle, and where does it get you? Soon we'll be old and all alone. And then what?" a customer sobs out to Bella's mother. Bella's most vibrant memories of her parents are in the shop. In one vignette her serene father lays out emeralds, diamonds, and sapphires for rich, vapid, sad Mrs. Bishowskaya, while she spills out her life story to him like falling pearls; she buys an exquisite set of jewels, and "having unburdened her heart, she flew out of the shop as if on wings." By contrast, Alta's solid presence reassures, coaxes, and flatters a large, vulgar family party into haggling over wedding presents for their dumpy daughter and her pale, terrified groom, complete strangers to each other.

As soon as our assistants saw the crowd, they made themselves scarce. It would take four or five hours to deal with this

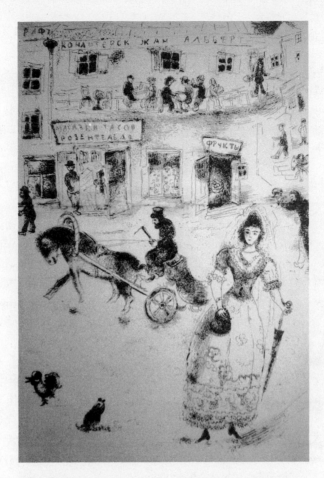

Chagall, "The Necklace," from *First Encounter,* showing
the Rosenfeld jewellery store and the café above

lot . . . Mother loomed up from behind the safe, sat down on her
high stool, and looked calmly round at the crowd. Her white col-
lar set off the radiance of her face, and the general effect seemed
to have a soothing influence on the excited family. Without say-
ing a word she drew them all around her . . . Someone handed
[her] an abacus of black and white beads. Mother's fingers flew
over them as if they were the keyboard of a piano . . . "Alta, you
must have a brain like a rabbi's!"

Meanwhile the child Bella "hung about Mother's high stool . . . Would
those wretched customers never go? But when they finally did, she started
wrapping things up and putting them away again. She was still on edge from

the bargaining and the haggling. Did I dare approach her now? But another customer might come in at any moment."

So Bella grew up solitary and introspective in a world of plenty. While Chagall's small home became more crowded each year with the arrival of another sibling, hers emptied out as one by one her brothers left Vitebsk to study or work, and she remained, the child alone in the house, curled up in the window seat reading or lost in dreams, creeping through cold rooms like the green parlour, used only for her father to pray in, or past the pair of forbidding narrow iron single beds in her parents' room.

Her inferior position in the family was a mirror image of Chagall's superior one: while he enjoyed revered status as the eldest son in a family of seven sisters, one of whom died in infancy, she was the forgotten youngest and "only a girl" among a gaggle of seven brothers, one of whom had also died as a baby.

Her role was in the domestic sphere. One of her first memories was of being invited to lick the spoon by the chief confectioner of the Brozi hotel, whose grand building housed the Rosenfeld apartment, as well as the Café Jeanne-Albert. As a child she was always the one asked to select patisseries; Chagall used to joke that his wife was "brought up chiefly on cakes." Writing in 1922 for a revolutionary audience, he mocked his bourgeois in-laws:

> Just imagine, they owned three jewellery stores in our town. In their showcases, multicoloured fires glittered and sparkled from rings, pins and bracelets. On every side clocks and alarm clocks rang the hour. Accustomed as I was to other interiors, this one seemed to me fabulous. At their house, three times a week, they prepared enormous cakes, apple, cheese, poppy-seed, at the sight of which I would have fainted. And at breakfast they served mounds of those cakes which everybody fell upon furiously, in a frenzy of gluttony . . . Their father fed on grapes as mine did on onions.

Only one of Bella's brothers, mild, quiescent Aaron, followed his parents to work in the shop, and of all the children only the eldest, Isaac, born in 1880, who was studying medicine in Switzerland during most of Bella's youth, remained devout. The others were demonstrably, often scornfully, secular and professionally ambitious: gentle Mendel became a doctor, clever Yakov, Bella's favourite brother, an eminent economist and lawyer. Chana,

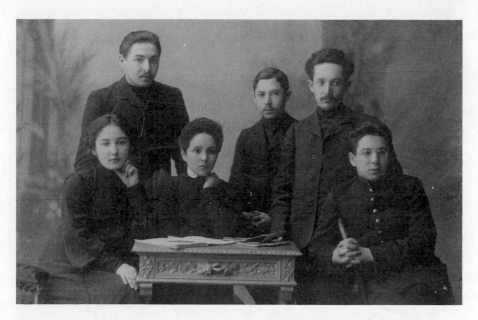

Bella and five of her brothers, from left to right: Abraske, her playmate and tormentor, the brother closest to her in age; quiescent Aaron; Yakov, her favourite; Israel; and Mendel, Vitebsk, 1900s

the elder sister, was a revolutionary socialist; her parents had to bail her out of jail in the tsarist days, and sometimes in the summer she and her high-spirited friends would turn up at midnight to cause havoc at the Rosenfeld dacha, then flee, laughing, into the night.

Bella, too, abandoned orthodoxy in her teens, but her memoirs are drenched in Jewish rituals and festivals. To Chagall "she was an extremely exalted soul, permeated with Hasidism, which weaved inside her a subtle lyricism and plastic quality." That was the undercurrent; by the time she met him, she had transmuted the fervour and mysticism of Hasidism to a new religion: art. She graduated from Vitebsk's Alexeyevskaya Gymnasium among the top four students in all Russia in 1907 and won a place at Moscow's Guerrier girls' college to study literature, history, and philosophy—an outstanding achievement for a Jewish girl at a time when quotas for Jewish students in St. Petersburg and Moscow were three percent. In Moscow, alive with the latest currents, she came to know Sergei Shchukin's collection at the Trubetskoy Palace and attended the latest avant-garde shows of Malevich, Larionov, and Goncharova. By the time she met Chagall, she had moved far beyond the emotional and cultural reach of her parents.

As a child, dressing up had been Bella's passion; now, unknown to her parents, she took drama courses given by Stanislavsky, founder of the Moscow Art Theatre and Chekhov's director, and in acting she was exhilarated that she could throw off her shyness and self-consciousness. Radically, Stanislavsky abandoned the nineteenth-century declamatory style for a psychological realism that made extreme demands of emotional discipline on his actors; they must, he would say, love the art in themselves rather than themselves in their art. Through this aesthetic rigour Bella sought the spiritual fulfillment that her parents had found in religion. "I now feel very confident on the stage," she wrote during her studies. "How quietly, lovingly, steadily the feelings pass there, they whirl around, coming to like a cobweb in the sky; they stretch and intertwine. I sit on the stage and wouldn't want to go anywhere, and at the end of everything, there's only a feeling of emptiness after such emotional elevation, like after the death of an actor–the ungrateful act of art." She determined to become an actress, though she was also a gifted writer and a scholar with wide literary interests; she wrote her university thesis on Dostoyevsky but also had a particular love of French literature. Above all, a life in art was what she wanted, a role in the sweeping cultural mainstream she had found in Moscow–a secular, intellectual life, she thought, as far from her provincial, commercial, backward Jewish mother's as she could imagine.

Bella's experience was typical of the wedge driven between parents and children as young Russian Jews flung themselves into national artistic life. She would have understood another Russian Jew, Leon Trotsky, who wrote of his father: "the instinct of acquisitiveness, the petit-bourgeois outlook and way of life–from these I sailed away with a mighty push, never to return." The violent socialist path that her sister had taken away from their parents did not appeal to the quieter Bella; for her as for Chagall, art was her exit route from Vitebsk.

These were the hopes and dreams of the nineteen-year-old girl who saw a handsome young man sprawled on Dr. Brachmann's sofa on a September afternoon in 1909. He had, she recalled, "curls all over his head, clustering over his brow and hanging down over his eyes"–the image of the wild, rebellious artist: "I couldn't tell whether he was going to talk to me or bite me with those sharp white teeth." After the meeting on the bridge, Bella fled home and sank back into her window seat with a book. But the next

evening she persuaded her brother Mendel to go out after the Sabbath sup-
per, choosing a bar near the station, close to the homes of both Thea and
Chagall. As they were leaving the bar, "a ray of light fell on a thin, pale face,
a pair of long eyes, and a mouth that was open over sharp white teeth . . . It
was he! . . . Had I been expecting him? Had I gone out to look for
him? . . . I could feel Mendel drawing away from me, as if I'd become a
stranger." Later Chagall lay in wait and accosted her on the bridge. She
noticed that he walked along beside her "sturdy as a peasant" and that his
hand was "soft and warm and firm." The autumn days were growing shorter,
and on the "small side" of town they stayed out on the banks of the darken-
ing Dvina. "The piles vanished into the water, and the wooden bridge stood
out on its own, all white. The river beneath turned from blue to steel grey;
its surface was furrowed like a ploughed field. The water murmured as it
flowed along."

Bella wrote the nostalgic vignette "First Encounter" thirty years after
that meeting, when she and Chagall together had carefully constructed an
image of Russian émigré chic. Photographs from 1910 show the tentative
beginnings of this image in Chagall: soon after he met Bella, most traces of
provincialism and gauche demeanour disappeared, his clothes smartened
up, and, visibly more relaxed physically, he began to acquire the persona of
the cultivated oriental bohemian. So although their memories are embell-
ished, there is no cause to doubt the broad tenor of both their memoirs
describing the beginning of their love affair in 1909, which was marked by
two major paintings that Chagall did in Vitebsk that autumn: the work that
came to be called *My Fiancée in Black Gloves* and its companion, *Self-
portrait with Brushes,* both imbued with the seriousness and grandeur of
classical portraiture.

In the former, the slender, soft figure of Bella, thoughtful but confident,
head tilted at an angle, fills the canvas. The dark ground, her close-fitting
white dress, the lilac undertones concentrated in the locket and echoed in
the beret, and the black gloves all recall Spanish portraiture from Velázquez
to Goya. Yet this first depiction of Bella is, as the Russian art historian
Alexander Kamensky observes,

> a resolutely modern work, linked by a thousand threads to the life
> of the Russian intelligentsia in the early twentieth century. This
> total emancipation, this bold look, this sharpness of thought
> relate the figure to the heroes of Chekhov and, to a certain

extent, to the poetry of Blok. The slight asymmetry in the face, in the placing of the hands and the carriage of the head, are equally modern characteristics.

A complicity between sitter and artist gives all Chagall's portraits of Bella a particular charm, but this one also contains mystery, an intense spiritual force, and the painter's new pride in his beloved. "I write to you," Bella told Chagall during their engagement, "because we tangle with our souls and the soul sometimes feels shared and sometimes different. It's strange that before the joint life stretched us, we tried to reach out in life alone."

Self-portrait with Brushes is as assured, as traditional in the restrained colour scheme: black tunic contrasted with shining white collar and with Chagall's golden brown face, sharply lit to emphasise the chin, nose, and broad brow–all determined, energetic features. Clutching his brushes in the deliberate pose of a seventeenth-century Dutch painter or an Italian mannerist, Chagall displays himself as master of his art, but there is also, Kamensky notes, "an ironic theatricality . . . a flaunted elegance, an artistic negligence. The poor Jew was amused to see himself in the trappings of a pretentious aristocrat." Art historian Alexander Romm, who became a friend of Chagall's shortly after he painted this work, noted at this time how Chagall seemed to converse with the Old Masters, talking in his letters of "crafty Cranach" and "thoughtless Fra Angelico"; he was, thought Romm admiringly, able to penetrate to the heart of "Cézanne, El Greco, Renoir and anyone he liked" and to incorporate this secret, "to fuse it within his own gift." A certain playfulness carries over in the exuberance of both portraits here: a hint of children dressing up, experimenting in the grown-up world. Meyer suggests that Bella, who loved both seventeenth-century painting and drama, was the impulse behind the intense theatricality of these and many other pictures painted in Vitebsk and St. Petersburg between 1909 and 1911.

These portraits were the public statements. Behind the scenes Chagall's romance with Bella was less certain, more agonised, longer drawn out, than the confident works and the memoirs suggest. At the same time as he was painting *My Fiancée in Black Gloves,* Chagall made a couple of sketches of his new friend in pen and ink that suggest a tentativeness, though a tender interest, as he seeks to understand her. In one, little more than an outline, he catches her tremulous, darting, fragile quality, as she half-approaches, half-leans back from a plant, almost like a bird in flight; her

voice, he said, was "like that of a bird from some other world." More ambiva-
lent is "a caricature of Berta"—a second title, "Bella," was added later—that
mocks her as a romantic bluestocking. With an earnest expression and the
same definite pose, hands on hips, as in the sketch and the painting, Bella
stands before her parents' jewellery shop with a rose in her belt, and a fork
and spoon in her hair—probably a tease about her love of cakes—and Alexan-
der Blok's *Verses on a Beautiful Lady* under her arm. This tone of ironic
admiration recurs in an early letter where Chagall writes of her: "the riches
of past and present experiments do not pass her by, and she nourishes a cer-
tain love of literature (without abusing . . . paper in any way), philosophy
and other branches of art." This, too, suggests that he is intrigued but not
yet committed.

For her part, Bella threw herself headlong into a passionate, serious
quest to understand and support his work. She had not had a boyfriend
before, and in eager loyalty, she saw his art, like her own acting, as some-
thing almost holy. "I would really like to tell you everything that your paint-

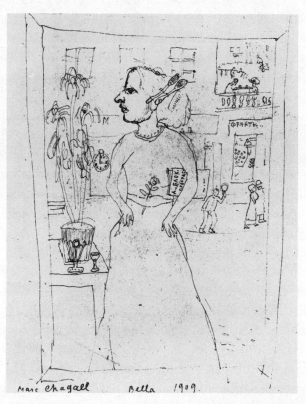

Chagall, "Bella," 1909, drawing

ings say to me," she ventured in a letter during their engagement, written in the elegantly rounded, flowing, assertive script that expressed her resolution and flair.

> I will be very strict and demanding, because like from myself, I want *something else* from you. Most importantly, I feel from you a sincere desire to struggle for the utmost, pure attitude to art. It is particularly important to reach that soon. You stand in front of them, and can't come any closer, that entire same lively authentic, not only calming but also worrying power. It was painful to leave that wild strength, after that omnipotent funeral procession [*The Dead Man*]. Is there any influence in it from your awe at the work of Ciurlionis? No? And also explain to me one thing. I've decided that talking about this is natural. I entirely refuse to acknowledge people like Larionov, Mashkov, Kuzenov, Goncharova. I don't understand. What are they thinking? Who could one fool with a contrived attitude to technique? How are they going to convince me that I am looking at some kind of art, some kind of life, even an imaginary one? Where is the art that gives me existence within it, the hand-made, when instead I see some characters made of cardboard or bread? Any kind of liveliness requires fullness of sound. In order to create it, blood must flow through all the capillaries, it needs this. I am not talking about realism. I don't need anomalies. I need art that can be discreet about its physicality, but is based on it, otherwise I won't believe in it. Or give me your fantasies, starry and echoing, unusual and surprising, as in what could only be Ciurlionis. You know, I have a certain impression from you. I won't pretend full comprehension, as I couldn't even sketch a line, but anyway I feel this quite brightly and sharply.

As a girl from an Orthodox family, she risked more by this friendship than did Chagall. Soon after their first meeting, she had to return to Moscow for the start of the new academic year, and Chagall went back to St. Petersburg, but in the first months of the new year she visited him there, probably without her parents' knowledge. There is a sketch of her, head bowed over a table, in the capital in 1910; and the sketch "The Room in

Gorokhovaya" (the title refers to a major artery through the city running just behind Vitebski Station) shows a couple locked together, fully clothed, on a single bed in a cramped bedsit–probably a double portrait from the early days of their romance.

These drawings, not for public consumption, suggest the edginess, uncertainty, and hurried meetings early in a love affair. Chagall wrote at this time of the "love that comes from the heart of a frustrated young man," of trying to put down on canvas "the bitter taste of fruitless meetings"; Romm recalled that "he spoke of love, conception, sadly with a wry smile." He wrote poetry, too, complaining about his hard life, portraying himself as "cruelly downtrodden," "punished by fate . . . since the morning" and destined for "an early death on the cross." In his mix of self-pity and youthfully excessive self-belief, he identified with Christ at this period, both as a persecuted Jew and as a misunderstood, radical, creative spirit. Self-portrait sketches of this period have titles such as "Me, with nothing to do," "Me dreaming," and "Me going mad."

Sexual love, Thea's or Bella's, might have given authority and colour to Chagall's work, but it had not solved his problems of how to develop as a painter in Russia, how to find a teacher who could help him do so, and how to settle his financial and legal status in St. Petersburg. He was worrying still when, in the autumn of 1909, just after he met Bella, another encounter, almost as significant for his art, presented itself. Visiting his studio at Zacharevskaya, Leopold Sev, who greatly admired his work and was soon to buy *The Dead Man,* gave him a note of introduction to his friend Léon Bakst. Chagall had no doubt what it meant. He wrote it in his memoir in three words: "Bakst. Europe. Paris."

Léon Bakst

St. Petersburg, 1909–1911

Léon Bakst was still asleep on the late autumn afternoon when Chagall appeared at his apartment at 25 Kirochnaya with a sheaf of sketches and the letter from Sev. "One o'clock in the afternoon and still in bed," Chagall mused as he nervously took in the silent, refined entrance hall. "No shouts of children, no perfume of a woman. On the walls, paintings of Greek gods, a black velvet altar-curtain, from a synagogue, embroidered in silver. Strange!" Then the master appeared, "smiling slightly and showing a row of shining teeth, pink and golden." Bakst was a dandy, "always neatly turned out, wearing a white shirt with pink stripes, a dark pink bow tie and, of course, always the flower in his buttonhole," according to the dancer Bronislava Nijinska. "His prominent blue-grey eyes looking out over the pince-nez which he rarely removed, his red hair carefully combed over his small, round, balding head, with that pompous moustache beneath his large, arched nose: one could not call him handsome, but beneath his attractive individuality one sensed the artist." Chagall perceived something else: "It seemed to me mere chance that he was wearing European clothes. He is a Jew. Above his ears reddish locks curled. He could have been my uncle, my brother."

Bakst was at the time the most famous Russian artist in the world. He was just back from the triumph of Diaghilev's first session of the Ballets Russes, which had opened in Paris in May 1909 and had introduced French audiences to a new vitality in dance, changing expectations of performances and productions in western Europe. The popularity of the Ballets Russes marked the real start of a Parisian craze for Russian culture—seen as exotic

and wildly primitive in its frenzy, boldness, bright colour—that lasted through the 1920s and for which Bakst's contribution, as designer of the extravagant sets and costumes for *Cleopatra* in 1909, was seminal. An aura of European success therefore clung to him as he travelled home in leisurely style, spending October in Vienna.

Bakst, who loved Rembrandt and Velázquez, was a classicist at heart—the Greek gods guarding his hallway had been carefully chosen—and his mix of classical grace and Eastern imagery brought the French cultural establishment to his feet. A draughtsman whose strength was his sinuous flowing lines, based on the art nouveau aesthetic, Bakst brought to his Ballets Russes designs an animation and graphic ornamentation that complemented the vitality of Diaghilev's productions. It was the sensual energy in Russian theatre that delighted Paris audiences; Bakst, dissatisfied with ballet's conventional staid backdrops, enhanced the impression with exotic sets in vibrant colours that were an essential part of the production, integrating vertical space with the movement onstage and thus revolutionising the role of theatre design. To Western audiences, fascinated since the late nineteenth century by Eastern civilisations, his lavish conception for the Egyptian drama *Cleopatra* of oriental and Greek refer-

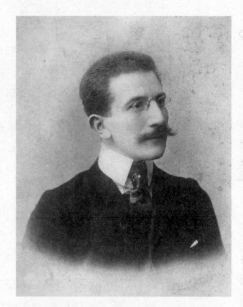

Léon Bakst

ences, geometric shapes (circles, chevrons, stripes), and mosaics and stylised plant motifs, was seductive and influenced contemporary fashion and interior decoration. "It is spellbinding and a constant thrill for the eye," wrote *Le Temps*. "Monsieur Bakst, the Russian painter, who created this wonderful picture with his colours for both the set and the costumes, is a truly great artist." For the first time, a Russian artist had astonished the West rather than vice versa, and young Russian critics exulted. "The intellectual, artistic and creative elements of Paris . . . took off their hats to the youthful, colourful, bacchanalian orgy that had come from the north-east," noted Anatoly Lunacharsky, while Yakov Tugendhold, Paris correspondent for the arts journal *Apollon*, told Russian readers the following year that "it was as if an electric shock had suddenly informed the whole of France of the feverish excitement which the word 'theatre' had meant for us Russians dur-

ing these last few years, and Paris somehow began to wake from its theatrical drowsiness."

Bakst's "fame, after the Russian season abroad, turned my head," Chagall remembered, but when the celebrated artist began to speak, he heard the accent from Grodno, a town in the Pale of Settlement not far from Vitebsk, and his sense of uneasy kinship grew stronger.

> He'll understand me; he'll understand why I stammer, why I'm pale, why I'm so often sad, and even why I paint with lilac colours.
>
> He stood before me . . .
>
> "What can I do for you?" he said. On his lips, certain words drawled strangely, a special accent . . .
>
> As he turned my sketches over which, one by one, I picked up from the floor where I had piled them up, he said, drawling out the words in his lordly accent:
>
> "Ye . . . es . . . es . . . es! There's talent here; but you've been sp-oi-led, you're on the wrong track . . . sp-oi-l-ed" . . .
>
> Spoiled, but not completely . . . Had anyone else spoken those words, I would have paid no attention. But Bakst's authority was too great for me to disregard his opinion. I heard it, standing, deeply moved, believing every word while, embarrassed, I rolled up my canvases and my sketches.

It was arranged immediately: Bakst was teaching at St. Petersburg's expensive, innovative Zvantseva School, and Chagall would join as his pupil, his fees of thirty rubles a month to be paid by a benefactor, Alicia Berson.

Chagall was mesmerised by Bakst. With his drawl and the exaggerated precision of his dress and manner, Bakst cast a spell over everyone, but Chagall studied him with the special interest of one who both comes from the same background and aspires also to leave it. "He was exotic, fantastic–reaching from one pole to the other. The spice and sombreness of the east, the serene aloofness of classical antiquity were his," remembered the dancer Tamara Karsavina. Born Lev Samoilovich Rosenberg to a lower-middle-class Jewish family in 1866, Bakst (he took his grandmother's name from 1889) was a decade younger than Pen, and as soon as he could, he had beaten a path directly to the heart of Russian culture. Like Chagall, he struggled as a young artist in St. Petersburg, painting shop signs and hand-colouring

alphabets for children's bookshops to make a living. He met Chekhov in 1886 and spent the summer of 1890 in the country home of the cultured Benois family in Oranienbaum, on the outskirts of St. Petersburg. He travelled to Paris and north Africa in the 1890s, and he combined in decorative work, book illustrations, and scenography for the Mariinsky Theatre opulent orientalism, the sinuous grace of art nouveau, and the colourful primitivism of Russian folk art. In 1898 he had founded with Alexandre Benois the Mir Iskusstva group, and thus, he wrote, "began my stubborn campaign for the art which I worship. I decided to dedicate my life to art, to do battle for it whatever the cost, to uphold its supremacy and independence over all other interests."

His celebrated portrait of his friend Diaghilev implicates both subject and artist in the privileged world he commanded by the time he came to the Zvantseva School in 1906. In the painting, completed that year, the impresario faces us boldly, but the psychological pull of the picture forces us beyond Diaghilev to a wispy figure in grey sitting by a black curtain in the

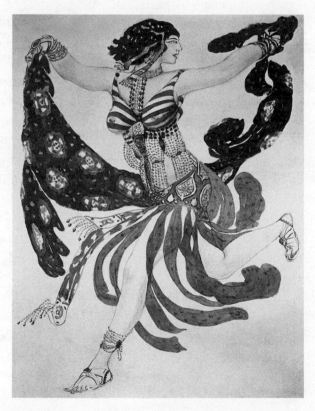

Bakst, "Cleopatra," 1909, costume sketch

corner: Nanny Dunya, who lived with Diaghilev and presided over the samovar at World of Art meetings, serving tea and jam to her charge's friends beneath a chandelier cut in the shape of a many-headed dragon. Asked towards the end of his life if he had ever hurt anyone, Diaghilev mourned that he had on one occasion run out of his apartment without kissing his nanny's hand and asking her blessing. The painting is gently suggestive of the childhood scars that turned Diaghilev into a Peter Pan figure, a dandy flitting across the surface of things, but it was painted in awareness too of the pain with which Bakst had left behind his own childhood. For in his rush towards the secular and Russian high society, Bakst had in 1903 taken a step that seemed slight at the time but that was to shadow his life: he had fallen in love with Liubov Gritzenko, widowed daughter of the fabulously rich Pavel Tretyakov, art collector and founder of Moscow's great museum, and in order to marry her–Russian law prevented marriage between a Jew and a member of the Orthodox Church–he had converted to Lutheranism in Finland.

"Without flowers and music half of happiness is lost," Bakst wrote lightly to Liubov during their engagement. He thought himself a pure aesthete, but changing his religion turned out to be a disaster. He had not realised how strongly Jewish he felt, and from 1903 onwards he suffered prolonged, frequent periods of depression. He soon separated from his wife and began to question all his achievements. By 1908 he was writing to Liubov (with whom he remained on good terms) that "the decline, aridity and mistakes in my artistic career" would soon be recognised and that even "my pupils will not acknowledge me then." The year after Chagall called at what appeared to be his effete bachelor apartment, the emperor himself signed the Baksts' divorce papers, and in 1910 Bakst reverted to Judaism. "Strange to feel horribly indifferent and almost despondent," Bakst wrote to Liubov at the height of his Parisian success. The experience contributed both to the limitation–the chaste reserve–in his work and to the European correctness of dress and manner that was Bakst's persona: his affectations, pernickety ways, and little conceits such as running around the tutu-ed dancers waiting for compliments after ballet performances, were all devices with which he tried to hold a divided personality together and give meaning to a life that had lost its core. The Jew in false garb, tormented by his own assimilation, was what Chagall saw at their first meeting, and it always coloured his view; when Bakst died in Paris in 1924 he noted, "I felt like chasing out all the Goyim who stood at a distance, in the hall, hats down, and even Ida Rubin-

stein [Bakst's dancer friend] in a false tragical pose. For here a Jew is lying. He just ostensibly walked in black tie, chased fame."

By then, Chagall had realised that Bakst's assimilation had not, finally, convinced anyone else, either. Jean Cocteau called him "a huge society parakeet with a violin d'Ingres on his head, a monster of Jewish duplicity . . . he boasts a lot and never sleeps with anyone." Diaghilev complained about his "slow-mocking voice" and the "crooked painful smile" spreading across his "red-cheeked face"; Benois went further and in a moment of jealousy told Serov: "I have never despised Jews, on the contrary I have a weakness for them, but I am aware of their specific defects which I hate, as with any specific defect. Bakst is specifically Jewish in the sense that he is greedy and gentle, compliant—a combination which makes him somewhat slippery and rapacious, snake-like, that is to say repulsive." Only the sympathetic Jewish critic Tugendhold saw in Bakst's art a civilised fusion of cultures that he defined as "Hellenistic Judaism." This was far from the experienced sense of reality in Chagall's own art or his solid connections with the Hasidic world of his parents. That difference was what made Bakst's example as an assimilated European at once fascinating and appalling to him, and the prospect of entering his school thrilling and daunting.

Riding high on Bakst's allure, the Zvantseva School in those days was known as "the only school [in Russia] animated by a breath from Europe." Standing on the corner of Tavricheskaya Ulitsa, it shared glamorous premises—a wedding-cake mansion with five tiers of circular rooms, each giving onto a round terrace fringed by art nouveau ironwork—with the home of the symbolist poet Vyacheslav Ivanov, who occupied the top floor; the leading Silver Age poets such as Alexander Blok gathered each week at the literary salon in what was called "Ivanov's Tower." At the school symbolist currents were tangible—a memorial in the middle of the circular classroom, an easel draped in brown velvet, had belonged to Vrubel—and symbolism was a strand in the work of Bakst and his fellow teacher, the graphic artist Dobuzhinsky. But the Zvantseva School was not a symbolist breeding ground. Founded in Moscow in 1899 by Elisaveta Zvantseva, a Russian painter who had lived in Paris in the 1890s, it was sought after by liberal-leaning students for its anti-academicism. The painters Serov and Korovin had taught there, but around 1905 their interest waned, and in 1906 Zvantseva, moving the school to St. Petersburg and inviting Bakst to lead it, made a bid for a new impulse towards contemporary teaching. Bakst brought to the task the breadth of his Parisian experience, created a school

open to the latest trends, and encouraged principles surprisingly removed from his own painting.

It was widely agreed that, as Serov wrote, Bakst was a "brilliant professor": enthusiastic, fiery, committed to his handpicked band of around thirty students, many of whom were women, and revelling in their hero worship. Julia Obolenskaya, a contemporary of Chagall's who left a memoir about life at the school, wrote that he praised tempestuous colour and the immediacy of a child's painting but deliberately refused to give examples for imitation, or to challenge each student's own artistic tendencies. Committed "not so much to teach" as to protect "the searching young eye from falsehood and routine," he believed that "the future painting calls for a lapidary style, because the new art cannot endure refinement–it's had enough of that." Like many gifted teachers, he was aware of the gap between what he taught, which he saw as the future of art, and what he practised, which he acknowledged as a mere byway. To his pupils' questions as to why he worked differently from what he asked of them, he would reply, "I am teaching you to paint as one ought to paint, not as I do." He referred them to art that did not, as he put it, recognise spiritual exhaustion but was warmed by "human efforts and smiles." The pathos in this made him at once an attractive and a tragic figure.

Classes at the school ran between ten-thirty and three; two days of drawing were followed by a day of drawing from memory, then two days of painting from a model were followed by a third of painting from memory. Every Wednesday Dobuzhinsky came to oversee the drawing class, but the focal point of the week was what Bakst called "battle day"–his supervision of the painting studies on Fridays. Obolenskaya recalled that on that day nobody worked; all waited for Bakst to appear, which he did with customary punctuality, smartly dressed and composed in manner. He then approached the first piece and asked everyone to pay attention. Standing the unfortunate artist before him, he "began to criticise all his intentions and shortcomings with ruthless accuracy . . . The class formed a circle round Bakst, the drawing, and the accused, who had a bright red right ear at the beginning of the tirade and a bright red left ear at the end, and who then joined the circle to review the work of his classmates."

Chagall, who had had no warning of this system, found himself on the receiving end of it in his first week.

> The study is finished. Bakst criticises on Fridays. He comes only once a week. Then all the pupils stop work. The easels are lined up. We are waiting for him. Here he is.

He goes from one canvas to the next, not knowing exactly to whom each belongs.

Not till afterwards does he ask: "Whose is this?" He says little—one or two words—but hypnosis, fright, and the breath of Europe do the rest.

He is coming towards me. I'm lost. He speaks to me; or, more precisely, he speaks about my study though he doesn't know (or pretends not to know) that it's mine. He says a few casual words to me, the way one makes polite conversation.

All the pupils look at me pityingly.

"Whose sketch is this?" he asks at last.

"Mine."

"I thought so. Of course," he adds.

In an instant the memory of all my alcoves, all my dingy rooms, passes through my mind, but nowhere had I been as unhappy as after that remark of Bakst's.

Slow to praise and quick to undermine, Bakst attacked on all sides, Obolenskaya remembered, often using coarse language, but no one was offended, and the harsh judgement was regarded as useful for the next week's work. This was not, however, how the oversensitive Chagall saw things. The following Friday it was the same: no praise. Chagall fled from the atelier. He claims that he did not return to the school for three months—which is either an exaggeration or a mistake; three weeks is more likely, as he was at the school for only about six months all together. During these weeks he worked alone, determined not to give up but to win Bakst's approval; when he returned, Bakst hung his new study on the studio wall as a mark of honour.

This recognition won grudging respect from Chagall's classmates but barely helped him integrate. He was intimidated again: Bakst and his select band, as well as the regular visitors—Benois, Vsevolod Meyerhold, Alexei Tolstoy—seemed grandly remote, sophisticated, exclusively close-knit. The women pupils were mostly from well-off St. Petersburg families and included Sofia, Countess Tolstaya, and a group of bluestockings who adored Bakst and referred to themselves as "apprentices of Apollo." Among the men were Bakst's nephew Alexander Ziloti, son of an acclaimed pianist, and Diaghilev's lover Vaslav Nijinsky, who, Chagall recalled, drew awkwardly, like a child. The most gifted students were the handful from the provinces, including Nikolai Tyrsa from the Kuban Cossacks and another shtetl boy, Meier Sheikhel. Most of the students formed a tight social circle

and kept together as a group, visiting exhibitions, attending the latest Mey-
erhold productions and the ballet, writing poetry, drawing caricatures, and
reading—according to letters exchanged between Obolenskaya and a friend,
"often Pushkin, and more often [Knut] Hamsun," whose radical novel
Hunger (1899) represented avant-garde taste. Few of them warmed to Bakst's
new student—except one, Alexander Romm, a year older and an elegant,
exceptionally well-educated student at St. Peters-
burg University, who immediately acknowledged
Chagall's greater talent and befriended him with
a passion.

Chagall and Alexander Romm, Paris, 1911

From 1909 twenty-three-year-old Romm re-
placed Mekler as the sophisticated, worldly,
bourgeois friend whose support and intimacy
were essential to Chagall as he forged a career
in unfamiliar surroundings: he would depend
on such figures until his marriage, when Bella
would incorporate the role into that of wife. An
early photograph of Chagall and Romm shows
an unlikely pair: Chagall short, thin, hungry-
looking, and uncertain, Romm confident, stocky,
and dapper in a slick white suit. The other Zvan-
tseva students looked on astonished as Romm,
who spoke many European languages fluently
and was compellingly attractive and successful
with women, played second fiddle to the shabby,
stuttering new shtetl boy.

In his memoir—which is complicated by his own bitterness at his lack of
success—Romm reported that the other classmates disliked Chagall for what
appeared his "insincerity" and "arrogance"; he combined diffidence and
pride, a shtetl sense of worthlessness with excessive self-belief. There was
no meeting ground with Sheikhel—"they disliked each other, these two
favourites of Bakst's. Chagall's sarcasm, outwardly juvenile and sentimen-
tal, but refined in a common-sense Lithuanian way, clashed with Sheikhel's
naïve faith, simplicity and serenity"—and only Romm appreciated Chagall's
dreaminess, remembering that he gave the impression when he joined the
school "of just having been embodied, of falling from the moon . . . The
most ordinary things sometimes elicited caustic comments from him or a
kind of amazement." Bakst, however, took him seriously, saying of Chagall

and Tyrsa, "I have two pupils, one walks on his head and the other on his feet, but I don't know which of them is best." Obolenskaya noted in her memoir that although the work Chagall did at the school did not seem significant, the class awaited with interest the studies he made at home.

For his part, Chagall, after the inferiority of his previous schools, acknowledged the seriousness of the other students here–"Bakst's pupils, all more or less gifted, at least knew where they were going"–and appreciated the milieu of what he called "a Europe in miniature." Announcing that Gauguin, Matisse, and Maurice Denis were the artists of the future, Bakst led his students towards a modern international idiom where they could find their own forms of expression in a spirit of intellectual independence. To simplify form, enhance colour and liberate brushwork were the goals. Still lifes were composed of simple, crude objects; models were chosen for their unusual silhouettes, and beautiful ones were not invited. Students painted on rough, coarse-grained canvases like sackcloth, used carpenter's glue for the ground, and wide brushes (narrow, fine ones were banned) to achieve sweeping strokes and a thick paint surface. To retain freshness of impression, underpainting and preparatory drawing were discouraged; colour combinations above all were emphasised. So was a certain monumentality: Bakst had made his name as a set designer in Paris and had his doubts about the future of easel painting, dreaming rather of a decorative style harmonised with architecture. Tyrsa painted frescoes in a church; Sheikhel made five-yard mural-like compositions of Jewish life called *Hasidic Dance* and *Torah Wedding*.

But mostly Bakst stressed the importance of colour. "I myself am head over ears in colour, and don't want to hear a word of black and white," he wrote from Paris. "Art is only contrasts," he used to say. "I have a taste for intense colour; and I have tried to achieve a harmonious effect by using colours which contrast with each other rather than a collection of colours which go together. . . . Bright, pure colour is the natural taste." Uninterested in naturalistic accuracy, he rated a painting according to the tone and texture, tensions and dialogues, among the colours; he encouraged simple drawing and forbade black outlines, because they interrupted the flow between colours. Chagall responded immediately. Obolenskaya noted that Chagall first showed a pink study on a green background, which may have been *Little Parlour,* depicting a room at his grandfather's house in Lyozno. The double curving of the back of the chair and the broken angle of the table give a sense of motion and airiness; Chagall followed Bakst's advice to

reduce the number of colours to master them better, and the pull between the dominant hues of rose pink and light green makes the interior vivid. Nevertheless *Little Parlour,* with its instability and disquiet, owes more to Gauguin than to anyone else.

How much did Chagall really learn from Bakst? Like Bakst, he was concerned all his life with colour and theatre. But he spent only six months at the Zvantseva, and he always called himself unteachable. "What is the use of pretending: something in his art would always be alien to me," he wrote, just as he had felt at Pen's three years earlier. "The truth is, I'm incapable of learning. Or rather it's impossible to teach me . . . Going to school was for me more a means of getting information, of communication, than of instruction proper." With Bakst, that communication was a turning point: Bakst opened a door on Europe. "My fate was decided by the School of Bakst and Dobuzhinsky. Bakst changed my life. I will never forget that man," Chagall wrote in 1921.

Bakst himself was increasingly turning away from Russia to Paris. In spring 1910 he arranged for the Zvantseva to have its first major exhibition, in St. Petersburg, at the offices of the arts magazine *Apollon.* It was Chagall's first chance to exhibit in public, and although Bakst insisted on anonymity for the hundred pictures, a caricature of the show by one of the students, Magdalina Nakhman, illustrates that his work stood out; *The Dead Man* is exhibit number one, and *Russian Wedding,* and a large lilac canvas, *The Peasant Eating* (now lost), are also prominent. But the exhibition was a flop—a thousand invitations were sent out for the preview but almost no one came. Nakhman's caricature shows just two crusty, dissatisfied-looking visitors. Obolenskaya wrote sadly that "the opening day should have been a great event for us, but was not." What really shocked the students was that Bakst himself never saw the show; now divorced, he left St. Petersburg a few days before the opening on 20 April, to work with Diaghilev and the Ballets Russes in Paris, and had no intention of returning to Russia. Chagall, who saw Bakst as his route to Europe, was despondent; a conversation about the possibility of his accompanying his teacher had been left open-ended and now tantalised him to distraction. At the end of April he wrote to Bakst in Paris, wildly hoping to be invited to join him in France. But "no reply from him (B)," he told Romm in May. "He's forgotten his student, amid the flurry of a ballerina, her twirling legs, he's forgotten his student (such an inevitable word), a little person . . . and that's why I'm sad."

Bakst left his students in limbo, knowing that he could not fulfill the

hopes they had invested in him. Shortly after his departure the nine-hundred-work Izdebski Salon, the first major avant-garde exhibition in St. Petersburg, arrived from Odessa, showing works by Matisse, Derain, Van Dongen, and Kandinsky, as well as the young Russians Larionov, Goncharova, Lentulov, and Alexandra Exter. Bakst could not compete with this new Russian avant-garde, which he believed was "blighted with the poison of negation" but would finally pass through "the lower ranks of coarseness" to allow Russian art to "blossom as a pure and splendid tree, laden with bright ripe fruit"—though not his own. Paris and Diaghilev's Ballets Russes were an appealing escape.

Chagall felt he could learn nothing from Bakst's successor at the Zvantseva, Kuzma Petrov-Vodkin, who painted in a neoacademic style influenced by icons and brought no international flavour to the school. A few weeks after Bakst's departure Chagall, too, left St. Petersburg. He spent May and June at the Germontes' lovely dacha at Narva, licking his wounds. He returned briefly to the capital and stayed with Goldberg, then on 7 July, his birthday, he went home to Vitebsk. After experiencing Bakst and the breath of Europe, he felt it intolerably backward. "I am happy with all of you," he told his native city. "But have you ever heard of traditions, of Aix, of the painter with his ear cut off, of cubes, of squares, of Paris?" The thought of Bakst's living and working in the French capital while he languished in the Pale tormented him. If he was fated to "melt away in solitude," he told Romm, he would stay in Vitebsk forever, for "it's better that this tedious and hardened earth should eat me here" than that he should ever have to endure St. Petersburg again without Bakst to brighten it and offer him a way forward. The avant-garde was now progressing rapidly within Russia—with Larionov's launch of the first "Jack of Diamonds" show in 1910 in Moscow a marker. The "Jack of Diamonds" united young artists including Ilya Mashkov, Aristarkh Lentulov, Pyotr Konchalovsky, and Robert Falk, who developed a primitivism based on bright decorative colour and elements of popular and folk art underlined by the heritage of Cézanne and cubism, and their show was acclaimed by Maxim Gorky. But this exhibition was peripheral to Chagall's concerns; he envisaged his own future, from the moment Bakst departed, only in Paris.

Bakst had told his pupils to work, "if not to complete exhaustion, then at least to blistered hands" over their vacations, and Chagall, hanging on his every word, painted furiously in the studio in his parents' courtyard through the summer of 1910. *Portrait of Anyuta,* depicting his resolute, sturdy eldest

married sister, follows Bakst's advice in its vivid colour, plastic moulding of the figure, and strong silhouette against a light background. The sinister "The Butcher," in shades of blue and ochre, portrays his grandfather, ax in hand, as a primitive giant. Chagall, dreaming of Paris, took the pulse of his family as if in valediction, making rapid pen and ink sketches of places that had significance—his parents' bedroom, with his mother asleep in one of the two heavy single beds and a painting of his on the wall; a sepia and water-colour of his grandfather's home in Lyozno; a graphite sketch of Thea's busy drawing room, where he had first set eyes on Bella, with its grand piano and musical instruments and himself partly hidden behind a curtain, only half there.

When he painted that summer the masterpiece of 1910, *Birth,* he was consciously closing the cycle of Russian-Jewish small-town life that had opened with *The Dead Man* in 1908. These two studies of birth and death form an arc across his first Russian period, with *Russian Wedding,* the nudes of Thea, and the portrait of Bella filling out the panorama of birth, copula-tion, and death in the Russian-Jewish prewar experience. Complementing one another, *Birth* and *The Dead Man* share a mix of symbolism, realism, and primitivism. Both are portraits of the artist's state of mind, heightened by theatrical presentation. But where *The Dead Man* is suffused by fear, *Birth* is full of anticipation, uncertainty, and excitement.

Like a curtain unveiled on a stage, the crimson hangings of a four-poster bed reveal a midwife holding a baby and the mother, white-faced and still

Chagall, "Birth," 1908, drawing

bleeding, lying on the mattress. The bed and the outline of the mother recall Rembrandt's *Danae,* which Chagall knew from the Hermitage; preliminary drawings emphasize the classicism of the figures. But the parting of the curtains was influenced by Byzantine icons of the Nativity and suggests the mystery of motherhood, and the midwife, too, erect and in frontal pose, recalls a barbaric icon. Romm insisted that *Birth* was inspired by symbolist poems by Blok and Andrey Bely, commenting that Chagall was obsessed at the time with themes of birth, death, the endless generations "whose life was years of searching." "I don't know what time is," he would say dreamily to Romm, "and this may be bad, very bad." In its fusion of Eastern and Western influences, however, *Birth* is a typical Russian avant-garde painting of 1910, with Chagall's own mix of mysticism and crude physicality stemming from his absorption in Hasidism and everyday life in Vitebsk. Feiga-Ita, watching her son complete this work, suggested he bandage the stomach of the mother with a white cloth, and "I immediately satisfy her desire. That was right! The body takes on life!" As in the paintings modelled by Thea, the woman is central; in comic counterpoint to her solemnity, the husband crawls out clumsily from his hiding place under the bed–secondary to the action–while in a golden circle of lamplight a group of whispering Jewish men await news of the birth. These figures, touching but grotesque, are evocative of characters in contemporary Hasidic-inspired Yiddish literature such as Isaac Peretz's *The Time of the Messiah* (1908), where birth as miracle, presentiment, and anticipation of momentous change is combined with humour and realism. This is the scene in Peretz, for which *Birth* could be an illustration:

> I enter the inn. A large room divided in two by an old curtain. Three men are seated by the door. They do not notice me, but I can see them clearly. Three different generations. The old man asks:
>
> "What's happened? Is it a girl, or what?"
> "No," replies the old woman. "A boy . . ."
> "Is he dead?"
> "No, he's alive," says the old woman without any joy.
> "Is it a monster?"
> "There are odd marks on his shoulders."
> "Marks of what?"
> "Of wings. Clear traces of wings."
> "Wings!"

The old man is worried; his son is stupefied. Only the grand-
son leaps with joy.

"That's wonderful! His wings must develop. Become large
powerful wings. Isn't that great! Man will no longer be tied to the
spot; he will no longer walk in the mud; he will live above the
Earth. Is the sky not better, more beautiful than the Earth?"

But the practical changes Chagall yearned for still seemed frustratingly
out of reach. In 1910 Viktor Mekler left for Paris, and the small, neat, anx-
ious letters he sent back were far from reassuring. Viktor struggled in Paris
and flailed before the advances that Chagall was making. "I personally don't
like air in painting and truth in letters," he whined.

> Oh, how often I have to say something and cannot express it
> enough . . . In my despair I began looking for other exiled peo-
> ple, but did I find them? . . . they aren't *you*. I still haven't lost
> you, and am relying on you, and our separation is becoming
> heavy, although sometimes there is nothing better in life than
> separation from one's best friends. Thus I came to terms with
> that silence . . . because the feeling of friendship is nurtured in
> silence, and the spiral shape of friendships establishes itself
> through exaltation! We won't dwell on the essence of this exalta-
> tion–these outbursts are our secret . . . I as always already begin
> to hate myself, and if it were possible for a man to meet *himself,* I
> would kill myself. Write to me, your Viktor. I'm bored.

Chagall was on a different track; ruthlessly, he had taken what he needed
and was on the point of being able to dispense with Viktor. First he lost Vik-
tor's letter and address; then he delayed replying. "For me (and I am not that
important)," he wrote, "you are a dear, from the past (you were necessary),
you have passed, you are almost nonexistent." Yet he grabbed at every word
about Paris. "I am already scared of the many misfortunes that have befallen
the immigrants there," he wrote. "How do you live? Do you have a good and
comfortable place? Is it true that you have a glass roof–a lot of light? I am
happy (God knows what about). In part, because I shall certainly be in Paris.
It will soon become clear."

But it was not becoming clear at all. Unlike wealthy, talentless Viktor,
Chagall had no means of getting to Paris. Hearing only silence from Bakst,

he asked Pen to apply to him on his behalf, and he wrote again himself in September 1910. "I have never written anything like it before, such an angry letter," he told Romm. "If he doesn't reply now, I'm finished. Even if nothing comes of it, I couldn't keep silent. I can't go to Piter [St. Petersburg] just like that. It was bad, intolerable [without Bakst]. I couldn't bear that."

Bella, in Vitebsk for the long vacation, watched as Chagall desperately tried to make plans to leave Russia. Their romance flared bright against the frustration they both felt with their backward native town. Bella spent most days at the studio in Javitch's; having been shocked when Thea had boasted of posing nude, she now did the same. The day after Chagall painted her, Feiga-Ita came in and saw her son's work hanging on the wall.

> "What's that?"
> A naked woman, breasts, dark spots.
> I'm embarrassed; so is she.
> "Take that girl away!" she says.
> "Dear little Mama! I love you very much. But . . . haven't you ever seen yourself in the nude? As for me, I only look and sketch her. That's all."
> However, I obeyed my mother. I put away the canvas and, in place of that nude, I painted another picture, a procession.

The sketch "Nude Seated" from this time shows a shy young girl in profile, one arm protectively crossed over a well-proportioned body. Chagall has drawn her with tenderness and a respectful distance, along with the sketchiest outline of himself, no more than a head and a hand holding a pencil, in the corner of the same sheet. They are a sort of disembodied version of the artist and his muse, with none of the passion that characterised the painted nudes of Thea. A brown ink gouache, "Hayloft," from the same period, has Chagall and Bella fully clothed and embracing, sheltering each other from the outside world, soft and happy, as a black cat creeps stealthily above them.

Bella's family was even less pleased by the romance than Feiga-Ita: a poor artist from the wrong side of town with no prospects was the last person they wanted as a son-in-law. They had already lost one daughter to revolutionary socialism; now another was abandoning Judaism for art. Before her mother, Bella "quailed. I didn't want her to be angry with me. She had enough problems with my brothers, who all did just as they pleased." Bella was absorbed

in her love affair but also confused and overawed. "I am afraid of this soul, I always feel ashamed in front of it, that I can't guess or know all of it–that it is very grand and very rich, and I am insulted by my untalented lack of knowledge," she told her lover. "I need to purify myself, I need truth–we are afraid to spoil everything and to make it too hard. This truth in art and in life, this is the end and beginning of life."

That her parents would agree to marriage while Chagall was still a student was out of the question. For his relationship with Bella, too, Chagall now perceived Paris as essential: he would study there and win the Rosenfelds' approval by his achievements. He and Bella saw their future in the cosmopolitan world of art and theatre–milieux incomprehensible to both sets of parents. "They are so honest, they so much matter, they are so silly, but very dear to me and I beat them by my wings . . . into their hearts. The drama of my life is to them a comical tragedy," Bella wrote to Chagall about Shmuel Noah and Alta. "The naïve and insulting directness of my mother expresses itself with all power and all ability to make one feel it. I've always been their servant, done their bidding. It's even a little bit disgusted, my attitude to my provincial parents." A few years later the poet Eduard Bagritsky wrote:

> *Their love?*
> *But what about their lice-eaten braids,*
> *Their crooked, jutting-out collar bones,*
> *Their pimples, their herring-smeared mouths,*
> *The curves of their horselike necks.*
> *My parents?*

The pull of the secular world, of Moscow and Paris, was irresistible.

Chagall and Bella got engaged in September 1910; then she left for the academic year in Moscow. Chagall gave her a photograph dated the day of her departure; then, alone and still waiting for a word from Bakst, on which he felt his next move hung, he fell into crisis. "I felt that if I stayed much longer in Vitebsk, I would be covered with hair and mosses," he later wrote. The ornamental arrangement of *Still Life with Lamp,* painted that autumn in Vitebsk, is infused with the influence of Matisse's all-over decorative method; from a distance Chagall was studying the new French art as closely as he could. Bakst meanwhile was renting Matisse's own studio and enjoying his first meeting with the man whom he considered a modern master. He

wrote home in October about the sensational paintings *Dance* and *Music,* destined for Shchukin's palace in Moscow, which "puzzled everyone." Fretting about his own place in history, Bakst querulously claimed that he had had an influence on Matisse: "Matisse's new picture . . . follows the tone of *Cleopatra* [his recent theatre set] completely, and although he does not conceal his admiration for my work–c'est un peu drôle. Entre nous," he told his former wife.

On 18 November he finally wrote to Chagall. "You are wrong to despise your surroundings," he told his pupil. "What I like best in your works is the provincial life around you. Just work, without waiting for the approval of those around you, produce sincere things that match up to your ideal. This material will come in handy later."

This advice was honest and foresighted–these studies in Russian life would be the foundation of Chagall's Paris work–but also defensive. Bakst had waited so long to reply because he already perceived Chagall as a rival, another potential magician of the Orient. He had been acclaimed ecstatically for his stage decorations and costumes for Rimsky-Korsakov's *Scheherazade* at the Palais Garnier in June 1910–winning even Picasso's admiration and also that of Marcel Proust, who sought an introduction and boasted that "of course he is charming to everybody, but I detected a certain *nuance.*" But for Bakst fame had precipitated an identity crisis; several months later he had all his works sent on from Russia to France and, when they arrived, burned the lot. He did not want Chagall in Paris challenging his precarious sense of balance. "You worry too much and spoil yourself. Remember–you're nervy, but I'm even nervier. I don't want to have to cope with this feature in you," he told Chagall edgily.

But all Chagall read in the letter was that Bakst was on his way home; the Ballets Russes were due to perform at the Mariinsky. Chagall left immediately for St. Petersburg, staying with Goldberg and pouring out his heart about his hopes of the reunion to Alexander Romm. The fateful meeting took place in January 1911.

> I say, stammering:
> "Léon Samuelevitch, could one . . . ? You know, Léon Samuelevitch, I'd like . . . to . . . to . . . go . . . to Paris."
> "Ah! . . . If you wish. Tell me, do you know how to paint scenery?"
> "Perfectly." (I hadn't the remotest idea!)

"Then here are one hundred francs. Learn that profession well, and I'll take you there."

The French money was in his hands, but the promise of the trip came to nothing: Bakst was not pleased with Chagall's efforts. He was in a bad temper anyway: for a performance before the tsarina at the Mariinsky, Nijinsky wore a shortened tunic that Bakst had designed for Paris but that was inappropriate for more prudish Russian audiences. Nijinsky insisted on keeping it, the empress was insulted, Nijinsky was sacked, and Bakst, Diaghilev, and the Ballets Russes left St. Petersburg in a hurry for Paris, where they premiered *Le Spectre de la rose* in April.

Chagall, left behind again in St. Petersburg, thought madly of going, penniless, to Paris. He appealed again to Bakst, and this time received a more crushing answer. "My lovely Chagall," Bakst began his reply—an ironic, distant address. (Use of the first name and patronymic would be usual even among acquaintances.) His letter, written in his florid handwriting on the notepaper of the Hotel Bourgogne, made clear to his pupil just what sort of jungle of competition he could expect in the French capital:

> How absolutely crazy that you're going to go to Paris with 25 rubles. It's such a crazy thing that I wash my hands of this crazy idea. I will not give you a penny. I can't. The reason is very simple, I have no money and I also have no job. I am a man who is very frightened and I have very bad nerves and if you come, I will cause you many troubles. You will be in a very bad mood with me.
>
> There are many Russians here who are literally dying from hunger. I give you this advice: you will receive neither money nor moral support from me. We are absolutely not a good couple—we're so different—and if you come, because I have a feeling of self-protection, I will try to avoid you in Paris—you have to know this.

The link with Bakst snapped: each was too vulnerable to empathise with the other. To Bakst, his student had youthful promise and self-belief, while he was negotiating a crisis of confidence and his anxiety about his place in history. To Chagall, Bakst represented the cosmopolitan art world, and by cutting the line that connected them, his mentor was consigning him to oblivion.

The outlook in Russia was bleak, too. In April Chagall got several works, including *My Fiancée in Black Gloves,* accepted at the "Union of Youth" exhibition in St. Petersburg, his first inclusion in a major show. Other exhibitors included Serov, Larionov, and Bakst himself, but Chagall's works were hung in the final, dimly lit room. Other paintings he submitted to a World of Art exhibition were not shown at all. He put his rejection down to prejudice against Jewish artists, the more so in spring 1911, when a fresh wave of anti-Semitism and pogroms swept across Russia after Mendel Beiliss, a Jewish clerk, was framed for the murder of a child. The right-wing press accused Jews of ritual torture and drinking Christian blood; Beiliss–acquitted in 1913, after an international appeal signed among others by Thomas Mann, Anatole France, and H. G. Wells–became Russia's Dreyfus. But France had in 1906 pardoned and reversed the nineteenth-century verdict against Dreyfus; the Beiliss case, by contrast, showed Russia at its most backward and corrupt and turned the thoughts of many Jews to emigration.

For Chagall, the escape route came out of the blue. In exchange for *Russian Wedding* and a drawing, and for *The Dead Man,* which became the property of his brother-in-law Leopold Sev, Maxim Vinaver paid for Chagall to travel to Paris and awarded him a grant of 125 francs a month to study there. "Beneath my feet, mother earth slipped away. The harsh river flowed turbulently; it wasn't the one beside which I embraced you . . . The Ouspene church, on top of the hill, the dome above it. The Dvina grows smaller and smaller in the distance . . . Vitebsk. I'm deserting you. Stay alone with your herring!"

A photograph of Bella and Chagall taken shortly before his departure shows an attractive, self-conscious young couple in a striking, angular, modern pose, both staring boldly ahead at the future. Bella's farewell gift was a damask tablecloth decorated with flowers, a memory of the bouquets she had brought him but also a symbol of domesticity. He soon subverted it: poor and short of canvases, he later painted *The Violinist* on it. Out of Bella's company, though, he cut a less certain figure. Although the plan was for Romm to follow him shortly, "I left Russia all alone, and full of misgivings," he recalled. In May 1911, taking all his works with him, he boarded the train for the four-day journey to Paris. It was the first time he had left Russia, and he looked so poor and disreputable that "even the German frontier officials, when they boarded our train to inspect our passports and our baggage, viewed me suspiciously and asked me 'Haben sie Lause?' ('Have you got lice?')"

Back in Vitebsk, evening after evening through the summer, Bella wrote him small postcards, spontaneous expressions of her day-to-day moods addressed in unfamiliar Roman script to Monsieur Chagalloff, poste restante. "I've just been sitting in your room–how sad. How I'd like your warmth," she wrote. And "I really want to see you, breathe the same dust as you. I am waiting for you. Send me your new address when you have it. I wish you every good thing from my entire soul."

Chagall and Bella, 1910

"Surnaturel!"

Paris, 1911–1912

Only the great distance that separates Paris from my native town prevented me from returning to it immediately or at least after a week, or a month" was Chagall's initial reaction to the French capital. "I even wanted to invent some sort of holiday as an excuse to go home." Yet in the unfamiliar brightness of Paris he felt as instinctively that "I seemed to be discovering light, colour, freedom, the sun, the joy of living, for the first time." Homesickness and ecstasy at what he called the "lumière-liberté" of France coexisted throughout his first years in Paris and are the twin impressions that shaped his painting.

"I arrived in Paris with the thoughts, the dreams, which one can only have at twenty," he recalled. No longer living as a second-class citizen in the tsar's empire, he was twenty-three and free at last of every constraint–political, civil, religious, sexual–that had moulded his existence in Russia. But he was terrified, too. He spoke no French, knew few people in Paris, and had barely a good word for most of the Russians he did know there: unwelcoming Bakst ("difficult to talk to . . . extremely nervous"); a colleague from Pen's school, the sculptor Ossip Zadkine ("thinks he's very important . . . he knows I hate him because he's insincere"); and another Pen student, already commercially successful and married to a wealthy American, Leon Shulman ("I am very far from him because he's nothing–in his art, it's a complete shame what he's doing").

When Chagall stepped out at the Gare du Nord, Viktor Mekler was waiting for him, and for the first days he stayed with his former confidant at his room in a hotel at the Carrefour de l'Odéon. But their alliance quickly broke down: after a year apart, each was aghast at developments in the other's

painting. Mekler stood uncomprehending before Chagall's latest vibrant canvases, while Chagall stared dully at Mekler's fancy portraits, made under the influence of John Singer Sargent and the Spaniard Ignacio Zuloaga, both celebrity artists of the fin-de-siècle. Shortly afterwards Chagall and Mekler had an argument at a café on the Boulevard St. Michel, and Chagall left, offended; Mekler returned to Russia a month or two later.

At first Chagall depended wholly on Russian-Jewish contacts. After Mekler he turned to Yakov Tugendhold, who as Paris correspondent for *Apollon* was a cosmopolitan critic, as familiar with Picasso and Matisse as with Russian art. "I knew no one in Paris. No one knew me," Chagall wrote.

> Leaving the station I looked at the roofs, at the grey horizon, and I thought of my future in this town. On the fourth day I wanted to go home. My Vitebsk, my fences. But Tugendhold took my canvases in his hand. He began to telephone all over the place, to invite me here and there. How many times did I ask him how I was to work; how many times did I not whine before him! And he, he consoled me.

He kept as mementoes the elegant, faded little visiting cards of recommendation, printed "Jacques Tugendhold, Homme de Lettres, présente M. Chagalloff," all his life.

The Russian painter Ehrenburg, cousin of the writer Ilya Ehrenburg, who was temporarily leaving Paris, invited Chagall to rent his studio on a little cul-de-sac, the Impasse du Maine, in the newly developed Montparnasse area in the fourteenth arrondissement, in the southeast of the city; the house was so small and hidden away that some letters addressed to Chagall there specify "maison au fond de l'impasse." A Métro link, the Number 12 or Nord-Sud, had just been built to connect this part of Paris with modishly bohemian Montmartre, and Chagall found himself in the vanguard: over the next few years Montparnasse replaced Montmartre as the artists' hub. Picasso moved there in 1912, and soon the polyglot cafés La Coupole, La Rotonde, and Le Dôme on the Boulevard du Montparnasse, with a clientele of Russian, eastern European, American, and German artists and hangers-on, were the most fashionable places in the capital. Ilya Ehrenburg, who had arrived in the city in 1908, remembered the Rotonde as a shabby lively place whose back room filled up at night with quarreling Russians. Ehrenburg's first impression of Paris was similarly the sense of freedom after prudish

tsarist Russia—he was astonished by the casualness with which young people milled about on the streets, how "on the café terraces lovers kissed unconcernedly—I even stopped looking away," and by the lights "and bright posters everywhere. All the time I felt as though I were at the theatre."

Chagall's first lodging was comfortable: "a flat with three rooms, one big one for myself to work, another one to let, and the third for everything else . . . I have a kitchen . . . But I am going to let [the flat], it's too grand for me," he told his sisters. The Matissean picture *The Studio,* with large areas of the room painted over in bright green and the furniture and hangings at disorientating angles, shows a well-furnished apartment with fine chairs and rugs in the French bourgeois style, and *My Fiancée in Black Gloves* on the wall. Like many pictures from Chagall's early days in Paris, *The Studio* was painted over a work bought from a shop in Montparnasse; it was cheaper to buy old pictures than new blank canvases.

Chagall sublet one of his rooms to the copyist-painter Malik and initially led a frugal solitary life. Vinaver's grant, which he collected each month from Crédit Lyonnais on the Boulevard du Montparnasse (the cashier always asked whether he wanted gold or paper notes), made him less impoverished than most of the eastern European artists converging on Paris in the years before 1914, but he was careful about money. Sticking timidly to a Russian diet, he used to buy a cucumber and a herring from the market, eating the head one day and keeping the tail for the next. "Food is not cheap at all. It's

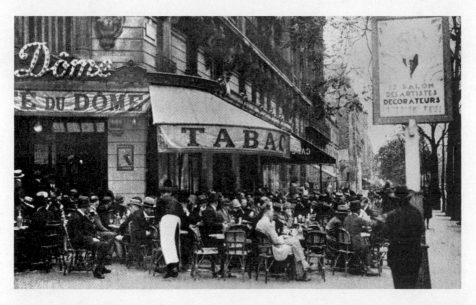

Le Dôme, Paris, 1910

Chagall, June 1911: the first photograph Chagall sent
home, to his father, from Paris

impossible to eat as well as in Russia," he wrote from the gastronomic capi-
tal of the world to Vitebsk.

> Meat, for example, is very expensive, and in restaurants they give
> you small portions; it's the same with eggs and milk. Our black
> bread doesn't exist at all, and the quality of their white bread and
> so-called black bread–it makes me feel sick when I see it. When
> you go into a restaurant for dinner, they immediately give you
> wine–red or white–but I am going to refuse this for the rest of my
> life because my stomach can't stand it. But even in this case you
> have to pay a tip–just to refuse it!

Like countless new visitors, Chagall spent his first weeks in the city wan-
dering through the streets, intoxicated by the grace and light of French life.

He sent his father a postcard-photograph of himself, well dressed in a long coat and straw boater, hands in his pockets, posing flâneurlike before the Observatory fountain: a French artist in the making. His expression here and in a snapshot taken in the Luxembourg Gardens with the effortlessly gracious Romm, who arrived in Paris in June, is uncertain, on guard, eager not to look out of place. "Now I will begin to look smart," he told his sisters, "because before I looked after myself very little . . . I have just bought some white shirts and new clothes. In Paris you have to dress smartly—everyone dresses very well, and it's not that expensive, just 30-40 francs (15-20 rubles). Compared to Russia, dresses and hats are cheap."

"I found my lessons in the city itself at each step, in everything. I found them among the small traders in the weekly open-air markets, among the waiters in cafés, the concierges, peasants, and workers," he remembered. "Around them hovered that astonishing light of freedom which I had seen nowhere else. And this light, reborn in art, passed easily onto the canvases of the great French masters. . . . Everything showed a definite feeling for order, clarity, an accurate sense of form, of a more painterly type of painting even in the works of the lesser artists." Above all it was the Louvre, which "put an end to all those hesitations" about staying or going home: "When I made the tour of the Veronese room and the rooms in which Manet, Delacroix, Courbet are hung, I wanted nothing more." In those days the paintings at the Louvre, as at the Hermitage under the tsars, were crammed together in an abundant jumble. "I loved those paintings that used to climb in serried ranks up to the mouldings. Everything was on a par. It was intimate," he remembered. He loved, too, the crowded commercial galleries along the rue Lafitte, whose dealers had made fortunes promoting impressionism and postimpressionism, and who now stood like emperors surrounded by paintings in heavy gold frames, layered up the walls: Durand-Ruel and "the hundreds of Renoirs, Pissarros, Monets"; van Gogh, Gauguin, and Matisse at Bernheims, Place de la Madeleine, where "the show windows are lighted up as if for a wedding"; and pioneering Ambroise Vollard, whose threshold Chagall was too timid to cross: "In the dark, dusty shop windows . . . my eyes searched eagerly for the Cézannes. They are on the wall at the back, unframed. I press against the glass, flattening my nose, and suddenly I come across Vollard himself. He is alone in the middle of the shop and he is wearing an overcoat. I hesitate to go in. He looks bad-tempered. I don't dare."

Nothing had prepared Chagall for French art. "I could of course," he recalled in the 1940s,

express myself in my faraway native town, in the midst of my friends. But I wanted to see with my own eyes that which I had heard so much about from afar: that visual revolution, that rotation of colours which spontaneously and cleverly melted into one another in a stream of thoughtful lines, as shown by Cézanne, or freely dominant, as shown by Matisse. One did not see all this in my homeland, where the sun of art was not shining so brightly . . . And it seemed to me then (and still seems to me) that there do not exist greater and more revolutionary "appeals to the eye" than those which I observed . . . on my arrival in Paris. The landscapes, the figures of Cézanne, Manet, Monet, Seurat, Renoir, Van Gogh, Fauvism and many other things overwhelmed me. These attracted me to Paris like a natural phenomenon of nature.

For a young painter on the verge of forging his own artistic identity, there could have been no more thrilling moment to arrive in Paris. "No academy could have given me all I discovered by gorging myself on the exhibitions of Paris, on its picture shop windows, its museums," he wrote. Modernism was already established: from Matisse and the Fauves, following Gauguin and Seurat, had come the explosive liberation of colour from the constraints of realism; from Picasso and Braque, evolving from Cézanne, the flattened geometric shapes, broken spatial planes, and shifting perspectives of cubism. Old artistic certainties had been dashed to pieces, but in the fragments lay infinite possibilities for new pictorial languages, fresh imagery, and previously inexpressible emotions. Swooping in on the pickings were the hundreds of young impoverished artists from all over Europe who converged on Paris in the half-decade before the First World War, their diverse origins and cultures immeasurably enriching the modernist experiment.

Many were Russian, including a good proportion of Jews–Zadkine, Nathan Altman, Shulim Wolf (Vladimir Davidovich) Baranov, who soon became Rossiné–and Chagall came across refugees of all backgrounds from every one of his St. Petersburg art schools: aristocratic Sofia Tolstaya from the Zvantseva; Yuri Annenkov, son of a revolutionary terrorist exiled to Siberia, from Saidenberg's; Alexandra Schekatikhina-Pototzkaya, who came from a Ukrainian family of Old Believers and had studied with Chagall under Roerich. Women artists, as able and innovative as their male colleagues and immediately accepted as such, had a unique position in the

Russian avant-garde; most came from privileged backgrounds and had the means to travel and study in Paris, where they made a striking impact in an artistic milieu accustomed to women only as models or mistresses. "Le soif d'être de son temps" (the thirst to belong to her times) was how Tugendhold described the artist Alexandra Exter's reaction to Paris when she arrived in 1907 and flung herself into avant-garde circles; this desire to live in unison with the epoch, to absorb the atmosphere of Paris, its museums, exhibitions, studios, and books, was one that the critic observed in all his fellow Russian visitors.

"I don't know whether anyone has been able to form a clearer idea than I of the almost insurmountable difference which, up to 1914, separated French painting from the painting of other lands. As for me, I've never stopped thinking about that," Chagall wrote in 1922. The timing of his arrival was impeccable: he reached Paris days after the spring 1911 Salon des Indépendants had opened and caused a sensation by presenting cubism for the first time as a coherent, radical movement of a group of French artists including Henri Le Fauconnier, Jean Metzinger, and Albert Gleizes; showing with them were Robert Delaunay with his fractured Eiffel Tower and Fernand Léger's "tubist" *Nudes in a Forest.* Cubism was on everyone's lips, and the day after he arrived, Chagall recalled, "I hurried at once to the Salon des Indépendants. I went quickly to the moderns, at the far end. There were the Cubists: Delaunay, Gleizes, Léger."

The term *cubism* had been coined by art critic Louis Vauxcelles in 1908, in response to Matisse's comment on the little cubes making up the simplified forms in Braque's landscape paintings. The movement, modern art's first radically new idiom, was heralded by *Les Demoiselles d'Avignon* of 1907, and developed in the works of Picasso and Braque in 1908–10. These works–though not the *Demoiselles*–had been shown at small exhibitions at the avant-garde galleries of Vollard, Wilhelm Uhde, and Daniel-Henri Kahnweiler, who gave both artists contracts and in 1920 published a chronicle of the movement, marking 1910 as the moment when Picasso "a fait éclater la forme homogène"–shattered the enclosed form. Although keenly watched by other artists, these early shows had neither aimed at nor attracted the wider public, which was generally unaware of the significance of work that, as cubism's historian John Golding later wrote, was "the most important and certainly the most complete and radical artistic revolution since the Renaissance . . . A portrait by Renoir will seem closer to a portrait by Raphael than it does to a Cubist portrait by Picasso."

While Picasso and Braque kept aloof, pursuing their experiment in soli-
tude–"intellectual isolation was a major operational hazard of cubism,"
according to Picasso's biographer John Richardson–their fractured surfaces
were soon copied and paraphrased by Metzinger, Gleizes, Le Fauconnier,
and other lesser artists who are now remembered, if at all, as "the salon
cubists." The critic Apollinaire dismissed their work in 1910 as "a jay in pea-
cock's feathers . . . listless and servile imitation of certain works . . . by an
artist possessed of a strong personality and secrets that he has revealed to no
one. The name of this great artist is Pablo Picasso." But a year later it was
through the imitators that cubism made its first major impact on the public
in the small, crammed room 41 of the spring 1911 salon, which Chagall saw
as soon as he arrived in Paris.

Its centrepiece was *L'Abondance,* a ten-by-six-foot portrait by Le Faucon-
nier of his Russian wife Maroussia with a basket of fruit, accompanied by a
mock cherub, which became briefly the most celebrated cubist painting in
the world. Picasso immediately identified it as an absurd, overblown acad-
emic pastiche. He did not deign to exhibit with the mob and his judgement
of the artists at the salon was borne out by history–he saw them as second-
rate, derivative "horribles serre-files" (dreadful stragglers), with the excep-
tion of Léger. Kahnweiler, too, dismissed the others as feeble theorists;
Léger alone he sought to add to his stable.

To almost everyone else, however, the salon cubists were *le dernier cri* in
radicalism. Even Apollinaire now swam with this current, announcing that
in room 41 "one finds . . . more forcefully than anywhere else–and I mean
not only at this Salon but anywhere else in the world–the sign of our times,
that modern style that everyone . . . is seeking." The response of Zsófia
Dénes, a young Hungarian from an artistically educated family who arrived
from Budapest days after the show opened and was taken there by the cubist
Alfred Reth, was typical. "We crossed a few rooms, he was dragging me by
my arms, and I was whining, because I wanted to stop," she recalled.

> The walls were plastered with the works of Rouault, Matisse,
> Marquet, Derain . . . all familiar names to me. 'Of course later
> you will have to come back and see all those too,' [Reth said.] 'But
> I want to make your head swim.' He dragged me straight to room
> 41 . . . To see cubism . . . physically manifested through the
> paintings hanging on the walls, that was something I had not
> seen and had not even imagined. That room 41 in the pavilion on

the banks of the Seine—in 1911—was simply beyond belief, something out of fantasy land.

"Overnight we had become famous. Almost unknown the day before, our names were now hawked by a hundred mouths, not only in Paris but the provinces and abroad," boasted Gleizes. Chagall, new to French painting, was swept up by the throng; at the salon, he wrote, "I went straight to the heart of French painting of 1910. And there I clung." In the 1960s he told Pierre Schneider that "ever since 1910, I have rarely been wrong"—the exceptions being that he underestimated Rouault ("he bored me") and that "I believed in Gleizes too much. I saw in him a sort of Courbet of cubism."

For a twenty-three-year-old Russian, it was an understandable error. Like every other serious painter in the years leading up to 1914, Chagall knew by instinct that he had to work his way through cubism. Le Fauconnier was an accessible starting point, and when Romm arrived in Paris in June, the pair went together to start classes at La Palette in Montparnasse, where towering, red-bearded, serious, shortsighted Le Fauconnier and his friend Metzinger taught. Both were kindly men, and Maroussia, Madame Le Fauconnier, attracted many Russians to the school. Through Aristarkh Lentulov, who was there alongside Chagall in 1911, Liubov Popova, Nadezhda Udaltsova, and other young painters who returned to Moscow, La Palette's influence on Russian cubo-futurism—the dynamic, rhythmic synthesis of French cubism, Italian futurism, and native neoprimitivism that was a major feature of the Russian avant-garde before 1914—was decisive.

But Chagall was never seduced by the cubo-futurist route of his fellow Russians. Also accompanied by Romm, he combined lessons under Le Fauconnier with classes at the Académie de la Chaumière at 14, rue de la Grande Chaumière, chosen for its speciality in providing opportunities to draw from nude models. Here Léger made studies, too, and Chagall's gouache "Reclining Nude," a figure stretched out on a bed with a répoussoir curtain in the classic Western tradition, but with a strongly stylised body and limbs made up of twisted shapes, closely parallels Léger's drawing "Femme nue" of the same date. Chagall's nudes of 1911—"Nude with Fan," "Nude with Comb," "Nude with Flowers," "The Couple on the Bed"—are cubist experiments, and there is something studied and tentative about the uncouth, primitive bodies. For all their threatening, barbaric postures, they have none of the sexual tension of the Thea nudes but rather are fraught with the emotional distance of the novice, trying to find his way in a foreign art school. "La

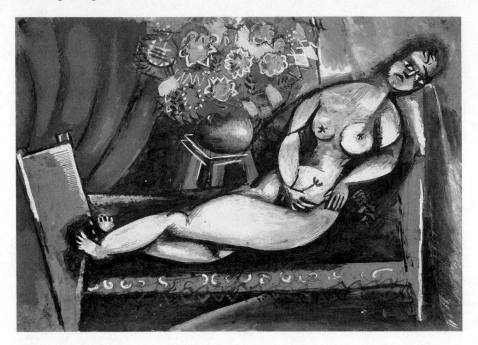

Chagall, "Reclining Nude," 1911, gouache on paper

Grande Chaumière" (The Large Thatched Cottage) was unquestioningly chauvinistic; when it was reported decades later to Chagall that Giacometti had met with indifference there, he exclaimed, "What did he expect? Academies are not places of feeling. I got cold-shouldered too at La Grande Chaumière not only as a *métèque* [foreigner] but as a Jew."

As in St. Petersburg, Chagall could not work properly at school, surrounded by alien eyes; it was in the works done at home, alone at his Impasse du Maine studio, that he had to come face to face with the impact of French art on his Russian sensibility, and before this urgent quest everything else was ignored. "Why don't you write about our mutual friends—or don't you have time to see them?" complained Pen; but Chagall was so engrossed that from the spring of 1911 until early 1912 he hardly saw anyone. A note to Alexandre Benois suggests something of the intensity of his efforts. "I am working in Paris." Chagall wrote. "I cannot for a single day get the thought out of my head that there probably exists something essential, some immutable reality, and now that I have lost everything else (thank God, it gets lost all on its own), I am trying to preserve this and, what is more, not to be content. In a word, I am working." There was a cagey reunion with

Bakst—" 'So you came, after all?' Bakst flings at me abruptly"—at the the-
atre, but "to tell the truth, at that moment, it made little difference to me
whether Bakst came to see me or not."

Instead, in his rooms in Montparnasse, Chagall began a new cycle in
which he returned obsessively to the major paintings of his Russian years
and recast them, one by one, in a new cubist idiom. It was as if the Vitebsk of
his memory were answering Paris: he had asked to see a new world, and "as
if in reply, the town seems to snap apart, like the strings of a violin, and all
the inhabitants, leaving their usual places, begin to walk above the earth.
People I know well, settle down on roofs and rest there. All the colours turn
upside down, dissolve into wine, and my canvases gush it forth."

Going backwards through the Russian-Jewish cycle of 1908–10, he began
with *Birth,* his most recent major work, and recast it as a vibrant tense inte-
rior in which the familiar Russian world rips apart at the seams and is recon-
structed in taut, geometrical blocks of luminous colours. Only the naked
mother and the blood-red baby recall the picture on the same subject a year
earlier. Here the mother lies on a simple, uncurtained bed at the front of a
room that appears to revolve, like a stage set toppling onto its audience.
Everything is unstable: shards of blue dart among red floorboards; these,
composed of triangles slatted together, tip whirling figures towards us. The
baby is about to shoot out of an indifferent midwife's arms into space, a
bearded Jew and an old woman throw up their arms and wail; others slump
over a falling table; an acrobat walks on his hands. Above, a luminous blue
roof is studded with circles like stars in the sky—as if the room is suddenly
thrown open to the elements, and a storm rages within. This is birth as psy-
chological reality: the sense of the indissolubility of life and death, and that
for each individual woman birth is at once miracle, symbol of hope, and
frightening physical ordeal. Significantly, in Russia this painting was not
known as *Birth* but as *What Happens at Home,* a title emphasising its every-
day aspect.

It was as if, wrote Abraham Efros, "some terrible cataclysm crumbled
Chagall's native world of shtetl Judaism." Chagall's worldview shattered in
the first months away from Russia as he abandoned an old style of painting
for a new. Arriving in Paris just as art was bursting every boundary of tradi-
tional representation, "it was from then on," Chagall said,

> that I was at last able to express, in my work, some of the more
> elegiac or moon-struck joy that I had experienced in Russia, the

joy that once in a while expresses itself in a few of my childhood memories from Vitebsk. But I had never wanted to paint like any other painter. I always dreamed of some new kind of art that would be different. In Paris, I at last saw as in a vision the kind of art that I actually wanted to create. It was an intuition of a new psychic dimension in my paintings.

Chagall's development of a language for that vision owed a great deal to the dislocations and fragmentations of cubism. Under its influence, and that of Delaunay's translucent patches of colour, the 1911 *Birth* began to express that psychological aspect, while recalling, too, the spirituality of the quotidian that had marked Chagall's earlier Russian cycle. The 1911 *Birth* depicted, wrote Tugendhold, "a crowded Jewish interior where people eat, pray, and give birth, and above it all, as in a dream, phantoms of people are flying as if falling from the opened sky . . . the synthesis of the eternally living mundane life and the fantastics hovering above it."

This violent modernist work both builds on the Russian version of *Birth* and points to the visionary paintings of 1912. Such a response was to become a characteristic adapting process over the years: each time Chagall moved to a new country or continent, his first works were new versions of important paintings from the previous period. It was not a question of repetition but of a programme by which he evolved in style: each time, he took command of a new idiom and made it his own by applying it to compositions and motifs that he had already mastered and that he understood from within.

"The stone grey landscape of Paris taught him to feel the borders of objects to a much greater extent than the crooked walls of the colourful provincial houses," wrote Tugendhold, the only observer who grasped what Chagall was doing in 1911. Paris "made his work more condensed by acquiring a sense for volume . . . He remained himself, but acquired what he lacked—form." Chagall made two new versions of *Birth* in 1911; he also reformulated *The Wedding* and *The Dead Man,* the two pictures sold in St. Petersburg, and actually painted over a fourth large Russian canvas, *The Funeral*—all in a cubist idiom. In each one the folkloric, narrative emphasis of the Russian work dissolves as formal elements—transparent flat colouration in geometric blocks—blend together in a modern dynamic rhythm.

Like the entire generation of Cézanne-dominated painters born in the 1880s—Braque, Picasso, Delaunay, Léger, Derain, Modigliani—Chagall belonged to what he called "an age of construction." For the next ten years

Chagall, *The Dead Man*,
1908. Oil on canvas,
68.5 x 87.7 cm

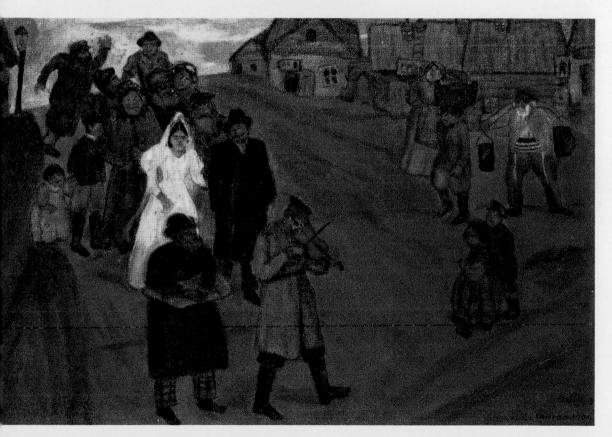

hagall, *Russian Wedding*, 1909. Oil on canvas, 68 x 97 cm

Chagall, *Red Nude,* 1909. Oil on canvas, 84 x 116 cm

Chagall, *Birth,* 1910. Oil on canvas, 65 x 89.5 cm

Chagall, *Birth,* 1911. Oil on canvas, 112.9 x 194.3 cm

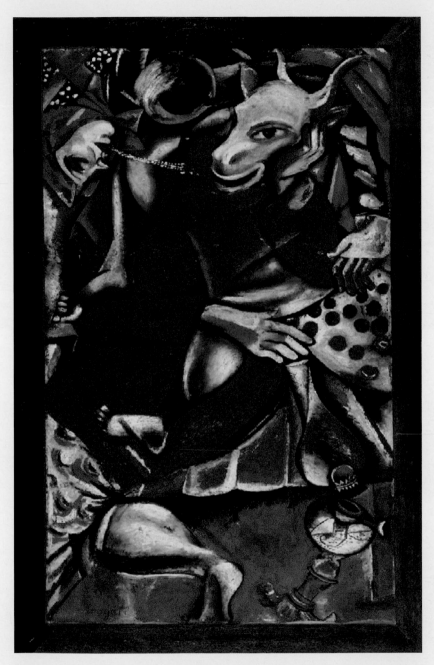

Chagall, *Dedicated to My Fiancée*, 1911. Oil on canvas, 196 x 114.5 cm

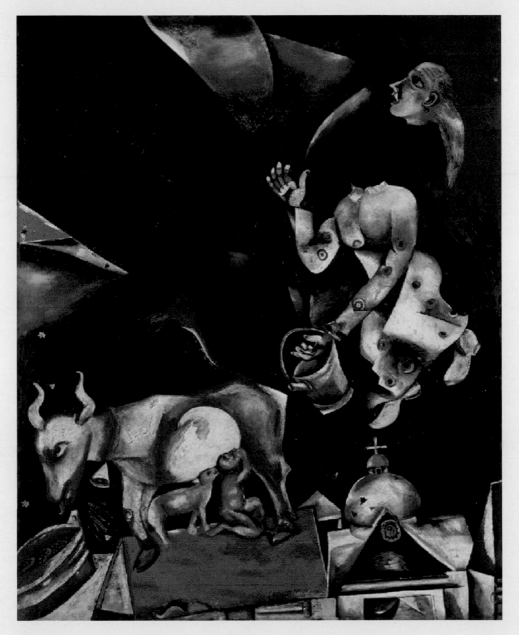

Chagall, *To Russia, Asses and Others,* 1912. Oil on canvas, 157 x 122 cm

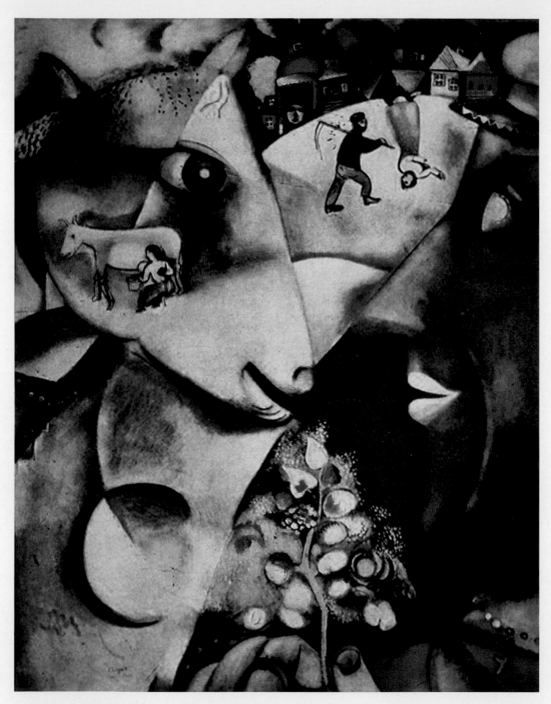

Chagall, *I and the Village*, 1912. Oil on canvas, 192.1 x 151.4 cm

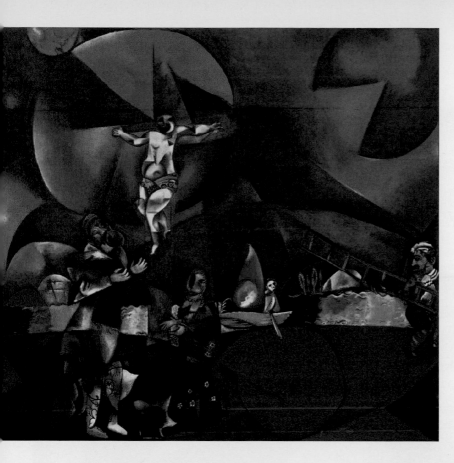

Chagall, *Golgotha,*
1912. Oil on canvas,
74.6 x 192.4 cm

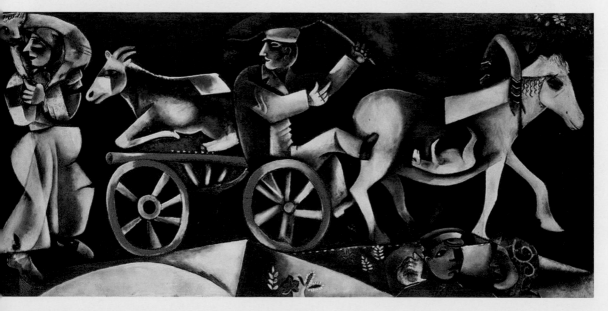

hagall, *The Cattle Dealer,* 1912. Oil on canvas, 87 x 200.5 cm

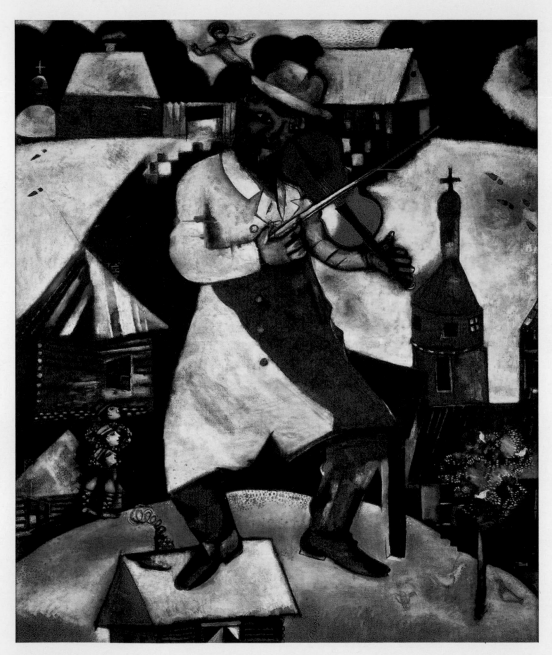

Chagall, *The Violinist*, 1913. Oil on canvas, 188 x 158 cm

he would integrate cubist elements into his paintings while maintaining nevertheless a distance from cubism. "Chagall confronted those aspects of Cubism to which his own art strove from inside him," wrote Efros in 1918.

> If by its nature the cold heady force of Cubism was strange to Chagall's fiery immediacy, in its results the triumphant Cubism gave it exactly what it needed . . . Cubism destroyed the value of any re-creation of objects in their normal "everyday" aspect; the mandatory, essential "deformation" of objects was pronounced as the basic principle of art. Thus the doors were wide open for Chagall's fantasy.

"I have admired the great cubists and have profited from cubism," Chagall said in the 1940s, but "I detested realism and naturalism, even in the cubists," who "seemed to be reducing everything that they depicted to a mere geometry which remained a new slavery, while I was seeking a true liberation . . . a logic of the illogical." But Paris in 1911 "was a time when dreaming was not considered right. Painters were then absorbed in their purely technical researches. One did not speak out loud these dreams."

But he could paint them. Assimilating cubism into his own vocabulary, he began in the autumn of 1911 to use geometric foundations to experiment with fantastical interiors full of disorientating perspectives and incongruous images—a cow and a woman with an upside-down head sitting at a vertiginously slanting table in *The Yellow Room;* a girl throwing herself at a bearded man and forcing open his mouth as a cow and a falling lamp rush at the couple in *Interior II.* Violent and sensual, these canvases were understood by no one and were, predictably, rejected both by the Salon d'Automne and, when Chagall tried to send them home, by the jury on the World of Art exhibition in St. Petersburg in January 1912. The gauche, nervy letter he wrote to Benois appealing for inclusion reveals the persistent sense of inferiority he still felt when addressing well-born figures in the Russian establishment. "I have written a few words and already come to a halt. It is as if I were asking myself, how dare I write to you?" he opened.

> Moreover my relationship to you makes it psychologically difficult. For me to write to you with a lighter heart, I would have to have the right to do so, and that is a great problem for me, a complicated and painful one. This is why I can in many cases be

accused of shyness with people, with you in particular, and espe-
cially in the present case. I should like to ask for forgiveness a
thousand times over . . . But still, one must . . . show others
what one is doing (and I do want that and can do it). I am not talk-
ing about my moral responsibility to those to whom I am unfortu-
nately still committed materially and who perhaps do not even
know why they have to support me, a feeling that pains me. Now
in Paris, my works . . . have not been accepted . . . For whatever
reason, the experiences that I have had have shocked me so much
that . . . I am convinced that everything is going wrong for
me . . . Forgive me for bothering you and many thanks that it
has, it seems, become easier for me to write, despite the terrible
cold in my room.

Yours devotedly,
Chagall

Alone and full of self-doubt, he worked on through the winter, and early
in the new year he had three large canvases, *Dedicated to My Fiancée, To
Russia, Asses and Others,* and *The Drunkard,* dreams of Vitebsk trans-
formed by French modernism, ready for the spring salon, Paris's annual
open exhibition, in March 1912. "I remember being approached by a young
painter who was timidly carrying his canvases to the Salon des Indépendants
and who did not know more than a few words of French. It was Chagall,"
recalled the critic André Warnod. Chagall, wheeling a handcart towards the
wooden booths on the Place de l'Alma, may have looked timid, but his new
paintings were his breakthrough to a bold, feverish new style unlike any-
thing he had done before. One was so erotic that hours before the
vernissage, the censor nearly ripped it off the walls, declaring it obscene;
Chagall, with the help of the Russian painter Nikolai Tarkov, appeased him
by touching up some parts with gold paint. Wandering through the maze of
galleries, Guillaume Apollinaire, Paris's most influential art critic, watched
the proceedings and published his verdict the next day.

"Room 15," he announced on 20 March. "Those who are in a hurry would
do well to begin their visit to the Salon in this room, which contains the first
really significant works. The Russian Chagall is exhibiting a golden donkey
smoking opium. This canvas had outraged the police. But a bit of gold paint
smeared on the offending lamp made everything all right." This was the

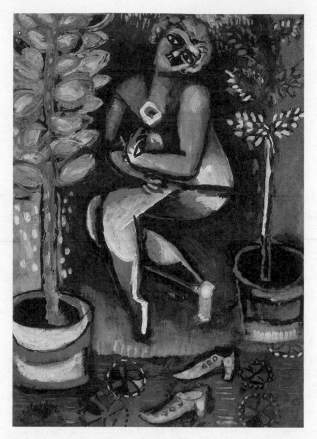

Chagall, "Nude with Flowers," 1911, gouache on paper

painting *La Lampe et les deux personnes,* which would become famous as *Dedicated to My Fiancée,* the title later suggested by Chagall's friend Blaise Cendrars. Apollinaire was wrong about the donkey; the "deux personnes" are a benign-looking, pensive bull who rests his horned head on his hands, and a woman whose vermilion legs tangle around the animal's red body. The woman's twisted head floats upside down in the corner of the picture, her empty eye sockets gazing at the beast while she darts a stream of spittle from her mouth to his. Other dislocated body parts, along with a falling lamp and a tumbling palette, revolve around the animal, whose turbulent rhythm commands the picture plane. The fiery centre radiates a rich light, touched with gold, black, and blue shadows; shreds of green and blue shoot across the shining surface. Chagall claimed to have painted this febrile erotic scene at one go, working through the night so intensively that when his oil lamp burned out, he did not stop to relight it for fear of interrupting his vision; he

painted on in the dark, entirely by touch. The painting is large, over six feet by four feet, and Chagall showed it in a flat wooden frame painted yellow and black that enhanced the compressed, nocturnal effect. The work, number 652 at the salon, made a dramatic impact at the vernissage.

Dedicated to My Fiancée hung on one side of the door to room 15; on the other side was *To Russia, Asses and Others,* painted on a fine sheet. The cosmos itself is the setting for this night fantasy, where ornamental flat layers of squares and diagonals work as a field of force governing the tension of the picture. A milkmaid descends like a messenger from the sky to milk a luminous pink cow; in her ecstasy at the coloured lights blazing across the black night, she leaves her head behind; beneath her, the cow stands on a roof suckling a calf and a child, next to the copper dome of an Orthodox church. A preliminary sketch shows a homely Russian village scene—a milkmaid descending a hilly pasture, a cow suckling its young. In the painting, Chagall rearranged these fundamental elements of everyday life to transform reality into cosmic dream: the nourishing cow becomes a benevolent icon, perhaps Mother Russia; the peasant, a mystic flooded with spiritual intensity.

This was the first appearance of key motifs—the flying figure, the almost anthropomorphic farmyard beast—that would become among the most famous and conspicuously unusual images throughout Chagall's oeuvre. Their mythic energy and appeal depend on Chagall's transformations of form and colour, which is why he spent a lifetime vigorously denying their narrative content, insisting that the figures were merely the starting point and that such works were abstract: "what I mean by abstract is something that comes to life spontaneously through a gamut of contrasts, plastic at the same time as psychic . . . In the case of the decapitated woman with the milk pails, I was first led to separating her head from her body merely because I needed [to fill in] an empty space there."

Framing the entrance to room 15, *Dedicated to My Fiancée* and *To Russia,* their jewelled colours shining radiantly from a lacquered background like icons, looked like strange, exotic intruders into Parisian art. Chagall followed them with *I and the Village,* another work that is iconlike in its glassy surface and the intense shimmer of its central red disk. The disk suggests the sun; around it fragments of earth and sky rotate before our eyes. The large white head of a cow forms an arc in the middle ground, and its mournful eye stares at the green mask-face of a young man; the two form a near-diagonal cross, around which are dotted scenes of village life—a domed

church and coloured houses, some of which are upside down, as is the peasant woman who flees a grim reaper, a harvester with a scythe over his shoulder. Life answers death with a delicate blossom that forms the lower arc of the disk and illuminates the scene like a candle.

I and the Village, with its mystical convergence of man and animal, day and night, earth and sky, and its nostalgic, Hasidic celebration of the connections between nature and human life in Vitebsk, brought to a zenith the incandescent, cubist-inspired series of 1911-12 in which Chagall transformed Russia into a fantastical vision and at the same time froze it in time like a memory. French modernism provided the new pictorial language; Chagall filled it out with his own imaginative motifs, rooted in memories and dreams, the unseen and the irrational, from his Russian experience. No one else, in Russia or in France, was doing anything like this. With speed, self-knowledge, and the instinct for assimilation that would never desert him, Chagall had in less than a year taken what he needed from Paris. The direct encounter with cubism shocked him into a response that at once acknowledged the movement's essential importance and asserted his refusal to lose his individual expression within it. From that tension, between accommodation and resistance, came his greatest, most innovative paintings—both in Paris and, later, in Russia.

It is hard now, after surrealism and a twentieth century soaked in psychoanalytical reference, to grasp quite how radical Chagall's hallucinatory, highly coloured world of flying headless figures, sensual bulls, and animals floating above the roofs of Russian villages were in Paris in 1912, and how incomprehensible they looked to audiences who were only just growing accustomed to cubist experimentation, which was carried out mostly in a subdued palette. Tugendhold, unable to find a contemporary painter with whom to compare such works, said they suggested "something erotic from Sodom, reminiscent of Bosch and Goya." He was among the first to see these "outbursts of painterly heat" at the Impasse du Maine, and they threw him off balance. "Chagall's fantastics and palette seemed overly tense, unhealthy and delirious, but you couldn't doubt their sincerity," he gasped. "While the mind-boggling structures of those Frenchmen exuded cold intellectualism and the logic of analytical thought, what was astonishing in Chagall's painting was some childish inspiration, something subconscious, instinctive, something unbridled—colourful." This is what Chagall brought to the history of modernism: an expressive, mystic sensibility that challenged the form-conscious rationalism of Western art. "Surnaturel!" mur-

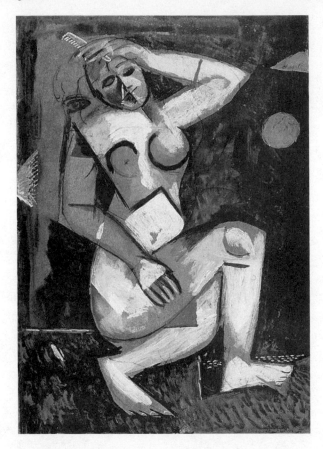

Chagall, "Nude with Comb," 1911, pen, black ink, and
gouache on paper

mured Apollinaire when he visited Chagall's studio. Later André Breton
claimed Chagall as the father of surrealism: "His positive explosion of lyri-
cism dates from 1911, the moment when, under his sole impulse, metaphor
made its triumphal entry into modern painting."

Today Chagall's emphasis on the unconscious and the world of dreams
strikes a chord with the Freudian territory of Picasso's *Demoiselles* and
Matisse's panels of primitive naked figures *Dance* and *Music:* modernism
and psychoanalysis, born around the same time in the 1900s and both
emerging from the journey to the interior that began with romanticism and
coloured all nineteenth-century culture, share obsessions with origins, the
primitive, fantasy, memory. But Picasso and Matisse, though disquieting
and disorientating to Paris audiences, at least took subjects—the human fig-
ure, still life—from within the Western tradition. Chagall's fantasies are out-

side it; he had not, after all, grown up with Western art history. "I didn't want to think anymore about the neo-classicism of David, of Ingres, the romanticism of Delacroix and the reconstruction of early drawings of the followers of Cézanne and cubism. I felt we were still playing around on the surface, that we are afraid of plunging into chaos, of shattering, of turning upside down the familiar ground under our feet," he wrote. "Impressionism and Cubism are foreign to me. Art seems to me above all a state of soul."

St. Petersburg had turned Chagall by alienation into a Jewish artist—his masterpieces from those years, *The Dead Man* and *Birth,* are proudly Jewish in motifs and tone; Paris correspondingly brought out his Russianness. Painted thousands of miles from Moscow and St. Petersburg, *To Russia* and *I and the Village* are in their elated cosmic disorder quintessentially prewar Russian works, and Chagall's definition of art as "a state of soul" finds echoes among all the major Russian artists of the time, from his early teacher Roerich to the new young star on the Moscow art scene, Kazimir Malevich. "We want to herald the unknown, to rearrange life, and to bear man's multiple soul to the upper reaches of reality," wrote Larionov in 1913, while the poet Vladimir Kirillov dreamed that "we shall arrange the stars in rows and put reins on the moon." In 1912 Kandinsky in Munich was painting *Black Spot,* which he explained was suggestive of the state of an awakening soul as a point of light flickering in darkness, and Malevich in Moscow was exhibiting tubular blocks and cubo-futurist rhythms in his paintings of ponderous peasants, reminiscent of icons, that would soon evolve into the abstract forms of suprematism. It is not a coincidence that two of abstraction's three creators were Russian; both Kandinsky and Malevich saw the movement, modern art's most radical alternative system of belief, in terms of the Russian spiritual sensibility, with its emphasis on the cosmic and the panoramic, which goes back to the art and literature of nineteenth-century Russia.

Chagall, too, was shaped by this sensibility, but he was a Jewish humanist, rooted in the figurative tradition, concerned with man's spiritual life rather than with cosmic systems or beliefs, and diverging more and more from the abstracting impulse taken by Russian art from 1912 onward. In March 1912, at the same time as Apollinaire was applauding him, Chagall sent the cubist version of *The Dead Man* to Larionov's "Donkey's Tail" exhibition in Moscow, where it was shoved into the corner of a small room and barely noticed amid fifty canvases each by Larionov and Goncharova and twenty-

three by Malevich. Larionov intended the "Donkey's Tail" to be the first exhibition to break away from Europe and assert an independent Russian school, where neither "lackeys of Paris" nor "decadent Munich followers" (i.e., Kandinsky and Jawlensky) were welcome. While Chagall looked incomprehensibly foreign to the French, he already looked too Western, Jewish, and individualistic to the Russians.

In his art, Chagall's unique genius was to fuse Russian, Jewish, and French traditions. But in his life, the continuing self-division was a torment. Writing in early 1912 to Romm, who had gone home, he described himself sitting alone in his cold room in the Impasse du Maine reading the Russian symbolist poet Nikolai Klyuev:

> Sometimes it's so boring to be in Paris, quite often I would like to leave and go to more beautiful, gentle, pleasant places. I know that something like that exists, if you have money, and can reach it. The most terrible salon has opened, you don't need to regret that you can't see a thousand more canvases–all painters are very bad here but you can find some beautiful pieces, some small Cézannes. The portrait by Matisse is very good . . . In general I hate Paris and all contemporary art although alas I am half French! I think it's impossible for us to mix up with the west . . . I don't know the future but without doubt truth and purity are on our eastern side.

In Moscow, Goncharova ("The west has shown me one thing: everything it has is from the east") and Larionov were shrieking the same thing; in Munich, Kandinsky also remarked on the "firm belief in salvation from the east" felt by those "capable of independent sentiment." Chagall's position was never as clear. Writing to Romm as a fellow Russian art student, he played up his Russian sentiment, but in fact he was much more seduced by French art than were his Russian contemporaries. "Here in the Louvre, before the canvases of Manet, Millet and others, I understood why I could not ally myself with Russia and Russian art," he wrote. "Why my very speech is foreign to them. Why they do not trust me. Why artists' circles ignored me. Why in Russia I am only the fifth wheel. And why everything I do seems eccentric to them and everything they do seems superfluous to me. But why? I cannot talk about it anymore. I love Russia." But by Russia he tended to mean not St. Petersburg or Moscow but Jewish Vitebsk. At the same time as

he wrote to Romm, he sent a long homesick letter to his sisters Zina and Lisa, asking them to read it aloud to his family—his illiterate mother would not have been able to read it herself, and even his father would have had difficulty with written Russian. "I can't imagine how it is at home," Chagall mused:

> Let us pray that God send all Jews and you and me an easier fate . . . Believe me, I wish it with all my heart and sometimes in my dreams I even cry. Sometimes I have a dream where I win a fortune and have lots of money somehow. What I would like to do then is to make life for my parents very easy. I would like them to sit down and sleep every day for a few hours one after the other— so father could have a rest, because I know how very well and happy he looks on a feast day when he can rest. In my childhood I had a dream that it would be a festival every day and father, and mother too, all would be calm and whenever they wanted, they could go to synagogue, go for a walk and drink tea with jam. For my sisters I would give them 2000 each as a minimum and I would like them to live happily . . .
>
> It's a dream. But when you're dreaming, it begins to feel like reality and you believe it will happen. In reality it would be better for me to come back myself—or to invite the parents here (yes, better here) . . . I can even ask you about the rest of the family . . . I had better not confide anymore. You can laugh but it's a sin to laugh in some cases. I can't explain it because it's a silliness in me. All the same, I feel that I can put down anybody.

That surge of confidence came from his new paintings—the very paintings that were rooted in Russian memory but diverged from all the paths, from the World of Art to the "Donkey's Tail," now being followed in Russia. Crucially, too, they distanced him from Bella. In the year when he had stood on the brink of the most stirring artistic adventure of his life, she had waited in Vitebsk, then in Moscow, for letters that never came. "My dear, I completely don't understand what happened," she wrote after returning to Moscow for the academic year. "You don't get my letters? Are you ill? Preoccupied with work? I can't imagine what. I suppose the whole. If anything important had happened I would surely have received a letter. I ask

you to send me something. To wait and be without news for so long–that can't be allowed. My address–Moscow, 38 Kuznezkaya, Flat 6. All the very best, Bella."

But for most of 1911 she was still waiting. "My dear, hello," she wrote again from Moscow, in the midst of exams. "How's your health? I haven't heard from you for quite a while. How's work going? Where are you exhibiting? Have you given any work to hang somewhere? Generally what are you working on, is the desire to work growing in you? Is it flourishing easily? Dearest, it hurts me not to know anything, which means communicating with me can't give you anything. And you remain alone. Sometimes I think otherwise."

She may have been right; Chagall once spoke of nights spent with a distant cousin from Lyozno who was passing through Paris; there are also rumours of an affair with a Jewish woman from Lodz, Fela Poznanska, who had studied philosophy in Switzerland. But neither of these liaisons, if they did take place, was a threat to Bella. Chagall was emotionally alone–but alone with painting. Bella had identified so passionately with his work that it never occurred to her to consider that painting was her rival. But Chagall, subsumed in a whirlwind of inventiveness, rarely replied, and thrown back on herself, signs of a vein of depressiveness that would haunt her life now emerged in Bella's letters. "My dear," she wrote,

> You are so far away that, when I feel you are so dear to me, I hesitate and don't trust myself and I am afraid that I am so far away now that I have to pay for that maybe with my and your souls. This is not just black, empty speech. If you understand me, you can understand how sad and crazy these kind of feelings are. But you have to understand, I don't complain. It is so difficult to be far away and I am so stretched to different corners and one side is so thin that it could be broken and I wouldn't be able to survive that. All this is so dense and this density could be a tangle in itself and as a result I wouldn't survive, I know myself. Everything which gives me my life, is this soul-like knot.

Chagall's side of this correspondence, such as it was, has not survived, but how much Bella's letters sustained and mattered to him is shown by the fact that he kept even the briefest postcards until his death. "Don't think that something happened with me. I will never stop loving you and I will

Chagall in Paris, 1911

never love anyone else and nobody else loves me. Just the contrary. I am more than ever alone and with every minute," she consoled him when he agonised and worried; she understood instinctively that his suspicious, edgy temperament would be won not by manipulation or teasing but only by long patience and loyalty. But in 1911-12 Chagall also needed freedom from the old allegiances—to her, Judaism, Vitebsk, Russia—in order to express himself fully, in his own new, charged language, as an artist.

"To surrender oneself to one's instinct, one must be young and not harassed by circumstances, by life," he wrote later. By the time he listed it in the Indépendants catalogue in March 1912, his name had become definitively Frenchified as Marc Chagall. Bella and his family still wrote to him as Moysey or Moses, but from his arrival in Paris he used Marc, following a trend among Russian Jews in Paris to adopt names that were at least easy for

the French to pronounce: thus Pinchus Kremegne became Paul, Chaim Lip-
chitz became Jacques. Among Russians, who use the first name and the
patronymic, he was known from then on as Marc Zakharovitch–Marc, son of
Zakhar, the Russian version of his father's name. Through 1911 and early
1912, however, Chagall was still receiving letters from Russia that used a
variety of spellings for Chagall, all more redolent of the Jewish ghetto than
the spelling he eventually chose. His brother David, working for Rattner, a
herring merchant in Prussian Königsberg, favoured German-looking
transliterations including Schagalov, Schagaloff, and Schagal; Romm began
using Chagaloff (with one *l*), then after his own sojourn in Paris used Cha-
gall; Bella, too, used Chagalloff–with two *l*s–initially. A notebook belonging
to Chagall in 1911 includes what appear to be practice attempts at writing his
name in Roman script; he eventually plumped for Chagall probably because
it looked gracefully French, though he joked that he chose the two *l*s
because the letter is pronounced "aile" (wing) in French. The idea of having
two wings pleased him; three, he added, would really have suggested the
thrill of flight into the unknown that he felt on his arrival in Paris.

Blaise Cendrars

Paris, 1912–1913

In the spring of 1912, having made his mark at the Salon des Indépendants, Chagall emerged from a year of solitary work and started to taste the life as well as the art of Paris. He began by moving to a room in La Ruche (The Hive), the colony of artists' studio-apartments in Montparnasse. Between 1902 and the 1920s this legendary run-down establishment was home to a long procession of painters and sculptors, most of them impoverished eastern European Jews attracted by the low rents—a hundred francs a year, rarely collected and never enforced—and by the familial émigré atmosphere. The beehive-shaped building was the creation of the sculptor-philanthropist Alfred Boucher, who had acquired vacant, cheap land in the unfashionable Vaugirard area near the city's slaughterhouses; after the Universal Exhibition of 1900 closed, he bought key structures from it and reassembled them at the Passage de Danzig. The main metal edifice was the Médoc wine pavilion designed by Gustave Eiffel; there was also the ornate forged iron gate from the Pavilion des Femmes, which formed the main entrance, and the caryatids of the British East Indies pavilion, which stood on either side of it. From a central stairwell, about one hundred ateliers on two floors radiated out in triangular wedges ending in large windows, and in each slice of what Ossip Zadkine called this "sinister wheel of brie" an artist, sometimes accompanied by his wife or mistress, lived and worked. Sculptors were mostly on the ground floor, and painters were on the first, though La Ruche also attracted writers, such as the poet Mazin who, slumped over a cup of coffee, modelled for Chagall, and Leo Koenig, cultural critic for Yiddish newspapers in Warsaw and St. Petersburg. It was

home, too, to a handful of Russian revolutionaries and anarchists, ranging from the serious Anatoly Lunacharsky (later commissar for arts and a friend of Chagall's) to the jovial painter Michel Kikoine, who wore nonmatching shoes of different colours and whom the French police marked as "Bolshevik non dangereux."

There was not much sanitation—water spilled out from the toilets and ran down the little garden, with its clutter of sculptures and rubbish. The place smelled, was infested with bedbugs, and grew increasingly dilapidated over the years. "I washed the walls in alcohol at ninety degrees, and covered the furniture with poison, but nothing stopped those little beasts. When everything was clean, I saw them again, imperturbable, coming down from the ceiling," recalled Vera Dobrinsky; she and her husband Isaac, a religious Jew who went daily to the synagogue and painted "in order to understand the mystery of Creation," arrived at La Ruche from Ukraine the same year as Chagall. But the studios were large and bright, the ceilings were high, and convenient sleeping lofts ran above a work space that doubled as a living room and kitchen. And for those living hand to mouth, there were encouraging figures in situ: the frame maker Oustrom and his small, warm-hearted wife lived behind the rotunda in a modest house that they ran as a cheap restaurant, serving tea to anyone at any hour—Chagall was a regular visitor; the myopic concierge, Madame Segondet, was honorary grandmother and friend to all; and around the corner at the avenue du Maine, intrepid, minute Marie Vasiliev from St. Petersburg held her soup canteen-cum-Académie Russe, presided over by Professor Fernand Léger, a tiny outfit where Chagall had his first solo show.

La Ruche, Paris

"In those studios lived the artistic Bohemia of every land," recalled Chagall. "While in the Russian ateliers an offended model sobbed, from the Italians' came the sound of songs and the twanging of a guitar, and from the Jews debates and arguments. I sat alone in my studio before my kerosene lamp." The artist-neighbour he remembered best was another recent Jewish arrival, the willowy, beautiful, popular Amedeo Modigliani, whom he described as "an Italianist like Botticelli"; Modigliani was then concentrat-

A typical studio at La Ruche

ing on sculpture and used to read aloud from Petrarch and Dante in the evenings. Fernand Léger had just left, and Diego Rivera, who would sit drinking with Trotsky at La Rotonde, came the following year; in this range, including artists from France, Italy, Russia, and America, La Ruche represented cosmopolitan prewar Paris in microcosm. Chagall was the first Russian painter there; the established Russians were all sculptors–the cubists Alexander Archipenko from Kiev, Jacques Lipchitz from Vilna, and Ossip Zadkine (whom Chagall knew from Vitebsk), as well as Morice Lipsi from Lodz and two other Vitebsk contacts, Léon Indenbaum and Oscar Miestchaninoff, who had come to Paris two years earlier with Viktor Mekler. In Indenbaum's memory, Chagall "as a *carte de visite,* painted a red flower on his window. He was very distrustful. He shut his door with a rope and rarely opened it. He was afraid of *tapeurs* [cadgers or borrowers: i.e., those who might steal his ideas]. One didn't dare disturb him; he lived shut away, on the margins of the community."

Chagall, too, remembered that "I was *un type à part* . . . They used to throw shoes at my illuminated window to mock me, who painted through the night while others made love or bombs." Of his first summer at La Ruche, he recalled that "on the shelves, reproductions of El Greco and Cézanne lay side by side with the remnants of a herring" and that it always seemed to be "two or three o'clock in the morning":

> The sky is blue. Dawn is breaking. Down below and a little way off, they are slaughtering cattle, the cows low and I paint them. I used to stay up all night long. It's now a week since the studio has been cleaned. Frames, eggshells, empty soup cans lie around helter-skelter.
>
> My lamp burned, and I with it.
>
> It burned until its glare hardened in the blue of the morning.
>
> Not until then did I climb into my garret. I should have gone down into the street and bought some hot croissants . . . but I went to bed. Later the cleaning woman came; I wasn't sure whether she came to set the studio to rights . . . or whether she wanted to come up and be with me.

Bella deleted the next sentences when she translated Chagall's memoirs into French for their first publication, but the Russian manuscript continues, "I love French blood. While gnawing at French painting, trying to overcome it, I wanted to savour the taste of a French body." When Chagall copied out the French, he rebelled against her editing: he added a drawing showing himself, stretched out and eyes shut in ecstasy, being kissed beneath the Eiffel Tower by a girl who looks nothing like Bella.

Sexually and socially, he was trying to leave the ghetto behind: how could he be faithful to Bella when the *femme de ménage* was eagerly compliant, and he was busy transforming himself from a Russian painter into a European one? He was more sophisticated and, thanks to Vinaver, better off than most of the eastern European painters who arrived through 1912 and 1913, and the last thing he wanted was to be reabsorbed into a poverty-stricken enclave of Vitebsk in Paris. "Il faut crever de faim pour faire des belles choses!" remembered Pinchus Kremegne, a friend of Romm's, who stepped out at the Gare de l'Est claiming to know only three words of French–Passage de Danzig–and for wages of five francs a night transported meat from the Vaugirard abattoirs. Rosa Kikoine could not afford a taxi home from the

Hôpital Boucicaut after giving birth to her and Kikoine's son, so she walked back to La Ruche carrying baby Yankel in her arms. In other legends one painter's wife allowed him to use a particularly expensive blue only on Sundays, and another took her husband's works to sell at the Paris markets, returning home triumphant each day—but only because she disposed of the canvases for nothing and sold herself on the streets. "We were hungry," recalled Vera Dobrinsky. "The rag-and-bone man's donkey stuck out its tongue. We would have liked to give it a crust of bread, but we were also in need. You mustn't see in all this the romance of poverty and squalor. I said to all the artists who subsisted there, that they came through the endurance test not thanks to La Ruche but in spite of La Ruche."

The more successful inhabitants, such as Moise Kisling, stayed only a few years; others remained in La Ruche until the 1930s. After Chagall, the greatest of the Russian painters was the tormented individualist Chaim Soutine, whom Chagall thought pitiful and avoided as "a morbid expressionist." Soutine, who never washed and was once found to have a nest of bedbugs in his ear, arrived in La Ruche from Vilna full of stories about having been beaten by the sons of a rabbi because he painted. The stench from his studio was often unbearable, because he acquired carcasses from the abattoir and spent so long depicting them, in thick impasto oils, that they rotted before he

Artists living at La Ruche, 1914

could throw them out. One night, according to La Ruche legend, Chagall saw blood dripping from his studio and rushed out screaming, "Someone's killed Soutine"; the blood was pouring from a carcass hanging from the wall.

As in any immigrant community, the established artists kept their distance from the disreputable new arrivals to Paris. Zadkine, who was outraged when offered Yiddish newspapers ("Je ne suis pas juif, moi!"), felt that La Ruche was a suffocating ghetto in miniature and was impelled to flee "ce petit monde moisissant de mélancolie" for the centre of Paris. Chagall's sharp competitive spirit made friendships with painters almost impossible anyway, but beginning a lifetime of friendships rooted in literary rather than artistic connections, he now started to forge links with the foreign writers who either lived in or hung about La Ruche. They had, of course, to be Russian-speakers, for only after he had met them did Chagall begin to learn French. One of the earliest was the poet Ludwig Rubiner, a gentle, serious German from a Galician Jewish family who had travelled to Russia in 1909 on the tracks of Tolstoy and had translated Gogol and Sologub, the Russian symbolist writer much loved by Chagall, into French. He and his wife Frieda became "wonderful and devoted friends" of Chagall, "indefatigable propagandists for modern art," and later conduits for Chagall in Germany. In Paris, however, their influence was limited; it was Chagall's next friendship that really propelled him to the centre of French artistic life.

In the summer of 1912 Chagall was lonely after the departure of his ally Romm, whom Jacques Chapiro, chronicler of 1910s Paris, remembered as "the interpreter of the artist's soul." Chagall's instinct for assimilation now led him to befriend a Swiss poet who had just returned to Paris from abroad and happened to be besotted with Russia. Many years later, asked to name the most important events in his life, Chagall replied in one breath, "my meeting with Blaise Cendrars, and the Russian Revolution."

Born Frédéric Sauser in 1887, the same year as Chagall, in the village of La Chaux-de-Fonds, Cendrars was in 1912 editing a Franco-German magazine called *Les Hommes nouveaux* from his room at 4, rue de Savoie, in the sixth arrondissement. The writers of his articles all had alluring bylines—Diogène, Jack Lee, Blaise Cendrars—and all were pseudonyms of Sauser. Among many claims from his colourful life was that his fiancée Hélène Kleinman had died in St. Petersburg in a fire started by an oil lamp,

an event that suggested the new title *Dedicated to My Fiancée* for the sexually charged *La Lampe et les deux personnes*. Sauser's fascination with fire—which exceeded Chagall's own—dictated, too, the name by which he was mostly known: both Blaise and Cendrars were chosen for their evocation of embers (*braise*) and ashes (*cendres*); the Latin *ars* in *Cendrars* suggests art arising phoenixlike from the ashes of the old world. Cendrars saw artistic creation as a radical act of transformation, and in the exotically Russian Chagall he thought he had found the ultimate "nouveau homme," one who made avant-garde art out of images of the fading nineteenth century. Chagall thus acquired a protector, a supporter, and a guide. "The light in his eyes was enough to console me," he wrote. Cendrars was the third of the trio of young men—he now replaced Romm, as Romm had replaced Mekler—to open up a new milieu to the dependent, timid, yet eager Chagall before his marriage.

No one was better placed to help Chagall discover worldly Paris. Tall and raffish, with a long, thin face, cropped hair, and a rough-hewn look, Cendrars declared that "it is not my ambition to write, but to live." He called his memoir *Bourlinguer,* which means "to knock about the world, lead an adventurous life," and at twenty-five Cendrars could certainly claim to have done that. In a peripatetic childhood, his feckless entrepreneur father dragged his family to Egypt, Italy, Paris, and London: " 'Money is meant to circulate!' my father would say. Sometimes there was too much of it at home, sometimes not enough. It drove my mother insane. And it is the reason I despise money. Life is something else." He attended, then abandoned medical college in Bern and at sixteen ran away to sea (some feat from Switzerland). He wound up in Russia, where he witnessed the 1905 revolution in St. Petersburg and worked for three years in Nizhni-Novgorod for an Old Believer jewellery merchant, Rogovine, from whom he parted in Persia. He spoke perfect Russian and, as the son, grandson, and great-grandson of Swiss watchmakers, had an intimate understanding of the jewellery business—a meeting ground with Chagall, for whom this milieu constituted, through Bella, a part of his Vitebsk memories. Cendrars boasted that he had a relationship with a Crimean Jewess of "milky complexion, languid and feverish," a cleaner and sorter of pearls renowned for her "magic touch." He was still preoccupied with the death of his first love, Hélène, in St. Petersburg, though he had since had other Russian lovers, including one named Bella. She was the best friend of his current fiancée, Fela Poznanska, whom he had met in Switzerland and who had accompanied him on some of his

travels. Cendrars's own "rich and overabundant disorder of the mind," he said, gave him an instinctive sympathy towards Russia and the Russians, with whom he was obsessed.

Fela was something of an adventurer herself. She had spent the summer of 1911 in Paris, when she had met and perhaps embarked on some sort of relationship with Chagall; then she travelled to America in November 1911 and sent Cendrars a ticket for the passage from St. Petersburg to New York–from where he returned, without her, to Paris in July 1912. His mind was bursting with the book he wanted to write about his experiences on the Trans-Siberian Express, of Russians "telling each other stories . . . day and night on the interminable Trans-Siberian trek, or the slow, long monotonous descent of the Volga by steam-boat; in order to assuage their sorrows, they speak of God, the universe, love, life; the famous *govoretschka* which turns the vastness of Russia, for a foreigner, into nothing but a temporary camp, a disturbing debate, where everything is held up to question." He was on the lookout for an artist who embodied his fantasy of what it was to be Russian when, at Fela's suggestion, he looked up Chagall.

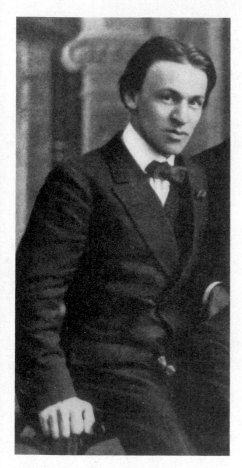

Blaise Cendrars

"He was the first to come and see me at La Ruche," Chagall said. "He read me his poems, looking out of the open window and into my eyes; he smiled at my canvases and both of us roared with laughter." Cendrars saw a room of "total disorder," full of sketches, paintings, and empty bottles, a broken lamp, a pair of worn-down shoes, a jar of chocolate, and just waking up, Chagall, whom he described as "a genius split like a peach." Instantly they became close companions, seeing each other every day. On the surface they were opposites, Chagall shy, cautious, distrustful, and naïve, Cendrars boastful, reckless, open, and experienced, but both were young men enthralled with their own creative powers in a new century and a foreign country. "What a book one could write about all those young unknowns who came to conquer Paris, that quilted star

stitched into the sky of Paris," Cendrars mused: the myth, as well as the reality, intoxicated them both.

Highly sexed and promiscuous, Cendrars observed that Chagall "paints with all the dirty passions of a little Jewish town / With all the exacerbated sexuality of the Russian provinces." He may have taken his new friend to his regular brothel in the rue Mazet, where, he said, "there was only one woman available, Madeleine the Scissors, a Jewess as lame as the Spanish Venus, vindictive and grasping. She gave rapid service, since, working alone, she had no time to waste between one ring at the doorbell and the next. The local painters queued up outside the door, and to tell the truth, Madeleine the Scissors was a real bungler à la Goya." He certainly introduced Chagall to his favourite bar, the Faux Monnayeurs on the rue Cujas behind the Sorbonne, off the Boulevard St. Michel, and he left a memorable picture of the flotsam and jetsam of downtown prewar Paris, yapping anarchists, taxi drivers, students, Salvation Army proselytisers, and comrades selling brochures on birth control, all of them

> the night-owls of the Boul' Mich', mute, grubby, intoxicated, reeking of absinthe, and the famished creatures who outnumbered those lucky devils who were eating a plate of sauerkraut, a sandwich, a plateful of mussels, onion soup, hot sausages, a sou's worth of chips in a paper cone or a saucerful of winkles, the bums feverishly chewing peanut shells to appease their chronic hunger pangs, the cadgers standing downwind from a smoker to inhale the smoke drifting from his pipe, and certain poor wretches so worn out from tramping day and night in pouring rain through the interminable streets of Paris that no sooner were they inside the overheated bar than they pissed themselves out of sheer exhaustion. They sat there dripping . . .
>
> Suddenly the pigeons from the Luxembourg Gardens swooped down into the square and then flew off again when a little train passed by on its way to Les Halles.
>
> The dawn was blue.

Chagall remembered Cendrars as "waves of sunshine, poverty, rhymes. Threads of colour. Of liquid, flaming art. Enthusiasm for pictures scarcely conceived. Heads, disjointed limbs, flying cows." Their modernist idioms were very similar: Cendrars's ruptured poetic style echoes the fantastical,

quicksilver rhythms and upside-down compositions of Chagall's first Paris years. In Cendrars's view, "life is a farce, a comedy, a universal tragedy"; he understood Chagall's own mix of fatalism and sense of the absurd.

A child of watchmakers, Cendrars was fascinated by time, its relativity, its effect on modern communications and technology—telegraphs, telephones, cars. "Every one of us is the hour sounding the clock," he wrote in *Profound Today,* his prose poem on speed and movement. "To control the beast of your impatience you rush into the menagerie of the railway stations. They leave. They scatter. The capitals of Europe are as the trajectory of their inertia. The terrible blast of a whistle furrows the continent. A tram slams into your back. A trap door opens under your feet. There's a tunnel in your eye. You're pulled by the hair to the fifteenth floor." He bragged—ludicrously, given the work that both Picasso and Italian futurists such as Filippo Marinetti and Umberto Boccioni were doing at the time—that in 1910-11 "Robert Delaunay and I were perhaps the only two people . . . who were talking about machines and art and who were vaguely conscious of the great transformation of the modern world." It was true, however, that he sounded the cultural pulse of his times and was a force in modernist poetry. Breaking lines of verse to suggest the jaggedness of conversation, he constructed events and images in his poems to coexist simultaneously, a literary equivalent of the planes and multiple viewpoints of cubism. Endlessly through the night he and Chagall discussed the latest currents, and he wrote several poems about Chagall intended to evoke the style and imagery of his paintings:

> *He's asleep*
> *He wakes up*
> *Suddenly, he paints*
> *He takes a church and paints with a church*
> *He takes a cow and paints with a cow*
>
>
>
> *And it's suddenly your portrait*
> *It's you reader*
> *It's me*
> *It's him*
> *It's his fiancée*
> *It's the corner grocer*

The milkmaid
The midwife
There are tubs of blood
They wash the newborn in
Skies of madness
Mouths of modernity

.

He commits suicide every day
Suddenly, he is not painting
He was awake
Now he's asleep
He's strangled by his own tie
Chagall is astonished to still be alive

That Chagall accepted Cendrars's titles for his paintings—*Dedicated to My Fiancée, To Russia, Asses and Others, I and the Village*—suggests Cendrars's intense rapport with his new friend's paintings, an intimacy with his way of working, a familiarity with his thoughts, references, and stories from his youth. No one but Bella ever came closer to Chagall the artist.

But Cendrars was not only a soul mate; he was also well connected—Delaunay, Apollinaire, Modigliani, and Léger were his friends, Picasso an associate—and passionately loyal in opening up his network to Chagall. Returning from abroad, Cendrars quickly saw that avant-garde Paris was a society whose collective imagination fed on exoticism, especially on the extravagant fantasies of Slavic savagery that it had lapped up since 1909 in Diaghilev's Ballets Russes and that reached a pitch of popularity with Stravinsky's *Firebird* and Rimsky-Korsakov's *Scheherazade* in 1910 and Nijinsky's stylised, sexualised choreography for Debussy's *L'Après-midi d'un faun,* played like a flattened painting against a sunlit Attic landscape in 1912; all three had designs by Bakst. Chagall felt bitterly that this was Russia refined and filtered through the effete sieve of the World of Art, "polished to reach society in a piquant and sophisticated style." Yet the impetus that Russian influence added to Western art was now apparent. Reviewing an international exhibition in Vienna in 1909, a critic noted that

a very short while ago it was a saying that if one scratched a Russian, one discovered a barbarian. Now we understand this more

correctly, and in this barbarian we find a great artistic advantage . . . We . . . envy them for the remains of barbarism which they have managed to preserve. The West has become a common meeting ground, invaded by distant and foreign peoples as in the last days of the Roman Empire, and while they wish to learn from us, it turns out that they are our teachers. The barbarian embraces with the most elegant of modernists, and each completes the other.

The Habsburg capital, halfway between France and Russia, perceived this confluence a year or two earlier; between 1911 and 1914 Paris, too, was gripped by a craze for things Russian, from which both Chagall and Cendrars benefited.

These were years when the most fashionable artists' salon was that of the aristocratic Russians Serge Jastrebzoff and Baroness Hélène d'Oettingen, who collaborated on their own canvases under the pseudonym Jean Cérusse (a pun on "ces russes"–these Russians); when the Russian alphabet started appearing in Picasso's paintings; and when Sonia Delaunay's multicoloured outrageous costumes for the annual Russian ball, the Bal Bullier, set the tone for Parisian fashion. Sonia also illustrated Cendrars's *La Prose du Transsibérien,* which the pair boldly announced in 1913 as the first simultaneous book. Printed (on Cendrars's own secondhand press) on a single sheet of paper two yards long, with images and text interwoven so that they demanded to be read and viewed simultaneously, it was an experiment, derived from cubism and from Delaunay's experiments with colour, aimed at capturing the prismatic reality of the modern world. Whether Cendrars had actually taken the train was in fact uncertain; what mattered, as one reviewer remarked, was that "he made us all take it." The work was hailed as a landmark in modernist aesthetics; much of its appeal was that it brought Russia closer to a Parisian audience.

Sonia Delaunay was the next staging post by which Chagall moved to the centre of Parisian artistic life. With thick dark hair, an oval face, and heavy strong features, she represented chic Russian Montparnasse. Born Sarah Stern in Ukraine in 1885, she was adopted at five by a rich uncle and renamed Sonia Terk before becoming, briefly in 1909-10, Sonia Uhde when she married the homosexual German art critic and early Picasso collector Wilhelm, from whom Delaunay wooed her in 1911. As with Cendrars and Chagall, her changing names signified ambition and cosmopolitan modernity. It was

through Sonia, a Russian-speaking, St. Petersburg-educated Jew, albeit a rich one, that Chagall became close to Robert Delaunay in 1912. Thus began the only sustained friendship he ever managed with another painter, the more surprising because Delaunay came from a comfortable family and lived in a vast apartment on the rue des Grands Augustins, where he and Sonia entertained lavishly. Chagall became a regular at their Sunday salons, and in 1913 he stayed with them at their country house in Louveciennes.

Delaunay was tall, smooth, loud, and boastful but kind. Temperamental differences gave the friendship life, though it probably lasted because Chagall's opinion of Delaunay's work diminished over the years. The French artist's use of contrasting transparent colour to break up space interested Chagall while he worked through cubism, but he may have sensed from the start that Delaunay, for all his vaulting ambition, would never be a great painter and was therefore no serious rival. "I have a higher opinion of Delaunay at the time when he was modest than later, when he was pushing himself. He used to reproach me, 'Chagall, you don't know the tricks of the trade.' But he knew them. And yet today, I notice, his work is falling apart" was his rather ungenerous assessment of his friend many years after his death in 1941. Delaunay, for his part, was drawn to Chagall as an innovative newcomer, who added spice to his salon and, at the start, showed flattering signs of absorbing his influence—most obviously in the acid lemon and green *The Ferris Wheel*. This was the first painting in which Chagall used Parisian imagery, including the Eiffel Tower, and he worked on it at the same time as Delaunay used the images of the

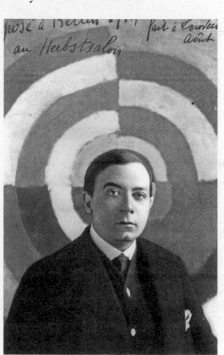

Robert Delaunay

big wheel and the Eiffel Tower in his *L'Équipe de Cardiff*. The word "Pari," inscribed at the bottom, is a pun on Paris and *pari,* meaning "bet," suggesting the Ferris wheel as a metaphor for the wheel of fortune. Delaunay's picture similarly bears the words "Magic Pari," and Cendrars used the pun in *La Prose du Transsibérien;* either may have suggested it to Chagall, whose French was then still poor.

Like Cendrars, Delaunay made impressive claims about his instinct for

the present—"I am ahead of Picasso and Braque. I am not just analyzing geometric forms. I'm trying to come to grips with the rhythm of modern life." The windows of his studio opened onto a view of the Eiffel Tower, and his Eiffel Tower series of 1910 had brought him renown as the artist of contemporary life, with the great iron structure his trademark symbol of modernity. Nevertheless, in 1912–13 he was in a state of near-permanent jealous rage against Picasso; according to Gertrude Stein, who damned Delaunay's work

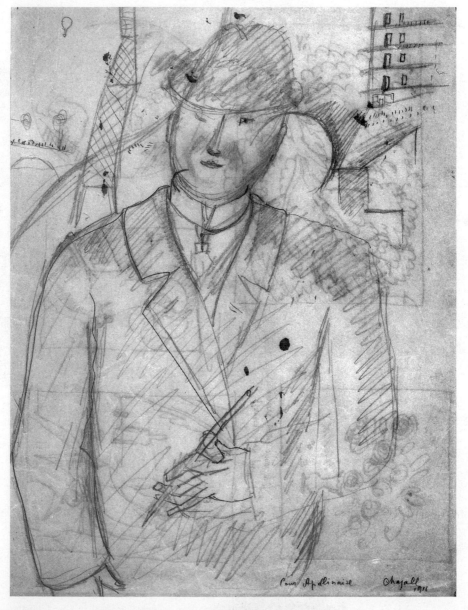

Chagall, "Portrait of Apollinaire," 1912–13, drawing

as either big and empty or small and empty, he "was always asking how old
Picasso had been when he had painted a certain picture. When he was told,
he always said, 'Oh, I am not as old as that yet, I will do as much when I am
that age.' " (He was just four years younger.) When Chagall met him in 1912,
he was busy courting Apollinaire who, shaky after his breakup with his
fiancée Marie Laurencin, was invited by the Delaunays as a houseguest, in
gratitude for which he switched from mockery to praise. He and Delaunay
soon quarreled, for Apollinaire's real loyalty lay with Picasso. But he had
been intrigued by *Dedicated to My Fiancée* at the spring salon and was not
averse to extending a little of his patronage in Chagall's direction.

Chagall was never wholly at ease with the haunted, ambitious gadfly whom
he called "that gentle Zeus." Guillaume Apollinaire was the pseudonym of
Wilhelm Kostrowitzky, illegitimate son of an aristocratic Belorusian adven-
turess and a father he had never known, either an Italian army officer or a Vat-
ican prelate—though Apollinaire, too, sometimes played for Russian chic and
claimed to come from St. Petersburg and even to be a Russian prince. This
hint of shared background never really shrank the distance Chagall felt from
Apollinaire's French outlook and education; he had been brought up by his
gambling mother in Monaco and educated at schools in Nice and Cannes
before becoming a celebrity critic in Paris. Chagall made several sketches of
him, including a tender, lighthearted watercolour portrait in violet ink that
captures Apollinaire's good-natured gentleness and fragility as well as his
gleaming voluptuousness; the picture is lit up by the smile that Chagall said
always "spread slowly over his broad face," while "he carried his stomach as if
it were a collection of complete works and his legs gesticulated like arms."

One day Apollinaire took Chagall to lunch at Baty's in Montparnasse,
where his guest sat astounded, watching the legendary appetite in action:

> Perhaps he has to eat so much to feed his mind.
>
> Maybe you can eat talent. Eat, and above all, drink and per-
> haps the rest will come of itself.
>
> Wine rang in his glass, meat clattered between his teeth. And
> all the while he was greeting people right and left. Acquaintances
> on every side!
>
> Oh! Oh! Oh! Ah! Ah! Ah!
>
> And at the slightest pause, he emptied his glass, resplendent in
> his huge napkin.
>
> Lunch over, swaying and licking our lips, we walked back to La
> Ruche . . . I dare not show Apollinaire my canvases.

> We go down the dark corridor where water drips ceaselessly, where piles of garbage are heaped up.
>
> A round landing; a dozen or so doors with numbers on them.
>
> I open mine.
>
> Apollinaire enters cautiously . . . sat down. He blushed, swelled out his chest, smiled and murmured: "*Surnaturel!*"

The visit was followed next day by the delivery to La Ruche of Apollinaire's poem "Rotsoge," written on a napkin and dedicated to Chagall. This was the famous encounter that later made Chagall in Parisian lore the ancestor of surrealism. Apollinaire himself evolved from using *surnaturel* to *surréel,* the term with which he described his own drama *The Breasts of Tiresias* (1917), where a housewife called Thérèse changes sex and allows her breasts to float up to heaven like balloons; André Breton adopted the word, and it gained currency with the publication of his Surrealist Manifesto in 1924. Chagall in the 1920s was careful to distance himself from surrealism, but he always appreciated Apollinaire's prescience. "In my work from the very beginning you can see these very surrealist elements whose character was definitely underlined in 1912 by Guillaume Apollinaire," he recalled, though he admitted that he did not understand the word when Apollinaire first used it. But the encounter was a milestone: recognition of his visionary, illogical work from cubism's leading apologist, the critic at the intellectual centre of the endeavours of French modernism. From 1912 on, Apollinaire wrote loyally about Chagall's appearance at the salons, though he never approached the perceptive understanding of Tugendhold or the instinctive sympathy of Cendrars. "One of the finest colourists in this salon" and "an impressive sense of colour, a daring talent, and a curious and tormented soul" were his typical refrains, as well as the summing up that revealed how bewildered was the early French reaction to Chagall: "an extremely varied artist, capable of painting monumental pictures, and he is not inhibited by any system."

Basking for the first time in the sustained support of a group of leading writers, artists, and critics, Chagall surprised himself by his integration into his new milieu. The energy, inventiveness, and rapid transformations in his work of 1912–13, as well as the vast scope of the canvases–many six feet high or wide–demonstrate feelings of connection and confidence in his environment. Recollections of Russia were still vital, but the glassy mirrorlike surfaces of the fantasies *I and the Village* and *To Russia,* whose hallucinatory melee of images evokes the closed-in, lonely world of memory itself, were

gone. A greater monumentality, and more concern with the human figure, now became apparent, and for the first time since his arrival in Paris, Chagall dared to paint a self-portrait.

Self-portrait with Seven Fingers, an ebullient depiction of the artist at work, is a young man's picture: proud, solemn, playful, full of the drive that the conceit of the seven fingers suggests–in Yiddish, to do something with seven fingers means to do it as well as one possibly can. Chagall has constructed his body out of loose rather than rigid geometric shapes and dotted it with flowers–like the *carte de visite* on his La Ruche window. His curled hair suggests flowers, a mauve cravat, spotted scarf, and yellow waistcoat with gold buttons enhance the lively decorative effect, and a triangle of painted paper fixed to his collar is a nod to cubist collage. A cubistically simplified face emphasises strength and vision–large almond eyes, determined nose and mouth. One hand holds a palette gleaming like enamel; the other, seven-fingered hand points to the canvas *To Russia* on the easel. Above floats a Vitebsk landscape; opposite a window opens on to Paris, on which Chagall has turned his back. "Participating in that unique technical revolution in art in France I returned in thought, in the soul, so to speak, to my own country. I lived as if I were turned back to front," he recalled. On a carmine wall the words *Paris* and *Russia* are written in Hebrew letters: a distillation of Chagall's three identities. "I was living in La Ruche. I was in fine form at that time. I was convinced that I would complete my picture in one week," Chagall wrote. "Although I was influenced by the Cubists, I had not denied my former inspirations. Why seven fingers? To bring about another construction, to make fantastic elements appear beside realistic elements."

Self-portrait with Seven Fingers was one of a series of large figure paintings of 1912–*Adam and Eve, Half Past Three* (*The Poet*), *The Soldier Drinks*–in which Chagall continued to grapple with the possibilities of cubism and the new reality of Paris. The masterpiece of this year was *Golgotha,* in which he dared through cubist dislocation to take on for the first time the key image of the Christian tradition. His Christ, a child composed of segments of translucent blue, with Stars of David on his loincloth, floats at the centre of a composition of green circles; the cross has disappeared–he is crucified on earth, the entire world his arena of suffering. In oriental dress Saint John and Mary lamenting are a Jewish couple based on Chagall's tall bearded father and short mother; a boat with a flamelike blue sail makes for the land of the dead, which glows with phantasmal light. "When I painted this picture in Paris I was trying to free myself psychologically from the icon

painter's outlook, as from Russian art altogether," Chagall said, but to Western eyes the painting still looks Byzantine and Jewish. "The symbolic figure of Christ had always been very familiar to me, and I was determined to give form to it in the guise imagined by my young heart. I wanted to show Christ as an innocent child," Chagall explained. "Christ is him / He spent his childhood on the Cross," wrote Cendrars; Chagall had often identified himself with Christ, and the picture alludes both to the destiny of the Jewish people and to the role of the artist in the contemporary world. "For me Christ was a great poet whose poetical teaching has been forgotten by the modern world," Chagall said.

The crucifixion would be an obsessive subject for Chagall in later life; for now, *Golgotha* marked the daring entrée of a young Russian Jew into the Western mainstream. He showed it, along with the cubist version of *The Dead Man* and *The Herdsman* (now lost), at the invitation-only Salon d'Automne of 1912. "I remember the impact they made in the Autumn Salon among the 'cubist' canvases of Le Fauconnier and Delaunay," wrote Tugendhold. "Next to the adult, too-adult works, as if by mistake, the works of some child, truly fresh, 'barbaric' and fantastic, had landed there."

The legendary, symbolic aspect that characterised *Golgotha* became yet more pronounced as Chagall fought his way through cubism to more fluid, dynamic large-scale figure paintings in 1912–13: the wide-eyed rabbi with corkscrew curls in *The Pinch of Snuff*; the green and mauve-tinted body, bent into an arc, as *Jew at Prayer* loses himself in devotion; a hunched workman silhouetted against Vitebsk's fences in *The Street Sweeper*. In the fresco-like, finely modulated red tones of *The Cattle Dealer*, Chagall's Uncle Neuch, who used to take him out on his cart, is a whip-cracking Everyman of rural existence, heading a procession that celebrates the connection between man and beast–pregnant horse, benign cow, and, bearing an animal on her shoulders, a peasant woman who, wrote Chagall's early German critic Theodor Däubler, "will remain on earth forever because she sees straight to the end of night." Each one of these individuals is foregrounded and made monumental by the architectural ornamentation and compositional solidity that Chagall learned through cubism's emphasis on form. Yet their Jewish-Russian character suggests that the longer Chagall was away from Russia, the more deeply he plunged into memory as the wellspring of his art. In *Paris Through My Window* in 1913 Chagall painted himself Janus-faced, looking both towards and away from a bright Eiffel Tower and an unreal city where a couple float by horizontally and an inverted train puffs

its smoke downwards. Should he look east or west? That was the dilemma that made individuals like the Cattle Dealer come to life and remain among the most striking, original figures in Western art in the decade before 1914. "Chagall's fantastics is saturated with the fears and superstitions of Lithuanian Jewry," wrote Tugendhold. "I feel in it, in those homeless and flying people, a burning thirst for mysticism, a tortured renunciation of the life of the contemporary ghetto, 'rancid, swampy and dirty.' "

Yet to any Russians outside his immediate circle, Chagall was too shy and proud even to try to explain his work. When he was asked, decades later, whether *Dedicated to My Fiancée* had been given as a present to Bella, he laughed that he was far too lacking in self-confidence at that time to have dared to give his paintings to anyone. After the Autumn Salon of 1912 Leo Koenig wrote a well-intentioned but crassly misunderstanding review of Chagall for the St. Petersburg Yiddish newspaper *Freind;* he also penned a virulent critique of Cendrars's poem about Chagall, which Cendrars tried to nullify by buying up every single copy of the paper from the Yiddish kiosk in Paris. Another La Ruche inhabitant, the Communist Lunacharsky, wrote a bewildered article for a Kiev paper in a series called "Young Russians in Paris," where he described Chagall as "a young Hoffmann from a slum around Vitebsk . . . an interesting soul, though no doubt, a sick one, both in joy and in gloom." He had tried to interrogate Chagall. "Why do you have this or that?–you ask. In haste, the artist mumbles, 'For me, you see, it was necessary to do it like this.' At first sight–unrestrained capriciousness. But actually, he is possessed . . . The genre he chose for himself is–madness."

Neither the Russian conservatives nor the Russian or French avant-garde understood him, Chagall felt. In the winter of 1912 he sent another stash of works to St. Petersburg for the World of Art exhibition, adding a defensive note to Dobuzhinsky–"I am sending you some pictures which I painted in Paris out of homesickness for Russia. They are not very typical of me; I have selected the most modest ones for the Russian exhibition"–but he was again rejected. In his immediate circle in Paris he had a more sympathetic though not especially comprehending response: for the prewar French he was an exotic, colourful creature–"authentically Russian," raved André Salmon, an incarnation of "the melancholy, suicide and health of the Slav soul"–but too risky and obscure for anyone to buy his paintings. By the summer of 1913, when he had been in Paris two years, he had not sold a major work in either France or Russia, and he began to wonder if he would ever have an audience anywhere.

"My Ferocious Genius"

Paris, 1913–1914

Yet there was one person in Russia who was waiting eagerly for his canvases from Paris. Not having seen Chagall or his latest work for nearly two years, Bella travelled from Moscow to St. Petersburg to visit the World of Art exhibition and demanded to see the rejected paintings. Her description of the exhibition manager, a former colleague of Chagall's at Bakst's, emphasising his non-Jewish appearance–"tall, thin and fair-haired, a round little nose and similarly round eyes, light as if he not only doesn't eat, but also would only think about eating after having finished a painting, especially if it were sold"–was code for their shared suspicion that anti-Semitism was the reason for the rejection. "It would hurt me if your work hung alongside the others in the exhibition–forgive me for my frankness," she wrote loyally to Chagall. "What hangs there are the insolent, self-centered Larionov and Mashkov, Kuznetsov, and even, if you want to know my opinion, Goncharova." Yet though she marvelled at "that assured way with which you apply each stroke of paint," her shock at the incandescent, turbulent distortions of his Paris canvases came tumbling out in a confused, barely coherent letter:

> You are still very young, you rush to express everything . . . that you *know*, everything, not just superficially, everything high and immortal. The impression is that you think you'll *amaze* with your knowledge of the most sacred, the knowledge of the very umbilical cord of people and knock them off their feet, pierce their heart. (Forgive me, I am perhaps exaggerating, but let me

finish.) What result follows? Excess objects and facts that have no union or connection, not coming from one experienced world-view. You rush to convince of excess things, with insistence, and it's all because (dare I say it) you aren't properly experienced, only in your mind, only with your brain. All the time I feel that you know all-important ideas, and though you've suffered, you suffered only for the fact that you couldn't really suffer for them . . . What is missing is that concern with which one must assert the sacred. You mustn't scare people, *knock them off their feet* with fear and rebuke. This is honestly–forgive me, crude, quite boyish,–your aspirations would have been appropriate, but here you revealed your true unrealised self . . . You couldn't restrain yourself from bragging. You can't bark something at people, this can't be allowed–it isn't artistic. An artist can't have such an attitude to life. He has to love and relish in his pains; he has to love his subjects. Only then will the audience suffer and love along with him. Especially you need to combat your distorted vista, fight your lack of modesty . . . Wouldn't it be so much better if it were some insignificant study, charged with this grandness, with your undivided soul inside? Look at Kustodiev, he showed only one painting of a small girl, but one can't take one's eyes away from it . . . such subtlety, ingenuousness, fullness of light and shadow. How did Botticelli and Rubens, with their facility for depicting crowds of people, manage to make each one of them individual? How did you, who know so much already, not manage to make anyone in your painting human, and thus dehumanise the whole work? It isn't that you are unfit to do this, but that manner of yours scares me because you do it aware, with a raised head and eyes wide open. "That isn't the point," you'll say, but not having inserted any lively ideas in those characters makes the idea of the whole painting dead as well, it becomes importune and offensive. I am reprimanding you too much. I would like you to reply to me as a friend and colleague notwithstanding.

Opening this loving, agonised, gauche letter in La Ruche, Chagall had to confront the chasm that was opening up between himself and Bella. He had no prospect of a single collector or dealer interested in his work, he was sur-

rounded by painters and writers such as Delaunay and Cendrars who were making a big splash, and now Bella was chastising him for showing off. He could have ignored her as a blast from backward Russia, but the evidence from his work is that he took her seriously. Significantly, he began his most important painting of 1913, *The Violinist,* on the tablecloth that had been Bella's parting gift, and whose weave adds texture and density, as if he wanted physically to incorporate her thoughts into his painting. The green-faced violinist, one giant foot thumping out his rhythm on the roof of a timber hut, is a solitary chorus on human destiny and the cycle of life, and the most monumental of all the figures he painted in Paris–he would later become, through the musical Chagall loathed, his most famous image: the fiddler on the roof. In the context of Bella's letter, *The Violinist* can be seen not only as concluding the cycle of fantastical Parisian work but also as opening the 1914 series of more sober Russian portraits. Certainly Tugendhold, writing in 1918 about the effect of the return to Russia on Chagall, used terms close to those in Bella's letter. "Without losing any of its mysticism, the whole Chagallian world became materially tangible: Chagall learned to see dreams while awake, in the middle of the sober day," said Tugendhold. "His return to his homeland also brought some humility to his observation, softened his satirical edges and screaming colourfulness."

From Bella's point of view, such letters announced a desperation to keep alive a relationship with Chagall and to sustain the connection between his art and Russia. Since spring 1912, while Chagall had been building up a new life in La Ruche, she had been in Moscow ostensibly continuing with her studies but had spent most of her time acting. *Hamlet* and the symbolist drama *Aglavaine et Selysette* ("a most beautiful play that I could have seen in childhood dreams, I want more of this, it's hard to believe in it") by Maurice Maeterlinck, then very fashionable as the recent (1911) Nobel literature laureate, are particularly mentioned in her letters. But still much of her time was spent waiting and aching for Chagall, whose correspondence remained sparse and unreliable. "Bless you, my ferocious genius! How grateful I am to you for your letter, though it's just a postcard," she wrote on a rare occasion when he replied.

> I sit here all the time without any letters. Strangers deceive and demand, it's difficult to come to agreements with people. I suffer a lot. Kiss me, kiss me darling, to pour warmth into me, faith, light and joy. Embrace and love me–I need once and for all *to love* . . . Well, you're now far from me, your heart doesn't hear.

God give you strength! I will help, love and believe in you. Your hand !?! We'll be friends. I don't want to leave you. It's cold and lonely, despite many pretending to be my friends.

Although in the summer of 1912 she had accompanied her mother to Marienbad–then in the Austro-Hungarian empire–which was more than halfway to Paris from Vitebsk, and she had longed to go on to see Chagall, there had been no meeting. Now in Moscow for the academic year 1912-13, she was subsumed in her work, breathless at her opportunities, living the life of the modern emancipated prewar woman. "I swear to God, it's my fault. I haven't written for so long. If you knew how busy I am!" she wrote. "Not only all day,

but also in my body and soul. I can't find a spare moment for myself. It's either someone or another. And everyone requires something, everyone pokes me with excuses and explanations, they wait and make demands on me. And me! I feel how much I can't hear myself think. They gave me another third role of a boy, eccentric, gifted, charismatic, with lively sins and clear thoughts. I will after all write in a few days. There's nothing new really. The main thing is that my director raised a question about my individuality in my work and about its character and direction. I don't know if I should live or die. I'll write this in more detail later. What's happening with you? I am living, giving my whole to the work, when I look back at my home, it's as if I am stunned. I am hardly at home during the day, which is why I don't have time to write, but anyway wait for my letters. I kiss you; write to me, I'll also write.

Through 1913 the stress of their separation weighed more and more heavily on her. "My dear, why don't you write? Why don't you answer? Has something happened? Answer me as soon as possible, I beg you. I want to see you very much, I want to caress my poor abandoned boy. I kiss you, embrace you. I am waiting," she pleaded in February, scrawling on the bottom of her card, "But send me your letter immediately!" This urged Chagall into action, and in March Bella wrote back,

I was very happy to receive your postcard. It has been quite hard, and you've seemed so kind and loving that I can't get rid of the

desire to be with you. Where are you, my sweetheart? I even thought that you've already left and didn't know where to write. In my imagination I think I write a lot, but in reality the result is either stupid or crude. What plans do you have? What exhibitions? . . . I don't write about myself because there is too much to do with rehearsals. I kiss you passionately.

There was talk of making a family visit that spring to Zurich to see her brother Isaac, but the plan came to nothing, and in May she wrote bleakly,

I'm still waiting for your letters. I don't know whether you exist. It's so cold and rainy here. As it happens we are not going anywhere . . . So we haven't had the chance to see each other, and this morning I suddenly saw some young man slip through our hallway and I nearly thought it was you. I'm now waiting for you in our homeland. Will you write to me? . . . How are you doing, how could I find out? Be happy and healthy. Goodbye. I travel further and further away from you.

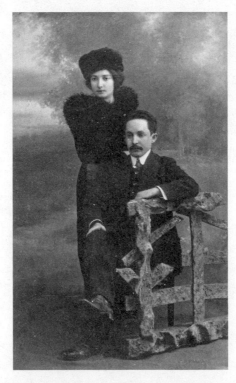

Bella and her brother Yakov Rosenfeld

By June, she was dreaming: "My dear, will you be home tomorrow? It's the beginning of the third year since I didn't greet you in life, couldn't touch your hand or your food. It's of course possible that we don't see each other for another three years, but we need to meet and then to feel." In July she returned home to Vitebsk from Moscow for the summer, writing disconsolately,

> I don't know . . . maybe something's already arrived from you, but I left–sad that there's nothing. Why don't you write, do you get my letters? I've already been in town for four days . . . I'd like to see your family, but for some reason you've asked me not to. My desire to see them is tainted by my fear of what they think. Did they write to you about me? Well, write to me, my dear, don't get annoyed. Don't! Or if you like, shower me with all your bitterness, but only don't be sad.

After two years of absence, misunderstandings were inevitable. Bella was young and beautiful and attracted other suitors, including a former friend of Chagall's; none of them interested her, and it was her unswerving loyalty that kept the romance afloat as Chagall either kept silent or used the correspondence as an outlet for the frustrations, doubts, and suspicions that mounted the longer he was away from home. Bella never exploited his jealousy; after each bitter exchange, she was full of remorse, nostalgia, and quiet conviction. "I've been sending quite a few letters and postcards recently," she wrote in November 1913.

> You don't reply. Have you received them? You don't respond, or write. You are angry and can't overlook the offence. Yet as God can see, I didn't mean to offend. It is simply due to my stupidity, crudeness, and the lack of discipline in my character. Don't grieve; don't poison yourself with any bad thoughts. I'm not a stranger to you and never will be, I'll always understand you, feel you, if only I don't lose the capacity. Write to me more often, remember our youth.

In December she followed with

> I don't even know what to think, but feel that something has blocked the way for us, something heavy and immobile like a tree.

You're angry. What am I guilty of, or is your fault? Are you ill? (Well, if it were just normal things we would write normally.) Whatever it is, you know yourself that with the human soul it can't be easy. I ask you sincerely, you must write an explanation immediately. My soul twists around in all directions, but unwillingly has to remain in the same place. God help you. I kiss you, Bella.

Chagall answered, but bitterly. She remonstrated:

A mean and scheming boy wrote that letter. You grunt, "When will I deserve it?" "Did you write to me?" "Have you sent it?" You "love me." It wouldn't be enough to smack you. You're as stubborn as a cockerel. You're inflated with macho pride . . . If you didn't think so much about yourself, it would be simpler. . . . By the way, today is my name day, send me your best wishes as after all I'm getting back into my life. I work, contemplate. Now and again it's all right, as though I forget myself, but when I look back with cold sober eyes, it becomes unbearable . . . It's a shame anyway that you're not kind. Not sympathetically kind– just *simply* kind. I'm still less kind than you are, and that's the worst thing about it.

Chagall had a sharp instinct for self-preservation. On his side he admitted that "that fourth and last romance had very nearly died of inanition . . . all that was left was a pile of letters. One more year and everything might be over between us." He knew he must go home soon if he wanted to claim his fiancée. From 1910 he had begun to transfer his dependence on his warm, indulgent mother to Bella; he could not survive without emotional sustenance from a woman. Images of maternity—*Birth,* the cow suckling a child in *To Russia, Asses and Others,* the foal within the horse in *The Cattle Dealer,* a wife feeding her husband in *The Spoonful of Milk*—recur in his work from 1911 to 1914. In May 1913 Fela Poznanska returned to Paris, and by the summer she was pregnant with Cendrars's first child. Sonia Delaunay, his other Russian-Jewish female friend, had given birth to a son, Charles, in the autumn of 1912. In 1913 Chagall made two large iconlike works featuring a pregnant woman, with her child showing in her belly, standing upright before a Russian village: the gouache *Russia* and the fiery yellow and red

painting *Pregnant Women,* exhibited in Amsterdam in May 1914 under the title *Fela,* a month after Fela had given birth to a boy called Odilon, named after the painter Redon. Derived from the *Maria Blacherniotissa,* the Byzantine Madonna type of Russian icon, their composition suggests a resurfacing of Chagall's pent-up longing for family and for Russia. He wrote to Pen, whom he generally ignored, at this time, asking him to "pop in to see my people, when you're in our area," adding "and don't think that I will be forever young, I have grey in my hair." Yet when Tugendhold, then in Russia, urged him to provide drawings to include in Larionov's prestigious "Target" exhibition in Moscow, Chagall first failed to reply ("Why the devil are you silent?" wrote his exasperated supporter), then was so dilatory about sending them that they were on display for only four days before the exhibition closed in April. It was as if he could not quite force himself to reconnect with Russia: he told Pen that "hopefully I will take a trip somewhere" that summer, and even as Bella was looking for him in her entrance hall, he was corresponding with Tugendhold about arranging for a grant from Vinaver to go to Italy. "I am very happy for you, my dear friend. Vinaver regards you very well," wrote Tugendhold in June. "He asked me to write to you after our conversation, that he will prolong your bursary for another year, and agrees with your going to Italy! Although I was slightly shy about mentioning the ticket, I am writing to him today, so that he may append another hundred francs."

Chagall never took that trip; nor did he make any immediate plans to go to Russia. "My dear, will you be home tomorrow?" dreamed Bella, continuing, "But since you want to stay, stay. It's clearer to you. Of course it's boring, but we'll have it your way. I received your letter today—it's as if you wrote it unwillingly . . . Anyway, I hope you will come, will shout at me—all will be well . . . Come to trade." She understood him well: after two years away, he did not want to return without something to show for it—and to trade with the Rosenfelds for marriage to Bella. Towards the end of 1913, however, his fortunes in the West began gradually to change: he could not leave Paris just as the tide was turning in his favour.

One of the paintings that occupied him most intensely in 1913 was the large, esoteric *Homage to Apollinaire.* It depicts a golden hermaphrodite whose single trunk divides in the upper part of the body to form a separate Adam and Eve, standing straight like the hands of a clock within a massive central disk. Crossed by diagonals and divided into coloured segments, the disk seems slowly to rotate like a huge celestial body; it also symbolises the

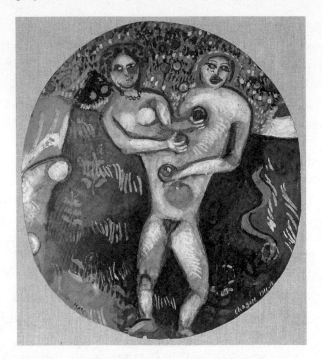

Chagall, sketch for *Homage to Apollinaire*, 1913-14,
gouache on paper

colour wheel, and the clock of eternity: the numbers leading up to midnight–9, 0 (indicating 10), and 1 (indicating 11)–are inscribed in the top left quarter. To Chagall's name in Roman and Hebrew letters is added a black heart crossed through with an arrow, around which are inscribed the names of his most important supporters–Cendrars, Apollinaire, and two new fans: Canudo and Walden.

A gleeful, darting, warm figure, Ricciotto Canudo was editor of the periodical *Montjoie* and hosted a Friday salon that Chagall attended regularly; in 1913 he organised a solo exhibition for Chagall in *Montjoie*'s offices, with works spread all over the tables and chairs, and in the *Paris Journal* described him as the most astonishing contemporary colourist. More important, he introduced Chagall in spring 1913 to a small, pale, spectacled German Jew who sat in the corner of Apollinaire's attic and scouted out French talent with his owl-like eyes. This was Herwarth Walden–né Georg Lewin, a banker's son–patron saint of the Berlin avant-garde and a man of far-reaching and cosmopolitan tastes, who had exhibited at his Sturm gallery German expressionists, French cubists, Italian futurists, and young

Russians. Walden, recalled Ilya Ehrenburg, "had the face of an emaciated bird and long untidy hair. He liked talking about Doppelgänger, intuition, the end of civilization. In the picture gallery where the walls were in a state of frenzy, he felt perfectly at home and treated me to coffee and whipped cream cake." Walden relished controversy–the Berlin press called his artists a *Herde farbenklecksender Brullaffen* (a gang of paint-spattering howling monkeys)–and compulsively sought the new. "This young man with extraordinarily bright eyes and curly hair was venerated by his Parisian friends as a prodigy–which he is, after all," he wrote of Chagall, and he invited him to participate in his "Erster Deutscher Herbstsalon" (First German Autumn Salon) in Berlin in September 1913. The three carefully chosen works Chagall sent, *To Russia, Asses and Others, Dedicated to My Fiancée,* and *Golgotha,* had something in common with the distorted perspectives and wild colours of the German expressionists and made an immediate impact. Bernard Koehler, patron of the Munich expressionist group Der Blaue Reiter (The Blue Rider), centered on the young Germans August Macke and Franz Marc and the older Russians Kandinsky and Jawlensky, bought *Golgotha.* This was the first major work Chagall sold outside Russia. Thus began Germany's love affair with Chagall.

Herwarth Walden

Walden now planned a large solo exhibition in Berlin for spring 1914, while Paris slowly took note. At the Salon des Indépendants in March 1914, Chagall showed *The Violinist, Pregnant Women,* and *Self-portrait with Seven Fingers.* "Cut off the legs and arms of all the men and all the women, make a raft, and we'll go down the Volga . . . I want to cry. Your *Violinist* is the most beautiful picture at the Salon des Indépendants this year," Cendrars told Chagall. When the Paris show transferred to Amsterdam, all three paintings were bought by the collector P. Regnault for 900 francs. (Chagall received nothing, because the gallery's cashier absconded to America with the money; the works are now in Amsterdam's Stedelijk Museum.) Meanwhile, in its February and May 1914 issues, Walden's *Der Sturm* magazine published futurist poems by Cendrars and Apollinaire dedicated to Chagall, cannily building up his image ahead of the solo show in June.

Now possessing some international ammunition, Cendrars persuaded the Paris dealer Charles Malpel on the rue Montaigne to put Chagall under contract. From April 1914 he was to receive 250 francs a month for six small pictures, larger ones counting for two–just over 40 francs per picture, a modest but not derisory sum. Kahnweiler in 1912, in his contract with Braque, negotiated 60 to 400 francs per canvas according to size, and similar terms with Derain; for Picasso the range was 250 to 3,000.

Canudo, calling Chagall one of the "maîtres de demain," aimed higher: he wrote a letter of introduction to the textile magnate and collector Jacques Doucet (future owner of *Les Demoiselles d'Avignon*), hoping to interest him in Chagall's canvases before they left for Berlin. Chagall presented his folder of works in May; it was returned by Doucet's valet after fifteen minutes with the message "We don't need the 'best colourist of our day.' " Chagall, who had been persuaded by Canudo into being uncharacteristically pushy, was embarrassed and hastily wrote to assure Doucet of his modesty.

The encounter showed how uneasy he still felt within the French establishment. In 1912 a *conseiller municipal,* Pierre Lampué, had moaned to the Ministry of Fine Arts that the large number of foreign artists was bringing the Autumn Salon into disrepute, and a socialist *député,* Jules-Louis Breton, had made the same complaint in the Chamber of Deputies. This was nothing new: the French avant-garde had always flourished against official conservatism. But by 1914 the new state of Germany, only forty years old, was obviously far keener to embrace modernising trends and, largely thanks to a cohort of rich, open-minded Jewish collectors, offered a more receptive market than France–even Picasso sold better there. "There is no doubt about it–Germany is our greatest source of enlightenment today regarding French art," Apollinaire wrote in July 1914. With Berlin awaiting his works, Chagall began to fix his attention on Germany, then Russia.

He hoped that Tugendhold, who had recently returned to St. Petersburg, might write the introduction to the Sturm catalogue, and wondered:

> I don't know whether they necessarily will regard me as a *Russian.* Most likely they will decide for themselves. I needn't say how I would be overwhelmed if you introduced it. You were the first, and up until now the only one to *at least* defend me from the evil and mistrust of people. Unfortunately the latter endures. I feel like I am 60, instead of 20 or 30. Good-bye, please write, I'm waiting for your letter . . . sometimes I meet our mutual friends,

but it is rare that I pay them visits. This isn't good. I will make amends.

Your faithful Chagall

Tugendhold's absence left a gap in Chagall's life, and his nervous, mournful side surfaced in his letters to the critic in 1914: "Dear Yakov Alexandrovich, why is there no word from you? How are you? I'd very much like to know. I hope you haven't forgotten me! I often feel, despite there being some friends around, very sad. Work sometimes calms me down, but naturally is seldom able to fully satisfy." Without his closest Russian friend in Paris, the need for Russia became more pressing. Chagall began to let himself dream of Bella again and painted *The Lovers,* where colours and forms merge in a memory of an embrace in his room in Vitebsk, with a twilit landscape of the church on the hill outside his window. Now twenty-four, Bella had finished her studies in Moscow in February and was waiting for him in Vitebsk. With the solo Berlin show and the deal with Malpel, he would finally have enough triumphs to dare to return.

In May 1914 the Russian consulate gave him a passport valid for three months; he tied the door of his studio in La Ruche with rope, turning down a request from Soutine to sublet it temporarily, and left Paris for Berlin. In the next three months he intended to see his Sturm show, travel on to Vitebsk, attend his sister Zina's wedding in the summer, and if all went well, marry Bella and return with her to Paris via Berlin, collecting the money for the works Walden had sold.

On the walls of the Sturm Gallery at 134a Potsdamerstrasse, forty paintings—almost all Chagall's Paris work—hung so close together that they touched; watercolours and drawings were scattered around on tables. This was the first public showing of many of the very large Paris works, including *Homage to Apollinaire, The Cattle Dealer,* and *The Pinch of Snuff,* as well as the first time so many major canvases had been shown together. The effect was electrifying, especially on young German expressionists such as August Macke and Franz Marc. The show was the single most important exhibition of Chagall's life, the foundation of his worldwide fame, and the beginning of two decades in which German collectors constituted the main, lucrative market for his work.

Cendrars, though disappointed that Apollinaire's poem rather than his own adorned the catalogue, was vigilant on Chagall's behalf towards the

slippery Walden. "Your letter to Walden is very clumsy," he scolded Chagall protectively, while to the dealer himself he insisted, "Le prix des tableaux de Monsieur Chagall ne peuvent en aucun cas être changé." He wrote in French, playing off Paris against Berlin, just after the show opened: "Si la 'situation allemande' ne peut se permettre ces tableaux, alors la 'situation allemande' doit y renoncer. J'en suis vraiment desolé. Chagall a déjà un nom, Monsieur Walden, et ce n'est pas votre travail, c'est le sien. C'est bien connu à Paris." ("The price of Monsieur Chagall's pictures cannot under any circumstances be altered. If the 'German situation' cannot support these pictures, then the 'German situation' will have to give them up. I am truly sorry. Chagall is already a name, Monsieur Walden, and it isn't your work, it is his. He is well known in Paris.")

In the event, it didn't matter. Chagall stayed in Berlin only for the opening of his show and to see the Old Masters at the Nationalgalerie and Paul Cassirer's big van Gogh retrospective; he did not therefore witness the continuing sales of his works. His final Paris paintings–scenes of torched Vitebsk huts in *Burning Houses* and *The Flying Carriage*–are often interpreted as presentiments of catastrophe. In hindsight, it is possible to see the entire current of prewar modernist painting, with its keynote of violent transformation, as a response to a Europe that was socially and politically fracturing, an anticipation of the breakdown of the stability of the long nineteenth century. Writing retrospectively in 1922, Chagall himself made this point: "Apparently in those days it was the cow that was directing world politics. Cubism made mincemeat of her, expressionism twisted her . . . Can we help it if we see world events only through canvas and painting materials, thickening and quivering like noxious gases?" Ehrenburg remembered of the Russian café chatter that "before the war the Rotonde had been a place where a sense of catastrophe was served to every customer with his cup of coffee." In November 1915 Apollinaire suggested, "If there had been a bit more cubism, that is to say modern ideas, the war would not have taken place." In Berlin they perceived it differently. Franz Marc, who saw the goal of art as "to dissolve the entire system of our fragmentary sensibilities . . . to shatter the mirror of life so that we may view our being from within," believed war to be a necessary purification for a spoiled European civilisation.

"My pictures swelled in the Potsdamerstrasse while nearby, guns were being loaded," Chagall wrote in his memoirs, but it never occurred to him that he would not be passing through the city again, en route to Paris, in a few months' time. He received letters in mid-June from Malpel, demanding

to know when he would return, and from Fela and Blaise Cendrars, who wrote, "I very much want to see you. Come back to Paris! Kisses." Chagall's mood was lighthearted when, hours before he boarded the train to Vitebsk on June 15, he sent a cheerful postcard, with the Sturm's reproduction of his *The Cattle Dealer* on the front, to Robert and Sonia Delaunay in Paris. "It is warm, it is raining, sauerkraut," he wrote. "German girls are quite extraordinarily not pretty. I am leaving today: Vitebsk, Pokrovskaya."

Chagall, *Jew at Prayer*, 1912–13, oil on canvas

Homecoming

Vitebsk, 1914–1915

W ell, this is Russia! Just look at it!" Chagall said scornfully as the Berlin train crossed the border into imperial territory. He shared a compartment with a bewildered French governess en route to a new post in Tsarskoe Selo. But in Lithuania the train made an unprecedented long stop, for the tsar "had taken it into his head to visit Odessa and was receiving delegations at the Vilna station." From the carriage window, past and present collided: the governess's expectations of nineteenth-century hierarchical Russia and preparations for a twentieth-century war as Tsar Nicholas II rallied troops across the country.

And then, to a mixture of rapture and deflation, Chagall was in Vitebsk– "a place like no other; a strange town, an unhappy town, a boring town . . . Is that Russia? It's only my town, mine, which I have rediscovered. I come back to it with emotion." Here were Bella, his parents, and his sisters. He lived again on his parents' doorstep, in a room in an outbuilding of one of his mother's tenants; he attended Zina's wedding; he and Bella were again inseparable; he painted the old view from the window. Seen through a wooden frame, with the last blocks of winter ice on the ledge, curtains fringing the panes, the hens and calf behind the fence, and the green-domed churches in the thin northern light, *Window, Vitebsk* is a quiet, masterful picture that sets the boundaries of Chagall's reacquired milieu. "I painted everything I saw," he said. "I was satisfied with a hedge, a signpost, a floor, a chair." Soon he rented a room of his own nearby in the house of a tall police-man with a drooping moustache. He lived opposite the Ilyinskaya Church, and here Bella visited freely and through half the night, tapping on the shut-

Chagall, "Interior from Bella's Window," 1914, drawing

ters and inflaming gossip by climbing in and out through the window when the front door was locked. The policeman's "little white cottage with its red shutters was like his summer helmet with its red trimmings. It was on a corner, by a long wall enclosing a convent standing in a large garden," she remembered. Chagall kept the shutters half-closed all day, to soften the light and for privacy.

As for any returning native, the enchantment lay in how things had changed and yet remained the same: Vitebsk's churches, its Moscow bank, the pharmacy, the scales and shelves of his mother's store. Suddenly these became the subjects of his paintings. *Street in Vitebsk,* depicting a green lane lined with wooden houses leading into countryside, typifies the new-found calm and gentleness. The road disappears in the depths of the land-scape, but nothing pulls us into the distance: reality begins and ends here in this self-enclosed half-rustic town. There is a lack of equilibrium in the houses, recalling that in *The Dead Man,* but here it serves to emphasise the everyday, provincial nature of Vitebsk, perceived all the more intensely in contrast to the grandeur and regularity of Paris. But what gives the entire

scene life is the soft luminosity with which the subdued velvety texture of the blues, greens, and browns blends and resonates.

Overnight Chagall's art transformed, as if he had undergone some psychic shock; at no point in his long life did his painting change so dramatically and instantaneously as it did in 1914, when he returned to Russia, and in 1922, when he left again. In Vitebsk in 1914 the overheated colours, exaggerated forms, and fantastical imaginings of the Paris period vanished; dislocated perspectives were straightened out, and ironic fragmentation was transmuted to a lyrical depiction of life around him. His hometown was no longer a visionary, ecstatic memory but an accepted, sometimes melancholy reality, and in harmonious, shimmering compositions, he plunged into the series he called his Vitebsk "documents" of 1914–15. Bathed in transparent colour, a touch of crimson enlivening its warm grey-yellow tonality, *House in the Shtetl, Lyozno* depicts a windswept shop sign at a bizarre angle and bored shopkeepers losing themselves in endless chatter. *The Barbershop* shows the interior of the hairdressing salon, its cheap wallpaper, misspelled notice, and dusty air lit by a pallid sun, and Uncle Zussy sitting resigned, vainly waiting for the next customer. "Thus a man speaks with delight in his native tongue after a break," wrote the Russian critic Mikhail Guerman, "hesitating for a second in the search for the right word, then pronouncing it, savouring it and listening intently to it."

In all these works it was as if time had stood still, life stopped. But layered into Chagall's response to his homecoming was the fear that the opposite was true: not only the new familial contentment but also the threat of war made him rush to set down the immediate reality, in the fear that it would soon vanish forever. A week after Chagall arrived home Archduke Ferdinand of Austria-Hungary was assassinated in Sarajevo. Pyotr Durnovo, interior minister and director of police, had warned Nicholas earlier in the year that if a war went badly for Russia, "a social revolution in its most extreme form will be unavoidable," but nevertheless on 30 July the tsar ordered a full mobilisation. By 3 August Russia was fighting Germany and Austria-Hungary, military censorship was in force, St. Petersburg was patriotically renamed Petrograd, and communication with western Europe ceased. "The First World War exploded suddenly: the earth began to quake under our feet," wrote Ilya Ehrenburg. The initial burst of excited patriotism with which many intellectuals in the West greeted the war was not generally shared in Russia. "A terrible sadness fills me," said Maxim Gorky. "I work and I think, but what is the point? For this war will fill the world with hate for at least a hundred years."

In the yellowish-green tones and menacing shadows of Chagall's painting *Smolensk Newspaper*, two Jews sitting at a table are stupefied by the single word *Voina* (War) printed on the *Smolensk News* lying between them. The younger man, in bowler hat and Western dress, is in a frenzy of anxiety; in the pensive expression of the older one, a bearded patriarch in traditional dress, we read a reflection on the continuing cycle of hostilities and suffering for his race. "German Jews are going to fight 'barbarous Russia' and speak of revenge for . . . the October pogroms. Revenge for whom? After all, there are tens of thousands of Jews in the Russian army, and the German army will have to devastate the self-same area of the Pale which had been ravaged earlier by the Russian pogroms. The tragedy of the situation defies description," wrote the Jewish historian Semion Dubnov in August 1914.

Vitebsk rapidly became a frontier town. Soldiers arrived to leave for the front from the railway station, and stretcher bearers returned with the wounded; German prisoners were herded through; refugees flooded in, fleeing from the Germans. Chagall painted them all. "Soldiers, moujiks in woollen caps, with *laptis* on their feet, pass in front of me. They eat, they stink. The smell of the front, the strong odour of herring, tobacco, lice. I hear, I feel, the battles, the cannonading, the soldiers buried in the trenches." Soon a million Jews on the western edge of the Pale of Settlement, hundreds of miles from Vitebsk, were absurdly accused of spying by Russia's anti-Semitic chief commander, Grand Duke Nicholas Nikolaevich, and were given twenty-four hours to leave their homes–or be shot. As anti-Semitism soared, a group of intellectuals, including Alexander Kerensky, Maxim Gorky, and Rimsky-Korsakov, issued a protest, "Appeal for the Jews." "Russian Jews have rendered honest service in all domains left open to them. They have given ample proof of their desire to offer supreme sacrifices for their country," they said. "Fellow Russians! Remember that the Russian Jew has no fatherland other than Russia and that nothing is more precious to a man than his native soil . . . The welfare of Russia is inseparable from the welfare and freedom of all its constituent nationalities." But such words were ineffectual; penniless and wretched, the Jews of the Pale trudged east. "I longed to put them down on my canvases, to get them out of harm's way," wrote Chagall. Sack on his back, a shabby Russian cap on his head, stick tilting in parallel to the lamppost on the ground, the old beggar who walks above the snow-covered velvety town in *Over Vitebsk* is the eternal Wandering Jew. Heavy but weightless, his disproportionate presence–he is taller than the Ilyinskaya Church, which dominates the composition–transforms the landscape from the commonplace to the mystical.

Chagall, "The Departure," 1914, drawing

In the compressed blocklike print *War* a soldier, knapsack on his back, stands out as a black shape against the huge station window; behind him another, about to depart, embraces his girlfriend, while across the sky run the words "War-1914-Russia-Serbia-Belgium-Japan-France-England." For "Wounded Soldier," a drawing of an injured man grimacing, his head twisted in pain, Chagall blacked out the paper with India ink, leaving eerie white areas for the bandage around the head, the eye sockets (one is empty), and the teeth. *The Newspaper Vendor,* a bearded, sorrowful figure shadowed against a crimson sky, wanders along a dark road and offers the grim news of the day, in a pile of papers whose overlapping geometric shapes and broken lettering are the ironic debt to the cubism of Chagall's Paris years. "Chagall's works which deal with war may be displeasing," wrote the faithful Tugendhold, "but where other painters glory in wood or iron Chagall evokes men." In another drawing on grey paper an old man, weary and mournful, clasps a journal with VOINA (WAR) written in large letters. This is the sketch for one of the first monumental portraits of figures from Vitebsk daily life that Chagall made on his return.

Chagall, "Wounded Soldier," 1914, drawing

No major twentieth-century artist, until perhaps Lucian Freud, painted so obsessively the members of his family, their lives and fates individualised and chronicled, and his immediate circle, including the down-and-outs and even the freaks of Vitebsk–the equivalents of Lucian Freud's Leigh Bowerys and Big Sues in the wartime Pale of Settlement–as Chagall did between 1914 and 1915. *Jew in Green, Jew in Red, Jew in Bright Red, Praying Jew (Jew in Black and White):* these monumental portraits of old beggars who wandered into Feiga-Ita's shop or the kitchen on Pokrovskaya were all made in the first months of Chagall's return. "Sometimes a man posed for me who had a face so tragic and old, but at the same time angelic. But I couldn't hold out more than half an hour . . . he stank too much," Chagall insisted. These figures are so true to life that we can feel their physical presence, the weight of their fatigue, the resignation in their lined faces and bent bodies. Yet although they move us to sympathy, even stronger is a sense of wisdom and the instinct for survival. Chagall's respect for old age recalls Rembrandt's old men, especially Rembrandt's *Old Jew,* but there is nothing imitative or academic about them, as there is in Chagall's old teacher Pen's portraits of

Chagall, sketch for *The Newspaper Seller,* 1914, drawing

Vitebsk Jewry. Chagall's Jews are symbolic, transcendental figures because they are also modern, ironic ones, distorted by sharp contrasts—each a mix of rounded forms and zigzags, edgy lines, geometric shapes—and defined by flamboyant nonnaturalistic colour that gives each picture its special tone. The series stands as a peak in his oeuvre and of early modernism: here Chagall overcame the battle with cubism, which had occupied him throughout the Paris years, to break through to his own mature individual style, uncompromising in its figurative impulse yet alert to every artistic current, and to the instability of history—soon these old Jews would disappear forever from the Pale.

"I had the impression," Chagall said of *Jew in Green,* "that the old man was green; perhaps a shadow fell on him from my heart." This man arrived and sat down mutely at the table in front of the samovar, and Chagall lured him to his studio.

I look questioningly at him: "Who are you?"

"What! You don't know me? You've never heard of the preacher of Slouzk?"

"Then listen; in that case, please come to my house. I'll make . . ." What shall I say? . . . How explain to him? I'm afraid he'll get up and go away.

He came, sat down on a chair, and promptly fell asleep.

Have you seen the old man in green that I painted? That's the one.

Suggesting the meditative countenance of the prophet Jeremiah, this beggar-preacher's inspired face is illuminated by the dusky gold of his beard; he sits on a bench carved, in Hebrew, with the biblical script in which God told Abraham that his was the Chosen People—the basis of the preacher's existence. "I start from the initial shock of something actual and spiritual, from some definite thing, and then go on toward something more abstract," Chagall explained. "This is what happened in the *Jew in Green* whom I painted surrounded by Hebrew words and script characters. This is no symbolism, it is exactly how I saw it, this is the actual atmosphere in which I found him. I believe that in this way I arrive at the symbol, without being symbolistic or literary."

The preacher from Slouzk also sat for *Jew in Bright Red,* in which his beard flows like lava and he sits before a cluster of red and pink houses like a giant, his face contorted by intense thoughts: a towering psychological presence, his frail form transformed by the strength of his faith. Around him the world of ideas is made concrete: a golden arc is covered with Hebrew characters, including Chagall's name; an ink stand and pen on a roof represent the Holy Scripture; a flowering tree suggests Aaron's staff. A companion picture, *Jew in Red,* has a dejected old man with a sack fleeing war; this work is inscribed, in combinations of Cyrillic and Roman lettering, with the names of Chagall's favourite artists: Giotto, Cimabue, El Greco, Chardin, Cézanne, van Gogh, "Mujik Brueghel" (peasant Brueghel), and Rembrandt—whose name is written in Yiddish. This is Chagall's homage to Western art and its preoccupation with the human figure, at a time when war divided him from it.

Another variation is the statuesque, despairing, yet resilient black and white figure draped in Chagall's father's prayer shawl in *Praying Jew* (*Jew in Black and White,* also sometimes known as *Rabbi of Vitebsk*):

Another old man passes by our house. Gray hair, sullen expression. A sack on his back . . .

I wonder: Is it possible for him to open his mouth, even to beg for charity?

Indeed, he says nothing. He enters and stays discreetly near the door. There he stands for a long time. And if you give him anything, he goes out, as he came in, without a word.

"Listen," I say to him, "don't you want to rest a while. Sit down. Like this. You don't mind, do you? You'll have a rest. I'll give you twenty kopeks. Just put on my father's prayer clothes and sit down."

You've seen my painting of that old man at prayer? That's the one.

Praying Jew, classical in colouring and the most overtly religious work of the series, was singled out as the "cornerstone of the revival of Jewish art . . . entitled to occupy the first place in a Jewish museum" by Issachar Ryback and Boris Aronson, in their nationalist plea "Paths of Jewish Painting" in 1916. It remained one of Chagall's favourites: for safekeeping, he stored it under his bed until he sold it to the collector Kagan-Shabshay, and he made two copies of it, enjoying, according to Virginia Haggard, "going through this act of creation a second and a third time, trying to probe its mystery."

Reabsorbed into the milieu of the Pale, it never crossed Chagall's mind, as a Jewish second-class citizen of the tsar, to think of enlisting in 1914. Nonetheless the war shaped his art. "Far from the Salons, the exhibitions, and cafés of Paris, I asked myself: 'Is not this war the beginning of a certain verifying of accounts?' " In 1914 he caught in its very last days small-town prerevolutionary Jewish-Russian existence, highlighting against a world of mass destruction the imaginative life of the individual. Each member of his family was lovingly painted, their changes in the last three years dwelt on. His father was more frail; the youngest child, Mariaska, had grown from little girl to gauche adolescent, her gamine charm caught in *Mariaska,* in red polka-dot dress and plaits; Chagall's favourite sister, Lisa, was a thoughtful 16-year-old, portrayed in the delicate *Lisa by the Window,* where she sits looking out at the world, unsure what life will bring. Sketches of the older sisters show that they had become sleek, modern young women, with slick Western-dressed husbands in tow, but David, back from Prussia and ill with

the beginnings of tuberculosis, is portrayed by Chagall defiantly making music in the cold blue monochrome of "David with a Mandolin." His distorted eyes and masklike face are shot through with pain; his exuberant pose, with its sharp angles of elbows, cheeks, and lapels, is frozen like that of a ghost: an image not only of a suffering young man but of all the tremors and uncertainties of 1914. The anxiety took its toll on Feiga-Ita, who in *Mother on the Couch* is an old lady (she was then forty-eight), huddled in a shawl lying asleep. The gouache close-up portrait *My Mother,* with its arrestingly lifelike treatment of the old exhausted face, the sad grey eyes still eager and piercing, the wrinkled brow framed by thin lank hair, is so harrowing that when Chagall's daughter Ida, herself then an old, ill grande dame in

Chagall, "David with a Mandolin," 1914, gouache on cardboard: a portrait of Chagall's brother

her seventeenth-century house in Paris, came across it in 1991, she identi-fied with her long-dead, unknown Russian grandmother so powerfully that she could not bear to have the likeness near her and sent the painting as far away as she could, as a gift to the Pushkin Museum in Moscow.

Most tender of all are the depictions of Bella that Chagall made on his return. An untitled work, showing her in profile and swathed in a black shawl that seems to dissolve into bright flowers, is painted with the gentle-ness and thrill of rediscovery: a solemn, pale, reassuring figure glancing towards but beyond us, her shawl warmly enveloping us and the picture as she turns away from an open window. Chagall's world now moved inwards; Tugendhold noticed how, returned to the warmth of his family and the love affair with Bella, he calmed down: "In those provincial streets, under a som-bre grey sky, with the heaped-up wooden houses, delicately puffed-up trees, native shop signs, and poor thin horses, you no longer hear the anguished scream. You sense in them some subdued humble love." Abraham Efros, the only other Russian critic to take Chagall's art seriously then, saw Vitebsk in 1914 as "a cure for Chagall. Like a prodigal son returning to his father's home, he returned to his Jewish shtetl world. He attached himself to it with the same zeal and fervour of spirit with which, in Paris, he crumbled and eroded its poor forms . . . He cultivates and lavishes all the subtlety and del-icacy of his amazing palette and the nobility of a refined painting to record respectably the face of his reacquired homeland."

But if the Vitebsk "documents" were an embrace of all Chagall had missed in the last three years, they were also a consolidation of everything he had learned in Paris, a play of masterly technique, style, and expression that was rigorously modern yet, in its emphasis on the human figure, at odds with the contemporary Russian avant-garde.

The clash of the Russian present and the sense of himself as a European artist that he brought back from Paris stimulated an intense identity crisis in twenty-seven-year-old Chagall during the months after his return. He painted more self-portraits in 1914–15 than at any other period in his life; they speak of waves of self-doubt, anxious self-assessment, as well as a virtu-oso contrast of styles, as he faced an uncertain future.

In *Self-portrait in Front of the House* he is in bow tie and dress suit, the proud, cosmopolitan native returning to his parents' home. In *Anywhere Out of This World* his head is cut off and, desperate to escape, floats away along a Vitebsk street that is turned upright to run along the edge of the pic-ture. *Self-portrait* has the mischievous look, laughing lips, and twisting face

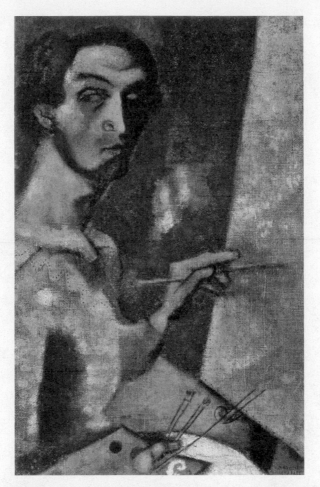

Chagall, *Self-portrait with a Palette,* 1914, oil on canvas

and neck, graceful and supple, of the long-limbed acrobats whom Chagall
also started painting at this time. The checkered costume of *Self-portrait
with a Palette,* given to Ilya Ehrenburg, also suggests a harlequin: with an
ironic half-smile, Chagall stands before an empty canvas tinged with vibrant
blue but painted so thinly that the weave of the actual canvas shows through
and appears to reflect the bluish tints of the artist's costume like a mirror, as
the painter-joker demands, what is art, what is reality, who am I? At the
other extreme, *Self-portrait with White Collar* is a confident classical work
in subdued colour and dark tones: clear features, composed gaze, and a face
surrounded by the leaves of a plant, like a crown of laurels—Chagall wanted
provincial Vitebsk, and especially the Rosenfelds, to see him as part of the

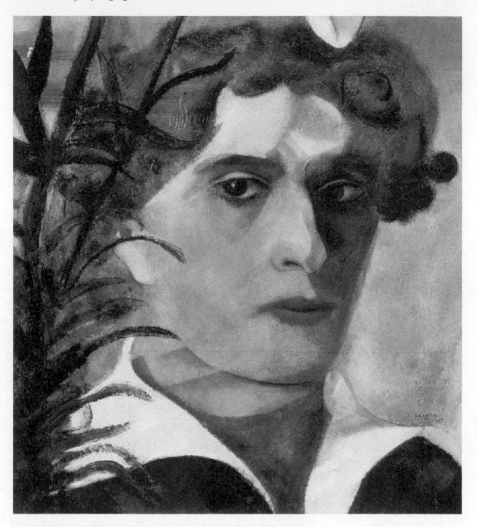

Chagall, *Self-portrait with White Collar,* 1914, oil on canvas

heroic Western tradition. But *Self-portrait with Hat* gives him a soft, effemi-
nate face, pretty lips, and curling locks. "It looks to me," said Alta Rosen-
feld, "as though he even puts rouge on his cheeks. What sort of husband will
he make, that boy as pink-cheeked as a girl? He'll never know how to earn his
living."

This, in 1914, appeared to be true. Chagall's studio in La Ruche, his
Paris dealer, his paintings at the Sturm exhibition, his Berlin gallerist–
everything he had painstakingly built up over the last three years was now
unreachable and irrecoverable. He had no money, there was no question of

his receiving any payments from Walden or Malpel, and he could only rarely get hold of canvas–most of his oils during the war were painted on cardboard. With the evaporation of his prewar prospects went his hopes to persuade the Rosenfelds that he was respectable enough to marry Bella, and he found Shmuel Noah and Alta not much keener on him than before: " 'You'll starve, with him, my daughter; you'll starve for nothing.' 'And besides, he's an artist. What does that mean?' 'And what will everybody say?' Thus my fiancée's family argued about me, and, morning and night, she brought to my studio sweet cakes from her house, broiled fish, boiled milk, all sorts of decorative materials, even some boards which I used for an easel."

Could he, should he get married? Chagall agonised to Tugendhold. Yes, said the critic, but no children. Tugendhold moved to make marriage a possibility, persuading Moscow collector Ivan Morozov in 1914 to buy *Window, Vitebsk, The Barbershop,* and *House in the Shtetl, Lyozno* for 300 rubles each. This was far more than Malpel had paid, and Chagall's first sign of acceptance in Russia since his return, but still throughout 1914 he thought ceaselessly about going back to Europe. In September his three-month visa expired. He had neither the papers nor the means to leave Vitebsk; he was "stuck involuntarily" in their homeland, he told Sonia Delaunay in November, in one of the few brief letters, stamped "War Censorship," that he managed to get through to the West: "How is the fate of our friends contemporaries acquaintances artists and writers? What happened to all our impulses and aspirations?" he wrote. ". . . I am longing for Paris. As to my exhibition [in Berlin], alas, against its will it became a prisoner of war." But he still hoped to return soon: a postcard written the same month to the poet Mazin, in response to a communication about his room in La Ruche, for which the rent was long overdue, begged him to mediate on his behalf with the concierge but, if the room must be given up, to "take my best belongings–photo albums, letters, carpet, pillow, bedclothes, best paintings– don't take anything else"–and ends "I beg you always to confide in me."

In Berlin his recent admirers Franz Marc and August Macke enlisted in the kaiser's army; Macke was killed in the first months of the conflict, Marc in 1916. In Paris, Swiss-born Cendrars had joined the Foreign Legion; pacifist Delaunay fled to Biarritz, then Spain, on the day mobilisation notices were posted; Apollinaire joined the artillery. The wider artistic Parisian community dissolved. Modigliani was rejected as unfit to fight. Braque and Derain went early to the front and became exemplary soldiers. Léger distinguished himself as a sapper in an engineering corps and became a legend

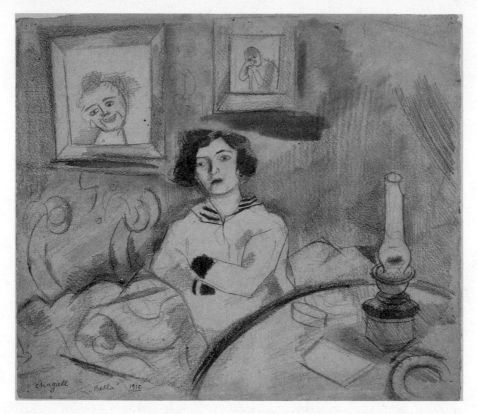

Chagall, "Bella with Arms Crossed," 1914, drawing

when his wife disguised herself as a soldier in order to make love to him in the trenches. Among the Russians in Paris, Zadkine became a stretcher bearer with the Russian ambulance corps on the French front, from where he managed to get a single letter through to Pen. "How are you feeling and what are you doing? How are our friends–Lissitzky, Libakov, Masel, Mekler, and Chagall? Please, for God's sake answer me, I would be so glad to hear how everyone is," Zadkine wrote. "I'm in fine health but tired of it all–it's utterly disgraceful, makes the soul turn cold. If only it could just end. What are you working on, what are you doing? Please write me." Zadkine was a cosmopolitan Parisian, yet his warm letter suggests that he also had a Vitebsk identity and saw himself belonging to an elite band of Pen's students, of whom Chagall, even at this stage, was a part. All those named by Zadkine became successful artists in Russia apart from poor Mekler, who ended up a Vitebsk schoolteacher in the 1920s and was last known to be alive in 1936.

But this was not a community with which Chagall could accept identification. He was, he moaned to Benois, "held up here by the war and bored to death" in Vitebsk. *The Clock,* in which he sits, a tiny figure dwarfed by his parents' big clock, and its pendant *The Mirror,* with the small outline of Bella, her head in her hands, crouched at a table below the giant mirror in her dark Smolenskaya drawing room, capture the claustrophobia Chagall felt in Russia, the instability and introversion, the sense of the individual's smallness and irrelevance before the march of history. "I cannot find words to express my grief," he told Benois, begging (as usual without success) to be included in the next World of Art exhibition. "Everything is stranded over there. My works are dear to me, each in its own way, I shall have to answer for them on the Day of Judgment. God alone knows whether I shall ever see them again. Quite apart from the money which I was going to receive for their sale there, and it is no small sum . . . I would come [to Petrograd] myself if you could accommodate me in the exhibition, although the main thing would be if you could attribute some artistic value to me."

But Benois and the World of Art exhibitions were now losing significance. The two major shows in Russia in the first half of 1915 were "The Futurist Exhibition: Tramway V," launched by Ivan Puni in February in Petrograd, and "The Year 1915," a massive overview of diverse contemporary trends organised by K. Kandarourov, which opened at the Mikhailova Salon on Bolshoi Dimitrievka in Moscow on March 23. To this important landmark, symbolic of the dramatic change in the status of the avant-garde since his departure in 1911, Chagall was invited to contribute twenty-five recent works: it was a turning point in his career and reputation in Russia. *Praying Jew* had a particular impact, and in his review Tugendhold singled out Chagall as "one of the great hopes of Russian art." By contrast, the figures who had been dominant when Chagall departed in 1911 were now fading: Larionov was represented by nine works and Goncharova by four. Larionov, one of the few artists to see active service, had returned from the front seriously wounded in October 1914, spent three months convalescing in hospital, and never recovered his creative talent; he and Goncharova left Russia early in 1915 for Switzerland, to work with Diaghilev.

The artists who would take their place were just emerging as stars: "Tramway V" was dominated by Vladimir Tatlin, who showed "painting reliefs" in tin, wood, iron, glass, and plaster, derived from Picasso but, in Tatlin's demand for real materials in real space, pointing straight to constructivism; and Kazimir Malevich, who was already developing his supre-

matist works but showed only advanced cubo-futurist paintings such as *Woman in a Tram* and *Portrait of M. V. Matiushin.* Both "Tramway V," despite its futurist title, and "The Year 1915" demonstrated the pluralism of styles that was a feature of the Russian avant-garde at this point: in Moscow there was remarkable figurative work, such as Nathan Altman's blue and yellow cubist *Portrait of Anna Akhmatova,* while in Petrograd Popova and Udaltsova showed cubist works from Paris. "The term 'Futurism' appeared here unlawfully," commented poet Benedikt Livshits in his memoir. "The movement was a stream of heterogeneous wills of different aspirations, characterised above all by a unanimity of negative aims." For a brief period, artists of diverse sensibilities and ambitions, united only by a desire to break down old academic models in the decade following cubism's breakthrough, coexisted in a liberal milieu. "I found the atmosphere much more sympathetic," Chagall recalled. "Collectors were more open-minded, there were more of them, too." One, the rich engineer Kagan-Shabshay, bought thirty of his works in 1915 for a projected Museum of Jewish Art.

During his first months back in Vitebsk, Chagall had lived almost reclusively, absorbed in the reunion with Bella and working at a frenzied pitch as he broke through to a new vocabulary—the second half of 1914 was one of the most richly productive periods of his life. Now in 1915 he seized the optimistic moment and forced the Rosenfelds at last to take him seriously. Bella had been at home waiting to marry her fiancé since February 1914; the war heightened their love affair and weakened the control of the older generation over the young. When Chagall and his brother were conscripted in early 1915 and David left for the Crimea, the Rosenfelds swung into action. Chagall's appeal for a passport to leave Russia was rejected, and so was his request, as a painter, to work on camouflage as his army service, so Bella's brother Yakov, who ran the Central Bureau for War Economy in Petrograd, came to the rescue with a clerical job that counted as military service. It was scheduled to begin in the autumn, and Chagall's marriage to Bella was fixed for July.

Weeks before it took place, Feiga-Ita died, exhausted by a life of struggle, aged forty-nine; she had waited for her favourite child to return from Paris, and now she knew he would be looked after. Chagall was, he says, not at home when she died; he may have been in Petrograd sorting out his war job and stayed away deliberately: "I couldn't have endured it. As it is, I feel life too keenly. To see, in addition, that 'truth' with my own eyes . . . to lose the last illusion . . . I can't . . . my mother's face, her dead face, all white. She

loved me so dearly. Where was I? Why didn't I go? It isn't right." Five years later he wrote:

> I shall always have a sinking feeling in my heart—is it from sleep or from a sudden memory on the anniversary of her death?—when I visit her grave, the grave of my mother. I seem to see you, Mama. You come slowly towards me. So slowly that I want to help you . . . Here is my soul. Look for me over here, here I am, here are my pictures, my origin . . . Lake of suffering, hair grey too soon, eyes—a city of tears.

The Vitebsk works of 1914–15, drenched in an idealized sense of community and mother-love, were Chagall's monument to Feiga-Ita. As soon as she was dead, he began a new, quite different series of paintings, conveying the rapturous interiority he now shared with Bella: the *Lovers* series, in which he shut out the world of war and began life as a married man.

Chagall, "On Mother's Tombstone,"
etching from *My Life*

Married Man

Petrograd, 1915–1917

Marc Chagall married Berta Rosenfeld on 25 July 1915 in a traditional Orthodox ceremony in Vitebsk. Chagall began their marriage portrait on his twenty-eighth birthday on 7 July 1915, when Bella appeared in his room laden with shawls, silk squares, and flowers. "You suddenly went and rummaged among your canvases and put one on the easel," she remembered, in a narrative dedicated to him.

> "Don't move," you said. "Stay just like that." . . .
>
> You dashed at the canvas with such energy it shook on the easel. You plunged the brushes into the paint so fast that red and blue, black and white flew through the air. They swept me with them. I suddenly felt as if I were taking off. You too were poised on one leg, as if the little room could no longer contain you.
>
> You soared up to the ceiling. Your head turned down to mine and turned mine up to you, brushing against my ear and whispering something . . . Then together we floated up above the room with all its finery, and flew . . . The brightly hung walls whirled around us . . . We flew over fields of flowers, shuttered houses, roofs, yards, churches.

The exhilaration of early married life merges here in Bella's memory with the impact of the painting *The Birthday,* which Chagall did not of course complete within minutes–a preliminary sketch exists–but finished in the days leading up to their wedding. It shows a wide-eyed, awestruck Bella gliding up to Chagall who, supple as an acrobat, swoops through space to kiss

her. This abundant, richly coloured painting, with its blend of fantasy and reality, expressed the intense hope, love, and poetic feeling that she brought to the marriage and that now influenced Chagall's art. "I had only to open my bedroom window, and blue air, love and flowers entered with her. Dressed all in white or all in black, she seemed to float over my canvases for a long time, guiding my art. I never finish a picture or an engraving without asking for her 'yes' or 'no.' " Later he explained, "She really *felt* me, she was part of my crazy inventions, they never seemed strange to her."

Above the Town is the married sequel to *The Birthday:* Bella, wearing the same black dress with white lace collar and cuffs, flies with Chagall above snowy Vitebsk, their bodies fused together, each having only one arm. Bella's face has lost the innocent expression it has in *The Birthday* and is sombre and full of longing as she stretches out her arm protectively over her hometown, suggesting both maternal shelter and the transcendence of love. The soaring couple also recalls the figures in flight that Chagall had first introduced into his canvases in Paris, but here the setting is naturalistic, and at ground level a man squats by a fence in the snow, relieving himself. With such a detail Chagall told prerevolutionary Russia that, despite his refined wife, he was still a man of the people.

Writing in 1922, after the Bolshevik victory, Chagall, keen to dissociate himself from the rich Orthodox Rosenfelds, described his wedding in terms that mock both bourgeois and Jewish tradition:

> Was it worth while to make friends with such high-class people?
>
> I arrived very late at my fiancée's house to find a whole syn-hedrion already gathered there . . . Around the long table, the great rabbi, a wise old man, a trifle crafty, a few big, imposing-looking bourgeois, a whole Pleiad of humble Jews, whose insides crisped as they waited for my arrival and . . . for the marriage feast. For without me there would have been no marriage feast. I knew it and I was amused at their agitation.

But the honeymoon was undeniably a bourgeois idyll, spent at the Rosenfelds' dacha in Zaolshe, a village a few miles from Vitebsk, in serene countryside similar to that in Lyozno, and with plentiful food supplies. Cows grazed nearby, and Chagall renamed the honeymoon "a milkmoon." Bella, who became pregnant immediately, fed him on rich fresh milk, "with the result that by the autumn I could scarcely button my coats."

"Woods, pines, solitude. The moon behind the forest. The pig in the sta-

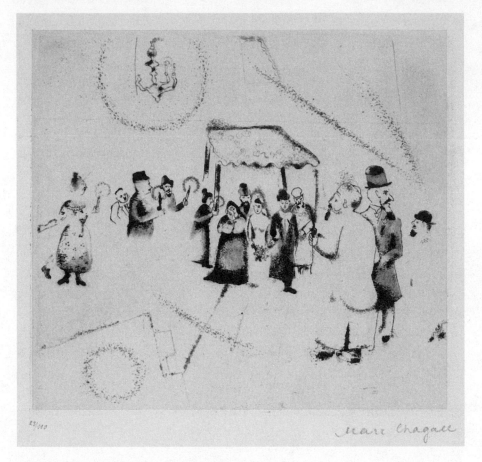

Chagall, "The Wedding," etching from *My Life*

ble, the horse outside the window, in the fields. The sky lilac": this is the tone of the peaceful honeymoon self-portrait *The Poet Reclining,* where Chagall lies dreamily in a field. In *Window in the Country* the masklike faces of Chagall and Bella, superimposed on top of each other, gaze contentedly at a silver birch forest, at one with each other and with nature. This was the first painting in a rural cycle of family life to which Chagall returned, staying again in the Rosenfeld dacha, in the summers of 1916 and 1917. Bathed in translucent light, *Country Interior, Bella at Table, Bella on the Terrace,* and *Interior with Strawberries,* centred on the dacha's dining room with its triple windows giving out onto a lush forest, soft sunlight streaming through the glass, have a special charm—a stage set apart from war and deprivation.

But "my wife preferred big cities. She loves culture. She is right." In September Chagall was due for military service in Yakov Rosenfeld's office at 46

Chagall, "Honeymoon," 1915, drawing

Liteini Prospekt, and the couple moved to Petrograd, staying first with Chagall's old patron Goldberg at 18 Nadezhinskaya, then in a small apartment in a four-storey building at a less fashionable address, 7 Perekupny Pereulok.

Life in wartime Petrograd was much tougher than in Vitebsk. At the war office Chagall was a liability, confirming the Rosenfelds' worst fears about his incompetence. "My chief made war on me. As he was my brother-in-law he was always afraid of being called down for my inefficiency so he kept a particularly close watch on me . . . He would sweep all the papers off my desk and shout, furiously, 'Well then what kind of method do you have? What have you done? Is it possible, Marc Zakharovich, you didn't know even that?' " Soon Yakov suggested his useless employee limit himself to reading the newspapers; in fact Chagall spent much of the time at his desk illustrating Yiddish books: the fantastical fables "The Rooster" and "The Little Kid" by Der Nister (The Hidden One), pseudonym of the writer Pinchus Kahanovich; and Isaac Peretz's sarcastic story of shtetl life "The Magician." Nevertheless in 1917 he complained that he had been forced "to serve three years of sheer torture in a department of the Central War and Industry Committee"; he never showed Yakov any gratitude for saving him from the front.

Every day after work, Chagall said, he went home and almost cried to Bella. Their flat was too cramped for him to paint, and it was hard to get materials. He had always disliked the Russian capital, and now his feeling of claustrophobia there returned. "My situation is getting more and more intolerable. I lie in bed (sick) or roam the streets, stopping at each corner exhausted. I am utterly alone and sometimes I am tempted to smile at the

first passer-by on the street in order to feel his sympathy," he wrote in a letter soon after his arrival. Replying to Sergei Makovsky, publisher of *Apollon,* who had sent him a welcoming note, he said, "The sun has only ever shone for me in France (it certainly did that!) I have got used to beating the streets of Paris, happy beyond words dreaming of a life 125 years long (with the Louvre in the distance). Having ended up in the Russian provinces, I have decided to die. Thank you for your greetings."

Around Chagall and the pregnant Bella, the fabric of city life was disintegrating. Petrograd depended on food supplies being brought in from a distance; in the autumn of 1915 shortages, caused by the disruption of the railway system, became so bad that women were bringing makeshift beds to queue overnight outside bakeries and butchers, waiting an average of forty hours a week in lines that became forums for revolutionary dissent. "We will soon have famine," Gorky wrote to his wife from the city in November.

> I advise you to buy ten pounds of bread and hide it. In the suburbs of Petrograd you can see well-dressed women begging on the streets. It is very cold. People have nothing to burn in their stoves. Here and there, at night, they tear down the wooden fences. What has happened to the Twentieth Century! What has happened to Civilization! . . . [I am] in such a state of sadness that I feel like banging my head against a wall. Oh, to hell with it all, how hard it has become to live.

From Petrograd in January 1916 Alexander Blok wrote, "I cannot understand how we can say all is well when our country is on the edge of collapse, when neither the society nor state, neither family nor even the individual exist any more."

The Chagalls shared their flat with Dr. Israel Elyashev, the Yiddish literary critic who wrote under the name Ba'al-Makhshoves (Mastermind), and his son Alya. A single parent whose wife had left him, Elyashev was partly paralysed and had served as a physician in the army. He was what Chagall called a "nerve doctor" before psychoanalysis became fashionable; with no patients, he tried to psychoanalyse Chagall, asking about his mother and father, and mused about why his own wife had rejected him, while Chagall sketched him. He and Chagall strolled the streets together day and night or sat in the only warm room, the kitchen, endlessly drinking tea while little Alya stood on the side, hungry, gloomy, and cold; a treat in those days, Chagall remembered, was horse meat.

Instability and anxiety are the mood of most of the small works Chagall managed to paint at this time. In the wintry *Bella on the Bridge* Bella totters unevenly–she was halfway through her pregnancy–and in a small 1916 gouache, *Bella in Profile,* her pale face is drawn and tense. In *Self-portrait with Bella by the Stove* Chagall hides behind Bella under the shadow of the huge cylindrical stove in their claustrophobic, bleak kitchen. Everything is grey except for the blaze of fire from the stove and Bella's crimson dress. Her face, with her large black eyes and frame of fashionably cropped black hair, is exaggeratedly long and sorrowing, but her emotional power dominates the work. Her love and spirit light up Chagall's life–her monumentality echoes that of Feiga-Ita in *Mother by the Stove,* which Chagall had painted the year before, and suggests the full force of his dependence on his wife.

Among his greatest work from this period is the inwardly-oriented cycle of 1915-17, *Dedicated to My Wife:* ten small paintings of twinned lovers' profiles based on himself and Bella, their two heads inclined towards each other, all the lines complementing each other in a combined, melodic movement. As in the series of old Jews, sparingly used colours, pure and light here, give each work its particular flavour; all are lyrical, reflective images of satisfied reciprocal love. Bella's influence, urging Chagall away from the savagery of his Paris period to a poetical version of the avant-garde rather than to the hard-edged radicalism of almost every other Russian painter at this time, was decisive here; yet still a heavily stylised, abstracting quality suggests a response to the currents in Russian art that were developing around him in Petrograd and Moscow. *Lovers in Green* (1915) encloses the couple in their own world, a circle set within the square of the painting and suffused with soft, subdued light. Chagall and Bella draw together as in a reverie: "for love, all love of other sights controls / And makes one little room an everywhere." In *Lovers in Grey* (1916-17) Bella, her strong, classical profile emphasised, protects Chagall, who rests on her shoulder. In *Lovers in Pink* (1916) she is the ecstatic bride, spiritual and intimate, long-lashed eye closed as she nestles against her husband. "Her lips had the scent of the first kiss, a kiss like the thirst for justice," wrote Chagall. "Bella's role as muse, which brought Marc such powerful inspiration, became a dominating one," suggested Virginia Haggard. "She was a brilliant intellectual, an ultra-refined woman. Marc was not aware of her domination, so completely did their personalities melt into each other." The *Lovers* series depicts that fusion of minds. "Bella blended really in my world–which she had inspired and directed," Chagall told Daniel Catton Rich, director of the Chicago

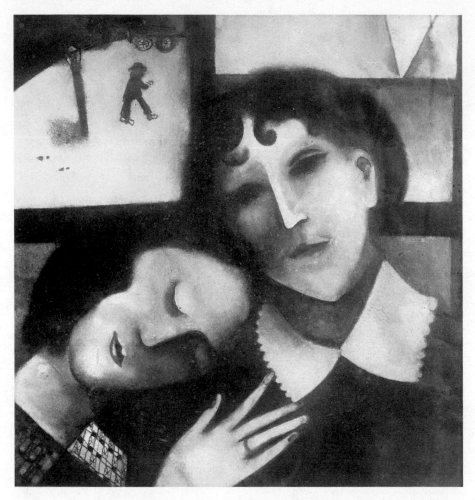

Chagall, *Lovers in Black,* 1915, oil on cardboard, formerly in the collection of the City Museum of Pskov, destroyed 1940

Institute of Art, in 1946. "This you see . . . in all different periods of my work."

There is nothing in twentieth-century art comparable either to the series of lovers or to the series of old Jews in achieving what the art historian Evgenia Petrovna calls "the literary visualisation of a poetic metaphor." Perhaps for this reason *Lovers in Pink* became an iconic work among the Russian intelligentsia in Soviet times, after the physicist Abraham Chudnovsky bought it on impulse to celebrate the love at first sight between him and his wife Evgenia; they married eight days after meeting in an hours-long queue to buy a train ticket. The painting suggested that a bright inner life survived in oppressive 1950s Moscow–Chudnovsky bought his first painting the day

after Stalin's death in 1953 and saw becoming a collector as an affirmation of hope. Chagall through this period was unknown to most Russians; when state-sponsored thieves broke down the door of Chudnovsky's flat in 1978 to steal the painting, they did not know which, among a collection of Maleviches, Larionovs, Goncharovas, and Tatlins, it was. They ripped off the gag with which they had bound Chudnovsky's son Felix and demanded that he show them the Chagall; he told them to look for it themselves, then directed them to another painting, which they stole instead. *Lovers in Pink* is now owned by the businessman Vladimir Nekrassov, a former psychiatrist, whose collection also includes Soviet-era portraits of Lenin and Stalin.

The intense interiority of the *Lovers* cycle was a response to the increasing bleakness as wartime Petrograd descended into chaos between 1915 and 1917. In two and a half years of war, Russia lost over five million men; inflation, profiteering, low wages, and food shortages were all pushing the country to the very edge of survival. In this harrowing time the Chagalls'

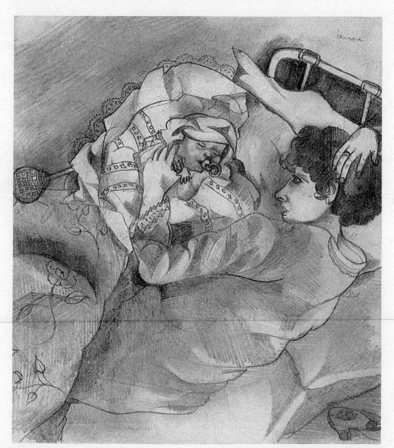

Chagall, "Bella and Ida," 1916, drawing

daughter Ida (nicknamed Idotchka) was born on 18 May 1916. Chagall was so disappointed that she was not a boy that he refused to visit mother or child for four days; then almost immediately Bella rushed Ida off to the safety of Vitebsk, wrapping her from head to toe for fear of the cold. Chagall found it hard to adjust to family life; milk was scarce, and Ida would not be fooled by sugared water and screamed ceaselessly.

> She yelled so loud I couldn't keep from dumping her furiously on the bed.
> "Shut up!"
> I can't stand children's piercing cries. It's frightful!
> In short, I'm not paternal.
> People will say I'm a monster.
> I'm losing their respect.
> What's the use of writing all that?

This was the daughter who later became her father's dearest, life-sustaining companion.

The earliest sketch of her is a fervent drawing called "Bella and Ida" of mother and newborn child in bed together. But the real painterly celebration of her birth was *Lilies of the Valley*. Lilies of the valley are a late spring flower, and here an enormous basket of them, festively decorated with two large pink ribbons, is placed on a trunk to take up almost the entire picture. As in icon painting, Chagall zooms in on this single detail–window, chair, pictures on the walls are minute by comparison–to imbue it with spiritual significance. The abundant clusters of bell-shaped white flowers and strong reedy stalks seem to burst out of the basket; the room itself can barely contain them as they take on a life of their own, animated so that they wave, stretch, and grow across the painting, a metaphor for youth and happiness. The mystical connection of *Lilies of the Valley* with the joy of Ida's birth is underlined by the small picture hanging on the wall above the flowers, which connects the generations and is also a reminder of death–the picture is the 1914 likeness of the dying Feiga-Ita, after whom Ida was named, and the very portrait that she herself, as she faced her own death, would banish back to Russia seventy years later.

Lilies of the Valley is one of very few works from this period that Chagall signed in Cyrillic, emphasising its connection with lineage and family. The theme of flowers, prevalent in his work in France after 1923, is rare among

his Russian paintings; flowers suggest a plenitude, generosity, and gentleness alien to wartime Petrograd. But not for nearly two decades did Chagall again endow flowers with so much life that they seem human, overwhelming a canvas and bursting its seams with emotion—and when he did, they were again connected with Ida: the tumbling white roses that take over in *The Bride's Chair*, painted for her wedding in 1934. That work is also an interior that has the intensity of an icon, and if *Lilies of the Valley* is a variation on Chagall *Birth* paintings, the later work refers similarly to his *Wedding* series: on the wall behind his daughter's bridal chair Chagall includes his own wedding portrait *The Birthday*. "I always used to think: we don't have many friends on earth: only our wife, because she has nothing against us," Chagall said. For the next thirty years the trio he formed with Bella and Ida would be the rock sustaining him, giving emotional constancy as he responded to revolution, exile, and war.

A photograph of Chagall and Bella in hats and scarves in wintry wartime Petrograd shows a prerevolutionary metropolitan couple, heads thrown back, hair short, jauntily playing up their role in Russia's artistic destiny. Although physical conditions were difficult, they threw themselves nonetheless into the capital's cultural milieu, beginning with Jewish connections that Chagall had formed before 1911. "Petersburg is now, thank God, a Jewish town," wrote S. Ansky in 1913, celebrating the lifting of the proscription against Jews. Chagall was cheered by the broader Jewish milieu when he returned in 1915, and in 1916 he joined the new Society for the Encouragement of Jewish Art, founded by Ginzburg and Nathan Altman, with his former patron Vinaver as president; the society commissioned him to paint decorations for a secondary school housed in a synagogue. At the collector Kagan-Shabshay's house he met a wide circle of intellectuals, and beyond that he came to know the writers Esenin, Pasternak, Mayakovsky, and Blok—Mayakovsky was too loud for his taste, but he was drawn to the gentler Esenin and to grave, blue-eyed, restrained Blok. In this avant-garde

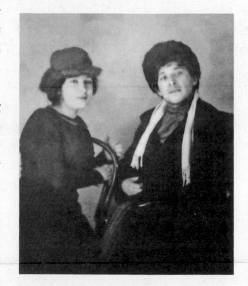

Bella and Chagall, 1915-16

company he won a commission to design the sets for Nikolai Evreinov's cabaret *A Thoroughly Joyful Song* at the Comedian's Halt, a popular theatre club, and he caused a minor stir by painting all the actors' faces green. The convergence of theatre and the fine arts was characteristic of the Russian modern movement; at the same time at Moscow's Kamerny Theatre, for example, Alexandra Exter designed the costumes and set for the innovative producer Alexander Tairov's *Famira Kifared,* working out a system of "synthetic theatre" where sets, costumes, actors, and gestures would be integrated as parts of a dynamic single conception.

Most significantly for his career, Chagall was taken on by Nadezhda Dobychina, whose Art Bureau on Marsova Polo (the Field of Mars) was the only private gallery showing avant-garde work in Petrograd. Between April 1916 and 1918 she collected his work herself and gave him five exhibitions; the first, showing his Vitebsk series, finally won over Benois, who wrote in the influential *Rech* (Speech) on 22 April 1916 that "he is a true painter, a painter right through to his fingertips, able, in his *moments d'élection,* to allow himself to be carried away by his inspiration, while submitting to the rules of his craft . . . What is charming in his work is not his exotic character but this capacity for capturing the soul of anything, of revealing the 'smile of God' in the most trivial everyday scene."

The real test of 1916–17, however, was the rise of suprematism, whose dominance after its launch in Petrograd in December 1915 at the ominously titled "0.10. The Last Futurist Painting Exhibition" heralded abstraction's role as the house style of the revolution. No artist living in Petrograd was immune to the sensation caused by this show, which began even before it opened when a fight broke out between its two leading figures as Tatlin claimed that Malevich's abstract works were inappropriate for inclusion. "The other artists were in despair," wrote Camilla Gray, who pieced together a record of the event from witnesses:

> It must have been a terrifying sight, the tall and weedy Tatlin with his desperate jealousy, and Malevich . . . a great big man with a passionate temper when roused. In the end, Alexandra Exter succeeded in stopping the fight and a compromise was found . . . Tatlin, Udaltsova and Popova were to hang their works in one room, and Malevich with his Suprematist followers in the other. To make the difference clear, Tatlin stuck up a notice over the door to his room which read "Exhibition of Professional Painters."

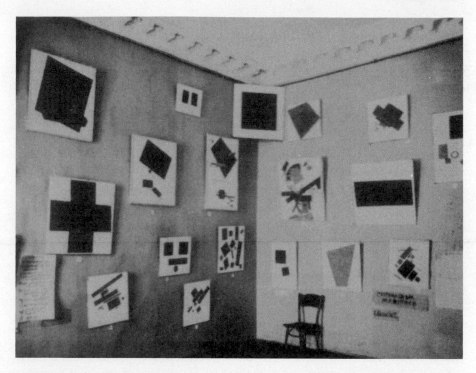

Malevich's suprematist works on display at "0.10. The Last Futurist Painting Exhibition," Moscow, 1915; *Black Square* is in the corner at the top, like an icon in a Russian home

The story conveys the frenzy, desperation, high-key moral impulse, and jostling for power that characterised the avant-garde by the end of 1915. Larionov and Goncharova, who had led the first stage of Russian modernism, had anticipated this mood with their nationalist cries. "We deny that individuality has any value in a work of art . . . Hail nationalism!–we go hand in hand with house-painters . . . We are against the West, vulgarizing our Oriental forms, and rendering everything valueless," they had announced in their manifesto introducing the short-lived abstract style of rayonnism in 1913. But they were well born and well travelled, had never shed the sheen of cosmopolitan refinement from their own works, and had practised the opposite of what they preached, finally leaving the East to live permanently in the West. By contrast the new stars Tatlin and Malevich came from poor backgrounds, had uneven educations, and brought a raw, brutal edge to the Russian avant-garde. In the atmosphere of Russia's isolation after 1914, when war threw the country back on its own resources and thus allowed it for the first time to shed a sense of inferiority and debt to Western influence, they came into their element. Around them was a cultural ferment: the

union of artists, writers, and composers for productions at the popular café-theatres; the electrifying, dadalike performances of poets such as Mayakovsky, "spoon in buttonhole and wearing ever more violent coloured shirts and jackets, pouring out rhymed abuse in his magnificent bass voice"; the return from abroad of some of Russia's most experimental artists–Kandinsky, given forty-eight hours to leave Germany after war was declared, came from Munich; El Lissitzky from Darmstadt, Puni from Paris. All contributed to the feverish debate and sense of unlimited possibilities, and in this climate Malevich broke through to the most absolute abstraction yet seen.

The entirely geometric abstract designs in black, white, and primary colours that made up his suprematist paintings in the "o.10" show soon dominated the artistic landscape. They evolved from cubo-futurism, of which Malevich had become a master with paintings such as *The Knife Grinder* in 1912, though suprematism's precise beginnings, and its utopian charge, can be traced to Alexei Kruchenykh's *Victory over the Sun,* a futurist opera produced at the Luna Park Theatre in St. Petersburg in December 1913. Collaborating with the futurist poet Velimir Khlebnikov, Malevich produced cubist costumes and sets, including a backcloth of a simple white and black square, for this story recounting how strong men tame the sun, bring it down from heaven, and plunge the world into darkness to prepare it for the advent of a new light. At "o.10" Malevich's centrepiece was *Black Square on White,* placed like an icon in a traditional Russian home.

To Malevich, the simplicity of these basic forms allowed them to signify a new beginning, and suprematism's sweeping rise reflected the longing for a new world in prerevolutionary Russia. Malevich's charismatic personality assured him instant disciples: Olga Rozanova, Exter, Puni, Popova, and many others embraced suprematism, which Malevich presented with the force of a new religion. "Only when the habit of one's consciousness to see in paintings bits of nature, madonnas and shameless nudes has disappeared, shall we see a pure-painting composition," he wrote in the manifesto accompanying the exhibition. "Only stupid and uncreative artists protect their art with sincerity . . . Things have disappeared like smoke before the new art culture. Art is moving towards its self-appointed end of creation, to the domination of the forms of nature." Soon he proclaimed himself, Marx-like, as the culmination of art history:

> Why do you not put on your grandmothers' dresses, when you
> thrill to the pictures of their powdered portraits? This all con-

firms that your body is living in the modern age while your soul is clothed in your grandmother's old bodice . . . The new life of iron and the machine, the roar of motorcars, the brilliance of electric lights, the growling of propellers, have awakened the soul . . . I say to all: Abandon love, abandon aestheticism, abandon the baggage of wisdom, for in the new culture, your wisdom is ridiculous and insignificant. We, suprematists, throw open the way for you. Hurry! For tomorrow you will not recognise us.

Chagall, steadily painting portraits of himself and Bella, made his own answer. Part of revolutionary idealism was the belief that man could prevail over natural phenomena like sunlight and gravity—the theme of *Victory over the Sun.* Chagall's art, by contrast, would always remain that of the tangible world. Rooted in Hasidic ideals of harmony between man and his environment and in Jewish fatalism, Chagall could never sympathise with Malevich's cold utopias, whose white icons emerge from a different tradition—the harsh absolutism of the Orthodox Church. Yet suprematism, and the abstracting tendency prevalent across prerevolutionary Russia, made their impact on him just as cubism had done in Paris, and the tense space in his paintings from 1916 to 1921 depends on the clash between two different responses to the world: the concrete village disposition encouraged by Vitebsk, and the global cosmic one of Russian abstraction. Chagall's unique ability was to harmonise the two, bringing the romance and utopia of Russian innovation to figurative painting. The genius of his work in Russia, as in Paris from 1911 to 1914, lay in his ability to assimilate the major forces around him even as he fought against them, as if for the survival of his individuality. This conflict, rooted in his triple Jewish-Russian-European identity, was always necessary to fire his greatest work.

It was a lonely path, and one that made Chagall ferocious and nervous by turns. Abraham Efros, who was working with Tugendhold on a book about Chagall, captured both sides in a prose portrait of the artist as he approached thirty:

He enters the room the way practical people walk in, with confidence and precision, overcoming space, striding forcefully . . . But look: at a certain step, his body totters and snaps drolly; like Pierrot collapsing in half in a puppet theatre, fatally stung by betrayal and bending slightly sideways, cracked . . . Chagall has the beaming face of a young fawn, but in conversation the kindly

softness sometimes evaporates like a mask, and then we think
that the corners of his lips are too sharp, like arrows, and he bares
his teeth tenaciously, like an animal, and the grey-blue kindness
of his eyes too often shines with the fury of strange explosions.

Efros's interest was welcome, for Chagall's position was still far from secure. In *Apollon* in 1916 the critic Sergei Makovsky published an article, "About Contemporary Russian Art," that ignored him completely. "I cannot and never shall admit of the thought that I am not on the right path," Chagall told Makovsky. "But how could I not regret that you, a person I respect, have shrouded me in silence . . . and . . . left me alone with my cruel self-doubts." He was gratified to be invited to submit forty-five works for Moscow's "Jack of Diamonds" exhibition in November 1916, but he hung alongside Malevich and his followers Popova and Rozanova, who made a more fiery impact. In 1917 *Apollon* reported that "people are almost equally interested in suprematist painting, *Famira Kifared* [Tairov and Exter's production at the Kamerny Theatre] and the speeches of Miliukov in the Duma." Tugendhold remained Chagall's chief champion: "Nowadays, when the mechanical culture is challenging the whole world and when the Futurist demon penetrates every pictorial work, art [like Chagall's] which expresses love for man . . . which is full of lyricism, is particularly important," he wrote. But Chagall knew that he now had to compete against a system that was set on exposing figuration—and ultimately easel painting itself—as old-fashioned and redundant. It was through negotiation with the abstract forms of suprematism that he produced over the next five years the most important work of his career.

In arriving back home to play his role in Russian art during the only epoch when it equalled or even outstripped western Europe in ambition and daring, Chagall had timed his return with the same impeccable sense of Zeitgeist that had led him to Paris on the eve of its cubist heyday. Malevich later claimed that suprematism must be seen as "anticipating the revolution in the economic and political life of 1917." Events such as Petrograd's "Carnival of the Arts" in 1917 embodied the revolutionary impetus: artists, writers, composers, and actors hired buses of every colour and proceeded down Nevsky Prospekt; bringing up the rear was a large truck chalked all over with the words "The Chairman of the World" and containing the poet Khlebnikov (self-styled "Velimir I, President of the Terrestrial Globe, King of Time") hunched in a soldier's greatcoat. Such was the context of the buildup to the revolution in which Chagall forged his own Russian style.

While baby Ida screamed from hunger as food supplies ran scarce, intellectuals in Chagall's wider Petrograd circle at the end of 1916 widely assumed the army to be incompetent and the monarchy to be discredited, and they openly discussed revolution. In December another young father, twenty-nine-year-old Prince Felix Yusupov, a homosexual who had recently married the tsar's niece, Grand Duchess Irina Alexandrovna, and whose daughter Irina was one year old, organised the murder of the tsarina's peasant confidant, "mad monk" Gregory Rasputin. Yusupov, heir to the family fortune after the death of his brother Nicholas, was leader of a group who thus expressed the frustration and resentment of the court at the tsar's inability to confront the realities of war. Yusupov was exiled, but the murder was symbolic of the lack of faith in the tsar at all levels of society. In February 1917 an arctic-cold winter, which had aggravated the breakdown of food supplies, melted unusually early in Petrograd into warm spring, and the queues of women outside shops mingled with demonstrations by resentful workers. The movement swelled into a general strike, and crowds converged on Nevsky Prospekt bearing placards calling for peace, bread, and freedom. Cossacks sent to crush the crowds refused to do so, and the strikers stormed the security police headquarters and set fire to it. At first the mood seemed controlled and even good-natured; cafés and restaurants fed protesters for free, and Petrograd residents accommodated the soldiers and strikers who swelled into the city. Arthur Ransome, correspondent for the London *Daily News,* described the first days of dissent as ones of "rather precarious excitement like a Bank Holiday with thunder in the air," while the London *Times* marvelled at the orderliness and good nature of the crowds.

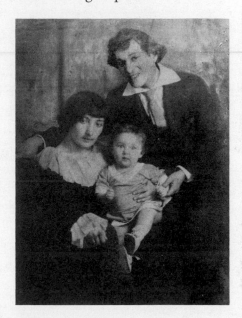

Bella, Ida, and Chagall, 1916–17

But this ambience was short-lived. On 26 February on Znamensky Square a company of the Imperial Guard fired on the crowd, killing fifty, and the next day sixteen thousand peasant conscripts of the capital's garrison mutinied and joined the rioters. Prisons were liberated, and a criminal element joined deserting soldiers, already brutalised by war, and ran amok, inciting the crowd to loot, rape, and kill. Tsarist statues were smashed, buildings were destroyed, policemen were lynched. Thousands of miles away at

Russia's military headquarters in Mogilev, Nicholas II tried to impose military rule, then abdicated on 3 March in favour of his brother Grand Duke Mikhail. The latter declined the throne, leaving Russia without a leader. A provisional government, headed by Alexander Kerensky, who still believed Russia could win the war and become a democratic republic, was elected by the Duma, the quasi-parliament. But across the empire over the next months, soldiers deserted en masse, commandeering military trains to take them home from the front. The army disintegrated into unruly groups of armed men set on seizing anything they could, or simply on returning to their villages, where in many cases mob rule prevailed, landowners were murdered or fled, and hungry, resentful soldiers grabbed land and property for themselves.

Chagall experienced the February Revolution, which included its share of anti-Semitic violence, at firsthand.

> Soldiers fled from the front. War, ammunitions, lice, everything is left behind in the trenches . . . Freedom roared in their mouths. Oaths hissed. I don't stay either. I desert my office, inkwell, and all the records. Good-bye! I, too, along with the others, quit the front. Freedom . . . I ran to Znamensky Square, from there to Liteiny [the War Office], to Nevsky [Petrograd's main thoroughfare], and back again. On all sides rifle fire. Guns were made ready. Arms put in order . . . Something was about to be born. I was living in an almost semi-conscious state.

Like most of his circle, he was euphoric and astonished at the speed of events. Although revolution had been discussed for months, "the most striking thing," wrote Alexander Blok, "was the utter unexpectedness of it, like a train crash in the night, like a bridge crumbling beneath your feet, like a house falling down."

In the next uneasy months of Kerensky's Provisional Government, Petrograd was hungry, violent, and ablaze with rumour, especially after Lenin's arrival in April. "Every wall in the town is placarded with notices of meetings, lectures, congresses, electoral appeals, and announcements, not only in Russian, but in Polish, Lithuanian, Yiddish and Hebrew," reported the *Daily Chronicle.* "Two men argue at a street corner and are at once surrounded by an excited crowd . . . The Nevsky Prospekt has become a kind of *Quartier Latin.* Book hawkers line the pavement and cry sensational pam-

phlets about Rasputin and Nicholas, and who is Lenin, and how much land will the peasants get." In June Gorky wrote that Petrograd "is no longer a capital, it is a cesspit. No one works, the streets are filthy, there are piles of stinking rubbish in the courtyards . . . It hurts me to say how bad things have become. There is a growing idleness and cowardice in the people, and all those base and criminal instincts which I have fought all my life and which, it seems, are now destroying Russia." With his job dissolved, Chagall removed his family from the capital and returned to Vitebsk, where they stayed with the Rosenfelds. Chagall painted in Pen's studio and, shielded by Pen from curious onlookers, in the countryside. Pen, whom Chagall had long despised, now represented security in troubled times. Touchingly, Pen and Chagall painted each other's portraits, Pen's Chagall in the unchanging realist-academic style that now looked quaint, Chagall's *Portrait of the Painter Pen* with strong cubist elements. Chagall depicted the old man at his easel, surrounded by portraits of Vitebsk's bourgeois Jews piled high above one another. Everything about this portrait, old-fashioned Pen clashing with revolutionary modernity, is unsettling and discordant, echoing Chagall's highly strung psychological state.

That nervousness characterises the landscapes from the uncertain summer of 1917. Chagall's joy at returning to painting on a large scale is evident in the exhilarated depictions of wide spaces, as in *Vitebsk: From Mount Zadunov,* and in the scope and size of the canvases. But each is also fraught with the historical and artistic moment, making this series far more interesting in its tension, and in its reflection of Chagall's stressed relationship to reality, than the Vitebsk works of 1914.

The rhythms here come from the fragmentation of forms, as sky and earth split into geometric shapes that echo those of suprematism and share its portent of revolution. In *The Cemetery Gate* vast blue and white abstract planes descend from the heavens, vanishing into emerald semicircular treetops shot through with flames. Everything is taut, reeling, blending only to pull apart, suggesting desperate movement and apocalyptic change; it is as if the centre of the canvas, like the central power in Russia, barely holds together. The upward surge, as forms layer into the pyramids of the massive gate and its crowning pediment, recalls the forward thrust of Malevich's abstract forms. Franz Meyer's description of this painting, that "every single form becomes a dynamic form, is endowed with wings, and a mighty current is set in motion above and beyond the material world towards a spiritual reality that is also the true reality of the here and now," emphasises its close-

ness to suprematism's methods and goals. Chagall has coopted Malevich's vocabulary but grafted it onto figurative painting. The inscription on the gates is the Hebrew words of the divine prophecy of Ezekiel: "Oh my people, I will open your graves, and cause you to come out of your graves, and bring you into the land of Israel." These words bring the painting into the realm of Jewish mysticism; with them Chagall fixed the brief moment when, in the crumbling of the tsar's empire, Hasidic spiritual longing for transformation met the cosmic and revolutionary fantasies of avant-garde abstraction. Like the old Jews and the *Lovers* series, these landscapes occupy an essential position in the story of the Russian avant-garde, but they go against it, too, as philosophical lyricism that transcends the sound and fury of the times.

In *The Cemetery* a dynamic pile-up of graves pushes up from the earth towards a fragmented sky. In *The Red Gateway* Chagall uses a decorative abstract pattern of triangles and diamonds, almost a direct quotation of Malevich's forms. The floating white-grey cubes in the foreground, echoing Malevich's white-on-white images, give the work airiness and volume and show how effortlessly Chagall gained command of the suprematist language. The Jewish theme, with the rooster and goat (symbols of the Day of Atonement), is again superimposed. In *The Grey House,* a rickety dwelling seems to rock beneath a turbulent sky whose suprematist forms contrast with the graceful churches of the old city; the agitated lonely figure of Chagall adds to the sense of foreboding. The tottering log hut that dominates *The Blue House* is also composed of abstract forms: its rafters are a trembling pattern of different shapes, while the vertical junctions of logs at its corners are rhythmical rows of circular forms that contrast with the horizontal layers. The embankment and the river, with its shaky reflections, are also faceted by geometric forms and wavy bands, flattening the picture surface; the crystalline blue of the house sets it apart, like a radiant memory, from the naturalistic depiction of an overcast Vitebsk behind it. Chagall painted *The Blue House* in a single sitting *en plein air* in the company of Pen and one of his students, M. Lerman, who recalled that, watching the work take shape, he found Chagall's depiction so persuasive that "the typically brown log house seemed to glisten with a deep blue colour."

Chagall thrills to the revolutionary theme here but also anticipates its destructiveness. "The atmosphere of the epoch has determined and moulded the perception of the new generation of artists in a quite remarkable way," wrote Boris Pasternak.

The world no longer presented itself in the form of a pre-ordained order but as a ceaselessly exploding firework whose flying particles had to be deciphered time and time again. Everything was uncertain, inconstant, could incessantly change its place or merge or mix or amalgamate with something else; old and new, church with village and city with mankind. It was a wild whirlpool into which all values were sucked. Art too found itself on a stormy sea, far from its protected harbour, somewhere between the terra firma of the old ideas which could no longer be saved and the infinite star cloud of these new convictions which were still to be discovered. The dizzy whirlpool carried within it a powerful, unsuspected premonition of the most violent phenomenon of our century, the gathering storm clouds of socialism and its unique manifestation in the form of the October Revolution.

In July Prince Lvov, prime minister of the Provisional Government, resigned. "Without doubt," he wrote to his parents,

the country is heading for a general slaughter, famine, the collapse of the front, where half the soldiers will perish, and the ruin of the urban population. The cultural inheritance of the nation, its people and civilisation, will be destroyed. Armies of migrants, then small groups, and then maybe no more than individual people, will roam around the country fighting each other with rifles and then no more than clubs. I will not live to see it, and I hope, neither will you.

Pressure and uncertainty about the future looms behind the full-length portrait of Bella that Chagall painted in the summer of 1917, *Bella with White Collar*. Still in the black dress with lace collar from *The Birthday*, a stylized figure composed of jagged, floating forms, she towers larger-than-life-size over Vitebsk. The innocent bride of *The Birthday* is now an icon of fulfilled motherhood and protectiveness, but weighed down with all the cares of Russia. A Madonna of Vitebsk, her head pressed against a bright sky of overlapping suprematist white clouds, she looks down on a small garden where the tiny figure of Chagall is teaching little Ida to walk. Muse and shield—that was how Chagall saw her role in his life. He would never paint so powerful an image of her again, for as Russian history, and the security of

Vitebsk that she represented, unravelled, so her own strength unwound and diminished in the coming years.

A visit to the dacha at Zaolshe yielded a few eerily calm paintings—the softly lit blue-green *Window onto the Garden,* with one-year-old Ida doll-like in a high chair, and *Interior with Flowers.* The Chagalls then returned to a chaotic Petrograd in the autumn. Dobychina showed seven of the Zaolshe paintings in an exhibition called "Summer Works": how incongruous these affluent interiors must have looked in a disintegrating city gearing up for another winter of unrest and hardship. Chagall also showed forty-three pieces in "Paintings and Sculpture by Jewish Artists," with Nathan Altman and Robert Falk, at Moscow's Galerie Lemercier. The old order hung on: even an intellectual, educated woman such as Frieda Gurevitch, wife of the Zionist poet Leon Jaffe, found Chagall's discordant Vitebsk landscapes alarmingly radical—"all these 'left-wing types' (Chagall, Altmann . . .) seem rather strange," she confided to her diary on 13 October. "They strive to leave beauty as we understand it behind. The path they follow leads from form to deformity, from harmony to discord. This is what they see as form, this is their idea of beauty." And Benois remained powerful enough for Chagall to begin a bitterly class-conscious letter to him on 1 October, "Why does a young man want to talk with an old man, pour his heart out to him? Yes, Alexander Nikolayevitch, you know quite well what young and old mean and above all what the one or the other means here in Russia."

Bella, wearing the dress in which she posed for the monumental painting *Bella with White Collar,* 1917

In that letter Chagall still stressed his lack of interest in politics ("external factors that I cannot influence and for which I have absolutely no understanding") and his dreams of Paris. "If fate spares me, I and my family might not be Russia's guests for much longer," he told Benois. "Unfortunately and fortunately I have a more than ample familiarity with foreign parts and will always be grateful to them. May God bless it, that sinful place [Paris] is my second home. Amazing that the nice, open and real people abroad get so close to one and quite the opposite happens here at home." Without his War

Office job, and with little prospect of selling paintings, he would soon be penniless. He made a final desperate plea to Benois to "accommodate" him under the umbrella of the World of Art, which "will always have my deep respect, if only because from time to time one was able to hear a human voice there." Though this was mostly flattery—he had always found the World of Art too effete—it was also a prediction of the years when the human voice ceased to matter in official Soviet culture. Within weeks of Chagall's supplicating letter, Benois would be a relic of the past, and the avant-garde, for the first time anywhere in art history, would form the cultural establishment of the nation.

Commissar Chagall and Comrade Malevich

Vitebsk, 1917–1920

"All the dark instincts of the crowd irritated by the disintegration of life and by the lies and filth of politics will flare up and fume, poisoning with anger, hate and revenge," Maxim Gorky predicted on 18 October 1917. "People will kill one another, unable to suppress their own animal stupidity. An unorganized crowd, hardly understanding what it wants, will crawl out into the street, and using this crowd as a cover, adventurers, thieves and professional murderers will begin to 'create the history of the Russian Revolution.' " Eight days later, at two o'clock in the morning on 26 October, Lenin's Bolshevik forces stormed the Winter Palace, announcing at five a.m. that they had seized power. By the end of October the Provisional Government had toppled, street fighting erupted around the Kremlin in Moscow, and Russia's barbaric civil war of Reds (Bolsheviks) versus Whites (counterrevolutionary former landowners and officers) began. In Petrograd, mobs went on the rampage and looted shops, while soldiers wrecked and robbed bourgeois apartments, killing as they went.

The capital emptied out. Its richer residents, or those with the wrong allegiances, fled or were imprisoned or killed. Chagall's patron, fifty-five-year-old Maxim Vinaver, escaped to the Crimea, where he became foreign minister of the White government during the civil war. Prince Felix Yusupov returned from exile to the Yusupov Palace to find the body of his head servant with blood pouring from gouged-out eye sockets; he had been tortured by Bolsheviks for refusing to reveal the family jewels. Yusupov grabbed his Rembrandts and departed for the Crimea. Vladimir Nabokov, a

democrat who had been part of Kerensky's government, was arrested and jailed; his eighteen-year-old son, the writer, joined the aristocratic exodus to the Crimea. There many noble Russians became "former people," sitting out the civil war on wealthy estates. By spring 1918, according to Mikhail Bulgakov, the cafés and cabarets of southern towns like Kiev were full of "pale depraved women from Petersburg with carmine-painted lips; secretaries of civil service department chiefs; inert young homosexuals. Princes and junkdealers, poets and pawnbrokers, gendarmes and actresses from the Imperial theatres." Meanwhile the population of Petrograd fell from 2.5 million on the eve of the revolution to 700,000 in 1919. At first the Bolshevik triumph even in the north of the country was not ensured. "Things are so unstable," wrote Chagall's friend from La Ruche days, Anatoly Lunacharsky, now a leading Bolshevik, on October 29, "that every time I break off from a letter, I don't even know if it will be my last. I could at any moment be thrown into jail."

But Lunacharsky, commissar for people's education, did not go to prison; he set up Narkompros, the new Bolshevik Commissariat of Education (the name was later changed to Commissariat of Enlightenment), and on 18 November he occupied the tsarist education ministry, where civil servants of the old regime gave him an enthusiastic welcome. He became for a few years the most powerful cultural figure in Russia, and his recognition of the avant-garde was instant: he immediately offered Chagall charge of the visual arts department of Narkompros in Petrograd. Meyerhold was offered the theatre section, and Mayakovsky literature. They accepted, but Chagall refused, and Lunacharsky appointed another Jewish friend who had also been a colleague at La Ruche, the cubist David Shterenberg, instead. Chagall did not wait even to say goodbye to his gallery owner, Nadezhda Dobychina; in November, "rushed and febrile," he, Bella, and Ida left Petrograd forever and returned to the safety and relative plenty of Vitebsk. Soon afterwards, in March 1918, Petrograd, Russia's window on the West, lost its status as capital to Moscow, whose connection to the East underpinned the Bolshevik desire to forge an identity independent of Europe. Of the new government ministers, only Lunacharsky remained in Petrograd—a sign of the deep divide between the pull of the old and the new.

It was characteristic that Chagall's first instinct was to retreat, to remain an individualist, removed from the seat of power. Since his first days in the capital in 1907, he had always dashed to Vitebsk at the first sign of trouble. He never explained his refusal of Lunacharsky's offer, but a lifelong lack of interest in politics, and Bella's very strong advice to play no part in the gov-

ernment, were the major reasons. Alexander Kamensky, who interviewed Chagall in 1973, suggests that "at this great turning point in history the artist from Vitebsk did not consider himself to be a man of action capable of resolving the country's fundamental problems in the realm of art. He was far from understanding the full import of the events, though he was sympathetic to the Revolution and it was close to his heart."

There is no doubt that as a Jew, a child of the working classes, and a leftist artist, Chagall celebrated the revolution. "It is impossible to describe the exhilaration and holiday atmosphere in the Jewish world," reported the Jewish journalist Ben Khayim in 1920. "There were no differences of opinion in the Jewish world. Class interest disappeared." For Chagall, it delivered a double emancipation: Jews were granted full status as Russian citizens, while as an avant-garde artist he represented the new epoch. Luxuriating in freedom and equality for the first time, Jews–Tugendhold, Shterenberg, Altman, Lissitzky, Isaachar Ryback, Isaac Brodsky–now became integral to the cultural establishment. In spring 1918 Tugendhold and Efros published the first book on Chagall, celebrating him as a Jewish artist–a perceptive volume that remains the touchstone for Chagall studies and was a barometer of his high reputation that year. The Moscow Circle of Jewish Men of Letters and Artists held its first exhibition in July and gave prominence to Chagall, as did the influential Yiddish article "Paths of Jewish Painting," published by Ryback and Boris Aronson in Kiev in 1919. "Jewish art is here. It is awakening," they wrote. "A special place is occupied by Marc Chagall."

The difference from the time, months before, when Chagall had wondered how to address Benois, was extraordinary. Now he talked to Benois as an equal. "I was glad that you of all people speak so simply and frankly," he wrote from Vitebsk. "How are you? You are hungry, perhaps things are a little easier here. Come to our district and eat your fill. Greetings to the family. What's afoot in the world of art? No newspapers get through. That's how it is here!" He gave his new address as Shmuel Noah Rosenfeld's shop, Smolenskaya; he told Benois he felt uneasy and unsettled there–"during these long, starlit evenings . . . when my work is behind me and I'm not even arguing with my wife (even that fails, she agrees with me anyway), I simply cannot find any peace." But by March, when he wrote his first letter to Dobychina in Petrograd, he was hopeful:

> Now I am here. This is my city, my tomb . . . Here I open up like
> the tobacco plant, to the rhythm of the evenings and nights . . . I

am working. God help me! Ultimately, it seems to me that He exists. He won't leave us, and at the last minute, He will save us. How are you? . . . Write to me one of these days. I imagine that times are awful and you probably have problems. But don't give up. I am already trying to live on "the holy spirit," it is so easy!

Although he had declined an official position, Chagall was swept up by the revolutionary spirit. The revolution "disturbed me with the prodigal spectacle of a dynamic force which pervades the individual from top to bottom," he later recalled, "surpassing your imagination, projecting itself into your own interior, artistic world, which seemed to be already like a revolution." *The Apparition* (*Self-portrait with Muse*), painted in 1917-18, catches that sense of the revolution breaking into the artist's inner life. A secular echo of El Greco's *The Annunciation,* its central image is a metaphor for the messianic role that was at first accorded to artists in the people's Russia. On one half of the canvas, in grey-white, Chagall painted himself sitting at an empty easel in a claustrophobic room—the prison of tsarist St. Petersburg. Flying through the window in suprematist clouds of shimmering blue, its wings like fractured ice, soars the Angel of the Revolution, suffusing the painting with a transparent, unearthly light and awakening the painter, as the Angel Gabriel awoke Mary, to his role in the new order. Chagall dated the origins of the work to his days as a Jew living illegally in St. Petersburg in 1907, a period also evoked by an echo, in the composition of the painting and especially in the folds of the angel's wings, to Mikhail Vrubel's *Princess Swan*—Vrubel was a painter Chagall had admired at the time. "Dreams overwhelmed me: A bedroom, square, empty. In one corner, a single bed and me on it. It is getting dark," he recalled.

> Suddenly, the ceiling opens and a winged creature descends with great commotion, filling the room with movement and clouds.
>
> A swish of wings fluttering.
>
> I think: an angel! I can't open my eyes; it's too bright, too luminous.
>
> After rummaging about on all sides, he rises and passes through the opening in the ceiling, carrying with him all the light and the blue air.
>
> Once again it is dark. I wake up.
>
> My picture *The Apparition* evokes that dream.

The revolution was the catalyst for the blend of fantasy, reality, and mystery that fills the painting. But the spiritual—the white-blue clouds that cover the ground—is as much part of the room as the delicately evoked objects in it, the embroidered cloth on the chair, the folds of the tablecloth draped over the pedestal table and its rounded feet, which the clouds transfigure and lift to a cosmic dimension. The painting was bought in 1918 by the artist Isaac Brodsky, a revolutionary whose own work changed almost overnight from lyrical postimpressionist landscapes to socialist realism.

Many Russian artists, writers, and intellectuals left records of how the revolution appeared to break down barriers between the inner and outer life. "I have lived through the Russian Revolution and have felt it to be something forced on me from outside," remembered the philosopher Nikolai Berdyaev, who fled the country in 1922. "Yet this revolution took place inside me, although I was critical of it and fought against it and rejected it. This revolution has appeared to me as something completely imperative and inevitable for a long time." The painter Kliment Redko wrote that "the experience of the ideas of the revolution captured the mind, but even more the heart, because the intoxication of the revolution does not know any borders and does not feel the time." Even artists from privileged backgrounds such as Kandinsky, who lost his entire fortune and property in the revolution, supported the Bolsheviks, while Alexander Blok, representative of the refined, symbolist old world of Russian culture, surprised his admirers with his 1918 epic *The Twelve,* which appeared to glorify the revolution: in the poem, written in harsh slangy language and with jarring rhythms, a dozen Bolshevik murderers and rapists, likened to Christ's apostles, march in a winter blizzard through the streets of revolutionary Petrograd behind Christ crowned with white roses. Trotsky called *The Twelve* "unquestionably Blok's highest achievement." He went on,

> At bottom it is a cry of despair for the dying past, and yet a cry of despair which rises in a hope for the future. It is the swansong of the individualistic art that went over to the Revolution . . . The twilight lyrics of Blok are gone into the past, and will never return, for such times will not come again, but *The Twelve* will remain with its cruel wind, with its placard, with Katya lying on the snow, with its revolutionary step, and with the old world like a mangy cur.

Chagall, whose background gave him more to gain from the revolution than Blok, responded at first with work that was as individualistic but less

ambivalent. Two of his most famous paintings of 1917-18, large double por-
traits of himself and Bella soaring above Vitebsk, celebrate an ecstatic
response to the revolution and family happiness in his hometown. Exuber-
ant, laughing figures, he and Bella flutter like banners waving towards a
heady future; the influence of poster art and agitprop—decorated trains and
ships sending the revolutionary message of leftist art across the nation were
among Lunacharsky's masterstrokes—is unmissable in the construction of
the images, the sharp contours, striking colours, and dynamic movement.
In *Double Portrait with Wineglass,* Chagall in bright red sits on Bella's
shoulders, raising his glass to toast joy and liberation; in miniature scale at
Bella's feet are the bridge of Vitebsk, the river, and the blue-domed cathe-
dral. As in *Bella with White Collar,* she is the column of the family temple,
her certitude holding up the structure of Chagall's life, rooting him in the
security of Vitebsk. The mood of the recent anxious, fracturing series
depicting Vitebsk is gone; everything is harmonious, elated, warm, and
glowing.

In *Promenade* Bella spins in the air on Chagall's arm like a flag across
their sapphire-green hometown, composed of a meadow and a sky of bold,
transparent geometric forms and cubic houses. The ornamentation of the
pleats of her skirt, as in a futurist rendering of movement, enhances the
swinging, dynamic effect; in the corner a red, flower-patterned cloth laid
with a decanter of wine and a glass echoes the church, whose pale rose dome
crowns Vitebsk, like a peal of bells. In his hand Chagall holds a small bird, a
reference to the allegorical fantasy *The Blue Bird* by Maurice Maeterlinck
(one of Bella's favourite writers), where the hero and heroine do not find
true love until they return from their travels to their simple home. Symbol-
ism, Matisse, cubism, suprematism, the *surnaturel* aspect of his gravity-
defying figures, the iconography of the city that Chagall had made his own:
all the strands of his art over the last decade are pulled together in this jubi-
lant record of personal joy and the revolutionary moment. Like the exultant
Lilies of the Valley, Promenade is another work from the period unusually
signed in Cyrillic: an affirmation of his connection with Russia.

Watching from Vitebsk, Chagall saw how throughout 1918, as the revolu-
tion turned the cultural establishment upside down like the figures in his
paintings, his fellow artists and writers found themselves in positions of
power. In 1918 Lenin signed decrees nationalising major private collections
such as those of Sergei Shchukin, who had emigrated to Paris, where he
died in 1936, and Ivan Morozov, who was offered the post of deputy director
of the new Museum of Modern Western Painting formed out of his collec-

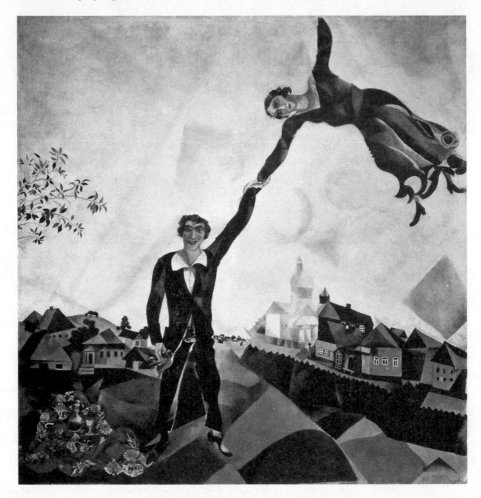

Chagall, *Promenade*, 1917, oil on canvas

tion, but turned it down and left Russia in 1918, dying in Karlsbad in 1921. The state became briefly a new, unimaginably spendthrift patron. "A miracle has happened!" wrote Tatlin in a hastily scribbled note to a fellow artist, suprematist Vera Prestel, in May 1918. "Lunacharsky came by for me in a car and now here I am [at the office of Narkompros]. Bring your paintings. We are buying everything. Like a prostitute, I now have money which I also carry around in my stocking." Across Russia similar scenes were repeated. In Simferopol in the Crimea, Tugendhold took charge of artistic affairs, abandoned all interest in the West, and fell in love with proletarian art. In Kiev Alexandra Exter headed the city's department for the arts and organised agitprop steamboats decked out with suprematist designs to float

down the Dnieper carrying the revolutionary message. In Moscow Malevich and Kandinsky, like Chagall a returning exile stranded by accident in war-time Russia, had influential positions. "We worked incessantly," recalled the artist Alexander Labas. "Travelling theatres, decorations, murals, posters at railway stations, whole thematic pictures on carriages and the walls of houses. Work bubbled."

From the sidelines of Vitebsk, Chagall now began to question his earlier refusal, and that summer he could not resist entering the fray himself, yet he did so characteristically on his own terms. Lunacharsky was committed to spreading culture through the provinces—one of his legacies is the range of avant-garde paintings still to be found in regional museums as far apart as Kostroma in the north, Astrakhan in the south, and Tatarstan in the east. Here Chagall's loyalty to Vitebsk concurred with Bolshevik ideology. He cut his hair and gave himself a new, clean-shaven look: the bohemian-romantic style of his early married days vanished in favour of the harder, leaner image of the revolutionary artist. "To love him, you have to get close to him, and to get close, you have to go through the slow and insistent temptation of pene-trating his hard shell," wrote Efros in 1918. In August, against Bella's advice ("my wife wept when she saw me neglect my painting"), he took the train to Petrograd to visit Lunacharsky. Dressed in a Russian blouse, with a leather case under his arm and a letter of appointment charging him "to set up art schools, found museums, initiate art shows and convene conferences, as well as to organize any other artistic events in the town or province of Vitebsk," he returned home commissar of arts for Vitebsk, an official of the Russian state.

Immediately the Chagalls moved from bourgeois Smolenskaya back to the unglamorous side of town, renting a small apartment on the street where Chagall had grown up, Pokrovskaya. Opposite stood the family home where Mania now kept home for Chagall's father; the herring business of his fat boss had been nationalised, but under the new enterprise he still worked as hard as ever, loading trucks. The older sisters were in Petrograd; letters from David, last heard from fighting at the front, had stopped coming—he died in 1918 in the Crimea; and the youngest but one sister, Roza, was ill and would die the following year. Money was short: "Have you been to see the Tugendholds? They'll soon have a small piece of news. They're going to buy some shoes," Chagall wrote to their mutual friend Moise Kogan. But personal hardship did not matter in the sweeping away of old oppressions.

Commissar Chagall's initial task was to respond in Vitebsk to Luna-

charsky's demand for celebrations on 7 November 1918 for the first anniversary of the Bolshevik victory. Lunacharsky wanted the streets "hung with immense canvases, the fences covered with lovely colours which expressed joy, colour, movement, battle." Chagall saw it as an offer of the biggest canvas he had ever had: the entire city. On 8 October he posted a placard asking all painters, including house painters and sign painters, to stop any other work and present themselves for registration. Seven triumphal arches were built in the main squares across Vitebsk; 350 enormous posters and countless banners and flags were hung from the facades of houses, shops, trams, and kiosks. At night red banners illustrated with symbols of the revolution–hammer and sickle, rising sun–were illuminated, as if Vitebsk were reborn in a different light. But the dominant images were Chagall's own, which he produced as sketches and insisted everyone else copy: upside-down multicoloured animals, a revolutionary tuba player riding a green horse across town, and *War on Palaces,* in which a militant, bearded peasant bears a colonnaded house in his arms, carrying it as lightly as if the revolution had changed the laws not just of property but of gravity as well.

Astonished Communist leaders asked what Chagall's animals had to do with Marx and Lenin, and the local newspaper *Vitebskii Listok* ridiculed the event, suggesting that, at a time of shortages, five thousand pairs of underpants could have been made from the red ribbons Chagall had used across the town. But the impact on working people who had never set foot in a museum or seen reproductions of works of art was terrific. Romm, whom Chagall–in a revolutionary reversal of their earlier roles–had recruited to help because his old friend had fallen on hard times after returning to Petrograd from war service in Turkey, remembered that the works were "exactly what street decorations should be: bold, unusual, striking. Yet you could sense the fine design and exquisite taste in them; they looked like large-format pictures in the leftist style." Altman and Shterenberg in Petrograd, and Exter in Kiev, were similarly dramatic, each taking tens of thousands of yards of cloth to cover whole buildings. This transforming of tsarist palaces and monuments, explained Tugendhold, new apologist for proletarian art, was essential to explode and undermine former feelings of oppression.

For a few months, from the time of his appointment until the beginning of 1919, Commissar Chagall was carried on the crest of this wave. Early in the new year the first state exhibition of the Russian avant-garde was held at the Winter Palace in Petrograd, and twenty-four of his major paintings from

1913–18 were hung in a place of honour in the first two halls. Critical reception was favourable: the Petrograd newspaper *Severnoja Kumuna* of 14 April 1919 likened Chagall to the hero of a Russian fairy tale who brought down the sun and used it to light his *izba.* Between 1918 and 1920 the Russian state bought ten of his paintings, including *Jew in Bright Red, The Mirror, Promenade,* and *Above the Town,* along with ten drawings, for 371 rubles. This was the peak of Chagall's acceptance in revolutionary Russia; the Winter Palace exhibition came to represent the height of freedom of artistic expression in either tsarist or Soviet Russia in the twentieth century, and Chagall's humanist canvases hung unproblematically alongside work as different as Malevich's suprematism and Kandinsky's abstraction. Nearby, Nathan Altman was showing red rectangles erupting out of white diamonds, symbolic of proletariat power, and Alexander Rodchenko's abstract spatial constructions, such as *Black on Black,* were exhibited with the explanation that "Christopher Columbus was neither writer nor philosopher, he was only the discoverer of new

Chagall, "Rider Blowing a Horn," 1918, watercolour, pencil, and gouache on paper: one of the sketches that Chagall made to be copied on posters and banners hung across Vitebsk celebrating the first anniversary of the revolution

worlds." At the same time, Tatlin was planning his Russian Tower of Babel, *Monument to the Third International:* the planet would be transfigured by revolution, and each architectonic element became a symbol, with the different elements spiralling to suggest the movement of the earth around the sun and the angle of the tower identical to that of the earth's axis–an expression of a new dawn when time would be perceived differently and man would be equal to the stars and planets. "His tower was born as our dream, as a poem of the future," wrote Labas. "Sitting in our studios and hostels around smoking iron stoves with their pipes sticking out of the windows, we discussed this tower. We perceived it with élan and hope–this unprecedented construction spiralling away into the celestial heights."

Chagall's *Apparition* and the self-portraits of himself and Bella flying to a bright new future were his individualistic, ego-driven variations on this cosmic-spiritual theme. That individualism would soon look out of place; in November 1919 Nikolai Punin reported that "Suprematism has blossomed throughout Moscow. Signs, exhibitions, cafés, everything is Suprematist. One may with assurance say that Suprematism has arrived." But while Cha-

gall's optimistic works, the most uncomplicatedly upbeat of his career, were
hanging in the Winter Palace, he could continue to believe in his future in
the revolutionary new country. He was selling paintings, he had an acknowl-
edged role as an artist-leader, and from Lunacharsky he was promised the
means for a new project: to set up a school, with a museum attached, where
children from poor homes would have access to art, and thus "to provide
Vitebsk with what I had missed there twenty years earlier."

On 28 January 1919 the Vitebsk People's Art College opened in the neo-
classical white mansion of the Jewish banker Israel Vishnyak on Voskresen-
skaya (Resurrection Street), now renamed Bukharinskaya, in honour of
Nikolai Bukharin, revolutionary and editor of *Pravda.* Vishnyak, a cultured
philanthropist in his late fifties, had fled to Riga and died destitute there in
1924. "Within its walls we never remember its former owner with grati-
tude," wrote Chagall, in an article in a weekly newspaper, *Shkola i revolut-
siya,* published by the city of Vitebsk. He must have been instrumental in
the repossession of the building from Vishynak–one of the first private
houses to be seized in Vitebsk–and now he crowed: "From the windows of
his house, day and night you can see the whole poor city. But today we don't
feel that poverty. You were poor, my city, when strolling in your streets, I
would meet no one but a sleepy storekeeper. But today I encounter many of
your sons, abandoning the poverty of their homes, on the way to the Art Col-
lege." The school was the embodiment of the revolutionary dream: the poor
boy from Pokrovskaya in charge at the local magnate's home on the "big
side" of town. School classes occupied the former entertaining rooms on the
lower floors of the mansion, and the professors took over the third story as
their living quarters; Chagall, Bella, and Ida had two small rooms there.

The school was open to anyone who wanted to come and was launched
with about three hundred students, mostly Jewish teenage boys, aged
between fourteen and seventeen, from working-class homes. Several later
remembered that Chagall invited them himself. The designer Efim Royak, a
tailor's son, joined the school after Chagall came to pick up a jacket that his
father had repaired and saw the boy's drawings. A skinny, attractive fifteen-
year-old boy called Lev Zevin, a talented student of Pen's, was another
teenager whom Chagall urged to join; he also encouraged thirty-year-old
Chaim Zeldin, a house painter who had helped with the anniversary decora-
tions of the city, and other house painters, to register. Most of the students
were passionate about the revolution and the Red Army; many came to
school in khaki jodhpurs and with guns on their hips. "Let the petit bour-

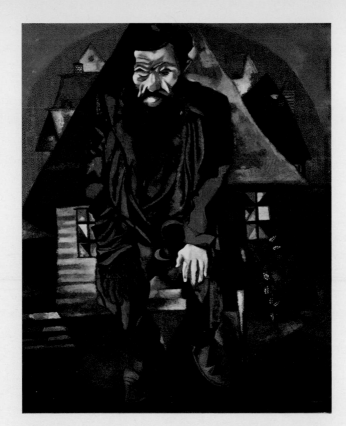

Chagall, *Jew in Red*,
1914. Oil on canvas,
100 x 80.5 cm

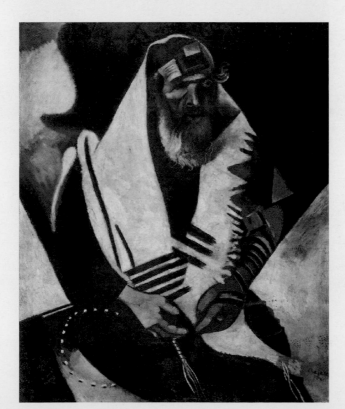

Chagall, *Praying Jew
(Jew in Black and White)*,
1914. Oil on canvas,
100 x 81 cm

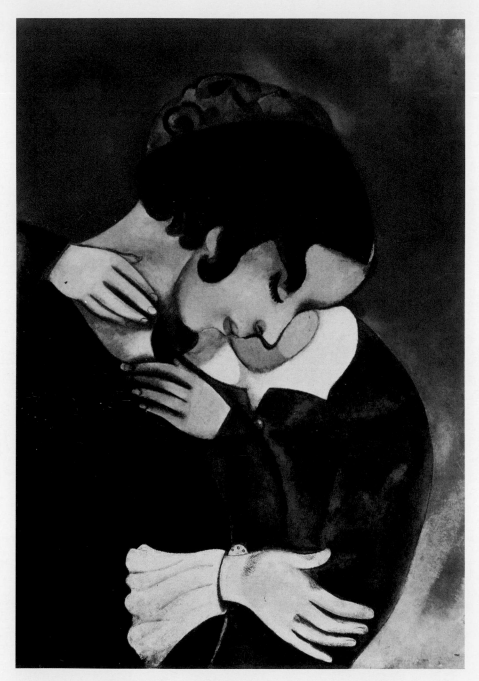

Chagall, *Lovers in Pink,* 1915. Oil on canvas, 69 x 55 cm

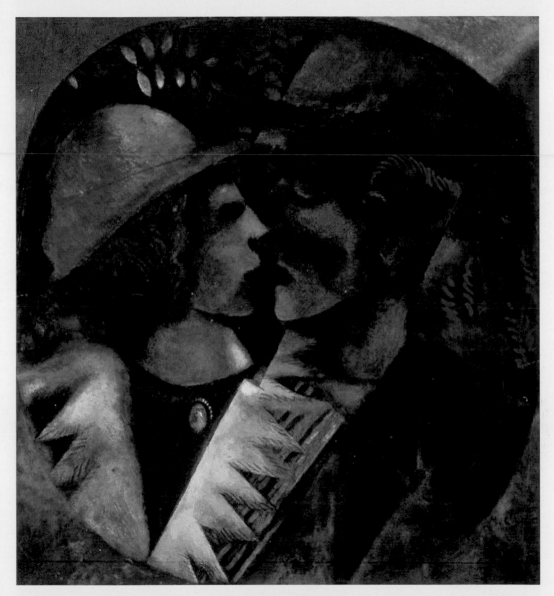

Chagall, *Lovers in Green*, 1914–15. Oil and gouache on cardboard, 48 x 45.5 cm

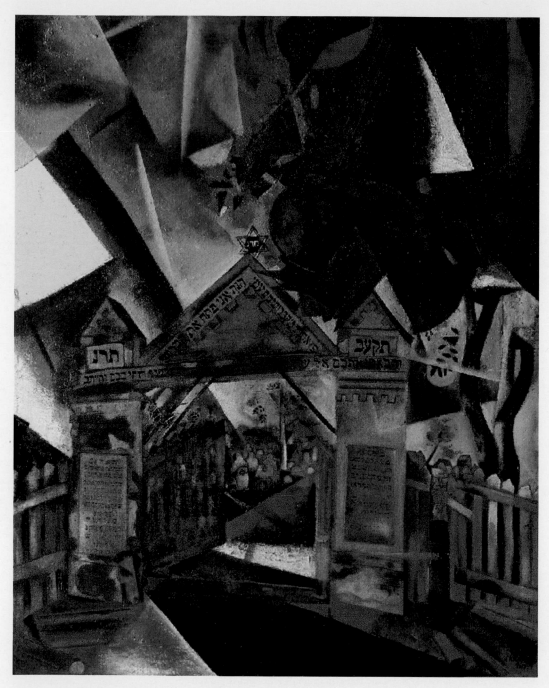

Chagall, *The Cemetery Gate,* 1917. Oil on canvas, 87 x 68.5 cm

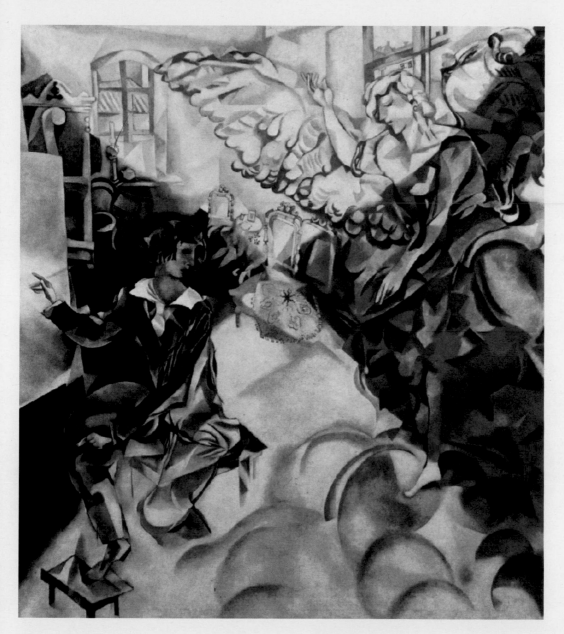

Chagall, *The Apparition*, 1917–18. Oil on canvas, 157 x 140 cm

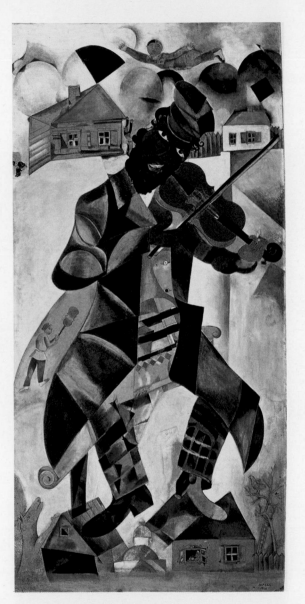

Chagall, *Jewish Theatre Murals: Music,* 1920.
Tempera and gouache on canvas, 213 x 104 cm

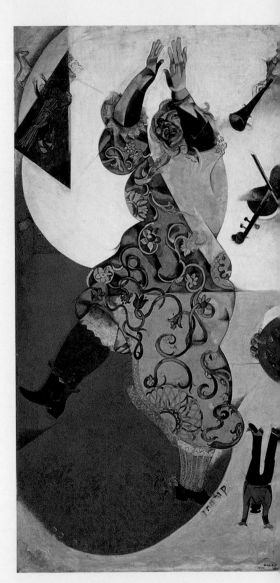

Chagall, *Jewish Theatre Murals: Dance,* 1920.
Tempera and gouache on canvas, 214 x 108.5 cm

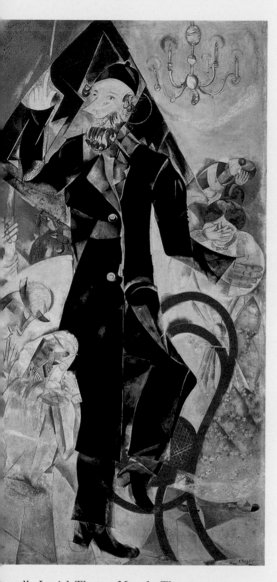

Chagall, *Jewish Theatre Murals: Theatre*, 1920.
Tempera and gouache on canvas, 212.6 x 107.2 cm

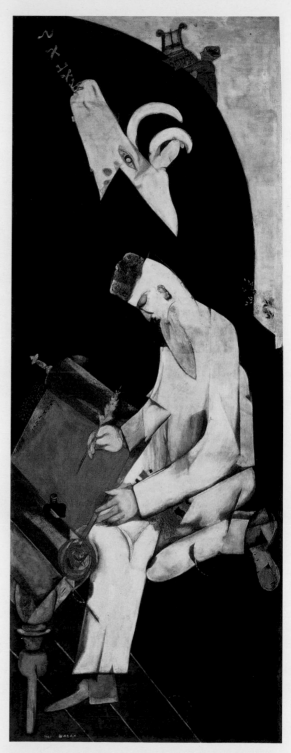

Chagall, *Jewish Theatre Murals: Literature*, 1920.
Tempera and gouache on canvas, 216 x 81.3 cm

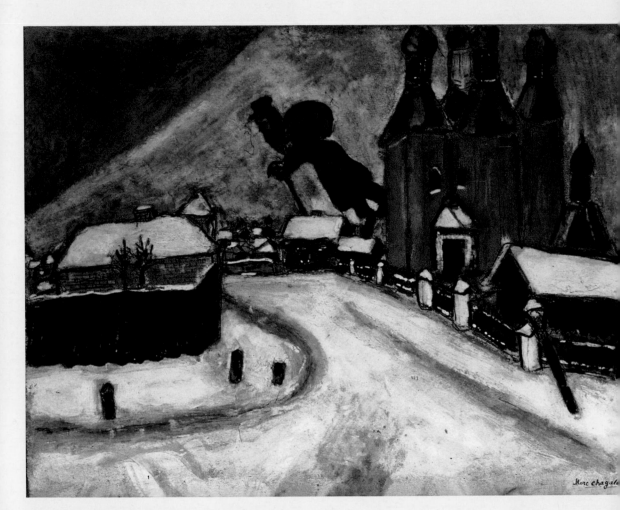

Chagall, *Over Vitebsk*, 1915–20. Oil on canvas, 66 x 91 cm

geois malice hiss all around us, we hope that new artist-proletarians will soon emerge from [the] working people," Chagall announced in a "Letter from Vitebsk" of December 1918, which ended with the rallying cry "Give us people! Artists! Revolutionaries-painters! From the capitals to the provinces! To us! What will tempt you to come?" He went to Petrograd and Moscow to recruit teachers–the futurist Ivan Puni and his wife Ksenia Boguslavskaya, for example, accepted a spur-of-the-moment offer from Chagall at a New Year's Eve party in Petrograd and arrived in Vitebsk three weeks later. Chagall worked hard to persuade his former Zvantseva teacher Dobuzhinsky to become director of the school; as a renowned World of Art figure, he would provide the new establishment with prestige. Dobuzhinsky accepted because Vitebsk's more plentiful food supplies enabled him to send packages to his family in Petrograd; other artists, notably Romm, also came in part because of Vitebsk's better conditions.

"From the lavish mansion of the banker Vishnyak, built on the blood and sweat, the suffering and tears of hundreds and thousands of people impoverished by usury–the dawn of a new culture rose above Vitebsk," announced *Vitebskii Listok* in January 1919. But the more left-wing *Izvestiya* reported that "it was to our great surprise and chagrin that we noted the sad fact that there were no workers present at the opening of this proletarian institution," and that the Communist Party's leading Vitebsk representative, Comrade Krylov, had said, "I must confess I did not like today's opening–it was simply too traditional, too old-fashioned. A left-oriented school should do without right-wing ways."

From the start the Bolsheviks perceived the People's Art College as a child of Red Vitebsk. By 1918 the town was a Bolshevik stronghold, the centre of the Red Army's reserves, occupied and surrounded by hundreds of thousands of soldiers fighting both the counterrevolutionary White Army and, a few miles away, the Poles. The cavalry of the Fifteenth Red Army and its twelve airplanes passed through and above the town, deserters were rounded up and shot. A Menshevik posting an anti-Bolshevik poster was shot on sight as early as summer 1918, and a Jew called Lazar Ratner found "guilty of malicious criticism of Soviet power and its activities" was sent to a concentration camp in 1920. A theatre, the Theatre of Revolutionary Satire (TeRevSat), was set up in Vitebsk to deliver revolutionary propaganda to Red Army soldiers in February 1919. Accompanied by cannon fire, the first performance took place on the square outside the ruined railway station, followed by many others on the front line itself. Chagall designed the sets for

the first ten productions between 1919 and 1920, which played to 200,000 soldiers.

Though Vitebsk fared better than starving Petrograd or Moscow, where urban life virtually collapsed, the atmosphere was tense. Chagall threw himself into the activities of the People's Art College, fighting for increased funding from Moscow and from the town of Vitebsk, procuring paints and materials, working on behalf of his students to exempt them from military service, and arranging evening classes, even, in May, a working boat trip to the village of Dobreika to teach drawing from nature. But like other left-wing Russian artists–Kandinsky, Exter–who had lived abroad and experienced the genuine political and artistic freedom of pre-1914 western Europe, he quickly detected signs of revolutionary liberation evaporating into bureaucratic control and then repression. The issue was built into the fabric of the system: even the urbane Bolshevik Lunacharsky tied himself in knots as he tried to steer a middle course between preservation and destruction. Narkompros's "basic policy in the field of art" was a masterpiece of compromise:

> We acknowledge the proletariat's absolute right to make a careful examination of all those elements of world art that it has inherited . . . At the same time we acknowledge that the preservation and utilization of the genuine artistic values that we have acquired from the old culture is an indisputable task of the Soviet government. In this respect the legacy of the past must be cleared ruthlessly of all those admixtures of bourgeois degeneration and corruption; cheap pornography, philistine vulgarity, intellectual boredom, antirevolutionary and religious practices . . . must be removed . . . The proletariat must assimilate the legacy of the old culture not as a pupil, but as a powerful, conscious and incisive critic.

As they travelled the road that led from the revolutionary avant-garde of 1917 to the socialist realism of the mid-1920s, many idealistic young Russian artists soon realised that great art rarely pleases either mass taste or political masters, and that in reducing art to agitation and the immediately comprehensible, the Bolsheviks were opening the door to a return to the naturalism that the avant-garde through the 1900s had fought to reject. By April 1919 Chagall was warning, albeit in the mandatory revolutionary language of the day, against the coming of socialist realism:

No, I will never be convinced that Antoine Watteau, the painter of elegant parties and the refined reformer of the plastic art of his century, is inferior to Gustav Courbet solely because the latter represented workers and peasants on his canvases . . . We must be very wary about defining Proletarian Art. Above all, let us be very careful not to define it by its ideological content . . . It is precisely this aspect that we must banish definitively. Let us not shout all over "Look, look: we are those same workers and peasants, we are struggling, we are fighting." Let us not underline it in our works. Whom do we want to impress? The voice of the masses will always recognise truth . . .

Unlike the bourgeois painter who is forced to pander to the taste of the mob, the proletarian painter is constantly struggling against routine and leading the masses after him. I repeat: we will remain indifferent to works that tell or represent the heroic struggle and the life of the workers and peasants; we do not feel the breath of the essential laws of the new Art in those works.

He ended with the hopeless contradiction that "to be the minority in art is [to be] the measure of its authenticity. But we won't be so for long . . . The coming days will remove all uncertainties and mutual incomprehension. Wait for the day of transfiguration! You will be with us! And with us the New World will awaken!"

Like many young liberals, Chagall was naïve and politically inexperienced, which made his open regime vulnerable. Among the old guard, Dobuzhinsky lost interest in the school and resigned almost immediately, returning to his family in Petrograd in April 1919; the Punis did not last much longer. Both departures were warning signs that the moderate centre could not hold. On April 16 Chagall sent a telegram of resignation as commissar for Vitebsk, which was not accepted; he also took Dobuzhinsky's place as director of the school. Here he soon made enemies, first harmless ones on the right, then dangerous ones on the left. The Isaac Peretz Society (Peretz was still Yiddish literature's brightest voice) complained that he was heavy-handed and dictatorial, and Pen, excluded from the initial teaching body, was mortified that his famous pupil had ignored him. His revenge was to paint a parody of a symbolist picture in which he depicted himself on his deathbed, giving the devil who came to fetch his soul a face that was recognizably Chagall's. He was mollified when Chagall invited him to teach after

all, and he joined the school in June; he was soon on harmonious enough terms with him to paint a portrait of naked three-year-old Ida Chagall. The *Vitebskii Listok* reported Pen's appointment and noted cautiously, "Students may register for Mr Pen's studio at the school office, which is open daily from 10 to 4. Presently all artistic tendencies are represented at the school: students are free to choose among the teachers the one whose orientation best suits them."

In July Chagall warned that it was imperative "to be careful not to erase the individual peculiarities of each person, while working in a collective." Freedom for staff and pupils to teach and learn as they pleased was fundamental to his vision for the school, and he was proud that he "offered all artists complete freedom . . . Nearly all schools of modern art were represented, from Impressionism through to Suprematism." Solomon Gershov, a thirteen-year-old member of the school in 1919, remembered that "he never prevented any teacher from teaching as he thought fit. This was so because, at the time, everything had been thrown into question, including art. The spirit of the Revolution was to give birth to a wholly new art and culture." The school's classes by summer 1919 ranged from Pen's academic training, which was unpopular, to Ivan Tilberg's sculpture studio, from evening classes for workers given by Nadezhda Liubavina (a Petrograd friend of Mayakovsky's), to those of Romm, who headed the drawing school and also gave a popular lecture series on El Greco.

Chagall, who had no particular methodology but much glamour, was initially the most loved of all the teachers, and his "free studio" had to be supplemented by a second because it was oversubscribed. He disdained academic copying and preferred still life–the Vitebsk archive contains a note from a local homeowner demanding the return of a vase, a bowl, and red and blue glasses that Chagall had borrowed from him for teaching purposes–or taking students on sketching trips in the environs of Vitebsk. "Chagall stood in the dead centre of the market, amongst carts, cows, goats and peasants, and began to work," recalled Gershov.

> We threw ourselves into the search for an interesting subject. Sometimes he stopped us: "Where are you going? Are you looking for a nice spot? But any idiot could paint that! You must choose an ugly spot and make it beautiful." Did Chagall have a method of teaching? It would be more true to say that he influenced his pupils by his own example and made them understand

Chagall with some of his students, 1919. Left to right: Lazar Khidekel; M. Veksler; Chagall; L. Tviperson; Lev Zevin (seated); Moisei (Mikhail) Kunin, who became a circus performer; Ilya Chashnik, who had left school at eleven to work in a factory; and Chaim Zeldin, the thirty-year-old house painter whom Chagall had encouraged to enrol at the school.

that the subjects for all creative work are to be found everywhere, in the street, at the market. It was impossible not to follow his example.

Mesmerised pupils such as Gershov and the gifted, fiery Moisei (Mikhail) Kunin—in works depicting a distorted, fragmented version of his native city such as *The Great Synagogue in Vitebsk*—drew and painted in Chagall's style; so did some of the teachers. Romm had his first and last exhibition in Vitebsk, showing graphic miniatures ("At the Market," "The Vitebsk Road"), where the influence of Chagall's Vitebsk "documents" is obvious.

Romm would not forgive Chagall for casting his long shadow; others were bewildered or confused by him. "This studio, which had been a dream for me, proved to be more like a madhouse," recalled the graphic artist Valentin Antoshchenko-Olenev, who was nineteen when he attended Chagall's free studio.

I would sit before an unrolled canvas, staring at the pretty nude model—but how could I paint her? In blue and red or yellow? After attending the Petersburg Society for the Advancement of the Arts [Roerich's establishment], Marc Chagall's school disconcerted me. How to paint a nude model with only three colours: red, yellow and blue? This grieved me and I began to accuse myself of backwardness and even ignorance. What kind of artist could I be? And yet everyone in the studio was doing precisely these kinds of studies.

This moment of confidence, when everyone was painting like Chagall, is captured in an early photograph of the school's teachers taken on 26 July 1919. Chagall, still a little refined looking with his curly hair and chiselled features, is handsome and composed in the centre. With his goatee and balding head, old-fashioned suit and formal tie, Pen at sixty-five cuts a curious figure among the rest, who are in their twenties or early thirties and represent a range of the young blood of the revolution: from intellectual, bespectacled Romm perched on a stool at one end, to a new arrival, Lazar Lissitzky, staring out aggressively with firebrand eyes from beneath a big hat and cloaked in a thick overcoat, at the other end, and flanked by another newcomer, fellow radical twenty-six-year-old Vera Yermolaeva, a tough survivor who had been paralysed and on crutches since childhood and whom Chagall mocked as the Gioconda of Vitebsk.

Chagall, ambitious for his school, wanted to attract exciting young talent and thus invited Lissitzky, whom he had known since childhood from Pen's, to join the faculty. Lissitzky had studied in Paris, where he was close to Zadkine, then in Darmstadt, before acquiring a diploma in engineering and architecture from Riga University during its wartime evacuation to Moscow. Between 1917 and 1919 he had concentrated on illustrating Jewish fables in a style similar to Chagall's own work for Der Nister, and Chagall assumed him to be a devotee. Recently, however, Lissitzky had come under the spell of Malevich in Moscow, and by 1919 he was experimenting with his abstract *Proun* paintings—*Proun* was an acronym for his Project for the Affirmation of the New. He arrived in Vitebsk from Kiev, Malevich's native city, which had just fallen to the counterrevolutionary White Army in battles of unspeakable cruelty—the Ukrainian pogroms there were the worst since the seventeenth century and left 200,000 Jews dead, 300,000 orphaned, and 700,000 homeless. Brutalised and inflamed with a fervour for the Red

Teachers at the Vitebsk People's Art College, 26 July 1919. Left to right (seated): El Lissitzky, Vera Yermolaeva, Chagall, David Yakerson, Yuri Pen, Nina Kogan, Alexander Romm.

Army, Lissitzky proved to be a troublemaker as soon as he arrived. Although Chagall had coexisted easily with the futurist Puni, Lissitzky now teamed up with Yermolaeva and another teacher, Nina Kogan, against him. Chagall hated factionalism, and in September he resigned, but he was still the local hero, and his students begged him to stay; their general assembly praised him as "one of the chief pioneers on the road to a new art . . . the school's sole moral support" and expressed "its full and unconditional faith" in him, promising "support in all his undertakings and actions." So Chagall remained, and while he was organising the "First State Exhibition of Paintings by Local and Moscow Artists," which included paintings by Lissitzky on Jewish themes, Chagall sent Lissitzky off to Moscow to buy materials for their workshop.

A couple of weeks later—the journey, using freight trains on a half-destroyed rail network, took four days each way—Lissitzky returned with his trophy and weapon: the stocky, pugnacious, broad-shouldered, thickset figure of Malevich. He had delivered Malevich an invitation, signed by Yermo-

laeva, rector of the school, to join the Vitebsk college. Malevich accepted and left Moscow with Lissitzky immediately, eager to avoid another winter of food and fuel shortages–unable to afford an apartment in the capital, he was living in a cold dacha in an outlying village–and to escape his fraught relationships with several powerful artist-administrators there including Kandinsky, Tatlin, and Shterenberg.

Three of Malevich's paintings, including one called *Suprematism,* were shown in the "First State Exhibition," which opened the week after his registration as a professor in Vitebsk on 1 November. But it was not until his first lecture on 17 November that his charismatic power made itself felt, and Vitebsk's young, politically inexperienced, idealistic students flocked to him as if to a messiah. Yermolaeva and Kogan, both impressionable young women, adored him; Lissitzky changed his name from the Jewish-sounding Lazar Mordukhavich to El, in homage to the epigram in Malevich's "On New Systems in Art," which the Vitebsk People's Art College published:

> *Static and speed*
> *I follow*
> *u-el-el'-ul-el-te-ka*
> *my new path*
> *Let the overthrow of the old world of art*
> *be traced on the palms of your hands.*

Before he ever set eyes on Malevich, Chagall had been shedding his bureaucratic role and, encouraged by Bella, had tried to resign from the school; Malevich now speeded up and made more traumatic a process that, for an artist as resistant to authority as Chagall, was inevitable. From the moment Malevich arrived, Chagall played out his endgame not only in the school but in Vitebsk and, ultimately, in Russia itself. Malevich, said the Russian writer Daniel Kharms, "seemed with his hands to part the smoke." Forty-one years old, he had spent more than half his career expounding the aesthetic and moral superiority of the system of abstract art that he had invented. A child of the Russian Revolution and the years leading up to it–unlike Chagall and Kandinsky, Malevich had never had the means to travel abroad, and this at once limited and focused his fiery vision–he spoke like a prophet, thought like a philosopher, behaved like an ascetic, and though a fine painter, regarded art as primarily a political and intellectual tool. Even in 1920 Efros complained that he had "no particular talent, not an

important painter," his pictures being mere "illustrations accompanying his theories." Nonetheless he was given a solo show in Moscow in 1919, and between 1918 and 1920 the state bought thirty-one of his paintings for a total of 610,000 rubles, nearly twice the amount paid to Chagall in the same period. (By comparison, Kandinsky did better than both; the state acquired 922,000 rubles' worth of his work, including twenty-nine paintings.)

While Chagall avoided conflict wherever possible, Malevich sought and thrived on it. Through the tsarist years he had fought the establishment—Benois had decried *Black Square* as "a sermon of nothingness and destruction" in 1915—and now he perfected his confrontational language. His destructive, utopian rants—"It is from zero, in zero, that the true movement of being begins"—seduced those intoxicated with the new who, he boasted, "have turned aside the rays of yesterday's sun from their faces." Back in 1915 he had written, "I am painting pictures (or rather non-pictures—the time for pictures is past)"; now in Vitebsk he barely painted but devoted himself to proselytising and approving works by his followers such as Lissitzky's aggressive red triangle piercing a white circle, *Beat the Whites with the Red Wedge.* Chagall, too, dreamed of transformation, but he was a painter above all, a constructor of worlds, not a destroyer, and he could find no meeting place with Malevich's nihilism. Objects and people imbued with spiritual meaning were the essence of his art, anchored in the Hasidic vision of his childhood. He had no problem with suprematism's being taught in Vitebsk, regarding it, like cubism, as another form of representation. But in 1919–20 it was easy for Malevich and Lissitzky to make Chagall's humanism look old-fashioned, bourgeois, decadent. "After the old Testament there came the new," wrote Lissitzky, "and after the new the communist and after the communist there follows finally the Testament of Suprematism." A battle between the suprematists, for whom there was only one true art and who advocated collectivism as a working practice, and Chagall, pluralistic as director and individualistic as an artist, soon broke out. Chagall must have anticipated it, for his immediate response to Malevich's arrival was to write to Moscow, on 17 November 1919, with a request to be transferred to a teaching job in the capital. But this was refused, and again his students urged him to stay. So for the first months of 1920 he settled into trying to run a school that had become "a veritable hotbed of intrigue" but was also, briefly, one of the most talked-about and exciting art institutions in Russia.

In January–February 1920 Malevich and Lissitzky, supported by Nina Kogan and Yermolaeva, formed the Unovis group (the acronym stood for

Utverditeli Novogo Iskusstva, or Champions of the New Art) and recruited large numbers of the Vitebsk students, many of them just fourteen years old. Their names and dates of birth (Lazar Khidekel, 1905; Abram Vexter, 1905; Vladislav Strzheminsky, 1905) are listed in Unovis files and suggest not only that they were young but that a large number of Jews crossed from Chagall to Malevich. Seventeen-year-old Ilya Chasnik was typical: the youngest of eight children in a very poor family, he had grown up in Vitebsk and left school at eleven to work in an optics factory but had managed to return to school at fourteen and studied with Pen. He left Vitebsk to study in Moscow but

Malevich (centre, with a work by Lissitzky in his hands) and members of Unovis at Vitebsk train station, preparing to depart for Moscow to participate in the All-Russia Conference of Students and Teachers of Art, June 1920. Lissitzky is in the second row, second left.

returned in 1920 because he wanted to work with Chagall, only to fall quickly under the spell of Malevich.

Chagall, however, was still Malevich's boss, and he, Bella, and Ida were also neighbours of Malevich and his wife, who moved into the professors' quarters of the "White House," where their daughter Una (named after Unovis) was born that year. (A granddaughter born to Malevich a few years later was called Ninel–Lenin spelled backwards.) Early in 1920 the Chagalls moved out, changing communal apartments frequently in the next few months; they lived first in two rooms alongside a militant Polish family near the barracks, then in the barely lit, nearly shut-up home of a wealthy old widower who hoped that, as director of the college, Chagall might protect him. At night the Cheka, the secret police force formed immediately after the revolution by the Bolsheviks, searched the house, passing through the Chagalls' bedroom; by day soldiers marched past the windows.

Outside and within the school, the Chagalls felt threatened. The atmosphere at the White House grew more poisonous; Unovis members worked in cells and closed studios with notices instructing "Outsiders Keep Out." Lissitzky made the rounds of students still loyal to Chagall, terrorizing them with revolutionary correctness: "The atomization of blinkered personalities within separate workshops is not in accordance with the times. It is counter-revolutionary in its general direction. These people are landlords and owners of their personal programs!" Chagall was isolated and, compared with the superb organisational skills of his adversary, a poor and chaotic administrator. He was also worn down by constant trips to Moscow to raise funds and acquire supplies; in his absence, Bella stood in for him, but "while I was away from Vitebsk, Impressionists and cubists, Cézannians and Suprematists, whether on the faculty or among the students, used to engage in a kind of free-for-all behind my back."

In April he wrote to collector Pavel Ettinger that "at present there is an extremely exaggerated formation of groups around 'trends': there are 1) young people following Malevich and 2) young people following me. We both belong to the left-wing artistic movement, although we have different ideas about ends and means. Obviously it would take too long to talk about this problem now." Apologising for the long delay in writing, he had been, he said, "unbelievably distracted and very busy. More than that, however, there's something else, something that doesn't give me the chance to take a pen in my hand. Probably this is also connected to the great difficulty I have in picking up my brush." When, occasionally, he did so, the pervasiveness of

suprematist forms in Vitebsk was apparent, even as he resisted them. In *The Circus,* for example, an enormous green sphere is set in a pink rectangle and spins men and animals around and around, up and down: it is a cosmic carnival, or a parody of Malevich, suggesting Chagall's horror of abstract forms dominating men's lives.

He reserved his full fury not for Malevich but for the treacherous Lissitzky. By early 1920 he was not on speaking terms with him, and while writing his memoirs two years later, he could not bring himself to refer to either Lissitsky or Malevich by name. Lissitzky, for his part, continued to make Malevich a god and wrote that "as far as expressionism is concerned, the whole Chagallian eroticism of powdered rococo inevitably paled before the power of this fossilised Scythian." The class overtones are significant: at this time the Cheka turned on the Rosenfelds. Chagall, who had condemned the banker Vishnyak cheerfully enough and occupied his property, now experienced Bolshevik destruction from the other side.

> One afternoon, seven cars belonging to the Cheka drew up in front of the dazzling show-windows, and soldiers began to gather up precious stones, gold, silver, watches, everything in the three shops . . . They even carried off from the kitchen the silver service that had just been cleared from the table.
>
> Afterwards they went up to my mother-in-law and thrusting a revolver under her nose:
>
> "The keys of the strongbox, or else . . ."
>
> At last, satisfied, they left.
>
> My wife's parents, who seemed suddenly to have aged, sat mute, arms hanging at their sides, eyes staring towards that distance into which the seven cars were disappearing.
>
> The crowd that had gathered wept silently.
>
> They had carried off everything. Not even one spoon was left.
>
> That evening the family sent the maid out to look for some ordinary spoons.
>
> The father takes his, lifts it to his mouth, puts it down. Tears stream down on the pewter spoon and mingle with his tea.

That night the Chekists returned, accompanied by an informer, and broke through the walls and ripped up the floors of the Smolenskaya apartment and shop, looking for hidden treasures.

Across Russia such scenes of class vengeance were enacted daily, and one of the shocks for the bourgeoisie like the Rosenfelds, once one of Vitebsk's most respected families, was the malice and destructiveness unleashed by the working class with whom they had appeared for decades to live peaceably.

After their home was ransacked, Bella's parents went to live in Moscow; most of their sons had already left Vitebsk. Early in the 1920s the Bolsheviks also turned against the revolutionary branch of the family—the husband of Bella's sister Chana, whom the Rosenfelds had rescued from jail in tsarist days, was denounced and killed, and Chana's sons were warned never to mention their father again.

In Vitebsk, "there was a rush to place orders with the young sculptors for busts of Lenin and Marx, in cement," which melted in the rain, but

> One Marx was not enough.
> On another street they had set up still another one.
> It was not any more fortunate than the first.
> Big and heavy, it was even less benevolent and frightened the coachmen whose cab-stands were just across the way . . .
> Wherever is Marx? Where is he?
> Where is the bench on which I kissed you once upon a time?

Like many who had lived in the West, Chagall's thoughts now turned back to Paris and Berlin. Already by 1920 the first wave of writers and artists were leaving Communist Russia—Jewish dramatist S. Ansky left for Vilna; poet Zinaida Gippius quit Petrograd on 24 December 1919 under the guise of giving a lecture to the Red Army in Gomel, then slipped over the border to Poland. Ivan Puni crossed the border to Finland illegally at the end of 1919 and made his way to Berlin, ending up Jean Pougny in Paris. Futurist David Burliuk began a tour of Japan in 1920, then moved to the United States. In 1920, too, Fyodor Sologub, the symbolist writer with whom the young Chagall had been obsessed, applied for permission to emigrate; when this was refused, his wife committed suicide by throwing herself into the Neva, and Sologub lived the rest of his life as a recluse. He was last seen at the Moscow Press Club in 1920, when "some of the speakers were saying that the era of individualism was over. Sologub nodded in obvious agreement. In his concluding words he merely added that a collective must be made up of units,

not of zeros, for if you add a zero to another zero, you won't get a collective but a zero." For those left in Russia, civil war and transportation breakdown made communication with the rest of Europe virtually impossible; none of Chagall's Western friends knew if he was alive or dead until 1919, when Communist Frieda Rubiner, wife of Chagall's German poet friend, travelled to Moscow, stayed at the Metropole Hotel, and at a lecture by Mayakovsky discovered that Chagall had survived the war and was in Vitebsk. The Rubiners had spent the war in Zurich, returning to Berlin in 1919. "The world has changed so much that we could recount so much to each other," she wrote. "You know, you are a famous artist in Germany, and your paintings sell very high. But who will get the money? Walden is now such a dealer and a cheat, I doubt whether he will pay you much." Frieda took back to Berlin Efros and Tugendhold's book on Chagall, which she aimed to translate into German, and a romantic view of Russia: "I'd like to imagine your life working for the Soviets," she wrote; she promised to contact Walden, but Chagall heard nothing; in the meantime Ludwig Rubiner died of lung disease, aged thirty-eight, in February 1920. In April 1920 Chagall begged the internationally connected Ettinger "Do you happen to have heard anything about the fate of my pictures in 'Der Sturm' in Berlin?" He added,

> Now at last "artists have the upper hand" in the town [Vitebsk]. They get totally engrossed in their disputes about art. I am utterly exhausted and . . . dream of "abroad." After all, there is no more suitable place for artists to be (for me, at least) than at the easel, and I dream of being able to devote myself exclusively to my pictures. Of course, little by little one paints something, but it's not the real thing.

In May Chagall returned from a trip to Moscow and found "across the facade of the school building, a huge sign: *Suprematist Academy.* Malevich and his henchmen had simply fired all the other members of the faculty and taken over the whole Academy. I was furious. I handed in my resignation at once and set out again for Moscow, in a cattle-car, as the railroads had no other rolling stock available even for travellers on official business." Events were not quite as condensed as he liked to remember: on 25 May his students announced their decision to leave him and join Malevich's studio, and he left Vitebsk on 5 June–humiliatingly, on the very same train that Malevich and his followers were taking to a conference in Moscow. His resignation

was confirmed on June 19. According to Ivan Gavrin, a twenty-one-year-old soldier who had returned from the front to join the Vitebsk school and was a member of Unovis,

> in the face of the massive influence of leftist art M. Chagall was himself no longer able to make a convincing case for his individualist-avant-garde ideology. Agitation had deprived him of his audience and there was growing evidence of student dissatisfaction with his work. Being a sensitive person, M. Chagall left his studio and went to Moscow when he became aware of the turn events were taking.

Among his final Vitebsk works was *Cubist Landscape,* in which the Vitebsk school, the White House on Bukharinskaya, is framed by an architectonic structure of suprematist forms. These segments, triangles, and semicircles are lightened and made graceful by a delicate colouring–pale blue, deep rose, light yellow–which makes the shapes appear to fly through space and produces a quite different effect from that of the hard, cold colours used by suprematist artists. The work is thus an allegory for Chagall's airiness versus Malevich's heaviness. A curtain sweeping towards the school is inscribed over a dozen times "Chagall," in Cyrillic and Roman lettering; outside the school door appears the outline of a Chagallian goat. It was Chagall's farewell to a Vitebsk now won over by Malevich.

For the next two years his bitterness overflowed. Efros, a patient listener in Moscow in the summer of 1920, recalled that when Chagall arrived in the capital,

> he didn't know what to do, and spent the time telling stories about his experience as commissar and about the intrigues of the Suprematists. He loved to recollect the time when, on revolutionary holidays, a banner waved about the school depicting a man on a green horse and the inscription "Chagall–to Vitebsk." The students still admired him and covered all the fences and street signs that had survived the Revolution with Chagallian cows and pigs, legs turned up and legs turned down. Malevich, after all, was just a dishonourable intriguant, whereas he, Chagall, was born in Vitebsk, and knew well what sort of art Vitebsk and the Russian revolution needed.

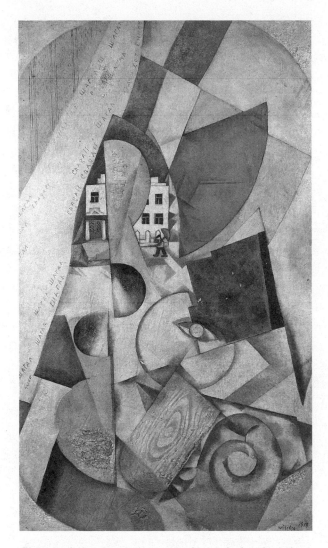

Chagall, *Cubist Landscape,* 1920 (wrongly dated 1918),
oil on canvas. The white house in the centre is the Vitebsk
art school; across the curtain Chagall has repeatedly
inscribed his own name, as if to assert his true supremacy
in his native town, despite Malevich's victory.

In 1922 Chagall still seethed that the features of his enemies were "sunk into my heart like logs of wood":

> Make me leave within twenty-four hours, with all my family!
> Make me take down my signs, my notices—stutter as much as you please! . . . I shan't be surprised if . . . my town obliterates all traces of me and forgets the man who, laying aside his own paintbrushes, worried and suffered and took the trouble to implant Art there, who dreamed of making ordinary houses into museums and the average citizen into a creator.

By then the suprematists had fallen out among one another and left the school, which by 1923 was a second-rate college of applied art. Even had Chagall not been driven out by Malevich, his art would not have survived there long, for from 1920 onwards, all avant-garde artists felt more pressure to toe the party line of socialist realism. In May 1920, at the same time as Chagall was routed from Vitebsk, Kandinsky in Moscow was ousted by the constructivists from the Institute for Artistic Culture, which he had helped to found. Lunacharsky began to speak a different language. "Futurism has fallen behind the times," he announced in 1920—by futurism he meant the avant-garde. "It already stinks. I agree it has only been in the tomb three days, but already it stinks. There is no need to look for a Picasso for the proletariat." Just after Lenin's death in 1924 *Art News* reported a story that encapsulated Malevich's uncompromising, doomed heroism:

> Malevich, who like all other Bolshevik artists, has been working to express the greatness of Lenin in a model for his monument, proudly exhibited a huge pedestal composed of a mass of agricultural and industrial tools and machinery. On top of the pile was the "figure" of Lenin—a simple cube without insignia.
> "But where's Lenin?" the artist was asked. With an injured air he pointed to the cube. Anybody could see that if they had a soul, he added. But the judges without hesitation turned down the work of art. There must be a real figure of Lenin, they reason, if the single-minded peasant is to be inspired.

Chagall's revenge on the suprematists was not just to live well but to live at all. Malevich was imprisoned in the 1920s, and although he was repre-

sented in Leningrad's jubilee exhibition commemorating Soviet rule in
1933, he and other suprematists were crowded into one small room–a room,
wrote one critic, that was "most memorable for, as it were, its curious
tragedy. Here are people who thought and invented and worked, but they
generated such a centrifugal force in their art that it carried them out of art
to the beyond, to nowhere, to non-existence." Malevich was now a powerless
artist and his late works mocked the return to representation in Soviet art;
depicting simplified faceless peasants as hieratic anonymous figures, he
identified with the helpless victims of Stalin's collectivization. Denied med-
ical help or permission to seek it abroad, Malevich died of cancer in 1935.
Few of his suprematist friends outlived him long. One of Chagall's chief
betrayers, Malevich's disciple Chasnik, who had followed him to Moscow in
1922, died in Leningrad in 1928. Ivan Gavrin, who became the school's
deputy rector in 1921, was arrested and killed in 1937; Lev Yudin perished on
the battlefield at Leningrad in 1941. Lissitzky fell out with Malevich, became
a propagandist for the state throughout the dark 1930s, and died in Moscow
in 1941; his wife was then sent to Siberia. If Malevich had played Lenin to
Chagall's Kerensky, Lissitzky gloried in the role of Stalinist annihilator of
them both.

Almost all "the women in the throes of suprematique mysticism," whose
magnetic attraction to Malevich so baffled the sexually timid Chagall ("what
means he used to attract them, I do not know"), had sad fates. Rozanova
died of diphtheria at the end of 1918; Udaltsova, whose army officer father
had been killed by the Bolsheviks in 1918, lived long enough to be arrested as
an anti-Soviet formalist in 1938, along with her husband Alexander Drevin,
who was shot dead weeks later. The cripple Vera Yermolaeva was sentenced
to five years' penal servitude in Kazakhstan and perished in the camp there
in 1938. Her friend Nina Kogan died in the siege of Leningrad in 1942.

Among others at the school, Romm returned to Moscow in 1922, and he
never exhibited again; inspired by the success of his art history lectures, he
became a leading Soviet art historian and shortly before he died in 1952
wrote a bitter memoir about Chagall. Antoshchenko-Olenev, the student
who had thought Chagall crazy, worked as a graphic artist in Central Asia
and was jailed without cause between 1938 and 1957. Mikhail Kunin, one of
the few students Chagall remembered, became a circus performer in the
early 1930s, often using drawing tricks as he toured the Soviet Union. Cha-
gall was so touched by this story–it was as if Kunin were living out one of his
own canvases–that he wrote to him ("You must remember how much I cared

for you, Kunin, and I wish you much happiness") and asked to meet him when he returned to Russia in 1973, but Kunin had died the year before.

The Vitebsk People's Art College changed its name several times, and not even its address survived: after Nikolai Bukharin became one of Stalin's first show trial victims and was executed in 1938, Bukharinskaya was renamed. "My town is dead. The Vitebsk course is run!" wrote Chagall. His father was killed shortly after he left in 1920, run over by a truck while he was working– "my father's face, crushed by destiny and by the wheels of an automobile." Chagall was then so emotionally fragile after his battles with Malevich that Bella "hid the letter announcing his death from me," and he did not go back to Vitebsk for the funeral or to help his sisters: "it's wicked that I wasn't there."

In January 1921 the Vitebsk Yevsektia, the Jewish section of the Communist Party, organised a public trial of the town's religious schools and oversaw their closure. The first synagogues to be shut down in Russia were those of Vitebsk in April 1921; photographs show Torah scrolls piled up for destruction and synagogues, wrecked or bare, inscribed in Yiddish with Bolshevik slogans about education as the path to Communism. Jews occupied synagogues marked for closure and held prayer meetings, but the army removed them, smashing the windows to the chorus of "Death to the Yids" and killing worshippers as they went. One synagogue became a Communist university, and several were used as workers' clubs; one was turned into a

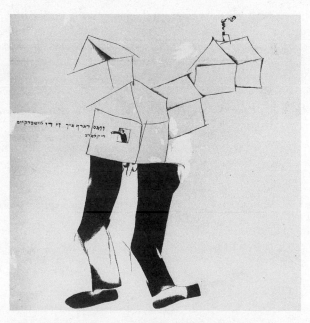

Chagall, "Man with Houses," 1920, drawing

shoe factory. This was the beginning of the Bolshevik campaign against Judaism, backed ideologically by the argument–Marx's own–that Jews, because they were predominantly traders, were a social group synonymous with capitalism. It was supported by the rank and file of the Communist Party who had never shaken off the anti-Semitism, fuelled by economic rivalries, of lower-class prerevolutionary Russia. Reactionary White Russian opinion was also prejudiced against Jews, as many leading Bolsheviks were Jews, and the Cheka had a strong Jewish contingent. "Hatred of the Jews," wrote a sociologist in 1921, "is one of the most prominent features of Russian life today; perhaps even the most prominent. Jews are hated everywhere–in the north, in the south, in the east, and in the west. They are hated by people regardless of their class or education, political persuasion, race or age." But the churches that were major landmarks in Chagall's paintings fared little better: the "Black Trinity" near his birthplace was struck by lightning and burned down in 1921; the Uspensky Cathedral and green-domed Transfiguration Church, which he had seen from his parents' window, were both demolished due to dilapidation in the 1930s.

Lisa, Chagall's favourite sister, had married in 1919 and left Vitebsk. Mania, the last remaining sister there, left the family home in 1921 and moved to Petrograd, taking with her the heavy wooden furniture–sideboard, armchairs, cupboards, chests–from Pokrovskaya. She transported it from one two-room flat to another until her death in 1948, when it passed to her daughter and son-in-law. He was "a very technical man who didn't understand art at all, as he himself said," and "with great difficulty he chopped [the furniture] into firewood. The wood was strong and couldn't be sawed easily, and he was proud to succeed, and glad to rid himself of the huge cupboard from the Chagall family house in Vitebsk." After they left in June 1920, Chagall and Bella never saw Vitebsk again, but both composed elegies for it: Bella in her Yiddish memoirs of the 1940s and Chagall, immediately, in his radical work for the Moscow Jewish Theatre, which was his farewell to Russia.

Chagall's Box

Moscow, 1920–1922

W hy not mix with the peasants, the speculators, that whole crowd loaded down with samovars, jugs of milk, infants!" wrote Chagall of his journey out of Vitebsk. A sense of Moscow, the big village, heart of Russia's medieval identity as well as her Communist future, began as soon as Chagall, Bella, and Ida boarded the freight train. "We piled up as best we could, one on top of the other, in a cattle car. The train progressed slowly with a concert of curses and insults. We lived in a stinking atmosphere. After many incidents, we reached Moscow. The station was occupied by an army of peasants flanked by countless bundles. When we succeeded in getting out of that horde, we went to find somewhere to live."

The Chagalls had no money–"we didn't need any–there was nothing to buy"–and no employment. "At last I found a little room, overlooking the courtyard," Chagall wrote. "Damp. In the bed even the blankets are damp. The baby [four-year-old Ida] lies in dampness. Pictures turn yellow. The walls seem to run." At first, as Efros recalled, Chagall simply "didn't know what to do." A photograph taken shortly after his arrival shows a thin-faced, anxious, weary Chagall with a hunted expression looking out from under the brim of a wide black hat. Lunacharsky accepted his resignation with alacrity, claiming to possess a file detailing numerous complaints against him as authoritarian and uncooperative, and he now found himself almost friendless among his fellow artists. Lunacharsky's regime awarded stipends to painters, and a committee including Malevich and Kandinsky placed them in three categories; Chagall was relegated to the third and so received only the most basic rations for food and other necessities. The state was vir-

tually the only arts patron at this time; the wealthy collectors who had supported the avant-garde had left the country, and popular taste was already shifting towards the conservative, heralding the rise of socialist realism, and during the civil war those few collectors who remained had neither the stability of outlook nor the funds to buy. No one was selling paintings, and few were making them—most of the avant-garde artists were engaged in agit-prop work, or performing administrative duties, or writing theoretical treatises (as Kandinsky and Malevich were doing), or undertaking projects such as theatre decoration for leading directors like Meyerhold and Tairov, who were funded by the state. Chagall was again an outsider. At artists' meetings it seemed that everyone else was a professor, and he was regarded with distrust and pity; a former leader of the "Jack of Diamonds" group pointed to a lamppost in Kremlin Square and muttered that soon everyone would be hung from it.

When the autumn snow came, conditions in the war-torn capital plummeted. Chagall dragged his rations over the icy roads; Bella tried to sell her jewellery at the Sucharesky market and was arrested as a counterrevolutionary. Her parents lived nearby in penury. Like almost everyone else, the Chagalls were hungry and cold; water poured from the walls and ceiling of their damp unheated flat, and Bella was terrified that Ida would freeze to death in the night. This was the year that Kandinsky's baby son Vsevolod (a year younger than Ida) and Irina, younger daughter of poet Marina Tsvetaeva, died of malnourishment in the Russian capital. "Mama could never put it out of her mind that children can die of hunger here," wrote Tsvetaeva's elder daughter Alya. Prince Volkonsky, a family friend, recalled that Tsvetaeva, daughter of the founding director of Moscow's Museum of Fine Arts, lived in 1920 in an "unheated house, sometimes without light . . . a bare apartment . . . little Alya sleeping behind a screen surrounded by her drawings . . . no fuel for the wretched stove, the electric light dim . . . The dark and cold came in from the street as though they owned the place." Even an artist as well established as Stanislavsky, working at the Moscow Art Theatre ("I am ashamed to say that my old friend *Uncle Vanya* comes invariably to my rescue"), described the postrevolutionary conditions in the capital bleakly: "I am afraid my wife finds life very hard. It depends on her entirely whether we have enough to eat or not, and but for her we should have been starving. This is very important for the children. Whatever we earn, we spend on food. Everything else we have to do without. We all look shabby."

Chagall, Moscow, 1920

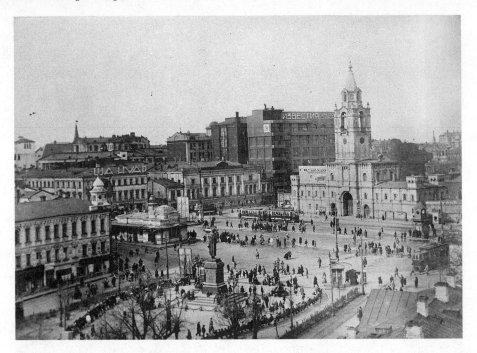

Moscow, Strastnaya Place, 1920s

For months Chagall languished in Moscow, licking his wounds from Vitebsk, psychologically and practically unable to work–canvas and paints were almost impossible to procure. His salvation came at the end of November, when Efros introduced him to another Moscow newcomer, twenty-eight-year-old Alexander Granovsky, who had arrived from Petrograd in the spring with his Jewish Theatre and was looking for a stage designer. His troupe, with the World of Art throwback Dobuzhinsky as designer, had failed in the old tsarist city, where it had presented Yiddish versions of Western classics from Shakespeare to Schiller–a theatre of Jewish assimilation. But in leftist, more southern, fiery Moscow, closer to the former Pale of Settlement from where a population of Jewish workers now streamed in, Granovsky was inspired to adopt a different, modernist conception; now he aimed to put the provincial Jew onstage in all his local colour and idiosyncracy, transforming ordinary life through use of the grotesque, exaggeration, and stylization. This radical theatre, which owed something to Meyerhold, was supported and funded by the state as a way of converting the Jewish masses–97 percent of Russian Jews still spoke Yiddish–to Bolshevik ideals, and it now took on a new lease of life. A few years later, when the Jew-

ish Theatre had become famous across Europe, Efros, who championed it
and the revolution, left a picture of how Moscow appeared to the new Jewish
arrivals in mid-1920:

> Feverish, raging, roiling Moscow, headquarters of the revolu-
> tionary state, potential capital of the world, shaken daily, hourly,
> by the thrusts and explosions of events, the turns of the wheel,
> the breakdowns of the machinery, engulfed with typhus, covered
> with rumours, starving on rations, heating its ovens with fences
> and furniture–but constantly seething to a triumphant, histori-
> cal effort of will, crystallizing the dim movements of the masses;
> emitting–"To everyone! Everyone! Everyone!"–protests,
> appeals, orders, slogans, thundering with the triumphant copper
> of hundreds of orchestras; in the weekdays of its new calendar,
> pouring the scarlet of its red banners over dense crowds march-
> ing through the streets; turning into reality the creative
> chimerae of dozens of directors, hundreds of artists, thousands of
> actors, bare-legged dancers, circus performers, dilettantes and
> adventurers; generously giving them money (though devalued),
> buildings (though falling apart), materials (though disintegrat-
> ing)–Soviet Moscow ignited in Granovsky a decisive spark.

Moscow worked its revolutionary spark on Chagall, too, as soon as he was
inside the walls of the Theatre on Tchernyshevsky Street, in the nationalised
house of a Jewish businessman called Gurevich who had fled the revolution.
On the second floor of this dilapidated turn-of-the-century mansion, the
large salon and some neighbouring rooms had been turned into a ninety-
seat theatre. The actors also lived in the building, which was in the process
of being repaired–stars of David still decorated the tiles of the corridors
from Gurevitch's days, but torn tatters of the civil war, ration cards, queue-
number tickets, lay on top of them. "Everywhere pieces of wood, old
newspapers, boards, sticks, and other rags were lying around," Chagall
remembered.

> One actor carried a ration of black bread and another carried a
> bottle of bluish milk mixed with water into his room . . . Piles of
> shavings mingled with my tubes of paint, with my sketches. At
> every step one dislodged cigarette butts, crusts of bread. "There

you are," said Efros as he led me into a dark room, "these walls are at your disposal. Do with them what you please" . . . And I flung myself at the walls.

The theatre was to open its doors on 21 January 1921 with a *Sholem Aleichem Evening*–three plays by the classic Yiddish writer of eastern European shtetl life. For a month and a half from the beginning of December, Chagall locked himself into the auditorium virtually day and night to paint what he would afterwards regard as the masterpiece of his entire career. Working in cheap lime-based tempera and gouache that he mixed himself, and sometimes using kaolin as a filler, he painted on canvases made from thin Dutch bedsheets sewn together, which were then fastened to the long wall on one side, the spaces between the four big windows on the other, the space above those windows and a back wall by the door. Following the proceedings, Granovsky and Efros soon found that they had got in their set designer more than they had bargained for. "He set us no conditions, but also stubbornly refused to accept any instructions," wrote Efros, astonished to see the friend who had been worn down with regret and indecision since his arrival in Moscow turn overnight into a mulish prima donna. "Chagall never left the small auditorium on Tchernyshevsky Lane. He locked all doors; Granovsky and I were the only ones allowed in, after a carping and suspicious interrogation from inside as from the guard of a gunpowder cellar; in addition, at fixed hours, he was served food through a crack in the half-open door. This was not simple intoxication with work; he was truly possessed."

With Granovsky, an intellectual assimilated Jew from Riga who spoke no Yiddish, Chagall struggled to find an aesthetic meeting place: "I, always anxious and worried about the least thing; he, confident, assured, given to mockery." Trained with Max Reinhardt in Berlin, Granovsky had revolutionary ambitions for a nonnaturalistic Jewish theatre, rooted in expressive movement and gesture rather than in language, which would speak at once to the Jewish masses and the urban sophisticates of Moscow. He directed his troupe in Russian, thus minimising the verbal Yiddish element of the theatre, and put them through a rigorously disciplined physical training that included acrobatics, dance, and rhythmic movement taught by the ballet master B. A. Romanov. "One thing each of us had–fiery will and readiness for sacrifice . . . And our leader told us it was enough!" wrote Solomon Mikhoels, who led the cast.

In selecting the actors for this radical experiment, Granovsky demanded

only that they had never worked on the stage and were twenty-seven years old or under—as with political appointments, sweeping away the old order, and anyone tainted with it, was essential. The single exception to his rule was twenty-eight-year-old Mikhoels, whose theatrical genius and extraordinarily emotive features made him irresistible. Mikhoels became Granovsky's right-hand man and the conduit by which the supercilious director really got his ideas across to the young former shtetl Jews who made up his troupe. Chagall, expressive, avant-garde, proletarian in origin, an artist at once rooted in Jewish themes but with an international reputation forged in Berlin, the city where Granovsky had honed his own avant-garde credentials, had seemed a perfect choice as designer, but only when Mikhoels befriended him did he form any relationship with the rest of the troupe.

Chagall and Solomon Mikhoels, Moscow, January 1921

> Once Mikhoels approached me with his mincing steps and said in measured, clearly veiled words, "Marc Zakharovitch, lend me your sketches, I want to study them. We cannot continue like this—you here and we there, everyone separate!" . . . Mikhoels's open and friendly approach was symbolic of a new type of Jewish man and artist at the beginning of the great revolution. Therefore, I cannot forget how, a few [weeks] later, I heard Mikhoels's long call from his distant room in the corridor, "Chagall, I under-stood . . . Where are you? I understood . . ." And he came up to my ladder holding the sketches. "See, Chagall!" With joy in his eyes, covered with a smile reaching to his feet, he stood and moved with Sholem Aleichem's text beaming from his mouth. There was no doubt: Mikhoels had found something, found the true nuance and rhythm—that is, the form, the content, the new spirit, the new actor. It was a new world!

Sometimes Bella and little Ida visited the theatre, but for much of the time Chagall was there alone, feverish, exhausted, and half-starving, or in the

company of Ephraim, the janitor and "sole representative of the working class in our theatre . . . His nose, his poverty, his weakness, his stupidity, his lice that hopped from him to me and back again. Often he just stood there, doing nothing and smiling nervously. 'What are you laughing at, idiot?' 'I don't know which to look at: your painting or you. One's as funny as the other!' " Ephraim brought him milk that was not real milk and bread that was not bread: "watery milk, with starch in it. Bread made of oats, of straw, the colour of tobacco. Perhaps it was real milk milked from a revolutionary cow."

Granovsky reckoned on over a hundred rehearsals for each production, but still chaos reigned the night before the theatre's opening. "We lacked everything," Chagall recalled. "No material for costumes and settings. On the eve of the opening, they brought me old worn suits. I painted them hastily. In the pockets I discovered cigarette butts, crusts of bread." Chagall threw a tantrum when Granovsky (" 'Who is the manager here, you or I?' ") hung a real tea towel on the stage, for, as Efros remembered, he

> hated real objects as illegitimate disturbers of his cosmos and furiously hurled them off the stage; with the same rage, he painted over—one might say plastered with colour—that indispensable minimum of objects. He cried real, hot, childish tears when rows of chairs were placed in the hall with his frescoes. He claimed: "These heathen Jews will obstruct my art, they will rub their thick backs and greasy hair on it" . . . He continued wailing and whining. He attacked workers who carried his handmade sets, claiming that they deliberately scratched them. On the day of the premiere, just before Mikhoels's entrance on the stage, he clutched the actor's shoulder and frenziedly thrust his brush at him as at a mannequin, daubing dots on his costume and painting tiny birds and pigs no opera glass could observe on his vizored cap, despite repeated anxious summonses to the stage and Mikhoels's curt pleas—and again Chagall cried and lamented when we ripped the actor out of his hands by force and shoved him onto the stage. Poor dear Chagall! He of course considered us tyrants and himself a martyr . . . He never understood that he was the clear and indisputable victor.

In just over a month, working in radiant colour and in a frenzy even greater than in Paris, Chagall created seven works that entirely covered the auditorium of what quickly came to be known as "Shagalovsky sal" (Cha-

Chagall working on a study for the mural at the Jewish
Theatre, Moscow, 1920–21

gall's room) or, because it was so small, "Chagall's box." An eight-yard-long
canvas of enormous, larger-than-life-size whirling figures and flamboyant
geometric forms is the *Introduction to the Jewish Theatre.* In addition four
large upright panels, each two yards high, depict Jewish archetypes—a
green-faced violinist; a *shadchan,* or marriage broker, a curvaceous woman
kicking thick legs and clapping her hands in a boisterous Hasidic wedding
dance; a *badchan,* a wedding jester in a long coat; and a Torah scholar. Shtetl
embodiments of *Music, Dance, Drama,* and *Literature,* they represent Cha-
gall and Granovsky's vision that contemporary Jewish theatre evolve from
the pantomime of eastern European Jewish folk tradition. Above them on a
long thin frieze called *The Wedding Table,* fruit, cake, fish, fowl, in violet,
pink, and ultramarine, shimmer on a white tablecloth. At the back, from a

square panel of translucent silver-white suprematist forms, an airy modern couple, an ethereal silhouette, emerges to twirl in a pas de deux across a stage in a near-abstract composition, *Love and the Stage;* a pair of ballet shoes bears the words "The Jewish Theatre." Love, ecstasy, light, religious ritual, the rhythm of art and life: in the multiple layers of the Jewish murals, the miraculous shimmers behind the ordinary order of things, and the spiritual is given form through Chagall's dazzling command of abstract images, even as these works confirmed him as the leading and most enduring figurative artist of the Russian avant-garde.

Influences new and old, from suprematism and the monumental figurative paintings of Chagall's wartime Russian period to the stormy overheated Paris fantasies–the violinist echoes his Paris ancestor painted on Bella's tablecloth–all collided here as Chagall thrilled to the violent rhythms and brash tones of civil war Moscow. As commissar in Vitebsk, he had been disillusioned by the bureaucracy and sectarianism among artists of the new state; now in Moscow he experienced the revolution again as a painter. "Outside, the Revolutionary wave raged," recalled Mikhoels, "and human eyes and too-human thoughts, scared and scattered, blinked in the chaos of destruction and becoming. At a time when worlds sank, cracked and changed into new worlds, a miracle occurred, perhaps still small, but very big and meaningful for us Jews–the Jewish theatre was born." The critic Viktor Shklovsky observed in April 1920 that "all Russia is acting, some kind of elemental process is taking place where the living fabric of life is being transformed into the theatrical." That atmosphere colours the murals. Chagall's individualism, Jewish roots, and European modernism were all infused by the spirit of the revolution in this series. Its mix of verve, fury, defiance, and pathos came at once from hope, from the exhilaration, after the Malevich debacle, of being given another chance to work in Russia, and from the sense that this, like Blok's *The Twelve,* would be his Russian swan song.

In the *Introduction to the Jewish Theatre* he paints himself with his palette, carried aloft by Efros and offered to the cool, aloof figure of Granovsky, watched by the red-haired dwarf actor Kraskinski, to be led on to mesmerising Mikhoels, who is depicted life-size several times over. "Eyes and forehead bulging, hair dishevelled. A short nose, thick lips. He follows your thought attentively, anticipates it and, by the acute angle of his arms and body, rushes towards the essential point. Unforgettable!" Chagall wrote of Mikhoels, whom he felt passionately was a kindred spirit. Mikhoels, born Shloyme Vovsi in an educated Hasidic family in Dvinsk in the Pale, had studied law in Petrograd; his cousin Miron Vovsi became Stalin's personal physi-

cian. Both Mikhoels and Chagall drew at once on the folklore and humour of the Hasidic tradition and on every modernist trend of the Russian avant-garde, and in the collision they found their own absurdist, tragicomic artistic expression and images—an outlook that would characterise the work of both of them for the rest of their lives, as if their theatrical effects had a permanence that countered the impermanence and mutability of the revolutionary world all around them. "Strong though short, thin but sturdy, practical and dreamy; his logic merged with feeling, his Yiddish language sounded as if it came from Yiddish books," Chagall wrote of Mikhoels, who became a close friend and gave lessons in Yiddish acting to Bella. "From afar I would hear her voice 'Bells are ringing . . .' " ("Kleene Glockele klingen," from a poem by Peretz Markish). For Bella still, as for Chagall and Mikhoels, the stage was where she saw her future. Mikhoels said,

> Looking for the means, how most sharply and conspicuously to uncover the tragic content of past Jewish life, condemned to disappear in our country, the theatre showed great diversity in evoking new stimulae . . . To hone the characteristics, to perfect the stage devices, uncover new social kernels hidden in the atrocious, often-anecdotal classical figures—this was our continuing path. Isn't tragicomedy one of the phenomena typical of our contemporary epoch?

Granovsky, Efros, Mikhoels, Chagall—none of these avant-garde Jewish figures, in 1920 so wholly consumed with making modern art and optimistic that Jewish culture could be integrated yet retain its own character in revolutionary Russia, would survive in the Soviet Union. If ever Chagall kept Jews safe on his canvases, as he had said he wanted to do during the war, he did so in *Introduction to the Jewish Theatre*.

"I wanted to paint myself into it, you, my own cities and towns," he told a Yiddish-speaking audience in 1944. A green cow, Chagallian goats, shtetl houses, the oil lamp from his parents' home, the names of his family, all already memories from Vitebsk, recur across the canvas; acrobats, one wearing Orthodox phylacteries, one inscribed with the names of Yiddish classic authors, walk on their hands, as the coloured circles and triangles that surround them seem also to dance across the surface like shafts of light. In this fantasy, a man rides a chicken, another eats a shoe: thus the strictures of everyday life—the entire theatre troupe was constantly famished and cold—and the Vitebsk humiliations from which Chagall still smarted, are tran-

Chagall, *Introduction to the Jewish Theatre,* 1920, tempera and gouache on canvas

scended, and shtetl life is immortalised as comedy. The poet Chaim Bialik compared Chagall to a cantor who sings to his congregation, then while they are praying, sticks his tongue out at them. Chagall himself likened his vision to that of Franz Kafka who, although his education was secular, was attracted to Hasidic mysticism. Kafka wrote *The Trial* in 1914-15, *Metamorphosis* in 1915, and began *The Castle* in January 1922–the period when Chagall evolved his own Russian tragicomic modernist idiom, with a similar emphasis on the clash between the absurd, the mundane, and the spiritual that makes both writer and painter precursors of surrealism. "Chagall insists time and again on his closeness to Kafka," reported Franz Meyer. Jews and near contemporaries, both felt the lack of a homeland and "the millennial yearning for release from earthly bondage. Both, too, belong to an age in which traditional Judaism's spiritual conception of the world can no longer form the basis of any real order."

When, five years later, in 1925, Granovsky adapted the theatre's Sholem Aleichem production into a film, *Jewish Luck,* Shklovsky reviewed it with the explanation,

> Such Jewish life no longer exists. The Civil War hit them hard. Pogroms rolled through the shtetl. The very places where the pasted-together huts stood were plowed up. Hunger came in the wake of the pogroms . . . The Revolution was a hulling mill for Jews. The old closed world was shattered. Everyday life is finished. Small trade, middleman trade, was crushed under the pressure of state capitalism and cooperatives. In the new tight life there was no room to spin around . . . The Revolution removed all limitations from the Jews and destroyed the most essential traits of the Jews.

As Granovsky directed Mikhoels to spin around and Chagall captured them on canvas, all were celebrating Hasidic spiritual enthusiasm and the Bolshevik liberation of the Jews at the very time when Jewish identity in Soviet Russia hung in the balance.

Meyer wrote that "Chagall referred back to the Moscow murals again and again . . . In the Jewish Theatre as Chagall saw it and represented here as a sort of world theatre, life overcomes all superficial strictures . . . Besides summing up the artistic results of the years he spent in Russia, these monumental works were aimed at a large public and have the significance of a manifesto." Chagall was conscious of this at the time–thus he had plunged into the work with an absorption that was absolute even by his own standards.

He had always liked a big canvas, the larger the better; now he conquered the whole theatre. When the curtain, decorated with goats, rose on the first night, the audience gasped at the eerie effect by which the actors, painted by Chagall and moving in exaggerated staccato bursts according to Granovsky's cinematic system of "stills," looked identical to the portraits of them in the largest mural: both were Chagall's creations, the only difference being that the live ones spoke, the painted ones stayed silent. The theatrical effect was utterly original. Critics spoke of "Hebrew jazz in paint," and the *Sholem Aleichem Evening* was so successful that it was repeated three hundred times, with even Efros acknowledging that "the whole hall was Chagallized. The audience came as much to be perplexed by this amazing cycle of Jewish frescoes as to see Sholem Aleichem's skits . . . Ultimately, the *Sholem Aleichem Evening* was conducted, as it were, in the form of Chagall's paintings come to life."

Moyshe Litvakov called the *Sholem Aleichem Evening* "an incredible sensation," and it established Granovsky's small troupe as a force as powerful as those of Meyerhold and Tairov. Russians who spoke no Yiddish thronged to this modernist pantomime that barely needed words. "When one sees this 'Jewish acting,' one cannot fail to be struck by the emotional appeal and rapidity of movement, the intensity of speech and vigour of gestures," wrote the Russian critic P. A. Markov.

Poor Jews in tattered garments and comical masks of rich Jews–
in frock-coats and stately old-fashioned robes with colourful
trimmings–would dart and dance about on the curious platforms
and crooked staircases, in an ecstasy of delight. They would stand

for a moment in solemn stillness, like monuments, before dashing away into the hum of the marketplace, or springing from one platform to another, or rushing down a flight of stairs and away.

The Jewish Theatre was so successful that within a year it was given larger premises, and the troupe moved at the end of 1921 to Malaya Bronnaya Street, taking over the concert hall in a mansion built by the businessman M. S. Romanov. Chagall's panels moved with them to the foyer of the new quarters, and throughout the theatre's heyday in the 1920s, critics accepted how much its stylized modern choreography, with what the German critic Max Osborn called its "picturesque, machine-like, mimic-acrobatic choir" performing to an orchestra of trumpets and kettledrums, owed to Chagall.

Osborn, who knew nothing of the theatre's background, visited Moscow in 1923 and was enthralled:

> The curtain goes up and you see a strange chaos of houses, intertwined in a cubist manner, rising one above the other on different levels . . . The cubist linear play of these forms is complemented and enriched by Cézanne's colours . . . High above the roof of one building, appears the figure of a Jew with a red beard and a green greatcoat, with a sack on his back and a staff in his hand. Instinctively I said aloud "Chagall!" And suddenly everything becomes clear: this is the world of Chagall. From him everything has emerged.

But for Chagall, it was a Pyrrhic victory. To Granovsky and Efros, he had appeared domineering, uncooperative, and nontheatrical. "The thick invincible Chagallian Jewishness conquered the stage, but the stage was enslaved . . . We had to break through to the spectacle over Chagall's dead body," complained Efros. Chagall was not asked to design for the Jewish Theatre again. In the revolutionary chaos he was never paid for the work. Throughout 1921 he made attempts to work with other directors, including Yevgeny Vakhtangov at the Hebrew Habima Theatre, and at the Moscow Theatre of Revolutionary Satire, but his designs were always rejected as extreme or unworkable. His style was too individual, too uncompromising, to sit easily with the vision of any director. None of the other Russian avant-garde artists—Alexandra Exter, Liubov Popova, Nathan Altman—who were in demand in Moscow as stage designers for Meyerhold or Vakhtangov had a

style as distinctive, or a reputation as difficult. Chagall complained that his work was influencing other stage designs, and he seethed that "at Habima they ordered another artist to paint *à la Chagall* . . . at Granovsky's, they were now going beyond Chagall!" But he himself was back where he had started when he arrived in Moscow: a third-class-ranked artist with nowhere to go, in a country on the verge of breakdown and famine.

Fragile after weeks of feverish activity, he accepted a job from Lunacharsky's administration as drawing teacher in the Third International Jewish School-Camp for War Orphans in Malakhovka, a village eighteen miles outside Moscow where other Jewish intellectuals, including the Yiddish writer Der Nister, whose books Chagall had illustrated, were forming a community. It was a stopgap solution, and from this moment Chagall ceased to think of his future as being in Russia. But he could not put the murals out of his mind. For the rest of his life he asked after them, talked about them, and returned in his art to the tragicomic vision of acrobats and harlequins that he had crystallised in revolutionary Russia. As early as February 1921 he was complaining to the Jewish Theatre that the murals were not given enough visibility:

> I can find no inner peace as a painter until the "masses" see my work. It turns out that the things had been put in a "cage" as it were, where they can be seen at the very best by (if you will forgive me for saying so) one hundred Jews at close quarters. I like the Jews a lot (there's enough "proof" of that) but I like the Russians as well and some other nationalities, and I am used to painting serious things for many "nationalities."

He demanded a special exhibition and got it in July, when the murals went on show at the theatre in an exhibition officially arranged by the Commissariat of Enlightenment. He made a cubist collage out of the invitation to the opening, showing him marching on top of a brown triangle, a mock-gravestone on which was engraved in Hebrew and Yiddish the word "Justice." Lunacharsky was among those he caustically invited:

> To paint *like this* I could have done only in Russia. I have been thinking endlessly about the destiny of art (especially of my kind) in Russia. Does what I did . . . have any meaning for anybody? Who needs it? Is my path altogether right? For it seems there is

nothing in the world more "individualistic" (despicable word) than I vs the "collective." But is it possible that I, the son of an eternally poor clerk-worker, don't have somewhere an intimate relationship to the masses?

He ended by asking Lunacharsky to meet him in a debate at the opening of the show:

> You don't like the West, Anatoly Vasilyevich. But I don't like it either. But *I love* those artists from whom I can learn, whom I can admire, who were in the West before 1914 . . . In the dispute arranged at the opening of the exhibition . . . I would like you to put your own dots on every *i,* even in relation to such an unbearable character as me.
>
> Devoted, Marc Chagall

It was not the letter of an artist who still seriously considered a career under Lunacharsky's regime. Even travelling between Moscow and Malakhovka, which he often did daily when trying to organise an exhibition or attempting to get his designs accepted at the theatre, was an ordeal in the punishing conditions of 1921.

> I first had to queue up for several hours to buy my ticket, then another hour to get as far as the station platform . . . Throngs of milkmaids banged their white tin cans mercilessly on my back. They trampled on my feet. Peasants pushed and shoved. Standing or stretched out on the ground they busily hunted lice . . . At last when towards nightfall the icy train slowly got under way, songs, plaintive and boisterous, resounded in the smoke-filled car. At last the train stops and I get out. So it goes day after day. It is night: I cross deserted fields and I think I see a wolf crouched in the snow . . . I turn aside, step back, then move forward cautiously until I'm sure it isn't a wolf. Only a poor dog lying there, motionless. In the morning I take the same road back to Moscow.

He, Bella, and Ida lived in rooms in the attic of a communal wooden villa in the village, a house that "still held the odour of its refugee owners, the

suffocating odour of contagious diseases. On every side lay medicine bottles, filth left by domestic animals"; upstairs, they slept on a single iron bed so narrow that "by morning your body was sore and bruised"; downstairs "a hilarious peasant," who turned out to be a prostitute living with the Red Army, presided over meals in the communal kitchen. The Yiddish-speaking orphans were the lucky ones plucked from absolute destitution. "You see them all over the cities and towns, and in the villages, in the railroad stations, hungry . . . naked, shoeless . . . They wander about first with a bewildered, forlorn expression, then with a hand stretched forth for a handout, and finally in a camp of little criminals, embittered, degenerate," wrote the Yiddish Communist journal *Der Emes* in February 1922. At Malakhovka the colony for such children consisted of three large houses, each run as a collective by some fifty victims of the White Army's Ukrainian pogroms. "The village was totally abandoned," wrote a former pupil. "Everything there had been looted, destroyed, broken. We had to repair everything: houses, roads . . . We had to plant, sow, harvest, make bread. Teachers and pupils alike, we all shared the tasks." The children, aged between eight and sixteen, not only cooked, cut and hauled wood, and did the washing but held meetings deciding on the running of the colony. They even arranged the payment of their teachers–in food and fuel–themselves, in a social experiment widely heralded at the time. Nevertheless they were, wrote Chagall,

> the most unhappy of orphans. All of them had been thrown out on the street, beaten by thugs, terrified by the flash of the dagger that cut their parents' throats. Deafened by the whistling of bullets and the crash of broken windowpanes, they still heard, ringing in their ears, the dying prayers of their fathers and mothers. They had seen their fathers' beard savagely torn out, their sisters raped, disembowelled. Ragged, shivering with cold and hunger they roamed the cities, clung on to the bumpers of trains until, at last–a few thousand among so many, many others–they were taken into shelters for children.

They loved drawing, and "barefoot, lightly clad, each one shouted louder than the other 'Comrade Chagall, Comrade Chagall!' . . . Only their eyes would not, or could not, smile."

There was, however, something inspirational about Malakhovka, captured in a photograph from the summer of 1921 showing the staff, including

Chagall, Der Nister, and the literary critic Yethezkel Dobrushin, all short-haired or close-shaven in the revolutionary style, huddled together with the orphans on a staircase. Everyone looks gaunt and weary with struggle, yet there is a mood of common encouragement, idealism, and protectiveness, too. The children had free passes to the Jewish Theatre, and Mikhoels was a frequent visitor to Malakhovka along with the Yiddish poet Itzik Feffer. Chagall did very little painting in this period, but many drawings in India ink survive. They feature sharp black and white contrasts, angular lines, simplified semigeometric shapes, and motifs such as a man with a row of houses on

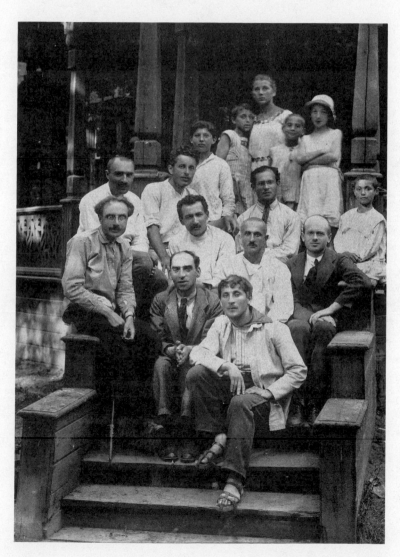

Chagall (at the front) with other teachers and some of the orphans at Malakhovka, 1921

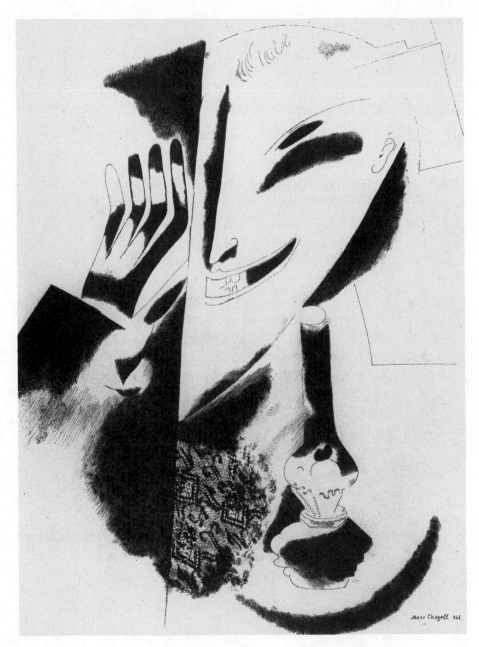

Chagall, "Man with Lamp," 1921, drawing

his shoulder, an acrobatic runner, a soldier appearing to stand on his hands with a rifle, and the futuristic construction of a half-face, single elongated hand and oil lamp in "Man with Lamp." All turn on the themes of war and flight, and capture the mood of reckless fatalism and disorder.

A series of these savage, satirical works were illustrations made in the winter of 1921–22 for the Yiddish verse cycle *Grief* written by the poet David Hofstein, another Malakhovka teacher; the poem turned on the mix of utopianism and violent brutality unleashed by the revolution. For many artists and intellectuals, the year 1921–22 was the point when they came to question their survival in a Communist Russia that was turning against the avant-garde. Kandinsky gave an interview in July 1921 complaining that the leaders of revolutionary art had abandoned painting in favour of experiments in laboratories. He planned his emigration and left for Berlin, with official permission, in December, although most of his works had to remain behind. Chagall watched Kandinsky's moves carefully and noted, too, the emigration to Berlin, through the help of Maxim Gorky, of Hebrew writer Chaim Bialik and Yiddish novelist David Bergelson the same year. Above all, the intellectual community saw the deaths of two leading poets at this time, Alexander Blok in 1921 and Velimir Khlebnikov in 1922, as symbolic. Both writers were weakened and eventually killed by starvation, but forty-year-old Blok especially seemed to have faded away, having given up hope for Russia's future. As for Khlebnikov, "Instead of a heart I seem to have something resembling a chunk of wood or a kippered herring," he wrote to Mayakovsky from Baku in 1921; his poem of that year, "In the Village," records the effects of the famine that claimed millions of lives:

> In the hut next door with the board roof
> A grim-faced father
> broke up the bread into breadcrumbs
> with hardened fingers.
> Only to look at.
> It wouldn't fill a sparrow, the one
> that chirped just now.
> You eat with your eyes nowadays.
> "Times aren't right," the father muttered.
> The black bread looked like topsoil
> with bits of ground-up pine cone.

> *At least their eyes can eat.*
> *Mother stood by the stove,*
> *White with pain.*
> *Black coals of hunger*
> *burn in the pits of her eyes,*
> *The thin slice of a white mouth.*

But in other places life went on, and art from opposite ends of the spectrum continued to coexist. In September 1921 Chagall wrote generously to congratulate Pen on a jubilee to mark his twenty-fifth anniversary as a teacher in Vitebsk "despite the new conditions":

> We, your very first pupils, will think of you before anyone else . . . Even though we have gravitated towards a different extreme in matters of art and have moved in a direction far from your own, your example as an honest artist and our first teacher towers above all else. I love you for that.

Pen, continuing to produce solid academic-realist portrayals of Vitebsk life, was ironically coming back into fashion as the move towards socialist realism took hold in Russia. Yet at the same time in Vitebsk El Lissitzky was still holding court with his theory of "Victory over Art," published in 1922:

> We live in a period of iron and concrete, a dynamic period: we do not depict or embellish, we hunt and create. We abandon on the one hand the artist with his representation, and on the other the engineer with his project . . . We are the footsoldiers of our movement which is unceasing and also incomprehensible as is the way of the lunatic from whom all withdraw in embarrassment.

The extremes were clear. "The old masters of Impressionism and Expressionism have been liquidated," Lunacharsky told the Berlin periodical *Aktion.* "They are incapable of doing anything and have not produced a single work of importance since the beginning of the Revolution. They are unable to do what we want." Chagall wrote in 1922, "Neither imperial Russia nor the Russia of the Soviets needs me. They don't understand me. I am a stranger to them," but he added, "I'm certain Rembrandt loves me": that is, his sole certainty was his self-belief as an artist. Early in the year he and the

family moved back to Moscow, to a small flat–apartment 8, 2 Sadova-Samotechnaya–and Chagall began pulling strings to be allowed to emigrate. A final blow was that Nathan Altman was given the commission to design the sets and costumes for Ansky's play *The Dybbuk,* a classic Chagallian shtetl fantasy subject, at Moscow's Habima Theatre, under extravagant conditions: whereas Chagall had had to make do with scraps, Altman was able to order any cut and material he liked. Chagall was present at the dress rehearsal of the play, which opened on 21 January 1922, and he pronounced it an "act of genius." The production was the last at the Habima to be directed by Vakhtangov, the dazzling fuser of Meyerhold's grotesque fantasy and Stanislavsky's realism. Afterwards Chagall would have nothing more to do with Altman and wrote in his memoirs that the Habima set was a copy of his own work: "Nevertheless, you will stage it my way, even if I am not there; there is no other way." He continued to rage, too, against other directors who had rejected him, such as Tairov, who had worked with Exter: "I *suffocated* in his theatre. All the little mannerisms and the purity of art, the intimiste character . . . the stylization of cubism, of suprematism."

An exhibition of forty of his works, including the murals, alongside paintings by Altman and David Shterenberg, ran at the Jewish Theatre from March to April 1922; this was the second time the murals had been shown in less than a year, but Chagall felt sour–he rarely cared to share the stage with other artists–and did not attend. Still, he organised his own party for a few friends to hear him read aloud from his unfinished memoirs, which he was writing, partly in emulation of Kandinsky's 1919 autobiographical *Characterising the Self,* aware that he was about to make an irreversible break in his life. The passages dealing with his recent experiences in Russia are flooded with resentment and anger, and the last page, a dramatic valediction, expresses what he felt by the spring of 1922: disappointment, sadness, and exhaustion after fighting in vain for a place in the country in which in 1917 he had placed so much hope:

> Those five years churn my soul.
> I have grown thin, I'm even hungry.
> I long to see you again, G . . . , C . . . , P . . . [Gleizes, Cendrars, Picasso]. I am tired.
> I shall come with my wife, my child.
> I shall lie down near you.
> And perhaps, Europe will love me and, with her, my Russia.

On 25 April the journal *Ekran* announced that Chagall would shortly be leaving; he obtained a passport through Lunacharsky, the Jewish collector Kagan-Shabshay advanced the money for his journey, and the poet Jurgis Baltrusaitis, Lithuanian ambassador in Moscow, allowed him to send his pictures to Kaunas by diplomatic courier; also included were those of his works owned by Kagan-Shabshay, who entrusted him to transfer them to his brother in Paris. The official justification for his trip, according to the newspaper *Red Star* in Vitebsk, was that he would take work by several Jewish artists, including Altman, for an exhibition in Berlin. This cover may have been why Bella and Ida did not leave with him. Bella, still trying to pursue a career onstage, was confined to bed for months following a fall during a rehearsal, and was unable to travel. Chagall, having received permission and an official reason to leave, dared not delay his own departure, and it was arranged that Bella and Ida would follow him. How incapacitated Bella really was is not clear; certainly, the incident was prophetic of a future in which she would repeatedly use physical ill-health as an explanation for the stress and depression caused by exile from Russia. This began even with the prospect of leaving. The emotional wrench was worse for her than for Chagall: she knew she would never see her parents again. Family tension was understandably high. "If I could only calm down a bit, come to myself, the family would be calmer here," Chagall told Pavel Ettinger on the eve of his departure.

Fifteen years earlier the first Russian stage production Chagall ever saw was Meyerhold's version of Alexander Blok's *The Fairground Booth,* which launched the theatrical avant-garde in St. Petersburg on 30 December 1906. Now, in a symbolic pattern that would not have escaped his notice, the very last Russian performance he attended was Meyerhold's production of the Belgian dramatist Fernand Crommelynck's tragic farce *The Magnificent Cuckold* at the cabaret Zon, with sets by Liubov Popova, which premiered on 25 April 1922 and launched the constructivist theatre of the 1920s. On an otherwise empty stage, Popova designed a three-dimensional bare wooden construction over which the actors, dressed as proletarian workers, clambered and leaped in a rhythmic choreography. "I took with me this last impression of joy," Chagall wrote from Berlin, but the play made him wonder, too: "Where has constructivism (theatrical, pictorial) got to, and has what we call art been definitively erased? Not yet?"

To answer such questions freely, Chagall had to leave Russia. In early May 1922, as anxious and alone as when he had left in 1911, he took the train for Kaunas, where he was welcomed by his old friend Dr. Elyashev. At an exhibition of his work "the Jews went oh and ah and the Lithuanians stayed con-

fused and pressed Ciurlionis to their hearts." Chagall held another evening reading of his three-quarters-finished memoirs, then moved on to Berlin, where Bella and Ida joined him in the autumn of 1922.

Very few people from Chagall's Jewish Theatre period survived the Stalin years. Vakhtangov died months after the triumph of *The Dybbuk* in May 1922, and Popova died of scarlet fever in 1924. Exter emigrated to Paris in 1924. Lunacharsky fell somewhat from favour and was appointed Soviet ambassador to Spain but died in Menton on the way there in 1933. Sergei Esenin, Chagall's favourite poet, committed suicide in 1925, and Mayakovsky shot himself in 1930. Granovsky and Mikhoels were both awarded the title People's Artist of the USSR in 1927, after which the Jewish Theatre was at last allowed to tour abroad, to Berlin and Paris, in 1928. Granovsky did not return to Russia with it but faded away in exile, dying in 1937. Meyerhold was arrested in 1939 and shot in prison in 1940. Tairov was labelled bourgeois by Stalin, and as a punishment, in 1936 his Chamber Theatre was merged with the Realistic Theatre and sent on a tour of Siberia; it was removed from his control in the 1940s. Tairov died of brain cancer in Solovievskaya Psychiatric Hospital in 1950. Among Chagall's Malakhovka colleagues, Der Nister was sent to the Soviet gulag in 1949 and died there in 1950; David Hofstein and Itzik Feffer were executed in 1952. Mikhoels's fate was unique. He was savagely murdered on Stalin's personal orders in 1948; under the organisation of L. M. Tsanava and S. Ogoltsov, he was lured to Minsk, where he was assassinated by Stalin's henchmen Lebedev, Kruglov, and Shubnikov. His death was masked as a car crash, and he was given a state funeral.

That the murals survived Stalin was a miracle. After Mikhoels's murder the Jewish Theatre was closed; according to official accounts, the commission responsible for shutting it down handed the murals to the Tretyakov Gallery, where they remained out of view in a storeroom. Granovsky's former wife, however, gave a different account: "the artist Alexander Tyschler, linked to the Jewish theatre over many years and a passionate admirer of Chagall . . . carried Chagall's works on his own back to the Tretyakov Gallery, since he knew that otherwise they were doomed."

"Chagall's box," the Chagall room on Tchernyshevsky Street, housed the family of a Red Army general between 1930 and 1960. The stage was turned into a bedroom. Its tenants claimed to remember traces of gold paint on the walls, which were erased, however, when the building was converted to offices in the 1960s. Today, according to art historian Alexandra Shatskikh, "computers stand where previously Chagall's immortal works graced the walls."

PART TWO

Exile

Der Sturm

Berlin, 1922–1923

"Marc Chagall and Franz Marc, the two painters, are now immortal because they are dead yet a few years ago they were starving," wrote the young artist Hilla Rebay, part of the Sturm circle, later Solomon Guggenheim's mistress and a supporter of Chagall's, in a report on the German art scene in 1920. Germany had heard no word of Chagall since 1914, and it was widely believed that he had been killed in the Russian civil war. When he reappeared in June 1922 in Berlin, therefore, it was as if he had returned from the dead. His reputation was ensured, his greatest work was behind him, but he would have more than sixty years left to live in an exile that would demand frequent rebirths. Berlin was the first challenge, the staging post on his route to becoming a Western artist whose inspiration remained, nevertheless, the Russia of his childhood.

His exile would span almost the entire existence of the Soviet Union, a unique period in cultural history when—even during the political alliance of the Second World War—there was virtually no artistic contact between western Europe and Russia. Russian contemporaries of his stature stood definitively on one or other side of this divide—Kandinsky transformed himself back into the German artist he had already become in the 1900s; Malevich never left Russia. But Chagall remained throughout a lonely symbol of Europe's self-division, alert to every Western development but rooted in his Russian-Jewish background. His work before 1922 has the heroic, hurtling inventiveness of early modernism: confident, original, assertive of his own vision as one of the building blocks of modern painting. After 1922 it plays out a different drama: of adaptation, assimilation of new cultures, negotia-

tion with the past, crises of identity, the search for a language in which to express the inexpressible horrors of the mid-twentieth century. The Russian period, which Chagall acknowledged as his best, formed inevitably the foundation for the work in exile. "In my imagination Russia appeared like a paper balloon suspended from a parachute. The flattened pear of the balloon hung, cooled off, and slowly collapsed in the course of the years," he wrote. Exile was at once Chagall's tragic fate, his separation from the sources of his paintings, and his opportunity to create an oeuvre, out of his own store of remembered images, which told the history of the twentieth century like that of no other artist.

"Come back to Europe, you are famous here!" his friend Rubiner, now dead, had written, adding, "Just the same, don't count on the money Walden owes you. He won't pay you, for he maintains that the glory is enough for you!" Arriving in Berlin with eight years' worth of Russian paintings in his luggage, Chagall had relied on reconnecting with the West through the Paris paintings he had left behind at Walden's. His first shock was to find that they had all been sold and were widely dispersed across Germany, and that the money Walden had in fact deposited with a lawyer on his behalf, in case he was alive, was worth nothing thanks to the hyperinflation of the Reichsmark. Throughout the war years and beyond, Walden had continued with some courage to champion Chagall, an enemy alien, with exhibitions drawing on the stock that had been left with him in 1914, which also included Russian paintings of 1908-11 of enormous personal significance to Chagall, such as *The Dead Man* and *My Fiancée in Black Gloves*. By 1922 everything had been sold, some of it very cheaply. Chagall was more acclaimed in Germany than he had ever been in Russia or Paris, but he was still as penniless as he had been when he left Berlin before the war.

Chagall never fully came to terms with this loss. Some of his works had gone to well-known collectors: seven Paris paintings with a distinctive cubist slant, for example—*Paris Through My Window, Homage to Apollinaire, The Holy Carter,* the cubist versions of *Birth* and *The Dead Man, Adam and Eve,* and the 1911 *Still Life*—had been bought from the 1914 Sturm show by department store magnate Franz Kluxen, but to protect himself and his clients, Walden refused to disclose his identity or that of any of the other buyers. Walden himself had cherry-picked from the Paris oils, selling seven of the most iconic—*Dedicated to My Fiancée, To Russia, Asses and Others, I and the Village, The Cattle Dealer, Half Past Three, The Soldier Drinks,* and *The Flying Carriage*—along with many gouaches to his rich wife Nell, who was Swedish, partly with a view to putting the "Russian" paintings beyond

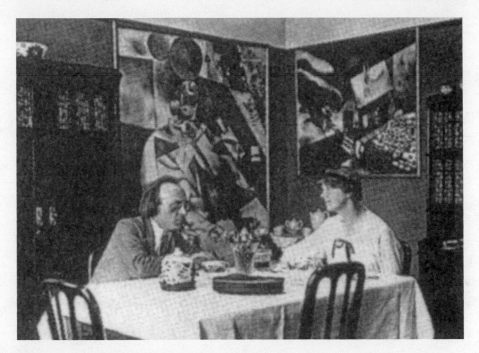

Herwarth and Nell Walden in their Berlin apartment, 1919; behind them are paintings by Chagall, left in Berlin before the war and for which Walden refused to pay post-inflation prices when Chagall returned in 1922

the reach of the wartime German police. A photograph from 1919 shows Herwarth and Nell calmly conversing across a breakfast table laid with white cloth and flowers in their opulent dining room beneath *Half Past Three* and *The Flying Carriage*. Ragged, thin Chagall, fresh from hunger and deprivation in Russia, seethed at the contrast with his own circumstances. He quickly put on weight in Berlin; sending a photograph home to his sisters, he apologised, "I am not as fat as I look in it–I am wearing too many clothes, and beer affects it as well. In another photo I look better."

Despite defeat and inflation, artists and dealers were still living well in bourgeois Berlin. By the Brandenburg Gate at the beginning of Unter den Linden, the city's grandest avenue, Chagall in his first days in the German capital stood alone outside the mansion of the Jewish impressionist painter Max Liebermann and wondered how to pull together the strands of his life.

> Beside Kaiser Wilhelm's palace stands his Jewish palace. Sadly, I watch this assimilated house . . . I wanted to walk into his palace, bring into his home the smell of the Malakhovka colony, of hundreds of tattered, homeless orphans . . . I wanted Vitebsk

to be felt in Liebermann's palace, for Liebermann finally to learn
about the new emerging generation of artists, who came out of
the ghetto, with no right of residence, unrecognised, mocked,
starving, but with souls fluttering with banners!

His own memories of Vitebsk in his first Russian works were now spread
across Germany. The expressionist collector Alfred Hess in Erfurt had *The
Couple,* depicting Thea Brachmann; the Jewish collector Sally Falk owned
Sabbath; The Holy Family belonged to Berlin director and theatre critic
Felix Hollander. Hanover gallery owner Herbert Garvens-Garvensburg
owned *My Fiancée in Black Gloves* and the first *Birth,* painted in Vitebsk,
along with the Paris *Rabbi* of 1912; ironically, these hung alongside paint-
ings by Chagall's old foe Lissitzky, for whom Garvens-Garvensburg also had
a passion. In Dresden Ida Bienert had eleven Chagalls in a collection includ-
ing Mondrian, Paul Klee, and ten Kandinskys, and in Cologne Joseph
Haubrich had nine. With no hope of retrieving anything, Chagall con-
fronted Walden, who eventually offered him one million Reichsmarks in
compensation. This was insulting: by now single Chagall pictures were sell-
ing at Wolfgang Gurlitt's gallery for one hundred million, reflecting a
healthy secondary market among Berlin dealers such as Gurlitt, Israel Bei-
Neumann, and Alfred Flechtheim. Chagall refused the settlement.

The numbers were dizzying, and so was the sense of loss. "Everything was
colossal: prices, abuse, despair," Ilya Ehrenburg wrote of Berlin when he
arrived there in 1921. Klaus Mann recalled seven and a half million marks'
being exchanged for a dollar, and an authentic Dürer for two bottles of
whisky, during this chaotic period. Chagall himself reckoned that Berlin "in
these difficult years of inflation and the birth pangs of the Weimar Republic
[had] . . . an atmosphere that was not unlike that of the early years of the
Russian Revolution." Coming so soon after his struggles in Petrograd and
Moscow, the upheavals here felt to him "like a weird dream, sometimes like
a nightmare. Everybody seemed to be busy buying or selling something.
Even when a loaf of bread cost several million marks, one could still find
patrons to buy pictures for several thousand million marks, which one had
to spend again the same day, in case they might become valueless over-
night." The climate was politically threatening, too. On June 24, within
days of Chagall's arrival, the Jewish politician and industrialist Walter
Rathenau was assassinated by right-wing army officers as he left his home on
the Wilhelmstrasse. A few months earlier, in March, Vladimir Nabokov,

father of the young writer, had been assassinated at a political meeting in Berlin. Such events were bad omens for both Jews and Russians in Germany. Rathenau had always advocated assimilation as the answer to anti-Semitism; his murder cannot have helped Chagall to feel settled in Berlin. Disoriented, he was reeling both from the Moscow fallout and from the realization that he had left Russia for good. Until Bella arrived in the early autumn, he was paralysed into inaction by fury at Walden and the fate of his works. During his entire fifteen-month stay in Germany he was, for the first time in his life, too traumatized to paint. The German critic Karl With, who met him soon after his arrival in Berlin, described a lost, confused figure: "he is moved by his instincts and full of movement, at the same time without actual activity or energy . . . deep down rather lazy, passive and without willpower, without a certain direction, without a goal."

As he had done when he arrived in Paris eleven years earlier, Chagall cast himself immediately on the mercy of the Russian émigré community. He lodged first with a diplomat on the Niebuhrstrasse in the suburb of Charlottenburg, then his Petrograd friend Dr. Elyashev found him an apartment on the Kantstrasse. He never committed himself to a studio in Berlin, and after Bella arrived, the Chagalls moved restlessly three more times within the next year–to Pariserstrasse, then to Weimarerstrasse in Charlottenburg, and lastly to Spessartstrasse in neighbouring Wilmersdorf. In 1922 these affluent southwestern suburbs were home to half a million Russians, some nobility living off the jewels and pictures they had managed to smuggle out, the rest–intellectuals, officers of the defeated White Army–working as waiters or taxi drivers. Berliners jokingly renamed Charlottenburg "Charlottengrad"; Berlin now had Russian cafés, theatres, bookshops, newspapers, hairdressers, grocers, a Russian orchestra playing music by émigré composers Stravinsky and Rachmaninov, and a Russian football team whose goal-keeper was Vladimir Nabokov. The city's eighty-six Russian publishing houses easily outnumbered the German ones, and the literary culture attracted not only political exiles but many Russians still loyal to the Moscow regime yet eager to exploit cultural connections with the West. Among former colleagues, Der Nister was in the city publishing his collections of short stories, and Lissitzky was in 1922 publishing a trilingual constructivist periodical called *Objet-Veshch-Gegenstand,* whose contributors included Picasso, Le Corbusier, André Salmon, Mayakovsky, Esenin, Tairov, and Meyerhold. Relationships with the Soviet art establishment were still fluid, too: IZO Narkompros organized an exhibition of Russian

art, with three canvases by Chagall, at Berlin's Van Diemen Gallery in October; at the same time Stanislavsky's Moscow Art Theatre turned up on tour in Berlin–with *An Enemy of the People, The Cherry Orchard,* and *The Three Sisters*–to rapturous acclaim.

"Berlin had become, right after the First World War, a kind of vast clearing house of ideas where one met all those who came and went from Moscow to Paris and back," remembered Chagall.

> In the apartments round the Bayrischer Platz, there seemed to be as many theosophical or Tolstoian Russian countesses talking and smoking all night around a samovar as there had ever been in Moscow and, in the basements of some restaurants in the Motz-strasse, as many Russian generals and colonels, all cooking or washing dishes, as in a fair-sized tsarist garrison town. Never in my life have I met as many miraculous Hasidic rabbis as in inflationary Berlin, or such crowds of Constructivists as at the Romanisches Kaffeehaus.

Ehrenburg, too, remembered that "at every step you could hear Russian spoken" and that while "the Hungarian painter Moholy-Nagy argued with Lissitzky about constructivism [and] Mayakovsky told Piscator about Meyerhold . . . stolid citizens on their way to Sunday services at the Gedächtniskirche glanced apprehensively at the Romanisches Café: it seemed to them that the headquarters of the world revolution had been established opposite the church."

With his paintings hanging in salons across the city, Chagall was among the most celebrated of the Russian visitors. Undeniably, Walden had made his name. The dealer was connected in literary as well as artistic circles–his first wife was the Jewish poet Else Lasker-Schüler, now, according to Chagall, wandering from café to café "like a dethroned queen or a prophetess." Walden made his mark not by seeking out traditional conservative buyers, such as the industrialists Krupp or Hugenberg, but by building up instead a market among a new breed of middle-class intellectual collectors who would sustain the fortunes of the avant-garde–and of Chagall–through the 1920s. These circles reckoned it a coup for Berlin that Chagall was there. The German capital in the 1920s, as in the early twenty-first century, was busy reinventing itself as cultural crossroads of East and West. "The Paris of the past has largely died in the war, just as the Moscow of the past has died," announced the artistic review *Kunstblatt* in 1922.

Berlin, cafés on Unter den Linden, 1922

A new point of contact is being sought. And this point of contact is Germany, the once despised and unpopular neighbour, which is daily being rediscovered by the Russian émigrés. Thus radiations of the Russian spirit from St. Petersburg and Moscow, and in a backwash also from Paris, are converging ever more densely on German soil. Alexander Archipenko, who arrived from Paris scarcely two years ago, was one of the first to open the march from the West. He was followed by Kandinsky—from Moscow—long a spiritual citizen of Germany. And now Marc Chagall has been added, a pre-war "Parisian," to whom everything German is completely new and strange, but every one of whose early works is at present on German soil.

Frieda Rubiner translated Efros and Tugendhold's book on Chagall into German, while Karl With began work on the first German biography, which appeared in 1923. The prewar French had interpreted Chagall in their own terms as a colourist; now the Germans adopted him as one of their own—an expressionist whose work reflected the chaos of the war from which Germany, locked in punitive reparation payments and internationally isolated,

was still emerging painfully. "A cosmic child is among us," suggested Theodor Däubler, "pure Struwelpeter romanticism . . . What is it all about? An analysis of the soul? Freud?" Of *The Dead Man* the poet Willi Wolfradt wrote, "A Golgotha sky sweeps along above the perpetual earth. The breath of death blows hugely at the sky, swells to a shrill pallor and hurls itself in a yellow glow above the earthly realm, so that living things stagger before its elemental force. The hurricane of the corpse's stillness lashes the conflagration of colours weary of life till they burn out with the groans of Laocoön."

Although With had described him as aimless and lost, Chagall was not slow to exploit the image of the exotic Russian in a city that still, as Kandinsky observed, looked for "salvation from the East." He threw himself into self-promotion: as early as 8 July 1922, weeks after his arrival, he wrote to Pen that some monographs on his work were being prepared, asking for reproductions of works left in Vitebsk; at the same time he told David Arkine that "there are plans here for a monograph (a large book, expensive etc). We don't yet know the editors: Efros (he works well) or Cassirer." Eventually he plumped for the European future–Cassirer–rather than Efros and his Russian past.

Paul Cassirer, a Jewish dealer and publisher of luxury art books, represented Berlin secessionists such as Lovis Corinth and Max Liebermann and had been the first to introduce van Gogh and Cézanne to Germany; he had done so well out of the French impressionists that his motto was said to be "durch Manet und Monet zu Money" (through Manet and Monet to Money). He was Walden's arch-rival and swooped in quickly to profit from the falling-out with Chagall. Refined and sensitive, with elegant nineteenth-century manners and a red-draped "Kunstsalon" in the Tiergarten quarter, designed by Henri van de Velde and hung with works by French impressionists, he was the opposite in temperament of the hawkish Walden and gently attractive to the nervous Chagall. Aged fifty-one, he was still suffering terribly from the repercussions of the war, for which, like many German Jews, he had signed up patriotically in 1914 but was invalided out of the army in 1916. His experiences turned him into a pacifist; in 1919 his son had committed suicide after being demobbed; now his second marriage, to actress Tilla Durieux, a Berlin beauty painted by Renoir, was on the rocks. He warmed immediately to Chagall and engaged with the project then closest to the artist's heart: an illustrated edition of his memoirs, which Walter Feilchenfeldt, manager of Cassirer's gallery, undertook to translate from Russian into German.

Nevertheless, as dealers lined up to represent him, Chagall initially

Bella, Chagall, and Ida, Berlin, 1923. Chagall sent this
photograph to his sisters in Petrograd.

trusted none of them. "Each of the gallery owners here (and in Paris) says
come to me, come to me . . . I want (à la fin) to be very practical and not to
have to learn the same lessons as I did with Walden," he wrote to David
Arkine, adding, "One cannot exaggerate the interest shown, in general, in
Russian art here." Walden was busy capitalizing on it: in early 1923 the first
issue of his *Sturm Bilderbuch* was devoted entirely to Chagall, opening with
a poem by Blaise Cendrars, the loyal friend from Paris who even in 1914 had
tried to protect Chagall from Walden's rapaciousness. It must have been
unbearably grating for Chagall to open the cover to find reproductions of
paintings such as *I and the Village* (the first work displayed) above the cap-

tion "Walden collection, Berlin," alongside invitations to collectors to drop in to the gallery on the Potsdamerstrasse every Wednesday evening at 7:45.

The *Sturm* issue was published to coincide with a large, well-attended exhibition of Chagall's Russian work, so far barely known in Berlin, which opened at Van Diemen's Lutz Gallery in January and attracted buyers old

Bella, Ida, and Chagall, Berlin, 1923

and new. "No-o-o. I won't go there–but there is something about that Chagall–No-o-o I won't go, I might like them," drawled seventy-five-year-old Liebermann, president of the Berlin Academy, when Cassirer invited him to see the work of his new protégé. Cassirer showed him some drawings anyway, and Liebermann responded, "This fellow has talent, but he is a little crazy"; he was, however, one of many observers who watched with fascination the stir created by "Marc Chagall und seine schöne Frau" (Marc Chagall and his beautiful wife), as Karl With described the couple.

As soon as Bella arrived, she set about asserting their position in Berlin avant-garde society. She spoke perfect German, and as an exquisitely posed photograph taken in an open carriage in the Tiergarten early in 1923 shows, she built up the public face of the family as the latest in émigré chic: she, Chagall, and Ida are swathed in expensive coats and dashing hats; six-year-old Ida clutches a doll and wears a white turban. Bella's bourgeois instincts and her upbringing in the jewellery shop on Smolenskaya, where she had learnt just the right measure of flattery, grace, and aloofness with which to woo rich customers, had been sublimated since the revolution; now they came to the fore as a survival mechanism in Berlin and, later, Paris. Chagall played his part happily enough, but it was Bella who wrote the script.

"I remember a gathering Chagall arranged one afternoon in a studio in Wilmersdorf, to which he invited quite a number of ladies and gentleman," the German painter Ludwig Meidner, who was sufficiently intoxicated with Bella to draw her portrait, recalled.

Frau Bella read aloud part of his autobiography. The master stood meanwhile behind a curtain, following the reading with a

tense face. I was sitting near him and was thus able to observe him for half an hour or more. Chagall had a very remarkable appearance, like a man with occult faculties, not at all intellectual, and not like a "modern painter," nor like someone from a Hasidic milieu, more like someone who possessed much rarer qualities than any of these types. At the same time one had the impression that he was unable to act quite naturally and that he could not forget for an instant that he was the famous Marc Chagall. Later I talked to him–he spoke Yiddish–also about the eastern Jewish world, which was known and familiar to me. But he was not one of those artists who reveal their soul and spirit in conversation, but one of those who do so only in their art. He was neither "interesting" nor witty, he uttered nothing that was unusual, eccentric, or even "fashionable," but showed himself a sensible man–although one could feel that he was inwardly burning with unrest.

For the frontispiece of his 1923 biography, With chose a strongly eastern image, the dynamic figure of the *Praying Jew.* He began the text with two definitions, that "Chagall is Russian" and "Chagall is an eastern Jew (Ostjude)," but recalling the Parisian portrait with a double face, he explored with sensitivity Chagall's self-division at this time:

One part of him is reserved . . . melancholic and eaten up inside by burning passion; imaginative, brooding, believing in miracles, explosive, driven from inside, suffering, defenceless, an immoderate fantasist; in need of consolation, small, godfearing and haunted by the world.

The other side of him is sensual, worldly, sensory, baroque, and blooming. He is lithe as an animal, agile, given to tantrums like a child, soft and charming, amiably sly mixed with a peasant-like coarseness and the delight of a provincial in everything colourful, dazzling, and moving. All this, however, without refinement, but with an unconscious natural sensuousness, between sentimentality and a panic-like malignancy. And it is this worldliness which drives him away from Lyozno into the European world, into the centres of excessive civilization and turns him into a man of the world, a modernist, a cavalier . . . But just as his worldliness drives him into the world, his inner

strength always drives him back to Russia, to the little miserable
people and houses.

With's analysis is borne out by the major work Chagall produced in
Berlin, the etchings to illustrate his memoirs. Typically, he adapted to his
new surroundings in a way that at once acknowledged what he found most
artistically significant there—Germany since Dürer had been the home of
graphic art—while throwing himself into memories of Russia. He had
reacted in the same way with the cubist reworkings of his Russian canvases
in Paris in 1911; thus he internalized and assimilated to a foreign city. But

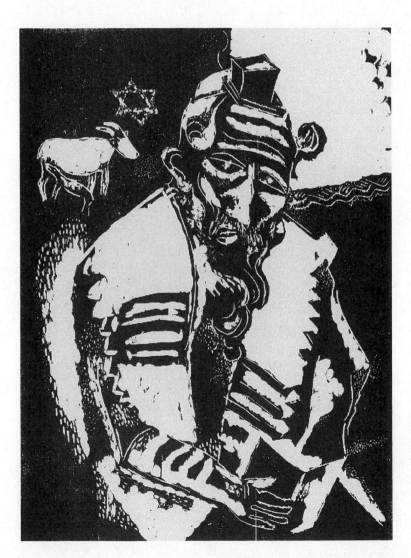

Chagall, "Praying
Jew," 1922-23,
woodcut

this time there were other advantages. In a period of tremulous adjustment, when he was unable to paint, mastering the new medium of etching was at once a challenging diversion and a distinct, self-contained activity, separate from the rest of his oeuvre, as he hung uncertainly between his past as a Russian painter and his future as a western European one. Moreover, his teacher, Zionist Hermann Struck, the master etcher whose 1908 *Kunst des Radierens* (Art of Etching) was the standard text on the subject and who had also taught Liebermann and Corinth, allowed him and Bella to be comfortingly reabsorbed into a Yiddish milieu. Struck, born Chaim Aaron ben David in Berlin in 1876, was an Orthodox Jew who had enlisted in 1915 and had recorded the Jewish homesteads and towns of Poland, Lithuania, and Latvia that he had experienced in army service; many of these lithographs illustrated Arnold Zweig's *The Face of East European Jewry,* published in 1920. Struck had something of Pen's unquestioning devotion to traditional Jewry; while he worked with him, Chagall turned back to Pen with affection (partly in reaction still to Malevich) and wrote to the Vitebsk authorities in January 1923 recommending him for director of the Vitebsk People's Art College. To his former teacher he suggested that he write a memoir on his experiences as one of the first Jewish artists, which he would undertake to get published.

The illustrations for his own autobiography, with its homage to his parents and its anger towards Russia, now occupied his creative energy. Cassirer commissioned twenty etchings; Chagall worked in drypoint, which allows the artist to draw directly with a steel needle on a polished copper plate, producing a sharp line softened by the burr that forms on the edge and that holds the ink during printing, while shading gives depth and rich chiaroscuro contrasts. The medium was perfect for the mix of sharpness and haziness of memory, and Chagall, concentrating on his early life–his parents and grandparents, their homes in Vitebsk and Lyozno, his grandfather sitting on the chimney, the birth of his brother, his Talmud teacher–brought to it freshness and vigour. He began with "Old Jew" and "Pokrova Street," where the stroke is still unsure, as if he were still finding his bearings; then the needle stroke becomes stronger and more confident, and the darting, half-fantastic, half-realistic tone of the autobiography is reflected in images full of humour, diversity, and pathos–the musician whose body merges with his cello, the upside-down lovers on the riverbank, the motorist carrying a 1910 model motorcar on his head. In "Father's Grave" Khatskel Shagal lies like a concrete slab on a velvety black ground, his geometric body crossed

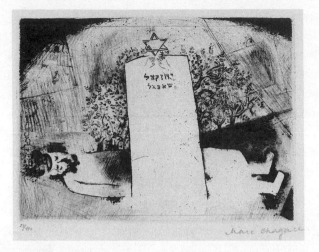

Chagall, "Father's Grave," etching from *My Life*

with a tombstone topped with a Star of David, behind which a tree bursts into abundant blossom; farther into the background, the fences and houses of small-town Vitebsk emerge from a pattern of cubes and rectangles. The effect, made by etching the contours, then completing the image with painterly drypoint drawing, is masterly, showing how rapidly Chagall gained control of the new medium and used it to distil his complex emotions of loss and guilt, regret and closure, hope and pessimism, ambition and competitive fury—he was still arguing here with Malevich's suprematist forms and wittily evoking cubist Paris. "My dear father," he wrote, "The longing of our last years tears me apart, and my canvases quiver under those blasts . . . I shall see your grave later. It is two feet from Mama's grave. I shall lie down full length on your grave. You will not come to life even then. And when I am old (or perhaps before) I shall lie near you. Enough of Vitebsk. It is finished." In a letter to David Arkine at this time, he sent sour greetings, "I don't know who to, to Moscow which I love in my way," and asked for news of his murals, "my infernal work which grows mouldy over there."

When he was halfway through his translation of *My Life,* Feilchenfeldt admitted defeat: nothing he could do would make Chagall's jolting, poetic, unstudied style reshape itself into a German that Bella, judge of style, would accept. So the text was dropped, and Cassirer published the volume of illustrations without it as *Mein Leben.* This liberated Chagall to produce the more freely associative images; he now moved away from Struck's represen-

tative style to make the new medium imaginatively his own. Discussing the etchings with Meyer, Chagall insisted that they marked an advance: "the stroke in drawing and the stroke in etching are fundamentally different," he said. "Work on the plates involves overcoming a resistance and impressing the artist's will on the material. This gives the expressive impulse a new dimension . . . 'Precisely in 1922 I was mature for that; everything comes at the proper time.' " The *Mein Leben* etchings, and some drawings and lithographs made at the same time–the angled figures, turbulent rhythms, and smouldering nocturnal black of "Man with Cane" and "Goat by Night"–are his last great expressionist works, made when he was still an eastern artist. The final image in *Mein Leben,* a self-portrait head with stylized almond eyes and an angular nose, has him carrying a wooden Vitebsk hut, his home, on his head, while beneath him, in heavy black, walk the small figures of his parents–a reversal of an earlier image where his mother is gigantic, icon-like, and he is tiny–alongside the lively, eager faces of Bella and Ida. This was what Chagall carried into exile, the material he would endlessly reshape. The conclusion of *My Life* makes clear his extreme dependence on Bella:

Only you–you are with me. The only one, of whom my soul will not speak in vain. When I gaze earnestly at you, it seems to me that you are my work . . . Everything you say is right. Then guide my hand. Take the paintbrush and, like the leader of an orchestra, carry me off to far and unknown regions.

It was Bella, with her love of French literature and a prewar Russian intellectual's idealization of the French capital, who now pushed for a permanent move to Paris, even though Germany offered a more vigorous and enthusiastic market for his work and France boasted just one collector, the art critic Gustav Coquiot. Paris, however, now showed potential: Ambroise Vollard, as soon as he saw Coquiot's pictures, demanded Chagall's address, and Chagall's old friend Blaise Cendrars got in touch with him in Berlin to say that the French dealer was eager to meet him. This was the urging Chagall needed, and by the spring of 1923 he was nervously preparing for his departure. At the same time the Russian and the Orthodox Jewish communities in Berlin both appeared to be fracturing: the Communist writer Alexei Tolstoy was the first of the Russian émigrés to return for good to Moscow–before he left, he "sat in silent gloom" in Russian-speaking cafés muttering,

"You'll see, no literature will come out of the emigration. Emigration can kill any author within two or three years." In 1923 Hermann Struck immigrated to Palestine. Although the Nazi threat was not yet strong, it was felt by those who cared to notice–in an early speech Hitler attacked Paul Cassirer as an example of a Jewish millionaire whose modernist taste was a corrupting influence on the German people. Anti-Semitism was present in civilised circles both Russian and German: in 1922 the close friendship between Kandinsky, then a Berlin resident, and the composer Arnold Schoenberg was broken when the latter heard that the former had discussed him in anti-Semitic terms. And Ilya Ehrenburg saw "Death to the Jews" slogans on "good bourgeois house[s]" in Berlin as early as 1921.

Once he was set on leaving, Chagall gave up on negotiation and on 12 June 1923 sued Walden before the supreme court, which ordered Walden to name the buyers to whom he had sold, and to increase the amount of compensation, but rejected Chagall's demand for the return of his pictures. The case dragged on for another three years and caused Chagall extreme stress. On 28 June he left Berlin to recuperate at the Sanatorium Schwarzeck in Bad Blankenburg, Thuringia. "Do you really think it's so easy for me to be without you?" he wrote to Bella on his arrival. The plan was for him to build up his strength and then go ahead to Paris and sort out lodgings and a dealer, while she wound up their Berlin affairs, arranged transportation of the paintings, and followed later with Ida. But already in Bad Blankenburg, Chagall's confidence collapsed as soon as she was out of his sight. His letters complained repeatedly of being in a terrible mood; he was barely able to enjoy the brief freedom of living independently of the daily routine that Bella imposed, of not shaving and getting up when he liked. She became suspicious and melancholy in his absence and wrote him a flood of sad letters.

"I sleep enough," Chagall wrote to her, "which means not in the morning but in the middle of the day. You hate it when it's like that–but I would like you to be here and sleep at those times that you don't like." In the formal German spa, he played up the image of the rough village boy, even to Bella, but mostly he sat and stared at the Thuringian hills. "Instead of good food, they give you good manners–and for me, that is absolutely useless–I need it as a cow needs a chair," he wrote.

> I look like a provincial boot maker in this suit–and with the blue
> jumper. So bring with you perhaps the brown suit, in that I will
> look myself. In this sanatorium my nerves could be relaxed and

returned to normal, all the rest will be devoted to that task, including my stomach . . . You ask me if I fancy some women—yes, of course. Only you have such a stupid man as me—by the years, step by step, I've become much more modest and let's make sure that you never have such thoughts in future. You don't need to have such dreams because of me. I'm sitting here and thinking—how I will live without you in Par . . . is. How I will reach Paris, how it's possible for me to go to Paris. Par . . . is (my dream).

In this place I can live, but what will it be next, when I am in town—I'm just frightened it will be repeated, the same story, as when I was in Berlin and you were in Moscow.

Shortly afterwards, his visa for Paris came through, and he left Berlin, Bella, Ida, and his paintings and set out alone, for France. He reached Cologne at lunchtime on 22 August and spent the day drinking beer, "messing around and sitting in the Dom," the Gothic cathedral on the Rhine, from where he sent a postcard to "dear Bellochka and my little daughter," recording tentatively that "so far I'm all right." Then he boarded the overnight train and arrived in Paris to take on the thrilling but terrifying challenge of becoming a Western artist.

Dead Souls

Paris, 1923–1924

It is a world of richness, luxury, art, the play of life," Chagall wrote to Bella from his single room number 53 at the Hôtel des Écoles on the rue du Cambon. "There is an atelier at the top of the house, with a big terrace from where you can see all of Paris–the air, the light, there you can hide yourself." This was the lodging at the Hôtel Medical in Faubourg St. Jacques, an unspectacular building in Montparnasse opposite a hospital, that he had found through the Russian émigré network. Other rooms there were occupied by Serge Sudeikin, a set designer for Diaghilev, and the modernist painter Aristarkh Lentulov, who had studied, along with Chagall, under Le Fauconnier in 1911.

The panorama of Paris, missed for so long, won him over, but would the apartment be good enough for Bella? Many years later Chagall mythologised that as soon as he reached Paris, the sun shone and life flowed smoothly, but the disjointed, distracted letters he wrote to Bella, still in Berlin, from August to October 1923, tell a more difficult story. "The bed that will be there, it will be *double,*" he underlined to Bella, adding a sketch of a bed with two pillows, and the heads of himself and Bella glued together. "If you could see what sort of person I am, I couldn't even live one month [without you]. I can't wait until the winter, come as soon as possible. My atelier and your atelier. When you come we will try to find something else, something different."

Since their marriage in 1915, Chagall and Bella had changed addresses more than a dozen times, lived in run-down communal flats and tiny rooms, endlessly moving Ida's cot, their samovar, and Chagall's canvases on long

rail journeys ending in chaotic, collapsing cities where each time they had had to start from scratch. The stress of so much upheaval and financial insecurity, as well as Bella's own dashed hopes for a creative life, all now built up to anxiety and mistrust, a need for space from each other as well as a passionate dependence. "We have to have different ateliers. I would be happy if you come here to live with me, but we have to have different studios. But we have to live together forever," Chagall wrote. "What's happening to you? It would be nice if you wrote to me, told me what you were eating. Ah? What! Is it possible you can come to me?"

A month before, at the German spa, Bella had worried about his devotion to her, but in Paris it was his turn to agonise. Ten days after his departure from Berlin, on 31 August, he had still had no word from her:

> My dear,
>
> I do not receive any letters from you, which makes me very nervous. What's happening? I don't know if you got my letters. How are you, what's happening? I have no doubt that it's not good. I was afraid it would be terrible and I blame myself that we didn't come here together. I'm afraid–how do we escape from this situation? I can't believe, don't want to believe, that something has happened to you. Are you very busy? Has someone tried to throw you out [of the Berlin apartment]? Or is someone torturing you? I have only lived here a week but it seems I live whole eternities without you. This is a difficult place to live alone, and the most important thing is, it's very sad and I'm not used to it. But I don't want to force you to come to me so that you wake up in my own hangover.

Hours later, he began another letter:

> My dear,
>
> It seems to me that I am often writing to you but I don't know if the letters reach you. How much I would give for you to be together with me. That's what I want. It would be warmer and not so frightening. What to do? You are right: whenever I go away, I immediately begin to worry about you and then I claim you. It's not sweet and I believe in you. When will you write to me (no?), or

to be more exact, when will I receive a word from you? I am very sad and I can't wait any longer. Otherwise, I will come to you, that's a good idea, I swear by God, to come to fetch you, I could take all the pictures and luggage and you and the child . . . I would just go and bring you with me.

He moved into the new rooms the next day, but within a fortnight was discontented. "I'm still not satisfied with the atelier," he told Bella on 14 September,

and am looking for one with a calmer atmosphere. I've begun loving and wanting peace and quiet—there's too much sound coming from the street. Particularly because there's a medical faculty, and even a maternity ward, outside. So even though it philosophically suits (the birth of new generations) I nevertheless want to move away . . . I just would like to find a more stable and fitting place for us to live and not have to put you through the burden of moving house when you get here. I am happy that your coming will work out, that you'll get here safely, the "volcano" seems to be slowly settling.

By now he had been away from her almost a month, and although he had ordered the preparation of canvases, without her he could not settle to do anything.

As for work, painting—I haven't yet begun. I'm not afraid. Soon the Autumn Salon will begin here, where everyone sends his things. And I do nothing. I'll wait a bit . . . Write to me. I'm sad that I can't see you. How are you managing alone? In a wide bed it's boring to lie down, get up, wash, drink coffee, have lunch, drink wine. When will we at last live together peacefully, work? Oh what thirst! I kiss you.

Bella was still waiting for her French visa; as Chagall worried about getting her and his paintings to Paris and finding a dealer, buyers, transport, and boxes for the canvases, a crushing blow came when he revisited his studio in La Ruche; he had not seen it since he fastened the door with a rope for what he thought would be a three-month trip away in 1914. Nine years later

he found a sadder, more desperate La Ruche, its pathways degenerated into rough ground, "without vegetation, without trees, and without those joyous shadows: it looked like *un domaine à l'abandon*," mourned another former resident, Jacques Chapiro. Most of the old habitués had moved on, and the most famous remaining tenant was the hapless Soutine, who had just surprised everyone by selling a hundred pictures from his bug-infested studio to a dapper American visitor, the millionaire collector Albert Barnes. Chagall's fate seemed the worse by contrast: the rope to his studio was unfastened and not a single work remained inside.

The poet Mazin had occupied the studio during the war, and there were stories of happy revelries there, including an introduction, over warm cinnamon-flavoured wine, between Modigliani and La Ruche's eastern European Jews. Now it emerged that Charles Malpel, the dealer with whom Chagall had signed a contract just before leaving, had felt free to draw on the stock of small paintings, gouaches, and drawings left behind there, but as with Walden, Chagall had received no payment. Thrice bitten–he had naïvely lost a year's work to the St. Petersburg frame maker in 1908, then more to Walden in Berlin–he now naturally became suspicious to the point of paranoia; who else had helped themselves to his work and profited from it? He accused his closest Paris friend, Blaise Cendrars, who had lost an arm in the war but was otherwise flourishing. Cendrars denied any involvement, but the closest male friendship of Chagall's life ended. With it the entire pre-1914 charmed circle that Chagall had immortalized in *Homage to Apollinaire* disappeared. That painting had referenced the quartet whom Chagall saw as his staunchest supporters in those days. Of the four of them, two (Apollinaire, who had been injured in the war and then succumbed to the 1918 flu epidemic, and Canudo) were dead, and the other two (Cendrars and Walden) had betrayed him. While Chagall and Bella were struggling with the uncertainties of moving between Berlin and Paris, Walden lived lavishly in the first and Cendrars was enjoying celebrity in the second. In October 1923 his ballet *La Création du Monde,* with jazz-influenced music by Milhaud and cubist decor by his new painter-friend Fernand Léger, opened at the Théâtre des Champs-Élysées. Although Montparnasse had losses to mourn, its inhabitants had experienced nothing like the traumas of revolutionary Russia; here the Russian Bals Bulliers continued as before the war at the avenue de l'Observatoire; the 1920s model Kiki de Montparnasse descended the Bullier staircase shedding one piece of clothing per step, so that she reached the bottom wearing only a feather diadem. Cendrars later

recalled that before one ball a troupe of artists donned harlequin costumes, and as he got ready, one artist accidentally sat in Robert Delaunay's palette, infuriating the artist because "at that time, he used a lot of lazuli in his blues, which cost him a fortune." Delaunay, after an easy war as a pacifist in Spain and Portugal, had slipped effortlessly back into Parisian life; Sonia lost her Russian fortune in the revolution but kept them afloat by starting a successful fashion business. Newly arrived, Chagall was the spectre at the door of the Roaring Twenties, still putting his life back together while his old friends were already enjoying the feast.

The greatest beneficiary of the illicit sales of Chagall's works was Gustav Coquiot, who when he died in 1926 left behind fifty-six of them. Unaware of how the sellers had obtained them, he was not in 1923 inclined to return anything; he had, however, written what Chagall called "a beautiful article about me," and it was through his influence that Chagall had come to Vollard's attention. Thus the Berlin story, in which the theft of his works resulted in his stock's rising, repeated itself in a minor key in Paris–and with it Chagall's increasing distrust of all dealers, buyers, and sellers. "I don't know in which hands [dealers] I'll find myself, but without them it will be difficult–catastrophe," he wrote to Bella. "Modigliani, for example, he was poor here, now he is famous but only after his death. If I'm not with a good dealer, I'll only be famous after my death."

In this mood, it was fortunate that he found Vollard instantly appealing. With his large forehead, which Picasso said resembled a fatty slice of tongue, astute, downcast eyes, greedy body, and gruff manner, Vollard–canny, intelligent, lazy, enthusiastic, vain, and charming–had the virtues and vices that Chagall admired and understood. It was a joke in Paris that he looked like a giant ape, yet "the most beautiful woman who ever lived," Picasso said, "never had her portrait painted, drawn or engraved any oftener than Vollard–by Cézanne, Renoir, Rouault, Bonnard, Forain, almost everybody . . . He had the vanity of a woman, that man." Although he stood at the heart of the Paris establishment, Vollard had begun as an outsider–he was born on Réunion Island and came to Paris as a French colonial to study law. This history appealed to Chagall, as did the fairy-tale element of his meeting with so revered a figure in his gallery in the rue Lafitte in 1923: his was the brightly lit window against which as a young man in 1911, desperate to see the Cézannes, he had pressed his face, too shy to go in. Now the dealer who had given Cézanne, van Gogh, Matisse, and Picasso their first solo shows was courting him. Vollard's clients included Leo and Gertrude Stein and

Albert Barnes; by the 1920s his wealth was funding his passion for publishing deluxe *livres de peintre* by artists such as Bonnard and Rouault, and he offered Chagall a commission to illustrate a children's book by the Countess of Ségur, *General Durakin*. Chagall countered with an alternative proposal, to illustrate one of his and Bella's favourite books, Gogol's *Dead Souls*. Vollard accepted, and Chagall soon began a series of 107 etchings. A measure of financial security was thus guaranteed. Just as important for Chagall, he retained a creative link with Russia and continuity with his last work, the etchings of small-town Russian life that he had made for *Mein Leben* in Berlin.

Still, "it would be good if pictures were necessary for someone," he wrote to Bella. The Cologne collector-dealer Sam Salz, who had bought *Over Vitebsk* from the Lutz gallery in Berlin, was interested in buying more, but Chagall fretted that "I can't understand how it's possible to sell in Cologne." Meanwhile the Russian paintings, stored in Berlin with Bella, had to travel by rail to Paris, "but when the train comes to the Belgian border, all luggage will be taken from the carriage on to the street and everything *opened*." Customs forms, receipts, would be needed for both countries; perhaps travelling via Amsterdam would be safer, although more expensive; while he dithered, he was getting no response to registered letters to Berlin; was the postal service at fault? Could Bella manage all these manoeuvres?

In her absence, the Russian-Jewish sculptor Moise Kogan made himself indispensable to Chagall in the practical business of getting the rooms in the Faubourg St. Jacques in order, then promptly demanded to move in until Bella arrived. "I'm afraid, all strange people, their presence could prevent me from beginning my work," Chagall told Bella. "I'm very capricious in this, he's given me a lot of trouble." He proposed sending Kogan instead to Berlin to help her move to Paris, as he grew more and more distraught without her:

> You have to write to me. Write to me. I can't! I can't! wait. Small studio together with rooms. These people paint them white, they will be very clean. The Punis [Ivan/Jean Puni, who had briefly been a colleague at the Vitebsk People's Art College, and his wife] are already here, what they'll do here I have no idea . . .
> What do you think? Possibly I could come to you and bring you with me to Paris? Autumn is coming and I don't know if you are

still in the studio or whether you changed to the room. I pity you
very much. My little cat, what's happening to you?

Their correspondence became sparser. Bella, tense and overwhelmed,
wrote less often; Chagall admitted to beginning letters to her that he left
lying around on the table in his studio, then started afresh but failed to send
to Berlin. By October, when her visa still had not arrived, he worried and
encouraged by turns:

> I don't know, I write to you a lot, and you write back quite rarely.
> It's you who write rarely, not enough, and slightly coldly. Eh? No?
> Dearest, don't get annoyed. Don't cringe; smile softly, laugh a lit-
> tle. How is your little body? Where do you sleep? How is the
> pussycat daughter? . . . I think about you all the time, when you
> are going to get here. Success will follow with my paintings. I kiss
> you.

At last, in late autumn, Bella and Ida arrived. Bella lost no time in stage-
managing Chagall's real entrée into French artistic society. A photograph
with Vollard at the end of 1924 shows all three Chagalls posing with theatri-
cal flair. Chagall, nervous but smiling, stands at the back of the group; Vol-
lard sits, looking pensive and mountainous; at the front seven-year-old Ida
in a striped French shirt and beret pretends to smoke a cigarette; beside her
Bella, bedecked with flowers and a white scarf, sports the latest cropped hair
style and fixes her eyes steadily on the camera. Both adult Chagalls look
frankly worn out but still fighting. Just as Moyshe had become Marc in Paris
in 1911–12, so Madame Chagall had given up the name Berta when she left
Russia—although there was at least one celebrated precedent of the name in
the Parisian art world, the successful Jewish gallery owner Berthe Weill—in
favour of the more French-sounding Bella, probably derived from the term
of endearment Bellochka (meaning "squirrel" in Russian) long used by
Chagall. At some point early in her stay in Paris, she also sliced six years off
her age, giving her date of birth on official forms as 2 December 1895. This
made her twenty-eight instead of thirty-four, and an unconvincing fourteen
at the time of the painting *My Fiancée in Black Gloves*—but that hung on a
wall far away in Hanover, and erasing traces of the past was one exhilaration
of émigré life.
In her luggage Bella had those Russian pictures that had not sold in

Chagall, Ida, and Bella, with dealer Ambroise Vollard, Paris, 1924

Berlin, as well as her own means of survival: a list of the best patisseries in Paris, and the addresses of those chic boutiques (such as "Robes, Choses à la Mode, Fourrures" at 67, avenue Louise, in Brussels) where she would have her furs and dresses custom made. She brought, too, the Kashmir shawls and rich Baku textiles of the sort that she had given Chagall in 1915 and that appear in the painting *The Birthday,* as well as that canvas itself. With Bella in charge, this iconic painting was quickly sold, to Sam Salz in Cologne in 1924. Its eastern exoticism and romance have always made it among the most popular of all Chagall's works, and the famous family photographs of 1924 appear a deliberate updated re-creation of its milieu. Here the three Chagalls play up Russian chic to the hilt. In one shot, in the corner of a large high room, Bella, in a silky black dress with a big white collar similar to the one she wears in the painting, encircles Chagall, who stretches out on a chaise longue strewn with patterned throws and cushions; at their feet Ida clutches her doll; above them hangs *The Birthday* itself, a representation of their younger, Russian selves; the opulent oriental rugs that frame it make it look more glamorous than ever. In another photograph Bella hugs chubby, laughing, velvet-clad Ida in the corner of the chaise longue; Chagall perches on the arm, presiding over them but also over his works. These poses are cannily chosen: framing the family group are two paintings with especially strong, monumental Russian-Jewish subjects, *Over Vitebsk* and *Praying Jew* (*Jew in Black and White*), the latter a copy recently made by Chagall. Their almost entirely black and white tonalities maintain their impact in a photograph.

The apparently casual poses and bohemian setting of both photographs are planned to the last inch. Not for nothing had Chagall been a set designer

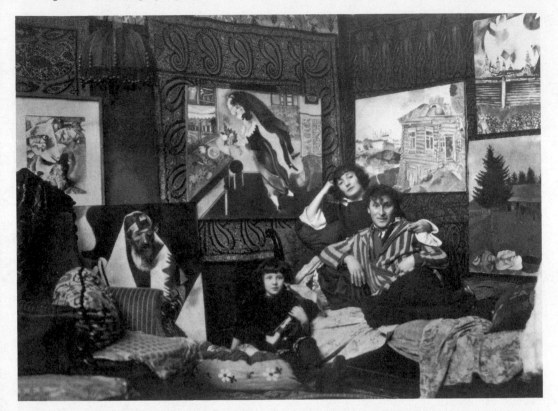

Ida, Bella, and Chagall in the studio at 110, avenue d'Orléans, Paris, 1924. Behind them are the paintings *I and the Village, Praying Jew (Jew in Black and White), The Birthday, The Blue House,* and *The Poet Reclining.*

and Bella an aspiring actress: with their unusually mobile features and striking gestures, their instinct for theatre was by now ingrained–and these showcases of their grace and style would have looked enchantingly exotic in 1920s Paris. As strong, though, is something they perhaps did not intend: the impression of a family, huddled together in a corner with the possessions most reminding them of home, who are only just removed from being refugees. Bella especially has a hunted look that from this time on never quite left her, and her sense of exhausted relief at finding a safe haven is palpable. Just two years earlier the family had been struggling in a damp Moscow apartment; Ida, whose early memories were of Yiddish-speaking Vitebsk, now started to learn her fourth language in eight years. She had never been to school, and it was a sign of the Chagalls' extreme close-knit inwardness, typical of émigré families, that even when they had decisively settled in Paris, they still did not send her. Ida had a French governess and

various private teachers including, for ballet and music, Madame Kshesin-skaya, former official mistress of Tsar Nicholas II. At home the family spoke Russian (Bella and Chagall were "Mamochka" and "Papochka"), and Ida learned from Bella to cook the staples of Russian cuisine: borscht, blinis, golupki. Ida and Bella, rarely separated, were intensely close, and through-out her life Ida was never heard to express a word of criticism of her adored mother; with her father, she developed a more fiery relationship, marked by loud, emotional rows and reconciliations underpinned by a fierce loyalty on her side and pride on his.

The setting for this photograph was the Chagalls' new home: a studio and apartment at 110, avenue d'Orléans, where they moved early in 1924. The Faubourg St. Jacques was not good enough: soon after her arrival, Bella quickly moved the family out by arranging a home exchange with the Polish-Jewish painter Eugène Zak, which gave the Chagalls a grander, larger space, and here, while Chagall threw himself into the Gogol etchings, she unpacked the art books and volumes of Russian poetry and launched the public face of their life in exile.

"You can come to him whenever you like–Marc sits there like a cobbler hammering away at his copperplates, an upright craftsman of God. His wife, who ministers to his art as a nurse ministers to a sick man's fever, reads the chapter aloud to him," recorded the German-French poet Ivan Goll, one of the polyglot circle that now congregated around the avenue d'Orléans. Goll gives a good impression of how Russian the family appeared to their new Western friends:

> They keep on laughing. Ida, their seven-year-old daughter, jumps down from the piano and wants to hear the story as well, and now the fantastic situations are recreated to the accompaniment of laughter by a strange family, with all the humour and tragedy of Russia. And father Marc, the craziest child of the three, makes faces, sticks out his tongue at his daughter, digs his wife in the ribs, pulls his hair down over his forehead–and draws at the same time . . . And all the time Marc laughs, makes faces, lets himself be pinched by Ida, bites, and groans his daily "Je suis si mal-heureux! Je veux mourir!"

The 1924 etching "Self-portrait with Grimace," where Chagall twists his features into mocking distortions, captures this mood. It was natural for the

Chagalls to play up to Gogol: in his tragic humour, Russian blend of satire and pity, fantasy and reality, playfulness and fatalism, Gogol was the Russian writer to whom Chagall felt closest. He had already designed costumes–unused–for a Moscow production of Gogol's *The Government Inspector;* in

1923 he chose *Dead Souls* for its many reverberations with his own art and life. The plot–detailing the rogue Chichikov's epic journey across provincial Russia, as he barters with bureaucrats and swindlers to buy up the names of dead serfs still registered with their puffed-up landowners–afforded him limitless scope for returning in his imagination to the rural Russia of his childhood. The *Dead Souls* etchings at the beginning of this new period in France were the psychological equivalent of the reworkings he had made of his own early Russian works when he arrived in Paris in 1911. Gogol, moreover, had written the book during a twelve-year stay in western Europe, looking at Russia from afar with some of the mesmerized despair that Chagall felt.

Chagall, "Self-portrait with Grimace," 1924, etching

Published in 1842, *Dead Souls* met a mixed reception, and reformists and reactionaries had fought to claim Gogol ever since. By Soviet times the book was served up as social criticism–which Chagall answered by recasting the novel in its nineteenth-century context as a *comédie humaine.* With warmth, vigour, wit, wry understanding, and a rich technical and imaginative inventiveness–subtle, finely gradated lines, soft, wiry, scratchy strokes, smudged or dotted textures–he depicted Gogol's characters, and even his animals, as flawed human types. Keeping close to the text, which Bella read aloud to him while he was working, he reproduced the stylization and hyperbole of the original: the round drunken coachman Selifan, accusing the central horse in the troika of leaving the work to the others; the two bargainers, crafty Chichikov and mellifluous Manilov, meeting in their overcoats, each keeping his bargaining position as closely wrapped as his body is bundled up against the Russian winter; a clerk's head growing up through the top of his desk because he is so rooted to his workplace; a government office dotted with an absurd pattern of desktops, inkwells, writing hands, and long noses; Madame Korobotchka extrav-

agantly piling up a surreal mountain of pillows into a featherbed. "For every picture a different technique, a different philosophy, a different outlook—every picture different, like every person and every day, how does he do it?" marvelled Goll. "One gay, another clear as snow, another seen through the magical haze of alcohol, calves in the sky and flowers in the stomachs of virgins; but what devotion—a Jewish St. Francis of Assisi."

There is an almost medieval literalness to Chagall's interpretation, set against a German expressionist influence that emphasizes the diabolical and the grotesque in Gogol. Chagall "looks at the writer's characters through the eyes of a twentieth-century artist, a visionary and expressionist who has already assimilated the experience of social upheavals inconceivable in the previous century," said the Russian critic Natalia Apchinskaya. In etchings of a vast, windswept Russia, wretched, inert, yet magnificent in its vitality, he distilled his own experiences of hope and disappointment in his homeland. Gogol had written of walking hand in hand with his characters as life rushed by, seeing the world through laughter and tears. Chagall brought that tragicomic verve to his illustrations but, already responding to the influence of Paris, added shades of French wit, which struck immediate

Chagall, "The Small Town," etching from *Dead Souls*

chords with his French supporters. "Chagall contrived to suggest, with remarkable truth, the rather Louis-Philippe appearance characteristic of Russia in Gogol's time," approved Vollard. Thus through Chagall's *Dead Souls* there courses his own optimism about survival and adaptation, the continuing stream of vibrant life, both for Russia and for himself. For the first year in Paris, Gogol was his lifeline to the past as well as his major source of income.

Gogol had complained that the prophet finds no honour in his homeland; with this lament Chagall chimed bitterly, and throughout the 1920s he could not leave alone the idea that still, somehow, he would find recognition in Russia. "To Moscow I am writing almost exclusively to you, for others have almost forgotten me and are hardly interested in me," he told Pavel Ettinger in March 1924, grieving that no Russian institution had ordered from Cassirer a set of *Mein Leben* etchings. The text of *My Life* remained unpublished in any language until it was translated into Yiddish and published in the New York–based journal *Di Tsukunft* in 1925 in five installments. By 1926 Ettinger, to whom Chagall continued to direct ludicrous demands for exhibitions of his work in socialist realist Russia and for the Jewish murals to visit Paris, was his only correspondent in his homeland. "You know, I am almost cut off from Russia," Chagall wrote. "No one writes to me and I have no one to write to. As if I were not born in Russia."

For both Bella and Chagall, contact with their families seeped away. In 1924 Shmuel Noah Rosenfeld, Bella's father, died a broken man in Moscow. Alta lived on alone, until in old age she was taken in by the widow of her gentle son Mendel, a doctor who died of throat cancer in the mid-1930s. Isaac,

Chagall, the final etching from *Dead Souls*

the oldest Rosenfeld brother and the only one who maintained an Orthodox Jewish lifestyle, was finishing his medical studies in Switzerland and invited Alta to live with him in the 1920s, but she was refused a visa, apparently on account of Chagall and Bella's defection from Soviet Russia. Saying kaddish (the Jewish prayer of mourning) for his father at the synagogue in Basel, forty-four-year-old Isaac got to know the rabbi, married his daughter Hinde, and moved with her to Paris, which gave Bella sustaining relations with this branch of her family. Hinde, extremely religious and not well educated, came to revere Bella and named the couple's only daughter after her– another Bella Rosenfeld. "Bellochka, don't forget, darling, that now you are Bellochka and that nothing was ever so perfect, so high for her," her cousin Ida wrote to this second Bella after her mother's death, conveying the admiration all three women felt for Bella Chagall. Throughout the Paris years the Chagalls regularly celebrated the Jewish festivals such as Passover with the Rosenfelds, though the relationship was not wholly smooth. Chagall, unable to forget the contempt in which the Rosenfelds had first held him, could not but exult at his own success vis-à-vis Isaac's continuing struggle to practice as a doctor, while Hinde's lack of sophistication made her an example of the despised ghetto Jew of Bella and Chagall's childhood. Bella respected Hinde's demand for kosher food and made her vegetarian dishes when she was their guest, but Ida used to complain that Hinde "smelt of gefillte fish," and after Bella's death, when her niece and namesake visited and requested kosher meals, Chagall, irritated at what he regarded as long-discarded, irrelevant customs, refused to comply.

With his own family, Chagall had less contact and little interest in keeping in touch. By the 1920s his five surviving sisters were all married and had young families. "Maybe one day you will send me your physiognomies. If possible I'd prefer spontaneous photos, without photographic retouching," Chagall wrote in 1923, but he was a lazy correspondent, long removed from the environment they now inhabited, while they soon preferred not to draw attention to their connection with a celebrated defector. Mania's daughter Ida Aronovna Goldberg (born in Leningrad in 1924, a cousin of Ida Chagall, and like her and a third cousin, Lisa's daughter Feta-Ida, named in memory of her grandmother) recalled that "in her childhood and youth the children knew nothing about Chagall. Their parents always whispered about him with an air of secrecy. Later on, when they were older, they saw that it was safer not to mention his name so that there wouldn't be problems at work."

In Paris, Chagall's nostalgia was mixed with ambivalence towards Russia.

The Russian émigré community was an initial port of call; one of Chagall's first visits in 1923 was to Bakst's elegant apartment, where he found his old teacher "polite . . . but he won't tear himself apart for me." He had better luck with Alexander Pozner, the writer who had been part of Vinaver's circle and had helped him in St. Petersburg between 1908 and 1911; Pozner was, with Vinaver, a pivotal figure in Russian Paris and now came to his aid again, helping with practicalities such as visas. "Pozner is a fine man; through him we'll get acquainted with many Russian writers and others," Chagall encouraged Bella. This Russia in miniature was a consolation–the Chagalls attended Vinaver's son's wedding; Bakst came to Ida's eighth birthday party; the Yiddish expressionist poet Peretz Markish agreed to translate Chagall's memoirs into Russian. But it also carried with it a fondness for the tsarist empire that Chagall, as a working-class Jewish avant-garde artist, could not possibly share. Many Russians also found it suffocating–Pozner's son became a Soviet spy, while Markish returned to the Soviet Union in 1926. For Chagall, old enmities and resentments flared; he fumed when Alexandre Benois travelled to Russia and wrote about the Russians in Paris without mentioning him.

At the end of 1924 the Chagalls moved to a small house near the Bois de Boulogne at 3, Allée des Pins, Boulogne sur Seine–a district crowded with aristocratic Russians who had supported the White Army and had mostly fled west via the Crimea, paying their way with bribes of diamonds and gold. On the rue Gutenberg, up the road from Chagall, Bella, and Ida, lived Prince Yusupov and his wife and daughter, in circumstances unimaginably straitened compared with their former position as Russia's wealthiest family. They survived–ironically like Chagall–by selling art, in their case the Rembrandts smuggled out from their St. Petersburg palace. Vladimir Nabokov *fils* described this generation of exiles as dead souls themselves: "hardly palpable people who imitated in foreign cities a dead civilization, the remote, almost legendary, almost Sumerian mirages of St. Petersburg and Moscow, 1900-1916 (which even then, in the twenties and thirties, sounded like 1916-1900 BC)." In the nearby cafés of the sixteenth arrondissement, figures from prerevolutionary Russian culture–writers Ivan Bunin and Marina Tsvetaeva, artists Larionov and Goncharova, composers Stravinsky and Prokofiev, the impresario Diaghilev–congregated; such a "ghetto of emigration was actually an environment imbued with a greater concentration of culture and a deeper freedom of thought than we saw in this or that country around us," suggested Nabokov. "Who would want to leave this inner freedom in order to enter the outer familiar world?"

Each Russian artist had to answer that question in his own way. Many were locked in the past, their art arrested at the point at which they left Russia. Thus Bunin and Rachmaninov remained nineteenth-century Russian romantics, while Larionov and Goncharova, once pioneers, between 1919 and 1929 reworked the same prerevolutionary costumes and set designs for Diaghilev's ballets. Chagall, whom Diaghilev had barely deigned to address before 1914, was now offered a permanent box at the Ballets Russes and went often. Yet he never wanted to lose himself in émigré clichés. He believed Diaghilev sold a parody of Russian exoticism to a French tourist audience; nor was he a White Russian exiled from a Crimean paradise, trying to re-create Chekhovian dachas in the French countryside. As a lonely Jewish Red Russian for whom the avant-garde dream and the revolution had gone sour, how could his art develop now? "What's new? And what do the artists do?–still Rodchenko? Or Malevich? Or are they searching quietly?" he asked Ettinger plaintively in December 1924, two and a half years after he had left Moscow. When he finally nerved himself to return to oil painting, he spent the first year in Paris painting replicas of those major works with Russian-Jewish motifs that he had lost in Berlin, left in Russia, or sold. It was as if he were reclaiming his property from Walden, as well as drawing up an inventory of what defined his artistic identity.

These were not reworkings in a new style; they were intended to be as close as possible to the original paintings, and in those cases where Chagall had the originals before his eyes—*Praying Jew (Jew in Black and White)*, entrusted to Chagall to pass on from Kagan-Shabshay in Moscow to his sister in Paris; *The Birthday*, which he copied before selling it to Sam Salz–the resemblance between the two versions, made a decade apart, was close. Other new versions made from memory, sometimes with the help of photographs—*The Green Violinist, The Cattle Dealer, I and the Village, Over the Town, Over Vitebsk, The Pinch of Snuff*—between 1923 and 1925 turned out more like variants: the compositional rhythm is freer and less intense, the form more open, the colour more nuanced and fluid. These reconstructions, looking back like the *Dead Souls* etchings to Russia, became the typical Chagall transitional works, pointing the way to a new French style that now announced itself decisively in the paintings focusing on fresh motifs from 1924-25.

This shift marked the third great change in Chagall's paintings, following the breakthroughs in 1911, when he first came to Paris, and 1914, when he returned to Russia. Many elements, as well as the geographical, were at play. The lessons of three years' work on the etchings for *Mein Leben* and *Dead*

Souls carried through to the oil paintings, gaining Chagall a new fluidity and sensitivity to tonal nuances. This sensitivity combined with the enchantment he felt again at the *lumière-liberté* of Paris, and with a rapturous discovery of the French countryside, whose gentleness and soft light are so different from that of Russia and which he now dared himself to reflect in airy, richly modulated paintings unlike any he had made before.

"Lumière-Liberté"

Paris, 1924–1927

I want an art of the earth and not merely an art of the head," Chagall said in 1924. Even before Bella arrived in Paris, he had consoled himself by making short trips out of town "where the nature is French. Marvellous! Pissarro, the grace and simplicity of the landscape please the eye, there is no artificiality as we saw in Germany. Cézanne becomes clear here." He knew that the way to become a French artist was through submersion in the French landscape, and as soon as he and Bella were settled in the avenue d'Orléans, they took every opportunity to travel beyond Paris. They began, in 1924-25, with northern France: the tranquil, verdant countryside of L'Isle Adam on the river Oise, close to van Gogh's Auvers. In this cultivated French landscape, whose avenues were laid out by Le Nôtre in acres of formal park and woodland, the Delaunays and their son Charles (five years older than Ida and fixated on jazz) spent every weekend at their country house, and the Chagalls were frequent guests.

Down the river at Septeuil a new Paris friend and supporter, Florent Fels, art critic on the Paris journal *Nouvelles littéraires,* also had a house, and Chagall and Bella came to feel so at home in the landscape here, between the Seine and the Oise, that they rented two rooms from a policeman, Albert Guy, at the nearby hamlet of Montchauvet, set in gentle hills, where they stayed intermittently until 1927. Here they ate fresh eggs and butter from the farm and lived in simple rooms with heavy country furniture and enormous featherbeds, an orange blossom wreath under a glass dome, and a photograph of Monsieur Guy as a First World War soldier on the mantelpiece. A postcard from Chagall to Bella inscribed "Montchauvet, La Grande Rue"

shows a narrow sloping path lined by neat stone walls, a tracery of shrubs and trees, and small village houses—a scene that, in contrast to avant-garde Paris, could not have changed in two hundred years. Chagall has added a second chimney and the figure of himself standing on the roof on one of the houses, and an angel flying across the sky. After the hardships of separation and the first year in Paris, his spirits soared in this rural haven. He completed the Gogol etchings and began to paint landscapes—the bare trees of L'Isle Adam in winter, Montchauvet's church and village square.

Fels, warm, witty, urbane, was an anchor. From 1925 he edited the innovative review *L'Art vivant,* and his country home attracted many writers, artists, and collectors: Vollard, who animated these weekend gatherings with a laugh that Fels compared to that of a cannibal devouring a young girl roasted *à point;* the painters Vlaminck and Derain; Max Jacob, now a Roman Catholic convert; Moise Kisling, a Polish Jew and socialite portraitist, whom Chagall knew from La Ruche; a young André Malraux; poet and art critic André Salmon, who had lived in St. Petersburg for five years and spoke Russian; and the poets Ivan and Claire Goll. *L'Art vivant* called itself a *revue d'élégance,* addressing not only fine art but Paris's *cafés chantants,* flea markets, jazz, and movies. Fels, grandson of Theodore Duret, the first historian of impressionism and a friend of Courbet's, had grown up in a luxury apartment on the rue Vignon, where even the maid's room was hung with paintings by Toulouse-Lautrec; Fels saw himself as defender of those he called the new savages, as his grandfather had been a couple of generations before.

In this cosmopolitan, erudite circle, Chagall blossomed. With the Delaunays and the Golls, both multilingual couples in their thirties, the Chagalls had sustaining friendships. Apart from bumptious, insecure, kindly Robert, all the members of this set shared a Jewish identity and the challenge of reinventing themselves as French. As in prewar Paris, their names told their stories. Sonia Delaunay (née Sarah Stern) was Russian. Claire Goll (née Clara Aischmann) was born in Nuremburg and described herself as a mix of Prussian aristocrat and ancient Jew. Ivan Goll (né Isaac Lang) came from an Orthodox family in divided Alsace, where he had spoken French at home and German at school; unlike the others, he still attended the synagogue for Yom Kippur and to mark the anniversary of his father's death. Crucially for the Chagalls, he was familiar with Russian literature; in 1922 he had published *Les Cinqs continents,* a world anthology of contemporary poetry including Mayakovsky, Esenin, Akhmatova, Blok, T. S. Eliot, Cavafy, Rabindranath Tagore, and the Parisians Cendrars, Apollinaire, and Jacob. The

Golls had met as pacifists in dadaist circles in Switzerland. Claire had a daughter, Doralies, from an early first marriage and in Germany in 1918 had briefly left Ivan for the lyric poet Rainer Maria Rilke, but in the end she had thrown in her lot with France and travelled with Ivan to Paris in 1919. The Delaunays returned there from Spain shortly afterwards.

Creative interchanges among the set were heady. Fels wrote about his artist friends. Delaunay painted Bella wearing one of the celebrated rainbow dresses designed by Sonia. Chagall drew the striking auburn-haired Claire, whose tense beauty had attracted artists from Jawlensky to Kokoschka, and he illustrated her *Poèmes d'amour,* published in 1925. The women—like Bella, each had limited her family to just one child—were as ambitious as the men, and Paris offered them a more sympathetic atmosphere in the 1920s than it had before the war. In 1925 Sonia presented work at the Exposition des Arts Décoratifs, and Claire followed up *Poèmes d'amour* with *Poèmes de la jalousie* in 1926. All promoted themselves vigorously; from their apartment at 49, Quai de Bourbon, overlooking the river, the worldly Golls threw themselves into French aristocratic society as well as into the Left Bank literary scene centered on James Joyce, a friend from their time in Switzerland. In photographs with her husband and their Siamese cat Mandalay, Claire looks like the star of a cocktail party; appallingly vain, she played up her reputation as a femme fatale to the end of her life.

Alone in this group Bella, more subtle, less showy, had no independent focus for her gifts and hopes, which she poured entirely into her husband's work. Always fragile, she had the first of many surgical operations in 1924, and her illnesses, which played a significant part in the Chagalls' lives, were exacerbated both by the difficulties of exile and by the stress and frustration of her role in Chagall's art. He described her to Virginia Haggard as "the first person in his life to play the role of permanent critic. No painting was finished until Bella declared it so. She was the supreme judge; she stuck to her opinion, even if it was different from his, and he usually came around to hers in the end." After her death he wrote, "For years her love influenced my painting. Yet I felt there was something within her held back, unexpressed; that she had treasures buried away in her heart. Why was she so reserved with friends, with me? Why that need to stay in the background?" His own genius—of a different order from Delaunay's and Goll's—was one reason: like Picasso and Matisse, although in a different manner, Chagall's creativity in the end subsumed within it any woman in his orbit. The breakdowns (Dora Maar) and suicides (Marie-Thérèse Walter, Jacqueline Roque) of Picasso's

companions are legendary; it is less remarked that both Madame Chagall and Madame Matisse spent much of the 1920s and 1930s ill or recuperating in bed. Pierre Matisse suggested that his mother was obliterated by "a veil of heaviness, a protective veil covering depths of anger and loss," and that the cause was the extreme demands made on her and their family life by Matisse's painting. Chagall admitted, "My whole life is made of work; the other things are secondary. Of course, love and death and birth are great shocks, but the work goes on just the same . . . If the work didn't go on, it would consume me from inside." Bella, whom he saw as co-originator of his works, was caught up within that creative energy but lacked her own expressive outlet; her neurosis over the health of all three of them–carried over to Ida, who was also often ill–was one result.

Her sustenance was to take over the practical side of Chagall's life, which she did with a meticulous sense of propriety and "flair for doing just the right thing at the right time." For the first few years in Paris Chagall had no dealer, and Bella, drawing on her experience of the shop, handled every negotiation, charming and intimidating collectors by turns. With Sam Salz in Cologne, for example, who followed the purchase of *The Birthday* in 1924 with *Over Vitebsk* in 1925, and his wife, she struck up a friendship and wrote in elegant German until the Salzes became less cooperative about paying, at which point she switched to haughty French. She and Chagall played a double act: he affected ignorance of the business of selling paintings; she had her father's mix of worldly authority and a spiritual air that reassured customers; but all the while the couple were in collusion. One collector remembered asking Chagall for the price of a picture, only to be told, "Je ne demande rien! Beaucoup d'affection, de l'amitié seulement." When he insisted, Bella was summoned ("Excusez, Monsieur, vous me gênez avec ces questions qui ne me sont pas familières. Peut-être ma femme pourrait vous renseigner. Elle est tellement plus au courant des problèmes matériels"), but as she took over the conversation, the collector saw Chagall make a sign in a mirror to her about the price she should ask. "Celà fait dix mille," she said.

André Salmon left a perceptive portrait of Bella, "the beautiful and perfect wife." Salmon was coopted with his wife Jeanne by the Chagalls to translate Chagall's Russian memoir into French. In despair over the need to meet Bella's high standards, Salmon took the manuscript to pore over in the garden of the Chagall home in Boulogne sur Seine. Salmon saw the Chagalls as "the couple suspended in space," and was so enchanted that he never got any work done. He remembered:

Bella was enthusiastic about the project. It would be worthwhile and charming . . . But Bella's tea, Bella's plates of dainty fish, Bella's savoury cucumbers, her excellent cakes, reduced to nothing, definitively, all our best intentions to work seriously. And when it wasn't tea that distracted us, when, by chance, we were deep in the battle of two vocabularies, Bella would surface and call my wife and me to the garden:

"Dear friends, quick, come and look at our beautiful child on the swing. Swing, Ida!" . . .

Ida on the swing, a really beautiful child, was a magnificent sight. Straightaway I wanted to jump on to the swing too. Then Bella ran to fetch her camera. So one of my memories of that period is . . . the double image of the lovely child Ida and the discouraged translator on a swing, raised high up, still far from the regions where Chagall transports his creatures to make them happy, immediately, in a few strokes of the brush, without much preliminary drawing.

Thus the Chagalls played their parts, and the cannier among the audience, like Salmon, knew they were performing it but lapped it up anyway. As muse, manager, and mother, Bella's life was full—but not independently so; she now keenly felt every brief absence of Chagall, which shook her fragile sense of well-being. "It's cold on the street and the same in myself," she told him in 1924. "If I would have one warm word from you, it would be better . . . Stop painting landscapes please because it's impossible to work outside in this cold. Write to me please. Why don't you?" Ida wrote in the same letter, "Father—I kiss you strongly," to which Bella added mournfully, "And I too. The shape of Ida's letters is already like kisses to your cheeks." Soon afterwards four sides of writing paper in shaky handwriting are taken up with her uncertainty over when he is returning.

Why do you want me to worry and stare out of the window and not let me know beforehand when you're coming? . . . It will always be like this with me. I want to find out when the train is arriving. Really, can't you advise me? Can't you telegraph when you arrive? Even if you come at night, but of course it would be better by day . . . Write to me anyway. Not everything in the world is done topsy turvy as you do it. So you see my dear how I wait for you now.

Sometimes Ida would add sketches of her and her mother, and her own greetings, in Russian or in French, in the tremulous, high emotional language–"On t'atend [sic] tous les jours, toutes les heures. Viens . . . De touts nos forces, La petite grande fille Ida Chagall"–which she picked up from Bella and which would define her own style. Chagall's "two women," as he called them, inspired guilt and protectiveness as well as love and dependence. "My dear little canary [*ptashka*–the same term of endearment Prokofiev used to his wife], have you forgotten about your jackdaw? You are so concerned about yourself, you have so much to do," he wrote on a Montchauvet postcard to Bella. "Look what an ideal husband I am, I am writing to you every day when I drink my coffee."

Ida Chagall, Paris, around 1929

Mostly, though, the trio travelled together, with Ida growing up a precocious studio child, absorbed in her parents' world, at ease with their friends and quite unused to other children. In March–April 1924 the Chagalls visited Normandy with the Golls. A windswept photograph of the two couples and Ida, arm in arm, perching on a balustrade, shows the men relaxed; the women, posing more eagerly for the camera, look less at ease; Ida plays the charmer. Claire Goll remarked tartly that "Chagall adored Ida, who tyrannized her father as only a seven-year-old knows how to do." But from the seaside resort of Ault, the Chagalls wrote to the Delaunays that "we are silly and happy here," and in June they returned to the northern coast for a holiday on the island of Brehat in Brittany. *The Window,* a view of meadow, trees, and houses, with a lighthouse topping a promontory that stretches out to sea, was painted from the top floor of their hotel; the landscape is framed by a window, in whose panes and sill the sonorous colours are reflected. The soft light unifies the two areas of this gentle picture, whose theme–the intimacy between the interior and the joy of nature–shows Chagall internalizing the French countryside, making it his own. The same web of chalky blues, emerald greens, and dusky greys falls across *Ida at the Window,* where the child sits on the sill next to a vase of flowers, with the view of sea and sky held in equilibrium with the scene inside.

Everything angular and brash about Chagall's painting during the Russian years is smoothed and modulated here. Draped in iridescent colour, *The Window* and *Ida at the Window* already look in their subtle texture and mellowed tonalities like French paintings, indebted to Bonnard and Monet, and they set the tone for Chagall's work through the 1920s. Even when he returned to Russian subjects—*Little Red Houses, The Watering Trough, Peasant Life*—in 1924-25, the tones are softer and the colour more diffuse, but these were anyway throwbacks; it was in French landscapes, paintings of flowers, and a few portraits that his art advanced in these years. All speak of a new harmony with and interest in nature; whereas in the first Paris period, his art had been metaphysical and passionate, the yearning expression of visionary youth, in this second French phase Chagall opened out to the world and the French countryside. He found the courage to express himself in a new idiom; away from ravaged Russia and its insistence on ideological positions, he was able to concentrate on painterly values. "What I have wanted to do has been to give concrete and human form to man's impotence in the face of Nature," he told art historian Maurice Raynal in 1927. "I have not tried to revenge myself on Nature but to create an expression parallel to hers, if I may so express myself. We have each our own personality, and we must have the courage to exteriorize it."

In a Paris buzzing in 1924 with the first surrealist manifestos on the one hand and a new classicism on the other, Chagall still stood out. The surrealists tried to claim him: André Breton, citing Apollinaire's 1912 description of the early Paris works as "surnaturel," argued that modernism's creative

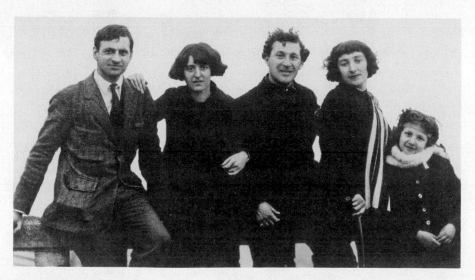

Ivan and Claire Goll with Chagall, Bella, and Ida, Normandy, 1924

point of departure owed much both to Chagall's dream pictures and to his sensuousness of impression. But Chagall remained detached. He distrusted surrealism's reliance on what Breton called "pure psychic automatism"– the practice of spontaneous writing or drawing, which the surrealists believed gave them direct uncensored access to their unconscious minds; as a consciously autobiographical artist, Chagall considered this approach fake, for "fantastic or illogical as the construction of my pictures may seem, I would be alarmed to think I had conceived them through an admixture of automatism." And he despised the quality of their work, which "offered so much less evidence of natural talent and technical mastery than the heroic period before 1914."

His own work, moreover, was now less "surnaturel"–less fantastical, less narrative. Instead, in landscapes and especially in the two portrait master-pieces of 1924-25, *Bella with a Carnation* and the *Double Portrait* of himself and Bella, Chagall began to reflect the return to order and the emphasis on figuration in 1920s French art. Both portraits are striking in their classical flatness and design. *Bella with a Carnation* was painted in response to a por-trait Delaunay made of Bella that aroused Chagall's jealousy. It drove him to outdo the French artist, to create an intimate likeness of his muse, with her questing intelligent look, slender face, and hunted expression, which also stands as a monumental portrait. He painted Bella in a black dress with large white collar and cuffs, a single flower in her hand, against a crimson ground. Some of the theatricality, even mannerism, of his 1909 *My Fiancée in Black Gloves* is retained, but Bella now is imbued with a graceful sobriety that goes beyond the playful charm of that painting. "This is a supreme work that equals the most perfect portraits of the greatest periods, portraits that are completely dark and unrelieved except for a touch of white in the linen or the face, those famous portraits which in their nobility remain the illustra-tion, *par excellence,* of the human countenance," wrote the critic Jean Cas-sou, Chagall's friend and later director of Paris's Musée national d'art moderne.

Bella with a Carnation is a private, melancholy painting. For *Double Por-trait* Chagall worked under another double likeness, *The Birthday,* and the finished picture is a public statement. It harks back to the *Lovers* series made in Petrograd in 1916-17; it has the solemnity of the Russian works, but larger in scale, it is classical in colouring and, in pose, dynamic élan, and upward sweep, has an art deco, modern look. Leaning forward, Bella and Chagall seem about to take flight, their vitality and engagement with the

world contrasting with the interiority in the earlier cycle. Holding a bouquet, Bella is dominant; she wears a splendid white dress, with her favourite Pierrot-like collar, and a beret and black gloves—references to similar accoutrements in *My Fiancée in Black Gloves*. The profile view, serious expression, and sidelong glance of her large eyes, too, evoke that first portrait.

With these works, so different in gravitas and painterly ambition from the posterlike double portraits made during the Russian Revolution, Chagall staked his claim as a Western artist, as well as highlighting Bella's role as co-creator of his artistic world. Such individualistic work would have been unimaginable in 1920s Russia; with it Chagall consolidated the achievements of "the heroic period before 1914" to which he considered he belonged. It pleased him deeply when Pierre Matisse, son of the artist and, at twenty-four, a young dealer seeking his own identity, organized Chagall's first French solo exhibition at the Galerie Barbazanges-Hodebert in December 1924. With such a pedigree, "Matisse and Picasso and Derain, and Vlaminck, Segonzac, and all those whose legs work, came to my exhibition," Chagall panted to David Arkine in Moscow. "What can I say about myself! Only that now I am on the lips of all the contemporary French painters and poets . . . The only thing worth having, is if masters such as Matisse acknowledge your existence. A test? Yes. Paris is the heaviest weight there can be for an artist."

Praise was not unanimous, though, partly because most of the works on display were from the Russian years and unfamiliar to French taste; Bella's letters to Chagall in this period are full of pleas to ignore the critics and "live alone and be your own best judge, as the great words of Pushkin go." When the exhibition went on to Cologne, by contrast, the Russian work found an ecstatic audience, with *Praying Jew* singled out as an essential marker for "the new art." In Paris it was those who stood at an angle to French culture who saw Chagall's significance. Ivan Goll, the bilingual poet, now assumed a diluted version of the role the multilingual Cendrars had taken before the war as Chagall's chief literary friend and promoter. He wrote that Chagall, "a god for Russia, a genius for Germany, was almost spat upon, and greeted by some journalists as an undesirable guest and alien," when he arrived in France, but was now "in the process of conquering Paris." Goll praised especially the French sensibility of *Double Portrait* and *Bella with a Carnation:* "No more anecdotes, no poetic fancies, simply robust painting, taut classical discipline and discovery of colour, the *odeur* in a picture. And look, here too Chagall achieves mastery at the first stroke! All at once he paints

like a Frenchman, yet there is not a line of Ingres, not a dot of van Gogh. It is all Chagall—he paints with areas of colour and no longer with ideologies: that is the vast difference between Paris and the East."

To the French, however, Chagall remained foreign, oriental, strange. It was a coup that in 1927 Maurice Raynal awarded him a place in his book *Modern French Painters;* clearly, though, he baffled the French art historian just as he had baffled Apollinaire. "Chagall interrogates life in the light of a refined, anxious, childlike sensibility, a slightly romantic temperament . . . a blend of sadness and gaiety characteristic of a grave view of life," Raynal wrote. "His imagination, his temperament, no doubt forbid a Latin severity of composition."

Chagall admitted to Jacques Guenne, interviewing him for Fels's friendly *L'Art vivant,* that his psychology differed from the Latin mind, though he considered Paris a living school and that he had been reborn in France. To Raynal he insisted, "I owe what I have done well to Paris, to France, whose air, whose men and whose nature have been the true school of my life and my art." But he was still hedging his bets. To *Tsukunft* editor Avrohom Lyesin in New York, he described himself in 1925 as a Jew in the style of his father, while to Pavel Ettinger in Russia he wrote in 1926, "Do I 'have to' become a French artist (never thought about it). And it seems: I don't belong there. And I often remember my Vitebsk, my fields . . . and especially the sky. My paintings scattered all round the world, and in Russia they apparently don't even think and are not interested in an exhibition by me . . . So you see, I am complaining . . . But against whom, against myself?"

Dead Souls was finished in autumn 1925, though thanks to Vollard's legendary slowness, it was still far from being published. But the two projects that Vollard suggested next showed his understanding of Chagall's identity crisis as he left Gogol and Russia behind. One was the Bible, drawing him back to his Jewish roots; the other was a commission that took the artist to the very heart of French culture: colour illustrations for the seventeenth-century classic, La Fontaine's *Fables.*

Chagall's drive in the mid-1920s was to assimilate, to adapt, and he eagerly embraced the French work. Certain traits in La Fontaine—satire, the archetypal characters, the provincial settings—overlap with *Dead Souls;* Chagall had always, moreover, enjoyed painting animals, who are its central characters. But most important was the challenge of using literature as well as landscape to understand France, just as he and Bella had left behind the Yiddish environment of their parents by gobbling up Russian literature as

teenagers in Vitebsk. "Once I used to write Yiddish well, but since I became a Goy, I write with mistakes or in Russian-Jewish," Chagall joked in 1924. Plans to illustrate the Bible, even though they were put on the back burner, were an undercurrent to the pagan *Fables* and Chagall's Janus-faced relationship with secular France. He begged Yiddish-speaking friends to find him a Yiddish Bible, as he did not read Hebrew well, writing to Koenig in September 1925, just as he was finishing *Dead Souls:*

> I shall do the Prophets . . . in spite of the fact that the "mood" all around is not prophetic . . . on the contrary it is evil . . . But we must oppose it. Strange as it may seem, in our time which, in spite of many achievements, I consider to be foul, one feels like escaping into other dimensions . . . For quite some time now art stinks because the purity of the soul has been substituted by a cesspool.

How bold he and Vollard had been in making their choice of a French text was shown by the furious reaction of many critics to a Russian-Jewish artist's presuming to take on this masterpiece of French style. "People could not understand the choice of a Russian painter to interpret the most French of all our poets," wrote Vollard; such was the outrage in the French press that he published an article in *L'Intransigéant* defending Chagall and pointing out that La Fontaine had used oriental sources—*Aesop* and the storytellers of India, Persia, and Arabia. This, he argued, informed La Fontaine's settings and atmosphere and made Chagall, "sympathetic to this magical world of the East," the ideal choice, "exactly because his genius appears to me to be nearest, and in a way related, to that of La Fontaine, being at the same time full yet delicate, realistic yet fantastic."

Chagall wrote gratefully that Vollard "was not so much a dealer as a mystic . . . a great precursor" who gave him confidence and the possibility of expressing himself freely. Vollard's support was crucial to Chagall's flourishing in France during the 1920s. In several ways 1926, when he began work on the *Fables* illustrations, was a watershed. Many people who had played key roles in his early successes died or disappeared from his life that year. In Paris Maxim Vinaver, his first collector, and Gustav Coquiot, his first French buyer, died. In Berlin the courtly dealer who had published *Mein Leben* and helped Chagall in his first days of exile from Russia, Paul Cassirer, calmly entered his solicitor's office, signed divorce papers from his

second wife Tilla, bowed politely, and asked to be excused for a moment. He walked into an adjacent room and shot himself dead. In Berlin, too, after a long-drawn-out correspondence with the lawyers, the Walden affair was finally resolved; Herwarth Walden had also separated from his second wife, Nell, and she consented to hand over several paintings of Chagall's choice in the final settlement of the case.

In surrealist France these pre-1914 Paris pictures with their wild colour and cubist flavour were far more to contemporary taste than were the Russian wartime works; they had rarity value, too. Thus, as soon as it was in his possession, Chagall immediately sold *Half Past Three (The Poet)*—the 1912 portrait of Mazin with his green head upside down—to Christian Zervos, who had just begun publishing his influential *Cahiers d'art;* later the painting went, with Marcel Duchamp as intermediary, to modernist collector Walter Arensberg in Los Angeles. At the same time Chagall sold *I and the Village* (also retrieved from Nell) and another picture to Brussels perfume magnate René Gaffé, the Belgian champion of surrealism and founder of *L'Echo belge;* he sold *I and the Village* in 1945 to the Museum of Modern Art in New York. Bella, signing herself as Chagall (all the business letters are in her handwriting), now imperiously demanded payment from Gaffé and other collectors in dollars: "malheureusement le franc laisse terriblement et comme je vous ai déjà écrit, je ne peut perdre ces deux tableaux qu'au prix convenu aux dollars." ("Unfortunately the franc is very weak and as I have already written to you, I can't part with these two pictures except for the price agreed in dollars.")

Chagall's stock was rising. There were exhibitions at the Katya Granoff Gallery in Paris, and a first solo show in America, at the Reinhardt Gallery on New York's Fifth Avenue. Letters from collectors across Europe wishing to acquire a Chagall now flooded in; Bella answered them all. Meanwhile, Chagall contributed etchings for Marcel Arland's novel *Maternité,* engravings for *The Seven Deadly Sins* (a volume by seven authors), and drawings for Gustav Coquiot's *Suite provinciale.* Chagall noted in 1926 that his paintings now disappeared as soon as his signature dried. By the end of that year he had a contract with the fashionable Bernheim-Jeune Gallery, whose stable included Cézanne, Renoir, Monet, and Matisse; the gallery had just moved to prestigious premises, inaugurated by French president Gaston Doumergue, on the avenue Matignon at the corner of rue du Faubourg St. Honoré. The contract gave thirty-nine-year-old Chagall financial security for the first time in his life. He could look forward in his forties to a lifestyle

that would have been unthinkable when he and Bella were hungry and cold in Moscow five years before. Yet he never wholly relaxed. When Bella once asked him "how much money he needed to feel totally secure . . . he replied, 'I shall *never* have enough money. I shall *never* feel secure.' " "Neither success nor glory banished his feeling of insecurity," Claire Goll remembered during these years. "He liked to play the part of a clown . . . It was only about money that he didn't jest . . . Money was always his problem." Boris Aronson remembered Chagall as so suspicious that, asked on occasions in cafés for the napkins on which he had doodled, he would deliberately tear them to pieces.

Nevertheless the burst into colour for *Fables* after the black and white of *Dead Souls* was expressive of the joy, exploration of nature, and stability in his life. Chagall's gouaches for *Fables* are a fantasy of lively hues and lustrous surfaces. Soft colours flood the forms in a harmony of fabulist dream and fidelity to nature: the azure, sapphire, and turquoise of sea or stream, and the terra cotta and ochre of the earth, combine with a pink-and-white-dappled wolf, a multicoloured arabesque of an elephant, and a cat-woman with a feline face and fishnet stockings. Brushstrokes are varied, fluent, thrusting, dabbing, springy, and splashing, suggesting the slippery texture of a fish, the bristling fur of a bear, the waves in the river, the rays of the moon. As in the Gogol, Chagall finds a different pictorial solution for each fable, animal, and setting, uniting all in a pastoral vision that sometimes recalls Russia–the hapless, absurd priest, the horse and cart in the silver-grey rural emptiness of "Le Curé et le mort"–but is mostly a celebration of France's verdant landscape through the seasons: the late summer sun reflected through foliage beneath the stone bridge in "The Sun and the Frogs," the twilit mountain dotted with shrubs encircling "The Mouse Metamorphosed into a Girl." The lifelong pleasure Chagall took in depicting near-anthropomorphic beasts, going back to Hasidic ideals of the oneness of animal and human life, came into its own here; working on *Fables,* Chagall wondered whether animals howled because they knew they were dumb and envied human beings the power of speech; this idea suggests an identification connected with his stuttering and sense of being misunderstood.

What brings modernist Chagall so close to seventeenth-century La Fontaine, shrinking the gap between the centuries, is that he fixes on the lively evocation of folly, vanity, and animal resourcefulness that courses through the text. Enlightenment and nineteenth-century readings had

Chagall, "The Cat," etching from La Fontaine's *Fables*

played up the moral element; Chagall, bringing to the project his own ambivalent relationship to social order, saw at once the irony and ambiguity of La Fontaine's apparent moralizing and ignored it. "It is Madame Chagall who reads the fables aloud in a high voice while he is at work, but Chagall always stops her at the moralising: 'That, that's not for me,' he says," noted Pierre Courthion, who watched the artist at work. The result is a French colour sequel to the *comédie humaine* of *Dead Souls*. The human characters, like those in Chagall's Gogol, are forces of nature, energetic in their canny self-promotion: the fortune teller, the young widow, the "fool who sold truth." Again this is a survivor's witty story of survival, but the sharp lines, appropriate to Gogol's asperity, are replaced by subtler, looser textures reflecting La Fontaine's sentiment and sympathy. The whole is infused with a joie de vivre and delight in nature—the work of an artist who has moved beyond the first tentative steps in the new country and is enjoying life, the world around him, and his own powers of invention.

Chagall worked on the gouaches, which he intended as draft illustrations to be made into colour engravings, intensely between 1926 and 1927, as the family began a voyage of discovery across central and southern France. They started in the spring of 1926 at Mourillon, then a small fishing village near Toulon, where they visited Georges and Marguerite Duthuit-Matisse, the artist's daughter and her husband. This was their first encounter with the Mediterranean, and like countless painters before him, Chagall was thrilled with the brightness of the sea and the luxuriant vegetation. Toulon, a naval port, was in the 1920s a centre for opium, brought back by colonial officers and sold openly in purple tins at the same time as a policeman in white armed with a pistol patrolled the beach, making sure no one undressed too far. All around lay the Provençal landscape of hills, olives, and vines. As usual, Chagall did not at first paint the unfamiliar scene directly but began a series of flower paintings, based on the lavish bouquets Bella brought home each day from the market. The dense, pure colours of the flowers—arum lilies, peonies, lilac—saturated in a light that reflects the brightness of the distance, formed his link to the new landscape. These are not traditional still lifes: rather, the flowers are like portraits, enlarged out of all proportion. In *Flowers on a Chair* the flowers are seated, as if they are human; they writhe and sway, as if reaching towards the small figure of the waiting Bella; their rich colour and texture, with heavily impastoed paint, contrasts with the watercolourlike transparency of the thinly painted sea and sky. In *Flowers in Mourillon* a bouquet of purple and red blossoms set within

Chagall, "The Fox and the Stork," etching from La Fontaine's *Fables*

dense foliage bursts out from a vase to dominate a bleached-out marine scene; large portions of the white ground are untouched, as in Cézanne's watercolours. The work may have been a tribute to Cézanne, who was an inescapable presence in this part of France.

Two paintings called *Bella in Mourillon* show a seated, absorbed figure beside a bouquet. In one Bella is on a terrace overlooking the distant village, with flowers towering over the landscape like a church; in the other she is cropped at the edge of the picture, engrossed in a book and enfolded in dusky blue-white light, the meditative tone suggesting her quiet presence. In a vase pale flowers in violet, purple, pink, and white gather the light energy of the blue ground; the picture is a portrait of contented intimacy and suggests the security and tranquillity Chagall took from Bella, as well as her own interiority of being—there are shades of the silent child devouring books in the window seat, as she described herself in the Vitebsk apartment. "Without her inspiration I wouldn't do any painting," Chagall said in 1927. In the erotic *Lovers under Lilies,* first exhibited as *The Kiss* in 1927, Chagall, clothed in black, is embracing a nude, full-breasted Bella, and their fused bodies form a vase for the large bouquet of lilies and peonies that fill the canvas. The different applications of paint give this beautiful work its interest: the lovers have the smooth surface of porcelain, while the rose and white flowers are encrusted with thick impasto, vivid against a tissue of other images evoking memory or dream. Such a work, with its illogicality and incongruity, made Chagall attractive to the surrealists—yet as glittering painterly webs of colour, his 1920s paintings are fundamentally different from their psychological game-playing.

The "flower period" of the 1920s is not Chagall's most profound. His art had reached greatness through a confrontation with a dominant style, or Zeitgeist, that he felt impelled to resist; by contrast, in 1920s France every instinct for human survival told him rather to give in, become French. Nor was there a trend as overwhelming as cubism in prewar Paris, or suprematism in revolutionary Russia, against which he needed to pit himself. Acceptance and acclaim, too, softened his art, which at this time has none of the iconic quality of his earlier work. But the flower period is nonetheless one of his most popular, and his lightness of touch corresponds to the mood of relief and diversion, as well as the search for order, during this postwar decade in France, when the Côte d'Azur came into its own as an artistic playground. The Train Bleu, launched in December 1922 to link Paris and the Mediterranean, outdid the Orient Express as the world's sexiest train,

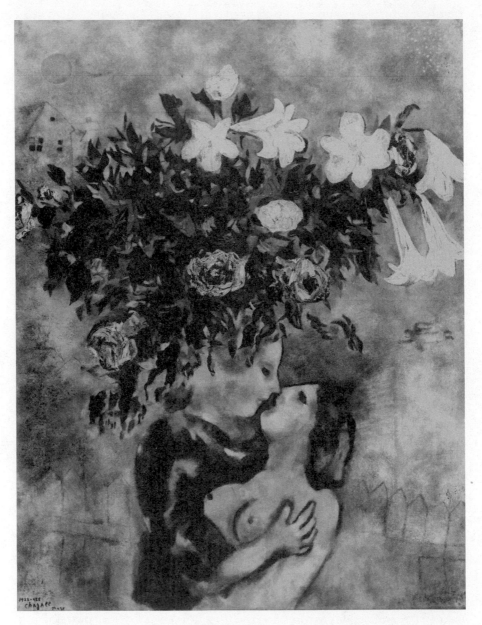

Chagall, *Lovers under Lilies,* 1922–25, oil on canvas

inspiring in 1924 a Diaghilev ballet with a Cocteau story, music by Milhaud, costumes by Chanel, and a curtain, *Woman Running on the Beach,* by Picasso. "Do you remember the light we had through the shutters? It came from below as if from theatre footlights," wrote Matisse. "Everything was fake, absurd, amazing, delicious." The great painters of the École de Paris at this time modified their prewar styles towards the decorative and more lighthearted—Matisse's odalisques, Picasso's classical portraits of his wife Olga, and their son Paul as a harlequin. Each of the others had to negotiate an art of peace, far from the revolutions of prewar Paris, and Chagall, working out his own path from Russia back to France, watched closely how they succeeded or failed. There was a general return to realism, varying from Léger's evolution of his tubist forms into proletarian, insentient Olympian figures, to the sinking of Derain, once the wildest Fauve, into a regressive naturalism from which he never recovered. Derain "now devoted himself entirely to the closed art of the museum," lamented Chagall. ". . . when you see it, you are filled with both laughter and sadness, that such an adult painter, wise and rich in devices, would refuse to understand that, no matter how beautiful and pleasant the miracle that borders on imitation of the old masters—it leads him to be an epigone." Some, such as Raoul Dufy, settled into a serene, lyrical style rooted in motifs of bathers and seashores; others, like Delaunay, burnt themselves out in repetition of old themes. "I don't know about him in the future," Chagall wrote soon after his friend finished his *Sprinters* series, "but at the moment he gives such a boring impression as an artist, unbelievable. However, he washes a lot better than I do—he even uses a ladies' tub. It's truly remarkable—everything is more than in order with him."

Chagall told Meyer that the 1920s decade in France was "the happiest time of my life," and the flower paintings celebrate that period. "It is my whole life that is identified with my work, and it seems to me that I am the same even when I am sleeping," he said in 1927 of these dreamy paintings, suffused with a rapturous response to the light and freedom of "la douce France" and with a dialogue with French painters: the strength of Cézanne, the colour and light of late Renoir and late Monet, and the intimism of Bonnard. In 1926, when Chagall discovered the Côte d'Azur, these masters were still living or only recently dead: Renoir had died at Cagnes in 1919, Monet was in the final year of his life. "Once in the Musée d'art moderne [in Paris], when I happened to be hidden by a screen," recalled art historian Werner Haftmann, "I observed how Chagall studied a still life by Bonnard very

attentively for a long time, then went across to a portrait by Vuillard, and afterwards returned to the Bonnard. Having discovered what he was seeking, he left the museum."

In April, May, and June, after the excursion to the Midi, Chagall delivered the first dozen gouaches for *Fables* to Vollard in batches of four or five. But the project really took flight at their next stop, the Auvergne in central France, where during the summer of 1926, Bella took a cure at the thermal baths in the nineteenth-century spa town of Châtelguyon, and then in Limoux near Carcassonne in autumn 1926 and 1927. The unfashionable Auvergne, landscape of volcanic peaks, rocky plateaux, fertile plains, and small villages, was more to the Chagalls' taste than the fashionable Mediterranean, and it became a favourite place in rural France; they returned there for the summer of 1927, when Bella and Ida were convalescing again, this time from an attack of blood poisoning. After the faded *belle époque* style of Châtelguyon, with its casino and grand hotel and formal gardens, the family stayed in a house on the village square in Lac Chambon, and Chagall painted the church and square and surroundings: farmyard scenes, Ida astride a donkey, a horse being shod, a cow being milked. The unspoilt countryside here was as close to Lyozno as anything in France and infused the pastoral idyll of *Fables*. The first Auvergne visit allowed Chagall to complete nineteen gouaches for the series, which he delivered to Vollard in October 1926; some eighty followed through 1927. The cycle was finished in Limoux while Chagall was on a jaunt with Delaunay in his new car, an Overland. "Today I finished *Les F.* The end," he wrote to Bella on 26 October 1927 from the Hôtel Pigeon. "An unusual feeling. I don't know what I've done–is it great or not? All I know is I was honest, sincere, and what else. People will say anything. It's always the way. But I feel better, freer. 'I got rid of it.' Oh I'd love to kiss you and our daughter for that. It's nice nonetheless that I made such works: *Dead Souls* and *Les F.*"

In high spirits he went on to Albi with Delaunay. On notepaper from the Hostellerie du St. Antoine, adorned with prints of visitors dismounting from their convertibles to admire the cathedral, Delaunay sketched a grimacing Chagall. "Delaunay made this drawing of me," he wrote next to it. "I am sitting in the hotel. We have come back . . . with Mr. Long Legs [Delaunay] and are waiting for his car to be fixed. He is comic to the point of absurdity." The car, which Chagall considered ridiculous but of which Delaunay was extremely proud, nearly exploded on the road, and the wheels got so hot that the pair of artists had to pour water on them to cool them off. Chagall

vowed to return to Paris by train; meanwhile, at the hotel, the artists were addressed as "Monsieur et Madame Delaunay" because Chagall wore layers of clothes to keep himself warm in the open car and arrived with one of Bella's hats on, tied with a scarf under his chin. "For some reason," he wrote to Bella, "I'm shaving every morning. We [he and Delaunay] have to share a room, but he's calm and under my control, he's afraid of me, and I tell him off now and again. How are you? Your feelings, your health? Don't be bored. Write with details about yourself. Don't worry about me. I am fine, which means in the best state." He added a postscript for eleven-year-old Ida–"Are you being mischievous? Write to me in Russian and with drawings. Do you draw? What's new? Do you have lots of new activities? Don't do too many things at once and don't ever hesitate to rest–from me. We'll go to the cinema to see the best films, but do go somewhere, see some people. I kiss you." In French, upside down at the bottom of the letter, Delaunay scrawled his own message of reassurance–"Chagall has been very good. He thinks too much of Bella Belllla Belllllla."

Back in Paris, Vollard paid between one thousand and two thousand francs per gouache for *Les Fables*–for Chagall a total of 192,000 francs. The dealer made a profit by selling them on at 4,000 francs each to Bernheim-Jeune, who showed them at an acclaimed exhibition in February 1930, which travelled on to the Flechtheim Gallery in Berlin; every work sold. As with *Dead Souls,* the illustrations never made it to book form in Vollard's lifetime. Technical difficulties in the colour reproduction were insurmountable, the preliminary results were rejected by both Chagall and Vollard, and the project was abandoned in favour of monotone etchings. Between 1928 and 1931 Chagall engraved a hundred copper plates, based on the gouaches; the rich tonal gradations and mysterious transparency reveal their origin as paintings. These, too, waited to be used, and in the end, along with the *Dead Souls* etchings, they were published not by Vollard but by the Greek publisher Tériade after the war. Ida later suggested that, "believing himself immortal," Vollard put everything off: he even had a saying, "Vous verrez, celà sortira plus vite que vous ne le pensez," which became a jokey catchphrase in the Chagall household. To Chagall, Vollard's slowness was a minor irritation compared with the dealer's ability to provide such engaging work, his enthusiasm to kick-start projects, and his financial and moral support. By the late 1920s, every day when Chagall was in Paris, dealer and artist would walk across the Bois de Boulogne to call on each other. The irrepressible Vollard suggested another project: illustrations on the theme of the cir-

cus, a recurring modernist subject since Picasso's harlequins and saltimbanques of the 1900s and the darker clowns of Georges Rouault, another Vollard artist.

Chagall immediately accepted the offer, and at the end of 1927 he produced nineteen gouaches entitled *The Vollard Circus*; the subject also features strongly in his oil paintings from 1927 to the early 1930s. In *The Acrobat* of 1927 a girl rider in red tights springs like a blossom growing

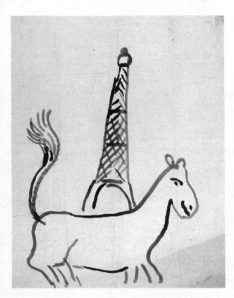

out of a bouquet that rests on her horse's back: the image dramatizes how Chagall's circus cycle grew out of his flower paintings. The girl soars into airy space, musicians play, and a tightrope walker balances on a sparkling blue ground. Like flowers, in their grace and transience, harlequins and acrobats appealed to Chagall as tragicomic emblems, mirroring life's joys and sorrows. Many works from 1927-28—*Acrobat on Horse, Clown on the White Horse, Clown with Bouquet, Clown with Donkey*—fuse the rural and flower motifs of the mid-1920s with the metropolitan milieu of the circus, reflecting the artist's own division between the French countryside and Parisian social life. He was a frequent guest of Vollard at his box at the Cirque d'Hiver. Beyond that, the theme took him back both through the French tradition—from Degas to Watteau, one of Chagall's favourite painters—and to his own Russian work: the acrobats and harlequins in the murals for the Moscow Jewish Theatre of 1920 and, earlier, his 1908 painting of Harlequin and Pierrot, *Fair at the Village*.

Chagall, "Horse at the Eiffel Tower," 1927, drawing

Since childhood, visions of circus people, whom he recalled visiting Vitebsk, had transfixed Chagall: "Why am I so touched by their makeup and grimaces? With them I can move toward new horizons." The only artist with whom he identified, he said in the 1920s, was Charlie Chaplin—whom he saw as a sort of secular equivalent of the holy fool of Hasidism. "Chaplin seeks to do in film what I am trying to do in my paintings," he told Jacques Guenne in 1927. "He is perhaps the only artist today I could get along with without having to say a single word." In Russia Chagall had stressed the tragicomic aspect of his circus and theatre people; now it came to the fore in works such as the sombrely beautiful *Equestrian* in 1931, where against the flaky gri-

saille of a night sky, Chagall in a velvety green jacket embraces the lithe, sensual figure of a bare-breasted girl, a younger version of Bella, wearing a raspberry-pink costume and mounted sidesaddle. The figures, with their still expressions, half rapt, half melancholy, have the porcelain delicacy of those in *Lovers under Lilies;* the embroidery on the dress and the silver-grey saddlecloth are especially finely painted, and in the soft brightness the horse is transformed into a magical creature.

Flickering light, fragility, nostalgia, sprinkled colour: with such circus pictures Chagall found new motifs to express psychological tensions that his art had explored from the start. For him, clowns and acrobats always resembled figures in religious paintings: "perfection is close to death. Watteau, Mozart," he said. He loved the theatrical melancholy underlying the lightness in these two artists—Mozart was his favourite composer, and "for me there is nothing on earth that approaches those two perfections—*The Magic Flute* and the Bible." The evolution of the circus works from the insouciant *Acrobat* to the poignant *Equestrian* reflects a gradual clouding of his worldview, and the circus performer now gave way to the prophet or sage in his work—a figure into whom Chagall poured his anxiety as Europe darkened, and he could no longer rely on the *lumière-liberté* of France for inspiration.

The Prophets

Paris, 1928–1933

I n 1928 the Moscow Jewish Theatre finally gained permission to tour abroad, and the troupe, still headed by Alexander Granovsky and Solomon Mikhoels, visited Berlin and Paris during the summer. When the Russians reached France, the Chagalls spent every evening in the theatre and gave receptions for the actors at their home. Photographs of the Russian actors posing around a gramophone and laden tables in the garden at Boulogne sur Seine emphasise how different the Chagalls–fashionably dressed, with an allure of wealth and confidence–looked from their old friends; the Russian women especially appear comically frumpy in the Paris setting. At the centre of the photograph the figure of Granovsky, the director and the only one of the eighteen-strong troupe to stare at his feet rather than at the camera, bristles with tension: at the end of the tour he defected to the West. At the edge of the photograph charismatic Mikhoels holds the picture as he held audiences. Chagall continued to feel close to the artistic vision of his friend, and the rekindling of their relationship brought home the gulf between his new life and his old.

Chagall's was a temperament always balancing a love of life and a determination to survive with melancholy. His triumph of reinvention in Paris between 1924 and 1928 now gave way to a nostalgic desperation to connect again with Russia and a renewed interest in his Yiddish contacts. The writer Edouard Roditi remembered meeting him at Le Dôme at this time with Ossip Zadkine, the Yiddish novelist Sholem Asch, the Soviet writer Ilya Ehrenburg, and "a number of others who came and went, all through an evening spent around a couple of café tables where one spoke French, Rus-

Marc and Bella Chagall in their garden in Paris, surrounded by visitors from the Moscow Jewish Theatre, 1928. Alexander Granovsky is third from the left, seated next to Bella; Solomon Mikhoels stands, first at the left.

sian, German and Yiddish." There were many reasons why he now sought contacts from home. He had won the fame he had sought in Paris but began to question whether he would ever really be understood there; that was isolating. "The essence of Latin materialism appears to my eyes, the eyes of an Oriental, as most cruel," he told a Jewish audience in 1931. "All of French art . . . is built . . . on a material base. Often it seems to me that it was my destiny to be alone in my dreams." The vein of xenophobia raised by right-wing reactions to Vollard's choice of Chagall as illustrator for *Les Fables* was unnerving; worse, it chimed with stories of mounting anti-Semitism in Germany and in the Soviet Union. That he was unable to visit made the glow of memory more intense, as his sense of being cut off from the sources that nourished him grew. "I hope you saw our small towns, landscapes, Jews. Look for me, too . . . How I envy you," he wrote to Joseph Opatoshu, who was visiting Poland and Russia in the summer of 1928; for the next decade their correspondence became Chagall's vital link with the Yiddish-speaking world. A note received from Pen at this time included a photograph of his old teacher in the yard of the former Shagal family home in Vitebsk, and sug-

Yuri Pen, second from the left in a cap, visiting the courtyard of the house in Vitebsk that had been the Chagall family home: a photograph sent to Chagall in Paris by his old teacher in 1928

gests that Chagall had begged Pen to visit and send him this record of Pokrovskaya.

Nostalgia for Russia was exacerbated by the death of another loyal friend, Tugendhold, the first and most sympathetically penetrating critic of his paintings; in a memoir of Tugendhold penned for a Soviet journal in December 1928, he included a plea to be allowed to revisit. The irony that some of his paintings were at last being shown in Moscow that winter in an exhibition called "Modern French Art" would not have been lost on him. Between 1928 and 1930 he painted numerous memories of Russia–his parents, his grandfather, Vitebsk's huts in *The Man in the Snow,* his parents' grandfather clock, weighed down by a single large wing, walking through snowy Vitebsk in *The Clock in the Street.* In the Savoy Alps the Chagalls discovered a winter landscape that brought echoes of Vitebsk, and the Hôtel Soleil d'Or in Megève now became their favourite winter destination. In January 1928 Chagall stayed on alone to complete paintings of the church and snowy mountain peaks seen through a window. "I infinitely love this pathway, and imagine that we are walking down it together," he wrote to Bella. "The nights here are blindingly beautiful . . . I couldn't resist going outside. The moon was mindlessly shining above the sleeping blue little town. I strolled wearily back and forth. The sky! If you were here, I would kiss you for the memory of this sky and stars–stars which seemed to be absolutely the same as in my childhood. I kiss you without end."

Bride and Groom with Eiffel Tower, painted in 1928, quotes directly from

the composition of Chagall's 1913 *Paris Through My Window,* whose unknown destination (Walden had sold it) nagged at Chagall until he located it in 1930 in Solomon Guggenheim's collection. The subject of both works is nostalgia. In the prewar work Chagall had depicted himself as two-faced, looking back to Russia and forward to Paris; in the 1928 painting he and Bella shelter on the edge of the canvas, while beneath them the gaiety of Paris—lovers strolling under a parasol, a horse and rider, a pair of acrobats, tiny cars—unfolds as in toytown: it is delicious but remote. Over it all flies an angel in green, with the features of Ida, offering a bouquet to the lovers. In another double portrait of the same year, *Lovers,* Chagall half-hides his face against Bella's shoulder, while she, in the familiar black dress with a lace collar, looks sad and withdrawn. With every painting that Chagall made of her in the 1920s and 1930s, she appears to retreat a little more into herself. But both pictures express, too, the intense family bond that kept them all afloat. "Hold on my dears, one more day and I'll get back to Paris. I've made some paintings here, we shall see what they look like at home. That is the main thing, if they look all right, then I haven't wasted my time," Chagall told Bella and Ida as they waited for him to return from Megève. What was keeping him there was important: "And oh! How I want to finish this series of paintings, so that we could finally go to Palestine, because I think that would refresh my imagination, and me—I might find a new direction."

Chagall, a chameleon who never quite felt he belonged anywhere, was pinprick sensitive to international currents. He recalled that one evening in the 1920s at the Rotonde, he and Bella "overheard Georges Braque saying 'These *métèques* are all coming here to eat our food.' " Below the French colour and playfulness, the 1928 portraits carry an undertow of anxiety, none more so than *Self-portrait with Phylactery,* where Chagall depicts himself, palette in hand, midway between a clown and a praying Jew wearing a Star of David. "Moi, Marc Chagall," he has written at the bottom, but the work is also signed in Hebrew. He was still working on the circus paintings but already he was pondering a new project, illustrations for the Bible, and in 1930 he accepted Vollard's commission for the work. Jewish identity, sublimated during the rush to assimilation of the mid-1920s, now returned. Chagall agreed to Lyesin's request to illustrate his volume of Yiddish poetry, even though the fee of $400 was far below his usual rates, because the book gave him scope to revisit the shtetl world. The drawing "Self-portrait with Adorned Hat" of 1928 shows his hat—suggesting the interior of his mind—weighed down with memories of Vitebsk's houses, violinists, love affairs.

Bella was yet more sensitive to anti-Semitic currents, and her response to

stress was, as usual, to get ill; she had several operations (probably for stomach ulcers) through 1929 and recuperated in the Savoy. "There is not a single Jew here, or even a Russian. So we feel our Jewishness even more, and what else," Chagall told Joseph Opatoshu. "If you were here, we would have chatted about everything, especially Soviet Russia, which I feel in my guts." Key paintings from 1929 are premonitions of political and personal unrest. *Flayed Ox* looks like an animal crucifixion set before a backcloth of Vitebsk. *Candelabra* has a bouquet of flowers dissolving into a seven-branched candelabra with the candles flickering, almost burned out. In the sombre *Russian Village,* a sleigh flies through a leaden sky over Chagall's hometown; the composition recalls the 1914 *Over Vitebsk* and was given to a travel agent in exchange for the fare to Palestine. An invitation from Hermann Struck, who had emigrated to Haifa from Berlin, stoked Chagall's wish to go there. The Bible project was crystallizing in his mind, and for that he believed a visit to Palestine was indispensable, though Vollard reckoned the Place Pigalle would do just as well as a source.

Yet as he looked beyond France for inspiration, he responded to intimations of instability by becoming more eager than ever to establish physical roots in his adopted country. Every trip out of Paris became a reconnaissance mission to find rural land on which to build a house; Céret in the Pyrenees, which had attracted many artists since Picasso's visit in 1912, was a possibility, and Chagall visited twice in 1928–29. Eventually, on Delaunay's advice, the Chagalls bought a piece of land near Mantes in the Seine and Oise countryside that had enchanted them in the early 1920s, but they never built anything on it. The need to fix a Paris base, on the other hand, felt pressing, and in the summer of 1929 they committed themselves to a new house in the Villa Montmorency suburb of Paris at 15, rue des Sycomores, near Porte d'Auteuil in the sixteenth arrondissement. It was large and grand, with a pavilion and extensive woody garden, and needed a lot of work; on 20 July 1929 they signed a contract for 210,900 francs' worth of renovation, and in August they warmly invited Opatoshu and his family to stay.

The timing was disastrous. Before the Chagalls even moved in, while they were visiting Port Vendres, the Wall Street crash of 24–29 October plunged the United States and Europe into recession. Bernheim-Jeune telegraphed immediately to cancel Chagall's contract. The flow of collectors dried up overnight; dealers became cautious or stopped buying altogether. Picasso's dealer Paul Rosenberg cancelled a solo show for his star artist planned for spring 1930 and did not buy another major work from him until 1934. Kahn-

weiler remembered sitting alone in a gallery bereft of visitors; he could no longer afford to employ an office boy. For the Chagalls, financial security evaporated. At the turn of the year 1929-30, when they were still waiting for work on the too-expensive house to be completed, they could look to Vollard's projects alone for a modest, steady income.

Chagall's response was to turn inward, back to memory. The motif of the old Jew, closed to the modern world, absorbed in his own spiritual experience, which Chagall had painted from life in 1914-15, returned in 1930 in *Old Man with Kid, Old Man Reading, Man with Torah in the Snow, On the Roof;* all were preparations for the prophets of the Bible illustrations. The landscapes of 1930, mostly done in Peyra Cava in the maritime Alps, show plunging valleys, wide ridges, and low clouds: *Peyra Cava Landscape with Eagle, The Thistles,* and *The Cloud* are softly modeled but have a heavy, brooding tone that distinguishes them from previous French landscapes.

At the same time, Chagall's need to sell himself became more urgent and was one reason why he and Bella travelled to Berlin in spring 1930 for the opening of the Flechtheim Gallery show of the *Fables* gouaches. Alfred Flechtheim, a flamboyant bisexual Jewish dandy, had made a fortune in the grain business, which he had spent, along with his wife's dowry, on Picassos and Cézannes before the war. He had come close to bankruptcy and suicide but after 1918 had transformed himself into one of Weimar Berlin's most adventurous, far-sighted dealers. How oddly French Chagall's soft, flowing colours, and fantastical images of rural life looked on his walls, in the city of satirical hyperrealism, dominated by the hard-edged Neue Sachlichkeit of Dix, Grosz, and Christian Schad; if anything persuaded Chagall that he had become a French artist, it was this visit to Berlin.

Eight years earlier he had been too shy to visit Liebermann in the German capital; now with Bella he paid a triumphal, symbolic visit–the young Jewish artist, a famous French modernist, paying his respects to the old German Jew, the last survivor of impressionism. At Liebermann's palace on Brandenburg Square, Chagall was nervous and glad for Bella's protection: "she walks simply, not tense like me. She walks ahead of me on the stairs, freely, easily, and I–as if I were slicing through a river." Liebermann appeared while they were waiting in the salon hung with Old Masters overlooking Königsplatz:

> I hear something rumbling in his eighty-year-old belly, but he immerses his gaze in my wife. He looks calmly into her eyes,

observes her hairdo, her features, her clothing from top to bot-
tom, and all the time he is stammering joyfully "Is this really your
wife? Are you both from the same city? How do you call your city—
Vitebsk? You met and got married there?"

I don't know what to do when he gazes at her like this. When
will he look at me too? I cannot just walk away to the side—can I?—
and leave my wife with him. Meanwhile, I observe the rooms. I
wait. Finally, he looks at me, but only to make a comparison
between me and my wife . . .

"So you live all the time in Paris . . . And you personally, do
the French treat you well? You don't suffer there as a Jew? Yes,
well, they will be well rewarded for that."

Chagall tried to talk of French-Jewish Pissarro, whom Liebermann had
known, but the assimilated German only muttered sarcastically about Pis-
sarro's patriarchlike beard and showed off his collection of Rembrandt
engravings. The Chagalls left sadly; as the model of a successfully assimi-
lated Jew, Liebermann, president of the Berlin Academy, filled them with
horror. Three years later Liebermann would be stripped of his office; of the
Nazi parades through the Brandenberg Gate beneath his window, he said in
his dense Berlin accent, "Ick kann ja nich so ville fressen, wie ick kotzen
möchte" ("It makes me want to throw up more than I can possibly eat"). He
died in 1935, and non-Jews were banned from attending his memorial exhi-
bition. Frau Liebermann, in her eighties, committed suicide hours before
police came to deport her to Theresienstadt in 1943. "He made a mistake,"
Chagall concluded, "rare for a Jew but natural for a German: he went to
study art not in Paris but in Holland. Hence, both Paris and Art took
vengeance on him. Liebermann's art assumed the specifically Dutch gray-
ness of Israels and did not place him on the same level as the French Impres-
sionists."

He was relieved to go back—home—to Paris, where the highlight of the
spring was the visit, in June 1930, of the Meyerhold Theatre; the Chagalls
spent evening after evening watching the Russians. At one performance
Hilla Rebay, friend and adviser to Solomon Guggenheim, noticed "a man
sitting off to one side. His glowing, changeable, devout and ecstatic face so
fascinated me that I no longer looked at anything else, and I suddenly real-
ized that he *had to be* Chagall." She demanded an introduction from Orthon
Freisz, who was sitting behind her, and then invited the Chagalls to meet

Guggenheim at a dinner at the Cochon au Lait. Hilla was captivated by the pathos of Chagall: "really such a dear fellow, and still poor. There is something special and beautiful about his art, and nobody else has it."

In their midforties the Chagalls were still a dashing, charismatic couple. Visitors to Villa Montmorency such as the Spanish poet Rafael Alberti, who arrived one afternoon in 1931 with French writer Jules Supervielle, remembered being charmed by their Russian-French accents, the tea drawn from a samovar in the garden, Chagall's clowning as he put on a false moustache, and improvised skits on the lawn, complemented by Bella's quiet seriousness and eccentrically old-fashioned swathe of silks and shawls, which reminded Alberti of Goya. The Chagalls at this period were sociable and outgoing and acquired an increasingly large group of friends; a new set in 1930 was the circle around the Catholic philosophers Jacques and Raissa Maritain. Like the Delaunays, the Maritains were a French-Russian-Jewish couple who reflected the Chagalls' own split identity; Raissa, born Raissa Oumansoff in the Crimea, was a Jewish convert to Catholicism whose family had emigrated to Paris, partly to give Raissa a better education, and the girl had ended up, aged seventeen, a philosophy student at the Sorbonne. Here she met Jacques, a lapsed Protestant, and the pair strolled hand in hand through a Paris park vowing to kill themselves within a year if they did not find a reason for living. That reason soon emerged–Catholicism. After the war the Maritains made their home, in the southwestern suburb of Meudon, a centre of spiritual enlightenment for Paris's disillusioned writers and artists such as Rouault and Max Jacob. Thanks to them, many converted or rediscovered their Catholic origins, most noisily Jean Cocteau, who claimed that Maritain weaned him off opium with communion wafers. Another intellectual convert was the Chagalls' Jewish poet friend René Schwob, who in 1928 introduced them to the Maritains; a warm friendship flourished from 1929, and the Chagalls were regular attendants at the weekly Sunday gathering in Meudon, where the agenda was how to return secular France to spiritual awareness and, increasingly, how to combat French anti-Semitism.

Half the Maritain set were louche, promiscuous high-livers who believed themselves damned and looked to Jacques and Raissa, models of restraint and tolerance, for salvation. This volatile group of Jazz Age Catholics, treading a shaky path between left and right and variously accused of being Marxists, reactionaries, and drug-addicted homosexuals ("By what disgrace . . . is . . . the Catholic intelligentsia so reduced" as to seek its flock

among "Cocteau and his little fairies from Le Boeuf sur le Toit," lamented the Catholic novelist Georges Bernanos), was a surprisingly comforting place for the Chagalls in 1930s Paris. The Maritains' Christian earnestness—Chagall, handed the telephone with Raissa on the line as he emerged from his bath, refused to take the call until he was dressed, because "I can't speak to Raissa in underpants"—was a small price to pay for their intelligence, commitment, and high culture. Raissa, who had fond memories of her Hasidic grandfather, was a Russian-Jewish mystic transplanted to the France of the philosophes; her morbidity and spiritual exaltation brought her close to Bella. Jacques, who interpreted Rouault's and Cocteau's harlequins and prostitutes as embodiments of Christian redemption, took a fervent interest in Chagall's work, especially the Bible illustrations. While the French were still arguing about his formal qualities, this circle saw Chagall as a Jewish religious artist. In 1931 Schwob published *Chagall et l'âme juif,* suggesting that his paintings sprang from "the incessant agitation of the Jewish soul." Raissa, in her book *Chagall ou l'orage enchanté,* described him in yet more colourful terms as a modernist prophet. Maritain himself was also a gifted critic and brought an intellectual perspective as well as an instinctive sympathy, unusual in a Frenchman; in the Mellon lectures given after the war, he called Chagall "the greatest master of the 'illuminating image.' "

Expressing a Jewish identity, and a spirituality that stood out against French secular currents, became important for Chagall in a hostile climate. He urgently turned his attention to publishing his memoirs in French, proclaiming his heritage. Salmon was amiably ditched as translator. " 'Salmon, it is cruel, you hide Chagall's naivity,' said Bella. The worst was, Bella was right," he recorded. Bella, assisted by Ida's French tutor and the writer Jean Paulhan, did the job herself. The result was *Ma Vie,* which appeared in 1931: a sparkling, lively, darting expressionist text that leaps between images and periods and merges painterly idiom with Bella's lyrical prose. For her, as she pored over each Russian sentence, rewriting and redrafting, the translation was a substitute for the creative work that she had stifled. Excising anything too blunt or risqué, such as Chagall's dalliance with the chambermaid in La Ruche, and never failing to consider the Chagall public image, she imprinted her own refined tones upon it. Her granddaughter called it "Marc's world through Bella's glasses."

With every year that passed, Bella's role in keeping Russia alive for Chagall became more important. "She was my Muse. The embodiment of Jewish

art, beauty and love. If not for her, my pictures would not be as they are," he told Yiddish writer Abraham Sutzkever. To Opatoshu in the autumn of 1930 he said he would like to mingle with the authentic Jewish characters of his stories. Opatoshu continued to travel freely between the United States and Russia. "You are going to Russia," Chagall wrote in early 1931. "I want to ask you to hide me in your pocket . . . and drop me off in Vitebsk . . . I love Russia. No matter what happens and no matter what you say, the blood is boiling over there." He was gratified to have been invited to Palestine, he said, but Vitebsk would have been better.

Nonetheless it was with excitement that he, Bella, and fifteen-year-old Ida boarded the P&O liner SS *Champollion* in Marseilles, bound for Beirut, in February 1931. Among the nine hundred other passengers were the Jewish writers Edmond Fleg (a French Zionist) and Chaim Bialik, who had left Odessa in 1921 for Palestine and was now a cultural leader in the new Jewish city of Tel Aviv. In French and Yiddish, they talked about the future of the Jews all voyage long. "I gazed all around, observed the sky, sought the features of the Land of Israel," recalled Chagall.

> On deck, with a tense face, Bialik strolled back and forth. He didn't seem to see anyone around him, he seemed to be alone on the ship. In a grey, wide long suit, a bicycle cap on his head, he gestured with both hands–spread them wide, or clenched them in a fist. Later he argued, tried to convince the travellers. Because of Bialik, the whole voyage became Jewish. I asked "Isn't it a Jewish ship?" And he answered: "We have no Jewish ships yet!" The whole sea seemed covered with Jewish letters, a Jewish Prophet was walking on the deck of a ship, speaking Yiddish aloud, hurling thunder and lightning at the Jewish fate. His face was seared, his grey and blue eyes sparkled and swirled on the background of the blue sea.

Writer and artist visited Alexandria, Cairo, and the Pyramids together, then from Beirut the Chagalls travelled by train to Haifa to visit Hermann Struck, and on to Jerusalem and Tel Aviv, where Chagall was the guest of the city's mayor, Meir Dizengoff, another Russian exile and one of the pioneers of modern Israel. Dizengoff had been a founder of Tel Aviv, constructed in the Jewish quarter of Palestine just north of Jaffa in 1909. He invited Chagall for Purim and to lay the stone of an art museum that he hoped would bring

Chagall in Palestine, 1931

cultural solidity to the new city–he knew it was a coup to get so internation-
ally renowned an artist. Lacking an army, he wheeled out the local fire
brigade to meet the Chagalls at the station, and organized in their honour
horse races on the beach (which Chagall enjoyed), and an exhibition of local
artists (which he did not). The reticence of the refined European Jew
towards the culturally raw new nation was embodied in his relationship with
Dizengoff, whose zest and activity he admired but whose artistic simplicity
maddened him. Dizengoff wanted to fill his museum with replicas of Renais-
sance figures of Moses and David and gifts from Jewish artists of any stan-
dard anywhere; Chagall dreamt of a Jewish artistic heritage that would rival
the best in Europe. He withdrew from involvement with the museum and
could not help noticing that culture was not flourishing here as the utopians
had imagined. Bialik, the host to whom he felt closest, had barely written a
line since leaving Russia.

On the roof of his house, where all Tel Aviv can be seen, with all
the Jewish courtyards,–I asked him; "Why don't you write any-

more? For you must be happy now. Eretz-Israel is not a ghetto. And here you are the first Jewish poet. Jewish earth glimmers around you like gold. Suntanned boys and girls are looking at you. Bearded Jews walk by your house and wait for your word, your gaze. The aroma of orange groves . . . reminds you of your first love. You just have to wonder on the sea shore, as Pushkin used to do on the banks of the Neva, and strophes will begin to stream in your mind. Why don't you write?"

. . . He was silent. A sad thought crept into my mind: the Jewish people don't yet understand pure poetry, real art . . . When we parted from Eretz-Israel, Bialik sadly told my daughter: "Pray to God, that I write."

But he did not: he died silent in Vienna three years later, another Russian artist unable to work outside Russia. Chagall, while he rejoiced at the freedom of Tel Aviv's Jews, noticing how assertively, calmly, confidently they behaved, never lost an ambivalence to Palestine and later to Israel when it came to exhibiting his own work there. Over the next few years he met pleas from Jewish leaders in Palestine for a Chagall exhibition with polite excuses: he knew there would be no buyers.

He had gone, of course, not to sell paintings but out of inner necessity. Unusually he painted outdoors in Tel Aviv, Jerusalem, and the holy hillside city of Safed in northeastern Galilee, as he sought to get the measure of the unknown landscape. But *Jerusalem, Rachel's Tomb, The Wailing Wall, Synagogue at Safed,* and other records, though suffused with a new light brighter than anything so far in his work, share the clarity, sombre precision, and melancholy undertones of the Vitebsk documents of 1914–15. Both times Chagall was coming to terms with long-dreamed-of or missed landscapes, and he was insistent on the comparison: Edmond Fleg recalled that as he painted, he pointed with his brush to the cactus, towers, and cupolas of Jerusalem and cried out that there was no longer a Vitebsk.

Chagall told Jacques Lassaigne that Palestine gave him "the most vivid impression he had ever received," but he was keen to play down the exotic, spicy element, explaining that whereas Delacroix and Matisse had found inspiration in the exoticism of North Africa, he as a Jew in Palestine had a different perspective. What he was really searching for there was not external stimulus but an inner authorization, from the land of his ancestors, to plunge into his work on the Bible illustrations. "In the East I found the Bible

and part of my own being," he said; for the next three years, as the threat of war and anti-Semitic violence grew across Europe, he turned away from the contemporary world and immersed himself in the history of the Jews, their trials, prophecies, and disasters. It was an extraordinary risk for a twentieth-century artist to take—on the one hand pitting himself against the greatest artists in the Western canon, a tradition bound up with Christian iconography until Rembrandt's time; on the other receding from modernist themes into an ancient past at just the moment when he had made his name as a leading contemporary painter.

"I did not see the Bible, I dreamed it," he told Franz Meyer. "Ever since early childhood, I have been captivated by the Bible. It has always seemed to me and still seems today the greatest source of poetry of all time." One reason for going to Palestine was to give crystalline reality to memory and inward perception. Although he had not been an observant Jew for thirty years, his Hasidic sense of the Bible stories as existing concurrently with everyday life—the place at the Passover table set for Elijah, for example, who might enter any moment "in the guise of a sickly old man, a stooped beggar with a sack on his back and a cane in his hand," as in his recent pictures—brought a unique sense of involvement and vividness to historical motifs. Chagall saw the Old Testament as a human story—he began, significantly, not with the creation of the cosmos but with the creation of man, and his figures of angels are rhymed or combined with human ones; thus the bearded angel in human dress on the first sheet has the hand of Adam; thus, in "Abraham and the Three Angels," the winged visitors with their animated, interested expressions sit and chat over a glass of wine as if they have just dropped by for dinner.

Chagall rarely used artistic models. He made occasional references to Rembrandt—in *Moses Breaking the Tablets of the Law,* the construction and airy forcefulness recalls the 1659 *Moses with the Tablets of the Law* in Berlin—and one to Rublev's *Icon of Three Angels.* But mostly independent of historical iconography, he brought immediacy, surprise, novelty, and an unyielding emphasis on human types, the spectrum of emotions and reactions at heightened moments as the universal narrative from Genesis to the prophets unravels. The tragic figure of Abraham huddles in solitary agony mourning Sarah, or cowers, knife in hand, as he is about to sacrifice Isaac and an angel swoops down like a nose-diving plane, breaking up the blackness of a Godless night. We see Jacob's lyrical meeting with Rachel, then his bowed figure, transformed by news of Joseph's death into an emblem of

Chagall, "Abraham and the Three Angels," etching from
The Bible

grief; Moses starting at the voice of the Lord from the burning bush; Joshua
humbled and amazed as Moses rises from waves of light to bless him; Miriam
dancing with the ecstatic fervour of the Hasidim; and Jeremiah lamenting in
the cistern. Each carries the weight of an archetype yet is individualized and
developed. Thus David–Chagall's favourite Old Testament character–
appears first as anointed boy, then as killer of Goliath; he plays his harp to
Saul, lusts after Bathsheba, and mourns his son. As a poet inspired by God,
he changes each time according to different periods of the story. Every-
where the drama is intensified by a sense of the intimacy of human and
divine, merging as fantasy and reality blend in Chagall's secular work.
Clouds, rocks, mountains, and foliage tremble and metamorphose into
faces, eyes, and wings, uniting man and the natural world. "For the Jewish
people alone these stories are the history of their ancestors and the living
reality from which, whether the individual realises it or not, his own history
stems," wrote the critic Erich Neumann of Chagall's Bible etchings. They

are suffused not only by Chagall's familiarity with these characters but by his sense of belonging to a history that is continually unfolding as he looks to the spiritual fathers of the Jewish people for illumination in the dark 1930s.

As with *Les Fables,* Chagall made gouaches as a starting point, then worked untiringly on etchings. Many involved up to twelve states, as he made extensive alterations, and their detail and liveliness went far beyond the attempt, as in *Les Fables,* to render the painterly quality of the gouaches in black and white. "Made by a painter who delights in colour and brush strokes," wrote Meyer Shapiro, the Lithuanian-born American art historian and friend–they shared a shtetl background–who knew and understood Chagall well, "they nevertheless show a delicacy of line and other intimate qualities that are possible only with etching."

Chagall, "Abraham Mourning Sarah," etching from *The Bible*

Chagall's cutting is so much ornamentation, lovingly conceived. In its minuteness, it reveals the artist himself. His etching needle weaves an infinitely fine network of dots, hatchings, lines and black flicks; it is a glistening veil, soft and closely woven, created with joy, filled with light and movement, often gay, occasionally serious, always fascinating, because of its shadings, its grain, its texture. It is characterized by the freedom of line in the hatching, a freedom that, since Rembrandt, has made etching a modern art.

Between 1931 and 1934 Chagall worked obsessively on *The Bible*—every trip away from Paris was connected with the work. In 1932 he went to Amsterdam to make a close study of Rembrandt's biblical paintings, and he visited Rembrandt's house in the middle of the city's Jewish quarter, where merchants were selling fish and chickens, as in Rembrandt's pictures. He imagined Rembrandt leaving his house for a few moments to secure the first Jew who came along as a model for his biblical kings and prophets. An exhibition of Chagall's own work was opened by the mayor of Amsterdam and included circus and flower pictures, *The Birthday, Bella with a Carnation* of 1925, and the 1917 *Bella with White Collar.* The exhibition was popular, there were lectures and celebrations; Chagall half-joked to Opatoshu that he feared it would all end in a pogrom.

He was still engrossed in the work the following spring, when Hitler came to power in Berlin. Anti-Semitic laws were introduced, and the first concentration camp, at Dachau, opened. His painting *The Rabbi,* at a museum in Mannheim, was one of the first to be held up as an example of degenerate Jewish art, paraded mockingly around the city in a wagon in June 1933. A year earlier Max Beckmann had begun the massive allegorical triptych *The Departure,* which now looked like a premonition of the emptying-out of the intellectual class from Germany. Beckmann was dismissed from his teaching post in Frankfurt in 1933. Bertolt Brecht and Heinrich Mann were among the first German writers to flee. Arnold Schoenberg moved to Paris and formally rejoined the Jewish faith; Kandinsky also left Germany immediately for Paris. "Europe is possible only without the Third Reich. Germany should be quarantined," wrote the Austrian novelist Joseph Roth, who was in Berlin when Hitler came to power, and also moved at once to Paris. Fifty thousand Jews left Germany in 1933, thirty thousand in 1934. Like many other left-wing Germans, Chagall's old adversary Herwarth Walden,

who had closed the Sturm Gallery in 1932, chose to go east rather than west–
he moved to Moscow and got a job as a teacher but soon became disillu-
sioned with Communism; he was killed on Stalin's orders in a prison camp
in Saratov in 1941.

Chagall, absorbed in the Bible, looked up from his work long enough only
to organise a retrospective of 170 works at the Kunsthalle in Basel in
Switzerland, symbolically on the German border, at the end of 1933. The
exhibition celebrated twenty-five years of his work, 1908–33, in some ten
galleries, and was well received, but very few people were buying paintings.
In January 1934, when he had completed forty Bible etchings, he received a
hard financial blow: the effects of the Depression forced Vollard to suspend
the commission.

The following month he was unsettled further by the right-wing riots in
Paris in the wake of the Stavisky affair–the suicide (or possibly police mur-
der) of the Russian-Jewish swindler Serge Alexandre Stavisky, who had con-
nections in financial and political circles. "The atmosphere was one of
complete anarchy," wrote Alexander Werth, reporter for the *Manchester
Guardian,* describing how on 6 February crowds gathered around a Place de
la Concorde "black with people" to pelt police guards with stones and
asphalt from the smashed-up pavement by the Tuileries, setting vehicles on
fire, slashing horses with razor blades attached to walking sticks. The riots
gave hope to the fascist parties in France, bringing the right-wing groups
Action Française and Mouvement Franciste to prominence. Many feared
that the Third Republic would be overthrown. Although it survived, the left-
ist prime minister Édouard Daladier was replaced by the conservative Gas-
ton Doumergue, and in a climate where foreigners were mocked as *métèques*
and there was endless talk of "the Jewish conspiracy," the Chagalls felt less
and less at ease.

Chagall kept his head down, continuing to work on the Bible etchings
even without Vollard's support. He travelled to Spain in 1934 to seek a dia-
logue with another great spiritual Old Master, El Greco, whom he called
"greater than the whole of Spain." Money was now tight: a letter from their
lawyer Fettweis requesting payment in 1934 reminded the Chagalls that
"the extreme modesty of my demands . . . shows you that I am not indiffer-
ent to your situation" and that he had not been paid for four years "because
of the difficult situation in which you find yourselves." A list of prices for
major works, drawn up by Bella for the Amsterdam exhibition in 1932,
ranges from 20,000 to 25,000 francs for the recent circus and flower pieces

to 45,000 francs each for the two most cherished paintings, *Bella with a Carnation* and *Bella with White Collar;* these last were not for sale, and the values may have been kept artificially low to keep insurance costs down, but the sums are indicative, and hardly princely. Chagall, aided by Bella, had always been a tight negotiator; now he bargained unashamedly. Agreeing to further illustrations for Lyesin's book in 1934, for example, he wrote:

> I love to crawl with my brush inside a warm Jewish soul. But now comes a small problem. It is a side issue but, unfortunately, important. The dollar has fallen almost in half. And life here is very expensive.
>
> I propose to make carefully conceived illustrations, with the best imaginative powers of my heart and my craft . . . I ask $100 for every illustration . . . I hear that every young Jewish artist in America gets much more. I don't have their chutzpah and I don't want it, but unfortunately, I make a living from art and to tell the truth, I am ashamed to diminish myself in comparison with the others. I believe you recognize that I am asking the minimum.

To Hilla Rebay the following year he wrote, "I have a great deal of moral success, but no one buys anything. It is quite discouraging." He begged her without success to persuade Guggenheim to consider taking up the Bible project that Vollard had had to suspend.

Without a publisher, he made slower progress on the etchings; by 1939 he had finished sixty-six plates and begun a further thirty-nine, which he took up again in 1952. The first forty works, for which Vollard had paid, sat in his storage room along with the Gogol and the *Fables* etchings. The Bible continued to be a direct source of motifs and inspiration for Chagall for the rest of his life, but the special evolution of the work begun in 1931 makes it fraught with historical meaning. At the start of the cycle, the figures are smaller and calmer and the tonality warm and rich; the prophets at the end are larger and more agitated, the compositions are more dynamic, and the tones are smoky-black. The reaction to Jewish persecution and impending war underlines the evolution, and the sense of the historical moment coexisting with the ancient text gives the work a special spiritual resonance.

The Bible work also had an effect on Chagall's oil painting in the 1930s. Through the humbler art of illustration, as an artist of the book excavating its timeless human themes, and also resulting from his close study of Rem-

brandt and El Greco, Chagall built up to a new monumentality, an enlarged
scope, dramatization, and stark simplicity that made his work from 1933
until the outbreak of war his most significant since the Russian theatre
murals of 1920. Then he had fled Malevich and the Soviet threat to make an
eloquent defence of his own modernist Jewish vision. Now, under threat
again, he did the same, but with a greater solemnity, maturity, and sense of
tragic grandeur, and a more solid and ambitious sense of his own position in
the Western canon. Once again his art reached greatness as he developed it
in answer to a powerful–lethal–adversary. He began or resumed several
complex allegorical compositions–*Time Is a River Without Banks, The
Falling Angel*–at this time, but the new style was most immediately evident
in the twin masterpieces, one sacred, one profane, which he painted in
direct response to the Nazi seizure of power in 1933: *Solitude* and *Nude over
Vitebsk.*

Both depict enormous solitary figures who appear like cutouts on the
canvas, dominating a view of Vitebsk. In *Solitude,* under a thunderous sky

Chagall, study for *Solitude,* 1933, drawing

an old Jew sits cloaked in a white prayer shawl that hangs over his shapeless body like a sack; he cups his face–gloomy, resigned, stoical–in one hand and with the other clutches the Torah, his only possession in exile. He is a descendant of the old men of the 1914-15 series but also of Abraham and the patriarchs in the Bible cycle: the Wandering Jew weighed down with suffering but also spiritually eloquent, embedded in the landscape, eternal. The painting has the stillness of the early Bible etchings and a monumental seriousness unmatched in the work of any French artist of the time. In a decade dominated by surrealism in the West and socialist realism in Russia, it was rare for an artist in the 1930s to dare to face the gravitas of the historical moment. Chagall and Picasso in France, Max Beckmann in Germany, Paul Klee in Switzerland, and Chagall's old rival Malevich in Russia, with his faceless peasants, were among the few whose work reflected the tragedies then engulfing Europe.

In this context, *Nude over Vitebsk* is a particularly brilliant work, reverberating with the times, exteriorizing Chagall's inward-looking response to them, and absorbing and personalising current trends in French art. The sensuous naked back of a sleeping woman with a thick auburn ponytail–seventeen-year-old Ida, who modelled for this picture in the garden at Villa Montmorency–floats in a silver-grey sky over a Vitebsk townscape drained of all colour. In the corner a bouquet of bloodred roses, their brightness sharpened by the grey hues around them, stands in a vase; they are painted to the same scale as Vitebsk's stone houses and cathedral. The polished style and classical drawing reflect Chagall's refined understanding of the tradition of nude painting viewed from the back; the incongruity and illogicality of the composition brings the painting as close to surrealism as Chagall ever came. He could not have painted this splendid original vision of Vitebsk anywhere but Paris. Yet this beautiful, prescient painting of youth and memory is not a surrealist dream but Chagall's consummately worked-out statement of art versus death, desire versus fear, as he responded to the omens heralding the destruction of the world that had nourished him.

Chagall, *The Bride's Chair*, 1934, oil on canvas. This melancholy interior was painted to commemorate the wedding of Chagall's eighteen-year-old daughter Ida to Michel Rapaport—a marriage into which a reluctant Ida was pressured by her parents. Chagall and Bella's own joyful wedding portrait, *The Birthday*, hangs on the wall.

Wandering Jew

Paris, 1934–1937

The summer months are the time for indiscretion," announced the Paris journal *L'Intransigéant* in a questionnaire in the summer of 1934 asking artists which landscapes had most influenced them. In the artistic community an almost manic lightheartedness prevailed, as if to deny the political warning signs. The invitation Chagall received from Yvonne Zervos to a *Cahiers d'art* dinner in 1934 insisted on "pas de discussions politiques, nulle allusion à la crise, pas de controverses esthétiques ou littéraires, un simple réunion de franche camaraderie." This state of mind was antithetical to the seriousness that conditioned Chagall's and Bella's conversations with their Russian-Jewish friends. "From time to time, don't forget your somewhat sad Chagall," Chagall wrote forlornly in Yiddish to Opatoshu that year, begging his friend, who was going to Moscow, to seek out Mikhoels and "tell them they all forgot me over there, and I don't know why."

A new blow came from eighteen-year-old Ida, for whom the summer of 1934 was indeed a time for indiscretion: at the end of it she told her astonished parents that she was pregnant. Since her early teens, their cosseted, high-strung daughter had attended a summer camp for Russian children in France. There she had met Michel Rapaport, a law student and son of professional Russian-Jewish parents. Michel, born in 1913 in Berlin, was, like Ida, the product of a rootless east-west upbringing–he had spent the First World War, as a baby, in Russia and moved to Berlin in 1920, then Paris in 1926–and the pair struck up a friendship the more precious to Ida because she did not go to school and had little chance of meeting people her own age.

By 1934 "Mademoiselle Ida . . . une ravissante jeune fille et très belle" was remarked on by many of the Chagalls' friends, not least those, such as Rafael Alberti, who stumbled across her father painting the stunning teenage nude under a tree in their garden. But in her parents' eyes Ida was still a little girl, and they were appalled by the news. From prudish Vitebsk, both Chagall and Bella had retained traditional ideas about female sexual behaviour. Ida was rushed first into an abortion and then into marriage with Michel in November 1934.

Chagall's commemoration was *The Bride's Chair,* in which a bunch of flowers rests on an armchair draped in a white cloth, and bouquets of white roses tumble abundantly beside it. A pink carpet sets off the flood of white, and on the wall hangs the Chagalls' own marriage portrait, *The Birthday,* linking the generations. The spontaneity and rush of life in that work heighten the sense of absence in this painting. The crossbar of the window frame in *The Bride's Chair* stands out like a memento mori, and there is something deathly, a whiff of decay, in this ghostly interior. Ida is not there: for all its gorgeous plenitude, which recalls the painting *Lilies of the Valley* made on Ida's birth in 1916, *The Bride's Chair* is funereal—a father's fantasy about an adored daughter whose heart is absent from her own wedding, into which she has been forced by his authoritarianism. In the wedding photographs Ida stands rigid with the glazed, expressionless look of a sleepwalker, numbly acting her part, wearing her veil like a shroud. Sacrificed to her parents' desperation for respectability in difficult times, she was unprepared to make a commitment to Michel and unready for marriage; at the start of her married life she telephoned her mother several times a day simply to ask what to do and to hear the warm encouragement she was used to at home. Thoroughly subsumed in her parents' lives, she could not function without them.

If she flailed without Bella, Bella, too, lost vitality without the reassuring presence of her daughter. *Bella in Green,* which Chagall painted in the winter of 1934-35, is his last great classical portrait of her and shows her fading away emotionally and physically. Green was her favourite colour, and the portrait was a homage to her; it is very finely painted. Every detail—the texture of her elegant dark-green velvet dress, lustrous lace collar and cuffs, and richly decorated fan—is lovingly picked out. Yet Bella looks sad, remote, her gaze no longer fixed on the outside world but within: lost in thought like one of the biblical characters in Chagall's etchings. Chagall told Meyer that while she sat for this portrait, she read passages from the Bible aloud to him

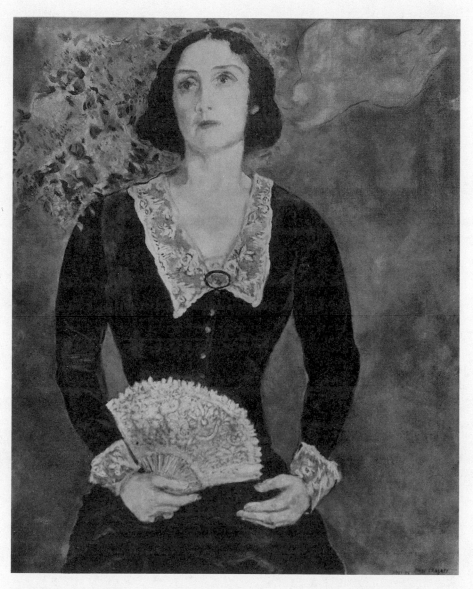

Chagall, *Bella in Green,* 1934, oil on canvas: "the entirely real figure of a woman
enduring nostalgia right to the very end," according to her son-in-law Franz Meyer

in Yiddish; the glaringly bright light that models her face and hands recalls that of the Bible etchings and highlights her prophetic gravity. In an early version an angel attends her, emphasising the closeness of the original conception to the Bible work, but Bella's strength of character, and Chagall's recent exposure to the severe psychological penetration of Spanish Old Master portraits by El Greco, Velázquez, and Goya, urged an undisguised figurative representation; the result is what Meyer calls "the entirely real figure of a woman enduring nostalgia right to the very end."

Increasingly, as depression took hold, Bella retreated to bed. From 1934 on Chagall family letters recurrently refer to her as recovering from "la grippe" or convalescing at a clinic after yet another operation. While anxiety stimulated Chagall again to invent new styles and motifs, her role in exile became shadowy. As her energy dwindled, Ida began to replace her as Chagall's helper, advisor, ambassador. She relished the role, which kept her tied to her adored parents; herself a talented painter, she was understandably too cowed by her father's achievements to pursue her own career, and it barely occurred to her to do anything but devote herself to promoting and protecting him. Brought up among cosmopolitan polyglot artists and poets, she spoke perfect French, German, and Russian and a beautiful idiosyncratic English; she had inherited both her parents' charm but had none of Chagall's class uneasiness or Bella's haunted Jewish psyche; she was fascinated by rather than ambivalent towards her Russian heritage. There were few people whom she could not win over, and she began in March 1935 by going alone to London for Chagall's first English exhibition, at the Leicester Gallery. The show was sponsored and opened by Lady Clark, wife of the British ambassador to Paris, to whom Chagall gave painting lessons—partly because he believed gentile friends were especially valuable in anti-Semitic times. Nineteen-year-old Ida's presence added an exotic element that helped make the show a success.

Her parents, worn down, had no heart to go themselves. In Ida's absence, they retired to the countryside outside Paris. Here Bella's isolation and longing for a Jewish milieu poured into a letter—written in her tremulous, soaring Russian style but studded with Yiddish phrases—to Meir Dizengoff in Tel Aviv:

> How are you? Are you entirely well? We have no time to write, yet
> we would like so much to know how you are, how is your health,
> are you in full bloom, how is Palestine now and simply we would
> like to embrace and kiss you.

We are now a few weeks in a village. We were sick and very tired. And here, in the expanses of fields and woods, we are resting. We travel by car on all the major and minor roads, as the Eternal Jews, and when we look at the old churches, rising to the sky, it seems to us that the true sky with the God that shines to us is with you. We often think and daydream about you. We are here, "grandpa and grandma" alone, our daughter is in London . . .

Well, when will we see you again? Please come especially to see us, where we would hug you hard and kiss you . . . If you cannot come to us, we shall venture out to you, but this is a dream, as sweet as Palestine *mit mandlen un rozinkes* [with almonds and raisins].

In this homesick mood, the Chagalls did not hesitate to accept an invitation from the Yiddish Scientific Institute in Vilna to open a new Museum of Jewish Art in August–September 1935. Vilna, known to them since childhood as "Yerushalayim d'Lita," the Jerusalem of Litah, had been the cultural centre of Yiddish life in the Pale and was as close to the Vitebsk of their memories, in its eastern European Jewish atmosphere, as they could get. Its skyline of domed churches, a city centre of baroque and neoclassical stone buildings set against a surrounding of low hills, the wooden houses and winding streets of the Jewish quarter, and the prevalence of Yiddish (around half the population was Jewish) and of Jews in traditional garb, of Jewish food at the marketplace, all had an almost hypnotic effect on Chagall and Bella, as if they were walking back into Vitebsk. The differences were slight: lying farther west than their native town, Vilna was softer and gentler, a seat not of Hasidism, with its oriental emotionalism and melancholy, but of the more rational Jewish Enlightenment, which brought it closer in tone to western Europe. "The city is like Vitebsk—even more beautiful," Chagall wrote to Opatoshu. "Great, warm regards almost from our homeland," Bella added on the same postcard. Just across the border lay Vitebsk, a Soviet city and thus forbidden; only an accident of fate had kept Vilna open to them—the city had changed hands several times, fought over by Soviet, Lithuanian, and Polish troops between 1918 and 1922, before ending up in Polish hands. Yet its Jews were barely free: many were on the brink of starvation: a census of the 1900s had estimated that 80 percent of Vilna's Jewish population had no idea the night before where they would get a meal the next day, and little had changed in the Depression. Polish anti-Semitism was rife. Chagall opened the Jewish Museum in the company of the seventy-five-

year-old Jewish historian Semion Dubnov and was distressed to see the son of this eminent scholar mocked on the streets and beaten by the Poles. Already it seemed to him that eastern Europe's Jews were in danger, and he painted limpid, intimate views of Vilna's synagogue interiors, paintings suffused with foreboding, for they were a record of a world he was sure could not survive. After the war Chagall wrote a Yiddish poem called "The Vilna Synagogue":

> *The old shul, the old street*
> *I painted them just yesteryear*
> *Now smoke rises there, and ash*
> *And the* parokhet *[ark curtain] is lost.*
>
> *Where are your Torah scrolls?*
> *The lamps, menorahs, chandeliers?*
> *The air, generations filled with their breath?*
> *It evaporates in the sky.*
>
> *Trembling, I put the colour,*
> *The green colour of the Ark of the Covenant.*
> *I bowed in tears,*
> *Alone in the shul—a last witness.*

At his side Bella, refined but fragile-looking in a sweeping white coat and matching beret, patted the orphans they met at a "Colony for Weak Children." Outwardly she brought a glimpse of French chic to a grim setting; inwardly she was in turmoil. She, who as a young woman had felt so constricted by Vitesbk, studying French and German to perfection and dreaming of travelling west, was exceptionally affected by again hearing Yiddish spoken on the streets after more than a decade in Paris; she now began to consider a project of her own—her memoirs, to be written in Yiddish. "Strange, but I suddenly want to write" is her opening line. "And to write in my faltering mother tongue, which I've hardly used since I left my parents' house. Far away as my childhood has drifted, it now comes back closer and closer, till I can almost feel its breath." Bella's voice is behind Chagall's in a note he wrote mourning Bialik's death a year earlier and calling for an "Ohel Bialik" (a Bialik house or shrine) in Paris where a new Jewish soul, free of material considerations ("une âme supplementaire, libre de toute préoccupation matérielle") could flourish to the satisfaction of "those who knew

the gentle serenity of the Jewish festivals and preserved their nostalgia in them."

For Chagall the visit to Vilna was another turning point in reasserting his Jewish identity. He enjoyed meeting Vilna's Yiddish poets, such as Abraham Sutzkever, and he, too, began to write in Yiddish; his sentimental autobiographical poem called "My Distant Home," was published in New York in 1937. "Well, Bella is better," he wrote to Opatoshu in spring 1936, "though she is in bed. And I work and sigh like all the Jews in the world, who are being beaten, now even in the Holy Land . . . And because of that, I become even more Jew. Pity on us."

But it was most of all his tormented relationship with Russia that Vilna rekindled. "A few kilometres from you, there is a land, actually just one city,

Chagall, study for *The Vilna Synagogue,* 1935, drawing

which I haven't seen in a long time, and which won't let go of me. I used your invitation and came to meander here awhile," he admitted in his address to the Yiddish Scientific Institute. "I don't know why, but between me and my homeland there is a one-sided affair." To "dear, dearest" Opatoshu he spoke in even more erotic, exalted terms, comparing himself to Moses, who was allowed to see the Promised Land but not enter it. "Vilna, Litah," he wrote. "To get up to the border of my city and tell her that she does not love me, but I love her . . . And shall return without entering her." His fatherland, he said, now only existed on his canvases: Russia was closed to him, France had a different spirit, and Palestine was unappealing because its Jews failed to appreciate art. To Benois, who despite his noble background had negotiated well enough with Soviet Russia to survive as keeper of the Hermitage's Old Master galleries until 1926, and who was now enjoying a position at the heart of the Russian émigré community, he penned a self-pitying letter at this time lamenting that he was a stranger to all Russia's regimes–old, Soviet, and émigré.

These feelings of rootlessness poured into illustrations for his friend Ivan Goll's epic ballad *Jean Sans Terre* (Landless John), which appeared in 1936. Its theme was the solitude of an Everyman character who no longer has a home in the brash mechanized world; it reflected Goll's own situation more than was generally perceived at the time–unknown to Claire, in 1933 he had begun a relationship with Paula Ludwig in Berlin and now deliberately courted danger by dividing his time between the French and German capitals. In a preface to the English translation, W. H. Auden interpreted Jean Sans Terre as not only an updated archetype of the Wandering Jew but an embodiment of modern man's cultural deracination:

> Jean Sans Terre is equally at home on the Ponte Vecchio and Brooklyn Bridge because neither is really his: he must sleep on "the mattress of the thousand truths" because he is personally committed to none . . . He is the Wandering Jew, forced to be forever on the move without any hope of finding hidden treasure or a Sleeping Beauty, without even the Whitmanesque exhilaration of the novelty of the Open Road, forever anxious about a future which he cannot imagine:
>
> *He asks the mirror if he will arrive on time*
> *On time no matter where nowhere.*

Chagall, study for *The Falling Angel,* 1934, India ink
on paper

Goll's poem captured the fraught, tense mood of those in the 1930s who had neither a settled identity nor the security of nationhood. One of the paintings that Chagall returned to repeatedly at the time, although he never resolved it, was *The Falling Angel.* Begun in 1922, it is a drama of rootlessness and lack of identity in which an angel hurtles to earth past a crucified Christ; now Chagall intensified and darkened it. No one in France, sandwiched between Nazi Germany and Civil War Spain, was lighthearted any longer; the bloody terrors in Spain, which led Picasso to paint *Guernica,* appeared as a prelude to catastrophe throughout Europe. For many Russian artistic refugees of the revolution, the longing for their homeland grew worse, not better, with time: the longer the separation, the more they were cut off from the sources of their inspiration, for Russian literature, music, and art are uniquely rooted in national history and the quest to explore the country's destiny. "When I left Russia, I left behind the desire to compose: losing my country, I lost myself also," said Rachmaninov, though friends in the 1930s commented that his house at Clairefontaine near Paris, bordering a Russian-looking pine wood and reached by sandy avenues flanked with tall old trees, "was very much like . . . an old Russian estate." To Russians, however, it would never be the real thing; by the 1930s it was clear, too, that there was no point waiting for the regime back home to change.

Some Russian exiles therefore now chose to return home. They had many reasons: economic hardship encountered during the Depression; the hope

that their country offered them a cultural role; the rise of Western fascism that made Stalinism look (as it did to Walden) like a better option. Away from the reality of Russia, political allegiances shifted unpredictably. Ilya Ehrenburg, for example, a vigorous opponent of Bolshevism since 1917 and a political exile since 1921, began in the early 1930s, in response to fascism, to write more favourably about the Soviet regime, becoming a reporter for *Izvestiya* in 1932 and writing novels that met Stalin's approval through the 1930s.

Maxim Gorky, who had also left Russia in 1921 and had settled in Sorrento, was one of the first to return: he moved to Moscow in 1931 because he was uneasy with the rise of Italian fascism. Welcomed back as a symbol of a cultural victory for Communism, and given a large mansion and private servants (who were in fact Lubianka spies), he was soon placed under NKVD surveillance; his son was killed in 1934, and his own death in 1936 was probably murder. In the extreme of Stalin's Great Terror in the mid-1930s, the slightest contact with a foreigner was enough to send a Soviet citizen to the gulag. Pavel Ettinger, Chagall's only correspondent, was in a uniquely privileged position, but even his letters to the West ceased between 1937 and 1945. Those outside Russia did not understand. Many European artists and intellectuals expressed support for the Soviet Union in the 1930s; among Chagall's Paris friends and acquaintances, Picasso, Léger, Paul Éluard, and the Golls joined the French Communist Party.

Victor Serge, a Belgo-Russian writer, had spent months in solitary confinement at the Lubianka prison, followed by years of exile when he was confined to Orenburg on the Ural River; he was released in 1936 and began a campaign to dispel the illusions of Western Communists in love with Russia, but few listened. He called Soviet Russia a "concentration camp universe" and published in the left-wing newspaper *L'Ésprit* an open letter to André Gide, who was invited to Moscow as a guest of the Soviet Union, warning: "Let me say this to you: one can only serve the working class and the USSR by seeing absolutely clearly. And let me ask this of you in the name of those over there who have every kind of courage: have the courage to see clearly."

It was, Serge wrote later in his memoir, "a tragic lapse of the whole modern conscience" that "nobody was willing to see evil in the proportions it had reached." Instead, several prominent figures, including composer Sergei Prokofiev and writers Sergei Efron and Marina Tsvetaeva, returned to the Soviet Union between 1936 and 1939, when Stalin's atrocities were at

their height. Ehrenburg had inexplicably won the trust of Stalin and was the only Russian intellectual to travel freely between Russia and the West (for many decades he was the Chagall family postman), but even he made a mistake at this time: he visited Moscow for what he thought was a vacation in 1937, only to be detained by Stalin and given a ticket to attend the show trial of his old friend Bukharin, upon which he was expected to report for *Izvestiya*. He remained on the fence: "I do not know whether it is peculiar to me or is a common experience, but in Paris and in Moscow I looked at things in a different way. In Moscow I thought about man's right to a complicated spiritual life . . . whereas in the Paris of the late 1920s I felt stifled: there was too much verbalistic complication, artificial tragedy, contrived originality." This statement was mock-innocent–Ehrenburg's experience was hardly common because no one else had the chance to taste both capitals– but it hints at an underlying force driving Russians to their homeland. Nevertheless, "don't come back to Russia–it's cold, there is a constant draught," Pasternak warned Tsvetaeva. But eventually she could not resist because "the poet cannot survive in emigration: there is no ground on which to stand–no medium or language. There are–no roots." But when she got to Russia, she found herself unremembered or ostracised, unable to work or live; former friends were too afraid to pick up contact with anyone who had lived in the West. Eventually Tsvetaeva found employment as a dish washer and in 1941 hanged herself.

Following the Vilna visit, throughout 1936 Chagall's letters suggest that he, too, contemplated a return to Russia. That as a defector he was banned from returning did not stop his fantasies; among the émigré community, those far less in sympathy with the revolution than he had been were allowed back. Efron, for example, had fought with the White Army during the Russian civil war and was recruited back as an NKVD agent. Restless in Paris, Chagall moved house and studio again towards the end of the year, to Villa Eugène Manuel near the Trocadéro. But to Ettinger in August he mused:

> I sit in a dacha and remember you. Our tree is different, the sky is different, it is all not that, and with the years, these comparisons play on your nerves . . . With the years, you feel more and more that you yourself are a "tree" which needs its own soil, its own rain, its own air . . . And I begin to think that, somehow, I hope soon, I shall pull myself together to travel to refresh myself in my homeland and work in art [there] . . . I am too much for-

gotten and alienated. Write sometime. Nobody writes to me
except you.

In October, contemplating his own fiftieth birthday the following year as
he wrote to congratulate Ettinger on his seventieth, he announced,
"Though in the world I am considered an 'international' and the French
take me into theirs, I think of myself as a Russian artist, and this is very
pleasing to me . . . My voyage [to Russia] ripens in me gradually. It will, I
hope, refresh or renew my art. But I shall not go, like the others, because of
the 'Crisis.' Not bread, but my heart."

What chord did these outpourings strike in Russia? Very little, for Cha-
gall had become a nonperson, rarely mentioned; his paintings were never
shown publicly. He believed that many of his former friends had denounced
him, for their own safety. This may have been true; moreover, any Russians
who had the opportunity of surveying his life in Paris may well have felt that
he had made all too comfortable a living out of memories of pre-Soviet
times. In the summer of 1936 he sold 60,000 francs' worth of work to
Solomon Guggenheim, including *The Birthday,* and although Hilla Rebay
commented that he was poor, that was by American rather than Russian
standards. By comparison with most Russian exiles of all political persua-
sions, he and Bella were living well—well enough to deposit the proceeds of
the Guggenheim sale in an English bank account as a safeguard against
instability in France. The majority of the émigré community, by contrast,
had no income and were living off sales of jewels or gold; Chagall's contem-
porary Prince Felix Yusupov stood out as especially wealthy among them
because he lived off the past in a different way: he sued MGM through the
English courts over the 1932 film *Rasputin and the Empress* and won
£25,000, an enormous sum at the time, for libel, not because he had been
shown as a murderer but because his wife Irina was portrayed as having been
raped by Rasputin.

Among artists, the situation on the eve of the First World War, when Cha-
gall and Kandinsky were the only two Russians with an international reputa-
tion, was fundamentally unchanged on the eve of the Second. Most of the
other Russian artists who had fled west, such as Larionov and Goncharova,
were declining into genteel poverty; Alexander Granovsky, Chagall's adver-
sarial colleague at the Jewish Theatre, who had defected in 1928, died poor
and obscure in Paris in 1937. Like Russian theatre directors, who now had
little outlet for their work, Russian writers, unable to publish in the Soviet
Union, found their audience shrinking as the next generation became

assimilated; with so small a market, none could make a living. Vladimir Nabokov, who left Berlin for Paris in early 1937, could afford only a shabby one-room flat in the French capital; he made the bathroom his study, propping up his work on the bidet while his young son played in the living room.

Chagall's success did not go entirely unnoticed in Moscow, and of course it was resented. A rare reference in *Novyi Mir* in 1934 had Abraham Efros, once such a supporter, explode with rage against the "confounding stupidity" of his bourgeois former friend who was "entirely pampered . . . knowing the whole world and known by everyone, having lived in his native land, Russia, as if he was on a mission to a foreign country . . . surrounded by material ease." Chagall, however, in his introspection, was incapable of considering how much luckier he was than most of his compatriots in exile, let alone those in Russia. Instead, the past pressed in on him as a constant shadow, like the grandfather clock that loomed above him in his parents' home. He used this clock recurrently as a motif, a symbol of time and memory, in the large compositions of the 1930s. In *Winter* a nude is encased within it in a setting of snowy wooden huts. In *The Clock in the Street* it has a wing and appears to sway down a Vitebsk road. In *Time Is a River Without Banks* (1936) it sails through the air above a cold Dvina River at twilight, its face blank, its brass frame and pendulum swinging upwards in defiance of gravity. This clock hangs down from the body of a shimmering green fish (a reminiscence of Chagall's father's labouring over vats of herring) topped with tropical red fin-wings; an arm projecting from the fish's mouth holds a violin and bow; violet shadows on the riverbank surge like a wave over a pair of lovers.

Absorbed in such memories of youth, Chagall in January 1937 made a stupid, dreadful mistake. For no reason other than mounting desperation and sentimentality as he began the year in which he would turn fifty, he attempted to make contact with his old teacher Yuri Pen. The idea had probably been simmering since the Vilna visit; now it was as if he lost his nerve waiting, and just writing the address "City Vitebsk, to the artist Yu M Pen," felt like a release. The letter was harmless enough. "Dear Yuri Moyseevich, how are you? I have not heard from you for a long time," he began ingenuously, as if he did not know how impossible it was to communicate outside Russia. The short letter continued:

> I am so eager to know how you are, how is your health, how are
> you working, and how is my beloved city. I am sure I would not
> recognize it now. And perhaps even my Pokrovskaya has changed.

And how are my little huts where I spent my childhood and which we both once painted together?

How happy I would be on my (alas!) 50th birthday, which is approaching–to sit with you on a porch at least for an hour, and paint a study. You must write. When I die–remember me.

In 1937 the eighty-two-year-old Pen was still working as a professor in the college founded by Chagall, now renamed the Vitebsk Technical Art School. He continued to produce the painstakingly realistic genre scenes of local life from which he had never swerved and that now coexisted easily with social-ist realism. His Judaism did not appear to cause trouble; for two decades he had worked under the Communist regime, outliving Malevich, much loved by his students and an extended family of nieces and nephews: he was a mon-ument to the quiet, apolitical life. But a month after Chagall sent the letter, on 1 March 1937, this innocent old man was murdered during the night in his apartment–almost certainly by the NKVD. Chagall's letter, partly damaged, was kept by the authorities (Pen may never have got it) and is now in Vitebsk's city museum; a visibly corrupt trial condemned a nephew, a niece, and a student for the murder, but no one believed in their guilt. The crime remains unsolved, but the link between the murder and Chagall's letter is likely, at a time when any connections abroad, let alone a relationship with so high-profile a defector, led to persecution.

Chagall never saw it that way. He wrote a distressed, self-indulgent letter to Pen's relatives, envying them being able to attend Pen's funeral and asserting his devotion to Russia, which he probably intended the authorities to see; a few months later he could not resist urging Ettinger, completely unrealistically, to persuade a museum to retrieve his own paintings from among Pen's property. The incident did, however, put an end to dreams about going to Russia, though he still moaned that Miró and Picasso, Span-ish residents of Paris, represented their country in the Spanish Pavilion of the International Exhibition at the Trocadéro in Paris in 1937 while he was not allowed to represent Soviet Russia.

His major painting of 1937 was *The Revolution,* a work with which he was never quite satisfied–he cut it into three parts in 1943 and radically reworked each of them. The original centres on Lenin's doing a handstand on a table–he had, politically and culturally, turned Russia on its head. By his side a praying Jew with Torah and phylacteries sits at the table, on which lies an open book; nearby is a samovar, and behind Lenin a donkey perches

on a chair. In the foreground a dead man lies on snowy ground—a reference to Chagall's first painting. On the left crowds of rebels with guns and flags surge forward, shouting, fighting—the political revolution. On the right, in floating blue, is the world of culture, religion, love: the Chagallian cast of lovers on a wooden roof, an old Jew with a sack on his back, musicians, the artist with his palette.

Pen's death, Chagall's ambivalence towards Russia, and his fears for the future and for where he stood as an artist, a Jew, and a Russian, all inform this turbulent canvas. Meyer suggests that he was answering French intellectual sympathy for Communism, especially strong after the Spanish Civil War, with his own experience; later Chagall insisted to Meyer that the work did not signify criticism of Lenin but positively suggested his revolutionary impact; but he said this in the 1960s, when he was dreaming of visiting his homeland and was cautious of implying criticism. The fury and terror of the painting, the cowering lovers, the old Jew turning his back and covering his face, and the symbolic dead man belie his words. *The Revolution* is the first of a series of monumental paintings that turned Chagall, from 1937 to 1945, into a political artist.

In the spring of 1937, after the Pen tragedy, Chagall threw his energies not into Russian fantasies but into the practical business of acquiring French citizenship, which he foresaw might save his life. This was not easy for eastern European Jews, even famous ones, in 1930s Paris, and Chagall's case was hindered by his having once been, as commissar of art in Vitebsk, an official of the Bolshevik regime. But he used contacts with Jean Paulhan and other intellectuals to pull strings, and even though the French police insisted that he be called Moise instead of Marc on the passport, he and Bella became naturalized French citizens on 4 June 1937. A month later, on 19 July, the Nazi exhibition "Entartete Kunst" (Degenerate Art) opened in Munich: Chagall as both a modernist and a Jew was a star exhibit.

White Crucifixion

Paris and Gordes, 1937–1941

How deeply this corruption of taste had eaten into the German mind was shown in the material submitted for hanging by artists in the 'House of German Art,' " announced Hitler in Munich on 18 July 1937, on the eve of the opening of the "Entartete Kunst" exhibition. Witnesses said he frothed at the mouth as he continued; among those in the audience with works in the show was Max Beckmann who, hearing the speech, became convinced that he could no longer do any good in Germany by remaining there and left for Amsterdam.

"There were pictures with green skies and purple seas. There were paintings which could be explained only by abnormal eyesight or willful fraud on the part of the painter," the Führer continued.

> If they really paint in this manner because they see things that way, then these unhappy persons should be dealt with in the department of the Ministry of the Interior where sterilization of the insane is dealt with, to prevent them from passing on their unfortunate inheritance. If they really do not see things like that and still persist in painting in this manner, then these artists should be dealt with by the criminal courts.
>
> I was always determined if fate ever gave us power not to discuss these matters, but to make decisions. Understanding of such great affairs is not given to every one.

The Nazis had begun their campaign against modernist art as soon as they seized power. Expressionist, cubist, abstract, and surrealist art–

anything intellectual, Jewish, foreign, socialist-inspired, or difficult to understand—was targeted, from Picasso and Matisse going back to Cézanne and van Gogh; in its place traditional German realism, accessible and open to patriotic interpretation, was extolled. The Nazi equation of contemporary art with national decline, converging as it did with lower-middle-class conservative and prudish cultural standards, was widely popular; its culmination was the removal, beginning in 1937, of around twenty thousand works from German museums confiscated as degenerate by a committee headed by Joseph Goebbels, minister for public enlightenment and propaganda. A choice selection—730 works—was exhibited in the "Entartete Kunst" show, which was presented as a sensational political event and received two million visitors in Munich, followed by a further million when the show toured Germany and Austria in 1938-39. Admission was free, and to the lurid reputation of the show was added the titillation of a ban on visitors under eighteen, thus emphasising the artists' moral-sexual subversiveness. In Munich an equally large exhibition of Nazi-approved "Great German Art" was shown next door and got only a fifth as many visitors.

"Entartete Kunst" presented the pictures hung close together in narrow rooms, some without frames, some resting on the floor against the walls, to create an impression of disorder—the opposite of the aura of contemplation and reverence encouraged by the traditional museum setting. Grouped into sections under insulting slogans such as "Mockery of German Womanhood," "Destruction of the Last Vestige of Race Consciousness," "Complete Madness," and "This Was How Diseased Minds Saw Nature"—each work was displayed with title and museum purchase prices (to inflame bourgeois taxpayers' outrage) and alongside cleverly manipulated art-historical reviews, which at once pilloried critics like Julius Meier-Graefe (who had led modernist taste in Germany), and flattered philistine audiences into indignation. Among Chagall's works were the paintings *A Pinch of Snuff* of 1923 (the portrait of a rabbi, confiscated from Mannheim's Kunsthalle), *Purim* (taken from Essen's Museum Folkwang and renamed *Russian Village Scene*), and *Winter* (from Frankfurt's Städel Museum), and his 1924 expressionist drawing "Self-Portrait with Grimace"—its self-mockery was said to be an example of the distorted Jewish psyche. Chagall indeed was a prime exhibit: the German press had swooned over him as early as 1914, so there was no shortage of texts. Thus an essay by Fanina Halle on his 1914-15 work as a joyous return to Vitebsk, for example, was reprinted as a mockery of green, purple, and red Jews shooting out of the earth, fiddling on violins,

flying through the air, cumulatively representing a Jewish catastrophe and assault on Western civilization.

The accent in the show was on German and Austrian expressionists–Beckmann, Kokoschka, Kirchner, Grosz, Dix, Heckel, Nolde–whose works were most readily available from German museums, but it also presented leading modernists of all nations: Kandinsky, Klee, Mondrian, Picasso. As "Entartete Kunst" progressed around Germany, other works–including Chagall's *Watering Trough*, confiscated from a Wupperthal museum in 1938–were added; at the same time preparations were made to dispose of all the degenerate art in Germany for a profit. Four German dealers were invited to arrange for purchases or exchanges. The most spectacular sale was on 30 June 1939, when a stash of valuable works, including a van Gogh self-portrait that fetched $40,000, was sold at a scandalous auction called "Modern Art from German Museums" at the Galerie Fischer in Lucerne in Switzerland. German galleries of course could not buy, and many international museum directors, such as MoMA's Alfred Barr, boycotted the auction; other collectors were unsure. Pierre Matisse, by then a prominent New York dealer, attended with the collector Joseph Pulitzer, whom he urged to buy his father's work. Pulitzer, who purchased Matisse's *Bathers with a Turtle,* later recalled, "We were faced with a terrible conflict–a moral dilemma. If the work was bought, we knew the money was going to a regime we loathed. If the work was not bought, we knew it would be destroyed. To safeguard the work for posterity, I bought–defiantly."

Among the few museums active at the auction, the Museum of Contemporary Art in Liège, Belgium, bought Chagall's *The Blue House* (confiscated from Mannheim's Kunsthalle) and the Basel Kunstmuseum purchased the 1923 portrait of a rabbi *The Pinch of Snuff.* The most bizarre point about the fate of this work, a Nazi trophy of Jewish decadence, is the contrasting destiny of its twin. The 1923 *Pinch of Snuff* was one of the paintings Chagall had remade after the rupture with Walden lost him most of his prewar works. The 1923 version is very close indeed in composition and tonality to the 1912 original, the chief difference being the freer compositional rhythm and more fluid colour of the later work; the only definitive marker, however, is that in high spirits the twenty-five-year-old Chagall had signed the first (1912) version upside down. Through the 1930s this first *Pinch of Snuff* (sometimes known as *The Yellow Rabbi*) hung, along with *Homage to Apollinaire* and works by Franz Marc and Aristide Maillol, in a streamlined new Mies van der Rohe house, with big picture windows, silk curtains, and state-of-the-art

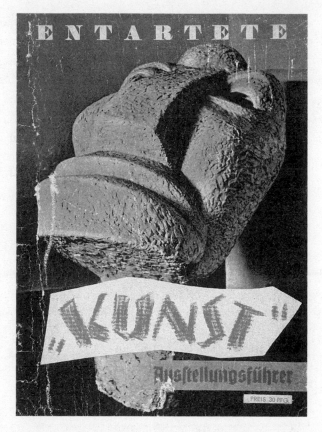

ENTARTETE

„KUNST"

Ausstellungsführer

PREIS 30 PFG.

Cover of the exhibition guide, priced thirty Pfenning, for
the Nazis' "Entartete Kunst" (Degenerate Art) show,
1937

roller blinds, at 91 Wilhelmshofallee, Krefeld, built for and owned by indus-
trialist Hermann Lange, an economic advisor to the Nazis. Here degenerate
art presided in the dining room over meetings with Nazi ministers; did any of
them ever look up to see the twin of the rabbi of the "Entartete Kunst" exhi-
bition, with its glowing Star of David, staring down at them?

A few German-owned Chagalls, most importantly the 1911 cubist *The
Dead Man,* originally owned by Jewish collector Franz Kluxen, disappeared
forever in the 1930s. Others left with their owners in 1933, such as those in
the collection of Salman Schocken, retail magnate and founder of Schocken
Books—his Chagalls preceded him to Jerusalem. But a great many German-
owned Chagalls were sold, were swapped, or like the 1912–13 *Jew at Prayer*
(another Walden theft) spent the war buried in the cellar of the Reichskul-

turkammer in Berlin. Ferdinand Möller, one of the four notorious dealers whom the Nazis appointed to dispose of confiscated works from their Berlin warehouse, exchanged a nineteenth-century landscape from the circle of Caspar David Friedrich (seen by the Nazis as patriotically German) for *Purim, The Watering Trough,* three Heckels, and one Nolde. *Purim* was subsequently bought by Kurt Feldhausser, a German collector who mopped up numerous modernist works in the late 1930s. Feldhausser acquired several top Chagalls of 1912–15 in German collections, including the great 1912 *Golgotha*—confiscated in 1937 from the son of the Jewish collector Bernard Koehler, Chagall's first German buyer—and the original versions of both *The Birthday* and *Over Vitebsk;* the latter was acquired from the Dresden Museum in 1936. Feldhausser died in an air raid in Nuremburg in 1944; his mother inherited the works and took them with her when she went to live in New York in the 1940s. They thus ended up briefly in the same city as their creator. *Golgotha, The Birthday,* and *Over Vitebsk* were bought by MoMA in 1949; the Jewish collector Louis Stern acquired *Purim* and *The Watering Trough* and bequeathed them to the Philadelphia Museum of Art.

C hagall's response to "Entartete Kunst" and the developments in Germany was to go to Italy, from where in September 1937 he sent a postcard to Opatoshu enthusing about the Tintorettos and Michelangelos. He did not even return to Paris for the World Yiddish Culture Congress, which was meeting in the French capital that month; his instinct now was to stay away from the city, its social unrest, and its rumours. He sent the congress a greeting in which he contrasted Hitler, screaming to make himself a god, with the godlike Italian Old Master painters. During the next four years the influence of the Italian Renaissance, especially the Venetian colorists Titian and Veronese, was strong. Chagall's paintings took on a rich sensuous beauty, the paint laid on more impulsively, broad areas of sumptuous colour determining the pictorial structure. It is as if he had developed a consciously late style, poignant, full of pathos. Never had he concentrated more intensely on pure painterly qualities in ambitious narrative canvases, as if he were turning his back on the world. Yet each work was also a political cry, the lyricism and colour carrying the message, and when among these works one monumental canvas—*White Crucifixion*—was drained of colour, it stood out to become, like Picasso's *Guernica,* Chagall's masterpiece and major political statement of the late 1930s.

Encompassing birth, marriage, and death, the three major works begun in 1938—*Madonna of the Village, The Three Candles, White Crucifixion*—can be viewed together as a trio of Jewish-Christian iconography that raises Chagall, as German critic Walter Erben wrote, "to the plane of the great accusers and passionate chroniclers among painters." "About suffering they were never wrong, the Old Masters," wrote Auden. Chagall's Madonna and Crucifixion, treating hallowed Old Master subjects, are infused with Jewish imagery as they claim a place for current events, and the desperate position of European Jewry, in the historical context of Western civilization. *The Three Candles* complements them: a wedding portrait of Chagall and Bella alone in a hostile world that cannot still their lyricism, it owes something to *Burning Lights,* Bella's memoir of her youth; she had just begun the work, to assert memories that she hoped would outlive her, in prose that Chagall described as "the style of a Jewish bride in Jewish literature." All three paintings say to the Christian world—do not forget us.

Nocturnal and oppressive, the first two paintings focus on the figure of Bella as Madonna of Vitebsk and Jewish bride. In *The Three Candles* she and Chagall stand on a red wedding canopy held by angels and pulled across a landscape filled with a lexicon of Chagall's imagery: a harlequin on a fence, a violinist, a shtetl house and Russian church, a lonely heifer, and funereal tumbling white roses, like those in Ida's wedding painting. Everything is chaotic: an angel falls to the ground, while another sweeps anxiously towards the edge of the canvas, as if chased out of the picture. The tapers cast a weak light; Bella and Chagall, clutching each other, contemplate them with foreboding.

Madonna of the Village is the Christian counterpart and has bridal overtones, too. This Madonna wears a long gown with veil, and her full-breasted, bare-necked figure is eroticised; a naked child clasps her, an angel kisses her. Beside her the picture space is divided into three colour zones, each set off by her cream-white dress. A dark Vitebsk landscape is illuminated with a fiery red glow, and a single candle soars out of the buildings into a wash of blue-white. This menacing sky contains two angels: a black one cowers, while a white one with a trumpet flies towards the Madonna. Above, a luminous yellow realm evokes memory: it contains a cow, more angels, and a man bearing flowers, but even this zone is under threat, and the Madonna/Bella, once a figure of stability and strength, is now a symbol of vulnerable humanity.

While Chagall was at work on these paintings, Nazi action against the

Jews intensified. On 9 June and 10 August 1938 the synagogues in Munich and Nuremburg were destroyed; on 15 June fifteen hundred Jews were sent to concentration camps; Polish Jews were deported at the end of October and on 9 November, on Kristallnacht, Night of Broken Glass, Jewish shops, properties, and synagogues were destroyed in Berlin. "Wars are fought nowadays as Hitler, the monster, fights them. And the more human one, the Frenchman, is, as usual, overcome by his strength. Unimaginable that the whole world talks day and night about a man with whom no intelligent person would talk more than five minutes because he is so average," wrote Chagall's friend Claire Goll in September 1938; two months earlier she had tried to kill herself in her Paris flat. Ivan, whose affair in Berlin with Paula Ludwig continued until 1938, was a firsthand witness of the mounting virulence of Nazism, and the Golls' letters from this time contain elaborate plans to flee Europe via Brussels. "Yesterday there was real alarm in my soul," Ivan wrote in 1938.

> At 7 o'clock I took the train to Brussels . . . in the streets the Hitler speech is being distributed. It doesn't please me at all and indicates the worst that might happen. Bad night, and this morning I decided to question the travel agents. But around noon all is calm and I am sorting out the newspapers, which already make light of everything in their democratic-optimistic way. Now I have a plan: if it comes to the worst, there is a boat from Antwerp to Gotenburg and Oslo every Friday, it arrives there as early as Sunday, a direct journey without port, relatively inexpensive and for the moment no visa required. From there there are direct boats to New York. So that would be *one* way to be quick. Otherwise more lengthy preparations and papers would be necessary, e.g. for Brazil . . . The situation is serious, take my word for it.

The Chagalls had no such practical plans, although already Chagall perceived America as the safe haven; in 1939 he told Opatoshu that Europe's hope lay in America. But he was subsumed in painting. As events unrolled, he altered *The Three Candles,* finished in 1940, and *Madonna of the Village,* not finally completed until 1942–just before Vitebsk actually was razed to the ground. But events of 1938 in Germany made him turn his attention most urgently to *White Crucifixion,* a work of Jewish martyrology that transforms the crucifixion into an emblem of contemporary tragedy.

Golgotha, wherein Chagall as a young man had departed from all iconographic tradition to depict crucified Jesus as a child, his body composed of blue cubist shapes, was the painting that had made his name in Germany in 1913 and that had also been his entrée into the Western mainstream. Now he returned to the subject with an interpretation as extraordinary, subversive, and pertinent. *White Crucifixion* is a portrayal of Jesus as a suffering man and Jew, rather than as Christianity's divine figure of redemption and salvation. Above his halo are both the Roman letters I N R I and the Hebrew inscription "Jesus of Nazareth King of the Jews"; wearing a loincloth cut from a Jewish prayer shawl, this Jesus is already dead, a motionless figure of suffering, head bowed, eyes closed–a silenced Jewish prophet. The diagonal white beam of light flows down to a halo surrounding a Jewish temple candlestick at the foot of the cross; in a heavenly zone above, Old Testament figures cover their eyes or weep.

Around them, in a style reminiscent of icons, are disparate scenes of violence: soldiers bearing a red flag surge to destroy a shtetl; burning houses are overturned; a boat with screaming survivors drifts across a river. A storm trooper (the swastika on his armband was later overpainted) torches a synagogue; its orange-yellow flames are the main shaft of colour breaking up the ivory-grey tonality. In the foreground Jewish figures, one with a sack on his back, one clutching a Torah, flee; the placard around the neck of the helpless bearded old man originally read "Ich bin Jude"; this, too, was later overpainted.

References to the Old Masters add gravitas and show how consummately Chagall still assumed and transformed influences. The slanting light about the figure of Christ, set off by the turbulence, recalls seventeenth-century mannerism; the elongated swaying prophets suggest El Greco's influence. But the impact of the painting owes most to its overall non-Western look: the fragmentary scenes and dotted colours build up to a scattered composition whose elements never fuse–as if Chagall were saying that the unity and beauty of Western classical painting had lost relevance and meaning. No Frenchman could have painted the chaos or the spiritual undercurrent of *White Crucifixion;* the work was Chagall's answer not only to Germany, which had too much mysticism, exploited for evil, but to rationalist France, whose lack of mysticism, he argued in a lecture at Mount Holyoke in 1943, almost destroyed the nation. When *White Crucifixion* was exhibited in February 1940, among the first to salute it was a Russian: Alexandre Benois praised it as a vision of "that untranslatable horror which has spread itself

over Chagall's co-religionists." But André Breton in 1941 also spoke up for Chagall as a Frenchman; decrying "the entirely unfounded suspicion that he had mystical inclinations," he wrote that Chagall's "work is surely the most resolutely magical of all time. Its superb prismatic colours waft away and transform the torments of the modern world, yet still it preserves the ingeniousness of ancient times in the way it delineates the basic pleasure principle proclaimed by nature: flowers, and terms of love."

White Crucifixion was a landmark in Chagall's religious art, foreshadowed by *Golgotha.* Between 1938 and 1940 he painted numerous, often personal, variations on the crucifixion. In *The Painter and Christ* he sits at his easel at the foot of the cross; in *The Painter Crucified* the figure on the cross holds palette and brushes; *The Martyr* of 1940, also centred on Christ wrapped in a prayer shawl, this time bound to a stake, and surrounded by flaming shtetls, includes small portraits of Chagall and his parents. This work is a reprise in colour of *White Crucifixion,* reasserting Chagall's lush chromatic intensity as a means of determining pictorial structure. The martyr's yellow body, underlined by his black and white prayer shawl, conveys tragedy; the dark blue of the mother and child accentuates their despair and terror; at the foot of the stake the pink of the veil and blouse worn by the grieving woman suggests sorrowful resignation. "All these colours are in other words the protagonists of the drama enacted in the picture against the neutral grey of a village over which hangs the thick pall of the heavy brown smoke of the destroying fire," wrote Chagall's friend Lionello Venturi in the 1940s. "The pity he has always felt for his people has become, because of the present war, a catastrophic vision of all mankind."

Amid fears of impending war, the Chagalls spent part of 1938 and the summer of 1939 in a farmhouse in the Loire valley, and along with the crucifixions Chagall returned to the rural and circus motifs of the 1920s and to mournful fantasies centered on Bella. A photograph from 1939 shows a tense, stiff Bella, staring ahead with a remote sorrowing gaze, sitting for Chagall for the double portrait *The Betrothed,* which shows a younger version of the couple embracing under a bouquet; the body of Bella, dressed as a bride, is so rigid that it suggests a corpse. This work won a Carnegie Prize in 1939. Among the finest fantasies of that year are another work featuring lovers, *Midsummer Night's Dream,* and *The Cellist.* The former is a tranquil revisiting of the erotic *Dedicated to my Fiancée* of 1912 in which an ass embraces a melancholy bride in a country setting; the blossom and vegetation in gentian blue, violet, and dark green are painted with such rich diffu-

Chagall and Bella by the painting *The Betrothed,* which
won a Carnegie Prize, 1939

sion as to appear as abstract saturated sweeps of colour. In *The Cellist* the
central character is a fusion of a man with a double face, an influence from
Picasso's *Weeping Woman* and other two-faced portraits of Dora Maar of the
late 1930s, and his instrument, which becomes his body, set in snowy blue
Vitebsk.

Chagall and Bella were at the farmhouse in July 1939 when news of Vol-
lard's death in a car accident at Versailles further deepened their sense of
isolation. Even when he could no longer count on Vollard for financial back-
ing, the dealer's enthusiasm had been a vital stimulus. Then on August 23
the Soviet-Nazi anti-aggression pact was signed, and it became obvious that
war was imminent. The Russian community was stunned. Ehrenburg was so
upset that he was unable to eat for months, taking only liquids; he lost
almost seventy pounds. Chagall said, "My first great disillusionment began
with the Nazi-Soviet pact. Bella and Idochka said I didn't understand, it was
pure strategy, but it shocked me profoundly." In the general panic and
expectation of war, Chagall felt terrified, and according to Meyer, he "imag-
ined he was in danger from the farmer and barricaded himself into his own
part of the house."

Just before France and Britain declared war on Germany on 3 September, the Chagalls moved to St. Dyé sur Loire. Bella was paralysed by despair; Chagall and Ida (her husband Michel was already in the army) returned to Paris in September to fetch his works from his studio. For the next few months France imagined itself protected by the Maginot Line of border fortifications along its eastern frontier, in the *drôle de guerre*—the phony war. In Paris exhibitions continued as usual. Chagall brought his pictures back to the capital for a show of large recent oils at Yvonne Zervos's new Galerie Mai, opening on 26 January 1940; *Revolution,* under the neutral title *Composition,* was hung in a back room as an only half-public antiwar work. For the first few months of the year Chagall travelled to and from Paris; Bella remained mostly at St. Dyé, writing nervous postcards whenever he was away. "Hello my dear, how are you?" she asked in March 1940, writing in French from the Hôtel de la Plage in St. Dyé hours after he had left for the capital. "You're not cold? Did you get the train straightaway? Did you get a hot coffee? Me, I ran quickly back home . . . For the moment, I'm in your room . . . and I'm writing to you and I'm not cold. I'm following you with my thoughts and I run after you. Be careful, don't catch cold and come back quickly, quickly. I hug you tenderly, tenderly."

As rumours increased that the Loire might become a military line of defence, the Chagalls moved south, taking Ida with them. During Easter 1940 they drove to Gordes, a seventeenth-century village near Avignon in Provence that spirals up around an outcrop of rock from the Vaucluse hills. In 1940 it was unknown, poor, and cheap. André Lhote had recommended it, and Bella and Chagall were charmed by the tall, pale stone houses and winding steep streets, called *calades,* through which shafts of sun cast illumination and shadow by turns. Many of the old buildings were run-down and empty, but on 10 May 1940, with the same devastatingly bad timing that had characterised their first property purchase in France in 1929, combined now with a stubborn blindness to events and a panicked desire to acquire some sort of security, the Chagalls bought an old Catholic girls' school in the Fontaine Basse quarter, a big long stone building standing on the lower edge of the village. Its largest room had big windows and made a perfect studio, with fabulous views over lavender fields and rocky mountainside. They hired a truck at Cavaillon and picked up the pictures from St. Dyé. The same day the Germans invaded Belgium and Holland, marching into France on 12 May. A month later, on 16 June, Paris fell, and France was disarmed. By the terms of the armistice, two-thirds of the country was occupied by the

German army, leaving the south-central provinces under control of a French collaborationist government, led by Marshal Pétain and based at the spa town of Vichy in the Auvergne. The only port in the unoccupied zone was Marseilles.

The speed with which France collapsed astonished everyone: the French army, with British support, capitulated even more quickly than Poland had done the year before when under attack from both Germany and Russia. Shock waves crossed the Atlantic for, as the *New York Times* wrote, Paris was equated with civilization throughout the non-Nazi world. Raissa Maritain, visiting New York at the time with Jacques, wrote in her diary that the fall of France made her feel as if she no longer had a future anywhere in the world. The Maritains stayed in America for the duration of the war; among the Chagalls' other close friends, the Golls had been there since 1939. The Delaunays fled Paris for the Auvergne. Robert, suffering from cancer, did not survive the upheaval of the move and died in 1941.

In France the civilian population reacted with panic. Eight million people took to the roads, fleeing south from German occupation. Lille's population fell from 200,000 to 20,000 in a few days, that of Chartres from 23,000 to 800. From country areas peasants dragged their livestock behind them until they abandoned dead horses and unmilked cows by the roadside. Trains to the Mediterranean were clogged with refugees, many of them Jews carefully acting as if they were on a casual visit rather than in flight. The civilian exodus revealed a psychological refusal, after the trauma of 1914-18, to face again the strains of war and transformed the fall of France from a military defeat into the disintegration of society.

The Chagalls were as astonished as everyone else by the rapidity of the collapse and did not at first accept the danger. What Amos Elon wrote of the German Jews in 1933–"an exaggerated faith in *Kultur* blocked an awareness of the danger and produced a highly selective sense of reality"–was emphatically true of the Chagalls in France. They had undertaken every effort of assimilation, squashing ambivalence and homesickness, in the belief that France stood rocklike for culture and civilization, and for them to realise that the country was no longer a haven needed an almost impossible leap of the imagination. The artist Leonora Carrington, when asked why she and her lover, German surrealist Max Ernst, who had lived in France since 1922, had not left the country in 1939, replied, "We couldn't imagine a world without Paris. You must remember what Paris was in those days, before the war. Paris was wonderful. Paris was freedom." Ernst was interned as an enemy

alien at Camp des Milles, a former tile and brick factory just outside Aix-en-Provence, where the company included Golo Mann, Thomas Mann's son and a professor of history at Rennes University, the Nobel Prize-winner Otto Meyerhof, the poet and dramatist Walter Hasenclever, and the novelist Lion Feuchtwanger.

Gordes was less than sixty miles from Camp des Milles, but it seemed in summer 1940 to radiate a peace that would last forever: far from the seething crowds, there was not a soldier or army vehicle or refugee in sight. Michel Rapaport was demobilized in July and came home to join them in the new house, and the four huddled together, uncertain, waiting. Almost immediately upon assuming power, Pétain set up a commission to redefine French citizenship that aimed to examine those naturalized since 1927 (this included Chagall and Bella) and strip "undesirables" of their French nationality. Not until 3 October 1940, when the Vichy government passed anti-Semitic laws ousting Jews from positions in public and academic life, however, did the older Chagalls really wake up to the danger they faced. By then they were trapped. It is not clear how much money they had at the time–they had just sunk funds into the Gordes house–or what access they had to savings abroad, but Chagall's major capital was his paintings, for which in war-torn Europe there were no buyers. Their only refuge could be America, and according to letters written there in 1940, they could not afford the passage to New York or the bond of $3,000 that each immigrant had to provide on entry to ensure that he would not become a burden to the state. Entry visas and exit visas from France took months to secure. Bella, locked in the past writing her memoir, had no energy to fight and felt that exile in America would be a death sentence. Chagall painted on regardless; a photograph shows him outside the house, standing beside *The Madonna of the Village* on his easel, its creamy white shimmering in the sun. "I hesitated for quite sometime," he admitted in 1941. "By nature I am lazy about the slightest move and have trouble travelling."

Only practical, efficient Ida perceived the need to act fast. Though she had inherited Bella's tendency to depression, she never overcame it better than in a crisis that demanded action, and especially one of the charm offensives that made her feel powerful. Even before the anti-Semitic laws came into operation, she contacted those associates in America who might be able to help them all out of France. Aware of censorship, she wrote letters in her stilted, quirky English, signed by Chagall, that were concealed but desperate cries of help, to Opatoshu and the literary critic Shmuel Nigger. Marked

"this letter is obviously only for you," the correspondence was intended for the Yiddish writers to show to as many influential English-speaking contacts as could be interested in their plight. "Very dear friend," Ida began to Opatoshu in September:

> It seems to me that we have not seen each other since a very long time, and that centuries have passed since our last meeting took place. How are you? I hope you can work as well as before, while I . . . Sure, now one must have some more courage than usual to do pictures . . . It is out of question, actually, to return to our Paris, in our homes, and we are asking ourselves how we will pass the winter. I miss you—your energy, your deep voice—very much, my dear friend. If I could expect to see you again one day, it would give me, perhaps, more courage for my work. I hope the same for my people, for my family . . . May I expect it? Perhaps it would be possible to have now a big exhibition of my work—and even to see it for once myself . . . Waiting impatiently for your answer and your encouragement . . .
>
> Marc Chagall

Did these letters work, or were moves already under way in America to help Chagall? In these confused, dangerous times, few documents and letters were copied or survive, so the exact details of how Chagall's trip to America was arranged remain unknown. From 1940 onwards, however, American intellectuals and Yiddish writers in New York worked in a frenzy through organizations such as the Emergency Rescue Committee (founded in June after the fall of France) and the Jewish Labour Committee's Fund for Jewish Refugee Writers, to try to save those under threat in Europe, and Chagall was famous enough to be a priority case. Crucially the United States, still neutral in the war, had diplomatic relations with the Vichy government, and an American consul general, Harry Bingham, was committed to helping Jews; from August 1940 he was assisted by a humanitarian hero, Varian Fry, a young American who had been a journalist in Berlin. A Harvard classics graduate and son of a Wall Street stockbroker, Fry had never forgotten witnessing an anti-Jewish riot on the Kurfürstendamm in 1935, when he took shelter in a café where a Jewish man was hiding in a corner, trying to look anonymous. Two Nazi storm troopers entered the café, and as

the man reached for his beer, "a knife flashed in the air and pinned his shaking hand to the table. The storm troopers laughed."

Unlike most Americans in 1940, Fry understood fascism from firsthand experience and was under no illusions about the future of France. On the other hand, he was an optimistic, youthful, can-do American, and when he read of the establishment of the Vichy government, he saw a sign of hope as well as doom: "a backdoor to Europe had been left ajar, after all." With backing from Eleanor Roosevelt, he travelled to Marseilles to set up an American Relief Centre. He arrived with a clutch of American visas and a list of two hundred artists, writers, and musicians to be secreted out of Vichy territories. Establishing himself at the Hôtel Splendide, he looked the classic naïve, unflappable, Yankee prig: tortoiseshell glasses, Brooks Brothers suit, homburg hat, Patek Philippe watch.

Chagall and Bella were on Fry's list, which had been drawn up by Alfred Barr, director of MoMA, and by émigrés already in America such as Thomas Mann and Jacques Maritain. Barr's names included Chagall, Matisse, Picasso, Dufy, Rouault, Max Ernst, and Jacques Lipchitz, Chagall's old

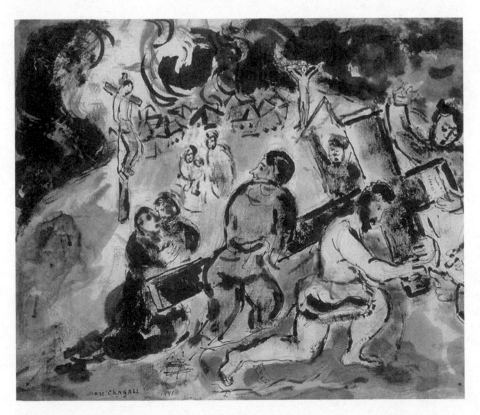

Chagall, "Carrying the Cross," 1941, India ink on paper

colleague from La Ruche; Barr sent them all invitations offering to host exhibitions of their work. Although they had been featured in the Nazi "Degenerate Art" shows, the Frenchmen on the list were not in fact in danger and declined Fry's offer. But Chagall, Lipchitz, and Ernst would owe their lives to Fry.

The queues outside room 307 at the Hôtel Splendide soon snaked along the corridor and down the stairs. Fry, authorized to grant two hundred American visas, managed to issue two thousand, getting about four thousand Jews to safety. The routes were limited: one had to board a boat sailing from Marseilles, or else proceed by train or foot–with guides who knew little-frequented pathways–through the Pyrenees, then through Spain to Portugal and by ship from Lisbon.

Solomon Guggenheim, encouraged by Hilla Rebay, put up some of the funds for Chagall while Bingham and Fry worked on his case. Guggenheim guaranteed the security for Chagall and Bella in November 1940, and with a letter of 17 December 1940 mentioning a proposed MoMA exhibition, and a telegram from Barr confirming the invitation, Fry secured their visas in January 1941. Funds were still needed for their passage, however; the dealer Curt Valentin of New York's Buchholz Gallery, who had known Chagall in Berlin, organized fundraising in February 1941 for the last $500: among those who contributed were Walter Arensberg in Hollywood and Helena Rubinstein. But the Chagalls, Bella especially, were determined to secure French reentry visas as well, and now, at the point when he was most endangered in France, Chagall drew on all his resources to proclaim himself a French artist.

"Since 1910 I have chosen France, my adopted country, where I arrived very young to absorb the artistic culture of this country of art and painting," he told Monsieur le Préfet du Vaucluse in Avignon in his application of 20 January 1941. "Since that date, my artistic career has unfolded entirely in France. I have always been very honoured to be considered as a French painter." Bella, declaring herself "sans profession," added her own muted claims that, in spite of the bureaucratic formal French, are imbued with a note of frailty and defeat. "I have always helped and collaborated with the organisation of all my husband's exhibitions, as well as all his artistic activity," she wrote. "I wish to accompany him to contribute within the measure of my means to the work which will devolve upon him in the United States."

Even at this stage in the war, their attachment to France blinded them to the urgency of the situation. Fry, who drove to Gordes on 8 March to discuss

the arrangements for their departure–the arrival of the big American car caused a sensation in the village–was struck by their reluctance and naïveté:

> Spent the weekend with the Chagalls at Gordes. Drove out with Harry Bingham on Saturday morning. We passed two truckloads of German soldiers between Marseilles and Aix, and not another car all the way. We arrived in time for lunch. Gordes is a charming tumbled-down old town on the edge of a vast and peaceful valley. It used to manufacture shoes, but then shoe-making machinery was introduced, its craftsmen moved away, and most of the town is now in ruins. The Chagalls' house is the only one in the immediate neighbourhood that has not fallen in. I can see why they didn't want to leave; it is an enchanted place.
>
> Chagall is a nice child, vain and simple. He likes to talk about his pictures and the world, and he slops around in folded old pants and dark blue shirt. His "studio" contains a big kitchen table, a few wicker chairs, a cheap screen, a coal stove, two easels, and his pictures. No chic at all, as *chez* Matisse. Chagall kept asking me anxiously whether there are cows in America. But he is already beginning to pack. He says that when they have gone, I can have his house to hide people in. A good, remote place.

What did Chagall make of Fry? American colleagues described him as a neurasthenic intellectual; certainly this energetic, upbeat American did not grasp Chagall's mix of fatalism, hesitation, and self-mockery. These qualities bore on Chagall's apparent reluctance to budge, but they also led Fry to misread their encounter. Chagall did not want to go to America, but he knew he had no other option. As for cows, was he suggesting that he was one himself–a dumb animal as in his paintings, caught in a stupid position? And he must have been thrown into confusion by Fry himself, rolling up in grand American style in tiny Gordes and looking so unlikely a saviour. "Imagine the situation," another refugee, Hans Sahl, recorded.

> The borders are closed; you're caught in a trap, might be arrested again at any moment; life is as good as over–and suddenly a young American in shirt sleeves is stuffing your pocket full of money, putting his arm around your shoulders and whispering in a poor imitation of a conspirator's manner: "Oh, there are ways to get you out of here," while damn it, the tears were streaming

down my face, actual tears . . . and that pleasant fellow . . . takes
a silk handkerchief from his jacket and says: "Here, have this.
Sorry it isn't cleaner."

For all Fry's efforts, there were still no visas for Ida or Michel—attempts to
raise money on their behalf in America were less successful. Ida had taken
upon herself the responsibility for getting Chagall's paintings out of France;
neither Chagall nor Bella was strong enough. But the anxiety about leaving
without Ida continued to make the Chagalls ambivalent even as they pre-
pared to leave Gordes.

The Chagalls were not alone among high-profile artists and intellectuals
in Vichy France who delayed their departure, but they were luckier than
many. Lipchitz, another Russian Jew who had seen Paris as a haven and been
naturalized in 1924, was still in Toulouse; he wrote later that he owed his life
to Fry's severe, clairvoyant letters urging him to leave. Chaim Soutine,
another long-term Russian-Jewish inhabitant of Paris and former resident
of La Ruche, was in hiding, moving constantly from one address to another;
he emerged in summer 1943 to seek help for an untreated stomach ulcer,
which perforated and killed him. Staying in a villa outside Marseilles, Max
Ernst was waiting to get to America; he offered to remarry his first wife, art
historian Lou Strauss, who was Jewish, in order to take her with him to
safety, but she declined and died in Auschwitz. Farther afield Vladimir
Nabokov and his Jewish wife Vera did not leave Berlin until 1937, struggled
in poverty in Paris, and did not sail for America until 1940, even though
Nabokov spoke perfect English and by then had published a novel in En-
glish. In Amsterdam Max Beckmann was making frantic efforts to get a visa
for the United States—he failed and spent the war in Holland. In Berlin
seventy-seven-year-old Ludwig Fulda, founding member of the Prussian
Academy of Arts, recipient of the Goethe Medal in 1932, killed himself in
1939 after being denied an entry permit to the United States, where his son
was living. "Since I cannot join my beloved boy," he wrote, "I join my good
parents in the only country that requires no hard currency, passports or
visas." Remaining in Paris and facing a terrifying future were Bella's brother
Isaac Rosenfeld, his wife Hinde, and their daughter Bella; the Chagalls had
no idea whether they were still alive.

In March 1941 Michel and Ida went to live in Nice with Michel's parents;
all were penniless. This eastern corner of France was under Italian occupa-
tion and had become a haven for Jews—43,000 were crowded into thirty
miles of coastline. They stayed in the less fashionable hotels, so as not to

draw attention to themselves, but the French press dubbed the area the "ghetto parfumé." Signs hung on the trees in Antibes saying "Mort aux Juifs," but the Italian troops were pleasant, closer in temperament to the southerners, and unlike the French, they had no anti-Semitic instincts and were so humane that the synagogue in Nice gave funds for the relief of Italian air-raid victims.

In April 1941, however, a Department for Jewish Affairs was set up in Vichy France. Jews who had been naturalized after 1936 were to lose their status as French nationals. The Chagalls were named in the *Journal officiel* as among those to be stripped of French citizenship; according to Fry, their names were deleted because they were so famous. In preparation for the voyage to America via Lisbon, however, they now moved to Marseilles, a city packed with frightened refugees waiting for overseas entry visas, French exit visas, Spanish and Portuguese transit visas, and money for tickets; as the visas all had expiration dates, they had to be applied for over and over again as one expired before another was issued.

The Chagalls stayed at the Hôtel Moderne; up the road Victor Serge, also waiting for a visa, was installed at the Hôtel de Rome and described the mood of the exiles in the city:

> Marseilles, flushed and carefree with its crowded bars, its alleys in the old port festooned with whores, its bourgeois streets with lattice-windows, its lifeless wharves and its brilliant seascapes . . . selling, buying and selling back documents, visas, currency, and tasty bits of information . . . running through the numberless varieties of terror and courage, anticipating every fate that we can imagine lying ahead . . . Here is a beggar's alley gathering the remnants of revolutions, democracies and crushed intellects . . . In our ranks are enough doctors, psychologists, engineers, educationalists, poets, painters, writers, musicians, economists and public men to vitalize a whole great country. Our wretchedness contains as much talent and expertise as Paris could summon in the days of her prime; and nothing of it is visible, only hunted, terribly tired men at the limit of their nervous resources.

A photograph shows Chagall and Ida on the cramped balcony of a dingy room at the Hôtel Moderne hung with a clothesline. Ida in an immaculate suit–appearances were everything in the need to keep up the semblance of

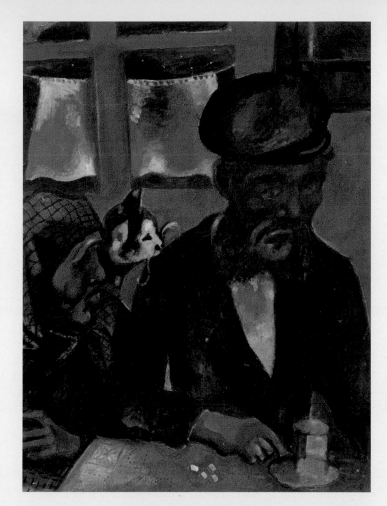

Chagall, *Father and Grandmother,* 1914. Tempera, paper on board, 49.4 x 36.8 cm

Chagall, *My Mother,* 1914. Gouache and pencil on cardboard, 25.6 x 21.6 cm

Chagall, *Self-portrait with Brushes,* 1909. Oil on canvas, 57 x 48 cm

Chagall, *My Fiancée in Black Gloves,* 1909. Oil on canvas, 88 x 65 cm

Chagall, *Self-portrait with Seven Fingers,* 1913. Oil on canvas, 126 x 107 cm

Chagall, *Self-portrait,* 1914. Oil on canvas, 54 x 38 cm

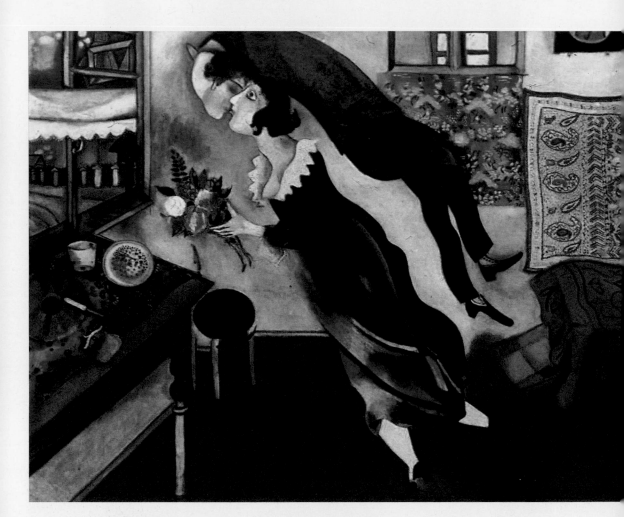

Chagall, *The Birthday*, 1915. Oil on canvas, 80.5 x 99.5 cm

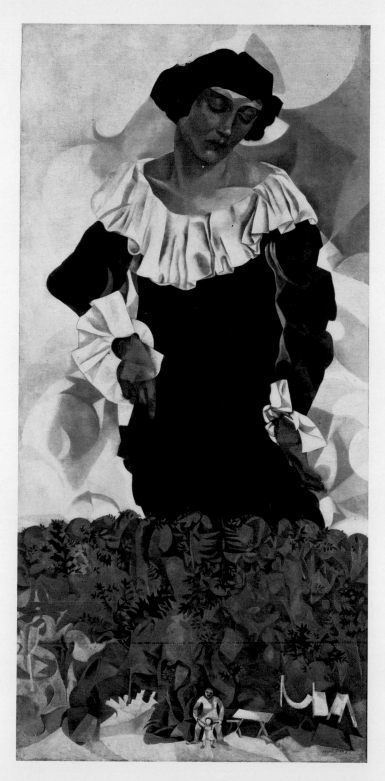

Chagall, *Bella with White Collar*, 1917. Oil on canvas, 149 x 72 cm

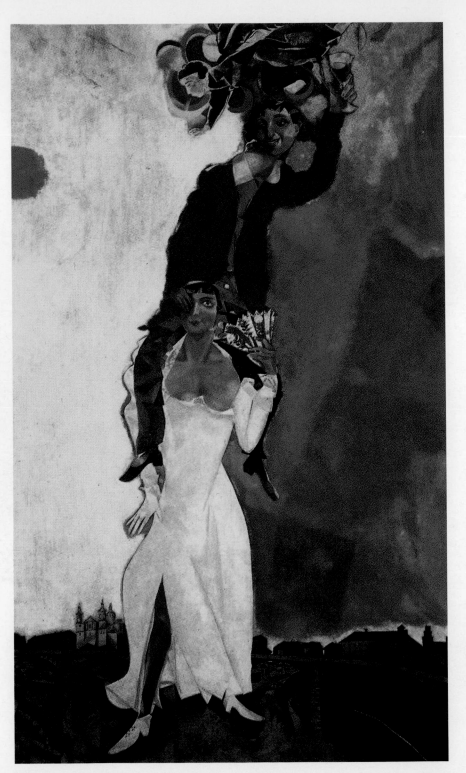

Chagall, *Double Portrait
with Wineglass,* 1918.
Oil on canvas, 235 x 137

normality—seems to prop up her father, who holds on to the rail of the balcony for support and gazes at the camera looking bewildered, upset, exhausted; for once the instinct to pose deserted him. Days after they arrived, on April 9, the first *rafle,* the round-up of Jews in Marseilles hotels, took place and included Chagall, who was taken to the police headquarters at the Évêche. Bella, in hysterics, telephoned Varian Fry, who called the police station and threatened to call the *New York Times* and cause an international scandal if Chagall were not released within half an hour—which he was. But the experience brought home the reality of the danger he faced.

A committee of French patrons supporting Fry was formed in May and included Matisse, Cendrars, and André Gide, but Fry knew that he would soon be expelled for helping so many Jews. On 7 May (Chagall chose the date because seven was his lucky number) Chagall and Bella left Marseilles for Lisbon by train, stopping at Madrid and arriving in the Portuguese capital on 11 May. Not all who took this route had so smooth a journey; Walter Benjamin committed suicide in September 1940 when he was held up on the French-Spanish border. And the Chagalls had timed their departure extremely finely: on the morning they left, 7 May, police trucks swept through Marseilles searching for refugees in hotels and restaurants, rounding up fifteen hundred and taking them to the port, where they were herded on board the *Massilia* and interrogated for three days. Three hundred were released; the rest were deported for forced labour in France or North Africa.

In Lisbon the Chagalls waited a month for the boat to New York. Bella, close to collapse, was convinced that she would never see Europe again and made Chagall promise that if she died in America, he would bring her body back to France.

Ida and Chagall, Marseilles, 1941

Meanwhile crates and cases containing Chagall's paintings, weighing a total of thirteen hundred pounds, were delayed in Spain; Ida worked frantically with French, Spanish, and American contacts to move them. She and Michel returned to Gordes in June; stripped of their French citizenship on 16 June 1941, they were now in danger. French policemen appeared at their door to demand the return of their papers; one was sympathetic and gave Michel twelve hours to find the documents. He rushed to Fry in Marseilles, who was

helpless; exit visas were refused to Frenchmen of military age. Fry reckoned that Ida and Michel would be stuck in France for the war.

Waiting in Lisbon and later during the voyage, Chagall, unable to paint, expressed his grief and fear by composing poems in Yiddish. "A wall grows up between us / A mountain covered with grass and graves," he opens "In Lisbon Before Departure":

> *Have you ever seen my face—*
> *In the middle of the street, a face with no body?*
> *There is no one who knows him,*
> *And his call sinks into the abyss.*
>
> *I sought my star among you,*
> *I sought the far end of the world,*
> *I wanted to grow stronger with you,*
> *But you fled in fear.*
>
> *How shall I tell you my last word,*
> *You—when you are lost.*
> *I have no place on earth*
> *To go.*
>
> *And let the tears dry out,*
> *And let the name on the stone be wiped out,*
> *And I, like you, will become a shadow,*
> *Melt like smoke.*

A note, written in French in Lisbon on 1 June on extra-thin paper to Solomon Guggenheim to thank him for making his departure possible, had a beleaguered tone: "I am happy to count you—at least I allow myself to think so—among the friends of my art. That moves me and gives me courage." To another American correspondent Chagall wrote, "Here in the harbour close to the ship, I discovered hundreds of my Jews with bag and baggage. I have never experienced such a sad event as when an author and his heroes take the same ship." In mid-June, along with many other Jewish refugees, he and Bella sailed for New York on the Portuguese SS *Pinto Basto,* not knowing whether they would ever see Ida, his paintings, or Europe again.

America

New York, 1941–1944

The Chagalls landed in New York on the evening of 21 June 1941. Pierre Matisse, the artist's dealer son, met them at the dock, offering them a link with the old world. Chagall and Bella stayed first at a hotel on East 57th Street, where Pierre had launched his gallery in 1931–two rooms on the seventeenth floor of Walker and Gillette's sleek art deco office block, known as the Fuller Building, around the corner from MoMA, which had opened two years earlier on West 53rd Street. Pierre was then far from the famous dealer he would later become–most people leaving the elevator at the seventeenth floor headed not for his gallery but for the Christian Science reading room next door, the *New York Times* art critic John Russell remembered–but he was a comforting, civilised presence, offering taste, refinement, superb food, and intelligent conversation. In this small hub of contemporary art, the Chagalls experienced a brief whiff of a celebrity welcome: Solomon Guggenheim and his wife Irene Rothschild-Guggenheim took them on a boat trip around Manhattan; Hilla Rebay supplied a car and driver to help find them a home.

Chagall likened New York to Babylon but was impressed enough by its pace and frenzy to pose for a street scene photograph in which he strides purposefully, arm raised in victory, the new arrival determined to make his mark in the new country. Bella, conscious as ever of appearances, took him to what they dubbed the "pederast" shop on Lexington Avenue, where they spoke French, and kitted him out in summer shirts in chequered mauve and pink, green and yellow, and velvet jackets in plum and ultramarine. Over the next three years, to repay his benefactors, Chagall would give lectures and

Chagall, New York, 1942

speeches in which his faux-naïve charm swung into play. "It has often been said that I create dreams in my painting," begins one note of thanks among his American papers, with a painstaking phonetic spelling of the English words he would include. "Alas, I have never been able to transplant them in my life. But isn't my arrival in New York a dream? And isn't New York itself a marvellous dream? But it isn't I who created this dream–it is you. And it is all of you whom I have to thank, you who gave me the chance to come to see this dream and admire it: which I do with all my heart."

Much of this, however, was putting a brave face on doubt and homesickness. "Grateful but unhappy," the writer Annette Kolb's reply when asked how she felt about reaching the United States, summed up a common response of the European émigrés. But Chagall tried to be optimistic. At precisely the time of his arrival in New York–nine p.m. on 21 June East Coast time, five a.m. on 22 June in Europe–Germany invaded Russia. From his first moments on American soil, Chagall held on to this coincidence of timing as a hopeful symbol: America would provide his own haven just as Russia was perceived as the hope of saving Europe's Jews. America would not enter the war until the end of the year, but on 14 June German assets in America

were frozen and in August Roosevelt and Churchill signed the Atlantic Char-
ter. The long stress of living under a regime where they had been victim and
enemy vanished; the longer ambivalence about and resentment of the Soviet
Union fell away, too. Knowing no English and having no intention of learn-
ing it, Chagall became again the exile drenched in thoughts of his home-
land, gripped by the drama of the war unfolding in central and eastern
Europe. When he went out, it tended to be to wander the back streets of
Lower Manhattan to buy Jewish bread and gefilte fish and to converse in Yid-
dish with the small Jewish shopkeepers, many of whom originated from the
Pale and would talk endlessly about what was happening there.

"God knows what happens to Russia–our Vitebsk is burning," Bella
wrote to the Opatoshus in July. Vitebsk, regarded as the gateway to Moscow
as well as a major manufacturing town, saw particularly heavy fighting.
Minsk fell on 28 June, but the Germans were stopped at the Western Dvina
River for a week starting on 3 July; then Vitebsk was captured on 10 July and
became a German fortress. The city had flourished in Soviet times and by
1941 the population of the greater Vitebsk area was 240,000; a third of
these people were killed in the war or in German concentration camps, and
when Vitebsk was recaptured by the Soviet Army in 1944 after hand-to-hand
fighting, just 118 survivors emerged and fifteen buildings were left standing.
Russia's uneducated Pale Jews, who had been so well treated by German
invaders in 1914 that in many places they greeted the Nazis as friends, were
taken wholly by surprise by the brutality meted out to them. Few Russian
Jews ever forgave the Germans, and many internationally connected ones,
like Chagall, would not set foot in Germany again. "The Germans are not
human," wrote his friend Ilya Ehrenburg in a 1942 article that was later
credited with inflaming Soviet atrocities against German civilians. "If you
have killed one German, kill another. There is nothing jollier than German
corpses." Chagall wrote in an address to his native city after its liberation
that "I know I shall not find the tombstones or even the graves of my parents
anymore . . . When I heard that your heroic fighters were approaching your
gates, I got excited and wished to create a big painting, where the enemy
crawls even into my childhood home on Pokrova Street and fights you from
my own windows. But you bring him the death he deserved." The descent of
civilised Germany into barbarism he interpreted personally: the country
that had given him his first exhibition and made his name as an artist had
destroyed the world in which that art was rooted. "I hurl back in his face the
recognition and fame that he once gave me in his country. His 'Doctors of

Philosophy' who wrote 'profound' words about me, now came to you, my
city, to throw my brothers from the high bridge into the river, bury them
alive, shoot, burn down, rob, and with their crooked smile, observe it all
through their 'monocles.' "

In cramped hotel rooms the Chagalls stayed fixated, listening to news
from Russia. After Vitebsk, nearby Smolensk fell on 16 July as the Germans
marched east. From 20 August 1941 Leningrad was under siege; by Septem-
ber the Germans, having taken Kiev and murdered more than 30,000 Jews
there, were nearing Moscow. In October the capital was in panic, with civil-
ians fleeing on trains, buses, and trucks. On 7 November the traditional Rev-
olution Day parade was held in Red Square, and troops marched directly
from it to the front—now just forty miles away. From their families, which
included Bella's elderly mother and her brother Abraham in Moscow, and all
Chagall's sisters, there could be no word.

Overcome by the news from Russia, convulsed with anxiety over Ida,
whose whereabouts they could not trace, the Chagalls could not focus on
settling anywhere. Chagall could not imagine working in the city, so in July
they drove out to New Preston in Connecticut. But once there Chagall
moaned to Opatoshu in a note from the Lakeview Inn, "There is not even
half a Jew here. And who knows what they think of us (not very highly,
I fear). We eat like real Americans. That is, a cucumber is not sour but
sweet . . . I would like to come back to N.Y. . . . it is after all quite gloomy
here." They soon "came back from the Goyish place" to the city, staying first
at Hampton House on East 70th Street and then at the Plaza, to try to fix
visas for Ida and Michel, with which Solomon Guggenheim assisted them.
Privately, however, Guggenheim wrote to Hilla in July that Chagall should
be helped with discretion; he did not want Chagall dependent on him rather
than MoMA, which, he reckoned, would claim all the credit for having
invited him to America.

In early September the Chagalls heard that Ida and Michel had sailed on
the Spanish boat *Navemare* via Cuba; when they arrived, they had their own
tales of horror. They had managed to cross into Spain, where Ida had used
her French, American, and Madrid connections (a Prado curator) to release
the crate of pictures held up at Spanish customs. Michel's father had bought
them, at $600 each, two tickets for the *Navemare,* which was supposed to
sail from Seville. Ida and Michel joined the crowds of Jewish refugees, most
of them elderly—those over sixty-five were at that time still allowed to leave
Germany with five dollars per person—waiting for it. When it docked, it

turned out to be a cargo ship intended for freight and just twelve passengers, which had been converted to a passenger ship with bunks in enormous holds for twelve hundred people. Deemed unhygienic by the American consul in Seville, it was refused permission to sail for the United States and went to Cádiz instead, where it took on more passengers and acquired a sailing permit. By this time many of its passengers' short-term American immigration visas had expired. The *Navemare* docked outside Lisbon, and day after day passengers were escorted in groups in small boats to land to complete the slow process of renewing them at the embassy there.

Eventually the overcrowded, filthy, foul-smelling ship sailed; riots over bottles of water and fights for chairs on deck (the safest, cleanest place to sleep) broke out on the first day. Sailors raped the passengers, and there were rumours of orgies in the lifeboats. A typhoid epidemic erupted, and sixteen passengers died–their bodies were thrown into the sea after a recital of the Kaddish. Through it all Michel and Ida organised themselves into a group with two other couples who protected each other and tried to make sure lines for food and tea were disciplined, but it was red-haired, charismatic Ida whom many passengers remembered, for day and night she rarely moved from a large, high crate on which she sat, high up like a queen, protecting it from anyone who kicked or stumbled against it.

Zigzagging to avoid German submarines, the *Navemare* took forty days to cross the Atlantic. By the time it reached Brooklyn conditions were atrocious, and Ida was very sick, had heart trouble, and had to stay in bed. But the crate containing Chagall's paintings was safe–unlike most of the other passengers' luggage, which had travelled in the lowest hold and had got so soaked during the long journey that it was pronounced rotten and thrown into the sea by customs officers in Brooklyn. This was the *Navemare*'s last successful voyage: it was torpedoed by German U-boats and sank on the way back to Europe.

While Ida recovered and Michel, who spoke no English, struggled to adjust and find work, Chagall and Bella moved into a small apartment in Manhattan at 4 East 74th Street and began to entertain again: the Opatoshus, the Maritains, the Golls, and art historians Lionello Venturi and Meyer Shapiro were part of a polyglot Yiddish-Russian-French circle that to some extent re-created their Paris milieu. Venturi recalled at this time that while Chagall "has been and is still very much the rebel in art . . . he is still, too, one of the sweetest, gentlest and most frightened of men on earth." Only the cocoon Bella wove around him gave him the stability to return to

his work. "Bella succeeded in giving their small apartment an atmosphere of
European hospitality that was greatly appreciated by their friends," accord-
ing to Franz Meyer; after her death Meyer Shapiro used to sob at the memory
of her banana cake. Sunday tea with Yiddish-speaking Shapiro was a ritual,
eagerly looked forward to; religious festivals such as Passover, which the
Chagalls had marked in Paris with Bella's brother and his family, were cele-
brated with the Opatoshus. Throughout their social circles the mood of nos-
talgia was heavy. Goll was writing his poem "La Grande Misère de la
France" (which runs "Le ciel de France est noirci d'aigles"). Raissa, like
Bella, was writing her memoir—and included a lyrical evocation of her
Jewish-Russian childhood in Marioupoul; Raissa gave Paris, where she had
converted to Catholicism, the role of holy city that Jewish Bella reserved for
Vitebsk. "Paris," Raissa wrote,

> I cannot write your name, oh my beloved city, without a deep
> homesickness, without an immense sadness; you whom perhaps I
> shall never see again, you whom I have perhaps left forever. Oh
> city of great sorrow and of great love . . . symbol of beauty, oh
> monument of Christendom . . . You where the air is so light and
> whose grey sky is so soft, whose delicate symphony of monu-
> ments tells with such discreteness so long and tragic and marvel-
> lous a history.

Like the rest of his circle, Chagall remained rooted in the past. The moves
to Paris in 1911, back to Russia in 1914, and to France again in 1923 had all
prompted definitive changes in his style. Now for the first time a new coun-
try changed nothing in his art. America was too different, and he was too
old, exhausted, and shattered by world events—Ida brought terrible news
from some *Navemare* passengers who had been released from concentration
camps—and uncertain about his future, to rise to the effort of integration.
When he returned to his easel in autumn 1941, the defining characteristic of
his paintings was a darkness and draining of colour that reflected his and
Bella's depressive state. The themes were a continuation of those in the last
years in France: crucifixions, scenes of snowy Vitebsk in flames, the occa-
sional Eiffel Tower in moonlight. In *Descent from the Cross* Chagall
engraved his own name on the I N R I tablet at the top of the cross; in *Winter,*
against Vitebsk's wooden huts, the crucified Jew has the face of a timepiece,
and his body is enclosed in the frame of that recurring image, the grand-

Pierre Matisse
with Bella and
Chagall in front of
*Double Portrait
with Wineglass,*
exhibited at the
Pierre Matisse
Gallery, New York,
1941–42

father clock from Pokrovskaya. The suffering of war and persecution is universal but personalised in familiar motifs: an assertion of the self in the surroundings. But "for all his apparent resilience and energy, his work betrayed a definite disturbance and fatigue," wrote MoMA curator James Johnson Sweeney. "Little that was fresh appeared in his painting . . . Forms did not have the gaiety and assurance which had come to be regarded as characteristic of Chagall. His colours were not clear. There was a repetition of old conceptions, a lack of conviction."

There was, unsurprisingly, little market for this work in a New York art scene moving towards abstraction–Jackson Pollock would have his first solo show at Peggy Guggenheim's Art of This Century Gallery in 1943. Against some resistance Pierre Matisse had introduced Miró to New York in the 1930s, and the line from European surrealism, via the Armenian émigré

Arshile Gorky, to American abstract expressionism is obvious. American interest in the European émigrés of the early 1940s was thus focused on the surrealists, such as Max Ernst, or on the abstractions of Mondrian, whose work underwent a late-flowering renaissance in New York before his death there in 1944. Chagall's figuration, by contrast, looked too concerned with narrative, quaint, old-fashioned. Nevertheless Chagall was immediately taken on by Pierre Matisse in 1941; his gallery, where French rather than English was spoken and Paris was still regarded as the home base, was the natural gathering place for European artists in New York, and in time his stable included many major modernists: Giacometti, Léger, and Dubuffet as well as Miró and Chagall and the American Alexander Calder, who had spent time in Europe.

Dour, reserved Pierre was never a kindred spirit or an inspiration to Chagall as Vollard had been or as his postwar French dealer Aimé Maeght would be, but he was straight, loyal, and supportive. ("My artists made me," he always insisted when congratulated on stage-managing the rise of this or that reputation.) Most important, he understood nervousness and insecurity like Chagall's as inevitable corollaries of the artistic temperament. "I grew up as the son of a painter and with painters in and out of the house," he used to say. "I have always known that every painter, however successful, is haunted by what he believes to be the fickleness of the public. He is convinced that he will wake up one morning and find that nobody will ever want to see his work again. It is for the dealer to help him to overcome that fear." During a bleak time his backing was crucial in enabling Chagall to continue to work in New York.

Matisse's exclusive contract offered Chagall a regular income of $350 a month from 1 October 1941; it was raised to $500 in November 1943 and $700 in April 1947, the increases reflecting both postwar stability and Chagall's rise in status in America. When sales were good, Chagall got more. Pierre was also quick to reassure the artist by mounting exhibitions. "Marc Chagall Retrospective 1910-1914," concentrating on the popular paintings from Chagall's first Paris period, which could be interpreted as a forerunner of surrealism, was a canny choice: featuring twenty-one works, it ran from 25 November to 13 December 1941 and was the first Chagall show anywhere since the exhibition at the Galerie Mai in Paris in early 1940. In January 1942 Chagall was included in "Figure Pieces in Modern Painting," a group show with work by Balthus, de Chirico, Derain, and Matisse; a stagy photograph shows Chagall, his arm around Bella, who looks tense but immaculate

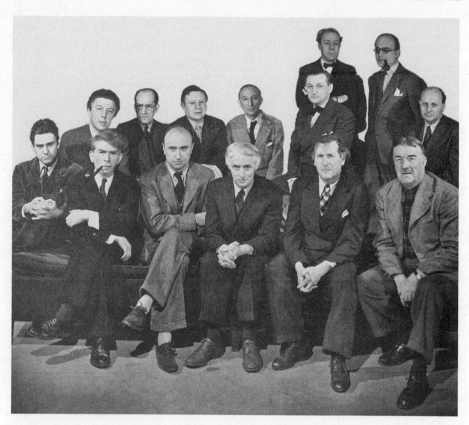

"Artists in Exile" at the Pierre Matisse Gallery, New York, 1942. Left to right, first row: Robert Matta, Ossip Zadkine, Yves Tanguy, Max Ernst, Chagall, Fernand Léger; second row: André Breton, Piet Mondrian, André Masson, Amédée Ozenfant, Jacques Lipchitz, Pavel Tchelitchew, Kurt Seligmann, Eugene Berman.

in a fur coat, standing on one side of *Double Portrait with Wineglass,* which depicts the couple in 1917, while Pierre surveys them and the painting with an air of calm authority.

Pierre was, his father said, the emperor of installationists: everything from the lighting and hanging to the catalogue and invitations was always perfectly executed. Never was this more stunningly apparent than at his next show, "Artists in Exile," in March 1942: it was a legendary assembly of the talent that had flooded into New York and juxtaposed artists who rarely if ever would have shown together in Europe. They included those who had crossed paths with Chagall at every stage in his life—Ossip Zadkine from Vitebsk, Jacques Lipchitz from La Ruche, Fernand Léger, fellow student at the Académie de la Chaumière in Paris in 1911, and André Breton and Max

Ernst, fellow travellers in the struggle to leave Vichy France in 1940-1. Now they were all washed up together along with Mondrian, Masson, French cubist Amédée Ozenfant, Russian surrealist Pavel Tchelitchew, and others. A famous group photograph of the fourteen suited artists is the very emblem of European high seriousness in harsh times. Chagall, who avoided and distrusted most of the other artists in New York as he had in Europe, sits, grim and ill at ease, in the front row between sturdy, pugnacious Léger and wiry, eager, white-haired Max Ernst–the French, Russian, and German middle-aged refugees of fallen Paris, all struggling in their own ways for survival.

Léger taught at Yale University; Ernst married heiress Peggy Guggenheim. Chagall's breakthrough came in the spring of 1942, when Russian choreographer Léonide Massine invited him to design the scenery and costumes, and direct the lighting, for a new production for the New York Ballet Theatre, *Aleko*, based on Pushkin's poem *The Gypsy* to Tchaikovsky's *Piano Trio*. It was an opportunity such as had not come his way since his work at the Moscow Jewish Theatre, and as in 1921, it came at a time when his fortunes had hit rock bottom. Now as then, he poured into this theatre project all his energy, knowledge, and hope, as well as the pent-up creativity of the preceding constrained years. Now as then, too, his work took fire as he set out to convey onstage, with striking modernist designs and high-pitched colour, the pathos of a passing world: as the murals had fixed on canvas the traditional Jewish life of the Pale as it was disappearing, so in *Aleko* Chagall and Massine brought alive the Russia of Tchaikovsky and Pushkin as their homeland struggled under Nazi attack.

Neither Russian had been in Russia for at least twenty years. By background and temperament Chagall and Massine were extremely different–the choreographer was aloof, introverted, formal, cold, and uncommunicative even to his troupe–but they shared a cultural understanding of the World of Art milieu of Diaghilev and Bakst in prewar St. Petersburg and Moscow and had met briefly in 1920s Paris. Massine, the son of a horn player in the Bolshoi orchestra and a soprano in the Bolshoi chorus, was born in 1896 and had been plucked from the Bolshoi ballet by Diaghilev in 1914; Bakst had depicted the beautiful youth in a portrait of that year, and Diaghilev, who had recently split from Nijinsky, briefly made Massine his lover. From 1915 Massine was a star of the Ballets Russes until 1921, when he, too, broke with the impresario to get married. He claimed that his time under Diaghilev was "a seven year period in which I have endured more than others will endure in a lifetime . . . I felt as though I was in a gilded cage which suffocated and

oppressed my entire spirit," though memories of the Ballets Russes would later reduce him to tears. His career as dancer and choreographer continued to flourish in London, New York, and Paris, where he worked with Picasso, Braque, Derain, and Matisse and counted many émigré Russians, including Larionov and Goncharova and Sonia Delaunay, among his friends. His work incorporated Russian folk dance and his last recollection of his father, visiting him in Italy as late as 1930, was that "every evening at sunset he would stand out on the patio, playing his French horn, and I shall always remember him, sunburned, white-haired but still erect, as he played us the lovely old Russian tunes which were part of my childhood."

Diaghilev loved to educate the young men in whom he was interested and made a point of taking them to galleries, to which Massine had responded with fervour and understanding. By the early 1920s he had amassed a fine collection of modern paintings. "I should very much like to come see your pictures, especially your Braque. Also to see you," Lady Ottoline Morrell wrote to him in 1922. As a choreographer, Massine was much criticised as a despot and an obsessive—"I did not ask of dancers what I did not ask of myself" was his justification. But this combination of pictorial sensitivity and unflinching dedication made him a perfect match for Chagall. Thus every day through June and July 1942, as terrible news came of the German victory at Sevastopol, the drive towards Stalingrad, and the mass murders of the Jews in the east, the two artists locked themselves away in Chagall's studio with the gramophone playing Tchaikovsky to work out the theatrical conception of *Aleko*.

Chagall's sketches incorporated detailed notations on the choreography (which included wild gypsy folk dances, stylised Russian dances, and classical pas de trois) and the action, as "the two Russians in exile forged a bond that would rise to a special level of intimacy," according to Massine's biographer Vicente García-Márquez. Crucially, thanks to his training with Diaghilev, pictorial design was an essential part of Massine's choreography: take away the designs, Frederick Ashton used to comment, and the ballets failed to work. Thus, "choreographer and painter worked as one and Massine submitted to the influence of Chagall's pictorial vision of the action in every smallest detail," says Franz Meyer. "For Chagall and his wife the months spent working with Massine were among the happiest of their stay in America and years later a few bars of the Tchaikovsky *Trio* sufficed to evoke the wonderful unison of that period."

With a cast of acrobats, clowns, and street dancers, *Aleko* is the tragic

story of a youthful hero who tires of the city and leaves it to join the gypsy Zemphira at her camp. Soon she rejects him for a new lover, despite his pleas that she return. In the finale a delirious Aleko summons visions from his past as the line between reality and fantasy vanishes, and he kills the lovers. Zemphira's father banishes him, and he is condemned to a life of wandering. "I hope that my dear friends and all other friends in America will see this ballet, which I made thinking not only about the great Russia, but also about us Jews," Chagall wrote to Opatoshu. At this point in his own exile, the romantic ballad of the steppes had for him the quality of a dream from a lost world. Taking familiar motifs from his paintings, he transformed them to reflect the spacious flowing movements of Massine's choreography and lavished onto four large backdrops the lush colour that had until recently been drained from his work. For the opening panorama, a purple rooster–phallic symbol of passion–storms through disturbed cobalt clouds while lovers embrace beneath Pushkin's pearly white moon, reflected in a lake; later scenes show a violinist-bear floating above a tilted village, a monkey swinging from a lilac branch, a golden cornfield with a fish head, and a peasant's scythe surging from the grass below two enormous bloodred suns; finally a doe-eyed white horse with chariot wheels for its back legs soars over a burning town into a black night sky illuminated by a golden chandelier.

The groundwork for this scenography was laid in New York, but it really took its shape–and especially its intense colour–in Mexico City, where at the invitation of the Mexican government the ballet was to premiere at the art deco Palacio de Bellas Artes, with its sumptuous Tiffany proscenium. Chagall and Bella travelled there with Massine in early August 1942, and they found the splendour of Mexico's violent colour contrasts, the hard sun, and the luminous nights deeply restorative after New York's greyness. All this found its way into *Aleko*. "Chagall's decorations are burning like the sun in heaven," reported Bella.

The Chagalls stayed first in the San Ángel district, an artistic colony on the city's fringes, then moved to the Hotel Monejo, close to the theatre. Massine, stiff in shirt, tie, and tightly buttoned-up suit and with sweat rolling down his face, rehearsed the company at the Hotel Reforma, while Chagall, bohemian in a new striped jacket in many colours that Bella bought him on a shopping trip, worked on the backcloths at the Palacio. Bella set up a studio in the theatre and made more than seventy costumes, which Chagall then decorated. Chagall saw in a stage costume not so much a garment as a representation of a character's physical and moral attributes. In Moscow in

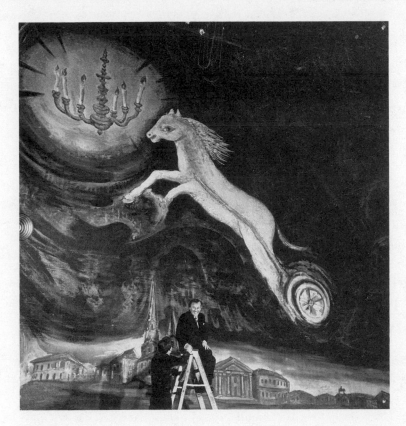

Chagall and the dancer George Skibine in front of the backdrop for the last act of *Aleko*, 1942

1921 he had thus transformed not only the appearance of Mikhoels but his entire role. Now he did the same for the heroine Zemphira, played by London-born Jewish dancer Alicia Markova, who was renowned for her purity of line and classical simplicity of movement. Now she was reinvented as a tempestuous fury, with sunburned makeup, wild hair, and a vivid red costume—a shock to audiences used to her *Giselle* and *Swan Lake*.

As at the Jewish Theatre, the Chagalls lived at the theatre day and night in the weeks before the premiere, and as before, he whined about the unfavourable atmosphere, the careless administration, and the lack of polish. But when the curtain went up at the Bellas Artes on September 8–Diego Rivera was in the audience–the undisputed glory of *Aleko* was the decor. Spotlights behind the backdrops accentuated the impression of the figures as charging into the sky and made the moons looks as if they were painted on stained glass: the entire production was a hallucinatory fantasy whose few naturalistic touches only highlighted the unreality. The audience was overwhelmed and gave nineteen curtain calls; Chagall, hiding in the bowels of

the theatre, was dragged out onto the stage to thunderous applause and repeated screams of "Chagall! Bravo Chagall! Viva Chagall!"

The triumph was repeated with New York audiences when the production transferred to the Metropolitan Opera House on 6 October; the critics were more ambivalent, but no one questioned the brilliance of the backdrops. So dominant was Chagall's input that the god of New York dance critics, Edwin Denby, wrote that *Aleko*'s only real subject was the decor; he also noted the sadness that pierced the phantasmagoria of colour, suggesting that the horse in the sky in the last backdrop was sadder than anything occurring onstage.

With hindsight, one can see that the *Aleko* scenography was a turning point not just for Chagall in America but for the next four decades of his work. America had delivered what France in two decades had never managed: the scope for monumentality. From now until the end of his life, Chagall would be irresistibly drawn to a stage, a ceiling, a wall, a cathedral window. It is surely symbolic that when he arrived in both Berlin and Paris in 1922 and 1923, he turned inwards, to an art of the book, in order to assimilate; in America, where he was ostensibly more the outsider, he embraced the large scale as the new country reawakened possibilities, dormant since Moscow's murals, that would shape the rest of his career.

In the short term, however, Chagall's buoyancy soon collapsed. By mid-September he was complaining in a letter to Pierre Matisse of exhaustion, the climate, and the food; he felt numb in Mexico and longed to get back to New York, though he feared for the exhibition that Matisse was organising of his recent work and pleaded for it to be delayed. Matisse ignored him and showed two dozen works of the last ten years in a show running from 13 October to 7 November, which attracted interest and reviews, though sales were poor. For Chagall it was important that the show, which coincided with the twenty-fifth anniversary of the Russian Revolution, include his 1937 painting *Revolution*. The Yiddish Communist newspaper *Morgn Frayhayt* reviewed the painting sympathetically, and Chagall responded with a letter of support for the Red Army and his Soviet friends and colleagues. This may have been a naïve attempt to reconnect with the Soviet Union–he had never given up hope of being invited back on a visit–but there is no doubting the sincerity of his claim, in the letter, that he could not assimilate in any other country.

The Russian bond further strengthened in 1943, when his old friends Solomon Mikhoels and Itzik Feffer visited New York as representatives of

the Jewish Antifascist Committee, which Mikhoels had formed in 1942 in Moscow; Feffer, a military reporter and a lieutenant colonel in the Red Army, was vice chairman and a popular Yiddish poet whose work was widely translated into Russian and Ukrainian. Theirs was an extraordinary, unprecedented visit in the middle of the war. Feffer and Mikhoels had come for the purpose of drumming up funds and support for the threatened Jewish people of the Soviet Union from wealthy Jews in the United States, and they did so successfully. At a mass rally at New York's Polo Grounds they addressed fifty thousand people, and their efforts made a substantial contribution to the $45 million that the Soviet state received during the war from various Jewish organizations, most of them American.

But the visit had another dimension. A committee of American Jewish Communists welcomed Mikhoels and Feffer on their arrival, and many people rightly suspected the Russians of being on a spying mission. Feffer was widely assumed to be an NKVD agent who prevented Mikhoels from talking freely; FBI papers later revealed that Mikhoels, with an interest in a scientific report prepared by a Russian physicist concerning the theory of atomic structure, was the more important spy. Among the high-profile Jews he met in America was Albert Einstein, honorary president of the Committee of Jewish Writers, Artists, and Scientists, which had been founded in New York in 1942 in response to Mikhoels's Moscow organisation and of which Chagall was a member. But Feffer had indeed joined the NKVD in 1943. Thus both artists were spies, each inhibiting the other: a microcosm of Stalinist society.

Feffer and Mikhoels arrived on 17 June 1943. In May the Warsaw ghetto had been annihilated: Feffer's epic poem *Di Shotns fun Varshever Geto* (The Shadows of the Warsaw Ghetto) was a tribute to the 750 Jews who lost their lives rebelling against the Nazis. On 11 June Himmler ordered the liquidation of all the Jewish ghettos in Poland. The destruction of Jewish life in Poland was inevitable, and it was generally perceived that only the Red Army could halt annihilation farther east. Already the tide had turned on the eastern front: the Nazi defeat at Stalingrad in February was a marker, with Soviet troops retaking Kharkov in August and Kiev in November. For Chagall, the rumours about spying were irrelevant: it was self-evident that he and Mikhoels and Feffer were on the same side, opponents of the destruction of their people. The visit of Mikhoels and Feffer, with their raw news of Russia at war, was the highlight of 1943 for him, and he saw them almost every day during their three-month stay; photographs show them clowning

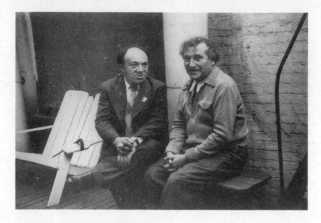

Solomon Mikhoels and
Chagall, New York, 1943

and laughing together, though an edginess to the Russians, always watched
by each other and by other Stalin spies in New York, is also apparent. "From
up close they are very good Jews," Chagall wrote to Opatoshu. "In any case,
I think it not necessary to 'criticize' them—they are our kind of Jews." Cha-
gall may have been naïve, but his instincts were closer to the truth than
those of suspicious American anti-Communists: Mikhoels (in 1948) and Fef-
fer (in 1952) were both murdered in Stalin's postwar anti-Semitic purges—
Jewish victims, not Soviet aggressors.

By the time Mikhoels and Feffer went home in October, they had charmed
many prominent Americans—notably the singer Paul Robeson—into friend-
ship, and they had seduced not only Chagall into a romantic attachment to
Russia more intense than ever, but Ida as well. At twenty-seven, with her ele-
gant figure, flawless style, and abundant, thick red-gold hair, sometimes
worn in pigtails to make her look more girlish, Ida cut a dashing figure in
New York. The move to America had given her confidence and strength, as
had the reversal of roles by which she now looked after her parents rather
than vice versa; her marriage to Michel Rapaport, however, could not sur-
vive the upheaval and the new stimulus. Ida was still trying to become a
painter but had a full and chaotic social life; Michel meanwhile had learned
English and found a job broadcasting (in French) to Europe with Pierre
Lazareff's Voice of America; hoping that his parents were still alive and in
France, he took the name Michel Gordey—from Gordes, Ida and Michel's
last home there—as a signal to them. He was preoccupied with his exciting
new career, leaving Ida free that summer to pursue an affair with the hand-
some, charismatic forty-three-year-old Feffer. He had known her as a little
girl in Moscow, and something of her adoration for her father must have

been transferred to her passion for him, as well as the glamour attached to the Russian heritage that the visitors represented. All the Chagalls felt bereft when they left: Chagall gave them two pictures and a letter to Russia, dedicating the works to his fatherland.

All Chagall's bitterness towards the Soviet Union now evaporated. Jewish and Western culture, he said in a speech to the Committee of Jewish Writers, Artists, and Scientists, had been defeated by Hitler, but while "Christian humanists . . . with few exceptions . . . are silent," in his homeland "a new sun has risen, red as blood and teeming with life–the great Revolution in Soviet Russia.–And the world looks at this sun, whose red colour drives you crazy and irritates the enemy. But isn't this sun our hope? The Jews will always be grateful to it. What other great

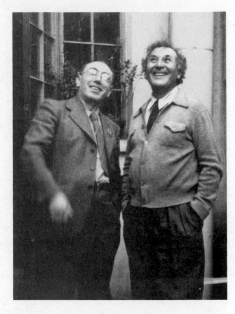

Itzik Feffer and Chagall, New York, 1943

country has saved a million and a half Jews from Hitler's hands, and shared its last piece of bread? What country abolished anti-Semitism . . . All this, and more, weighs heavily on the scales of history."

Bella, listening in the audience, whispered to a German-speaking friend that Chagall's speech was like a prayer. Engrossed in finishing her memoir, *Burning Lights,* she was suffused by memories of Jewish religious life. Her letters of this period are compact and sad ("Horror to think what happens in this world") and suggest an emotional landscape hemmed in by grief and the past. Installed at a desk in the bedroom of the New York apartment, looking out at the Manhattan skyline, she recalled "Father, Mother, the two grandmothers, my handsome grandfather, our own family and others, weddings and funerals, rich and poor, our streets, our gardens–they all float before my eyes like the deep waters of our river, the Dvina. My parents' house no longer exists. Everything, everyone is dead or gone." She was tormented by not knowing the fate of her mother, about whom the Moscow visitors could tell her nothing, about her favourite brother Yakov, and about Isaac, her elder brother stranded in Nazi-occupied Paris. Yakov survived the war but suffered twelve years of deportation from Leningrad, where he had been dean of the law faculty at the university. Alta had in fact died in the spring of 1943, in her eighties–her grandson Boris, Abraske's son, a mathematician

and a product of Communist atheism (though after perestroika he emigrated to California), claimed that "superstition killed her" because she refused, during Passover, to eat leavened bread, which was all that was available in wartime Moscow, and thus she died of weakness and starvation. Bella never knew this, but she shared with her mother now a yearning for ritual and tradition. Chagall watched her sitting up late in bed, reading Yiddish books by the light of a small lamp, and confided to Opatoshu how Bella, despite her excellent Russian education, was writing in Yiddish because "she cannot in any other way." In tremulous, flickering prose she returned to the language of her childhood to evoke life in Vitebsk festival by festival, taking the reader through Jewish feast days–Sabbath, Rosh Hashanah, Hanukkah, Purim, Passover–as experienced by a child. She wrote in an airily rhythmic, lilting Yiddish style, a Hasidic mix of the spiritually exalted and the down to earth, full of prosaic, witty detail, for which there was no model, and whose easy flow belies the formal effort behind it. "She wrote as she lived, as she loved, as she greeted her friends. Her words and phrases were a wash of colour over a canvas," wrote Chagall.

Women writers in Yiddish were rare, and it is painful to read her diffidence when writing to the Opatoshus to thank them for correcting mistakes, which she saw as typical of an uneducated woman, to a chapter on Yom Kippur that was published in September 1942 in the journal *Idisher Kempfer.* Shyness had held her back from writing for years, Chagall told Opatoshu; only as she felt she was dying did the urge to create–to bear witness–triumph. Throughout 1943 she was aware that her health was deteriorating; Chagall, with optimism and creative confidence, once again assimilated to the new country through his work–in this case *Aleko*–while her strength faded, replaying, between 1942 and 1944, the familiar scenario as this final exile killed her will to live. Ida noticed that she grew weaker every month; she looks ill, frail, and stressed in photographs from 1943-44.

Her memoirs, bathed in a sentimentality about the Russian-Yiddish community, are nevertheless ambivalent, especially when she describes how, as a little girl, she ran to watch a wedding in the nearby reception rooms, lingering near the bridal throne, which has all the bittersweetness of the picture Chagall painted for Ida's wedding in 1934; each bride leaves part of her weeping heart on the old chair. She and Chagall had set out to escape together the restrictive horizons of Orthodox Jewry for a cosmopolitan shared artistic life. From the outside it looked as if those hopes had materialised: "Always present–watching, advising, refining–she supplied echo

and answer to artistic questions, formed contacts, removed obstacles," wrote Franz Meyer. But the subtext of *Burning Lights* is that being the light in the darkness for her husband during the long decades of exile was not entirely fulfilling. Bella's desperation for Russia rings out; in the final section of her notebooks, called "The Train" and written as the cattle wagons were shuttling east to the death camps, she describes Vitebsk's grand *belle époque* station and the thrill of waiting there:

> I'd always thought our town was at the extreme limit of the world. At the railway station, all the trains that came in at one platform were coming to Vitebsk, and all the trains that went out at the other platform were leaving from Vitebsk . . . But was Vitebsk at the beginning or the end of the world? . . .
>
> The waiting room was full of agitation . . . All the people there were waiting anxiously for their train. But they might hear the warning bell ring three times and still have to watch the train disappear without them: their destination had not been announced. So they'd start waiting all over again, as if for the Messiah . . .
>
> The engine roared, breathed out flames, and swallowed up carriage after carriage of passengers . . . The train was taking leave of our city in a cloud of smoke . . . I felt as if I were going home from a funeral. The train was on its way, and I was going back to the town as to a deserted house. Would the trees still be there? . . . Everything is silent, I thought. Is Vitebsk still there?"

These were the last lines of Bella's book. In America she had come full circle–Vitebsk was the beginning and the end of her world.

Decades later, after Chagall's death, one of the émigré friends whom they made in America, Anne-Marie Meier-Graefe, a painter who helped on the set of *Aleko,* claimed that she had an affair with Chagall at this point, with Bella withdrawn into her own world. The story was neither accepted nor dismissed by members of the Chagall family, although no other evidence for it survives.

Born Anne-Marie Epstein in Berlin in 1905, and always known by the nickname "Bush," she was the widow of the distinguished German art historian Julius Meier-Graefe, forty years her senior, and had also come to America in 1941. She spoke perfect French and had inherited Meier-Graefe's home, furnished with fine Berlin furniture, and his exquisite library of

inscribed Rilkes and Thomas Manns, at St. Cyr sur Mer. Meier-Graefe had championed the postimpressionists, been friends with artists and writers from Edvard Munch to Joseph Roth, and had written the first best-selling biography of van Gogh; as his young wife, Bush had absorbed the cosmopolitan Jewish-European culture that the Chagalls found familiar, and now her company made them feel less homesick in America. Small and round, with a friendly, cheerful face, Bush had none of Bella's physical grace, but she was intelligent and lively and soon became a close family friend—she would later share Ida's apartment in New York and be godmother to one of her children. She was known for her truthfulness and rigour; Chagall certainly proposed to her at least once, in the 1950s, and there is no apparent reason why she would invent an earlier affair. Maybe she confused dates, or exaggerated an important friendship into something more, or maybe she and Chagall were pulled together by the thrill and fiery mood of *Aleko* and she gave him consolation when Bella was most withdrawn.

Through 1943-44 Bella found New York unhealthy and longed for the country air, but when they drove out of the city, the effort was exhausting, and she never failed to comment on the lack of Jews in the country. "Here the only Jews are God Himself and . . . us," she wrote to the Opatoshus from Cranberry Lake in the Adirondacks in July 1943. "The food is American, the talk is American, nature—American-Russian, French-Swiss. A lake—as large as the sky and the air—strong and clean. This is the place to gather strength. But . . . in a week we are dragging ourselves again." The Chagalls spent several months in 1943 and 1944 at Cranberry Lake, where the birch trees, forests, snow, and panoramic lake country were sufficiently "American-Russian" to evoke their homeland; this landscape, transformed by memories of Vitebsk, characterises Chagall's paintings in these years.

The dark tonality that had marked his work since his arrival in America continued, but a new forcefulness followed from *Aleko.* Inspired by the ballet, he returned to his circus cycle with figures such as the mysterious bird-man-artist, with the old Vitebsk grandfather clock draped, Dali-like but imbued with tragedy, over his wrist like a rag, in the purple-whirling *The Juggler,* or the acrobat on a blazing steed above a bridal couple in *The Red Horse.* But the majority of his paintings continued to turn on war, his fears for Russia, and the Jews. In *War* a dead man lies, arms outstretched as if crucified, on a wintry street—Chagall's first mature work, *The Dead Man,* comes to mind here; around him soldiers advance with bayonets, houses with snowy roofs burn, a massive horse, echoing *Aleko*'s final backcloth, rears in

terror, and a Madonna sails through a fiery sky, her hair like flames. The burning sky and tumbling crucifix, peasant cart with crying child, and blue horse of *Obsession* refer again to world catastrophe through an image of Vitebsk. The twilight-blue *The Sleigh* has a man driving forward a sleigh whose runners end in a woman's face, framed by Bella's dark hair, wide-eyed and frightened; in *Sleigh in the Snow* a woman hurtles forward across an upside-down Vitebsk street. *In the Night* positions Bella as a bride and Chagall, painted in a caricaturelike style evocative of the 1917 painting *The Wedding,* on a snowy street, clasping each other beneath a huge hanging lamp such as the one in Chagall's early Jewish interiors *Birth* and *Sabbath;* the lamp brings the street scene indoors, locating it in the couple's shared memories of Vitebsk as they waited to hear news of its liberation, which occurred in February 1944.

The liberation of Chagall's other holy city, Paris, was eagerly awaited through 1944. In the most compelling of his American paintings, *Between Darkness and Light,* the vocabulary of Vitebsk–sleigh, snowy shtetl– combines with allusions to France in a painting that originated as a self-portrait and turned into a double portrait suffused with war and premonitions of personal catastrophe. The French title, *Entre Chien et Loup,* conveys better the sense of menace of this wintry landscape bathed in pale moonlight, with its surreal touches of a bird-Madonna and a lost streetlamp with legs crossing the road, but casting no light.

In the original canvas Chagall gave himself a pair of wings; in 1943 one wing disappeared in swirling snow, and Chagall's face became a blue mask, drained of personality. His palette is without colours, and against him on the edge of the picture presses the deathly face of Bella, who appears to have come from nowhere and to have no body. She is already a ghost; but she is wrapped in a red shawl, which fills the space that was the other wing and that lines up with Chagall's blue face and Bella's white one to form a French tricolor, standing out amid blue-grey-murky cream tones.

Bella and Chagall listened to the news of the Normandy landings and the liberation of Paris from a summerhouse at Cranberry Lake. "All around us– a lake, a forest with peasant trees–we want to draw strength from them," Bella wrote to Joseph Opatoshu at the end of a letter from her husband in August 1944. During these weeks, according to Chagall, Bella, "fresh and beautiful as always," was busy in their hotel room arranging her manuscripts, drafts, copies. " 'Why this sudden tidiness?' She answered with a wan smile, 'So you'll know where everything is.' All calm and deep presenti-

ment. I can see her again from our hotel window, sitting by the lake before going into the water. Waiting for me. Her whole being was waiting, listening to something, just as she had listened to the forest when she was a little girl."

She, even more than Chagall, was elated when news came, on 26 August, that Paris was free. The Chagalls planned to return to France as soon as possible, but before they could even get back to New York, Bella fell ill with a viral infection. Anxious not to be a burden, she made light of the sore throat at first but kept calling to Chagall for boiling-hot tea. When she became feverish, Chagall in a panic, marooned in the country, with no friends nearby and speaking not a word of English, telephoned Opatoshu (who told him to find a doctor) and Ida (who set out immediately from New York by train). It took her twelve hours to reach Mercy General Hospital, Tupper Lake, in upstate New York, which, because of wartime restrictions, had no penicillin to treat a simple streptococcus infection. Bella went into a coma; by the time Ida arrived, she was dead.

"The thunder rolled, the clouds opened at six o'clock on the evening of September 2, 1944, when Bella left this world. Everything went dark."

Virginia

New York and High Falls, 1944–1948

For six months the canvases in Chagall's studio were turned to face the wall, and he did not pick up a brush. It was the only time in his life when he was unable to paint, apart from the year of upheaval in Germany in 1922–23, when practical circumstances had made painting impossible. Now at Ida's apartment, he writhed on the floor, howling that he, too, wanted to die. At first he was too stricken to act and remained shrouded in grief, unable to answer telephone calls of condolence or the letters and telegrams that poured in, in Russian, Yiddish, French, German, English, unable to relate to the external world at all. "I do not know if I lived. I don't know / If I am alive. I watch the sky, / I don't recognize the world," began one of the poems he wrote soon after Bella's death. "I have never seen such sadness. But I don't want to try to lift your unhappiness. It is another way of being with her, of still feeling her around you," one of their friends wrote to him. "She was so warm, so kind, so alive, that it is doubly difficult for me to realise that she is dead," wrote Varian Fry. "My thoughts are constantly with you," wrote Bush Meier-Graefe, "and I know my words can't comfort you. I know what I have lost, for myself, so I must be silent when I think of your grief, but I have to tell you, what I can no longer tell Bella, I had such admiration for her, such love, and I know her genius [and] depth of soul . . . I will continue to live with her."

It was Pierre Matisse who sent telegrams to their friends about Bella's funeral, which took place at Riverside Chapel on 76th Street, New York, on September 6 and was attended by a large proportion of America's émigré community, who were shocked to see Chagall weeping uncontrollably. "At

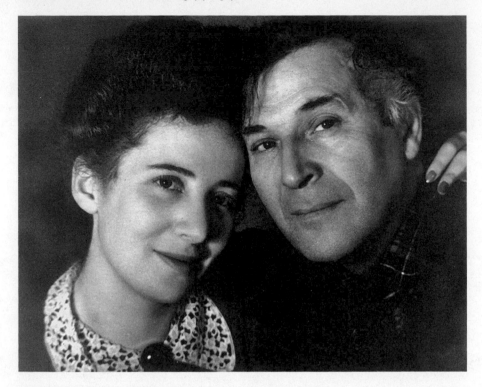

Ida and Chagall, New York, 1944-45

the funeral I saw him shattered, broken, tragic," wrote Claire Goll; sculptor Chaim Gross recalled that it was heartrending to see such a strong man sobbing like a baby. Kaddish was said on the next four Sabbath evenings at the Free Synagogue at West 68th Street, followed by a memorial service for two hundred invited guests, organised by the Committee of Jewish Writers, Artists, and Scientists, at Carnegie Chamber Music Hall on 6 October. Chagall on all these occasions leaned heavily on Ida, who herself was in a state of shock. "My dears, I don't know how to tell you," she wrote half a year later to her uncle Isaac Rosenfeld, on hearing that he and his family had survived the war, hiding in a cellar in Paris.

> Perhaps it was Fate that spared you all these months by not letting you hear about the resounding tragedy that broke us. We have remained alone, without our guardian angel, without Bella, without Mama. It is over. It is over . . . Papa cannot write. He isn't strong enough to write. You understand. He has suffered so much that I would like to spare him that torture of telling you . . . We

are living with Papa, we have been with him ever since and we live in the same apartment . . . Papa has been *very very* sick and it is a struggle every day to help him recover his strength.

Chagall's despair was tinged by guilt: had his inability to take Bella's illness seriously led to her death? Over the next year that fear metamorphosed into the invention—did he end up believing it himself?—of a story that shifted responsibility to a familiar enemy: anti-Semitism. According to this version, which has no substance, Chagall recalled,

We were having a holiday in the Adirondacks, and she suddenly got a bad sore throat . . . The next day she was so feverish that I took her to the hospital, and when she saw a lot of nuns in the corridor, she became upset. I must explain that in another place where we had been staying, in Beaver Lake, she had seen a sign saying that only white Christians were welcome, and she had been brooding on that . . . When she got to the hospital, they naturally asked for particulars—name, age—but when they asked "religion" she wouldn't answer. She said, "I don't like it here, take me back to the hotel." So I took her back, and the next day it was too late.

Thus, as news poured in through 1945 of the Holocaust at the European concentration camps, Bella took her place in Chagall's mind with the millions of Jewish victims. Maybe Chagall was trying to acknowledge a poetic truth: exile from Europe had sapped Bella's will to live.

What he did recognise was that in losing Bella he had lost his vital link to Jewish Russia and thus to the living inspiration for his work. If anything mattered now, it was his Russian connections: thus one of the few telegrams to which he did reply was that of Mikhoels and Feffer in Moscow. "Deeply moved your cable thanks from all heart stop Bella's greatest joy and aim was always loving devotion to fatherland art and deep friendship for you stop Cruelly wounded I want to believe that will find strength for more work and life stop embracing you all heartily faithfully your Marc Chagall," he wrote. Ida added, "Missing you bitterly stop Mamotchka dreamed of seeing you both again stop Your cable greatest comfort stop Living together with father stop Gathering all strength to help father and have him at work Always with you." Later Chagall wrote again to his Russian friends:

Your condolence–like rays which sprinkled from the sun. Some
lines from your letter and your friendship in the most tragic days
of my life I will never forget. I am grateful to you from all my heart
for your good attitude and delicacy–these are features of our
great motherland. You feel the depth of the abyss which is before
me, and the height of the sky where she, precious friend of my
life, my squirrel, is flying. If I must say to you this, you know this–
how she with her talent and soul, a daughter of our motherland,
was always faithful to this land.

To the elderly Pavel Ettinger in Moscow, with whom he had not corre-
sponded since the terror of 1937, Chagall wrote in April 1945, "I am sure you
have heard of my personal tragedy–on 2 September 1944, I lost her, who
was the meaning of my life, my inspiration. Now–as 'easy' and [un]clouded
as my life was, so it is now full of tragedies. I am lost." His sparse correspon-
dence for 1945 also included a naïve letter to Joseph Stalin; he was still hop-
ing for an invitation to Russia.

In the large apartment they rented at 42 Riverside Drive, overlooking the
Hudson River, Ida encouraged her father to work on the only project that
roused him from despair: publication of Bella's memoirs. Ida's marriage was
dissolving, Michel was often absent, and now father and daughter, who in
the sad, glazed-eyed photographs of that year incline together with the inti-
macy of a married couple, pored over the Yiddish text that Bella had dedi-
cated to them. "I write for you," she opened to Chagall. "Our town is even
dearer to you than to me, and you with your great heart will understand what
I haven't been able to say. The one thing that worries me is whether my little
girl, who spent only the first year of her life in my parents' house, will under-
stand. I dare to hope so." For Chagall, sorting out the notebooks, which
were incomplete, with the chapters unordered–it was his idea to arrange
them according to the Jewish year–gave him the illusion of hearing Bella's
voice, and with it the world of his childhood, again. His first creative work
after her death was the illustrations–twenty-five drawings, often no more
than sketchy outlines, whose airy rhythms complement and animate her
text. It was their last collaboration. Chagall began his condensed biography
of his wife with depictions of her as a little girl, her thick black hair tumbling
down her naked back at the Jewish bathhouse or sitting, absorbed in her
book, enclosed in a huge winged grandfather clock that flies over Vitebsk.
During the next few years he continued the sketches through to their meet-
ing on the bridge and Bella as a young woman, her face hovering over his as

Chagall, the cover image for *First Encounter,* depicting him and Bella as a young couple: his illustrations for her memoir, published after her death, formed their final collaboration

he stands at the easel. *Brenendike Licht* (Burning Lights), the first volume, detailing Bella's childhood, was published in 1945; *Di Ershte Bagegenish* (First Encounter), the second volume, appeared in 1947.

Ida's act of homage to her mother was to translate the text from Yiddish into French; *Lumières Allumées* was published in France in 1948. By early 1945 she had recovered her energy and was eager to return to Paris. During the next few months she and Michel were swept up in the postwar explosion of energy and optimism: while Michel, as a journalist with the Voice of America, "rushed in and out of the house all the time in tremendous haste," Ida was in her element with a vibrant social life, hoping to become an artist herself, making ambitious plans to build her father's reputation. Chagall described her to Ettinger as a very fine painter who was otherwise, luckily, quite unlike her father–though at other times he would boast that "she's more than a daughter . . . she's a real Chagall!" Crowds of her friends, some in GI uniforms, blew in for impromptu parties, and Chagall began to resume

social connections. "I have recollections of much coming and going, in an apartment on Riverside Drive where everyone spoke French, German, Russian or Yiddish besides English," wrote Edouard Roditi, who visited him at this time at a gathering that included Ivan and Claire Goll, Ossip Zadkine, and Alain Bosquet, editor of the magazine *Hémisphères.* At one such party, after guests had retired to the studio, a loud crash came from the dining room. "Marc got up slowly. 'It's all right, it's only *The Cattle Dealer.* I hung it up yesterday.' There was a large gash in the painting, and Ida remarked with a chuckle that if anyone else had hung it up, there would have been trouble."

Michel, hearing that his parents, too, had survived the war in France, left for Europe for a radio assignment. There came also the good news that his uncle and aunt Ossip and Leah Bernstein were alive; they had the keys to Chagall's Paris home and had, in 1941, risked saving the paintings that remained there, transporting them by horse and cart to André Lhote's house in Le Raincy, where they remained for the rest of the war. Chagall could not but be stirred by this news. In February he received a letter from the French art critic Jean Grenier, who had visited him in Gordes, and replied, "I am very miserable at this time. I have lost the one who was everything to me–my eyes and my soul. If I continue to create and live, it is because I hope to see France and the people of France again soon. My happiness, now, is the rebirth of France, which I had never doubted. How could one live without that certainty?"

As the news flooded in from Europe–both good and bad, liberation and victory, the revelations of Auschwitz and Dachau–it was also impossible for Chagall not to think of how he would have shared it with Bella. V-E Day was celebrated on 8 May 1945; six days later Chagall wrote to Opatoshu that

> despite all my thoughts about work, exhibition–I am still steeped in thoughts about [Bella]–[her] attitude toward Yiddish–toward art in all aspects. It seems to me–I am falling into pits on my roads, wherever I stroll or travel. I must cure myself of myself.
> If she could she would have said to me: let me rest in peace.

The instinct to survive was, with Chagall, inseparable from his drive as an artist. When spring arrived, he turned his canvases back from the wall and made the first tentative steps towards painting again, though in a photo-graph showing him at the easel, wearing one of the checked shirts Bella had bought him, his expression still suggests an emotional state close to col-

Chagall, 1945

lapse. "Papa is working; he has resumed his work after a break that was very hard to overcome. You know how he could always work only with Mama, with her devoted help," wrote Ida in March 1945.

The past is another country, and as when he had arrived in a new place, he had only one way to resume work: by recapitulating what had gone before, transformed by the new context. Between 1945 and 1948 Chagall's paintings emerged from several large canvases that he had begun in France and taken unfinished to America, which he now cut up or adapted. There were aesthetic reasons for changing these ambitious canvases that had not worked before, but the driving force was that Bella had been familiar with them, and he knew her comments, approval, reservations: thus her voice still reverberated in his mind, guiding and encouraging; without it, he could not have returned to his easel at all.

Les Arlequins, a canvas more than three yards wide, from his 1930s circus

cycle, was the first to be attacked. Packed with typical Chagall images–bride and groom, musicians and acrobat, goat-headed man with wings, flying Jew with a Torah, bouquet, Vitebsk's huts and domed churches, candle and samovar–its themes go back to the Moscow murals, and it must have appealed as an inventory of his and Bella's world. Although it was a chaotic composition, its focal point was a half-length portrait of a young Bella in a delicate rose costume with a fan; Chagall himself appears with his head upside down, the better to see, above him, a glassy globe containing a Vitebsk landscape.

Chagall sliced this canvas in half, making the globe the centre of *Around Her,* derived from the left part of the picture, while the right side became *The Wedding Candles.* Both new works were considerably overpainted, the mood darkened and intensified, the circus theme giving way to mourning. *The Wedding Candles* retained the winged goat's head, but the emphasis shifted to the wedding procession, now reminiscent in its melancholy, subdued colouration of *Russian Wedding* of 1909; the scene is lit, however, by an immense chandelier with flaming candles–suggested, presumably, by Bella's *Burning Lights.* In *Around Her* the bright, upright young Bella of 1933 becomes a sweeping lamenting figure; she and the upside-down Chagall are drawn closer than in the original version, framing the view of Vitebsk that is their common memory. The dark blue of twilight fading into night suffuses both works. "Of course I work. I just don't know what comes out of the working. Since Chagall is still as on his paintings–head upside down," Chagall told the Opatoshus in July, when he was concentrating on *Around Her,* adding, "Now the night is so hard that I crawl into bed to forget myself."

Neither picture is strong or holds together compositionally, and both– especially the blurry *The Wedding Candles,* whose images are as remote as a dimly perceived recollection that refuses to come into focus–herald a problem that Chagall's painting, in the absence of Bella, was to suffer from for the rest of his life: objects, portraits, and landscapes all lose the brilliant individuality, specificity of form, and commanding power that had made his images iconic in the past. These characteristics were inextricably linked to his relationship with Russia and the inspiration he took from Russian-Jewish life. Like almost all twentieth-century Russian artists, he did his greatest work before he left Russia for good. Kandinsky, Larionov, Goncharova, and many others all stalled or wilted once they left permanently; unlike them, Chagall had managed to draw inventively on Russian-Jewish

motifs for two decades after his departure. In the 1920s and 1930s it was as if, through Bella's solid presence and unwavering character, he continued to observe or feel Russia from life. As soon as she was dead, however, the lifeline to his homeland snapped, and as he fell back on fading memories, the definition of things and people in his paintings disappeared, replaced by a shimmering luminous haze of colour. But this tendency to abstract could not conceal the increasing weakness of his formal invention as, in the long term, memory slipped into sentimental nostalgia. Chagall was rightly accused of making mere pastiches of his earlier images. The paintings of 1944-48 show the beginnings of that dilution; compositionally, many of them also fall apart as Chagall, furious, frustrated, and lonely, pervaded by thoughts of lost happiness, grappled with large, unresolved canvases from his past.

To My Wife, which Chagall dated symbolically 1933-44, is almost a statement of the problem. A young Bella lies naked on a red divan in a Titian pose; she is physically vivid, but the well-known motifs around her—bridal couple, winged clock, donkey with candelabra, Russian village—are indistinct, not fully recoverable from the misty past. *The Black Glove* (1923-48), begun in Paris as a portrait of Bella as a bride accompanied by Chagall at his easel, is another confused, uncertain mourning picture where, above a Vitebsk street, the couple are fused, his arm encircling their single body with its full breasts, and shrouded in snow as in a diaphanous veil; his palette has replaced her hand and fan, and his easel has partly morphed into a clock (metaphor for his arrested art?) while Bella's gloved hand is left by itself in the snow, holding a book.

No Russian artist, writer, or composer who left Russia in the first half of the twentieth century entirely escaped the issue of an arrested style. The writer Nina Berberova spoke for them all when she said in Berlin in the 1920s that "our tragedy was our inability to evolve in terms of style," and Chagall in the late 1940s "often pondered whether that powerful heritage would continue to nourish him indefinitely." Among writers, only Nabokov, by a move as radical as changing language, was able to create a masterpiece—*Lolita*—in exile; his American naturalisation in 1945 was a statement of intent, of not looking back. Chagall, without Bella and with more complex, shifting allegiances, had to take on a challenge that was almost as great in order to triumph over the same problem: after 1944 he ceased to be innovative as an easel painter, but with extraordinary resourcefulness, he would over the next forty years find a vigorous new language in stained glass, pub-

lic murals, and theatre scenography. That theatricality was his salvation as an artist, and although it was anticipated from his earliest work–*The Dead Man* of 1908 was inspired by a Meyerhold staging–it was America that inspired him to the monumentality of his postwar oeuvre.

Beginning with *Around Her* and *The Wedding Candles,* the paintings of 1944-48 are in this context transitional works. By choosing to dissect or rework his biggest, most compositionally problematic canvases, Chagall was looking back to Bella but also forward to large-scale projects for cathedrals and theatres. His recent experience with *Aleko* came into play; in 1945 he was invited to design the American Ballet Theatre's production of *The Firebird,* and his lavish stage sets there had a decisive impact on his easel painting. The massive 1937 *Revolution,* with which he had never been satisfied–its ambivalence struck at the heart of his own tormented relationship with Russia–was cut into three during this period, and the figure of Lenin was replaced by a crucified Christ, with whom Chagall identified. He also turned his attention to a second large painting called *Arlequins,* symbolically dated 1922-44 and reminiscent, with its figures of writer, musician, acrobat, and dancers, of the Moscow murals–the figure of Chagall is even carried onto its "stage" by a peasant. Most indicative of his pull towards the theatre in these years was the completion of the problematic *The Falling Angel* (1923-33-47), which in its American revision came to resemble the scenography for a play: the jagged red angel shatters the stagy darkness and scatters Chagall's terrified dramatis personae (rabbi with Torah, purple crucified Jew, cow with violin, green-faced Jew with stick) to the edges of the canvas. In Paris in 1923 this harsh, dissonant canvas had been inspired by the violence of the Russian Revolution, from which Chagall had fled; in 1933 he had altered it, darkening the sky and tightening the rhythm, in response to the Nazi threat; now it encompassed world events of 1939-45 but above all his own exile–without Bella, from the world of their youth. The angel falling to earth must find an identity: what would his be now?

T he first of these canvases, *Around Her,* was on the easel in June 1945 when Ida, worn out from Chagall's demands and from her own marital problems, cast around for someone to care for her father while she took a holiday. In the immediate aftermath of Bella's death, thrown together without her stabilising presence, father and daughter had an emotional relationship that was complicated by Ida's demands for part of her mother's

inheritance or its equivalent in paintings. Chagall considered these demands outrageous, but the law was on Ida's side, and the two lawyers among their New York friends, Louis Stern and Bernard Reis–both Chagall collectors–discreetly supported Ida. The quarrels were loud and bitter, and at one point Chagall tried to throw a chair at Ida. After another tiff the housekeeper left: Chagall still spoke not a word of English, and when he made drawings to indicate what he wanted done, she could not understand him.

As inevitably as he returned to painting, Chagall, once he emerged from paralytic despair, began to look for a woman who would mother him and provide sexual companionship. The traditional Jewish one-year period of celibacy following the death of a spouse was not yet over, but he asked Bush Meier-Graefe to move in anyway. She turned him down: living off the sale of Meier-Graefe's pictures, she could afford to be independent and was savvy enough to realise that following in Bella's footsteps would be crushing. As Meier-Graefe's wife, she knew about the disadvantages of marriage to a famous older man with a giant ego.

Then in Central Park a friend of Ida's met an educated young English-woman with a child, who had fallen on hard times and was in need of a job; her Scottish husband, John McNeil, was a failed painter suffering from depression and unable to work. When she came over to 42 Riverside Drive to darn some socks–one of the few practical skills that Bella had failed to teach her daughter–Ida asked her to pose for a sketch.

Ida saw a very tall, very thin woman of thirty, upright and erect in her bearing, with a long face, straight long brown hair that was lank but neatly cut and fringed, and a hesitant look. Her daughter, aged five, with the same haircut, stood demurely at her side and looked like a miniature version of her mother; they were inseparable, as Jean could not be left with her unpredictable father.

Virginia, gazing at Ida, saw "a handsome woman with abundant curly hair of a reddish gold, like Titian's Flora, turquoise blue eyes and a wide Chagall smile with the same perfect teeth.

> She spoke in an elegant manner and walked with a dainty mincing step. Some of her pictures stood around the walls; they were delicate, vaporous paintings that tried modestly to shine with sincere conviction. Over her head a large painting [*Nude over Vitebsk*] by her father showed her naked in a cloud of white drap-

ery, floating over the town of Vitebsk. I thought she was coura-
geous to work under a picture by Chagall.

The Cattle Dealer hung in the dining room; around the apartment were
other works from Russia and the first period in Paris: *Russian Wedding, The
Studio.* On a high stone mantelpiece above the fireplace stood Chagall's
favourite picture of Bella as a young girl: "pale oval face with enormous
eyes, dark hair tied behind her head."

Virginia, the daughter of a British diplomat, Godfrey Haggard, who had
been posted to France, then the United States, explained that she had once
met Chagall at an embassy reception in Paris in the 1930s. Born in Paris, she
had studied at various art schools, including La Grande Chaumière–which
Chagall had attended twenty years before her; she had known Giacometti,
Miró, and Max Ernst. Then she had rejected her privileged background,
broken with her parents, and thrown in her lot with her painter husband,
who had Communist sympathies and no ability to make a living. She spoke
French fluently. Ida engaged her on the spot as the new housekeeper and led
Virginia into the studio, where the smell of linseed oil and turpentine
brought back memories of her own days at art school. Among giant plants a
mobile of a figure with a man's body and a goat's head by Alexander Calder (a
gift from the artist after Bella's death) swayed gracefully against large win-
dows giving a view of the glittering Hudson. Chagall greeted Virginia with
the dazzling smile she remembered from Paris, "but the eyes had lost some
of their shine. They were misty, and the lights in them flickered like candle
flames. His soft, fuzzy greying hair stood out in three tufts like a clown's
wig . . . he nodded approval . . . and went back to his easel. His softly shod
feet took short steps, and his sturdy figure was supple and light. He was
wearing sagging trousers and a many-coloured striped tunic, open at the
neck."

Over the next few days she watched him struggling with *Around Her:* "as
he worked, his face was tense and painful. He seemed to be in a sort of rage,
as if he were trying to put something back into the world that had disap-
peared with Bella." With her daughter at her side, Virginia cleaned Ida's
part of the house; Ida, reassured by the calm and order, then departed.

Soon Chagall and Virginia were lovers. Chagall told her that "it was Bella
who sent you to look after me. Rembrandt had his Hendrickje Stoffels to
console him after Saskia's death; I have you." Virginia was young, pretty,
friendly, open-minded, and refined in manner–Chagall was only ever

Virginia McNeil

attracted to upper-middle-class women–and easily available; according to her account, she flirted with him almost immediately by asking why, in the seething New York summer, he did not remove his shirt: " 'Because I have a hairy chest,' he said. 'But I like hairy chests,' I told him." For her, the choice was between a miserable bully of a husband who had crushed her spirit and with whom, she claimed, she had not slept for five years, and one of the world's most famous, charismatic painters, in the affluent setting of River-side Drive. It was no contest. The relationship, begun with stolen kisses in the bedroom while Jean ran around the studio, was kept secret from both their daughters: Jean was shuffled out of the way to a local nursery school; before Ida, Virginia continued to address her new lover formally as "Monsieur Chagall" and to remain in the kitchen, from where Ida graciously invited her in for a glass of vodka at the small party she gave for Chagall's fifty-eighth birthday in July. But she sensed the familiarity between them and probably rejoiced that it gave her breathing space. That summer she took a house in Sag Harbour on Long Island for herself and Chagall and asked Virginia and Jean to accompany them.

The house had big rooms with threadbare carpets, an oak staircase, and a wide balcony that linked all the bedrooms together, so Virginia could slip easily out of her own and into Chagall's room at night. Once Jean woke and, finding her mother gone, screamed in fear; Virginia ran back to her room just as Ida was coming out of hers, and the two young women bumped into each other in embarrassment. Virginia was still officially housekeeper and cook, but when she overseasoned the soup, Chagall's son-in-law, Michel, called to the kitchen, "They say that when you put too much salt in the food,

it means you're in love!" On another occasion, after a brief trip back to Manhattan to visit her husband, Virginia returned to Sag Harbour covered in purple powder that someone had thrown at her through the train window, and Ida insisted on sponging her down in the bath. "Comme vous êtes belle," she said spontaneously. On beachside picnic parties, with Jean running in and out of the sea, a wary friendship began between these two women; just a year apart in age, they had much in common—both were at a crisis point in their marriages, both had wanted to be painters—but were also so different. "Ida was kind to me, but our relationship was bound to be delicate," wrote Virginia.

> I admired her strong personality, her excellent intellect, and her sense of humour, but she made me feel ill at ease. Sometimes she scrutinized me until I was completely out of countenance and blushed hotly. She was seductive and charming, but I didn't know what she was really thinking. I was awkward, naïve and inhibited; she was emotional. Marc avoided speaking about me, and Ida was discreet.

But in New York the secret was out when Virginia, under questioning, confessed to her husband; he threatened suicide, she briefly left Chagall and packed up from Sag Harbour, then returned a few days later, taking the confused Jean back and forth with her. Ida was edgy and cleared out, leaving the new lovers alone.

That summer Chagall was working on the designs for *Firebird,* to open in New York in the autumn. The project took him back to his earliest artistic associations. Diaghilev had commissioned the score from the young Stravinsky in 1909 for the Ballets Russes; the choreography was by Fokine; and Chagall's old friends/adversaries Bakst and Benois had played an influential part in the conception of the piece, based on a Russian folk tale about a princess held captive by a magician and freed by a prince with the help of the enchanted, dangerous Firebird. In 1926 Diaghilev had commissioned new sets from another Russian rival, Natalia Goncharova; it was satisfying, therefore, that when Stravinsky made a new version of the score in 1945, to be choreographed by Adolph Bohm, Chagall was regarded as a draw as the new designer.

The new stimulus was what he needed, and *Firebird* was the first project in which he abandoned himself after Bella's death. Drenched in Russian cul-

ture, it brought him back to the world they had shared—yet his designs for the fiery love story took a fresh erotic charge as he worked with Virginia at his side. Tamara Karsavina, the original Firebird, told Margot Fonteyn, when she coached her for the role in the 1950s, that this was the most tiring ballet she would ever dance; she must forget her graces before the rebellious, unmanageable Firebird. The ballet's passion echoed Chagall's own emotional turbulence; he was still in mourning, but he was also liberated, after three decades of marriage, from having to live up to Bella's high expectations and from immersion in Russian-Jewish nostalgia, to embark on a sexual adventure with a young goyish woman twenty-eight years his junior, who towered over him and whose origins, values, and belief systems were completely, excitingly unfamiliar.

A poem Chagall wrote at this time was doubly addressed to "My departed love / My new-found love." The painting *The Soul of the City,* based on a 1940 self-portrait sketch, was completed in 1945 and expresses his self-division in his devotion to Bella's memory and his attraction to Virginia. He depicts himself with two faces, one turned towards his easel and a canvas of the Cruxifixion, the other towards two women. One is Bella in a wedding dress, diving down with great force like a huge white flame; the other is Virginia, an earthly, brown-haired woman cradling a cockerel. The sky is murky grey-blue, and the streets and houses are seen as through a veil, but everything is dominated by the dynamism and glowing white of Bella's spiralling bridal train. *Self-portrait with Wall Clock* the following year recapitulated the mood. Chagall painted himself as a red cow holding a palette; draped over him is his sensual lover, an elongated turquoise Virginia, while the painting on the easel depicts, against Vitebsk, his suffering, spiritual alter ego: a crucified Jesus in a tallith, embraced by Bella as a bride.

Virginia remembered Chagall's listening to Stravinsky's music through the summer of 1945 in a huge bedroom with three windows looking out over Long Island Sound, sketching feverishly; she watched a bird woman emerge with outstretched wings against an ultramarine sky, a twirl of gold that turned into a bird, a celestial wedding of exploding cakes and candles in reds and yellows. "You must be in love!" remarked Opatoshu to Chagall when he saw *Firebird.*

The production opened at the Metropolitan Opera House in October, with Ida supervising the costumes as Bella had done for *Aleko*; Virginia helped with the sewing. As with *Aleko,* Chagall was dictatorial: "in my opinion, everything on the set has to be made up, painted, as if it were a human

face," he told an interviewer. "That's why I can't do only the decor, but [must do] also the costumes for the characters. In a ballet, everything must harmonise and become a picture." While Ida dressed the dancers, he dabbed paint straight onto their costumes, breaking up a line, heightening a tone. The result, again, was a victory for Chagall and no one else. "Chagall's set designs stole the show," said John Martin in the *New York Times;* Edwin Denby wrote that "Marc Chagall's decor for the new version of 'Firebird' is as wonderful a gift to the season as a big Christmas present to a child . . .

> It is heartwarming and scintillating, it is touching and beautiful, as the eye plays in its fairy-tale depths and fairy-tale coruscations. You can fly in the sky, you can peer into a magic wood and see people living in a dragon. One sits before it in child-like enchantment, watching the drops and costumes while the orchestra plays Stravinsky's elegantly enchanted score rather poorly and while, alas, Markova, Dolin, and the Ballet Theatre company wander about, hop, lift each other, or merely stand endlessly like an opera chorus waiting for a big effect. Dancing there is none to see . . . The charms of Chagall's decor left me in so happy a frame of mind, I couldn't be angry at the silly sequences the poor dancers had to execute . . . the decor is so beautiful a work of art.

Chagall and Ida attended the opening, then Ida walked out on her marriage, leaving Riverside Drive to stay with friends. Michel stayed on in their part of the apartment, and Chagall invited Virginia and a disoriented Jean to move in. Jean, tearful and demanding, quickly exasperated Chagall—who found children difficult at the best of times—and Michel, too. Jean remembers one moment when she sensed the beginning of a relationship with Chagall, when he took her for a walk and a large dog leaped out at them; in spite of his own terror of dogs, he swept her up in his arms to make her feel safe. But her hopes were short-lived; without hesitation, Virginia responded to Chagall's disequilibrium by sending Jean to boarding school in New Jersey. Shortly afterwards she announced that she was pregnant.

This was hardly what Chagall had had in mind when he tried to lighten his loneliness. A year before he had been married to Bella, with whom he shared half a century of Russian-Jewish experience. Now at fifty-eight he had sleep-walked into family life with two children with a gentile English woman

whom he barely knew, whom he had barely chosen. He was appalled: he could not face the thought of the baby; he could not face Virginia; he could not face Ida or his friends, with their idealized memories of Bella. Virginia went off to the country, to Walkill in southeastern New York State, for two weeks and came back determined to have the baby. She dragged Chagall to see a palm reader, who predicted that she would have a boy and advised her to leave her husband definitively. Chagall mellowed. Fragile and fatalistic, his one instinct was to ensure that he was looked after: keeping hold of Virginia was thus easier than letting her go. But he stipulated that if she were to live with him, Jean must be sacrificed to boarding school. Virginia took Jean to say goodbye to her father but found their old apartment empty: on the door McNeil had left a note confessing that he could not face the farewell. The child's plush penguin and two teddy bears were sitting on the chairs, and "suddenly Jean realized the whole extent of her sorrow. She knew she would never see her father again in this home of hers, and she let out a heart-rending wail. She sobbed disconsolately all the way back to Riverside Drive," recalled Virginia. "Many years later I spoke to her of this incident, but she remembered nothing, it had thrust so deeply into her subconscious." Then Jean, renamed Genia by Chagall because it sounded more Russian, was returned to school, and Virginia–now Virginichka–began life as Chagall's common-law wife. McNeil refused to grant her a divorce but signed a document stating he was not the father of her unborn child.

Chagall was too embarrassed to present his new love in public or to tell Ida about the pregnancy; scared of scandal, for the next few years he remained discreet about the relationship. Virginia was dispatched back to Walkill to find a home in the country where they could live anonymously, and in March 1946 Chagall bought "a simple wooden house with screened porches, near a superb catalpa tree," in High Falls, near Rosendale, for $10,000. "A grassy valley lay before it; behind, the ground rose to a jagged ridge of rocks, crowning a wooded ravine. Next to the house was a small wooden cottage that immediately enchanted Marc–it reminded him of an *isba.*" The Opatoshus alone were told the real reason for the move and for Virginia's seclusion, though Pierre Matisse, who turned up every few months over the next two years to take his pick of paintings, soon found out. Chagall disclaimed all responsibility: "What can I do if things happen without me and 'for me'?" he asked the Opatoshus, though he noted keenly, "There will be a *separate* atelier in a hut outside the house." The first works he made there were an escape from his difficult domestic situation into

heightened exotic fantasy: gouache studies for *One Thousand and One Nights,* commissioned by émigré publisher Kurt Wolff. Chagall chose those tales dealing with lost love, reunion, and death. Influenced by the fairy-tale orientalism of *Firebird,* he created a resplendent world where image slides into image–breasts become shining milky moons, fish grow horns or asses's heads, mermaids' tresses dissolve into seaweed–just as Scheherazade's narrative transformations hold the Sultan spellbound. Published in 1948, the work is acknowledged as the greatest achievement in colour lithography in America before 1950.

Chagall made a certain effort to encourage Virginia to convert to Judaism–a child is considered Jewish only through the maternal line–and she dutifully begged Adele Opatoshu for help. But Ida ridiculed the idea, and the matter soon slipped. Virginia, who was attracted to palm reading and tarot cards sooner than to any religion, was not a spiritual person; indeed, it was her ability to repress anything difficult or conflicting that allowed her relationship with the anxious Chagall to develop so easily and quickly. She accepted unquestioningly her place in the shadow of Bella's memory: Chagall, she wrote, "often spoke to me of Bella; he believed that her spirit lived on somewhere and was watching over us. He said I must try and be worthy of her; needless to say, I felt that was impossible–Bella was a sort of saint." From the start, she mothered him to the point of self-effacement; it was obvious to her that "his mother remained a central figure in his life," that Bella had been a mother figure as well, and that Ida, too, was diverting her maternal instinct towards her father. Photographs show Virginia looming over Chagall protectively, rarely looking at the camera but instead tensely surveying him to assess whether he is contented, stressed, needy. Her daughter, meanwhile, languished in boarding school. Later Jean believed that Virginia nurtured and mothered weak or sick men–Chagall would not be the last–to compensate for her lack of maternal instinct towards her children, an instinct that was undeveloped as a result of her own bleak childhood, when she, too, had been packed off to boarding school, often without seeing her parents for years at a time. Her poor relationship with her parents instinctively worried Chagall–it confirmed prejudices against goy coldness, too; he would later call her a "cold beauty"–and he insisted she seek a reconciliation with them.

In the studio and in the kitchen, Virginia tried devotedly to fill Bella's shoes; she squared up canvases and moved pictures, and she read aloud to Chagall as he worked. Since she could not read the Russian classics, he pre-

ferred biographies of artists, especially those like Goya, Gauguin, and van Gogh with whose misfortunes he could identify. She vainly attempted to cook Russian dishes that Chagall described but had no idea how to make. Though she was knowledgeable about art, Bella's gravitas was missing. The Opatoshus, who were very kind to Virginia and whom she adored as substitute parents, pointed out to Chagall that she did not read much; she also lacked Bella's practical flair and diplomacy. When she was forced to play a role in negotiations, the results could be excruciatingly gauche, as in a letter she wrote to the immensely wealthy collector Louis Stern demanding $1,000 for a bookplate that was expected to cost $200. ("As you can imagine the bank balance is in need of replenishing . . . he wants to ask you for $1,000 and hopes you will not think that too much.")

Ida, on the other hand, had inherited Bella's ability to finesse the line between business and friendship, and with Pierre Matisse playing a passive role, she occupied herself with stage-managing Chagall's role in the art world. Chagall divided his time between High Falls and Riverside Drive, Michel left to live in France, and Ida moved back in. In public Chagall and Ida concealed the inheritance conflict that continued to flare behind a front of solidarity: "I thought it well, after Bella is no more, to give [Ida] several of those canvases that I wanted to 'remain,' " wrote Chagall peaceably (in a letter in English carefully worded by Ida herself) to Daniel Catton Rich at the Art Institute of Chicago. Through 1946–47 her attention was consumed by the organization of two large retrospectives–the first since the one in Basel in 1933–that would crystallize Chagall's postwar reputation: one curated by James Johnson Sweeney at New York's Museum of Modern Art, which opened in April 1946 and transferred to the Art Institute of Chicago in the autumn, and Jean Cassou's prestigious show, scheduled to reopen the Musée d'art moderne in Paris in 1947.

In an America that was moving towards abstraction, the 144 works in the MoMA show could not but emphasise that Chagall's art flowed against the contemporary current there. Sweeney noted that in an age that had fled from sentiment, Chagall had, by contrast, drawn constantly on it, reclaiming poetic subject matter for painting. The exhibition was extremely well received, and thanks to Ida's negotiations, Chicago acquired *The White Crucifixion* from Chagall; MoMA had bought *I and the Village* from the Brussels collector René Gaffé in 1945. But inescapably Chagall, like the rest of the École de Paris, seemed to embody the end of a long tradition rather than the fount of anything new: his friend Lionello Venturi published a book that

year entitled *Painting and Painters: How to Look at a Picture from Giotto to Chagall.*

Chagall himself found joy at MoMA and then at Chicago in encountering again works he had not seen for decades. The monumental *Praying Jew*, made upon his return to Russia in 1914, was in both the exhibitions; works from the first Paris period that crossed the Atlantic for the shows included *Homage to Apollinaire, The Soldier Drinks,* and *Pregnant Woman*—it had been painted when Cendrars's lover Fela was expecting a child in 1913, and it must have struck an extraordinary note when Chagall saw it again thirty years later as Virginia was entering the seventh month of her pregnancy. She did not attend the show's triumphal opening with Chagall and Ida but went alone and unrecognized a few days later. Ida, who had discovered the reason for her absence from Riverside Drive, wrote to Virginia reassuringly, "You must on no account be sad about any possible misunderstanding or discord between us, because there isn't any. You mustn't blame yourself for any-thing. Papa felt guilty and embarrassed, that was normal, inevitable. It could only have been avoided if there had been complete frankness between us; but that's difficult with one's daughter. I hope everything is smoothed over now." Then she took off for Paris to prepare the ground for Chagall's first postwar journey there.

Loaded with food packages, Chagall followed on 23 May, sailing on the SS *Brazil* from New York five weeks before Virginia was due to give birth, for a visit to Europe that would last until the autumn: he was determined to miss both the birth and the early months of the child's life. Virginia remained in High Falls, and the Opatoshus were asked to keep an eye on her. "I knew he couldn't be expected to behave like any normal father," explained Virginia. "He was obviously scared of birth, as he was of any physical suffering. When a member of his family fell sick, he unconsciously vented his ill-humour on the victim." As soon as he was gone, Jean moved from school into her new home.

Chagall arrived in Paris on 4 June 1946, almost exactly five years after he had left it with Bella. "Returning to France isn't a project, it's making a dec-laration of love," he told an interviewer. "One rediscovers France as one rediscovers a woman one loves." It did not matter that conditions were hard, food still rationed: for the huge number of foreigners who flooded back in 1945-46, returning to Paris was enough. Full of bittersweet memories, Cha-gall, staying in three rooms Ida had rented for him in the critic Jacques Las-saigne's house on the avenue d'Iena, basked in the springtime city for the

first couple of days of his visit. Then on 6 June, like a homing pigeon, he made for the offices of the Yiddish Communist newspaper *Di Naye Prese*. There he was feted, and his speech "To the Jewish People in Paris," comparing tattered, impoverished Jewry to the spiritual figures in Rembrandt's paintings, was published in a special Chagall issue of the paper. Shortly afterwards, at an emotional reception organised in his honour by the Yiddish Culture League, symbolically held at the Hôtel Lutetia–the former Nazi headquarters in Paris–he told an audience of concentration camp survivors and Jews who had served in the French Resistance, "May we find comfort in our stubbornness and in the spirit of our fallen, of those who left us, who beg us and pray for us. For we Jews live not only with the living but also with the dead."

For three months Chagall lived like a divided soul: half haunted by memories of Bella in Paris and finding among the shattered Jews of Europe an audience for his expressions of grief; half entranced by news from Virginia in America. His son was born on 22 June in New York and named David after his brother. Love letters poured from the avenue d'Iena to High Falls. "You don't know yet how much I love you. You know very well I don't say such things lightly, but you feel, you know you're my life," Chagall told Virginia, adding that fate had sent her to him after Bella. At the same time he wrote to the Opatoshus (the only friends to be told the news) asking them to "give her a flower in my name":

> Well, what do you say about me! About her it is clear. It is *Nature itself* in its simplicity, and why does God do it to me and where does he lead me, that I, so weak and sad, must smile because somewhere there a little boy came into the world.

Joseph Opatoshu presided over the circumcision (even though Virginia had not converted) on 29 June, then saw Virginia off on the journey back to High Falls. She was briefly cared for by an aunt but soon found herself alone with a new baby and a murderously jealous six-year-old. Chagall had failed to leave enough money for the household bills, the doctor, the laundry, and new furniture to equip the bare house, and she had to ask the Opatoshus to lend her $100; at the same time she was still fixing up the studio for Chagall's return and also trying to forge a creative life of her own, as Bella had, by writing. But she sent only happy photographs and buoyant news to Paris. "You can't imagine my emotion!" Chagall answered after seeing the first snapshot of

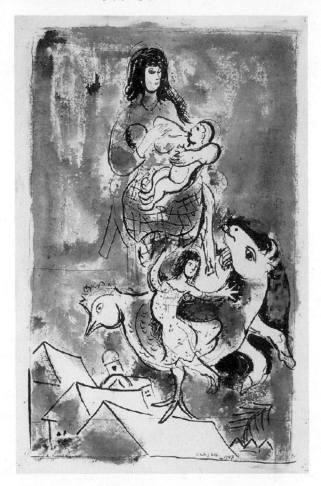

Chagall, "Virginia and Child," 1946, drawing; Chagall's
new stepdaughter, Jean, aged six, is in the foreground

his son. "He looks all right, but I'm worried. Does he eat enough? Was Jean
like that, with a big head and skinny body? . . . I'm so happy for us both.
Thank you for the child . . . We shall love him with all our might."

Repeatedly, he told Virginia how eager he was to come home, to see the
baby, to work in the solitude of High Falls. But Paris held him: Matisse,
Picasso, Jean Cassou, and the organisation of his exhibition; Vollard's heirs
and a battle to publish *Dead Souls* and *Les Fables;* a new book project, *Le dur
désir de durer,* in collaboration with a new friend, the surrealist Communist
poet Paul Éluard, who had also recently lost his wife; and a visit to the home
of André Lhote at Le Raincy, to retrieve the art hidden there during the war.
Most of all, here were cultural currents to which he could respond after years

of artistic isolation. On black paper he made a large number of gouaches and pastels of Paris that celebrate his reencounter with the city like a fireworks display, the coloured chalk on the black glowing like a fluorescent screen. Nearly a decade later, when his life was more stable, he worked these images up to gleaming oils such as *Night,* in which a pair of lovers and a somersaulting red cockerel float in a phosphorescent dance over a midnight city, above the Seine's illuminated bridge and a glittering Eiffel Tower. They are classic postwar European pictures, colour blazing out of blackness, hope out of ruins; months after Chagall left Paris a young dealer, Aimé Maeght, made his name by opening his new gallery with a radical show called "Le noir est une couleur," showing how Matisse, Braque, Rouault, and others were using black in their paintings. Maeght would become the gallerist of the postwar era; soon he, too, would be at Chagall's door.

Chagall affected not to care about artistic connections. "I lunch and dine. I see endless people. Impossible to be alone," he told Virginia. "You know that I don't feel 'famous.' I am still the same. I love solitude, the simple life, and you—because you are simple, very honest and charming, in my style." But he did not arrive back in High Falls and meet his son until the second week of September.

"Only that land is mine / That lies in my soul," he said in the poem "My Land." "As a native, with no documents, / I enter that land. / It sees my sorrow / and loneliness." He wrote the poem in Russian, then translated it into Yiddish, while he was staying in France, contemplating his return to America. Never had he agonized more about where to make his home. He opened a speech in Chicago in 1946 with polite gratitude to America but closed with a cry for France's rebirth. But in a speech in Paris, he praised the heroes of Soviet Russia and dissociated himself from the Western tradition, announcing to a Jewish audience that all he ever wanted was to be close to the spirit of his father and grandfather. To Virginia he said, "I know I must live in France, but I don't want to cut myself off from America. France is a picture already painted. America still has to be painted. Maybe that's why I feel freer there. But when I work in America, it's like shouting in a forest. There's no echo."

For two years he worried, panicked, and postponed the return that he knew was inevitable. He was wary of French anti-Semitism. ("The French have always been chauvinistic . . . quite frankly, I'm afraid of rubbing shoulders with people who have sent Jews to gas chambers.") He feared Russian aggression, too; he was stunned and deeply upset when news emerged of the

murder in January 1948 in Minsk of Solomon Mikhoels, which opened a new phase of brutality against the Jews in Russia. Chagall dreaded another war in Europe and a Soviet victory that would land him in Siberia. He enjoyed the calm of High Falls (once Jean had again been packed off to boarding school) and fretted about how Virginia would be received in Paris. And he felt guilty about leaving Bella behind; he made a pilgrimage to her grave with the Opatoshus on 2 September 1947, knowing this would be the last time he would be there for the anniversary of her death. That month, as if in compensation, he wrote of plans to publish a memorial to her in Europe, including her notebooks, his paintings of her, and writings about her by Jacques Maritain, Éluard, and Paulhan. "Your white dress swims over you, / My flowers untouched, / Your stone glimmers, gets wet, / I get gray as ash," he wrote in a poem entitled "Bella," as he prepared to leave America the following year. "Today, like yesterday, I ask you: / Are you staying here, are you following behind me?" The major painting of 1947, the clamorous, savage *Flayed Ox,* another reworking of a canvas begun in the 1920s, is a self-portrait as a crucified cow, the carcass crimson and vermillion against a night shtetl scene: an expression of his fears for a Europe in which his art was inextricably rooted.

The pull of France was too strong to resist. French dealers were competing to represent him–the serious battle was Louis Carré versus Aimé Maeght–and he was getting no stimulation from Pierre Matisse. Like most of his European generation, he was barely interested in American abstraction; neither it nor New York ever sparked anything in his own work, and he continued to see Paris as the capital of art. "What do you think they have incorporated from us?" Matisse asked Picasso in 1946, poring over American catalogues of Jackson Pollock and Robert Motherwell. "And in a generation or two, who among the painters will still carry a part of us in his heart, as we do Manet and Cézanne?" Friends including the Maritains, the Golls, and Lionello Venturi had already gone home; so had most of the artists–Léger, Zadkine, Ernst–who had shared his exile. In France Ida, now divorced and involved with the Greek publisher Tériade and with an artist called Robert Villers, was liaising with museums–Amsterdam's Stedelijk, the Tate, the Kunsthaus Zurich, the Kunsthalle Bern–to arrange a starry trajectory for Chagall's work after the Musée d'art moderne opening. Tériade was publishing *Dead Souls,* the first of the books that Vollard had failed to bring out. To Virginia, Ida was eloquent on Chagall's need to return: "People are waiting for him. Their expectation is something to be treasured,

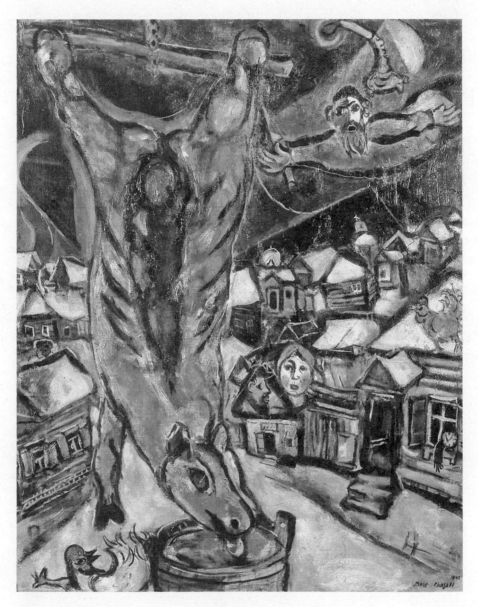

Chagall, *The Flayed Ox*, 1947, oil on canvas

not despised. He owes Paris at least a semblance of a return. It's like a gift; it must be given at the right time. Paris is Paris, beautiful, decaying, full of sweetness and bitterness. The artistic, literary and political battles are often fruitless, but they are indispensable."

Yet Chagall hesitated even about making a second trip to Paris, this time for the opening of his exhibition. "Here in our place it is now so beautiful it isn't Jewish at all–berries, worms, chicken, wild grass–everything whispers to me: become an American, don't go," he told the Opatoshus in July 1947. "Dovid is as beautiful as his mother, who always laughs and is happy. I get ashamed of my Jewish sadness. You have to hear her, how she whispers about living-so–" He broke off the letter abruptly, as if caught short by his unexpected life with Virginia. He told Hilla Rebay in August 1947 that he had retreated from public life because he was still suffering from a personal tragedy; nevertheless he sailed on the RMS *Mauretania* to Cherbourg in October. From the ship he wrote to Virginia that "Your sun gives me life . . . It is terribly sad to be alone and I would already like to return." He was famous enough to be recognized on the boat and was constantly approached but was too shy to undress in his shared cabin, where he slept in his trousers and sweater and regretted that Virginia was not there with him.

The Paris exhibition, and its European tour in 1948, was a triumph that pushed Chagall to a new level of celebrity. The German critic Walter Erben, writing in the 1950s, recalled that this "great retrospective . . . established him in his true artistic rank.

> His work was thoroughly modern in all its phases, and equal in originality and inventiveness to that of his youngest contemporaries . . . The consistency with which Chagall had followed his chosen path became manifest. He had put into effect the prophecy which his poet friend Canudo had made . . . three decades before: he had become the greatest colourist of his day. The exhibition was also shown in London and Amsterdam. The example which these works gave to a world suffering from the after-effects of a murderous war created an artistic and moral sensation.

At the Venice Biennale in May 1948 the acclaim continued: Chagall was given a room to himself in the French pavilion and awarded the Grand Prix de Gravure, largely for *Dead Souls.* Ida and Michel sent him separate, warm

greetings for David's second birthday in June. "Paris is waiting for you and so are we. Kisses for the little '*imeninnik,*' " wrote Michel.

"Our voyage to the abysses-perhaps of Europe approaches," sixty-one-year-old Chagall told Opatoshu in July 1948. "I want to go as much as you want to dance . . . I am toiling on the packages together with the thin, young Virg, who must also taste a bit of what it means to be a Jew with the sack on your back." He tried to let the house at High Falls to Bush Meier-Graefe and her new lover Hermann Broch; the deal fell through, and wary of burning his boats, Chagall kept the house anyway–partly because he did not want Pierre Matisse to know they were leaving for good. But Pierre was both canny and loyal. As he had waited on the dock in June 1941 to greet Chagall and Bella when the SS *Pinto Basto* arrived from Lisbon, so now, bearing chocolates and lollipops, he came on 17 August 1948 to see Chagall off. Pierre's waving hand was their last sight of America as Chagall, Virginia, and the children sailed for Europe.

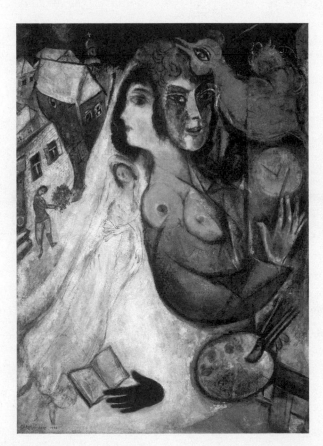

Chagall, *The Black Glove,* 1923–48, oil on canvas: one of the paintings which Chagall reworked after Bella's death. He symbolically dated it between 1923, the year he and Bella arrived in Paris, and 1948, when he returned there from exile in America. The title, and the gloved hand alone in the snow, alludes to his very first painting of her, in 1909, called *My Fiancée in Black Gloves.*

Return to Europe

Orgeval and Vence, 1948–1952

Ida was there to welcome them at Le Havre and drove them straight to L'Aulnette, a chaletlike house with gables and wooden turrets that she had found for them in the village of Orgeval. This was the Seine and Oise countryside, the impressionist heartland, where she had spent happy weekends with her parents in the 1920s. "It was like a fairy tale gingerbread house, surrounded by enchanted woods," Virginia wrote; around them were orchards and avenues of elms, and a crumbling eleventh-century church with a pointed steeple in the village. Ida had made the house comforting and attractive. In a drawing room with three French windows giving out to a terrace and gardens, she had hung paintings from all periods of her father's work, as if recapitulating his life as he returned to Europe: the Gauguinesque pink and green *Little Parlour, Dead Man* and *Russian Wedding* from his early days in St. Petersburg, *The Studio,* depicting his first room in Paris with the portrait of Bella on the wall, and *The Cattle Dealer; Cubist Landscape,* the paraphrase of suprematism that was his farewell to Vitebsk, alongside *Revolution,* the 1937 work recently altered in America. Upstairs, large light bedrooms were converted into studios, one of which was banned to all other members of the household. There was also a bedroom for Ida, who came every weekend from Paris bringing with her a phalanx of guests.

She had set the scene for her father's reintegration into Parisian society, and during the next year friends old and new, many competing for favours, regrouped in what looked like Chagall's fantasy castle: the dealers Maeght and Carré, publishers Tériade and Zervos, art historians Jacques Lassaigne, Jean Cassou, and Lionello Venturi, the Golls and Maritains, alongside Ida's

Chagall in the drawing room of "L'Aulnette," Orgeval, 1949. Behind him are *Cubist Landscape*, a study for *Revolution,* and a painting by Ida Chagall.

younger circle, which included her new boyfriend, the Swiss artist Géa Augsbourg, Michel Gordey and his new wife Marina, and leftist editor and Resistance fighter Claude Bordet, who had survived Buchenwald, and his wife Ida, tennis champion of France. In the autumn Chagall and Virginia went with Ida and Géa to Venice, where Chagall was most excited by Tintoretto's floating figures in the massive *Paradise* in the Doge's Palace, and the quartet of visitors were rowed in Peggy Guggenheim's private gondola to La Fenice to hear *Don Giovanni.*

But beneath the surface, tensions were already brewing. Virginia could not help noticing the passionate relationship between Ida and Géa and comparing it to her own: "As a couple we were more romantic than sensuous, and our pleasures were simple. Marc's sensuousness went into his paintings; mine, because of my unhappy marriage, was still developing." Back in Orgeval in October, the big rambling house was cold and difficult to heat,

and at the end of April Chagall was still complaining about its chilly atmosphere. Virginia was upset to hear that it had been used as an interrogation centre by the Germans during the war; Resistance workers had been executed in the stables that they now used as a garage for their Peugeot. Chagall felt restless and dreamed of the south. The proximity of the children drove him crazy, and his temper was short; David was a demanding toddler, and eight-year-old Jean–renamed Jeanne Chagall and trying to learn French and adjust to the village school–was nervy and unpredictable. On her arrival at Orgeval, Jean had flown into a tantrum of despair when she discovered that Ida, charged with selecting and packing possessions at High Falls for removal to France, had thrown out all her toys; Ida, learning of her mistake, rushed in contrition to the most expensive toy shops in Paris and returned with gleaming new ones, failing to grasp that "these were not the same at all." Photographs taken in spring 1949 that were supposed to idealise the new domesticity–the family taking tea from a table decked with a checked cloth on the terrace–are a monument to misery. Chagall, his features taut almost to the breaking point, looks as if he would rather be anywhere else, while a sombre Virginia regards him anxiously but is also wary of a cross, withdrawn Jean at her side; only three-year-old David plays to the camera.

"My Dovid'l . . . is poetry, a poem, a painting that cannot get on to the canvas. His mother is not bad either. The same innocent soul, you can do nothing about it," Chagall wrote to the Opatoshus in May. He still found her attractive, comparing her willowy beauty to a palm tree, and she in turn noted that "Marc was growing more and more handsome.

> The tufts of hair on each side of his prominent cheekbones had become almost white, lending a softness to his face. The contours of his upper lip were without clear definition, constantly changing, but his lower lip was hard and slightly protruding, like a ledge cut out of rock. It showed strength and determination, but also revealed the more difficult side of his character, the untrusting, uncharitable side. His smile had the astonishing power to light up his features from inside, producing the dazzling effect of a new moon that spread suddenly across his face.

The magnetism was still there, but it was beginning to be not enough. From the start of their relationship Chagall's letters to the Opatoshus had

Virginia, Jean, David, and Chagall, Orgeval, 1949

been his outlet for expressing his mix of pleasure, irritation, and frank astonishment at those characteristics in Virginia that to him appeared quintessentially "goyish": her uncomplicated attitude to life, her robust health and closeness to nature, her optimism and insouciance. He told Opatoshu that he envied him the Jewishness of America; isolated from these currents in France, the Yiddish letters increased and became something like an expression of Chagall's Jewish conscience, his loyalty to Bella, the milieu and memories where Virginia could not follow him.

Writing in French, he assumed a different personality. Where his Yiddish persona was nostalgic and mournful, his French one was upbeat and integrated, elegantly enjoying the intellectual attention paid to him, meetings with other artists, and public acclaim. Between 1945 and 1950 the grand old men of the École de Paris were still making the most exciting, relevant work in the world: Matisse's cutouts, Picasso's monumental grey *Charnel House* and *The Kitchen*. Thanks to the postwar reinstatement of modernism—fascism's enemy—at the heart of artistic and political life, their reputations

now surged. As Pierre Matisse pointed out, in the 1940s "the only aspect of France's immediate past in which she could still take unqualified pride was the achievement of her artists." "I saw your father, and I was so happy to talk with him. He is marvellous" ran Chagall's first letter back to Pierre. The Lithuanian-Jewish photographer Izis, commissioned by *Paris Match* in 1949 to visit Orgeval, caught something of Chagall's divided personality at this time in portraits that are lively but tinged with melancholy; when asked what struck him most about the artist, Izis replied, "The mobility of his face,"

> which was sometimes so closed and far away and at other times literally penetrated you with its mischievous and captivating stare. Perhaps our origins brought us closer together. We got on well. We used to go for walks together in Paris, with no professional goal in mind. We would walk around, stopping in little bistros, he reliving his memories. In this way, we made a pilgrimage to the places where he had lived, such as La Ruche . . . Every time it was a poignant journey into the past for him.

For Virginia, such consorting with photographers and celebrity artists suggested an unhealthy interest in fame. She did not grasp, as Ida instinctively did, that after spending a lifetime on the margins, the sixty-one-year-old Chagall could not possibly resist the new, enhanced status on offer to the heroes of modernism who had survived war and fascism. Chagall and Picasso were accepted in establishment circles as never before, while Frenchmen such as Derain and Vlaminck, who had rashly accepted offers to tour Nazi Germany, never recovered their reputations. But as early as October 1948 Virginia wrote disapprovingly of Chagall's preoccupation with other artists and of his and Ida's quest for a public role. She had thought of their relationship as almost that of a brother and sister, played out in the comfortable backwater of High Falls; now the incompatability concealed by that veneer of simplicity began to emerge, with Ida's high-octane personality a complication. "Oh, my daughter, she is the most beautiful wave that washes everything," Chagall wrote in 1950: "everything turns around her like the planets around the sun." He tried to paint her but was dissatisfied with the result: was she so dominant that her presence—or his wish to please her, or the powerful identity between them—stifled his expressiveness? In person and through frequent lengthy telephone calls, father and daughter always spoke Russian, excluding Virginia, and with Ida alone Chagall dis-

cussed his business dealings and the extent of his fortune. "Sometimes it happened that Marc and I agreed on some plan of action that Ida disapproved of, and Ida would talk him into agreeing with her. He would then quickly disavow me, assuring her that he had never been of my opinion. He was childishly disloyal," Virginia recalled.

In summer 1949 Ida, who had pushed herself to the limit travelling and working for her father's interests, fell ill, and after an operation to remove two stomach ulcers, she moved into Orgeval to convalesce, just as nine-year-old Jean symbolically moved out–this time banished for a year to live with her grandparents in England: her fifth home in four years, not including her boarding schools. Virginia thus purchased another lease of peace for Chagall, though Jean later believed that her mother, struggling to play an angelic and devoted role, was almost as disturbed by her daughter's jealous, emotional behaviour as he was. Jean considered that she was her mother's dark side, the dependent weak aspect Virginia tried to deny in the adventure with Chagall.

While Virginia felt effaced and frustrated, Chagall expressed his unhappiness on canvas. Virginia was no muse: his significant work continued to be epitaphs to Bella. The most important painting he completed in Orgeval was *Wall Clock with Blue Wing,* a paraphrase of his 1930 canvas *The Clock in the Street,* but every image is muffled or transformed by mourning. The central motif is the old grandfather clock from Vitebsk, its pediment layered with snow and its pendulum a big golden dot. Here as in 1930 it has a single flapping wing, but whereas in the earlier work it has a shoe and trips lightly across the street as in a surrealist joke, here it hovers uncertainly above the ground, going nowhere. A cockerel shrouded in darkness surveys the scene disconsolately, and the faint figure of an exhausted beggar is dimly sketched in the snow on one side of the clock; on the other an abandoned bouquet lies dying. Barely discernible within the dark clock case, a pair of lovers are pressed stiffly together like ghosts–cut off from the world, arrested by time.

It is a painting that suggests emotional collapse: Chagall was finishing the work just as news came from Russia of the disappearance of Jewish intellectuals including his friend Feffer, as well as Peretz Markish and David Bergelson, writers with whom he had worked in the 1920s. Ehrenburg in Paris lied, saying he had seen the Jewish writers in Moscow–perhaps he meant in the Lubianka prison, from where Feffer was wheeled out when his friend from New York, Paul Robeson, visited Russia later that year. Cleaned up and dressed in a suit, Feffer was installed with Robeson in a bugged room

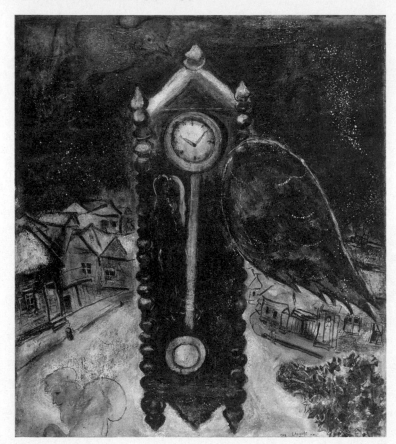

Chagall, *Wall Clock with Blue Wing,* 1949, oil on canvas. "How unhappy I must have been to paint that," Chagall said of this painting many years later.

but indicated by gestures that Mikhoels had been killed and that his own execution was imminent; Robeson noticed that he had no fingernails–he had been tortured–but said nothing on his return to America. In the West it was widely assumed that all the writers had already been murdered; for Chagall it was the last disillusionment about Soviet Russia. He did not speak out–from concern for his sisters, he said; he had no idea whether any of them were alive. (He later learned that all five had been evacuated from Leningrad to Samarkand during the war, and that three, ill and worn out, had died soon after their return, between 1945 and 1948. His favourite sister, Lisa, and his youngest, Mariaska, however, still lived there.) Doubts and grief about Russia, therefore, fed into *Wall Clock with Blue Wing* as well. According to the writer Yuri Trifonov, Chagall, on seeing a reproduction of this picture when he was in his eighties, "muttered in a scarcely audible voice, not to us but to himself, 'How unhappy I must have been to paint that.' " To Opatoshu he wrote from Orgeval, "I myself cannot get out of Vitebsk . . . So the question

is: what am I doing? And how long can it go on?" He was, Virginia noted, "perpetually anxious . . . He was never really happy unless he was worrying about something."

> I often saw him literally wring his hands in anguish over some seemingly trivial thing, the outward sign of a deep anxiety . . . Once he told me "Sometimes there are waves of sadness blowing through me, like wind in a field of wheat—you know the way it scurries through the wheat in a dozen places at a time. It's beautiful to see, but it's always sad." When it rained he was miserable, as if ink were falling from the sky. Once when I played him a Mozart record to cheer him up, he listened for a while and said "Ah, Mozart! There's a happy man for you!" "Mozart had his share of sorrows too," I reminded him. "Yes, but nothing ever killed his joy."

The best escape was the South. The Chagalls spent four months in early 1949 as guests of Tériade in St. Jean Cap Ferrat, the exclusive headland between Nice and Monte Carlo where the publisher's Villa Natasha stood in grounds overlooking the sea. Here Chagall made richly worked gouaches, mostly in lustrous, liquid blue: *Fishes at St. Jean, The Blue Landscape,* and *St. Jean Cap Ferrat,* which prefigure the Mediterranean as a major inspiration of his final years. Tériade was grandly hospitable: lavish meals and champagne were served by his housekeeper under the orange trees, and Chagall was wooed and fussed over. Tériade, a massive, warm, keenly intelligent, empathetic figure like Vollard, but better-natured, had written flatteringly on Chagall since the 1920s and now succeeded Vollard as his postwar publisher; among his recent masterpieces was Matisse's *Jazz* of 1947. Chagall was particularly seduced by Tériade's erudition. A Greek steeped in classical traditions, Tériade had a role to play as this stretch of the Mediterranean became in the late 1940s and 1950s a last site of classicism and modernist pleasure. Bonnard had just died in Le Cannet, Renoir's house at Cagnes sur Mer was for sale, and Matisse's 1946 exhibition at the Palais de la Mediterranée in Nice had symbolised the postwar cultural relaunch of the Riviera. After the First World War, European art had seen a marked return to classicism, a yearning for the order and unity associated with the classical world; after 1945 the Mediterranean and its classical heritage exerted a pull for some of the same reasons. Now Chagall and

Virginia joined the great survivors who lined up along the coast with their new, much younger companions. Picasso, making work infused with Mediterranean and classical themes such as *La Joie de vivre,* was at Antibes and Vallauris with Françoise Gilot and their two young children. Matisse, working on the designs for the Chapelle du Rosaire in the ancient walled town of Vence, lived with Lydia Delectorskaya in Cimiez. Lydia, born in 1910 in Siberia and an orphan of the revolution, was the oldest and most stable of the three women and had wholly subsumed her own existence into the working life of eighty-year-old Matisse; Virginia and Françoise were younger and more ambivalent about playing subordinate roles to artists who would in the final resort sacrifice any human relationship for their art.

The younger generation of animators of the Côte d'Azur was led by dealer Aimé Maeght and his vivacious Provençal wife Marguerite; they had a home in Vence, and from his print shop on the Cannes seafront Maeght had supported the elderly frail Bonnard through the war. Afterwards he opened his first gallery in Paris and fought cannily to acquire many important artists– his stable would include Miró, Giacometti, and Braque. Like Tériade, Maeght had a special bond with Matisse: born in Hazebrouck, near Matisse's native Cateau-Cambrésis, by the French-Belgian border in 1906 and orphaned by the First World War, he shared the artist's Flemish qualities of sturdy endurance, hard work, and pragmatic sharpness–and he now made a bid for Chagall as well. Virginia remembered that Maeght "never quite let himself go. But his small blue eyes observed everything and his thin lips wore a faint smile that was half amusement, half diplomatic amiability. He was gifted with a rare natural flair for discerning true quality in art along with a brilliant business mind." In 1949 he won the battle to represent Chagall, though not with the exclusive rights he usually insisted on: an exception was made so that Ida, who had been making a living as her father's dealer, could continue to do so. She was so successful that by the end of 1949 she was able to buy a large seventeenth-century townhouse on the Quai d'Horloge in Paris. The front gave a magnificent view of the Seine and the Pont Neuf; at the back was the quiet, secluded Place Dauphine, a favourite haunt of the surrealists, who joked that its narrow triangular shape reminded them of the tapering tip of a woman's legs.

Ida's home became Chagall's temporary base in Paris. But he was so delighted by the warmth, sun, sea, and company at Cap Ferrat that he decided to move south for good. He closed up the house in Orgeval in Octo-

ber and moved to Vence with Virginia and David; early in the new year he bought on Ida's advice a big wreck of a *belle époque* villa, Les Collines (The Hills), lying on the slope of the Baou des Blancs, on the road from Vence to St. Jeannet. The seller was Ida's friend Claude Bordet; his mother Catherine Pozzi had lived there with her lover Paul Valéry, and the house was full of his watercolours. During Claude's activities in the Resistance, a room in a separate building, with a door opening on to fields, had been his hideout; a bell rung in the house warned him of danger. Ida earmarked this, always known as "Claude's room," as her bedroom; Chagall, too, made his studio in this building, whose big windows gave a distant view of the sea and looked over the rooftops and medieval cathedral of Vence across a garden of date palms and orange trees. Chagall treasured the solitude of the arrangement, Ida the private access it secured to her father. The only disadvantage of Les Collines was that it stood a few hundred yards down from the Chapelle du Rosaire, for which Matisse was completing his designs; the busy street that ran past in a wide arc was about to be renamed in his honour, and the eighty-year-old painter, knowing Chagall's jealous sensitivities, joked that the sellers had better conclude a deal quickly, for if they did not, Chagall would be unable to bring himself to buy a house on the avenue Henri Matisse.

Since the war the Bourdets had rarely occupied the house, and everything was dilapidated, but Virginia set to work with builders, and Ida had Bella's elegant furniture from the Chagalls' Paris homes in the 1930s brought out of storage at last. Maids, a housekeeper, and a full-time gardener were hired, and in the spring of 1950 the Chagalls moved in. The art historian Walter Erben, arriving one May afternoon a few years later, described surroundings of vineyards, peach orchards, and olive groves. An ivy gatepost was hung with a carefully painted sign, LES COLLINES, above a wrought-iron gate opening onto a large park, "at the far end of which the tall villa-like house and the front of the more modern studio sparkled among the greenery of tropical trees . . ."

> The gravel of the drive dazzled the eye. The trees stood in their own circular shadows; not a breath of air stirred their foliage. On the other side of the path, terraces rose one above the other and apple trees towered above the tangled grass . . . The park ended at a further walled terrace, where carefully tended lawns and flowerbeds were visible between tall cedars and mighty palm trees. Now the whitewashed house gleamed quite close. The high

pistachio-green shutters were closed. The little side-building served as a garage, whose great doors stood wide open. Above it was a studio, with two big, white-curtained windows . . . Joined on to the right side of the house was a roofed terrace . . . A large drawing had been scratched in the smooth plaster of the wall: a female figure and an animal that was at once a donkey, a horse and a cow . . . The drawing looked like a relief, white in white with lilac shadows—an unusual Chagall.

Les Collines became Chagall's home for sixteen years: far longer than he had lived anywhere before. It was a showcase as well as a home: *Bride and Groom with Eiffel Tower,* announcing a definitive loyalty to Paris, hung over the marble fireplace in the living room; *The Cattle Dealer* presided over the dining room; visitors were often served tea in an adjoining room at a table beneath the 1910 *Russian Wedding;* and *The Falling Angel,* whose tortured composition reflected his own tortured sense of identity, glowered down from the top of the staircase; Virginia was right but disloyal to remark that its lack of real strength disturbed her every day as she passed it. She was disappointed by the grandeur; she had dreamed of a country home with cows and chickens, but Chagall answered that in France he was somebody of importance and could no longer live, as in High Falls, with cow dung on the driveway. Her response was to take up, soon after they moved in, with some proto-hippie friends living at Roquefort les Pins; their alternative lifestyle—vegetarian diet, nude bathing—was an escape, as her palm-reader friend in America had been, from the high refinement of the art world, as she watched Chagall grow acutely conscious of the lifestyles, as well as the work, of his two more famous neighbours.

By 1950 Picasso and Matisse's relations were, according to an observer, "roughly those of one crowned head with another," but neither could be friends on anything like equal terms with anyone else. In Paris in the 1920s and 1930s Chagall had given them and most other artists a wide berth; he possessed no works by any other painter, and only a handful of sculptures: a Renoir bronze nude, a small Maillol, an earthenware figure by Henri Laurens. It was characteristic of his instability, his mix of ambition and victim complex in the early 1950s, when he was emotionally vulnerable, that he now took up residence between Picasso and Matisse only to smart with anxiety and envy. Ida, meanwhile, was busy seducing both old men. Chagall was at once jealous and proud that she had posed for a series of drawings by

Matisse, while at a lunch with Picasso—a sumptuous Russian meal which she prepared herself—at Tériade's, "she put on all her charm for Pablo, and told him how much his work meant to her . . . She was rather well set up, with curves everywhere, and she hung over Pablo almost adoringly," according to Françoise Gilot. "By the time she was finished, Pablo was in the palm of her hand, and he began telling her how much he liked Chagall."

In High Falls, Ida had instructed her father to write to Picasso enclosing a photograph of David; Picasso—whose son Claude was born a year later—was touched and pinned the picture on his bedroom wall. Now she persuaded Tériade to follow up the gesture with a lunch for Picasso and Chagall at Villa Natasha. Chagall was nervous; even the mention of the name Picasso made him stammer with resentment. When Picasso turned up in his large car with liveried chauffeur, he was in a devilish mood, refusing to sit down before Tériade had removed a Bonnard painting because it sickened him. Then he set eyes on Virginia, who, reported Gilot,

> had a very pretty face, but was exceedingly thin and so tall as to tower over Chagall and Pablo and everyone else. Pablo, I could see, was aghast at her thinness. In addition she was, I believe, a theosophist and her principles prevented her from eating meat and about three quarters of the rest of the food on the table. Her daughter, about ten, was there too, and followed the same dietary laws. Pablo found that so repugnant he could barely bear to eat either.

Françoise was also at her thinnest; Picasso's loathing of skinny women was well known—here he was probably perceptive enough to see their reluctance to eat as some sort of emotional protest.

His mood worsened. He taunted Chagall for having lived comfortably in America after the liberation rather than suffering French postwar hardship; then he asked why he never went back to Russia. Characteristically, he touched the rawest nerve: at just this time Michel Gordey had gone on a journalistic assignment to Moscow, meeting Mrs. Feffer and seeking news of Feffer, whom Chagall now knew to be alive but imprisoned, and Chagall's letters to Yiddish friends were full of his despair. To Abraham Sutzkever that summer he complained that Vence was a Gentile city and that in murderous times he longed for Jews. But to Picasso he only flashed a broad smile and suggested that as a member of the Communist Party, he should go first, for

"I hear you are greatly beloved in Russia, but not your painting." Then, reported Gilot, "Pablo got nasty and said, 'With you I suppose it's a question of business. There's no money to be made there.' That finished the friendship, right there. The smiles stayed wide and bright but the innuendoes got clearer and clearer and by the time we left there were two corpses under the table."

Further meetings were sparse. Chagall, like many artists in the South, was drawn to experimenting with the Provençal craft of ceramics as an art

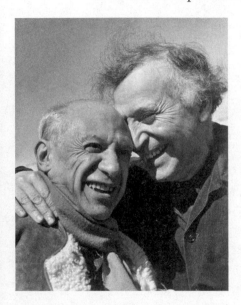

Picasso and Chagall, 1952

of the earth, and the two men came across one another from time to time at the Vallauris pottery works, though Chagall did his best to avoid Picasso's overbearing presence there; on one occasion when Picasso appeared, he left for "a breath of fresh air," returning to find the plate he had been about to work on beautifully decorated with his own motifs and in his own style by Picasso. Each continued to keep his eye discreetly on the other. A few years later the gallerist Eberhard Kornfeld, who was compiling the catalogue raisonné of Chagall's drawings, was driving with Chagall past Picasso's Villa La Californie when Chagall, determinedly looking straight ahead at the road before them, flicked his thumb to the right and muttered, "Ici habite l'Espagnol." Picasso, who knew of Kornfeld's association with Chagall, met him soon afterwards and opened, "Comment va le Russe?" Chagall could rarely bring himself to say a good word about Picasso. ("What a genius, that Picasso. It's a pity he doesn't paint," he told Gilot.) Picasso in the early 1950s could afford to be more generous, especially as he gloomily faced the impending death of Matisse. "When Matisse dies, Chagall will be the only painter left who understands what colour really is," he told Gilot. "I'm not crazy about those cocks and asses and flying violinists and all the folklore, but his canvases are really painted, not just thrown together. Some of the last things he's done in Vence convinced me that there's never been anybody since Renoir who has the feeling for light that Chagall has."

Picasso may have been talking about *The Red Sun* (1949), the first new work displayed at Les Collines, which, reported Erben, "hangs in the

entrance hall . . . and the glow of its colours emerging from darkness greets all who enter." An elongated blue female figure (tall skinny Virginia had an impact here) soars diagonally across the picture, met by a youth in yellow who slices across a blazing red sun. These three primary colours, the spectrum of the sun, dominate; the spaces between them are indeed filled by the Chagallian cock, donkey, and flying fiddle, as well as a candelabrum and bouquet, all painted in gentler hues to offset the major chromatic chords. Most remarkable, and heralding the future, as Erben noticed on his visit, is that the outlines of the lovers and the sun are "emphatic and forceful, resembling the network of lead in stained glass windows between which the light streams in all its brilliance." The same effect of almost transparent colour is visible in *Blue Circus* (1950), depicting a twirling acrobat—another lean, agile figure slicing the canvas—and a fish, horse, and moon outlined against a blue background dotted with shadowy motifs. The major influence here is surely the simplicity and stark beauty of Matisse's chapel, with its abstract shapes and restricted, Mediterranean chromatic range—the lemon yellow of the sun, intense green of vegetation, blue of sea and sky—flooding coloured light through the stained-glass windows. Chagall watched Matisse at work on the chapel between 1949 and June 1951, when Pierre came to Vence to represent his father at the consecration. A few paces up the road from Les Collines, the work and the towering figure of Matisse remained an unforgettable presence.

Gilot unkindly claimed that when Picasso visited Matisse, the pact was that Matisse would not mention Bonnard (who was Picasso's bête noire) on condition that Picasso refrained from talking about Chagall (who was Matisse's). But in person Matisse was far more cordial to Chagall than Picasso was. Chagall and Virginia made several visits to Cimiez, paying court while a talkative yet slightly intimidating Matisse lay in bed drawing on the ceiling with a stick of charcoal on the end of a bamboo pole or cutting out large pieces of coloured paper for Lydia to paste onto board. Chagall had admired Matisse all his life; their friendship, observed Jean Cassou, was one of calm and smiling. Even a large grey and white cat given him by the older artist received special treatment at Les Collines, being the only animal among many pets singled out by any sort of name: it was always referred to as "le chat de Matisse."

Chagall understood Matisse's constant anxiety because he suffered from it himself. At this stage he could also sympathise with Matisse's heroic work against the odds of frailty and ill health; he himself underwent a prostate

operation in December 1950, during which he stayed in the hospital in Nice for two months. Ida stayed there with him, and Virginia slept in his hospital room each night and noted that "he never smiled and rarely talked . . . he had a piteous expression all through these two months . . . he was completely wrapped up in himself and uncommunicative, and the warm contact between us suffered." She had opposed the operation in the first place, believing, on the advice of her Roquefort friends, that cancer could be cured by diet, and she had tried to impose a strict regime on a grumpy Chagall. "I need just one little sweet thing to put in my mouth," he would murmur to Virginia at the end of every meal; it was usually denied (the only dessert Virginia could make was rice pudding) and the refusal was a symbol for the sweetness missing from their relationship. Ida made up for it, invariably arriving laden with tasty and lavish presents. In December 1950 she wrote that her own stay in the clinic with Chagall made her tired and nervous; for two months she commuted between the hospital and Switzerland, where a landmark exhibition of 1950–51 in Zurich and Bern included work from Walden's collection that Chagall had not seen since 1914.

Chagall, Virginia reported, was always on his best behaviour with Matisse. For an artist who found contact with other painters almost impossible, he was uncharacteristically generous, too. Cassou relates that in 1951 he paid a visit to Les Collines, just after Matisse had completed his then controversial chapel:

> Ida came to fetch me in her car to take me to "papa." At least it wasn't Virginia . . . When I got to Chagall's, he told me that Matisse had telephoned to ask if I had already arrived and to insist that I saw the chapel in the best light. "We're going to have lunch very early," said Chagall, "and then straightaway afterwards we'll go to the chapel . . . Chagall was completely at ease showing his scrupulous desire always to please Matisse. We did as he said. I saw the chapel in the best conditions, and I admired it in all sincerity . . . On our return to Chagall's, he said to me; "Not a minute to lose, you must telephone Matisse at once. That's what I would do." And I ran to the telephone and felt with what impatience Matisse had been waiting to hear what I would say, and how, immediately, he seemed to rejoice deeply.

Chagall took an intense interest in the chapel. Matisse had fought a long battle with the Catholic Church to be allowed a free hand, achieving victory

only when a Dominican monk, Father Marie-Alain Couturier, a specialist in stained glass and a leading moderniser, took up his battle. Couturier, a sophisticated intellectual who, like his friend Jacques Maritain, moved easily between church circles and secular high society, was also at this time wooing Chagall; he wanted him to decorate the baptistery for his modern church, Notre Dame de Toute Grâce, on the Plateau d'Assy in Haute Savoie. Thanks to Couturier's enlightened vision of modernist religious artists ("better a genius without faith than a believer without talent . . . a great artist is always a great spiritual being, each in his own manner" so "we must take them as they are . . . barely Christian at all"), the church already had work by half a dozen artists who were Communists, Jews, atheists, or all three, as well as a dark stained-glass window by the devout Catholic Rouault. Léger had done a mosaic, Matisse a yellow-tiled altarpiece, Bonnard a painting, Germaine Richier a bronze crucifixion, and Jacques Lipchitz a bronze virgin inscribed, "Jacob Lipchitz, a Jew faithful to the religion of his ancestors, made this virgin for the good understanding of mankind upon the earth, as long as the Spirit reigns."

Couturier, draped in sweeping white ecclesiastical robes tailor-made by Balenciaga, was a dashing and charismatic guest when he came to Vence; he melted before Ida, though he was icy to Virginia when she drove him back to Nice and chattered about a temple uniting all religions in a mystical philosophy. Chagall hesitated, accompanied Couturier to Haute Savoie, hesitated again, unsure of his position as a Jew working for a Christian church, and wrote to ask every Jewish authority he could think of, from the chief rabbi of France to Opatoshu and Sutzkever to Chaim Weizmann, president of Israel, all of whom were unopposed. Eventually he accepted but did not complete the work until 1957, after Couturier's death. Perhaps what Chagall was really angling for in 1950–51 was the offer of a synagogue instead; after *Aleko* and *Firebird* in America, his constant refrain was "Give me walls." Giotto's frescoes at the Scrovegni Chapel in Padua, which he had seen at the end of 1948, had also made a profound impression; now he made two bids to decorate chapels of his own, *à la* Matisse, in Vence–the Nice diocese turned down both.

Matisse had been specific in referring to his chapel as theatre: "I don't need to build churches . . . I'm doing something more like a theatre décor . . . the point is to create a special atmosphere: to sublimate, to lift people out of their everyday concerns and preoccupations." Chagall at this time also longed for a theatre; he always associated actors and circus people with religious figures, and his paintings from 1950 on can be seen as

rehearsals for the more public art of stained-glass windows or murals. He began in Vence with a return to religious paintings: the starting point was again an old unfinished work, "Abraham and the Angels" of 1931, which led on to canvases of the mural proportions that now interested him: *King David,* where (as in *The Red Sun*) the lavish red of David's robe gleams out, icon-like, from a dark background, and *Moses Receiving the Tablets of the Law.* "Just then," wrote Franz Meyer, "Chagall's biblical thought was centered in David and Moses. He revered them as the two greatest leaders at the beginning and the peak of Israel's first heyday."

Israel, too, was wooing Chagall; the new country had no power to command international loans, but Chagall and Ida agreed to lend works from their private collection for exhibitions in Jerusalem and Tel Aviv. As usual Ida went first to supervise the hanging and to preside over the opening, and she returned on the crest of a wave, saying her visit had been the most tremendous event of her life. Virginia was less impressed: she thought Ida worked like a demon to build up Chagall's fame at the cost of her own health and the happiness of them all.

Virginia was reluctant to go to Israel, having no wish to trail after Chagall on a celebrity tour. She was trying to find time for her own writing and for her Roquefort friends; one was a poet to whom she was romantically drawn, though he did not respond to her. She was anxious about leaving the children (Jean had returned to Vence in summer 1950) and convinced that she would cut an odd figure as Chagall's goyish companion. But Chagall, still shaky after his operation, felt unable to go without her. He had his own worries about visiting the new state: distrustful of non-Jews, he was often even more distrustful of Jews when he believed they were trying to hitch a ride on his own international standing. He fretted, too, as he always had done, about Jewish cultural ignorance and about how paintings of the shtetl would go down in a society whose most urgent drive was to look forward, not back. And impossible to forget was the last visit he had paid to Palestine, twenty years before, with Bella at his side. For all these reasons he dithered about when to make the trip, postponed it at the last minute, and finally set off in June 1951 with grave misgivings.

In photographs from the trip Virginia, silhouetted against the harsh Israeli sun, seems taller than ever, dwarfing the uncertain figure of Chagall as she tries to support him. The couple looks distant and strained, and Virginia recalled there was little warm contact between them. Chagall was uneasy both with her and in his own skin in Israel. His hosts offered a luxuri-

ous home and expenses if he would consent to make Haifa his winter quarters, and they pressed him to make a commitment to the country; he attended dinners with Golda Meir, David Ben-Gurion, and Chaim Weizmann. Chagall's answer was to repeat the mantra that art lives in France: it was the excuse he still used–to keep his options open with the Soviets–for having left Russia twice, as well as for having left America. Like many European Jews of his generation, he found it difficult to admit to himself that he did not really feel at home in Israel. He admired the energy, hard work, and optimism in the new state, and as in 1931 he was struck by the strength and healthiness of the people, but he commented tartly to Opatoshu that over two thousand years Jews had adapted to climates other than that of Bedouins. Once he returned, he was able to idealise it again as the land that, for all its faults, nonetheless was the Jewish homeland. The company he most enjoyed there was that of Sutzkever, the poet from Vilna who was fighting (with little success) to preserve Yiddish culture in Israel. Virginia noted that Sutzkever, who spoke to Chagall exclusively in Yiddish, "squared Marc's conscience with regard to Bella by being slightly aloof with me." Among friends from Palestine in 1931, and those, like Sutzkever, from Vilna in 1935, the talk was inevitably of deaths–of Bella, Mikhoels, Feffer. From Jerusalem, Chagall wrote to Opatoshu that here "they cry with tears from Vitebsk, my parents' tears and even Bella's."

Israel cruelly exposed the wedges that were driving Chagall and Virginia apart: fame, Judaism, a young woman's difficulty connecting with a man who largely lived through memories that excluded her. The sexual pull of a young relationship was gone; Chagall, in his mid-sixties, perhaps did not miss it. "Marc was an essentially chaste man and prudent where relations with the other sex were concerned. He was totally faithful–temptations were never great, for the tremendous temperament went into his paintings," Virginia wrote. "I longed for some of the passionate tenderness that filled Marc's paintings, and it was something I couldn't explain to him. By nature, Marc was shy and undemonstrative in love . . . He talked a lot about love in general, he painted love, but he didn't practice it."

This absence chimes with other evasions: the painter of the great themes of birth, love, and death spent much of his life avoiding personal confrontations with all three. "It is dreadful not to have put up a monument yet for papa, nor for Rosine, nor for David," he mourned in his memoirs in 1922; he had not returned to Vitebsk for the deaths of either of his parents, and now he frequently lamented that he had left Bella alone in America without a

proper tombstone. Births had been as frightening–he had taken four days to visit Ida and three months to accept David. Love, too, after Bella's death became an abstract concept; the sentimental lovers in his work after 1950 verged on self-parody. When Bella was alive, he had not needed to sell himself as the artist of romantic rapture, but as soon as he arrived back in France he adopted two words–*amour* and *chimie*–as mantras that he repeated every time he was asked to explain his art. He did not define them, but *amour* stood roughly for the themes of his paintings and *chimie* for their colours, and both were useful as he played up the persona of the peasant mystic, at odds with French rationalism. "In Orgeval, rich impressionist country," remarked Jean Cassou, "he rediscovered certain things . . . which he cherished under the names *amour* and *chimie*. He always pronounced these names with fervour, mystery, and preciosity. He affected to understand nothing which could be reduced to comprehension and played the role of Ivan, the village idiot." If this irritated friends, it infuriated Virginia, who watched how "he got so good at playing the part of Chagall (the 'Chagall' people expected him to be) that it was impossible to say whether he was acting or not."

But behind closed doors, the village idiot was a petty tyrant. "Marc gave me neither a banking account, nor housekeeping money," Virginia recorded. "I had to ask for money whenever I needed it and explain what I wanted it for. I got all the food on credit and he paid at the end of the month, a practice which undoubtedly cost him double, for the tradesmen were not always above a little 'arranging.' Curiously, he trusted them more than me!" He scolded and grumbled about signing cheques and reminded Virginia "repeatedly that he had saved me from poverty and given me inestimable material benefits." The frosty response Virginia evoked from many of Chagall's European associates–from Picasso to Cassou to Couturier to Sutzkever–did not help her status at home and was humiliating by contrast with Ida's sparkle. Only Claire Goll, who came to stay in Vence after the death of Ivan in 1950 but was generally resentful of Chagall, sympathised with her; in Claire's room Virginia broke down in tears, sobbing that "every night I have to show him the accounts and he discusses every expense: flour, oil, coffee . . . I am his maid, his secretary, his model, his driver, his accountant, and in spite of his millions, he hardly gives me enough to buy food."

Jean, now eleven, shrank into the background as visitors poured through the house and fussed over David, because he was Chagall's son, while ignoring her; only the playful, kindly poet Jacques Prévert bothered to make a

friend of her, too. She remembers at this time "feeling that David is a better person than me and I will devote my life to looking after him." Although she now called Chagall Papa, his communication with her was limited to asking "Are you helping your mother?"—it was as helpers to their mother that Chagall remembered his own sisters. Jean came to think of the family as containing three children, of whom Chagall was the most demanding; under a charming, childlike facade of everyday incompetence, she noticed, he shirked every adult responsibility, expecting her mother always to hasten to the studio to look after him. If visitors appeared in Virginia's absence, Chagall assumed that Jean would play hostess and make them lunch, which she politely did. Virginia saw Jean being groomed for a place in the Chagall ménage and grew more resentful than ever. Chagall was oblivious; he took pleasure in everyday life—strolling around the garden, enjoying good food and drink, savouring pleasant company—and otherwise spent his waking hours in the studio.

Virginia, neglected and feeling that her presence was taken for granted, vainly tried to write, sitting at her desk after Chagall had gone to bed. He insisted she give up her study and write in their bedroom—as Bella had done. Then he complained about mealtimes with the children; Virginia responded by bringing him his meals on a tray in his studio. Rather than risk a confrontation, Chagall summoned Ida, who demanded explanations from Virginia: "She was there almost all the time now, acting as an observer and sometimes intervening." Ida's next boyfriend, Swiss art historian and curator Franz Meyer, sometimes came, too; they had met during Chagall's shows in Switzerland at the end of 1950, and Chagall was thrilled when they announced their engagement. He saw sober, intellectual Franz as an ideal son-in-law and a calming influence on Ida. Franz came from a wealthy Swiss family of art collectors, had studied in Paris, and was an outstanding, rigorous art historian. Ida was making a match that was a secular parallel to that of her grandmother Alta, who united her own wealth and vivid public presence with the retiring personality and immense scholarship of Shmuel Noah Rosenfeld. Chagall enjoyed long, serious German discussions about art history with Meyer; by chance, even the subject of his doctorate—the large rose window at Rheims Cathedral—struck a perfect chord with Chagall's developing interests. Virginia, who privately wondered how vivacious, worldly Ida was going to be happy with such a dry, earnest, inexperienced younger man, hoped nonetheless that Meyer might distract her from Chagall, but the opposite happened: Meyer soon settled down to work on a study of Chagall's

graphic work, followed by a major monograph, published in German in 1961 and in English in 1964. Written through the 1950s with Ida's help, research, and intimate understanding, and with many insights provided by Chagall himself, it is, along with Tugendhold and Efros's 1918 text, the most impor-

tant, perceptive, and scholarly book ever written on Chagall, even though as a biographer Meyer's hands were tied—he was forbidden, for example, to mention the existence of Virginia or David, although David appears and is named in one of the photographs illustrating Chagall at work.

In September Chagall and Virginia made a brief visit to Le Drammont, where he painted her nude for the first and last time. Maybe he sensed that she was slipping out of his grasp; a long letter to Opatoshu from the resort, however, is steeped in unhappiness at the fate of the Jewish intellectuals in Russia and the memory of "my small and great dear friend who lies over there, poor thing, in N.Y., and now she is seven. How long will she lie there alone—who knows."

Franz and Ida Meyer on their wedding day, Vence, 19 January 1952

Back home in the autumn, the Belgian photographer Charles Leirens, who had made portraits of Chagall in America, turned up to film him at Les Collines. A courteous, dapper, sensitive man a year younger than Chagall, he had a weak heart, and a bored, flirtatious Virginia carried his camera around for him; Chagall looked on unenthusiastically as Leirens taught her the rudiments of photography. Like John McNeil and Chagall, who had been lonely and distraught when she met him, Leirens was another ill, needy case whose vulnerability attracted her.

Leirens's lively, penetrating portraits were much appreciated in artistic and literary circles, and he was invited back to Les Collines to photograph Ida's wedding in January 1952. Ida requested that the wedding reception be in Chagall's studio, where under *The Blue Circus* Chagall danced with Jacques Prévert, and the pair of them tried to dunk Ida's nose in a glass of champagne before she crowned Franz with the last tier of their wedding cake. The party continued through the night in the dining room beneath *The Cattle Dealer;* other guests included the Bordets, the Maeghts, Jacques Lassaigne, and Tériade. Ida reported that it was a warm, joyful day during

which Chagall had looked very happy. He is smiling at the centre of a family wedding photograph with the Swiss art historian Arnold Rudinger, Meyer's best man, and a laughing Bush Meier-Graefe. Ida stands between Meyer and Chagall; Virginia poses uneasily at the edge of the group. In the garden after the guests had gone home, she told Chagall that now it was their turn to get married. John McNeil had finally agreed to a divorce, and Chagall was eager to legitimise David. A few weeks later Virginia left Vence for London to attend the court hearing in February 1952. "I love you even more. No doubts . . . I think of you always and I need you . . . Many kisses," Chagall wrote to her. But thanking Opatoshu at the same time for a photograph of Bella's grave (Ida had asked Louis Stern to put flowers there to mark her wedding), he said: "How sad, how grey . . . It seems to me I have no strength to cry . . . You see, my dear, how I am still cut up and cannot heal my wound."

When Virginia returned, having won a decree nisi and full custody of Jean, she and Chagall were caught up in the preparations for Chagall's first ceramics show, which was opening along with a display of the *Fables* etchings (at last published by Tériade) at the Galerie Maeght in Paris in March. Leirens reappeared, ostensibly to film another Chagall exhibition at Nice's Galerie des Ponchettes. He and Chagall left the same morning for Paris, Chagall travelling by train and Leirens by car; in his luggage were the wedding photos for Ida, which he had arranged to deliver to her at her home at the Quai d'Horloge. Virginia was to follow later in another car, bringing the ceramics for the show. But when Leirens arrived in Paris, he telephoned Virginia, then took a plane back to Nice and they spent the night at a hotel. Virginia told Chagall that she was staying with friends in Menton, but he telephoned there and discovered that she was elsewhere. He wrote to her edgily that night: "How are things? You? The children? The house? So, see you soon, kisses."

Leirens flew back to Paris for his meeting with Ida, not daring to arouse her suspicions by not showing up. Virginia dithered; Chagall wrote three days later, asking when she would come, missing her and worrying, suggesting she drink herb tea, lamenting that he needed to talk to her but could only express his love for her in a painting or a Russian poem.

En route to Paris, Virginia broke her journey at Auxerre to spend another night with Leirens. Then on 20 March, the evening before the vernissage, she, too, reached the Quai d'Horloge, where an icy Chagall and Ida awaited her. Virginia was defensive: as she unpacked the ceramics, her first words were to accuse him of being a plaything of dealers and editors. But Chagall's

suspicions were further alerted when, as soon as they reached their room at the Hôtel Voltaire, Virginia locked herself in the bathroom–to read a letter from Leirens. Chagall snatched it as she emerged, and the story tumbled out. According to Virginia,

> he beat me to the floor with iron fists, pounding me on the back repeatedly; and when I began to recover, he pounded me again and shouted, "How could you do this to me? It's the vilest treachery. That man is a monster! He dared to come to Ida's house as if nothing had happened. He's a liar and a hypocrite! And you're no better" . . . He struck me again . . . now he wanted the truth.

Then he slammed out of the room and went to tell Ida. Virginia immediately phoned Leirens; walking along the banks of the Seine, they planned their future. The next day, she says, Chagall flung her to the floor again when she refused to attend the opening at the Galerie Maeght; she went. But her resolve stiffened: she was leaving Chagall.

He–and Ida–argued, begged, threatened, and tried to negotiate, during the next ten days, when Chagall and Virginia stayed together in the claustrophobic room at the Hôtel Voltaire. At the beginning of April they drove silently back to Les Collines for her to pack and pick up Jean and David. Chagall hoped that the sight of the house and the children would change her mind, but she had fixed a departure date of 16 April and booked train tickets to Paris, where Leirens would meet them. To soften the blow, she told Chagall she was going first to England to think over the situation, but nothing now deflected her. Chagall threatened never to see David again if he were being brought up in the house of another man, but Virginia had uprooted Jean at exactly this age–nearly six–and had few qualms about doing the same to David. So "for two weeks absolutely dreary," wrote Ida, "she packed in front of father's nose, doing it so calmly, so cold-bloodedly, without forgetting anything, araising [sic] even in their mutual address-book, the names and addresses that were more of her friends than of his."

Chagall lived through this fortnight dazed, numb, half-disbelieving. He and Virginia continued to share a bed, and some meals, but he rarely spoke and put on a mask of fatalistic resignation. He spent his days in the studio, making drawings and watercolours in books that he inscribed "Ma vie, mon art, mon amour, ma Virginia" and presented to Virginia with a martyred air. Ida meanwhile mobilised the heavyweights on the Côte d'Azur to plead Cha-

gall's case: the Maeghts, Tériade (who summoned Virginia to St. Jean to tell her that she had a sacred duty towards Chagall as an artist), and even Lydia Delectorskaya, who telephoned Virginia with an invitation–not accepted– from eighty-three-year-old, bedridden Matisse to visit him in Cimiez, and the message that had he been able to, he would have come to Vence himself. Only Picasso, at seventy still sexually competitive, was unsympathetic; when Ida met him and Françoise Gilot at the ballet, he jeered at the news. " 'Don't laugh,' Ida said. 'It could happen to you.' Pablo laughed even louder. 'That's the most ridiculous thing I've ever heard,' " he said. But within a year, Gilot had left him.

"After seven years of living with Virginia, I am almost crushed, as upset as you can imagine," Chagall wrote on 10 April, breaking the news to the Opatoshus. "Some character (old), came, some photographer, a sick man, to make (ostensibly) a film about me at my home, and she 'fell in love' with him." She had accused Chagall of being an egoist and a materialist; his house was too big, his paintings too expensive, his friends too well connected, his nerves too frayed for the children to grow up happily.

> Now you see the story of my life after Bellochka's death, when she came as a "poor maid" to Riverside Drive . . . and I dreamed of making her into a princess . . . Had she, at least, fallen in love with a young man–that is understandable, but . . . among millions of people, a sick man, a "cardiac" case with asthma, 62 years old. This is the human, "philosophical" offence, which I as an artist, supposedly valued by the world, did not deserve.

Reading Chagall's letter alongside the justification Virginia wrote dramatises the gulf of understanding that had always separated them; the miracle is that they stayed together as long as seven years. "I wanted this new love more than anything," Virginia explained. "My frequent urges to begin again came from a deep feeling of inadequacy. I lived in expectation of a brighter future, when I would at last feel adequate. But each time I brought suffering to others. Perhaps I would stop hurting people when finally I learned to accept myself . . . Meanwhile, I had to rely on other people's acceptance, and now it was Charles who gave me confidence in myself." For Chagall, this was irrelevant, trivial, set against his art, from which his own identity was inextricable. "I think that in her craziness she fell in love with him . . . because she didn't understand my mission in life and art," he wrote.

But if she had the genius to *feel* art–and my art, she would have understood what kind of person I am . . . but . . . she did not (could not) get to the wellspring of the art. It means she did not have in herself even $^1\!/_{10}$ of the genius of Bella, and in general of our Jewish wives of artists who stand at their posts, holy and devoted . . . This is my tragedy and my mistake . . . And now, dark life has opened for me a grave more bitter than Bella's grave, because with her death I *lamented naturally* and our love stayed whole for eternity. But here there are *two tragedies.* The second one is the insult . . . I ask God that if [Virginia regrets,] I have the strength to answer that she can remain wherever she is. In spite of my own terrible love for her and my rage over my son whom she takes away with her.

On April 16 the Maeghts sent their chauffeur to Les Collines for Chagall, half an hour before Virginia was due to leave. He kissed her and the children goodbye and told twelve-year-old Jean "tell your mother to come back." "But of course we're coming back," replied the child, who thought they were going on holiday. As soon as they were out of sight of the house, Virginia explained that they were now going to live with Charles. "Which Charles?" asked Jean, for the family knew two, "both old men": Leirens and the critic Charles Estienne. In fact, Jean and David were both sent to school in England immediately and stayed there until the end of July, while Virginia moved in with Leirens, whom she married on 14 May. Chagall did not speak to Virginia again, though she later revisited Vence and retraced the steps of his walks in the village in the hope of seeing him. In 1956 she took David to an exhibition of his father's work at the Galerie Maeght in Paris, and they chanced to meet Chagall there; he shook her hand but said nothing, and they never saw one another again.

CHAPTER TWENTY-THREE

Vava

Vence, 1952–1960

While Virginia sped north from Vence to Paris, Ida made the journey the other way, arriving at the Maeghts' house on the evening of 16 April to escort her father home to Les Collines. She was accompanied by Ida Bordet and a friend of hers, a small, dark, elegant Russian-Jewish woman in her midforties. This was Valentina Brodsky. Born in 1905 in Kiev and distantly related to the city's famous Brodsky family, sugar magnates and among the richest Jews in Russia, she was an exile from the revolution and had, like Chagall, lived in Berlin and Paris before the war. She was divorced and ran a millinery shop in London and had agreed, for a trial period, "to come and keep the house, keep company and make things run for Father." It was, Ida wrote on 2 May, "a temporary solution that will be probably none, but I wanted to gain time for his own sake and health . . . What will happen now, I do not know. Father, after dreadful weeks of frenzy, is in such sadness and so despaired now that it is worse to see him than before . . . His cardiograms are not good and it adds to my anxiety."

"One great calamity is that I cannot live alone. And not work," Chagall wrote to the Opatoshus. "And why did God punish me–I don't know. Whom did I harm?" He was not, however, entirely passive. He knew that he needed a wife, he wanted her to be Jewish, and he was quite unable to play the field. He had never been much of a seducer–Virginia had arrived on his doorstep, and he had not seriously courted a woman since Bella in 1909. Nor did he have close, independent female friends: the women in his circle, such as Claire Goll and Sonia Delaunay (both now widows), had always been there as

part of a couple. The exception was Bush Meier-Graefe. A close friend of both Chagall and Ida's since 1942, he had proposed to her in 1945, and she claimed that they had had an affair before that. In the meantime she had married Hermann Broch, returned from America to live at St. Cyr, and been widowed in June 1951. While Valentina–neat, attentive, efficient, reassuringly Russian-speaking–hovered in the background, Chagall made a hasty, desperate attempt to forge an intimate relationship with the newly available Bush.

He had been en route to Israel when Broch died in June 1951. "I send you my kisses and sentiments of love," he had written then. "You know how much we all love you. Endure this fate–you are philosophical. I've often said to you that I noticed with you that calm, philosophical force and I love your good character." Bush had been welcomed as part of the family circle at Ida's wedding–she would later be godmother to one of Ida and Franz's children–and she had been among the first to hear, from Ida, the news of Virginia's departure. In early May, Chagall wrote her a scrawled note ("I am still very sad and unhappy . . . Write to me") in shaky, uncontrolled handwriting on the back of a reproduction of his 1923 picture *Lovers,* showing himself and Bella flying on horseback through a moonlit sky. Shortly afterwards he addressed "Ma bouche cheri" [sic]:

> I want to see you, I want to come to you for a bit. I am too sad. They've got me a housekeeper at home (a Russian woman from England). But God knows how hard it is for me to get used to her in spite of her good character. After Ida, you are the only one with whom I feel at home, without speaking of my feelings for you. I want to see you. She is here for two months. Write to me how to come . . .
>
> I hug you with all my heart, Marc.

Three more letters and cards followed in the next couple of weeks, all messy, agitated, crossed out and blotted, the French spelling worse each time ("Excuse moi me fautes de Fransais"), and each begging that Bush let him visit her–provided she had no other guests, for "I am at the moment too sad to see strangers"–or meet him at Toulon, halfway between their homes, or in Paris, where he was not ready yet to show his face but "I want to make this trip . . . above all to see you." "Je t'embrasse bien," he pleaded, but when

they met in June, the visit was not a success. Chagall returned by train to Nice, disconsolate, and called Ida from the station: "She turned me down." Bush was an intelligent, independent woman; she did not want to be a muse. To Opatoshu Chagall wrote on his return, "You can imagine how low I feel, if [I don't write] even to you . . . No natural death and no other 'natural' calamity has upset me so much as this pretty false catastrophe . . . I am at a loss of breath to live, not just to understand."

But now time was running out with Valentina. The same age as Bush, she, too, had built an independent life for herself out of war and dislocation, and she was not going to abandon her business in London for the insecurity of being a stopgap housekeeper in Vence. She made it clear that either Chagall would marry her or she would leave. It was perhaps a calculated gamble played on a vulnerable man who was beginning to find her presence comfortingly familiar and would have no idea how to find a replacement. But Valentina also had emotional needs of her own.

The closest relationship of her life had always been with her brother, Michel Brodsky. When Valentina was thirteen, brother and sister had travelled together to Berlin from Kiev, which in 1918 saw the worst pogroms of the civil war years, with a massive White Army-led orgy of murder, torture, and rape of pre-teenage girls. Valentina completed her education in the German capital, taking the school-leaving exam the *Abitur* in 1923–the year Chagall and Bella left the city. Valentina also moved on to Paris and then, in the 1930s, to London. She and Michel supported each other through thick and thin and had the ability, typical of bourgeois Russian exiles of the period, to make thin look like thick: neither had much money but spent what they did have on expensive clothes, outwardly keeping up appearances while living in homes (never open to visitors) that were run-down and even squalid. They were an odd pair of survivors: charming in a discreet way but secretive, too, careful to keep up a mystique about their origins and connections to the well-known Brodskys of Kiev. They were also reticent about their religion–Valentina was rumoured to have converted, for pragmatic reasons, to Christianity (although Chagall may not have heard this)–and about their own unorthodox private lives. Michel was homosexual and had a French lover in the fashion business; Valentina was an emotionally withdrawn virgin–her first husband had been a homosexual with whom she had lived briefly in an unconsummated *mariage blanc.* So she knew all about marriages of convenience but nothing about sex. She was forty-seven years old, and for her Chagall was the chance of a lifetime.

Chagall and Valentina (soon Valya, then Vava) were married on 12 July 1952 at the Bordets' house in Rambouillet. Chagall, who had a hatred of promiscuity and had retained ideals of bridal innocence that were old-fashioned by the 1950s, and had irritated Virginia, thus married for the second time a Russian-Jewish virgin who was willing to devote her life to his art. At the reception Claude Bordet toasted the "Agency Ida-Ida" for arranging the match. Chagall certainly felt pressured into it from all sides, but his instinct for self-preservation also came into play. Both Chagall and Vava came from families in the Pale where arranged marriages had been the norm, and Vava's background weighed in her favour– Chagall boasted to the New York critic Emily Genauer that Vava had "yiches" (class), and that while his father had been hauling herrings, the Brodskys of Kiev were buying Tintorettos. Vava thus completed the trio of upper-middle-class women

Valentina Chagall, 1952

who became his companions. Like Bella, she was typical of well-to-do eastern European Jewish wives in combining the role of business-woman (her experience in her millinery shop paralleled Bella's as jeweller's daughter) with hostess, of calculation with warmth. She also spoke and wrote five languages perfectly and understood, as cosmopolitan Bella had and Virginia had not, the different nuances in French, German, and Jewish responses to Chagall and calibrated his correspondence and business dealings accordingly. She was efficient, steady, calm, and cultured and had a lively sense of humour that developed as she thawed emotionally in the first years of the marriage. Under her reign, Russian again became the language of the house, with Yiddish spoken sometimes, too. Russian customs, such as sitting down just before leaving for a journey (to ensure a safe return), which Chagall had never ceased observing, were unquestioningly accepted. Russian food was cooked, and desserts–not for nothing had the Brodskys been Russia's "sugar kings"–were back on the menu. "He drank tea from a glass in a chased silver holder, such as the Russians love . . . There was sliced sponge cake and very sweet jam," reported one visitor soon after their marriage. The Marchese Bino Sanminiatelli, who hosted the couple on a visit to Florence in the mid-1950s, thought that Vava resembled a cat; he noted that she smoked cigars and that Chagall enjoyed pretending to be scandalised.

Later the balance of power in their relationship would shift, but what never wavered was that Vava brought Chagall the tranquillity and security essential for him to work. The marriage, he hoped, would help put the

trauma with Virginia behind him. "There must be an end to my life with the English woman," he told the Opatoshus ten days after the wedding. "And now, you see, the Jewish woman who came the same day, April 16, to rescue me from the sadness alone in the house, became my wife on July 12. That's it. I hope that somehow the other one will gradually let me have David . . . For me she is dead. Sometimes I'd like to pity her. But she didn't have pity for me . . . My soul is not the same." He refused to see David, or communicate with him in any way, for the next year. His letters express anxiety for his son, grief at his plight, and dreams that he could adopt him—he had no legal rights, John McNeil's statement that he was not the child's father having turned out to be worthless in law, and David bore McNeil's name. But in fact Chagall took the (for him) characteristic course of evasion: he did not answer pictures and notes sent by the six-year-old, and he refused a plea by Virginia that David visit Vence for the holidays in Christmas 1952, in an elegantly chilly letter addressed to "Dear Madame," written in English and signed by Vava.

Protecting a nervous Chagall from any provocation became Vava's overarching concern—a concern conditioned by his fragility when she entered his life. His letters from the early months of the marriage suggest that, though he was not catatonic with grief as when Bella had died, he remained at first in a state of near emotional shutdown. "You probably know," he wrote to Sutzkever in August, "how strange the one who made me happy (after Bella), the English woman, that blond one, who inexplicably left me with my son. I am still jittery, though I was forced to get married to another one (a Jewish woman), so that I wouldn't go berserk alone in the huge house, and still be able to work a little. I cannot write about it in a letter, but I am not the same person you knew (somewhere not the same)."

He wanted to be courteous to Vava, however, and to make this marriage work; he also wanted a respite from Vence with its bitter associations. So the newlywed couple took a long honeymoon through the summer and early autumn of 1952, beginning with a week in Rome, then travelling to Athens, Delphi, and the island of Poros. The idea came from the loyal Tériade, who commissioned a series of colour lithographs as illustrations for the classical romance *Daphnis and Chloe;* he felt Chagall would benefit from an encounter with Greece "in both the geographical and spiritual sense." This turned out to be true: "Greece seemed to him just as incredible as Palestine," according to his friend Jacques Lassaigne, and on this trip, he told the German art historian Werner Haftmann, he began to think of the Acropolis

in Athens as "the necessary counterpart to the temple in Jerusalem; the brightness and lively vigour of everything Greek formed the counterpart to the solemn holy splendour of Jerusalem." This perception would have an effect on the classicising component, as well as the bright colour, of his late work. It is symbolic that this watershed in his thinking occurred on his honeymoon, when he was looking for new beginnings; Vava moreover tended to assimilation more unambiguously than Bella and may have liberated him away from Jerusalem towards Athens.

On this trip he made gouaches and pastel drawings inspired by the new experience of landscape–the bay of Poros in the evening light, a moonlit boat trip with local fishermen–and preparatory work for *Daphnis and Chloe.* Eventually published in 1961, it turned out to be among the weakest of his book illustrations: a cloying, sentimental, almost parodic version of the idylls of lovers from his earlier work that betrays its beginnings in this period of emotional disorientation. The theme of lovers had been launched in his work at the time of his first marriage and honeymoon in 1915, in major paintings such as *The Birthday* and *Window in the Country,* where the bodies or faces of Chagall and Bella are fused. Now, when the gap between the passionate first love of Daphnis and Chloe and the pragmatic circumstances of his current honeymoon was cruelly evident, he fell back on a diluted, almost automatic recapitulation of those old images, reduced them to cliché, and drenched them in a new, intense Mediterranean colour scheme: gaudily bright blues, shiny yellows, pale purples. These and similar lithographs on romantic and pastoral subjects have, however, been enduringly popular; in the 1950s Chagall achieved a technical mastery over the coloured lithograph and through it, encouraged by Vava, reached a new audience and market.

In 1952 the pleasure of discovering the sea, the archaic sculpture, and the landscape and light of Greece was salutary, and so was the gentle, undemanding companionship of Vava. Chagall was not expecting romance, but she was finding romantic fulfillment for the first time, and there is something girlish about her expression and demeanour in a photograph taken just after their marriage, showing her in a casual summer dress, watching Chagall with a familiar, understanding gaze in his studio. In other early photographs, too, with Vava swathed in Russian shawls reminiscent of Bella's style, her thick black hair gracefully coiffed and her dark eyes sparkling, the newly married couple look at ease together, with none of the tension that marks all the photographs of Chagall and Virginia. Ida was cautiously hope-

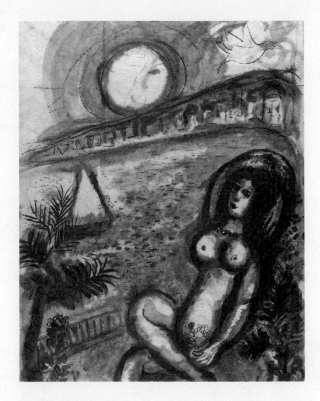

Chagall, "Nude in the Bay," circa 1960, India ink
on paper

ful when they returned from Greece to Vence in October. "Father has not recovered yet . . . Only time and peace can cure him," she told the Opatoshus, but she was optimistic about Vava: "I cannot imagine you not liking her. She is a golden heart. She adores father, and in so many ways I cannot help thinking of mother. Father's instinct pushed him to marry her, so that she should remain, but his eyes are seeking still Virginia, that poor, poor, fool who was more cruel than if she were bad."

If only because of David, Virginia was neither forgettable nor eager to be forgotten. She wrote to their best friends, such as the Opatoshus and the lawyer Bernard Reis, with her own version of the breakup and a characteristically cheerful take on its consequences, saying that as long as parents are kind to each other, children need not suffer when families split up. Her own life was not easy; almost immediately after they married, Charles Leirens became bedridden, and thus she nursed him for a decade, until his death in 1963. She was not one to bear grudges; in general she talked generously

about Chagall and Ida, and Chagall was surprised when, stumbling across one of her English notebooks left behind in Vence, he had it translated and read her loving and caring comments.

Nevertheless, finding out in November that the Opatoshus had seen her, he complained at what he perceived as disloyalty, and in response they broke off all contact with her and forwarded to him the letter in which she had elucidated his faults. He still smarted from the memory of the betrayal ("for years she plotted something") but was stoical. "May God save her from downfall, may she have some pleasure in her life, though she threw me into a strange pit," he told Opatoshu. "I am waiting and waiting for months to cool off, to heal, to find the taste of life (and even art), and to get closer and closer to the woman who came to me–to be near me and help . . . And though I am 'innocent,' I believe in a God of some kind who will not want me to finish my life in bitterness."

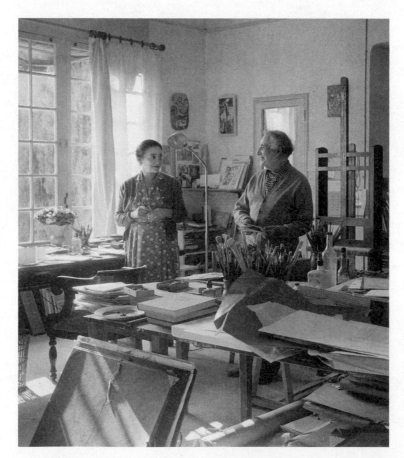

Vava and Chagall in the studio at Les Collines, Vence, 1952

On his first wedding anniversary, in July 1953, when he had just become a grandfather–Ida's son Piet was born in Zurich that month–he was still rehearsing the same arguments with Opatoshu, mourning the loss of David, hoping for strength to forget Virginia, trying to find stability with Vava. "God knows how my life is twisted and, it seems, tortured, and when you imagine, through such a false human being," he said, yet "today is my day, our day . . . when Valya became my wife–and it seems she is happy and I have a very nice friend for my life." A year later, in letters written to ask for Opatoshu's help with a memorial book on Bella to mark the tenth anniversary of her death, he said that he was calmer and was able to cope with occasional visits from David. There is a photograph of the eager, slightly lost-looking eight-year-old visiting his father, Ida, and her three children in Paris in spring 1954. Her twins Bella and Meret (named after the Swiss surrealist Meret Oppenheim) were born ten months after Piet in May 1954, when Ida was staying in Paris. With still-fresh memories of the Holocaust and fears of war in Europe, she had wanted all her children to be born in Switzerland so as to be guaranteed Swiss nationality, but the twins arrived early, one evening after she had visited Braque's studio; had she called on Picasso that night, it was joked, she would have produced triplets. In the photograph Chagall, seated in a family group before one of his ceramic jugs, looks relaxed, holding David with one hand and Piet with the other. Vava, he wrote, "keeps the house–well . . . She is filled with Jewish manners. And in yet another while, I shall be like everybody else." In public he remained charming, animated, and pensive, a handsome, approachable figure with curly white hair and bright blue eyes: a dignified yet playful persona, somewhere between a harlequin and a prophet, who affected utter unworldliness and whose perfect complement was Vava–worldly, organised, practical, and fierce when necessary: a constant, calm, steadying presence.

With Vava at his side–he rarely went anywhere without her–Chagall now entered his first period of stability since the upheavals of the war. It made itself felt in his work immediately and lasted until his death in 1985– he was married to Vava longer than he was to Bella. From the start the marriage gave him an immediate burst of confidence and the peace of mind to revisit unfinished work (such as the Bible etchings, completed between 1952 and 1956 and finally published by Tériade), and a series of sketches of Paris started in 1946 (which developed into a major painting cycle from 1952 to

1954) and to consider ambitious projects. The courage to work in new media, especially on stained glass, was decisive for his future; he also spent increased time on ceramics, sculpture in stone and bronze, tapestries, and colour lithography, learned at Fernand Mourlot's distinguished workshop in Paris and in collaboration with the master lithographer Charles Sorlier, "mon petit Charles," who became a close friend. In 1952 he visited Chartres to study the stained-glass windows, and from 1958 he worked at the glass atelier of Charles Marq in Rheims. His interest in all the new media made possible the monumental-decorative tasks of his last three decades; it was fuelled by an interest in achieving a synthesis with architecture and in integrating image and material–the fusion of colour and light in stained glass, the purification of colour by fire in ceramics, the ability to reflect light and create spatially expansive compositions in mosaics, the sense of reproducing the "fabric of life" in tapestries.

All the new techniques stimulated him and fed back into his paintings; in the years following his marriage, all aspects of his work and life therefore had a sense of new beginnings, definitive moves. As Vava established herself in his life, moreover, she encouraged Chagall to break with aspects of his past. She eased out members of his entourage, from his doctor, Camille Dreyfus, to his daughter, who was informed in 1956, just as she was gathering up her children and luggage into the car to return to Switzerland after a visit to Vence, that she was no longer to be his dealer. In 1957 Chagall celebrated his seventieth birthday at Ida's house on the Quai d'Horloge in Paris with André Malraux as a guest of honour, but already to safeguard his and her own peace, Vava was setting the Chagall grandchildren at as much distance as she could; soon they were receiving cheap toys instead of drawings and watercolours as gifts. Vava also kept David at bay: dispatched, as a condition of Chagall's paying him an allowance, to boarding school in Versailles and so beyond Virginia's influence, he rarely saw his father. He smarted over the decades and had his revenge by writing a short story, published in 2003, in which he refers to Vava throughout as "Elle" and ends by drowning her in the Mediterranean. Despite other disunities, the extended family joined in liking the story, Virginia (then eighty-eight) remarked acidly, because "everyone had hated Vava."

Ida had more immediate problems. The conflict with the stepmother whom she had so carefully put into position made her ill; she had further operations for ulcers in 1955 and 1958, when Chagall also had an emergency operation for appendicitis, and Vava and Ida battled it out in the hospital

Chagall and Vava,
Vence, 1955

over how he should be treated. The same year he and Vava divorced in
March, in order to remarry, with a more advantageous marriage settlement
for Vava, in September. The move was illegal under French law, which
demands that those affected by the settlement (i.e., Ida) be informed before-
hand; she knew nothing about it, and when she asked Chagall to discuss it,
he moaned helplessly in Russian, "Ya ne mogu, ya ne mogu" (I cannot, I
cannot). Ida continued to visit and, at one remove, to devote herself to her
father's art—in 1959 she travelled to Russia to search for paintings and docu-
mentation for her husband's magnum opus on Chagall. There she had
emotional meetings with Chagall's two surviving sisters (whose lack of
education shocked her, though she sent them gifts from the West for the rest
of their lives) and with Bella's brothers Abraske, with whom she had little in
common, and Yakov, whom she adored. But she knew that, in a familiar sce-

nario, she had been sacrificed in the interests of peace and harmony for her father's work. Vava, she told the collector Louis Stern in 1959, "is a great *stratège* and to say that she is dangerous is not enough, but he is amused by all this and anyhow respects it." Without Ida's activities, Chagall's association with Maeght strengthened, and his reputation was efficiently stage-managed by this powerhouse of postwar modernism. At the same time the landscape changed as death picked off important friends and colleagues: in 1952 Paul Éluard, in 1954 Matisse and, to Chagall's shock and grief, Joseph Opatoshu; with him Chagall's intimate contact with the Yiddish world vanished, too. Vava filled all the gaps and was soon indispensable emotionally as well as practically.

Around him Chagall watched the École de Paris, too, more or less disappear in the 1950s: Dufy and Francis Picabia died in 1953, Derain in 1954, the same year as his old fellow Fauve Matisse, Léger in 1955, Rouault in 1958. The major painters among Chagall's Russian colleagues were dead, too: Malevich in 1935, Lissitzky and Jawlensky in 1941, Soutine in 1943, Kandinsky in 1944; those who had become obscure and been unproductive for decades, such as Larionov and Goncharova, lived on in poverty. In a reversal of their roles forty years earlier, when Chagall had been the outsider in Moscow and St. Petersburg, he now helped his impecunious fellow Russians. "My dear Chagall," wrote the former avant-garde leader in a pathetically shaky hand in 1951, "I'm very grateful to you for your pleasant and friendly attitude, and for your sending me the 3000–especially because we are personally not very acquainted. Please excuse my handwriting–I also have limited control of my hand. I am very obliged to you. M. Larionov." Through the 1950s and 1960s, Picasso, Miró, and Chagall were the great survivors: all faced the challenge of preventing a long career from turning stale, at a time when there was a general crisis of confidence in European easel painting. All three answered the challenge in part with a move to other media and a decorative monumentality: Picasso's ceramics and large-scale paintings for the Château Grimaldi (now the Picasso Museum) in Antibes; Miró's murals at the Terrace Plaza Hotel in Cincinnati in the United States and ceramic wall decorations in Paris; Chagall's stained-glass and mural projects in Europe and America in the 1960s. Matisse had done the same. "Paintings seem to be finished for me now. I'm for decoration," he wrote in 1945. "There I give everything I can–I put into it all the acquisitions of my life. In pictures I can only go back over the same ground." For Chagall, an artist rooted in the narrative reality of a land from which he was separated, and instinctively hostile

to abstract art, this turn to decoration was even more critical than for the others. Picasso and Miró were southern artists of a naturally classicising tendency; they had always been driven by a formal inventiveness, which in the 1950s struck chords with the international move towards abstraction. Chagall was a lone Russian who had endured more serious emotional upheaval and loss, was less secure, and still felt constantly nervous and alienated; aged seventy-one, he admitted to being as tormented about a Paris exhibition as a boy of seventeen. He knew the stakes for an art of old age were high; although Vava made enemies, her single-minded devotion made possible the thirty-year period of paintings, murals, mosaics, stained glass, and theatre decoration that coheres as late Chagall.

This period opens with *Red Roofs,* the most important work in the cycle of twenty-nine paintings and many lithographs that make up the *Paris* series shown at the Galerie Maeght in 1954. This was Chagall's first major show in France since the landmark retrospective in 1947 that had won him prestige and a wide young audience in Paris. It was also his first exhibition since his

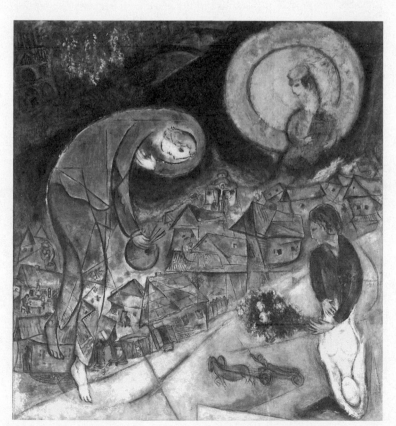

Chagall, *Red Roofs,* 1953, oil on cardboard pasted on canvas

marriage to Vava, and it demonstrated a new ambition, scale, and consistency of vision that had been absent from his work in the decade after Bella's death. The entire cycle–including *The Eiffel Tower, The Carousel of the Louvre, Bridges over the Seine,* and *Night*–is a lyrical homage to the city that had been his and Bella's second home, conceived from the drawings and pastels made in 1946 on his first visit there after the war. *Red Roofs,* however, restricts the Parisian motif to an upper corner showing the Seine with its bridges, the bank with Notre Dame and blossoming trees; this view sinks into darkness beside a blazing-red panorama of Vitebsk that occupies a central horizontal colour band. Bending low before it, his entire body a deep arc reminiscent of his 1912-13 painting *Jew at Prayer,* is the long, slender figure of Chagall himself. His gesture of veneration is directed at his native town and at two other figures: a strange upside-down composite of himself and Bella as a bride and, in the upper corner, a Jew holding the Torah scroll who appears within a yellow sun, itself enclosed by a circle of soft rose; against the warmer colours, the Torah gleams like a blue jewel. So Chagall saluted his heritage, his past, and heralded the mysteries of sacred and secular love as the themes of his late work.

Red Roofs inevitably recalls *Self-portrait with Seven Fingers* and *Paris Through My Window,* both made nearly a half-century earlier, in which he painted himself already divided between Vitebsk and Paris. Those, however, were a young man's pictures, full of urgent individual dilemmas of identity; here the subject is memory, conveyed almost entirely in terms of colour as Chagall in his sixties depicts himself merging through a wash of red with his native town. Painted in oil on cardboard, which provides a smooth ground for the luscious colour, laid on flatly with broad, free brushstrokes in vast unbroken zones as in lithography, the work also demonstrates a new abstracting tendency. Such sweeping chromatic bands and blocks mark the *Paris* series: the broad washes of contrasting red and yellow composing *Banks of the Seine* and the brilliant pink upside-down rooster shining against the midnight city in *Bridges over the Seine,* both of which include a Madonna and child referencing Virginia (she had just given birth to David when Chagall worked on the preliminary sketches for the work in 1946); the swathe of blue enveloping Vava, highlighting a white splash that is her bridal veil and the vermilion sun sliced by the Eiffel Tower, its curves paralleled by those of Chagall's green head as he looks away from it and down to a shadowy Vitebsk, in *Le Champ de Mars.* Bella, Virginia, Vava, his own self-portrait, the familiar themes of love, maternity, motherly security, memory:

thus the *Paris* series encapsulated what had happened to Chagall since 1944 and at the same time announced the new predominance of colour in his late work. Monet was the painter who most occupied his thinking in the 1950s, Titian in the 1960s; both had lived to an extreme old age, and as in their late work, Chagall's colouring became gradually richer, more tightly woven, more abstract, with each decade that passed.

"Paris, my heart's reflection," Chagall wrote in an issue of Tériade's magazine *Verve* published to coincide with the Maeght show in 1954, "I would like to blend with it, not to be alone with myself." As often in his oeuvre when periods of turbulence gave way to stability, the *Paris* cycle is a transitional work: Paris represented a past, and a part of France, that he could internalise before he was ready to do the same for the Mediterranean. From the mid-1950s, however, his paintings began to be suffused with the light of the South, the lush vegetation and lazy rhythm of life in Vence. These works reprise the saturated sweeps of colour and sensuous style of the bittersweet fantasies of the late 1930s such as *Midsummer Night's Dream*—a tenor entirely absent from his haunted, dark American canvases. Only after he had settled into the marriage to Vava did Chagall feel he had truly returned from exile to France and allow himself to luxuriate in the Mediterranean setting of his new home; he did not paint Vence, his home from 1949, until 1952.

Then he began to respond again to its grace and brightness with a painterly joy that, from around 1955, recalls the lyrical serenity of his discovery of the French countryside in the 1920s. The refulgent *The White Window* (1955) is a marker: a view of a Mediterranean landscape is glimpsed across overflowing vases of flowers—pale red roses, sparkling white daisies, huge white calla lilies—above a pair of sketchily painted lovers. The window opening onto a landscape, a classical-modernist image much used by Matisse and Picasso, is rare in Chagall; with this work he stakes his place again in the French mainstream. The painting echoes *Ida at the Window* of 1924, with which thirty years earlier he had opened a decade of engagement with French art after his return from Russia. The paintings share the same psychic tension between inner and outer world; in *The White Window,* however, the paint is more freely handled, the light more diffuse, the rhythms airier and more vibrant. In all these respects the work set the tone for his landscapes and flower studies of the next thirty years until by his eighties, in a work such as *La Baou de St. Jeannet,* the natural world in his paintings seems to dissolve into pure colour.

Like *The White Window, La Baou de St. Jeannet* (1969) depicts a Mediter-

ranean view filtered by enormous bunches of flowers, on one side a flutter-
ing spray of white blooms that shoot upwards to a nocturnal sky, their white-
ness suggesting the cold light of the moon, and on the other a smaller red
and yellow bouquet whose warmth and radiance evoke the last daylight.
Between them a dark mass is a night panorama of the craggy mountain and
walled village of St. Jeannet, its roofs and citadel mere shadows, while the
mountain peak is transformed into two dark faces–those of eighty-two-year-
old Chagall and sixty-four-year-old Vava. Human life and love merge with
nature, and everything is suffused with colour, the quivering images with
their irrational, iconlike proportions–huge flowers, tiny village–suggesting
the way memory crystallises in the imagination.

In parallel to these romantic works Chagall was engrossed, from the mid-
1950s until 1966, in a series of large paintings, approaching dimensions of
two by three yards, and many related lithographs, on Old Testament sub-
jects. Returning to complete the Bible etchings begun in the 1930s, he was
swept up in this theme from his childhood. Here he could return to the
world of Jewish Vitebsk without Bella as intermediary, through the written

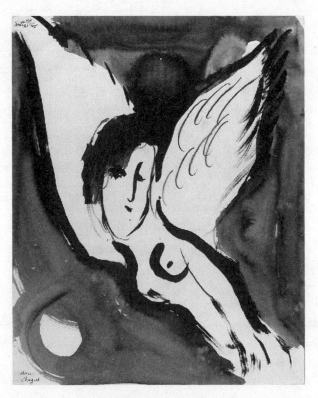

Chagall, "The Angel," 1955-60, drawing

word of the Bible, and it is this immediacy, the ability to pierce reality with the power of legend in painting that nonetheless has the conviction of a secular modernity, that makes his religious work unique in the twentieth century.

For every scene, form and colour deliver meaning, enrich narrative. In *Adam and Eve in the Garden of Eden* Paradise is a wash of gentle blue-green warmed by touches of red and purple blossom and a yellow acrobat; angel-fish, roosters, and other beasts or hybrids float past lovers and even the serpent looks benign. In "Abraham and the Three Angels" a rigorous pattern of horizontals and verticals underlines the severity of the divine message; out of a red ground, the luminous white wings of the angels lined up in a row seem to project out of the canvas, while Abraham, face divided into one red half, one pale, embodies the forces of good and evil, life and death. The five paintings illustrating the *Song of Solomon,* dedicated to Bella, are exquisite modulations on a saturated carmine-crimson-pink-rose tonality; in the first painting, Bella's hand beckons to Chagall from the bank of the Dvina; towards the end of the series we see the hill of Vence. *Jacob's Dream* is a circus, *King David* a Hasidic Jew in scarlet coat with gold crown and a green beard, dancing and playing the harp with one green hand, one white; coming to greet him from twilit Vence are a group of jubilant Jews, while an elongated bridal couple soar above Vitebsk and a wedding canopy. Chagall calls to mind David's roles as king, artist, lover; the two festive processions, one celebrating divine love, the other a secular wedding, merge; in a companion picture, Chagall portrays David as a lover kneeling before Bathsheba, with the Place de la Concorde as backcloth. "The Jewish soul has suddenly bared its own legend in the form of painting," wrote Werner Haftmann of these works; when they were shown at the Musée Rath in Geneva in 1962, Jean Leymarie wrote that "by making a fresh start on a task which had been left in such a hopeless situation it seemed to have been postponed indefinitely, Chagall reached out beyond the frontiers of his century and accomplished, without betraying either one or the other, a synthesis never previously achieved of the Jewish culture, which for long had remained indifferent to painting, and modern painting, which had become a stranger to the Bible."

It is impossible to overestimate how eagerly in the 1950s and 1960s a society shattered by war and stunned by the horrors of the Holocaust, and for whom the building of international peace was the paramount political idea, hungered for an art whose themes were love and religion and welcomed them especially from a Jewish artist-survivor able to encapsulate a lost world

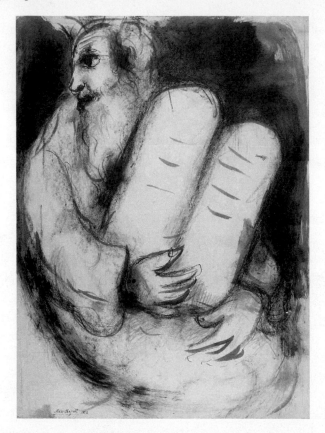

Chagall, "Moses with the Tablets of the Law," 1952,
drawing

in a particular, instantly recognisable set of images. This public neither
knew nor cared that Chagall's lovers, religious figures, villages, and flowers
of the 1950s and 1960s were diluted versions of the radical modernist aes-
thetic with which he had forged a place in postcubist art history between
1911 and 1921; his was a narrative art that met the psychological needs of the
age and gave pleasure and consolation as no other visual artist of his stature
did at that time. The thirst for a spiritual art that followed the Second World
War was answered, on the international stage, by abstract expressionism,
which in the hands of artists such as Barnett Newman and Mark Rothko—
both Jews—made enormous claims of transcendence but was incomprehen-
sible to the public of the 1950s and 1960s. Chagall, on the other hand, was in
a unique position to deliver art with an easily accessible spiritual message.
In 1960 Chagall and Oskar Kokoschka, another great survivor, were jointly

awarded the Erasmus Prize in Copenhagen; the title of Sir Kenneth Clark's address, "Two Human Painters in the Age of Abstraction," summed up popular response to Chagall.

After Matisse's death, the only living artist more famous than Chagall was Picasso. In America the Academy of Arts and Letters made Chagall an honorary member in 1959; in Europe his reputation was consolidated through the 1950s with a series of exceptional retrospectives: at Basel and Bern in 1956, at Amsterdam, Brussels, and Salzburg in 1957. Germany did these particularly well: Chagall was shown at the first "Documenta" exhibition in Kassel in 1955, at exhibitions in Hanover in 1955, and in Hamburg and Munich in 1959, where four hundred works hung at the Haus der Kunst, site of the 1937 "Degenerate Art" exhibition. (Chagall was secretly satisfied, but officially surprised, to learn that visitor numbers–3,600 on the opening day–exceeded those for a recent Picasso show on a similar scale.) The chords of cultural revival, renaissance, repentance, and hope that his art struck across postwar Europe were especially resonant in Germany. That he continued to refuse to set foot in the country himself was a stark statement that the Holocaust could never be forgotten; that he sent his art nevertheless was a symbol of reconciliation and peace-making. In his poem "To the Slaughtered Artists" he described his own dreams as a young man, recalling his mother's and Bella's empowering love, as typical of those of the Jews of his generation who had then been led to slaughter:

> They were led to the baths of death
> Where they knew the taste of their sweat.
> Then they saw the light
> Of their unfinished paintings.
> They counted the unlived years,
> Which they cherished and waited for
> To fulfill their dreams—
> Not slept out to the end, overslept.
> In their head, they sought and found
> The nursery where the moon, circled
> With stars, promised a bright future.
> The young love in the dark room, in the grass,
> On mountains, in valleys, the chiselled fruit,
> Doused in milk, covered with flowers
> Promised them paradise.

The hands of their mother, her eyes
Accompanied them to the train, to the distant
Fame.

I see: now they drag along in rags,
Barefoot on mute roads.
The brothers of Israels, Pissarro and
Modigliani, our brothers—they are led
With ropes by the sons of Dürer, Cranach
And Holbein—to death in the crematoria.
How can I, how should I, shed tears?
They have been soaked in brine—
The salt of my tears.
They were dried out with mockery. Thus I
Lose my last hope.

Throughout the 1950s debate about the possibility of creating art and literature after the Holocaust raged. In his Yiddish poetry and letters Chagall was usually at his most melancholy, but in his painting he did not lose his last hope, balancing instead the tragic by colour, beauty, harmony. "I beg you not to be a pessimist," he wrote just after his seventieth birthday to his old friend Daniel Charny in New York. "Life is always beautiful even though it is sad: good people and some close to us leave us." It was such hope out of darkness that kept his 1950s audience enthralled; it is encapsulated in his greatest painting of the decade, *Clowns at Night* (1957), wherein a band of circus performers (a Chagallian analogy for the artist) discharged from the bright arena wander forlornly across a stormy dark field under two sinister moons. The blackish-blue ground is almost monochrome, enlivened by a few muted colour accents that look as if they are encrusted into a thick, granulated earthy surface—the influence of modelling, incising, and engraving clay, which Chagall called an art of the earth, is clear. Out of the darkness the leader of the troupe, a spectral white violinist with a face like a mask, stares at the viewer; at his side a bird-headed figure carries a ghostly white singer; around them other musicians are discernible in the shadows. Of this picture, Chagall told Franz Meyer soon after he finished it, "Painting is a tragic language." No other picture of Chagall's, says Meyer, "is so full of heart-rending grief, of deep, vital, tragic pain." Yet the motifs submerged in the material mass of colour burst out like a life-force from the dark night of the

Chagall, *Ida at the Window,* 1924. Oil on canvas, 105 x 75 cm

Chagall, *Bella with a Carnation*, 1925. Oil on canvas, 100 x 80.5 cm

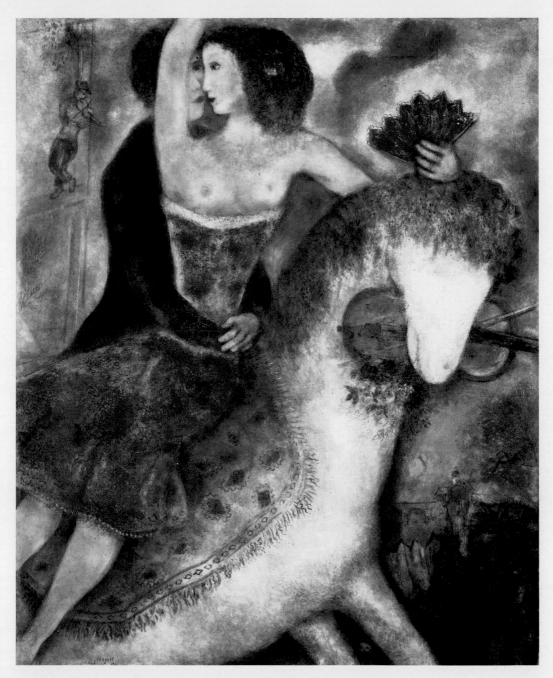

Chagall, *Equestrian*, 1931. Oil on canvas, 100 x 80.9 cm

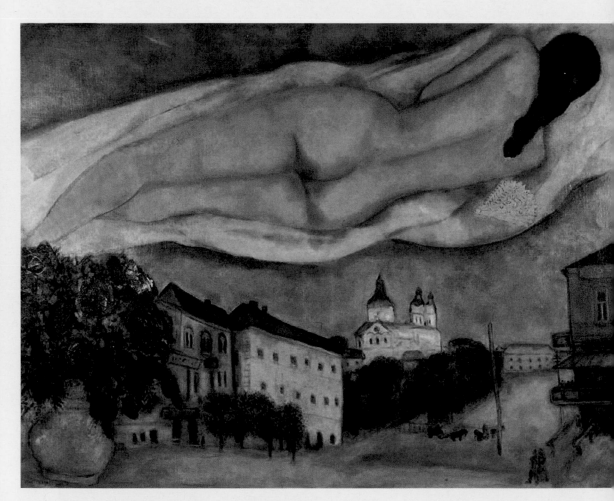

Chagall, *Nude over Vitebsk,* 1933. Oil on canvas, 87 x 113 cm

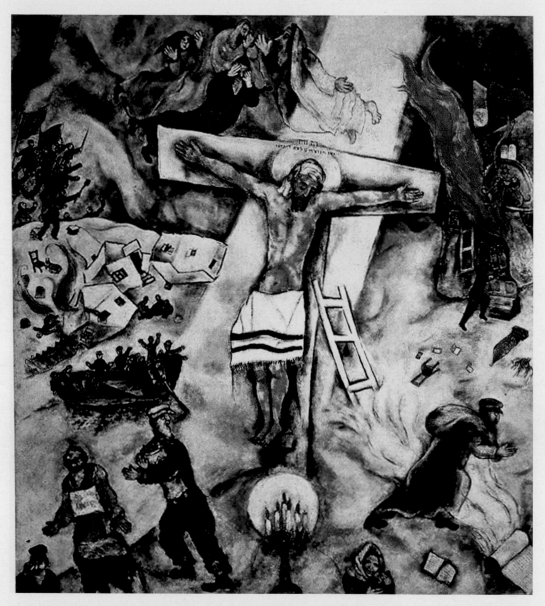

Chagall, *White Crucifixion*, 1938. Oil on canvas, 154.3 x 139.7 cm

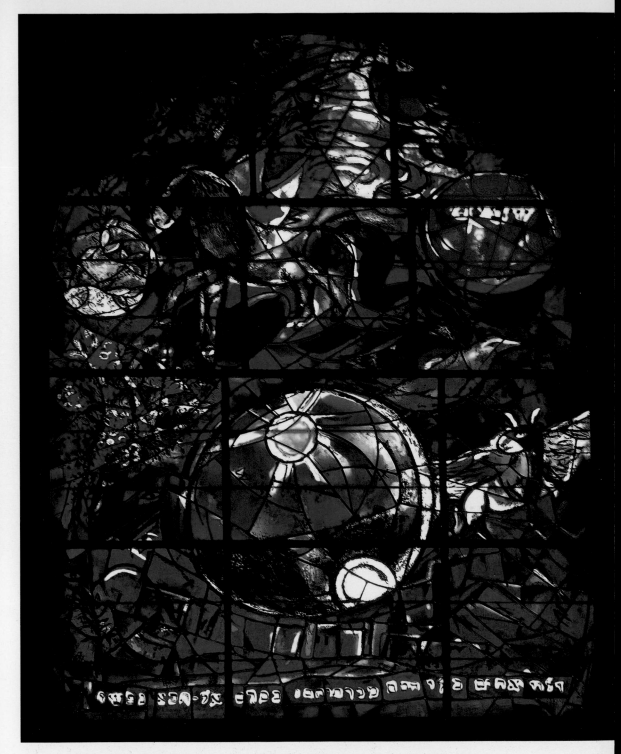

Chagall, *Tribe of Simeon,* Stained-glass window for Hadassah Synagogue, Jerusalem, 1961

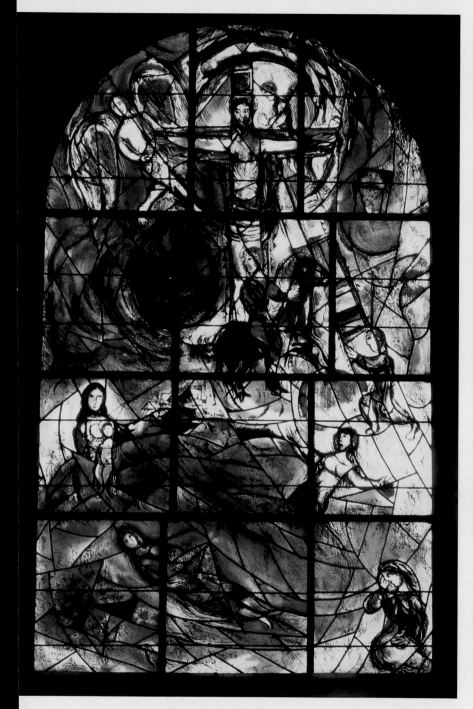

hagall, Stained-glass windows for All Saints, Tudeley, England. Installed 1967–85

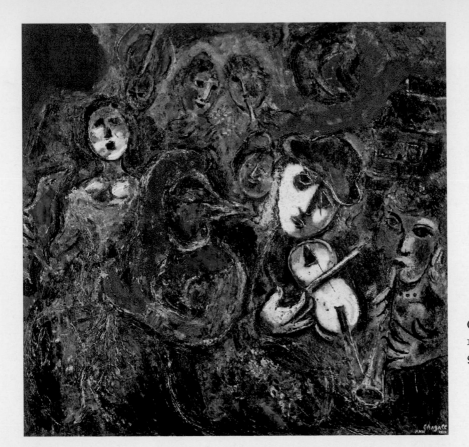

Chagall, *Clowns at Night,*
1957. Oil on canvas,
95 x 95 cm

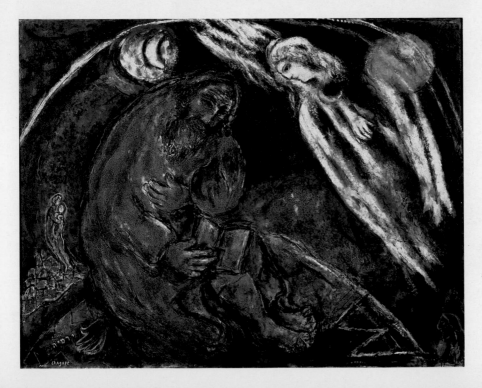

Chagall, *The Prophet
Jeremiah,* 1968. Oil on
canvas, 114 x 146.3 cm

soul. "The melancholy knowledge of the limits of human participation in the bright forces of reality is concentrated in the moon-white face of the young man with the hat," wrote Meyer. "But he is also the violinist and his melody resounds in the night as a challenge, as solace and, for all its sadness, as glorious unison with the world's deepest joy."

France, where this sort of fantasy had been incomprehensible or at best was yoked to surrealism in the 1920s and 1930s, now welcomed it as a bastion of figuration, and Chagall became a beacon of national art at a time when France finally lost cultural impetus to America; in art histories and encyclopedias of the period he is invariably listed as a French, not a Russian, artist. In 1956 he took a holiday in Italy that included a ceremonial visit to I Tatti, where art historian Bernard Berenson—an assimilationist so perfect that few knew of his shtetl roots—noted approvingly that Chagall did not look Jewish at all. (Berenson was harder on Vava, who reminded him of a high-class Hindu.) In 1957 Chagall bought an apartment on the Quai d'Anjou, on the Île St. Louis, the heart of aristocratic Paris and a symbol of his final integration. The retrospective at the Musée des arts décoratifs in the Louvre in 1959 was another landmark, but the pointer to the future was that France now delivered what he had been waiting for since 1923: the opportunity to work on a public scale that Russia had offered him at the Moscow Jewish Theatre in 1920 and America with *Aleko* and *Firebird* in the 1940s. In

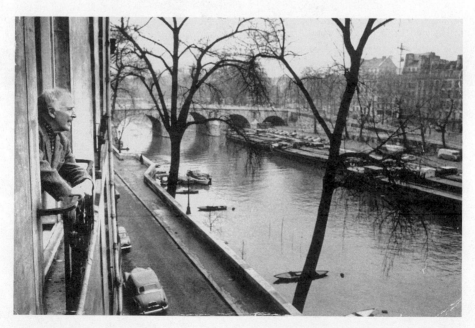

Chagall at the window of his apartment on the Quai d'Anjou, Paris, 1958–59

1958 he designed the sets and costumes for Ravel's *Daphnis and Chloe* at the
Paris Opéra, work arising out of the colour lithographs on the subject that
continued to occupy him, but still, "Je cherche un grand mur," he told the
German art historian Walter Erben in 1958. Frankfurt replied with an invi-
tation to paint a mural for the foyer of its new opera house; the huge *Com-
media dell'Arte* painting was regarded as a symbol of postwar renaissance
and reconciliation. France answered with a commission from Robert
Renard, chief architect of Metz Cathedral, to design several stained-glass
windows to replace those that had been destroyed by bombing during World
War II.

"We have to realise a masterpiece," Chagall wrote to Charles Marq, pro-
prietor of the Jacques Simon Glass Works in Rheims. Marq, a devout Chris-
tian, became the closest collaborator and friend of Chagall's last years,
almost a Lydia Delectorskaya to Chagall's Matisse. From 1960 onward easel
painting occupied Chagall less and less; instead he poured his energy,
knowledge, and courage, the joy and melancholy and wisdom of his old age,
into a new medium that afforded him creative freedom and the chance to
fuse light and colour on a monumental scale.

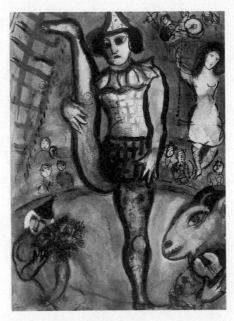

Chagall, "The Acrobat," 1955, drawing

Decade of the Large Wall

Vence and St. Paul, 1960–1970

C hagall called his stained-glass windows "the transparent partition between my heart and the heart of the world." After the war, when many old churches were being restored and new ones built, several major artists turned to stained glass, and the revival of old cathedrals through modern art was a symbol of cultural and spiritual renaissance. In Chagall's work the dovetailing of present and past was uniquely powerful. Stylistically, the art of stained glass pushed him forward as a natural step in the evolution of his painting towards pure light, an almost abstract treatment of colour, and monumentalism. But thematically he returned to his childhood in an art that, pervaded by religious subjects, was rooted in the spirituality of his Hasidic upbringing. Its medieval character perfectly attuned him to the craftsmen of the medieval cathedrals. "Like medieval stained glass, his works provided not so much a window onto the outside world, as an understanding of its inner essence," wrote the Russian critic Natalia Apchinskaya. "His windows embody the experience of a different reality with great force." Cut off from memories of Russia by Bella's death, Chagall returned in his seventies to that aspect of his childhood that was accessible through the Bible (he continued to read it in Yiddish) and fashioned from it a postwar art that brought him a wide new audience, including many people who would never have entered an avant-garde gallery like the Maeght, and fame on a new scale.

Dedicating three lancets to the prophets Moses, David, and Jeremiah and placing above them a pair of small quatrefoils surmounted by a rose window showing Jesus spread out on the cross wearing the Jewish tefillin and with-

out a halo, Chagall began work in 1959 on designs for the windows in the ambulatory of the Cathedral of St. Étienne in Metz. The Moselle city in southeastern France was a symbolic starting point for his stained-glass oeuvre because it had a history of close links between its Catholic and Jewish populations. Soon after he began the work, Chagall received a counterbalancing commission from Israel for twelve stained-glass windows for the synagogue of the Hebrew University Medical Center at Ain-Karem near Jerusalem, a proposal originating with Hadassah, a women's charitable organisation in the United States. At three metres high by two and a half metres wide (3 yards by 3 yards), the twelve round-arched windows for the synagogue are significantly different in proportion from the long, narrow stained-glass windows of the Gothic Christian tradition; the Jewish ban on portrayal of the human figure also gives them their specific character. Their themes are the twelve tribes of Israel, evoked by symbols, animals, plants, fruit, landscape, and above all colour: marine blue, the colour of creation, for the oldest tribe, Reuben; yellow, colour of light and spirituality, for Levi, the intermediary between God and the people; theatrical purple for the dramatic, embattled history of the tribe of Judah; green for the peace and serenity of Issachar. "Man is absent from them only to be absorbed into the universe," wrote the French critic Jean Leymarie of these rich, detailed works that take on the brilliance of jewels as the Mediterranean sun pours through them, suggesting a medieval vision of a celestial Jerusalem but also, in the triangles, diamonds, and circles, great washes of colour, modern abstraction where ever-changing light itself is, as Franz Meyer suggested, the real medium.

Chagall told Meyer that he saw glass painting as a continuation of oil painting. He began with small drawings, then did coloured sketches, and finally detailed designs in gouache, from which Charles Marq made the cartoons. Chagall had total respect for the consummate skill of craftsmen such as Marq, who for his part called Chagall's maquettes perfect works of art, impossible to copy slavishly; rather, he described how Chagall "mysteriously incites [him] to make the gouache come alive by translating it into glass." In a technique worked out by both men, Marq marked the lines of lead, as Meyer observed, "to match the rhythm of the colour in the sketches and designs.

Next the glass was treated with acid to produce white areas or other lighter tones . . . The lightening thus obtained is the con-

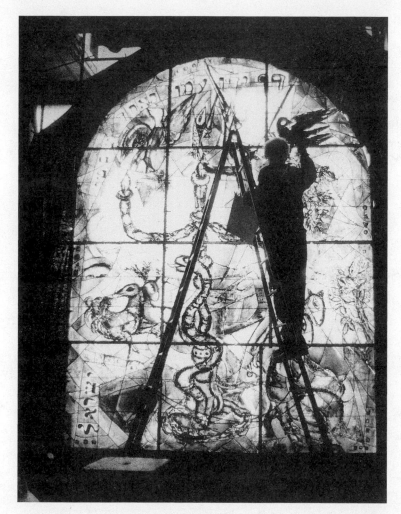

Chagall in Rheims, 1961, working on the stained-glass window *The Tribe of Daniel*, for the Hadassah synagogue, Jerusalem

verse of the grisaille painting. The definitive work is the outcome of both. At this point Chagall takes over the work on the mounted glass, exchanging colours, and modifying highlights; but he chiefly uses grisaille, drawing lines, spreading the pigment, diluting it, dabbing it with a rag, adding accents, hammering, scratching with the brush handle.

Thus Chagall added his own hand before the final firing. The role of the lead further enhances the sense of his own free design: though needed to join the pieces of coloured glass together, it does not have a traditional cloisonné effect but is arranged instead in sweeping lines that arch across the

entire composition. Marq made a range of colours in laminated glass that allowed modulation within a single piece; because the lead was not needed to separate the colours, it was free to follow and playfully enhance the expressiveness of the forms—it shapes the body of the dominant angel, his arms spread in an expansive gesture, in *The Dream of Jacob* at Metz, for example, the curves of the goat's back in *The Tribe of Joseph* in Jersusalem, and the organic form of a tree in a pair of windows in the parish church of Tudeley in Kent.

Spending much of his time in Rheims with Marq, Chagall worked on the projects for Metz and Jerusalem simultaneously; the windows for the cathedral eventually took a decade, while those for the synagogue were finished in 1962. Marq commented that Chagall never skimped on learning every aspect of technique, immersing himself in the workshop and showing a deep reverence for the experience of the craftsmen and an attention to detail, making small corrections that were "hardly visible themselves but taken together give the vibrations essential in his work."

With Vava at his side, Chagall attended the consecration on 6 February 1962; photographs show him looking as ill at ease as he always did in Israel. The squat, small modern synagogue, which reinforced his sense of Israel as uncultured and unaesthetic, so infuriated him that he broke chairs in his bad temper, though he regained his equilibrium enough for the opening to make a peaceable speech about uniting all cultures. He refused payment for any art made for a place of worship, and throughout the work, his assistants at the Rheims workshop reported, "he was conscious of being inspired by a higher power." The windows at Metz—and later those for the bombed cathedral of Mainz in Germany, which he commenced in 1976, aged eighty-nine, and which were finished by Marq after his death—were symbolic of postwar reconciliation and acquired further resonance as the work of a Jew in Catholic places of worship; but the Hadassah synagogue windows were bound up with the tragedy and victory of Jewish history. Chagall's past now informed his present so comprehensively that he did not always separate them: "Ich gleib az s'vet gefeln main taten" (I hope my father will like this), he remarked in Yiddish to the Lithuanian photographer Izis who was recording the progress of the windows.

Before the Hadassah windows went to Israel, they went on display in the summer of 1961 at the Louvre, where Meyer reported that they "gave the effect of a mighty chain of radiant links . . . Through the sequence the warmth of the colour rises and falls . . . The natural depth of the colours in

the transparent picture and their vivid radiance give the beholder an almost physical thrill." Among the visitors was Peggy Rockefeller, accompanying her husband David on a business trip to Paris. David Rockefeller was looking for an artist to design a window in memory of his father, who had died in 1960, for the family's Union Church in Pocantico Hills in the Hudson Valley; it already had a Matisse window made in honour of his mother Abby, one of MoMA's founders. The next morning Peggy sent David straight to the Louvre. The Hadassah windows then went to MoMA, where they were seen by more than a quarter of a million visitors–then a record for a MoMA show. Among them were other members of the Rockefeller family; those who had thought Chagall too modernist or mystical or both were now converted, and in 1963 David Rockefeller visited Vence and commissioned Chagall to make a window on the theme of the Good Samaritan, for the narthex of the

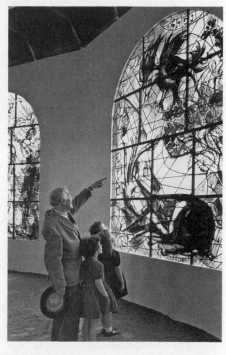

Chagall showing his grandchildren Meret, Bella, and Piet Meyer his Hadassah windows, 1961

church. Eventually the commission was extended to include eight other windows. Rockefeller believed that Chagall accepted the New Testament Good Samaritan theme, from Luke's Gospel, because it evoked memories of Varian Fry and the Emergency Rescue Committee, which had been principally funded by the Rockefeller Foundation.

International public commissions now came thick and fast during what Erben called Chagall's "decade of the large wall." In 1964 Chagall completed the large painting *La Vie* for the "Chagall hall" of his dealer's Fondation Maeght, the temple to modernism in St. Paul de Vence. Built as a memorial to Bernard, the Maeghts' eleven-year-old son who had died of leukaemia, it was supported by artists including Braque, Miró, and Giacometti. Chagall was also working through the summer on a triptych of tapestries for the Knesset–a gift to Israel. Then on 17 September 1964 Chagall and Vava travelled to New York for the unveiling at the United Nations headquarters of Chagall's stained-glass window *Peace*, dedicated to the memory of Dag Hammarskjøld, the United Nations secretary general killed in a plane crash in 1961. This was a secular commission for which Chagall

drew on his inventory of myth and fantasy, taking as his guiding text verses from Isaiah: "The people that walked in darkness have seen a great light . . . For unto us a Child is born, unto us a son is given; and the government shall be upon his shoulder: and his name shall be called Wonderful, Counsellor, the mighty God, the everlasting Father, the Prince of Peace." The dominant colour of the window is blue, symbolizing life and peace; in the centre an angel soars out of a bouquet and bends towards a child; the right side is full of prophets and martyrs who sacrificed their lives to peace; on the left figures fighting for peace range above a mother protectively encircling her child.

Six days after the United Nations unveiling, Chagall and Vava were back in Paris at the Garnier Opéra for the opening of the redecorated opera house. Its new ceiling was commissioned from Chagall by André Malraux, minister of culture under de Gaulle. Malraux was a figure so heroic in post-war France that when Picasso had asked the young Françoise Gilot whom, among his huge network of distinguished friends and acquaintances, she would most like to meet, she chose Malraux without hesitation. Both de Gaulle and Malraux had attended the gala performance of Ravel's *Daphnis and Chloe* for which Chagall designed the sets and costumes; during the intermission it occurred to Malraux that Chagall could give the old opera house a face-lift by painting the two hundred square yards of ceiling, divided into twelve sections beneath a vast dome and framed by gilded stucco. Chagall hesitated before taking on so daunting a task, but the offer was irresistible: it represented his final assimilation into the French establishment. He loftily made the work as a gift to France, from one who had taken so long to be accepted as its subject. The Gobelins factory workshops were put at his disposal, and when they turned out to be too small, the work was transferred to an airship hangar built by Eiffel.

Izis, the only photographer allowed to record the work in progress at the Gobelins, wrote that "the pervading atmosphere there evoked in me a sense of the Renaissance ateliers, with immense canvases on the ground and walls. And maquettes on the easels, Chagall working feverishly in his white shirt, and the music of Mozart emanating from a record player." Chagall, he said, "used to sit down to his work like a typical labourer, every day at fixed hours.

> I've seen him work passionately for hours at a time, manipulating brushes, knives, and cloths, and then he would step back–his

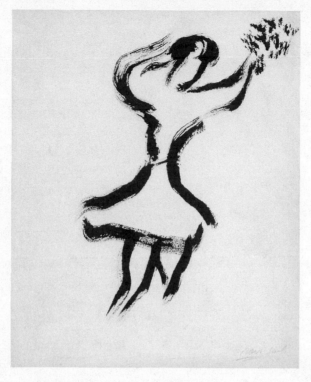

Chagall, "Dancer, "1963, drawing

shirt damp with perspiration—and at that moment he would "discover" his work. Sometimes with a cheerful smile, sometimes with a disillusioned air. When he was satisfied, he would ask his wife (who silently witnessed the creation of his important works) what she thought of it. But I've also seen him disappointed, like when he noticed that Boris Godunov's head . . . was too noble. "He's an assassin," he said, and started to fix it. The hours passed and, irritated at not achieving the desired result, he asked to be left alone. When we came back, he was doing something else, without a thought for Boris.

When the panels came to be moved by truck to the opera house, Chagall stood by with apprehension. "And then the panel slowly started to slide, and he uttered a terrified cry. Later, whenever a panel had to be moved, he would leave the atelier so as not to have to watch the operation." At the opera house, Chagall was there in overalls supervising, touching up details. David

McNeil, now an eighteen-year-old student in Paris and granted the occasional meeting with his father, remembered a break at a bistro around the corner from the Palais Garnier where white-haired Chagall, in paint-splattered shirt, sat among builders and interior decorators.

> "Vous avez un chantier dans le coin?" demanda l'un d'eux. "Je refais un plafond a l'opéra," repondit mon père, attaquant son oeuf dur mayonnaise.
> ("Are you on a local site?" asked one of them. "I'm renovating a ceiling at the Opéra," answered my father, attacking his egg mayonnaise.)

Architect Charles Garnier had dreamt of his neobaroque ceiling enlivened with colour; this is what Chagall delivered in the twelve panels, each dedicated to a ballet or opera on the theme of love. The vocabulary was again the angels, lovers, bouquets, and half-animals that had become the scaffolding of his monumental work, surrounded here by depictions of Paris's landmark buildings–Eiffel Tower, Opéra, Arc de Triomphe–and Vitebsk's domed churches. As in the Hadassah windows, colour conveyed spiritual value: blue for the peace and hope of Mozart's *Magic Flute* and the cupolas of Moscow that surround the figures of Mussorgsky's *Boris Godunov;* green for love as the dominant hue for Wagner's *Tristan and Isolde* and Berlioz's *Romeo and Juliet;* the red and yellow of mysticism and ecstasy for Stravinsky's *Firebird* and Ravel's *Daphnis and Chloe.* This was the opera performed, with Chagall's sets and costumes, on the opening night. It had been more than forty years since Moscow's hundred-seat Kamerny Theatre had been transformed into "Chagall's box." Now towards the end of the opening piece–the finale of Mozart's *Jupiter* Symphony, chosen as one of Chagall's favourite works–the giant central chandelier was switched on to illuminate the new ceiling. The two-thousand-strong audience burst into spontaneous applause, and the Paris Opéra was his.

Among the figures on the ceiling, as well as sitting in the audience on the opening night, was the quizzical face of Malraux–painted by Chagall with the gesture of a Renaissance artist paying homage to his patron. Chagall was soon rewarded with the red rosette of the commander of the Légion d'Honneur; "Isn't it terrible," he responded, "that de Gaulle and Malraux make me work for the state?" But if he affected to disdain worldly honours and refuse payment for such works, he was nevertheless buying for himself a

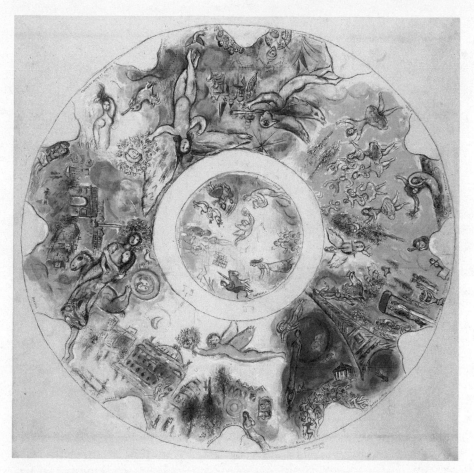

Chagall, "Final Study for the Ceiling of the Paris Opéra," 1963, gouache and watercolour on paper

place in art history that would last as long as Europe and America's cathedrals, synagogues, and palaces of culture. The Paris Opera was followed in 1966–67 by the universally acclaimed sets and costumes for New York Metropolitan Opera's production of *The Magic Flute*— thirteen full curtains, each seventy feet tall, 26 partial curtains, and 121 separate costumes: "the biggest one-man Chagall exhibition in the world," noted one critic. Chagall also completed the murals *The Sources of Music* and *The Triumph of Music* for the Metropolitan; soaring over Lincoln Center Plaza, they are seen by millions of people every day. During the installation the positions of the two murals were unfortunately and irretrievably reversed, and when Chagall arrived in New York, he "yelled as I never have before. My mother, when she gave birth to her children, didn't yell as much. I could doubtless be

heard all over Lincoln Square." He later accepted the swap as a benevolent accident.

Chagall's celebrity in America had been assured by the 1964 Broadway musical *Fiddler on the Roof,* which he had had nothing to do with, but was associated with him because the designer, Boris Aronson, used his imagery from the great Moscow mural *Music*–Aronson had worked with Chagall at the Moscow Jewish Theatre forty years earlier. An eleven-page cover story in *Time* magazine in 1965 confirmed his fame. Chagall turned up for the meeting with a group of editors on the forty-seventh floor of the Time-Life building and duly played his part, pronouncing himself "enchanted with the view of Manhattan, particularly the bright mosaics of neatly parked automobiles on the roofs below. 'Très Chagall,' he said, and wished he could paint them right then and there." He was less enchanted when the Paris correspondent Jonathan Randal turned up in Vence and filled countless notebooks during the sort of interrogation guaranteed to unnerve the suspicious artist; Chagall demanded to see every word. But then Randal was summoned to Algeria to report on the overthrow of Ben Bulla. Chagall was impressed: on his return the journalist became "mon cher" and Chagall and Vava granted him sessions of Campari and soda on the terrace.

Although he quoted Jean Cassou's warning that "Chagall is one of his own images. He is the manager of his own fairyland," Randal was completely won over. "In the azure light that angles steeply down the slopes above the French Riviera, a sparkling translucence seizes nature," he opened. "This light takes hold of a man too. For painter Marc Chagall, it is a daily baptism in color." The white-walled studio-house with its haphazard canvases and palettes ("Vive disorder"), photographs of paintings, samovar, and gramophone playing Mozart, Bach, Ravel, or Stravinsky was similarly idealized; so was the garden of orange trees and cypresses, Vava, and the staff–cook, chauffeur, maid. This was, *Time* asserted, Chagall's "Rainbow period," dotted with pots of gold as museums in America and Europe "have realized that the history of modern art would seem vacuously cold without Chagall . . . 'It's absolutely essential to have him,' says Los Angeles County Museum Director Richard Brown. Adds a London dealer: 'The one painter sought by all museums is Chagall. He has already become an old master.' " Thus Chagall was delivered to an American audience: a grand, sweet, unthreatening slice of history.

There was, however, one American who was encountering a different Chagall. In the 1960s Varian Fry, now working for the International Rescue

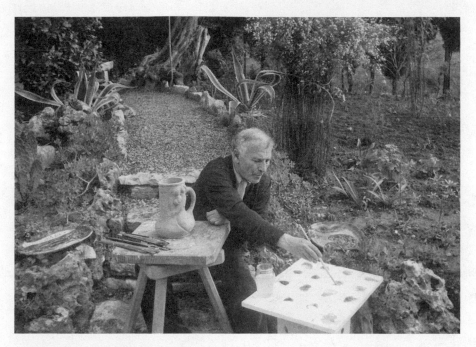

Chagall in Vence, 1960

Committee, set out to raise funds by publishing a portfolio of lithographs by artists whom his wartime committee had helped. Max Ernst, Jacques Lipchitz, and André Masson, as well as eminent names less directly involved–Picasso, Miró, Giacometti, Kokoschka–agreed to contribute, and in October 1964 Fry travelled to Vence to add Chagall to his list. He found Chagall inestimably wealthier and more famous than when he had put him on his more desperate list twenty years earlier, but diminished in human terms. Fry noted "the sweat on his face, and other signs of his anxiety, when I saw him at Vence. He was embarrassed not to be able to promise a litho and afraid his second wife would make a scene. He took out his pencil to sign the Hungarian lithos, but his wife forbade him to. 'Non, Marc, tu ne peux pas. Elles sont déjà dans le catalogue.' 'Ah, oui, oh oui.' " Where other visitors had been seduced by Les Collines, Fry thought it had "all the appearance of a very wealthy épicier en gros [wholesale grocer] whose wife has employed a decorator, given him a large sum of money with which to decorate the house, and said she wants to have some Chagall originals on the walls." Nothing he said would persuade Chagall, who cowered behind Vava. "Unfortunately, he's one artist who may not be impressed even by Picasso," Fry noted. "Madame asked what artists had already agreed to contribute lithos. I men-

tioned P. 'Pas un artiste,' said this ex-millinery saleslady, with a contemptu-ous downsweep of her right hand."

For the next three years, Fry pitted himself—with all the righteous deter-mination he had shown in fighting Vichy in 1941—in a campaign against her. His first ally was Ida, whom he chanced upon at Giacometti's studio and who pronounced herself ashamed of her father for his refusal. Malraux, Gia-cometti, Lipchitz, Mrs. Kermit Roosevelt (who wrote personally to Cha-gall), Michel Gordey, and Dina Vierney (the Russian-Jewish model of Maillol and a Resistance contact of Fry's) were among others who put pres-sure on him. All of them knew that at that time a single Chagall lithograph sold for $1,200, and that throughout the decade he was producing thou-sands of them—of varying quality and, increasingly, diluting the strength of his original imagery in an Arcadian blur of repetition and sentimentality. Franz Meyer diplomatically defended the lithographs as a way of spreading Chagall's work across the world; they were also moneymakers that counter-balanced the lavish gestures to Metz, Israel, the United Nations, the French state—on which he worked without payment for years. It would have cost Chagall almost nothing to acquiesce grace-fully and rapidly to Fry. But it took him until 1967 to agree, as the protracted negotiations and excuses—his dealer, his publisher, would not let him—went through Vava. By the time he delivered the lithograph, Fry was dead.

Vava and Chagall, 1960

David Rockefeller, who had visited Les Collines a year earlier than Fry, observed, too, that Vava was her husband's astute business manager; other visitors also noted privately that they had to nego-tiate around Vava, and that she timed their meet-ings with her husband, escorting even friends from his presence when the hour that she had allocated them was up. For those who stood to gain from Chagall's continuing productivity, such as the Maeghts, Vava was simply the force who kept Chagall alive and was therefore to be forgiven for the way she chose—or needed—to do it. Where they could, the Maeghts smoothed over the rough patches that resulted, such as Chagall's unreliable treatment of David. They accompanied Chagall and Vava to visit him at boarding school, once taking

David out to a lavish lunch in Versailles, another time presenting him with a trumpet in a plush velvet case; on his rare visits to Vence, they took him fishing in Cannes. Suffering through these years from the death of their own son Bernard, their sympathetic understanding of David was exceptionally generous.

Those at one remove were more critical. The loyal Jewish American collector Louis Stern complained bitterly to Ida about Chagall's selfish manipulations and inconsiderate attitude; Vava treated Stern like a puppet on a string, ignoring him until he could be useful, insisting that he lend his paintings for important shows but declining to loan a single work from Chagall's own extensive collection to compensate him for the empty walls in his home. The Jewish dealer Heinz Berggruen, who left memoirs about Picasso, Matisse, and his late modernist Paris stable of artists in the 1950s–1970s, admitted that he had not written about the Chagall ménage because he had nothing nice to say. Chagall was always intelligent and entertaining company, he admitted, though he affected a maddening false modesty, pretending not to understand his paintings; while he loved being addressed as "Maître," he always replied self-deprecatingly, with a show of a tiny span with his fingers, "I am not maître, I am centimetre." Vava controlled life behind the scenes and knew exactly what she wanted; Chagall's insecurities were close to the surface and therefore easy to deal with and make allowances for; the most complicated member of the family, never fully at ease with herself despite her extroverted charm, was Ida. Chagall was the only one of Berggruen's many exhibiting artists who refused to make him a gift of the illustration he had made for his catalogue cover, asking instead, "What would you like to pay me for it?" then demanding double what Berggruen had suggested. Berggruen's gift of caviar, produced on each visit, went "straight into the icebox" and was never shared with visitors; of all the artists he encountered, from diverse backgrounds, Berggruen felt that Chagall was the most suspicious and had least overcome his memories of deprivation. The photographer Izis concurred, writing, "Sometimes I feel as if I'm in the presence of an extremely naïve person, at other times he's very cunning," when Chagall was in his eighties.

Michel Gordey told Fry in 1965 that the Chagalls had millions of dollars but Vava wanted still more and that Chagall was completely controlled by her. Yet surely Chagall hid a part of himself behind Vava. She was intelligent and perceptive and understood him: they shared a background of hardship, and loss, as well as the need to adapt and survive, which had made them both

distrustful of the world. But where Chagall, with his tender, timid smile, had an instinctive warmth and demonstrativeness–in old age he would take the hand of those he liked and play gently with their fingers while he talked to them–Vava was austere, orderly, and impossible to ruffle. Chagall's portraits of her have none of the eroticism that animated the elderly Picasso's portraits of Jacqueline Roque or Matisse's of Lydia Delectorskaya, but they emphasise, in the balanced oval face and thoughtful wide eyes, just these steadying qualities. The portraits' evolution–from the uncertain, soulful expression in *For Vava* in 1955, when he was still getting to know her character, to the authoritative stance of the lovingly detailed, familiar, green-faced *Portrait of Vava* of 1966–charts her increasing dominance within the marriage. That he painted her at all is significant–Bella and Ida had been the only other subjects of his portraits since 1922, and though Virginia's features and physique appear in some works, he never made a classical portrait of her. In the two major portraits of Vava, separated by eleven years, moreover, the same large sensual donkey's head (a frequent Chagall self-image) nuzzles against Vava's upright, tranquil figure, as if she were the rocklike, rational centre against which the painter could both set himself and repose. Virginia, who corresponded with Vava–not Chagall–about David, generously observed from a distance that she was Chagall's "perfect guardian and protector, curator of his possessions, lucid and imaginative organizer of his life, all of which delighted him." Chagall himself called Vava "my procurer general": just as the marriage with Bella had been also a business partnership, so now it fell to Vava to be the hard exterior front while Chagall played her soft, helpless companion.

The truth was less straightforward. Chagall had told Bella in the 1930s that no amount of money would ever make him feel at ease: the insecurity that drives forward the self-made wandering Jew. In old age he was engaged in a double negotiation with the world: on the one hand compulsively if needlessly for financial security; on the other for his position in art history, about which, as Pierre Matisse understood, he was permanently anxious. The first led to an overproduction of less-than-top-quality works and petty greed; the second drove him to create public art, made to seduce a mass audience on a world scale, as if his dream of an art for the masses in revolutionary Russia had come true. Two identities thus fought within him until the end: the benign, wise, prophetlike figure who donated art of a rare spirituality and comfort to a war-shocked world, and the nervy, suspicious, opportunistic exile. But he was also capable of throwing all his imaginative

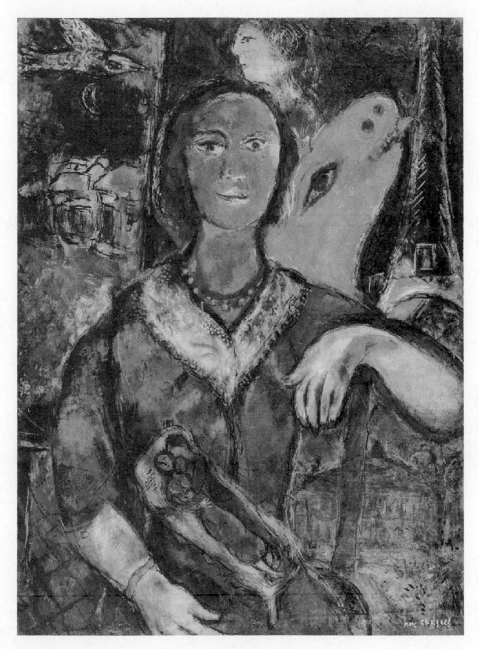

Chagall, *Portrait of Vava,* 1966, oil on canvas

power and personal empathy into smaller projects in which he passionately
believed, such as the twelve stained-glass windows for the tiny parish church
at Tudeley, a small village in Kent. These were commissioned by Lady
d'Avigdor-Goldsmid to commemorate the drowning of her twenty-four-year-
old daughter in a sailing accident; on a luminous blue background suggest-
ing both sea and sky, Chagall shows the girl engulfed in the water, then
carried triumphantly on her favourite horse past a crucifixion, as if to
heaven. The Chagall who engrossed himself wholeheartedly in this project
was as genuine as the one who feared that callers like Fry or Berggruen had
come to fleece him.

Virginia had remarked in the 1950s that the richer he grew, the more he
distrusted people. "My life is work, I only know work. I have few friends," he
told Walter Erben. The artisans with whom he collaborated–the two
Charleses, Sorlier and Marq; Fernand Mourlot–were among the few friends
he trusted in his final decades, after the deaths of most of his prewar circle
and his alienation from many others. Cendrars and Claire Goll were among
former friends who published ungenerous accounts of Chagall at the end of
their lives, though shortly before Cendrars's death in 1961 Malraux, a
mutual friend, engineered a sympathetic reunion. Jean-Paul Crespelle, who
wrote a book on the artist in 1969, found a "robust man" with "the smile of a
candid faun, shifting abruptly from cheerfulness to melancholy . . . an
astonishing mixture of Charlie Chaplin and Mephisto," who was "quickly
wounded by the least lack of warmth" and plunged into despair and fury by
criticism. The Chagall grandchildren commented on his continuing desper-
ation, through the 1960s and 1970s, to be loved. "Grandfather would ask us,
quite sheepishly, always in doubt, as to whether his work would be liked or
understood, if we liked his painting," remembered Bella Meyer, "and then
encouraged by our somewhat mandatory positive answer, he'd usually
return to his canvas and say, 'Ah, now it just needs a little more Chagall.' "
"Do you love Chagall?" he would ask all visitors, as if he were already a repu-
tation rather than a living person. Berggruen, who after 1946 sold the late
work of Picasso, Matisse, and Chagall in Paris, reckoned his thirst for
acclaim was unquenchable and far in excess of that of the others.

Was this because, for all the fame and adulation, Chagall could not
entirely ignore the verdict, which even *Time* magazine's flattering article
had to acknowledge, that "the art establishment has tended to judge his
major accomplishments over by 1922"? Franz Meyer, his most eloquent art-
historical defender, who completed the scholarly volume on his father-in-

law in 1961, made the best attempt to answer such criticisms when he tried to link the early symbolist work with the fluid alchemies of colour of the 1960s canvases in the context of the postwar crisis of religion and culture, concluding, "We are suffering from an unbalance in which all our spiritual world is menaced. There is only one way out: to put the soul, the mysterious centre of the human creature, above all else. It is to this revolution that the painting of Chagall is dedicated." But in truth Meyer had already lost interest: while working on the final stages of the book, he had been engaged in an exhausting battle with its thankless subject via the controlling hand of Vava, and when it was finished, he began a love affair with American abstraction. This marked his growing distance from Ida, who remained locked in adoration of her father. The couple divorced in the 1970s, leaving Ida, at loggerheads with her stepmother yet still consumed by the desire to promote her father, an isolated and tragic figure.

For an artist to suffer a chorus of praise for his early rather than his current work is not uncommon. Late Matisse and Picasso also provoked hostility—few took Matisse's cutouts seriously at first, and the exhibition of Picasso's last works, shown in Avignon months after his death in 1973, was almost universally derided. That contemporary work in general was what the critic David Sylvester called the "art of an aftermath" was also a widely held viewpoint. In an essay in 1957 Sylvester named a dozen modern masters, including Matisse, Picasso, Munch, Braque, Derain, Vlaminck, Rouault, Kokoschka, de Chirico, and Chagall, who early in their careers "reached a level that they subsequently failed to sustain," adding that

> the classic relationship between the art of a great creative period and that of its aftermath is that the latter develops in an extreme degree, in a narrow way, and at a lowered emotional temperature, certain discoveries made by the former, with a tendency to isolate those discoveries from their context and to exaggerate their peculiarities. This is essentially a kind of exploitation, and therefore tends to be richer in ingenuity than in energy.

Both Matisse and Picasso, however, were still renewing and changing their work, and both had an unshakable inner confidence in their artistic progression that has proved valid—their late work is today acknowledged as important and groundbreaking, within their own oeuvre and for art history. But this is not the case for Chagall. Stained glass, mosaics, and murals in

part concealed it and also stimulated certain innovations on canvas. His late work, however, for all the pleasure and consolation that his public art continues to give, is an elegantly orchestrated coda, a rearrangement of what went before, rather than anything new. His late decades are moving for the energy of the survivor, the fidelity to his childhood and to the Jewish theme, the optimism and the protean ability to reinvent those themes in new media. Fundamentally, though, he had no battles left to fight, no conflicts with the art establishment from which to take fire, and meanwhile what had always given his art strength—the overriding autobiographical imperative—now became a weakness, because his personal story was exhausted, the reinvention of the exile played out. That fading is poignantly caught in the late self-portrait called *In Front of the Picture:* on a large easel, the artist as a donkey paints a portrait of himself as a young man being crucified against a deep black ground; watching him like shadows emerging from old photographs into substantial being are his father and mother.

Distressed by the development of the Côte d'Azur in the 1960s, and in particular by new buildings near Les Collines that meant they could be overlooked, Chagall and Vava moved from Vence in 1966 to nearby St. Paul, where they had a new house, La Colline, built with a more convenient ground-floor studio. It had less character than Les Collines but was securely gated and practical—it had only two floors, and Vava had a lift installed between them—and was surrounded by woods. Chagall also felt reassured by its proximity to the Maeghts, who as he grew older increasingly assumed the role of guardians and facilitators. The new Maeght Foundation became a cultural force in the area in the 1960s, and he used to enjoy wandering in and out, strolling through the gardens dotted with Giacometti and Miró sculptures. Though it appeared to shut the Chagalls symbolically off from the world, the new studio gave Chagall's easel painting an immediate new impetus, and between 1967 and 1968 he created some of his most experimental, intriguing late canvases, fuelled by the stimulation from his works in other media, as if they opened up for him a new dialogue with his own familiar motifs.

The large flower painting *The Studio at St. Paul* (1967) opens this series. It is an echo of those joyful paintings of bouquets, seeming to explode to fill the entire canvas, made at various moments of contentment in his life, such as the 1955 *The White Window. The Studio at St. Paul* has the same free handling of paint and airy rhythm as the 1955 work, and some of its tension between inner and outer world—a window gives a view of a splash of Mediter-

ranean blue and olive green. But the light is more crystalline, and the sur-
face has a broken, granular quality that suggests the influence of Chagall's
work on mosaics. The effect is destabilising, emphasising the transitory
quality of the surging bouquet; it recalls the inequilibriums of late Bonnard.
"The end of life is a bouquet," Chagall used to say—by which he meant not
only the honours accorded to him but the imminence of decay, the death
that inevitably follows ripeness. At the first hint of wilting, Vava would
throw out the bouquets that always filled La Colline; *The Studio at St. Paul* is
about the despair of nature as well as its beauty.

In *Mauve Nude,* also completed in 1967, a gritty, pulverised texture is
applied to a night scene; shards of colour scratched, graffitilike, onto a dark
surface, cohere into the figures of a clown, a donkey, and a voluminous clas-
sical nude. The incised lines and glowing enamel hues suggest the impact of
his experiments with ceramics; the colour bursting out of the night owes its
effect to Chagall's mastery of stained glass, evoking its brilliant light-in-
darkness. Rarely seen in public, *Mauve Nude* sets harmony against disinte-
gration, oriental colour against classical form, showing how even at eighty
Chagall proceeded by a mixture of assimilation, assertion of his cultural
roots, and alertness to new currents. Its superimposed layers and textures
are echoed in several works from 1968–70: in *The Players* and *The Magician,*
where the central figures are composed from broken geometric shapes
assembled almost like cubist collage; in *The Sun of Poros,* built up from five
abstract blocks of colour; and in the collages of gouache, India ink, cloth on
paper, and newspaper, such as *Couple with a Red Goat, Dancer on a Mauve
Background, Harlequin,* and the unusual, Picasso-like (de Kooning-like,
even) sexualised *Woman with Red and Green Hands.* All demonstrate Cha-
gall's ability to respond to abstraction, to the fragmentation of the image,
and to the disintegration of fixed disciplines that were the characteristics of
art in the 1960s. He now made fewer ceramics and sculpture; he had inter-
nalised the ingredients that mattered to him on canvas. Braque at this point
called Chagall "the guarantor of painting."

Suggesting black strips of lead against translucent stained glass, two
large, potent religious works of 1968, *The Prophet Jeremiah* and *Passover,*
owe their theatrical composition and colour contrasts most clearly of all
Chagall's canvases to his cathedral and church work. Drenched in luminous
yellow, Jeremiah is a descendant of the tragic, solitary rabbi in *Solitude* of
1933 and before that of the old Jews of Vitebsk of 1914–15. Alone and spiritu-
ally rapt like them, his fervour is conveyed through the force of colour burst-

ing from the black ground, the yellow (Chagall's colour of mysticism) complemented by a white angel slicing diagonally across the right half of the composition.

Heaven and earth, divine mystery and human yearning, are similarly juxtaposed in *Passover*. Under shining blocks of red and green, the basic tonality is black and white. Depicted in scratchy lines, four old Jews huddle in prayer shawls outside Vitebsk's tumbling wooden houses; only the crimson of the Passover wine relieves the gloom. The sky is stormy, a moon bathes the shtetl in icy light, emphasising the exposed, menaced position of the four believers. But above them, too, soars a winged angel; peeping out of the dark latticework, a large yellow animal's face watches, its colour bringing warmth to the ghostly scene. "And Passover! . . . Nothing excites me as much as the Haggadah, its lines, its pictures and the red wine in full glasses," Chagall had written in memory of his childhood.

> In its reflections, deep purple, royal, the ghetto marked out for the Jewish people and the burning heat of the Arabian desert, crossed with so much suffering. And the night light, streaming down from the hanging lamp–how it weighs on me! . . . My father, raising his glass, tells me to go and open the door. Open the door, the outside door, at such a late hour, to let in the prophet Elijah? A cluster of white stars, silver against the background of the blue velvet sky, force their way into my eyes and my heart. But where is Elijah and his white chariot?

Nearly seventy years after he had ceased to be an observant Jew, Chagall made this Jewish painting at the same time as he made the intimate windows for the Tudeley parish church: the works share the consoling message that in the drama of threatened human existence, faith gives meaning to tragedy.

Religious themes preoccupied Chagall in the late 1960s. Once he had settled into the new house at La Colline, his attention was consumed by the plan to build a home for his biblical paintings. The first stone of the Musée National Message Biblique Marc Chagall was laid in Cimiez, a hilly suburb of Nice with magnificent views across the town, in 1969. That same year Chagall and Vava travelled to Israel for the opening of the Knesset, the new parliament building in Jerusalem, which contains his mosaic *The Western Wall* and three major tapestries, *The Prophecy of Isaiah, Exodus,* and *The Entry into Jerusalem,* produced over the course of five years under his supervision

at the Gobelins workshop in Paris. When he returned home, it was to make preparations for his most comprehensive exhibition yet, of 474 works, *Hommage à Chagall,* at the Grand Palais in Paris, which ran to acclaim from December 1969 to March 1970. It was the sort of triumphal retrospective that is often staged just after an artist's death. As he entered extreme old age, Chagall was becoming a monument in his own lifetime.

"I Was a Good Artist, Wasn't I?"

St. Paul, 1971–1985

In 1971, in another return to the key Passover image from his childhood, Chagall completed the model for *Elijah's Chariot,* the mosaic for the facade of his Musée National Message Biblique. Negotiations and preparations for the opening preoccupied him and Vava for the next two years; the deal–typical Vava-Chagall, brokered by André Malraux–was that Chagall donated the works, and the French state paid for the museum, a low, light-filled, state-of-the-art white building designed by André Hermant, a follower of Corbusier. Chagall was a constant visitor to the construction site and involved in every stage of the design, for which his stained-glass windows were an integral part. The coup was not only that eighty-five-year-old Chagall was thus supervising his own memorial but also that the museum was the final, permanent reinvention of "Chagall's box" fifty years earlier–a set of walls and a stage where he controlled everything. His arguments with Hermant and Jean Chatelain, director of the museums of France, were thus long drawn out, and Charles Marq was summoned as an expert on glass to support Chagall's case.

In a choreography where life for once matched the rhythmic contrasts in his paintings, he received shortly before the museum opened the invitation for which he had been waiting half a century: the Soviet minister of culture Ekaterina Furtseva (Shostakovich nicknamed her "Catherine the Third," after the great empress-patrons of Russian history) invited him to Leningrad and to Moscow to revisit the original "Chagall's box." A year earlier the first retrospective of his work behind the Iron Curtain had opened in Budapest to a triumphant reception, but his work was still almost unknown, his name rarely mentioned, in the Soviet Union.

He and Vava left for Russia in June, taking with them a Russian friend from the Côte d'Azur, Nadya Léger, widow of Fernand Léger; he had married her three years before his death, and she had guarded his reputation ever since. Born Nadya–but sometimes known as Wanda–Khodasevich in a Belorusian village in 1904, she was a gaudy, loud, fur-draped figure and a most unlikely friend. A suprematist painter, she had studied–ironically enough–under Malevich, and like Léger, she was a Communist; she also corresponded with the KGB. Did Chagall know or care? It was an expression of his lifelong need for Russia that he made such a friend in the first place, and of his nervousness now that he took her there with him.

Chagall refused to visit Vitebsk: "At 86 years old, there are memories which one should not disturb. I have not seen Vitebsk for sixty years. What I should see there today would be incomprehensible to me. And moreover, that which forms one of the living elements of my painting would prove to be nonexistent. That would be too sad, and I would become ill because of it." In Leningrad, there were reunions with his two surviving sisters, Lisa and Mariaska, and their families, and in Moscow an exhibition of his lithographs. The chief object of his quest, the mural paintings for the Jewish Theatre, were rolled up on a drum and stored in a church building that the Tretyakov used as a storeroom; almost no one at the gallery had ever seen them, apart from a restorer who had examined them in 1966. Only Ida, in her role as path-breaker, had paved the way towards them by making friends with curators and historians who adored Chagall but were too frightened to say so publicly. In particular Vsevolod Volodarsky, head of the department of Russian nineteenth- and early twentieth-century art at the Tretyakov, had helped her locate photographs of her father's works for Franz Meyer's book and treasured an autograph of Chagall's that she had sent him in thanks. "My colleagues all knew that I was 'crazy about Chagall' and viewed me either with condescension or with pity," he wrote. Now on 8 June 1973 Volodarsky and a party of curators and restorers were there to welcome Chagall to the Serov room at the gallery, where under Serov's famous impressionist paintings *Girl with Peaches* and *Portrait of the Actress Yermolayeva,* the panels lay on the floor in two rows, unrolled from the drums.

Volodarsky asked Chagall's permission to take notes and left a moving, moment-by-moment record of this visit that was the highlight of Chagall's old age. "We pulled back the curtain and entered the room–and suddenly found ourselves plunged into a complex dance, with an intricate step pattern, into which all were drawn," he wrote.

Chagall on Red Square, Moscow, 1973

Without lifting his gaze from the paintings stretched out on the floor, Chagall strode purposefully down the corridor along the left hand side of the room, then back up the right hand side, back down to the middle, and back to the door. He almost flew across the room, and, in his slipstream, the rest of the party were drawn along. Only Valentina Grigoryevna and Nadya Léger stopped immediately at the first painting at the door and launched into a heated discussion about it. Chagall's flight was ended as abruptly as it had started. He froze in front of "Love on the Stage." Everyone fell silent, and suddenly I heard him murmur quietly "Oh what musicians, what golden musicians!" I saw how he was staring at the lower part of the panel. Again, without lifting his gaze,

he moved along to "Introduction to the Jewish Theatre," and began to speak in a staccato fashion, pausing in between utterings, "You have remarkable restorers . . . restorers are brilliant people . . . so well preserved–I really didn't expect that! It can go on show . . . it can be exhibited so well!' "

He described himself to Kovaliev, head of the restorers, as "You know my style–the one who paints with violet" and engaged in a detailed discussion with him about restoration and possible exhibition. Then he admired *The Wedding Feast*–"Ah, that's colour for you! The best colours in the best Seurat tradition"–before someone pointed out that the murals were unsigned.

Flamed with passion he proclaimed "I shall sign them all–now." Then he fell silent and continued in a completely different tone. "But I have no right." Then after another pause he changed his mind, "No I shall sign them." Someone gave him a black felt pen, and he drew two lines in my notebook to test it. "No, that's too black." "What about oil paint in turpentine?" suggested Kovaliev. Chagall was radiant. "Yes, that's just right." While someone scurried to get him the paint, he took another long look at his work, and said to Valentina Grigoryevna, "I was a good artist, wasn't I? The figure has faded a bit . . . Oh was I young! I was so incredibly young then! That is painted with the soul."

Then he panicked again–a photographer nearly stepped on one of the canvases, he had forgotten how to write a Cyrillic *G,* and he "became quite agitated . . . 'I don't know which side I should sign,' he cried almost in despair. 'Sign both sides then,' Valentina Grigoryevna suggested calmly. He calmed down immediately and replied dryly, 'No, no, for the public it's one picture.' He added softly, 'Otherwise they'll cut it in two afterwards.' "

After Chagall returned home, talk of restoration and exhibition was silenced, and the murals went straight back into storage. They stayed there until 1991, when the Fondation Martigny in Switzerland funded their restoration; they are now on permanent display at the Tretyakov Gallery. Chagall's visit was regarded as a major publicity coup for Russia, and many in the West felt that the elderly artist had been duped. But he was beyond the political reality: he was an old man of eighty-five who wanted to see his homeland and his greatest work once more.

Returning home to St. Paul, he went straight from the past to his future: the Musée National Message Biblique Marc Chagall opened on his eighty-sixth birthday, on 7 July 1973. The opening was attended by André Malraux, and there was acclaim for *The Creation,* the triptych of stained-glass windows that Chagall had designed for the museum's auditorium. There were also critics; in April 1973 Picasso had died aged ninety-one, and some remarked that even he had had to wait until after his death for a museum to be opened in his name. Chagall was the first artist in France for whom a museum was built in his lifetime. His masterstroke was to play up even at this late stage the role of spiritual seer to perfection. "I pray when I paint" was one of his late mantras. The "Message Biblique" designation, with its secular ideal of spirituality without creed or division, laid less stress on his individuality and more on the brotherhood-of-man, world-peace idealism of the early 1970s and carried the day. It was one of the landmarks–along with the Fondation Maeght, Matisse's Rosary Chapel and museum, and the Museum of War and Peace dedicated to Picasso in Antibes–with which the Côte d'Azur established itself as a place of cultural pilgrimage between the 1950s and 1970s. In the twenty-first century it has the air, like the others, of a temple to high modernism.

"He takes so many commissions so that he will not have time to die," a New York dealer said of Chagall in old age, while Pierre Schneider commented that "he seems to have foiled the ravages of time, like a refugee who has eluded a hundred police round-ups. This man of eighty years and more is possessed of stupefying physical vigor and mental vivacity. His eyes are now mocking, now tender, his smile ready, his step and speech rapid." Through the 1970s he continued to accept large-scale projects: three stained-glass windows for the choir of Notre Dame Cathedral in Rheims and a mosaic, *The Four Seasons,* for First National Plaza in Chicago in 1974, a window for Chichester Cathedral, three for the Art Institute of Chicago, and the first of a set of nine, *The Tree of Life,* for St. Stephan's Cathedral in Mainz, in 1979. This last commission was accepted very reluctantly, under pressure from Vava at a time when Chagall's resistance was failing. He still refused to go to Germany; Vava, whose mother had lived in Berlin after the war, visited the country without Chagall and struck up a friendship with Mainz's rather dry priest Father Klaus Mayer, who admired her keen intelligence and called her "a superb woman." Vava urged Chagall to complete the project window by window, and its success was an example of her assimilating tendencies winning him over; similarly, as he got older, she discouraged Yiddish cor-

respondents and hid Yiddish newspapers or news from Israel that might upset him. Mainz's towering scriptural figures against a luminous blue background are a poignant symbol of hope and reconciliation, unique in Germany.

Gradually through the later 1970s and the 1980s, with the exception of the Mainz windows (which Charles Marq completed after his death), Chagall's emphasis shifted to smaller works; series of etchings, lithographs, and illustrations gave him particular pleasure. Just as stained glass afforded him the chance to enter into dialogue with his stock images by using an unfamiliar medium, so illustrating books opened a window into the imagination of others that served to fuel his own. Éditions Mourlot published his two-volume *Ulysses,* including eighty-two lithographs, in 1974–75. The large easel paintings *Icarus* (1975), where half the canvas is a swirling symphony of white paint, and *The Myth of Orpheus* (1977), constructed from geometric blocks of colour–turquoise, yellow, red–on a dark ground, also reflect his interest in representing Mediterranean classical myth through the prism of twentieth-century abstraction.

"As always, there is a coming and going of visitors with more or less honest proposals," Vava reported–the snobbish tone was typical, and one that Chagall's correspondents, who now all had to go through the conduit of Vava, grew to live with–to Pierre Matisse at the end of 1975. "We are both quite well. Chagall is working a lot. He is now preparing a book with a text by Malraux. That gives him a lot of work and cares. So he is very busy but he feels that he needs it." Illustrating books kept Chagall au courant with writers, editors, publishers, and printers, preventing the creative isolation of extreme old age. The remnants of his and Bella's first circle of friends in Paris in the 1920s all died in the 1970s: Jacques Maritain in 1973 (Raissa had died in 1960), Claire Goll in 1977, and Sonia Delaunay in 1979. With fifteen etchings for *And on the Earth* Chagall thanked Malraux for the Musée National Message Biblique; the work also involved a stimulating year-long correspondence, from 1975 to 1976, between artist and writer. Through the late 1970s Chagall was also making fifty black lithographs for Shakespeare's *The Tempest* (published by Sauret in Monte Carlo), twenty-four engravings for Louis Aragon's collection of poems *He Who Says Things with Nothing to Say* (published by Aimé Maeght's son Adrien), and thirty black etchings on an ochre background for the *Psalms of David* (printed by Gerald Cramer in Geneva in 1979). Chagall had always been an exceptional artist of the book, reflecting perhaps the Jews as a people of the book; as he had done since

Dead Souls and *Les Fables* in the 1920s, he now engrossed himself entirely in the texts and produced illustrations that enhance and interpret them in fresh ways. "The very special care which Chagall brought to the pages of each work is reflected in his love and profound respect for hard work, the hard work of others and the piece of work well made," wrote his grand-daughter Meret Meyer, who observed him engaged in these late book illus-trations. "The beauty of the paper, of the medium, the flow of typography, the design, the staging of each element and the essential role of white space—the same artistic attention accompanies them all. His eye was sure, he judged in the twinkling of an eye: his hands caressed the paper and seized the future message of the illustrated book, conveyed through black and colour. And suddenly, the memory of the prayer book springs up again."

In *Return of the Prodigal Son* eighty-nine-year-old Chagall imagined returning to Vitebsk, embraced by his father, who had been dead for nearly sixty years. Behind the painting lies a memory of Rembrandt's last unfin-ished canvas, *The Return of the Prodigal Son,* at the Hermitage; Rem-brandt's paintings there had especially sustained him in his unhappy time at art school in St. Petersburg seven decades earlier. The following year he cel-

Chagall, "Artist and Model," 1975, India ink on paper

ebrated his ninetieth birthday at the Palais de la Mediterranée in Nice, with a concert given by Mstislav Rostropovich, Isaac Stern, and Hermann Prey; among the honours accorded him that year were the Grand-Croix of the Legion of Honour, which he received at the Élysée from Prime Minister Jacques Chaban-Delmas in Paris in the company of beaming sixty-year-old Ida, and, from Mayor Teddy Kollek, the honorary citizenship of Jerusalem. There was also an acclaimed exhibition at the Pierre Matisse Gallery in New York. "Keep a little friendship for me, for I have a great deal for you," Ida wrote to Pierre. "Your hanging seems to have been done in the very grand style which probably doesn't exist anymore. On all sides, I hear only praise. And I am happy that this 'celebration' is a homage of your talent to Papa's youth. I cannot thank you enough for that joy." Her father's art continued to be the light of her life, but her own health was not robust, and she was beginning a decline into alcoholism. A photograph of Chagall between his wife and daughter at an opening at the Fondation Maeght in 1981 is shocking for the disparity between seventy-six-year-old Vava, glowing, alert, stylish, and confidently supporting her ninety-four-year-old husband, and a bloated, bleary-eyed Ida, whose sunken features cannot conceal a middle age of loneliness and disappointment.

With a resilience that was much rarer in the 1980s than in the twenty-first century, Chagall in his nineties continued to enjoy reasonable health, short trips abroad (Florence, Switzerland for the installation of a small rose window at Zurich's Fraumünster, and to see the doctors) and, unceasingly, his work. In 1980 he was still so enthusiastic about colour lithography that when Aimé Maeght obtained some especially big lithostones, he immediately began producing his largest colour lithographs ever: a series of thirteen works, each around 95 by 60 cm (40 by 20 in.), including "Couple at Dusk," "In the Sky of the Opera," "The Parade," and "Red Maternity": an anthology of all his familiar subjects–lovers, flowers, acrobats, Vitebsk, Paris–presented in monumental size. He took a lively interest, too, in the projects of the Musée National Message Biblique–in 1980 he decorated the underside of the lid of a harpsichord presented to him by the museum's American Friends–and at the Fondation Maeght, where he turned up playfully in disguise, wearing dark glasses, to the "Hommage à Miró" show in spring 1984 and whispered complaints about the work on display.

Miró had died in 1983, leaving Chagall the sole survivor among the great names of European modernism; he had also outlived the famous, more privileged Russians whose journey into exile had paralleled his own: Prince

Chagall and Vava at La Colline, St. Paul, circa 1977. Behind them is *The Cattle Dealer* and a bronze sculpture from 1952, *The Virgin with Child.*

Yusupov had died in Paris in 1967, Vladimir Nabokov in Montreux in 1977. Among his surprising young friends was the Rolling Stones' Bill Wyman, who built a house near La Colline and frequently entertained Chagall and Vava at afternoon tea. Chagall rarely had a good word or indeed any word to say about his son (they had almost no contact now, and David in his distress was turning into an alcoholic) but he kept up his contemporary credentials with Wyman by boasting about David's prowess as a guitarist and song-writer. (David had written a song called "The Magician" about his father, which Chagall declined to listen to.) Wyman meanwhile turned visual artist and shot some of the most tender, relaxed, and happy photographs ever taken of the elderly Chagall and Vava.

As with all artists who continue to work in extreme old age, by his nineties Chagall's hand was strong at some moments but wavering and less steady at others, and the lack of definition, shadowy fusing forms, and blur of colour that had been a feature of his painting since Bella's death became more pronounced. On the visit to Russia he had invoked Seurat; now his rich patches of colour and splattered brushstrokes recalled the technique of pointillism. His theme, more than ever, was memory: he and Bella lying by the banks of the Dvina in *Couple on a Red Background* (1983); a bridal couple in a sky

merged with flowers in *The Dream* (1984); a self-portrait as a young man back-to-back with a musician in a fantastical landscape in *Back to Back* (1984).

By now he believed in part his own myths, which his art sustained; the human casualties–Ida and David–were largely out of sight. "Marc was not a weak man, as some would have it, but a strong one turned inside out, made vulnerable by his desire for protection," Virginia wrote. Now on her fourth husband, she was writing her memoir in the 1980s, so that it would be ready to go into print (partly to bolster David's claim to inherit) as soon as Chagall died. "I realize," she concluded, "that Marc's life turned out exactly the way he wanted it to."

> He received all the honours he could hope for, and many others he never dreamed of. He outlived all of the most illustrious artists of his generation and reached the great age of ninety-seven without ever putting down his brush. He acquired a handsome fortune. He had a devoted wife, children, and grandchildren and count-less hosts of admirers; he is known from one end of the world to the other. He accomplished his Message Biblique, his opus mag-num, and his soul is in peace.

But Virginia had become an outsider. Vava knew better: not even the golden cage could protect Chagall from himself. His health faltered during 1984, and he could no longer use his legs; a carer called André pushed him everywhere in a wheelchair. Chagall continued to paint, and large bouquets of flowers were brought daily into the studio after he became too infirm to go out. Vava wrote to Charles Marq, "You are the only person who has under-stood Marc's condition and what he is thinking at this time. Even though he is surrounded by cares and affection, he suffers because, as he says, he is imprisoned; but as in life, one doesn't have a choice, you have to accept things as they are, and this applies to us too."

An exhibition at the Fondation Maeght in the summer of 1984 was fol-lowed by a major retrospective of his paintings at the Royal Academy of Arts in London, which opened in January 1985. Just before it closed, on 28 March, after a day spent quietly working in his studio, Chagall had a heart attack as he was leaving the elevator from his studio to the living quarters of La Colline, and died instantly.

He had superstitiously refused to discuss his funeral, and Vava, tense in

response to queries, was momentarily and uncharacteristically too shocked to act; Ida was also incapable of organising the burial. The mayor of St. Paul de Vence offered a plot in the small, beautiful graveyard, lined with cypress trees, that juts out like a rock at the end of the village, and to the distress of many of his Jewish admirers, Vava accepted and buried Chagall in this Christian cemetery. Ida and her children attended the funeral on 1 April, as did thirty-nine-year-old David, who was not allowed to sit with the family and stood crying in a corner. There were no religious rites, but Jack Lang, France's minister of culture, made a short speech. A Yiddish journalist asked to say the kaddish; Ida forbade him but her son Piet insisted, and so, as the coffin was lowered into the earth, this unknown young man stood forward from the crowd and quietly uttered the Jewish prayer for the dead.

Chagall towards the end of his life

REFERENCES

An English source is given where one exists. Translations from French and German sources are my own; for translation from Russian sources, I gratefully acknowledge the help of Dmiti Smirnov and Elena Firsova.

Short titles of principal sources cited in the notes:

Archives Chagall	Archives Marc et Ida Chagall, Paris
Archive Marbach	Deutsches Literaturarchiv, Marbach
Amishai-Maisels	Ziva Amishai-Maisels and Susan Tumarkin Goodman. *Russian Jewish Artists in a Century of Change: 1890–1990*. New York, 1995.
Années Russes	Suzanne Pagé. *Marc Chagall: Les Années Russes, 1907–1922*. Exhibition catalogue, Musée d'art moderne. Paris, 1995.
Apollinaire	Leroy C. Breunig, ed. *Apollinaire on Art: Essays and Reviews 1902–1918*. Translated by Susan Suleiman. New York, 1972.
Apter-Gabriel	Ruth Apter-Gabriel. *Tradition and Revolution: The Jewish Renaissance in Russian Avant-Garde Art, 1912–28*. Jerusalem, 1987.
Avant-Garde	Evgenia Petrova and Jean-Claude Marcadé. *The Avant-Garde, Before and After*. Exhibition catalogue, Palais des Beaux-Arts. Brussels, 2005.
Bowlt	John Bowlt. *Russian Art of the Avant Garde: Theory and Criticism, 1902–1934*. New York, 1976.
Breton	André Breton. *Surrealism and Painting*. Translated by Simon Watson Taylor. London, 1965.
Cassou	Jean Cassou. *Chagall*. London, 1965.
Cendrars	"Portrait" and "Studio," in "Nineteen Elastic Poems." In *Blaise Cendrars: Complete Poems*. Translated by Ron Padgett. Berkeley and Los Angeles, 1992.

Cirque Marc Chagall. *Le cirque: Paintings, 1969–1980.* Exhibition
 catalogue, Pierre Matisse Gallery. New York, 1981.

Ciurlionis Alfred Erich Senn, John E. Bowlt, and Danute Staskevicius.
 Mikalujus Konstantinas Ciurlionis: Music of the Spheres.
 Newtonville, Mass., 1986.

Claire Goll Claire Goll. *La poursuite du vent.* Paris, 1976.

Clark T. J. Clark. *Farewell to an Idea: Episodes from a History of
 Modernism.* London, 1999.

Connu *Chagall connu et inconnu.* Exhibition catalogue, Grand
 Palais. Paris, 2003.

Crespelle Jean-Paul Crespelle. *Chagall; L'Amour, le rêve et la vie.*
 Paris, 1969.

Culture Benjamin Harshav, ed. *Marc Chagall on Art and Culture.*
 Stanford, Calif., 2003.

Efros Abraham Efros and Yakov Tugendhold. *The Art of Marc
 Chagall.* Moscow, 1918. In *Marc Chagall and the Jewish
 Theater.* Exhibition catalogue, Guggenheim Museum.
 New York, 1992.

Ehrenburg I Ilya Ehrenburg. *Men, Years, Life.* Vol. 1, *Memoirs of
 1891–1917.* Translated by Anna Bostock and Yvonne Kapp.
 London, 1961.

Ehrenburg III *Men, Years, Life.* Vol. 3, *Truce 1921–33.* Translated by Tatania
 Shebunina. London, 1963.

Elon Amos Elon. *The Pity of It All: A Portrait of Jews in Germany,
 1743–1933.* London, 2002.

Erben Walter Erben. *Marc Chagall.* Translated by Michael Bul-
 lock. New York, 1966.

Figes Orlando Figes. *A People's Tragedy: The Russian Revolution
 1891–1924.* London, 1996.

First Encounter Bella Chagall. *First Encounter.* Translated by Barbara Bray.
 New York, 1983.

García-Márquez Vicente García-Márquez. *Massine: A Biography.* London,
 1996.

Gilot Françoise Gilot and Carlton Lake. *Life with Picasso.* Lon-
 don, 1989.

Gitelmann Zvi Gitelmann. *A Century of Ambivalence.* Indiana, 2001.

Goll Letters *Iwan Goll/Claire Goll, Briefe.* Mainz, 1966.

Gray Camilla Gray. *The Russian Experiment in Art, 1863–1922.*
 Revised and enlarged edition. London, 1986.

Guenne Jacques Guenne. "Interview with Marc Chagall." *L'Art
 Vivant* 72 (Paris, 15 December 1927). In Benjamin
 Harshav, ed. *Marc Chagall on Art and Culture.* Stanford,
 Calif., 2003.

Guerman Mikhail Guerman and Sylvie Forestier. *Marc Chagall: The
 Land of My Heart, Russia.* Bournemouth and St. Peters-
 burg, 1995.

Guggenheim	*Marc Chagall and the Jewish Theatre.* Exhibition catalogue, Guggenheim Museum. New York, 1992.
Haftmann	Werner Haftmann. *Chagall.* Translated by Heinrich Baumann and Alexis Brown. New York, 1972.
Haggard	Virginia Haggard. *My Life with Chagall.* New York, 1986.
Harshav	Benjamin Harshav. *Marc Chagall and His Times: A Documentary Life.* Stanford, Calif., 2004.
Hosking	Geoffrey Hosking. *Russia and the Russians.* London, 2001.
Izis	Machiel Botman, Leo Divendal, and Bernadette van Woerkom. *Izis Photographs Chagall: A World in the Making.* Amsterdam, 1993.
Kamensky	Aleksander Kamensky. *Chagall: The Russian Years, 1907–1922.* Translated by Catherine Phillips. London, 1989.
Kasovsky	G. Kasovsky. *Artists from Vitebsk: Yehuda Pen and his Pupils.* Moscow, no date.
La Ruche	Jeanine Warnod. *La Ruche and Montparnasse.* Paris, 1978.
Leningrad	"Chagall's Letters in the Russian Museum in Leningrad." In Christoph Vitali. *Marc Chagall: The Russian Years 1906–1922.* Exhibition catalogue, Schirn Kunsthalle. Frankfurt, 1991.
Maritain	Raissa Maritain. *We Have Been Friends Together.* Translated by Julie Kernan. New York, 1942.
Merzbacher	*The Joy of Color: The Merzbacher Collection.* Exhibition catalogue, Israel Museum. Jerusalem, 1998.
Meyer	Franz Meyer. *Chagall.* Translated by Robert Allen. London, 1964.
Modernities	Blaise Cendrars. *Modernities and Other Writings.* Edited by Monique Chefdor. Nebraska, 1992.
My Life	Marc Chagall. *My Life.* Translated by Elizabeth Abbot. New York, 1960.
Natasha's Dance	Orlando Figes. *Natasha's Dance: A Cultural History of Russia.* London, 2002.
Neverov	Oleg Neverov. *Great Private Collections of Imperial Russia.* London, 2004.
Obolenskaya	Y. L. Obolenskaya. "In the School of E. N. Zvantseva." Moscow, 1927. In *Marc Chagall, "Bonjour, La Patrie!"* Exhibition catalogue, Tretyakov Gallery. Moscow, 2005.
Painting Revolution	John Bowlt. *Painting Revolution: Kandinsky, Malevich and the Russian Avant-Garde.* Maryland, 2000.
Petrova	E. N. Petrova. "Chagall and His Family Bonds with Russia." In *Istorii otechestvennogo iskusstva* [Pages from the History of National Art], vol. 6. St. Petersburg, 1999.
Planus	Blaise Cendrars. *Planus.* Translated by Nina Rootes. London, 1972.

Pruzhan	Irina Pruzhan. *Bakst: His Life and Work.* Harmondsworth, 1987.
Raynal	Maurice Raynal. *Modern French Painters.* Translated by Ralph Roeder. London, 1929.
Renaissance	Marc Chagall. "Quelques impressions sur la peinture française." *Renaissance: Revue trimestrielle de l'École des Hautes Études de New York* 2-3 (1944-45). In Robert Heywood. *Works of the Mind.* Chicago, 1947.
Richardson	John Richardson. *A Life of Picasso,* Vol. 2. London, 1996.
Roditi	Edouard Roditi. *Dialogues in Art.* London, 1961.
Salmon	André Salmon. *Souvenirs sans fin,* Vol. 3. Paris, 1961.
Schneider	Pierre Schneider. *Louvre Dialogues.* Translated by Patricia Southgate. New York, 1971. In Benjamin Harshav, ed. *Marc Chagall on Art and Culture.* Stanford, 2003.
Schouvaloff	Alexander Schouvaloff. *Léon Bakst: The Theatre Art.* London, 1991.
Shatskikh	Aleksandra Shatskikh. *Vitebsk: The Life of Art.* Translated by Katherine Foshko. London, 2008.
Slezkine	Yuri Slezkine. *The Jewish Century.* Princeton, N.J., 2004.
Spurling I	Hilary Spurling. *The Unknown Matisse.* London, 1998.
Spurling II	Hilary Spurling. *Matisse the Master.* London, 2005.
Sullivan	Rosemary Sullivan. *Villa Air-Bel; The Second World War, Escape, and a House in France.* London, 2006.
Sweeney	James Johnson Sweeney. "An Interview with Marc Chagall." *Partisan Review* 11, no. 1 (Winter 1944). In Benjamin Harshav, ed. *Marc Chagall on Art and Culture.* Stanford, Calif., 2003.
Tarenne	Viviane Tarenne. *À la Russie, Aux ânes et aux autres, Le regard des poètes sur la peinture de Chagall 1910–19.* Paris, 1997.
Tretyakov	*Marc Chagall, "Bonjour, La Patrie!"* Exhibition catalogue, Tretyakov Gallery. Moscow, 2005.
Venturi	Lionel Venturi. *Marc Chagall.* Geneva, 1956.
Vitali	Christoph Vitali. *Marc Chagall: The Russian Years, 1906–1922.* Exhibition catalogue, Schirn Kunsthalle. Frankfurt, 1991.
Vollard	Ambroise Vollard. *Recollections of a Picture Dealer.* Translated by Violet MacDonald. New York, 1978.
Warnod	André Warnod. *Fils de Montmartre; Souvenirs.* Paris, 1955.
With	Karl With. *Chagall.* Berlin, 1923.
World	Marc Chagall. *My Own World. Di Tsukunft* (The Future), 1925. Translated from the Yiddish. In Benjamin Harshav. *Marc Chagall and His Times: A Documentary Life.* Stanford, Calif., 2004.

NOTES

PROLOGUE

5 "In my imagination": *My Life,* 100.

5 "to wake up": Chagall to Bella, 31 August 1923, unpublished letter, Archives Chagall.

6 "stretches of my own": Abraham Sutzkever, *Siberia* (New York, 1961), 7.

CHAPTER 1: "My Sad and Joyful Town"
Vitebsk, 1887–1900

9 "Every painter is born somewhere": Sweeney, in *Culture,* 83.

9 "my sad and joyful town": *My Life,* 2.

9 "the Russian Toledo": Shatskikh, 3.

11 "If I were a stranger": Moshe de Shalit, "On the Fire Watchtower," in *Sefer Vitebsk,* ed. B. Krupnik (Tel Aviv, 1957), in Harshav, 44.

11 a slim, slight girl of twenty: Chagall claimed in a "Curriculum Vitae" of 5 March 1921 (deposited at the Russian Museum, Petrograd) that his mother was forty-five when she died in 1915–and thus sixteen when she married, seventeen when she gave birth to him. Some scholars have accepted the claim, but it conflicts with an official family birth certificate dated 1 January 1908, preserved among family papers and reproduced by his son-in-law Franz Meyer in *Chagall* (London 1964), p. 25. That document states Feiga-Ita's age as forty-one, her husband as forty-four, and her sons as twenty and sixteen at the turn of the year 1907–8. The birth date of Feiga-Ita's last child, in 1905, also strengthens the claim for 1866 rather than 1870 as her year of birth: since contraception was not practiced for religious reasons, Jewish families in the Pale were unusually large even by late-nineteenth-century standards; women customarily com-

pleted their families only when their fertility declined, and thirty-nine is a more likely age for a final child than thirty-five.

Chagall made a habit of falsifying the birthdays of those close to him and other significant dates; he was notoriously vague about time, but the mistakes were always in his favour, making him appear younger, more precocious, or more vulnerable. Thus he often claimed to have been born in 1889 instead of 1887, suggesting that his father had added two years to his age because sons born farther apart had a better chance of avoiding military service. His wife Bella, born in 1888 or 1889 (a dated photograph from the year she left school confirms this), similarly claimed on official documents to have been born later, in 1895 (see Chapter 15). Chagall connived at this deception, using the 1895 date on her gravestone.

11 "lay half his life": *My Life,* 8.

11 "his daughters browse . . . lies on the sofa . . . is still on the stove . . . is still sitting in his same place": Ibid., 18.

11 "nowhere else in Europe": Hosking, 15.

14 "my father had not been a poor young man": *My Life,* 4.

14 "If I have made pictures": *Cirque.*

14 "It needs a withinness": Meyer, 41.

15 "Dreams, I am a dreamer": Chagall to Zina and Lisa, 1912, unpublished letter, Archives Chagall.

15 *My Life:* Chagall began writing his autobiography, in Russian, in 1921–22, and he read excerpts of it aloud to friends in Moscow. It was not publishable in Soviet Russia; he intended to have it translated into German, and to illustrate it himself, for publication in Berlin when he moved there in 1922. But Chagall's whimsical, expressionistic style, freely associative and defying straightforward chronology, defeated the German translator, so the illustrations were published alone as *Mein Leben.*

The text was first published in a Yiddish translation by Peretz Markish in the journal *Di Tsukunft* in 1925; this version has been translated into English under the title *My Own World* and appeared in 2004 in Benjamin Harshav, *Marc Chagall and His Times: A Documentary Life* (Stanford, Calif., 2004).

The Russian text was translated into French by Bella Chagall, who under Chagall's guidance refined some of the language and excised certain risqué passages. This version was published as *Ma Vie* in 1931 and translated into English as *My Life* in 1960, then back into Russian in 1994.

The two versions are broadly similar and contain most but not all the same material. *My Life* reads more smoothly than *My Own World,* and for quotations I have therefore used the English version of 1960, with occasional amendments of my own to the French-English translation. The exceptions are quotations relating to three incidents (see notes to pages 21, 40, 42, 50, and 150), which are dealt with more expansively in *My Own World.*

15 "My mother told me": Marc Chagall, interview by Jacques Chancel, Radio France, 1971.

15 "That little house": *My Life,* 1.

16 "I did not want to live": Ibid.

16 "the mob": Maritain, 4.

18 "an old town": "Vitebsk," *Encyclopaedia Britannica,* 1911.

18 "See what a little one": *My Life,* 32.

18 "For us the bridge": *First Encounter,* 215.

18 "houses stand crooked": Marc Chagall, "My Old Home," *Literarishe bleter* [Warsaw] 9 (25 February 1938), in Guggenheim, 187.

20 "with a whole wagon": *My Life,* 8.

20 "Often when he went": Izis, 21.

20 "Marc always": Haggard, 19.

20 "I am a little boy": *My Life,* 9.

20 "I was still so timid": Roditi, 33.

21 "when I was too frightened": *My Life,* 27-28.

21 "Was my mother . . . She loved to talk": Ibid., 7-9.

22 "all there was to that little old woman": Ibid., 5.

22 "Begin here . . . Mama went to temple": Ibid., 36.

22 "Have you sometimes seen": Ibid., 2-4.

23 "an object lesson": Meyer, 22.

23 "that nothing was ever": *My Life,* 22.

23 "in particular we liked": Ibid., 21.

23 "I never quarrelled": Haggard, 44.

23 "In spirit": Kamensky, 10.

23 "serene, intelligent . . . It is difficult": Ida Chagall to Louis Stern, 18 September 1959, in Harshav, 871.

24 "the whole family . . . fibs and fantasies": Petrova, 62.

24 "I scraped out something": *My Life,* 34-35.

24 "Why does one run": Ibid., 35.

24 "big, confident": Petrova, 59.

24 "She hides": Bella to Chagall, 1912, unpublished letter, Archives Chagall.

24 "a talented person": Ibid.

24 "with one condition": Chagall to Zina and Lisa, 1912, unpublished letter, Archives Chagall.

24 "My sisters laugh": Guggenheim, 187.

25 "A brilliant, light person": Petrova, 62.

25 "Around me come and go": *My Life,* 2.

26 "We hadn't even": Ibid., 43.

26 "my sweet stars . . . Every night": Ibid., 2, 43.

27 "Eh, listen": Ibid., 13.

28 "Like the cold": Maritain, 10.

29 "I didn't have": "To My City Vitebsk," *Eynikeyt,* 15 February 1944, in *Culture,* 9.

29 "For my parents": Haggard, 24.

29 "Every holy day": *First Encounter,* 48.

29 "clear and pure . . . somber nights": Ibid., 48.

29 "Where is Elijah": *My Life,* 39.

30 "heavy with adoration": Maritain, 12-13.

30 "there stretched": *First Encounter,* 79.

31 "That this 'Jewish hole' ": Benois, "On the Exhibition of 'Jewish Art,' " in *Rech* [Petrograd] 109 (22 April 1916), in Kamensky, 363.

31 "How doth": *First Encounter,* 185.

32 "Among the petty traders": Roditi, 30.

32 "This black night": Efros, 142.

33 "An old house": "My Old Home," in Guggenheim, 187.

33 "over my boyish": *My Life,* 46.

33 "I was afraid": Ibid., 46–47.

33 "At home": Roditi, 30.

CHAPTER 2: At Pen's

Vitebsk, 1900–1907

35 "The cockade": *My Life,* 47.

36 "Looking at it": Ibid.

36 "Ta-ta . . . To hell": Ibid., 49.

37 "I was unbeatable . . . I lacked": Ibid., 51.

37 "Pray morning": Ibid., 46.

37 "could not acquire": Gitelmann, 9.

38 "I know nothing . . . I was successful . . . all I dared . . . whether it was": *My Life,* 69–71.

38 "I heard": *First Encounter,* 223.

39 "I don't remember": *My Life,* 52.

39 "This particular boy" Roditi, 30.

40 "Seeing that": Spurling I, 45.

40 "I knew": *World,* 119.

41 "Gurevich's Bakery": Marc Chagall, "Yuri Pen," *Razsvet* [Paris], 30 January 1927, ibid., 175.

41 "a man who . . . it never occurred . . . but he also": Roditi, 32.

41 "almost imploringly . . . for my part . . . prepare yourself": *My Life,* 56.

42 "Art isn't": Roditi, 33.

42 "Here he is": *World,* 122.

42 "is a fine thing": *My Life,* 63.

43 "artists were": Yehuda Pen, "Zichroines fun a Kinstler," *Stern* [Minsk], 1926, 24, in Kasovsky, 15.

43 "the entire history": *Russki Yevrei* 1, 1881, 33–34, ibid., 18.

43 "I don't need": *Russia!* exhibition catalogue, Guggenheim Museum (New York, 2005), 158.

43 "a village" *Natasha's Dance,* 406.

44 "We all considered": Roditi, 35.

44 "The entire goal": Kasovsky, 19.

45 "with our albums": R. Masel, "Memoirs," in *Connu,* 20.

46 "You see": Kasovsky, 58.

46 "How are": Chagall to Pen, January 1937, "Chagall Days in Vitebsk," in *Vitebsky Kurier,* 3 July 1992, in Harshav, 453.

46 "When the exhibitions": *Natasha's Dance,* 198.

47 "water carriers": *My Life,* 58.

47 "I sought to recreate": Kasovsky, 32.
47 "they were meant": Meyer, 47.
48 "Black hair . . . Ignoring the wealth": *My Life,* 62.
49 "go with me": Ibid., 70.
49 "the face of ": Ibid., 68.
49 "We meet": Slezkine, 69.
50 "where we": *World,* 124.
50 "He is pathetic": Chagall to Zina and Lisa, 1912, unpublished letter, Archives Chagall.
50 "Even if": Chagall to Pen, 14 September 1921, State Archives Vitebsk, in Kamensky, 39.
50 "If I am": Marc Chagall, "Yuri Pen," *Razsvet,* in Harshav, 175.
52 "he had a strikingly": *First Encounter,* 201.
52 "I have chosen": Chagall, lecture at the Committee on Social Thought, University of Chicago, March 1958, in *Culture,* 126.

CHAPTER 3: Forbidden City

St. Petersburg, 1907–1908

53 "Terror gripped me": *My Life,* 65.
53 "snatched from the plough": Figes, 114.
54 "Rooms, alcoves": *My Life,* 77.
54 "enthusiasm . . . It was hard": Ibid., 95.
55 "A large majority": Vladimir Nabokov, *Lectures on Russian Literature* (London, 1981), 2.
56 "this porridge . . . some strange heavy spirit": Ciurlionis, 31, 29.
57 "a city": Fyodor Dostoyevsky, *Crime and Punishment* (New York, 1968), 444.
57 "low ceilings": Ibid., 397.
57 "I love you": Alexander Pushkin, "The Bronze Horseman," in *Collected Narrative and Lyrical Poetry,* trans. Walter Arndt (Ann Arbor, Mich., 1984), 420.
57 "the most abstract": Fyodor Dostoyevsky, *Notes from the Underground. The Double* (Harmondsworth, U.K., 1972), 17.
58 "More than ever": Alexander Blok, *Selected Poems,* trans. Jon Stallworthy and Peter France (Manchester, U.K., 2000), 19.
58 "effeminate": Ciurlionis, 42.
58 "a new and unknown": Colin Amery and Brian Curran, *St. Petersburg* (London, 2006), 153.
59 "they have undermined": Slezkine, 156.
60 "In my stay": *My Life,* 96.
60 "roared": Ibid., 78.
60 "there were days . . . an angel": Ibid., 81.
61 "after having": Ibid., 82.
61 "But the studies": Ibid., 78.
61 "to the smell": Ibid., 86.

62 "What did I": Ibid., 78.

62 "In those communal": Ibid., 82.

62 "Is it possible": Ibid., 65.

63 "My heart": Meyer, 90.

64 "vacillating": Marc Chagall to Alexander Romm, in Yakov Bruk, "Chagall and Alexander Romm: Introduction to the Published Letters from M. Chagall to A. Romm 1910-1915 and to A. Romm's memoir 'Marc Chagall,' 1944," in *Iskusstvoznanie* [Moscow] 22, no. 2 (2003), 586, translated in Yakov Bruk, *Marc Chagall in the Bakst School,* in Tretyakov, 74.

64 "I suppose": Roditi, 35.

64 "I'm going to": Neverov, 222.

64 "Bakst and his friends": Roditi, 35.

65 "here at least": *My Life,* 83.

66 "He's drowned": Ibid., 85.

68 "looked as": Ibid., 98-99.

68 "small . . . constantly doubting . . . private . . . saying anything": Chagall to Baron Günzburg, in *The Suffering Artist Will Understand Me: The Petersburg Years of M. Z. Chagall,* ed. A. Firnin (Leningrad, 1990), 8, 107, 109, translated in Yakov Bruk, *Marc Chagall in the Bakst School,* in Tretyakov, 72-73.

68 "Oh tell me": Ibid.

68 "The main thing": Ibid., 74

69 "managed . . . to ask . . . He told": Roditi, 36.

70 "Perhaps you know": Chagall to Roerich, 10 June 1908, in *Années Russes,* 238.

70 "heartwrung": Ibid.

71 "What if": Richardson, 306.

71 "I well remember": Erben, 27.

71 "joyless": Tretyakov, 81.

71 "What kind": *World,* in Harshav, 135.

71 "to take off . . . along . . . the blurred . . . the metallic . . . a vague": Tretyakov, 74.

CHAPTER 4: Thea

Vitebsk and St. Petersburg, 1908–1909

72 "By faint light": *My Life,* 61-62.

72 "How could I": *Marc Chagall,* exhibition catalogue, Musée des arts décoratifs (Paris, 1959), 128.

73 "in harmony": Efros, 136.

73 "Everything is": Leonid Andreyev, *Plays* (Moscow, 1959), 94, in Tretyakov, 77.

73 "referring to": Meyer, 136.

74 "My eyes": *My Life,* 61-62.

74 "captivated": Tretyakov, 75.

74 "What is death": Ibid., 73.

74 "the unreality": Meyer, 88.

75 "Of course": Gustav Coquiot, *Les Indépendants 1884–1920* (Paris, 1921), 58, in Meyer, 88.

75 "If I were not": Marc Chagall, "On Jewish Art, Leaves from My Notebook," *Shtrom* [Moscow] 1 (1922), in *Culture*, 40.

75 "shtetl alleys": Ibid., 39.

76 "The realistic life": Efros, 137.

76 "could realize": Ibid., 143.

77 "I shake": Marjorie Perloff, "The Great War and the European Avant Garde," in *The Cambridge Companion to the Literature of the First World War*, ed. Vincent Sherry (Cambridge, U.K., 2005), 151.

78 "The gods change": Haftmann, 13.

78 "the contagion": Neverov, 228.

79 "he worked": Chagall to Zina and Lisa, 1912, unpublished letter, Archives Chagall.

79 "the artist must": Merzbacher, 154.

79 "Jawlensky!": Roditi, 36.

80 "One day": *My Life*, 80–81.

81 "A famous lawyer": Marc Chagall, "Maxim Vinaver," in *Razsvet* [Paris], 24 October 1926, in Harshav, 194.

81 "an unhealthy": Efros, 143.

81 "the farther": *My Life*, 58.

81 "Chagall's fantasies": Meyer, 87.

82 "I detest": Schneider, in *Culture*, 162.

82 "a sombre": Tretyakov, 77.

82 "Poor Thea!": Venturi, 24.

83 "it's so bad": Spurling I, 68.

83 "I find": Neverov, 224.

83 "turning point": Meyer, 83.

83 "third . . . I grew bolder": *My Life*, 72.

84 "She held people . . . Thea sometimes": *First Encounter*, 195–97.

86 "coming upon": *My Life*, 13.

87 "the walls": A. Lisov, "Zadkin and Vitebsk," in *The Chagall Festschrift* (Vitebsk, 1996), 183, in Tretyakov, 28.

87 "To reach": *My Life*, 75.

87 "with holes": Ibid., 72.

87 "I lay down": Ibid., 73.

88 " 'This is": *First Encounter*, 200.

88 "suddenly Thea's": Ibid., 204, 206.

89 "Suddenly I feel": *My Life*, 74.

89 Bella: She was known as Berta until she left Russia in 1922, when she adopted the more glamorous-sounding Bella, derived from Chagall's nickname for her, Bellochka, which means "little squirrel" in Russian. To avoid confusion, she is referred to as Bella throughout this book.

CHAPTER 5: Bella
Vitebsk, 1909

90 "God only knows . . . each carries": *First Encounter,* 3-4.
90 "Wherever thou art": Brenda Maddox, *Nora* (London, 1988), 492.
92 "my pious . . . pondering": *First Encounter,* 265.
92 "Hands stretched out": Ibid., 120.
92 "busy all day": Ibid., 332.
92 "never had time": Ibid., 213.
93 "couldn't be bothered": Ibid., 253.
93 " 'Why . . . only father": Ibid., 270.
94 "There was no piano": Ibid., 190.
94 "The murmur": Ibid., 52.
94 "When you think": Ibid., 324.
94 "having unburdened": Ibid., 276.
94 "As soon as . . . Someone handed": Ibid., 323, 328.
95 "hung about": Ibid., 285.
96 "brought up": *My Life,* 125.
96 "Just imagine": Ibid., 121.
97 "she was": Chagall to Joseph Opatoshu, 1944, in Harshav, 544.
98 "I now feel very confident": Bella to Chagall, 1911, unpublished letter, Archives Chagall.
98 "the instinct of acquisitiveness": Slezkine, 137.
98 "curls . . . I couldn't tell": *First Encounter,* 198.
99 "a ray . . . Had I . . . I could feel": Ibid., 210-12.
99 "sturdy . . . soft": Ibid., 217.
99 "The piles": Ibid., 215.
99 "a resolutely modern": Kamensky, 51.
100 "I write to you": Bella to Chagall, 1912, unpublished letter, Archives Chagall.
100 "an ironic": Kamensky, 48.
100 "crafty . . . Cézanne . . . to fuse": Tretyakov, 78.
101 "the riches": Ibid., 89.
101 "I would really like . . . I will be very strict": Bella to Chagall, 1912, unpublished letter, Archives Chagall.
103 "love . . . the bitter . . . he spoke": Tretyakov, 76.
103 "cruelly . . . an early": Ibid., 73.
103 "Bakst": *My Life,* 88.

CHAPTER 6: Léon Bakst
St. Petersburg, 1909–1911

104 "One o'clock . . . smiling": *My Life,* 87-88.
104 "always neatly": Schouvaloff, 25.

104 "It seemed": *My Life,* 87.

105 "It is spellbinding": Schouvaloff, 84.

105 "The intellectual": Anatoly Lunacharsky, "A Russian and an American at the Paris Season" in *On Music and the Musical Theatre* [Moscow] 1, no. 18 (1981), in Pruzhan, 7.

105 Yakov Tugendhold: *Apollon,* 1910, in ibid., 25.

106 "fame . . . He'll understand": *My Life,* 88–89.

106 "He was exotic": Pruzhan, 30.

107 "began": Schouvaloff, 19.

108 "Without flowers": Bakst to Lyubov Bakst, 26 July 1903, in Pruzhan, 15.

108 "the decline": Bakst to Lyubov Bakst, 1908, in Tretyakov, 66.

108 "Strange": John Bowlt, *The Silver Age: Russian Art in the Early Twentieth Century and the "World of Art" Group* (Massachusetts, 1979), 232.

108 "I felt": Marc Chagall, "Bakst," in *Razsvet* [Paris] 26 (4 May 1930), in Harshav, 189–90.

109 "a huge": Schouvaloff, 25.

109 "slow-mocking": Ibid., 97.

109 "I have never": Ibid.

109 "Hellenistic Judaism": Efros, 142.

109 "the only": *My Life,* 86–87.

110 "brilliant professor": Ibid., 66.

110 "not so much . . . the future": Obolenskaya, 66–67.

110 "I am teaching . . . human efforts": Ibid., 67–68.

110 "battle day": Bakst to Lyubov Bakst, 6 December 1906, ibid., 65.

110 "began to criticise": Ibid.

110 "The study": *My Life,* 90–91.

111 six months: Documentation in letters published in *Chagall,* " 'Bonjour La Patrie,' " exhibition catalogue (Moscow, 2005), has made it clear that Chagall joined the school not in 1908, as used to be thought, but at the end of 1909.

111 "apprentices": Tretyakov, 66.

112 "often Pushkin": Ibid.

112 "insincerity": Ibid., 72.

112 "they disliked": Ibid.

112 "of just having": Ibid., 74.

113 "I have": Ibid., 72.

113 "Bakst's pupils . . . a Europe": *My Life,* 89–90.

113 "I myself": Bakst to A. Ostromova-Lebedeva, 12 November 1910, in Pruzhan, 222.

113 "Art is only": Bakst, interview with George Gombaut, in Schouvaloff, 29.

113 "Bright, pure": Bakst, "The Paths of Classicism in Art," *Apollon* (1909), in ibid., 77.

114 "What is the use . . . The truth": *My Life,* 89, 91.

114 "My fate": Marc Chagall, "Curriculum Vitae," 5 March 1921, manuscript in Tretyakov Gallery, in *Années Russes,* 246.

114 "the opening": Tretyakov, 69.

114 "no reply": Ibid., 80.

115 "blighted . . . the lower . . . blossom": Ibid., 71.

115 "I am happy": *My Life,* 94.

115 "melt away . . . it's better": Tretyakov, 80.

115 "if not": Ibid., 67.

117 "whose life was years": Ibid., 76.

117 "I don't know": Ibid., 77.

117 "I immediately": *My Life,* 94.

117 "I enter": Isaac Peretz, *Rasskazy, skazki* [Moscow] 1941, in Kamensky, 70.

118 "I personally": Mekler to Chagall, June 1910, unpublished letter, Archives Chagall.

118 "For me . . . I am": Chagall to Mekler, undated fragments of letters, in Harshav, 199.

119 "I have never": Tretyakov, 80.

119 " 'What's that": *My Life,* 76.

119 "quailed": *First Encounter,* 213.

120 "I am afraid": Bella to Chagall, 1911, unpublished letter, Archives Chagall.

120 "They are so honest . . . The naïve": Bella to Chagall, 1912, unpublished letter, Archives Chagall.

120 *"Their love?"*: Slezkine, 168.

120 "I felt": *My Life,* 94.

120 from a distance: Chagall's claim in his memoir that he arrived in Paris in 1910 has been accepted by Western scholars from Meyer in *Chagall* (London, 1964) to Harshav in *Marc Chagall: A Documentary Narrative* (Stanford, Calif., 2004), and this painting has been cited as showing the immediate impact on his work of his arrival there. However, letters in the Archives Chagall, backed up by Yakov Bruk's publication of Chagall's letters to Alexander Romm in *Iskusstovnanie* [Moscow] 22, no. 2 (2003) (see note to page 64 above), prove that he arrived in Paris in May 1911. *Still Life with Lamp* shows instead the intense preparatory attention he paid to contemporary French art while still in Russia. The error in the date, like attempts to move his birthday two years forward, is typical Chagall; see note to page 11 above.

121 "Matisse's": Tretyakov, 68.

121 "You are wrong": Bakst to Chagall, 18 November 1910, in Tretyakov, 83.

121 "of course": George Painter, *Marcel Proust,* rev. and enlarged ed. (London, 1996), 2:160.

121 "You worry": Bakst to Chagall, 18 November 1910, Tretyakov, 72.

121 "I say": *My Life,* 92.

122 "My lovely Chagall": Bakst to Chagall, 1911, unpublished letter, Archives Chagall.

123 "Beneath my feet . . . Vitebsk": *My Life,* 93, 95.

123 "I left Russia": Roditi, 37.

123 "even the German": Ibid., 37.

124 "I've just been sitting": Bella to Chagall, 1911, unpublished letter, Archives Chagall.

124 "I really want": Bella to Chagall, 1911, unpublished letter, Archives Chagall.

CHAPTER 7: "Surnaturel!"

Paris, 1911–1912

125 "Only the great": *My Life,* 100.

125 "I seemed to be": Roditi, 37.

125 "lumière-liberté": *Renaissance,* 24.

125 "I arrived": Ibid., 23.

125 "difficult": *My Life,* 105.

125 "thinks he's": Chagall to Zina and Lisa, 1912, unpublished letter, Archives Chagall.

125 "I am very far": Ibid.

126 "I knew": Marc Chagall, "In Memory of Ya. A. Tugendhold," in *Iskusstvo* [Moscow] 3–4 (1928), in Kamensky, 73.

127 "on the café . . . bright": Ehrenburg I, 65.

127 "a flat": Chagall to Zina and Lisa, 1912, unpublished letter, Archives Chagall.

127 "Food is not cheap": Ibid.

129 "Now I will": Ibid.

129 "I found": *Renaissance,* 24.

129 "Everything showed": *My Life,* 102.

129 "put an end . . . When I": Ibid., 100.

129 "I loved": Schneider, in *Culture,* 158.

129 "the hundreds . . . the show windows . . . in the dark": *My Life,* 106–7.

129 "I could of course": *Renaissance,* 23–24.

130 "No academy": *My Life,* 102.

131 "Le soif": Jacques Tugendhold [Yakov Tugendhold], *Alexandra Exter* (Paris, 1922).

131 "I don't know": *My Life,* 102.

131 "I hurried": Schneider, in *Culture,* 155.

131 "a fait éclater": Daniel-Henry Kahnweiler, *The Rise of Cubism,* trans. Henry Aronson (New York, 1949), 10.

131 "the most important": John Golding, *Cubism: A History and an Analysis, 1907–1914* (London, 1959), 15.

132 "intellectual isolation": Richardson, 160.

132 "a jay": Apollinaire, 114.

132 "horribles": Richardson, 211.

132 "one finds": Apollinaire, 151.

132 "We crossed": *Hungarian Quarterly* 45, no. 174 (Spring 2004).

133 "Overnight": Daniel Robbins, *Albert Gleizes 1881–1954 (New York, 1964), 18.*

133 "I went straight": My Life, 102.

133 "ever since": Schneider, 156.

134 "What did": Haggard, 16.

134 "Why don't": Pen to Chagall, 1912, unpublished letter, Archives Chagall.

134 "I am working": Chagall to Benois, 1911, Leningrad, Vitali, 146.

135 " 'So you came . . . to tell the truth": *My Life,* 105–6.

135 "as if in reply": Ibid., 94.

135 "some terrible": Efros, 137.

135 "it was from then": Roditi, 37.

136 "a crowded": Efros, 142.

136 "The stone grey . . . made his work . . . He remained": Ibid., 143.

136 "an age": Meyer, 112.

137 "Chagall confronted": Efros, 137.

137 "I have admired": Sweeney, 82.

137 "I detested": Schneider, 162.

137 "seemed to be": Roditi, 37.

137 "was a time": *Renaissance,* 23.

137 "I have written": Chagall to Benois, 1911, Leningrad, Vitali, 146.

138 "I remember": André Warnod, *Fils de Montmartre: Souvenirs* (Paris, 1955), 152.

138 "Room 15": Apollinaire, 214.

140 "what I mean": Sweeney, 82–83.

141 "something erotic": Efros, 142.

141 "outbursts . . . Chagall's fantastics . . . while the mind-boggling": Ibid., 141.

141 "Surnaturel!": *My Life,* 115.

142 "His positive": Breton, 64.

143 "I didn't want": *My Life,* 101.

143 "Impressionism": Ibid., 115.

143 "We want": Bowlt, 79.

143 "we shall arrange": James Billington, *The Icon and the Axe* (London, 1966), 490.

144 "lackeys . . . decadent": Gray, 121.

144 "Sometimes it's so boring": Chagall to Romm, 1912, unpublished letter, Archives Chagall.

144 "The west": Bowlt, 58, 87.

144 "firm belief": *Kandinsky, The Path to Abstraction,* exhibition catalogue, Tate Modern (London, 2006), 158.

144 "Here in the Louvre": *My Life,* 101.

145 "I can't imagine": Chagall to Zina and Lisa, 1912, unpublished letter, Archives Chagall.

145 "My dear, I completely": Bella to Chagall, 1911, unpublished letter, Archives Chagall.

146 "My dear, hello": Bella to Chagall, 1911, unpublished letter, Archives Chagall.

146 "My dear, You are so far away": Bella to Chagall, 1912, unpublished letter, Archives Chagall.

146 "Don't think that": Bella to Chagall, 1912, unpublished letter, Archives Chagall.

147 "To surrender": Meyer, 132.

148 A notebook: See Warnod, 66.

CHAPTER 8: Blaise Cendrars

Paris, 1912–1913

149 In the spring of 1912: Chagall's claim that he moved to La Ruche in 1911 has been accepted by all previous scholars, but letters written by and to him in the Archives Chagall show the date was in fact April or May 1912, as the Impasse du Maine address is documented in use until April 1912. Letters from Romm, then his best friend, are addressed there from 1911 until 17 April 1912.

149 this "sinister": *La Ruche,* 122.

150 "Bolshevik": Ibid.

150 "I washed . . . in order": Ibid., 144.

150 "In those studios": *My Life,* 103.

150 "an Italianist": *La Ruche,* 14.

151 "as a *carte*": Ibid., 41.

152 "I was *un type*": Ibid., 14.

152 "on the shelves . . . two or three . . . the sky": *My Life,* 103.

152 "I love": *World,* in Harshav, 144.

152 "Il faut crever": *La Ruche,* 143.

153 "We were hungry": Ibid., 144.

153 "a morbid": Ibid., 14.

154 "Je ne suis": Ibid., 44.

154 "ce petit": Ibid., 125.

154 "wonderful . . . indefatigable": Roditi, 39.

154 "the interpreter": Jacques Chapiro, *La Ruche* (Paris, 1960), 77.

154 "my meeting": Erben, 64.

155 "The light": *My Life,* 108.

155 "it is not": *Planus,* 112.

155 " 'Money": Ibid., 51.

155 "milky . . . magic": Ibid., 21.

156 "rich and": Ibid., 15.

156 "telling each": Ibid., 16.

156 "He was the first": *My Life,* 112.

156 "total . . . a genius": Cendrars, 61-62.

156 "What a book": *Planus,* 138.

157 "paints with": Cendrars, 60.

157 "there was": *Planus,* 14.

157 "the night-owls": Ibid., 13.

157 "waves of sunshine": *My Life,* 111-12.

158 "life is": *Planus,* 61.

158 "Every one": *Modernities,* 3-4.

158 "Robert Delaunay": Ibid., ix.

158 *"He's asleep"*: Cendrars, 60-61.

159 "polished": *My Life,* 104.

159 "a very short": Ludwig Gewaesi, "V Mir Iskusstva," in *Zolotoye Runo* [Moscow] 2/3 (1909), in Gray, 119.

160 "he made us all": *Modernities,* xi.

161 "I have a higher": Schneider, 156.

162 "I am ahead": Axel Madsen, *Sonia Delaunay: Artist of the Lost Generation* (New York, 1989), 91.

163 "was always": Gertrude Stein, *The Autobiography of Alice B. Toklas* (New York, 1961), 98.

163 "that gentle": *My Life,* 113.

163 "spread slowly . . . he carried . . . Perhaps": *My Life,* 113-15.

164 "In my work": Sweeney, 86.

164 "One of the finest . . . impressive": Apollinaire, 356, 285.

164 "an extremely": Ibid., 400.

165 "Participating in that": *Renaissance,* 25.

165 "I was living": Kamensky, 135.

165 "When I . . . The symbolic": Erben, 50.

166 "Christ is him": Cendrars, 60-61.

166 "For me Christ": *Renaissance,* 22.

166 "I remember": Efros, 141.

166 "will remain": Theodor Däubler, *Der neue Standpunkt* (Leipzig, 1919), 134.

167 "Chagall's fantastics": Efros, 142.

167 "a young Hoffmann": Anatoly Lunacharsky, "Marc Chagall," in *Kiyevskaya Mys'* [Kiev], 14 May 1914, in Harshav, 214.

167 "I am sending": Chagall to Mstislav Dobuzhinsky, 1912, Leningrad, Vitali, 147.

167 "authentically Russian . . . the melancholy": *Montjoie* [Paris], March 1914.

CHAPTER 9: "My Ferocious Genius"

Paris, 1913-1914

168 "tall, thin . . . It would hurt . . . that assured . . . You are still": Bella to Chagall, 1912, unpublished letter, Archives Chagall.

170 "Without losing": Efros, 143.

170 "a most beautiful": Bella to Chagall, 1913, unpublished letter, Archives Chagall.

170 "Bless you": Bella to Chagall, 1913, unpublished letter, Archives Chagall.

171 "I swear": Bella to Chagall, 1913, unpublished letter, Archives Chagall.

171 "My dear, why don't you": Bella to Chagall, 4 February 1913, unpublished letter, Archives Chagall.

171 "I was very happy": Bella to Chagall, 20 March 1913, unpublished letter, Archives Chagall.

172 "I'm still waiting": Bella to Chagall, 25 May 1913, unpublished letter, Archives Chagall.

173 "My dear, will you": Bella to Chagall, 10 June 1913, unpublished letter, Archives Chagall.

173 "I don't know": Bella to Chagall, 8 July 1913, unpublished letter, Archives Chagall.

NOTES TO PAGES 173-182 543

173 "I've been sending": Bella to Chagall, 7 November 1913, unpublished letter, Archives Chagall.

173 "I don't even": Bella to Chagall, 4 December 1913, unpublished letter, Archives Chagall.

174 "A mean and scheming": Bella to Chagall, 16 December 1913, unpublished letter, Archives Chagall.

174 "that fourth": *My Life,* 117.

175 "pop in": Chagall to Pen, 1913, unpublished letter, Archives Chagall.

175 "Why the devil": Tugendhold to Chagall, 16 March 1913, unpublished letter, Archives Chagall.

175 "hopefully": Chagall to Pen, 1913, unpublished letter, Archives Chagall.

175 "I am very happy": Tugendhold to Chagall, 22 June 1913, unpublished letter, Archives Chagall.

175 "My dear, will you": Bella to Chagall, 1913, unpublished letter, Archives Chagall.

177 "had the face": Ehrenburg I, 12.

177 "*Herde*": Erben, 54.

177 "This young man": Tarenne, 46.

177 "Cut off": Blaise Cendrars to Chagall, 14 January 1914, Archives Fond Blaise Cendrars, ibid., 45.

178 "maîtres": *Paris-Journal,* 11 July 1914, 1.

178 "We don't need": *My Life,* 108.

178 "There is no doubt": Apollinaire, 415.

178 "I don't know": Chagall to Tugendhold, spring 1914, unpublished letter, Archives Chagall.

179 "Dear Yakov": Ibid.

180 "Your letter": Cendrars to Chagall, 1914, unpublished letter, Archives Chagall.

180 "Le prix": Cendrars to Walden, 1914, Archives Walden, Staatsbibliothek zu Berlin, Preussicher Kulturbesitz, in Tarenne, 47.

180 "Apparently": *My Life,* 116-17.

180 "before the war": Ehrenburg I, 189.

180 "If there had been": Richardson, 343.

180 "to dissolve": Merzbacher, 121.

180 "My pictures": *My Life,* 117.

181 "I very much": Cendrars to Chagall, June 1914, unpublished letter, Archives Chagall.

181 "It is warm": Meyer, 206.

CHAPTER 10: Homecoming
Vitebsk, 1914–1915

182 "Well, this is": *My Life,* 119.

182 "had taken": Ibid., 112-18.

182 "a place": Ibid., 119.

182 "I painted . . . I was satisfied": Ibid., 119, 120.

183 "little white": *First Encounter,* 227.

184 "Thus a man": Guerman, 90.

184 "a social revolution": Norman Davies, *Europe: A History* (London, 1997), 894.

184 "The First World War": Ehrenburg I, 158.

184 "A terrible sadness": Kamensky, 193–98.

185 "German Jews": Semion Dubnov, *The Book of Life* (Moscow and Jerusalem, 2005).

185 "Soldiers, moujiks": *My Life,* 126.

185 "Russian Jews": Gitelmann, 83.

185 "I longed": *My Life,* 134.

186 "Chagall's works": Tugendhold, "A New Talent," in *Russkie Vedomosti* [Moscow] 71 (29 March 1915), in Kamensky, 361.

187 "Sometimes a man": *My Life,* 120.

188 "I had the impression": Meyer, 222.

189 "I look": *My Life,* 120.

189 "I start": Haftmann, 92.

190 "Another old man": *My Life,* 120.

190 "cornerstone": Amishai-Maisels, 229.

190 "going through": Haggard, 60.

190 "Far from": *Renaissance,* 31.

192 "In those provincial": Efros, 143.

192 "a cure": Ibid., 137.

194 "It looks": *My Life,* 122.

195 " 'You'll starve": Ibid.

195 "stuck . . . How is": Chagall to Sonia Delaunay, 20 November 1914, in Harshav, 223–24.

195 "take my best": Chagall to Mazin, November 1911, unpublished letter, Archives Chagall.

196 "How are": Zadkine to Pen, 16 November 1916, in Shatskikh, 19.

197 "held up . . . I cannot": Chagall to Benois, 1914, in Vitali, 147–48.

197 "one of the great hopes": Kamensky, 361.

198 "The term 'Futurism' ": *Avant-Garde,* 25.

198 "I found the atmosphere": Roditi, 40.

198 "I couldn't": *My Life,* 147.

199 "I shall always": Ibid., 7–8.

CHAPTER 11: Married Man

Petrograd, 1915–1917

200 "You suddenly": *First Encounter,* 228.

201 "I had only": *My Life,* 123.

201 "She really *felt*": Haggard, 27.

201 "Was it worth": *My Life,* 123.

201 "with the result . . . Woods, pines": Ibid., 125.

202 "my wife preferred": Ibid., 129.

203 "My chief": Ibid., 130.

203 "to serve": Chagall to Benois, 1 October 1917, in Vitali, 149.

203 "My situation": Chagall to Benois, 1915, in Vitali, 148.

204 "The sun": Chagall to Sergei Makovsky, 1915, in Vitali, ibid.

204 "We will soon": Figes, 300.

204 "I cannot understand": Kamensky, 193.

205 "for love": John Donne, "The Good Morrow," *Donne Poetical Works* (Oxford, 1977), 7.

205 "Her lips": *First Encounter,* 345.

205 "Bella's role": Haggard, 58.

205 "Bella blended": Unpublished draft of note from Chagall to Daniel Catton Rich, 1946, Archives Chagall.

206 "the literary": *Avant-Garde,* 53.

208 "She yelled": *My Life,* 149.

209 "I always used": Schneider, 167.

209 "Petersburg is now": Apter-Gabriel, 26.

210 "he is a true": Benois, "On the Exhibition of Jewish Art," in *Rech* [Petrograd] 109 (22 April 1916), in Kamensky, 363.

210 "The other artists": Gray, 206–7.

211 "We deny": Ibid., 136–37.

212 "spoon in buttonhole": Ibid., 216.

212 "Only when": Ibid., 208.

212 "Why do you not": Malevich, *From Cubism and Futurism to Suprematism: The New Painterly Realism* (1915), in Bowlt, 125–35.

213 "He enters": Efros, 135.

214 "I cannot": Chagall to Makovsky, September or October 1916, in Vitali, 149.

214 "people are": Gray, 239.

214 "Nowadays": Kamensky, 361.

214 "anticipating": *Avant-Garde,* 30.

214 "Velimir I": John Milner, *A Slap in the Face, Futurists in Russia,* exhibition catalogue, Estorick Collection (London, 2007), 12.

215 "rather precarious": Figes, 309.

216 "Soldiers fled": *My Life,* 135.

216 "the most striking": Figes, 351.

216 "Every wall": Ibid., 368.

217 "is no longer": Ibid., 400.

217 "every single": Meyer, 250.

218 "the typically": Shatskikh, 327.

218 "The atmosphere": Vitali, 42.

219 "Without doubt": Figes, 421.

220 "all these": Vitali, 55.

220 "Why does . . . external . . . If fate . . . accommodate . . . will always": Chagall to Benois, 1 October 1917, in Vitali, 149.

CHAPTER 12: Commissar Chagall and Comrade Malevich

Vitebsk, 1917–1920

222 "All the dark": Figes, 495.

223 "pale depraved": Ibid., 555.

223 "Things are": Ibid., 501.

223 "rushed and febrile": Chagall to Nadezhda Dobychina, 12 March 1918, in *Années Russes,* 240.

224 "at this great": Kamensky, 264.

224 "It is impossible": Ben Khayim, "Di role fun d idishe arbeiter in der rusisher revolutsie," *Funten* 1, no. 8 (25 March 1920), in Gitelmann, 89.

224 "Jewish art": Amishai-Maisels, 229.

224 "I was glad . . . during these long": Chagall to Benois, 1918, in Vitali, 150.

224 "Now I am here": Chagall to Nadezhda Dobychina, 12 March 1918, in *Années Russes,* 240.

225 "disturbed": *Renaissance,* 31-32.

225 "Dreams . . . Suddenly": *My Life,* 82.

226 "I have lived through": Vitali, 42.

226 "the experience": *Avant-Garde,* 54.

226 "unquestionably": Leon Trotsky, *Literature and Revolution* (Moscow, 1924), trans. Rose Strunsky (London, 1925), 119-20.

228 "A miracle": *Painting Revolution,* 32.

229 "We worked": *Avant-Garde,* 54.

229 "To love": Efros, 135.

229 "my wife wept": *My Life,* 136.

229 "to set up": Tretyakov, 35.

229 "Have you been": Chagall to Moise Kogan, 1918, in *Années Russes,* 247.

230 "hung with": Kamensky, 267.

230 "exactly": Tretyakov, 36.

231 "Christopher Columbus": "Declaration for the catalogue of the State Exhibition, Moscow 1919," in *La Russie et les avant-gardes,* exhibition catalogue, Fondation Maeght (St. Paul de Vence, 2003), 192.

231 "His tower": *Avant-Garde,* 55.

231 "Suprematism": Gray, 209.

232 "to provide": Roditi, 42.

232 "Within its walls . . . From the windows": Chagall in *Shkola i revolutsiya* (Vitebsk, 1919), in Harshav, 269.

232 "Let the . . . Give us": Chagall, "Letter from Vitebsk," *Iskisstvo komuny* [Petrograd], 23 December 1918, in Harshav, 259.

233 "From the lavish": G. Grillin, "On the Opening of the People's Art College in Vitebsk," *Vitebskii Listok,* 30 January 1919, in Harshav, 264.

233 "it was": Shatskikh, 29.

233 "guilty": Clark, 229.

234 "We acknowledge": "Theses of the Art Section of Narkompros and the Central Committee of the Union of Art Workers Concerning Basic Policy in the Field of Art," 1920, in Bowlt, 184.

235 "No, I will . . . to be the minority in": Chagall, "The Revolution in Art" in *Revolutsionnoe Iskusstvo* (Vitebsk, 1919), in *Culture,* 31-32.

236 "Students may": *Vitebskii Listok,* 18 June 1919, in Shatskikh, 333.

236 "to be careful": *Shkola i revolutsiya,* in Harshav, 269.

236 "offered all": Roditi, 42.

236 "he never prevented": Kamensky, 277.

236 "Chagall stood": Ibid., 278.

237 "This studio": Shatskikh, 46.

239 "one of the chief": "On the Departure of Comrade Chagall, a Resolution of the General Assembly of Students of the People's Art School," ibid., 55.

240 *"Static"*: Clark, 226.

240 "seemed with his hands": *Painting Revolution,* 17.

240 "no particular . . . illustrations": Vitali, 68.

241 "a sermon": *Kazimir Malevich: Suprematism,* exhibition catalogue, Deutsche Guggenheim Berlin (New York, 2003), 18.

241 "It is from zero": Ibid., 3.

241 "have turned aside": Ibid., 47.

241 "I am painting": Clark, 226.

241 "After the old": *Painting Revolution,* 158.

241 "a veritable hotbed": Roditi, 42.

243 "The atomization": Clark, 266.

243 "while I was": Roditi, 44.

243 "at present": Chagall to Pavel Ettinger, 2 April 1920, in Vitali, 73.

244 "as far as expressionism": Ibid., 72.

244 "One afternoon": *My Life,* 153.

245 "there was a rush . . . One Marx": *My Life,* 139-40.

245 "some of the speakers": Ehrenburg I, 87.

246 "The world . . . I'd like to imagine": Frieda Rubiner to Chagall, 19 March 1919, unpublished letter, Archives Chagall.

246 "Do you happen": Chagall to Ettinger, 2 April 1920, Vitali, 74.

246 "across the facade": Roditi, 44.

247 "in the face": Vitali, 74.

247 *Cubist Landscape:* Chagall dated this incorrectly 1918; it was painted in 1920.

247 "he didn't know": "The Artists of Granovskii's Theatre," in *Iskusstvo* (1928), in Guggenheim, 156.

249 "sunk into . . . Make me": *My Life,* 144-45.

249 "Futurism has": Clark, 263.

249 "Malevich": *Art News,* 5 April 1924, ibid., 225.

250 "most memorable": Charlotte Douglas, *Malevich* (London, 1994), 40.

250 "the women . . . what means": *My Life,* 142.

250 "You must remember": Chagall to Kunin, undated, in Shatskikh, 51.

251 "My town": *My Life,* 146.

251 "my father's . . . hid the letter . . . it's wicked": Ibid., 147.

252 "Hatred": Figes, 676.

252 "a very technical": Petrova, 56.

CHAPTER 13: Chagall's Box
Moscow, 1920–1922

253 "Why not . . . We piled up": Guenne, 323.
253 "At last . . . Damp": *My Life,* 156.
253 "didn't know": Vitali, 68.
254 "Mama could never": *Natasha's Dance,* 535.
254 "unheated": Ibid., 534.
254 "I am ashamed": David Magarshack, *Stanislavsky: A Life* (London, 1950), 349.
254 "I am afraid": Ibid.
257 "Feverish": Guggenheim, 155.
257 "Everywhere": Marc Chagall, "My First Meeting with Solomon Mikhoels," in *Yidishe Kultur* (January, 1944), ibid., 151.
257 "Piles of " . . . "There you are": *My Life,* 159.
258 "He set us": Guggenheim, 156.
258 "I, always": *My Life,* 162.
258 "One thing": Guggenheim, 43.
259 "Once Mikhoels": Ibid., 152.
260 "sole representative": *My Life,* 160.
260 "We lacked": Ibid., 164.
260 " 'Who is": Ibid., 165.
260 "hated real": Guggenheim, 157.
262 "Outside": Ibid., 43.
262 "all Russia": Susan Compton, *Love and the Stage,* exhibition catalogue, Royal Academy (London, 1998), 13.
262 "Eyes and forehead": *My Life,* 163.
263 "Strong though . . . From afar": Ibid.
263 "Looking for": Ibid., 48.
263 "I wanted to": Guggenheim, 151.
264 "Chagall insists . . . the millennial": Meyer, 91.
265 "Such Jewish": Guggenheim, 158.
266 "Chagall referred": Meyer, 296.
266 "Hebrew jazz": Erben, 74.
266 "the whole hall": Guggenheim, 156.
266 "an incredible": Ibid., 162.
266 "When one": Ibid., 44.
267 "picturesque": Ibid., 48.
267 "The curtain": Ibid.
267 "The thick": Ibid., 156.
268 "at Habima": Ibid., 167.
268 "I can find": Vitali, 89.
268 "To paint . . . You don't": Chagall to Lunacharsky, summer 1921, in Harshav, 299–300.
269 "I first": *My Life,* 168.
269 "still held . . . by morning . . . a hilarious": Ibid., 170–71.

270 "You see them": *Der Emes,* 2 February 1922, in Gitelmann, 95.

270 "The village": Kamensky, 313.

270 "the most unhappy": *My Life,* 169.

273 "Instead of": Velimir Khlebnikov, *Collected Writings,* trans. Paul Schmidt (Massachusetts, 1987), 1:128.

273 *"In the hut"*: Ibid., 3:106.

274 "despite the new . . . We, your very": Chagall to Pen, 14 September 1921, in Vitali, 61.

274 "We live": El Lissitzky, "Victory over Art," in *Ringers* [Warsaw] 10 (1922), 32-34.

274 "The old masters": Erben, 76.

274 "Neither imperial . . . I'm certain": *My Life,* 173.

275 "act of": Apter-Gabriel, 91.

275 "Nevertheless": *My Life,* 166.

275 "I *suffocated*": Chagall to David Arkine, 11 December 1922, in *Années Russes,* 225.

275 "Those five years": *My Life,* 174.

276 "If I could": Chagall to Ettinger, May 1922, in Harshav, 305.

276 "I took . . . Where has": Chagall to Arkine, 26 June 1923, in *Années Russes,* 225.

276 "the Jews": Ibid.

277 "the artist": Alexandra Shakskikh, "Marc Chagall and the Theatre," in Vitali, 76.

277 "computers": Ibid., 81.

CHAPTER 14: Der Sturm
Berlin, 1922–1923

281 "Marc Chagall": Harshav, 311.

282 "In my imagination": *My Life,* 100.

282 "Come back": Meyer, 315.

282 "Just the same": *My Life,* 173.

283 "I am not": Petrova, 57.

283 "Beside Kaiser": Marc Chagall, "My Meeting with Max Liebermann," in *Di Tsukunft* 40 (May 1935), in Harshav, 357.

284 "Everything was": Ehrenburg III, 14.

284 "in these difficult": Roditi, 46.

284 "like a weird": Ibid.

285 "he is moved": With, 7.

286 "Berlin had": Roditi, 46.

286 "at every step . . . the Hungarian": Ehrenburg III, 18, 13.

286 "like a dethroned": Meyer, 316.

286 "The Paris": Erben, 77.

288 "A cosmic": Ibid.

288 "A Golgotha": Ibid., 78.

288 "salvation": *Kandinsky: The Path to Abstraction,* exhibition catalogue, Tate Modern (London, 2006), 158.

288 "there are plans": Chagall to Arkine, July/September 1922, in *Années Russes,* 228.

289 "Each": Ibid.

290 "No-o-o": *Chagall und Deutschland, Verehrt, Verfemt,* exhibition catalogue, Jüdisches Museum Frankfurt and Stiftung "Brandenburger Tor" Berlin (Munich, 2004), 50.

290 "Marc Chagall und": With, 8.

290 "I remember": Erben, 80.

291 "Chagall is . . . one part": With, 6.

294 "My dear father": *My Life,* 147.

294 "I don't know": Chagall to Arkine, July/September 1922, in *Années Russes,* 228.

295 "the stroke": Meyer, 319.

295 "Only you": *My Life,* 148.

295 "sat . . . You'll see": Ehrenburg III, 25.

296 "Death . . . good": Ibid., 14.

296 "Do you really": Chagall to Bella, 29 June 1923, unpublished letter, Archives Chagall.

296 "I sleep . . . Instead . . . I look like": Chagall to Bella, July 1923, unpublished letter, Archives Chagall.

297 "messing around . . . dear Bellochka . . . so far": Chagall to Bella, 22 August 1923, unpublished letter, Archives Chagall.

CHAPTER 15: Dead Souls

Paris, 1923–1924

298 "It is a world": Chagall to Bella, September 1923, unpublished letter, Archives Chagall.

298 "The bed": Ibid.

299 "We have to": Ibid.

299 "My dear, I do not": Chagall to Bella, 31 August 1923, unpublished letter, Archives Chagall.

299 "My dear, It seems": Chagall to Bella, 31 August 1923 (separate letter from above), unpublished letter, Archives Chagall.

300 "I'm still not satisfied": Chagall to Bella, 14 September 1923, unpublished letter, Archives Chagall.

300 "As for work": Ibid.

301 "*un domaine*": La Ruche, 159.

302 "at that time": Ibid., 150.

302 "a beautiful": Chagall to Bella, 31 August 1923, unpublished letter, Archives Chagall.

302 "I don't know": Ibid.
302 "the most beautiful": Richardson, 174.
303 "it would be good . . . I can't understand . . . but when": Chagall to Bella, 31 August 1923, unpublished letter, Archives Chagall.
303 "I'm afraid . . . You have to": Ibid.
304 "I don't know": Bella to Chagall, 1 October 1923.
307 "You can . . . They keep": Erben, 88.
309 "For every": Ibid.
309 "looks at": Natalia Apchinskaya, *Marc Chagall's Graphics* (Moscow, 1990), 217.
310 "Chagall contrived": Vollard, 261.
310 "To Moscow": Chagall to Ettinger, 10 March 1924, in Harshav, 326.
310 "You know": Chagall to Ettinger, September 1924, in Harshav, 344.
311 "Bellochka": Ida Chagall to the Rosenfelds, 27 March 1945, in Harshav, 554.
311 "Maybe one day": Chagall to his sisters, May 1923, in Petrova, 57.
311 "in her childhood": Petrova, 56.
312 "polite": Chagall to Bella, 31 August 1923, unpublished letter, Archives Chagall.
312 "Pozner is a fine": Chagall to Bella, 14 September 1923, unpublished letter, Archives Chagall.
312 "hardly palpable": Vladimir Nabokov, *Speak, Memory* (Harmondsworth, U.K., 1969), 216.
312 "ghetto of emigration": Brian Boyd, *Vladimir Nabokov: The Russian Years* (London, 1990), 161.
313 "What's new": Chagall to Ettinger, December 1924, in Harshav, 332.

CHAPTER 16: "Lumière-Liberté"
Paris, 1924–1927

315 "I want": Florent Fels, *Propos d'artiste* (Paris, 1925), 33.
315 "where the nature": Chagall to Bella, 1 October 1923, unpublished letter, Archives Chagall.
317 "the first person": Haggard, 108.
317 "For years": *First Encounter*, 345.
318 "a veil": Spurling II, 287.
318 "My whole life": Haggard, 30.
318 "flair": Ibid., 57.
318 "Je ne demande": Claire Goll, 180–81.
318 "the beautiful . . . the couple . . . Bella": Salmon, 209.
319 "It's cold": Bella to Chagall, undated 1924, unpublished letter, Archives Chagall.
319 "Why do you": Bella to Chagall, undated 1924 (separate letter from above), unpublished letter, Archives Chagall.
320 "on t'atend": Ida to Marc Chagall, 1924, unpublished letter, Archives Chagall.

320 "My dear little canary": Chagall to Bella, 1924, unpublished letter, Archives Chagall.

320 "Chagall adored": Claire Goll, 180.

320 "we are silly": Meyer, 337.

321 "What I have wanted": Raynal, 55.

322 "fantastic or illogical . . . offered so much": Sweeney, in *Culture,* 86.

322 "This is": Cassou, 141.

323 "Matisse and": Chagall to Arkine, December 1924, in *Années Russes,* 228.

323 "live alone": Bella to Chagall, 1924, unpublished letter, Archives Chagall.

323 "a god . . . in the process . . . No more": Erben, 90.

324 "Chagall interrogates": Raynal, 56.

324 "I owe": Ibid.

324 "Do I": Chagall to Pavel Ettinger, December 1926/January 1927, in Harshav, 345.

325 "Once I used": Chagall to Sh. Nigger, 23 August 1924, in Harshav, 329.

325 "I shall do": Chagall to Leo Koenig, 21 September 1925, in Harshav, 337.

325 "People could": Vollard, 260.

325 "sympathetic": Vollard, "De La Fontaine à Chagall," in *L'Intransigéant* [Paris], 8 January 1929.

325 "was not so": Vollard, xv.

326 "malheureusement": Chagall to René Gaffé, February 1926, unpublished letter, Archives Chagall.

327 "how much money": Haggard, 55.

327 "Neither success . . . he liked": Claire Goll, 180, 177.

329 "It is Madame": *Marc Chagall: Les Fables de La Fontaine,* exhibition catalogue, Musée d'art moderne, Ceret, and Musée National Message Biblique Marc Chagall, Nice (Paris, 1995), 26.

331 "Without her": Guenne, 322.

333 "Do you remember": Mary Blume, *Côte d'Azur: Inventing the French Riviera* (London, 1992), 73.

333 "now devoted": Chagall, "On Modern Art," lecture at HaBimah Theatre, Tel Aviv, 31 March 1931, in *Culture,* 50.

333 "I don't know": Chagall to Bella, 26 October 1927, unpublished letter, Archives Chagall.

333 "the happiest": Meyer, 350.

333 "It is my whole life": Guenne, 325.

333 "Once in the Musée": Haftmann, 114.

334 "Today I finished": Chagall to Bella, 26 October 1927, unpublished letter, Archives Chagall.

334 "Delaunay made this": Chagall to Bella, October/November 1927, unpublished letter, Archives Chagall.

335 "believing himself . . . Vous verrez": Ida Chagall, undated, unpublished note, Archives Chagall.

336 "Why am I": *Cirque.*

336 "Chaplin": Guenne, 324.

337 "perfection": Schneider, 159.

337 "for me": Emily Genauer, *Chagall at the Met* (New York, 1971), 52.

CHAPTER 17: The Prophets
Paris, 1928–1933

338 "a number": Roditi, 29.

339 "The essence": Chagall, "On Modern Art," lecture at HaBimah Theatre, Tel Aviv, 31 March 1931, in *Culture* 46, 49.

339 "I hope": Chagall to Joseph Opatoshu, 1 July 1928, in Harshav, 346.

340 "I infinitely love": Chagall to Bella, 5 January 1928, unpublished letter, Archives Chagall.

341 "Hold on . . . And oh": Ibid.

341 "overheard": Haggard, 22.

342 "There is not": Chagall to Opatoshu, undated 1929, in Harshav, 349.

343 "she walks simply": Marc Chagall, "My Meeting with Max Liebermann," *Di Tsukunft* 40 (May 1935), in Harshav, 357.

343 "I hear something": Ibid., 358.

344 "Ick kann": Elon, 393.

344 "He made a mistake": Marc Chagall, "My Meeting with Max Liebermann," *Di Tsukunft* 40 (May 1935), in Harshav, 359.

344 "a man . . . really such": Ibid., 355.

345 "By what disgrace": Stephen Schloesser, *Jazz Age Catholicism: Mystic Modernism in Postwar Paris, 1919–33* (Toronto, 2005), 186.

346 "I can't speak": Haggard, 83.

346 "the incessant": René Schwob, *Chagall et l'âme juif* (Paris, 1931), 106.

346 "the greatest master": Jacques Maritain, *Creative Intuition in Art and Poetry. The A. W. Mellon Lectures in The Fine Arts* (Princeton, N.J., 1952), 227.

346 " 'Salmon": Salmon, 209.

346 "Marc's world": Meret Meyer, conversation with the author, 2004.

346 "She was": Chagall to Abraham Sutzkever, 14 June 1949, in Harshav, 679.

347 "You are going": Chagall to Opatoshu, 4 February 1931, ibid., 370.

347 "I gazed": Marc Chagall, "With Bialik in Israel," *Literarishe Bleter* [Warsaw] 30 (1934), in *Culture,* 52.

348 "On the roof": Ibid., 53.

349 "the most vivid": Meyer, 385.

349 "In the East": Erben, 103.

350 "I did not see": Meyer, 384.

350 "Ever since": Marc Chagall, "The Biblical Message," 1973, in *Culture,* 172.

350 "in the guise": *My Life,* 39.

351 "For the Jewish": Meyer, 383.

352 "Made by": Meyer Shapiro, "Introduction to Chagall, *The Bible,*" *Verve* (Paris, 1956), in Julien Cain, *The Lithographs of Chagall,* trans. Maria Jolas (Monte Carlo and London, 1960), 20.

353 "Europe is possible": Sullivan, 85.

354 "The atmosphere . . . black with": Ibid., 46.

354 "greater than": Meyer, 400.

354 "the extreme modesty": Fettweis to Chagall, 10 November 1934, unpublished letter, Archives Chagall.

355 "I love to crawl": Chagall to A. Lyesin, 15 March 1934, in Harshav, 435.

355 "I have a great deal": Chagall to Hilla Rebay, 25 March 1935, in Harshav, 441.

CHAPTER 18: Wandering Jew
Paris: 1934–1937

359 "The summer months": Editoral board of *L'Intransigéant* to Chagall, 1934, unpublished letter, Archives Chagall.

359 "pas de discussions": *Cahiers d'art* to Chagall, 1934, unpublished letter, Archives Chagall.

359 "From time . . . tell them": Chagall to Opatoshu, 1934, in Harshav, 435.

360 "Mademoiselle Ida": Otto Schneid to Chagall, 15 May 1934, unpublished letter, Archives Chagall.

362 "the entirely real": Meyer, 400.

362 "How are you": Bella and Chagall to Meir Dizengoff, 1 May 1935, in Harshav, 443.

363 "The city": Bella and Chagall to Opatoshu, 12 August 1935, in Harshav, 445.

364 *"The old shul"*: "The Vilna Synagogue," in Guggenheim, 192.

364 "Strange, but I": *First Encounter*, 3.

364 "une âme . . . those who knew": Chagall, undated 1934, unpublished note, Archives Chagall.

365 "Well, Bella": Chagall to Opatoshu, 22 April 1936, in Harshav, 449.

365 "A few kilometres": Marc Chagall, speech at the World Conference of the Yiddish Scientific Institute, Vilna, 14 August 1935, in *Culture*, 56.

366 "dear, dearest . . . Vilna": Chagall to Opatoshu, 16 July 1935, in Harshav, 445.

366 *Jean Sans Terre*: Ivan Goll, *Jean Sans Terre*, introduction by W. H. Auden (London, 1958), 7.

367 "When I left . . . was very much": *Natasha's Dance*, 544-45.

368 "Let me say": Sullivan, 61.

368 "a tragic lapse": Ibid., 62.

369 "I do not": Ehrenburg III, 138.

369 "don't come back": *Natasha's Dance*, 570.

369 "the poet": Ibid.

369 "I sit in a dacha": Chagall to Ettinger, 29 August 1936, in Harshav, 449-50.

370 "Though in the world": Chagall to Ettinger, 4 October 1936, in Harshav, 451.

371 "confounding . . . entirely pampered": *Années Russes*, 157.

371 "Dear Yuri": Chagall to Pen, January 1937, in Harshav, 453-54.

CHAPTER 19: White Crucifixion
Paris and Gordes, 1937–1941

374 "How deeply . . . There were pictures": Peggy Guggenheim, ed., *Art of this Century*, exhibition catalogue (New York, 1942), 7.

376 "We were faced": Eddie Silver, "Turtle Diary," in *St. Louis Riverfront Times,* 12 July 2000.

379 "to the plane of": Erben, 115.

379 "About suffering": W. H. Auden, "Musée des Beaux Arts," in *Collected Poems* (London, 1994), 179.

379 "the style": *First Encounter,* 345.

380 "Wars are fought": Goll, 212.

380 "Yesterday": Ibid., 211.

381 "that untranslatable horror": Alexandre Benois, "Les Expositions: Chagall, oeuvres recents," in *Cahiers d'Art* [Paris] 15, nos. 1-2 (1940), 33.

382 "the entirely": Breton, 64.

382 "All these colours . . . The pity": Lionello Venturi, *Painting and Painters: How to Look at a Picture, from Giotto to Chagall* (New York, 1946), 229, 231.

383 "My first great": Haggard, 29.

383 "imagined he": Meyer, 431.

384 "Hello my dear": Bella to Chagall, 28 March 1940, unpublished letter, Archives Chagall.

385 "an exaggerated faith": Elon, 394.

385 "We couldn't imagine": Sullivan, 13.

386 "I hesitated": Chagall to Solomon Guggenheim, 1 June 1941, in Harshav, 499.

387 "this letter . . . Very dear . . . It seems": Chagall to Sh. Nigger, 1 September 1940, in Harshav, 483-84.

388 "a knife": Sullivan, 189.

388 "a backdoor": Ibid., 185.

389 "Since 1910 . . . Since that date . . . sans profession . . . I have always": Copies of applications for re-entry visas, 20 January 1941, unpublished material, Archives Chagall.

390 "Spent the weekend": Harshav, 495-96.

390 "Imagine the situation": Sullivan, 181.

391 "Since I cannot": Elon, 402.

392 "Marseilles, flushed": Ibid., 169, 167.

394 "A wall": Guggenheim, 192.

394 "I am happy": Chagall to Guggenheim, 1 June 1941, in Harshav, 500.

394 "Here in the harbour": Erben, 115.

CHAPTER 20: America
New York, 1941–1944

396 "It has often": unpublished note, 1941, Archives Chagall.

396 "Grateful but": Jean-Michel Palmier, *Weimar in Exile* (London, 2006), 494.

397 "God knows what": July 1941, in Harshav, 513.

397 "The Germans are not": Hosking, 498.

397 "I know . . . I hurl": Marc Chagall, "To My City Vitebsk," *Eynikeyt,* 15 February 1944, in *Culture,* 92–93.

398 "There is not even": Chagall to Opatoshu, 29 July 1941, in Harshav, 512.

398 "came back": Chagall to Opatoshu, September 1941, in Harshav, 513.

399 "has been and is": Venturi, 232.

400 "Bella succeeded": Meyer, 437.

400 "Paris, I cannot": Maritain, 14.

401 "for all his apparent": James Johnson Sweeney, *Marc Chagall* (Chicago, 1946), 63.

402 "My artists": E. J. Thaw, "Pierre Matisse and his Artists," *New Criterion* [New York], May 2002.

402 "I grew up": John Russell, "Dean of Dealers Reflects on the Art World," *New York Times,* 5 July 1981.

404 "a seven year": García-Márquez, 171.

405 "every evening": Ibid., 215-16.

405 "I should very much": Ibid., 173.

405 "I did not ask": Ibid., 179.

405 "the two Russians": Ibid., 292.

405 "choreographer . . . For Chagall": Meyer, 438.

406 "I hope": Chagall to Opatoshu, 10 September 1942, in Harshav, 519-20.

406 "Chagall's decorations": Bella to Opatoshu, September 1942, in Harshav, 520.

410 "From up close": Chagall to Opatoshu, 24 July 1943, in Harshav, 534.

411 "Christian humanists . . . a new sun": Marc Chagall, "Unity–Symbol of our Salvation," speech at the Conference of Jewish Writers, Artists, and Scientists, February 1944, *Eynikeyt* [New York], 15 February 1944, in *Culture,* 189.

411 "Horror": Bella Chagall to the Opatoshus, undated 1942, in Harshav, 517.

411 "Father, Mother": *First Encounter,* 3.

412 "superstition": Bella Zelter, Bella Chagall's niece, conversation with the author, 2004.

412 "she cannot": Chagall to Opatoshu, undated 1942, in Harshav, 517.

412 "She wrote": *First Encounter,* 345.

412 "Always present": Meyer, 465.

413 "I'd always thought": *First Encounter,* 337-42.

414 "Here the only Jews": Bella to the Opatoshus, 24 July 1943, in Harshav, 535.

415 "All around": Bella to the Opatoshus, 8 March 1944, in Harshav, 537.

415 "fresh and . . . Why this": *First Encounter,* 346.

416 "The thunder": Ibid.

CHAPTER 21: Virginia

New York and High Falls, 1944–1948

417 "I do not know": Marc Chagall, "Your Call," Guggenheim, 195.

417 "I have never seen": unpublished letter, September 1944, Archives Chagall.

417 "She was so warm": Varian Fry to Chagall, September 1944, unpublished letter, Archives Chagall.

417 "My thoughts": Bush Meier-Graefe to Chagall, September 1944, unpublished letter, Archives Chagall.

417 "At the funeral": Claire Goll, 281.

418 "My dears": Ida Chagall to the Rosenfelds, 27 March 1945, in Harshav, 554.

419 "We were having": Haggard, 23-24.

419 "Deeply moved": Chagall to Jewish Anti-Fascist Committee, September 1944, unpublished letter, Archives Chagall.

419 "Missing you": Ida Chagall to Jewish Anti-Fascist Committee, September 1944, unpublished letter, Archives Chagall.

420 "Your condolence": Chagall to Jewish Anti-Fascist Committee, September 1944, unpublished letter, Archives Chagall.

420 "I am sure": Chagall to Ettinger, 30 April 1945, in Harshav, 558.

420 "I write for you": *First Encounter,* 4.

421 "rushed in": Haggard, 35.

421 "she's more than": Ibid., 25.

422 "I have recollections": Roditi, 29.

422 "Marc got up": Haggard, 29.

422 "I am very": Chagall to Jean Grenier, 7 February 1945, in Harshav, 551.

422 "despite all my thoughts": Chagall to Opatoshu, 14 May 1945, in Harshav, 557.

423 "Papa is": Chagall to the Rosenfelds, 27 March 1945, in Harshav, 554.

424 "Of course": Chagall to the Opatoshus, July/August 1945, in Harshav, 558.

425 "our tragedy": *Natasha's Dance,* 545.

425 "often pondered": Haggard, 73.

427 "a handsome": Ibid., 13.

428 "pale oval": Ibid., 28.

428 "but the eyes": Ibid., 14.

428 "as he worked": Ibid., 18.

428 "it was Bella": Ibid., 57.

429 " 'Because I have": Ibid., 17.

429 "They say": Ibid., 38.

430 "Comme vous": Ibid.

430 "Ida was": Ibid., 37.

431 "My departed": Harshav, 567.

431 "You must": Haggard, 42.

431 "in my opinion": Unpublished note, 13 October 1945, Archives Chagall.

432 "Chagall's set designs": John Martin, *New York Times,* 11 November 1945.

432 "Marc Chagall's": Edward Denby, *Dance Writings* (New York, 1986), 331-32.

433 "suddenly Jean": Haggard, 49.

433 "a simple wooden . . . A grassy": Ibid., 51.

433 "What can I": Chagall to the Opatoshus, 25 March 1946, in Harshav, 575.

434 "often spoke": Haggard, 57.

434 "his mother": Ibid., 111.

434 "cold beauty": Chagall to the Opatoshus 10 April 1952, in Harshav, 789.

435 "As you can imagine": Virginia Haggard to Louis Stern, 12 April 1948, in Harshav, 647.

435 "I thought it well": Chagall to Daniel Catton Rich, 8 December 1946, unpublished letter, Archives Chagall.

436 "You must": Haggard, 59.

436 "I knew": Ibid., 62.

436 "Returning": Unpublished note, summer 1946, Archives Chagall.

437 "May we find": "Comfort Ye My People," Speech at Yiddish Culture League, Paris, 8 July 1946, *Parizer shriftn,* 4 September 1946, in *Culture,* 108.

437 "You don't know": Haggard, 65.

437 "give her . . . Well, what": Chagall to the Opatoshus, 25 June 1946, in Harshav, 588.

437 "You can't": Haggard, 66.

439 "I lunch": Ibid., 65.

439 "Only that land": Guggenheim, 186.

439 "I know": Haggard, 65.

439 "The French": Ibid., 22.

440 "Your white": Guggenheim, 196.

440 "What do you think": Spurling II, 442.

440 "People are waiting": Haggard, 79.

442 "Here in our place": Chagall to the Opatoshus, 9 July 1947, in Harshav, 612.

442 "Your sun . . . it is terribly sad": Chagall to Virginia, 3 October and 7 October 1947, in Harshav, 619-20.

442 "great retrospective": Erben, 128.

443 "Paris is waiting": Haggard, 77.

443 "Our voyage": Chagall to Opatoshu, 28 July 1948, in Harshav, 645-46.

CHAPTER 22: Return to Europe

Orgeval and Vence, 1948–1952

444 "It was like": Haggard, 82.

445 "As a couple": Ibid., 86.

446 "these were not": Jean McNeil, conversation with the author, 2003.

446 "My Dovid'l": Chagall to Opatoshu, 16 May 1949, in Harshav, 677.

446 "Marc was growing": Haggard, 94.

448 "the only aspect": Spurling II, 438.

448 "I saw your father": Chagall to Pierre Matisse, September 1948, in Harshav, 657.

448 "The mobility": Izis, 21.

448 "Oh, my daughter": Chagall to Abraham Sutzkever, October 1950, in Harshav, 717.

448 "everything turns": Haggard, 144.

449 "Sometimes it happened": Ibid., 115.

450 "muttered": Yuri Trifonov, *Vechnye Temy* [Moscow] (1984), 627, in Guerman, 120.

450 "I myself": Chagall to the Opatoshus, 28 July 1949, in Harshav, 684.451

451 "perpetually": Haggard, 40.

452 "never quite": Ibid., 114.

453 "at the far end": Erben, 9, 10.

454 "roughly": Spurling II, 442.

455 "she put on": Gilot, 263.

455 "had a very": Ibid., 264.

456 "I hear": Ibid.

456 "What a genius": Ibid., 265.

456 "When Matisse": Ibid.

456 "hangs in": Erben, 128.

457 "emphatic and": Ibid., 128.

458 "he never": Haggard, 142.

458 "I need": Jean McNeil, conversation with the author, 2003.

458 "Ida came": Cassou, 293–94.

459 "better a genius": Couturier, interview by Roberts Schwartzwald, *Harper's Bazaar,* December 1947, 121–22.

459 "we must": Spurling II, 450.

459 "I don't need": Ibid., 452.

460 "Just then": Meyer, 508.

461 "squared": Haggard, 147.

461 "they cry": Chagall to Opatoshu, 13 July 1951, ibid., 757.

461 "Marc was": Haggard, 111.

461 "I longed": Ibid., 154.

461 "It is dreadful": Ibid., 146.

462 "In Orgeval": Cassou, 284.

462 "he got so good": Haggard, 109.

462 "Marc gave me": Ibid., 133.

462 "every night": Goll, 282.

463 "feeling that . . . Are you helping": Jean McNeil, conversation with the author, 2003.

463 "She was there": Haggard, 163.

464 "my small and great": Chagall to Opatoshu, 11 September 1951, in Harshav, 762.

465 "I love you": Chagall to Virginia, 12 February 1952, in Harshav, 775.

465 "How sad": Chagall to the Opatoshus, February 1952, in Harshav, 772.

465 "How are things": Chagall to Virginia, 4 March 1952, in Harshav, 783.

466 "he beat": Haggard, 167.

466 "for two weeks": Ida to Bernard Reis, 2 May 1952, in Harshav, 791.

467 " 'Don't laugh": Gilot, 265.

467 "After seven years": Chagall to the Opatoshus, 10 April 1952, in Harshav, 788–89.

467 "I wanted this new love": Haggard, 169.

467 "I think that in her craziness": Chagall to the Opatoshus, 10 April 1952, in Harshav, 788–89.

468 "tell your mother . . . Which Charles": Jean McNeil, conversation with the author, 2003

CHAPTER 23: Vava
Vence, 1952–1960

469 "to come . . . a temporary": Ida to Bernard Reis, 2 May 1952, in Harshav, 791.

469 "One great calamity": Chagall to the Opatoshus, 10 April 1952, in Harshav, 789.

470 "I send you": Chagall to Anne-Marie Meier-Graefe, 17 June 1951, unpublished letter, Archive Marbach.

470 "I am still very sad": Chagall to Meier-Graefe, 9 May 1952, unpublished letter, Archive Marbach.

470 "Ma bouche cheri, I want": Chagall to Meier-Graefe, 18 May 1952, unpublished letter, Archive Marbach.

470 "Excuse moi me fautes": Ibid.

470 "I am at the moment . . . I want to make . . . Je t'embrasse": Chagall to Meier-Graefe, undated 1952, unpublished letter, Archive Marbach.

471 "She turned me down": Meret Meyer, conversation with the author, 2004.

471 "You can imagine": Chagall to the Opatoshus, 30 July 1952, in Harshav, 794.

472 "He drank": Erben, 150.

473 "There must": Chagall to the Opatoshus, 23 July 1952, in Harshav, 795.

473 "You probably know": Chagall to Sutzkever, 11 August 1952, in Harshav, 811-12.

473 "in both the geographical": Meyer, 547.

473 "Greece seemed": Ibid.

474 "the necessary": Haftmann, 160.

475 "Father has not": Ida to the Opatoshus, 17 October 1952, in Harshav, 813.

476 "for years . . . May God": Chagall to the Opatoshus, 14 November 1952, in Harshav, ibid.

477 "God knows": Chagall to the Opatoshus, 12 July 1953, in Harshav, 817.

477 "keeps the house . . . She is filled": Chagall to Opatoshu, 16 September and 26 April 1954, in Harshav, 832, 821.

478 "everyone had hated": Virginia Haggard, conversation with the author, 2003.

479 "Ya ne . . . is a great *stratège*": Ida to Louis Stern, 8 September 1952, in Harshav, 872.

480 "My dear Chagall": Larionov to Chagall, 22 March 1951, unpublished letter, Archives Chagall.

480 "Paintings seem": Spurling II, 428.

483 "Paris, my heart's": Meyer, 545.

485 "The Jewish soul": Haftmann, 142.

485 "by making": Ibid.

487 *"They were led"*: Guggenheim, 197.

488 "I beg you not": Chagall to Daniel Charny, 30 August 1957, in Harshav, 844.

488 "Painting is . . . is so full . . . The melancholy": Meyer, 558.

490 "Je cherche": Erben, 153.

490 "We have to": Chagall to Charles Marq, 19 August 1958, in Harshav, 859.

CHAPTER 24: Decade of the Large Wall
Vence and St. Paul, 1960–1970

491 "the transparent": Natalia Apchinskaya, "Marc Chagall: Artist of the Bible," in Tretyakov, 147.
491 "Like medieval": Ibid.
492 "Man is absent": Erben, 156.
492 "mysteriously": Susan Compton, *Chagall,* exhibition catalogue, Royal Academy of Arts (London, 1985), 254.
492 "to match": Meyer, 589.
494 "hardly visible": Izis, 18.
494 "he was conscious": Tretyakov, 148.
494 "Ich gleib": Izis, 22.
494 "gave the effect": Meyer, 589.
495 "decade": Erben, 153.
496 "the pervading atmosphere": Izis, 23.
496 "used to": Ibid., 22.
497 "And then the panel": Ibid.
498 "Vous avez": David McNeil, *Quelques pas dans les pas d'un ange* (Paris, 2003), 96.
498 "Isn't it": "Midsummer Night's Dreamer," *Time,* 30 July 1965.
499 "the biggest": Genauer, 57.
499 "yelled": Ibid., 46.
500 "enchanted": "Midsummer Night's Dreamer," *Time,* 30 July 1965.
500 "Chagall is . . . In the azure": Ibid.
500 "have realized": Ibid.
501 "the sweat on": Harshav, 901.
501 "all the appearance . . . Unfortunately": Varian Fry to Jacques Lipchitz, 4 February 1965, ibid., 902.
503 "Maître . . . What would you like . . . straight into": Heinz Berggruen, conversation with the author, 2004.
503 "Sometimes": Izis, 23.
504 "perfect guardian": Haggard, 180.
504 "My procurer general": "Midsummer Night's Dreamer," *Time,* 30 July 1965.
506 "My life": Erben, 13.
506 "robust man . . . the smile . . . quickly": Crespelle, 294-96.
506 "Grandfather": Bella Meyer, "Chagall in Moscow," Tretyakov, n.p.
506 "the art establishment": "Midsummer Night's Dreamer," *Time,* 30 July 1965.
507 "We are suffering": Meyer, 598.
507 "art of . . . reached a level": David Sylvester, *About Modern Art: Critical Essays 1948–97* (London, 1997), 71.
509 "The end of life": Crespelle, 296.
509 "the guarantor": "Midsummer Night's Dreamer," *Time,* 30 July 1965.
510 "And Passover!": *My Life,* 39.

CHAPTER 25: "I Was a Good Artist, Wasn't I?"
St. Paul, 1971–1985

513 "At 86": Kamensky, 15.
513 "My colleagues": Vsevolod Volodarsky, "Chagall at the Tretyakov Gallery 1973," in Vitali, 129.
513 "We pulled back": Ibid.
515 "You know . . . Ah, that's colour": Ibid., 129-32.
515 "Flamed": Ibid., 132.
515 "became quite agitated": Ibid.
515 'No, no': Ibid.
516 "I pray": Bella Meyer, lecture at San Francisco Museum of Modern Art, 26 July 2005.
516 "He takes so many": "Midsummer Night's Dreamer," *Time,* 30 July 1965.
516 "he seems to have foiled": Schneider, 156.
516 "a superb": Father Klaus Mayer, conversation with the author, 2003.
517 "As always . . . We are both": Vava to Pierre Matisse, 13 November 1975, in Harshav, 946.
518 "The very special": Patrick Cramer, *Marc Chagall: The Illustrated Books: Catalogue Raisonée* (Geneva, 1995), 15.
519 "Keep a little": Ida to Pierre Matisse, 23 April 1976, in Harshav, 947.
519 "Your hanging": Ida to Pierre Matisse, 13 June 1977, in Harshav, 949.
521 "Marc was not": Haggard, 185.
521 "I realize": Ibid., 187.
521 "You are the only": Vava to Charles Marq, 28 November 1984, in Harshav, 955.
522 Ida forbade: Meret Meyer, conversation with the author, 2004.

INDEX

Numerals in *italics* indicate illustrations.

A NOTE ABOUT THE AUTHOR

Jackie Wullschlager is chief art critic for the *Financial Times*. Her books include a prizewinning life of Hans Christian Andersen and an acclaimed group biography of children's book writers, *Inventing Wonderland*.

A NOTE ON THE TYPE

This book was set in Bodoni, a typeface named after Giambattista Bodoni (1740-1813), the celebrated printer and type designer of Parma. Bodoni's innovations in type style included a greater degree of contrast and a more angular finish of details.

Composed by North Market Street Graphics,
Lancaster, Pennsylvania
Printed and bound by R. R. Donnelley,
Harrisonburg, Virginia
Designed by Wesley Gott